CULTURE JAMM

Culture Jamming

Activism and the Art of Cultural Resistance

Edited by

Marilyn DeLaure and Moritz Fink

NEW YORK UNIVERSITY PRESS

New York

NEW YORK UNIVERSITY PRESS
New York
www.nyupress.org

Foreword to this volume copyright by Mark Dery.

Culture Jamming: Hacking, Slashing, and Sniping in the Empire of Signs originally appeared in the Open Magazine Pamphlet Series, no. 25 (1993). Copyright by Mark Dery. Reprinted with the permission of the author.

"Pranking Rhetoric: 'Culture Jamming' as Media Activism" originally appeared in *Critical Studies in Media Communication* 21, no. 3 (2004). Copyright by Taylor & Francis. Reprinted with permission.

An earlier version of "Never Mind the Bollocks: Shepard Fairey's Fight for Appropriation, Fair Use, and Free Culture" appeared on *Confessions of an Aca-Fan: The Official Weblog of Henry Jenkins*, January 13, 2010. Copyright by Evelyn McDonnell.

An earlier version of "The Poetics of Ruptural Performance" was published in *Liminalities: A Journal of Performance Studies* 5, no. 3 (2009), as "What the Fuck Is That? The Poetics of Ruptural Performance." Copyright by Tony Perucci.

An earlier version of "Turning Tricks: Culture Jamming and the Flash Mob" appeared in *Liminalities: A Journal of Performance Studies* 7, no. 2 (2011), as "Badgering Big Brother: Spectacle, Surveillance, and Politics in the Flash Mob." Copyright by Rebecca Walker.

An earlier version of "Billionaires for Bush" appeared on the *Reality Sandwich* website, 2009. www.realitysandwich.com. Copyright by Andrew Boyd.

References to Internet websites (URLs) were accurate at the time of writing. Neither the authors nor New York University Press is responsible for URLs that may have expired or changed since the manuscript was prepared.

ISBN: 978-1-4798-7096-7 (hardback)
ISBN: 978-1-4798-0620-1 (paperback)

For Library of Congress Cataloging-in-Publication data, please contact the Library of Congress.

New York University Press books are printed on acid-free paper, and their binding materials are chosen for strength and durability. We strive to use environmentally responsible suppliers and materials to the greatest extent possible in publishing our books.

Manufactured in the United States of America

10 9 8 7 6 5 4 3 2 1

Also available as an ebook

For culture jammers around the world:

past, present, and future . . .

CONTENTS

FOREWORD

MARK DERY

Has culture jamming, that 1990s mash-up of "media hacking, information warfare, terror art, and guerrilla semiotics," gone the way of all fads? "The old rhetoric of opposition and co-optation assumed a world where consumers had little direct power to shape media content," Henry Jenkins contended in 2006, in his book *Convergence Culture*, "whereas the new digital environment expands the scope and reach of consumer activities" (215).

Is jamming a quaint anachronism in a networked world where Facebook and Twitter pass the mike to anyone with a Net connection, giving her access to a global PA system, free of charge? Where smartphone videos of the beat downs and murders of black people by white cops are driving the national conversation about race? Is jamming just more of the same crankypants elitism and gloomy declinism familiar from Neil Postman's *Amusing Ourselves to Death* (1985), *the* foundational text of the shoot-your-TV school of media criticism? Were the culture jammers of the 1990s heirs apparent to Marxist killjoys like the Adorno and Horkheimer of "The Culture Industry: Enlightenment as Mass Deception" (1944)? Were they vanguardist snobs whose disdain for the masses, so easily gulled by the hidden persuaders and subliminal seducers of Madison Avenue and Hollywood, was equaled only by their obliviousness to the conundrum at the heart of their argument: namely, if the media pull the wool over our eyes, how had *they* managed to spy out the truth? Is jamming's tactical irony—its attempt to regard the Society of the Spectacle from a critical distance—mere comic relief in the eyes of millennials born into a world where subcultural resistance is almost instantly appropriated by corporate coolhunters? Was jamming *always* an ornament to power (the irony!) in its paranoid insistence on the mind-controlling powers of the newsmedia, advertisers, and mass

entertainment? In the twenty-first century, has culture jamming become irrelevant to the struggles of our moment because "the old rhetoric of opposition and co-optation" is laughably outdated, rendered obsolete by the digital disruption that has flattened media hierarchies, expanding "the scope and reach of consumer activities"?

Of course, no one would deny that we live in a media galaxy far, far away from the one jammers inhabited in the 1990s. The web— specifically, the many-to-many video-sharing sites like YouTube; social-media platforms like Facebook, Twitter, and Reddit; and alternative sources of news and commentary such as the *Drudge Report* and *Breitbart* on the Right and *Truthout* and the *Daily Kos* on the Left—have (at least in theory) broken the chokehold that TV and "papers of record" such as the *New York Times* had on public discourse and popular opinion. Jamming in the 1990s was a subcultural backlash, given intellectual momentum by critics such as myself, against a society in which a powerful few spoke while millions listened. Broadcast news shaped the national conversation about current events, mobilizing mass consent for elite agendas and marginalizing dissenters who challenged the status quo consensus of pols, pundits, and think-tank hacks. Commercials ginned up consumer desire for fetishized commodities, drawing on mass psychology and Freudian analysis to bathe those commodities in an aura of powerful emotional associations.

By contrast, those who've grown up in the Digital Age are wise to the ways of the persuasion industry, immunized by their visual literacy, not to mention all those semiotics courses at Brown. Or so we're told. And anyone with wi-fi access can speak truth to power. Anyone in the right place at the right time, smartphone in hand or dashboard cam rolling, can commit an act of journalism, the story goes.

It could also be argued that many of the tactics devised for semiotic guerrilla warfare in a pre-web world—when access to opposing viewpoints and platforms for public address was far more limited—are irrelevant in our networked age. And if not irrelevant, ineffectual: billboard banditry, *détourned* ads, media hoaxes, street theater, and guerrilla interventions seem absurdly analog ways of hacking the matrix, circa 2016.

But since this is, after all, a foreword to an anthology of essays on culture jamming, it seems only fitting that I monkeywrench some of these received truths. To begin, the presumption that if, as A. J. Liebling ob-

served, "freedom of the press is guaranteed only to those who own one," then the claim that the web has radically democratized journalism conveniently ignores the fact that the social media where most of us swap memes and post links (to brand-name websites, more often than not) is private property masquerading as the town square. Whether we're Liking LOLcat photos or lifting our voices in righteous rage about the social injustice of the day, we're working as unpaid content providers for Lords of the New Economy like Mark Zuckerberg, who are only too happy to mine our personal data and sell it to advertisers. And while we're on the subject of LOLcats, the web isn't exactly bringing up a bumper crop of I. F. Stones and George Seldeses, though it has proven fertile ground for sites like Buzzfeed, Gawker, and Thought Catalog, which attract advertisers by providing platforms for user-generated content, much of it listicles by overshare-y Millennials, most of it unpaid, and precious little of it fact-checked.

Meanwhile, back in the Desert of the Real, the consolidation of big-media outlets into fewer and fewer multinational brands continues apace, thanks to the 1996 Telecommunications Act, which eviscerated the regulation of cross-media ownership. Major print and TV news outlets are chain-sawing staff and shuttering foreign bureaus at a moment when geopolitical literacy is more important than ever. Ad copy crafted to look like news coverage is blurring the boundary between reported fact and "sponsored content." Simultaneously, the proliferation of niche media markets on the web and around the cable dial—unquestionably a good thing when it comes to a diversity of opinion—turns out to have a downside: from Fox News and its legions on the Right to *Democracy Now!* and *The Rachel Maddow Show* on the Left to *Vibe* out on the gonzo-dude fringe, it's easier than ever before to seal yourself in an ideological hyperbaric chamber and breathe the heady atmosphere of 100 percent pure confirmation bias. Dan Pfeiffer, a former senior adviser at the White House, lays part of the blame for the ideological polarization that has led to congressional gridlock at the feet of the news media, which "has changed so that people select only sources that will confirm their preexisting beliefs." Pfeiffer told *New York* magazine, "We don't have the ability to communicate with [the Republicans]—we can't even break into the tight communication circles to convince them that climate change is real. They are talking to people who agree with them,

they are listening to news outlets that reinforce that point of view, and the president is probably the person with the least ability to break into that because of the partisan bias there."

The question I asked in 1993, "How to box with shadows? What shape does an engaged politics assume in an empire of signs?" is as relevant as ever. TV's influence may be waning, and the web may have popularized the idea of culture as a conversation, not a monologue, but news, entertainment, and advertising media continue to exert a powerful influence on our mental lives—more so than ever before, arguably, given the amount of our lives we spend on the other side of the screen. "TV," for 1990s jammers, was only ever shorthand for broadcast news and advertising as delivery systems for state propaganda, fables of the Good Life (as defined by consumption and careerism), paeans to capitalism, panegyrics to washboard abs, and all the other narratives that bound our sense of possibility as individuals and as a society.

The Society of the Spectacle, as the Situationist Guy Debord called it, is still very much with us—a matrix world where what was once "directly lived" is experienced, increasingly, in virtual form; where our social interactions are "mediated by images" and "the commodity completes its colonization of social life." Debord commits the Rousseauvian sin of harking back to an Edenic "authenticity," when the word and the thing, representation and reality were one, but he's dead on when he decries the Spectacle as the commodification of lived experience and the privatization of community. (How many Facebook "friends" do you have? How many Twitter "followers"? Quantify your social status; tally up your net worth in emotional capital.)

Following Debord, culture jamming reminds us that what Marshall McLuhan called the "folklore of industrial man"—the shared mythology of brands and pop songs and TV shows and movie franchises and online communities that is our common culture—is, more often than not, wholly owned by multinational corporations. The web's, and social media's, empowerment of *citizen* activism lags notably behind the dizzying proliferation of opportunities to consume, and to engage with the culture brought to us by corporations—a cultural dynamic that harmonizes sweetly with growing corporate subversion of democracy in the wake of the Supreme Court's rollback of campaign-spending regulation in *Citizens United v. Federal Election Commission* (2010).

If culture jamming is anything, it's the dream of reclaiming our sense of ourselves as citizens in a culture that insists on reducing us to consumers—wallets with mouths, in advertising parlance. Inspired by jamming's first wave, the political activists, consumer-culture refuseniks, tactical-media insurgents, and practitioners of "semiological guerrilla warfare" (Umberto Eco) who are chronicled and critiqued in these pages have updated the theory and practice of 1990s jamming for a more virtual world. Contemporary jammers give the lie, as the Occupy movement did, and as recent protests against law enforcement's open season on black men have, to the postmodernist canard that the streets are dead capital. They inspire us to loop our virtual lives back into things directly lived, harnessing our online social networks to activist ends, circulating images and information that rouse us to action. They urge us to disseminate the stories the corporate newsmedia won't cover, forcing them onto front pages and nightly newscasts through sheer viral ubiquity. And, yes, they inspire us to update the Situationist tactic of "using spectacular images and language to disrupt the flow of the spectacle" (Debord), dreaming up ways to punch through the seamless surface of the matrix to expose the emptiness of its promise.

As I've written elsewhere, "culture jamming's startling vision of a better world, where we are citizens actively engaged in civic life and public discourse rather than passive consumers of media myths, is not easily forgotten. Haunting the commodified images of the good life in our magazines or on our TV screens, jamming troubles our collective sleep, darkening the dreams that money can buy." Jamming—whose philosophical roots are, after all, in the carnivals of the Middle Ages, in which pigs were baptized, clerics mocked, and the god-given rights of religious power and royal privilege challenged, however briefly—reminds us that culture really is a contest of narratives, a war of stories, and that for every orthodoxy there is an equal and opposite blasphemy.

ACKNOWLEDGMENTS

From Moritz: This project began with a misunderstanding. When I first encountered the term "culture jamming" as a student at the University of Munich, I linked it to my understanding of "jamming" as a form of "playing with," as in a musical jam session. (Since I'm a musician myself, this association seemed obvious, and it turned out that I shared this "misunderstanding" with others working with the concept.) I soon learned that "culture jamming" also had a very different, more critical meaning for many scholars of popular culture.

The original idea behind this volume was to assemble a reader of key texts on culture jamming. In 2010, I began to track down various authors who had published work on the topic, starting with Mark Dery. Mark kindly answered my e-mails—a cold approach by some German guy he'd never met—and agreed that if I found a publisher, he would participate. So, my first thanks go to Mark for having been supportive of the idea from the very beginning.

A second lucky coincidence was that among the scholars I approached was Marilyn DeLaure, who would become my co-editor and friend. I just happened to be traveling through California shortly after reaching out to Marilyn in early 2011, so we were able to meet in person at the beautiful University of San Francisco campus. Marilyn's key role in developing the project can't be emphasized enough. She suggested we put out a call for new scholarly essays, created the idea for the Culture Jammers' Studio section, and was not only an excellent proofreader (taking care of more than just my ESL issues) but also a great manager of the project as a whole. What I once considered my personal intellectual baby has become ours over the years, and I'm sure that without this transatlantic collaboration, this book would never have taken shape.

Nor would this book exist without the ongoing support of my wife, Alex Fink; my greatest personal thanks, therefore, go to her. I also would like to thank my friends Franz Halas and Flo Sedlacek, who always be-

lieved in the realization of this project, even when I doubted it would ever come to an end.

From Marilyn: Though I had no idea what I was getting into when I said "yes," I'm grateful that Mo invited me to join him as co-editor for this project way back in 2011. What a journey it has been! Thanks to David Silver, Brent Malin, Joan Faber McAlister, Brian Ott, Donovan Conley, Maximilian DeLaure, and Bruce Gronbeck for feedback on various drafts of the introduction. (I'm fortunate to have had Bruce as my doctoral adviser and steadfast champion; I'm sorry he's not here to see this book in print.) Finally, I am grateful for the support from friends and family over the years—especially Joan, Nicole, Kari, Sarah, the Two Jens, Melissa, and most of all Max, Naiya, and Oriana.

From both of us: We appreciate the patience and good will of our many contributors as we've alternately told them to "Hurry up!" and then "Wait . . ." We thank Ciara McLaughlin at New York University Press for some good suggestions at the very early stages, and especially Alicia Nadkarni for her enthusiasm for the project, and for guiding us through the publication process. The Faculty Development Fund at the University of San Francisco offered generous support for this book, including the funding of three outstanding research assistants: Steven Slasten, Isabella Neterval, and Emma Elliott. Additional thanks go out to Henry Jenkins for his sage advice, as well as our anonymous reviewers whose critique helped improve the final manuscript.

Introduction

MARILYN DELAURE AND MORITZ FINK

November 18, 2011. University of California-Davis students demonstrating in solidarity with Occupy Wall Street sit with their arms linked, blocking a sidewalk. When they refuse to disband, campus security officers shower them with pepper spray. A photograph of Lieutenant John Pike casually shooting an orange stream at the bowed heads of students goes viral as the meme "Casually Pepper Spray Everything Cop," where Pike is photoshopped into various scenes representing US democracy, including the Statue of Liberty, Mt. Rushmore, and John Trumbull's 1819 painting *Declaration of Independence*. These images become emblematic of the excessive police force deployed against peaceful protestors and reveal the limits to America's sacred right of free speech.

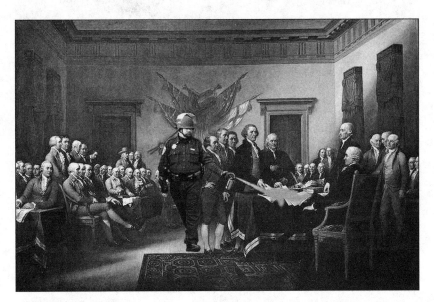

Figure I.1. Pepper Spray Cop on Trumbull's *Declaration of Independence*.

June 4, 2013. Chinese web activists seeking to mark the anniversary of the Tiananmen Square protests circulate creative parodies of the iconic "Tank Man" photograph, as search terms related to the incident are blocked on Sina Weibo, China's popular micro-blogging site. In one, the tanks have been replaced with four giant yellow rubber duckies (evoking the rubber duck sculpture in Hong Kong's Victoria Harbor); in another, the scenario is built out of Legos; in yet another, the scene is reenacted by a cow facing down a line of approaching bulldozers. Through these remakes of the "Tank Man" image, Chinese dissidents could commemorate the Tiananmen massacre, even while the authoritarian state seeks its official erasure.

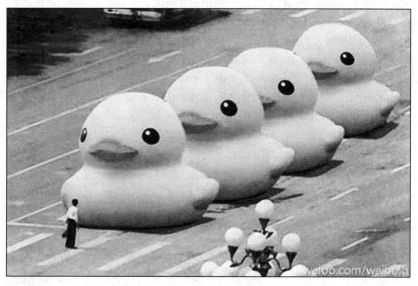

Figure 1.2. Rubber Ducky Tank Man.

November 23, 2013. A group of activists stage a photo shoot in the Brooklyn, New York, IKEA store in response to the home furnishing giant's purging images of a lesbian couple from the Russian edition of *IKEA Family Live* magazine. IKEA had removed the photographs to comply with Russia's new law banning "gay propaganda." To protest the Russian law and IKEA's capitulation, photographer Alexander Kargaltsev (granted asylum in the United States based on his LGBT status) snaps shots of smiling gay and lesbian couples posing in kitchens and

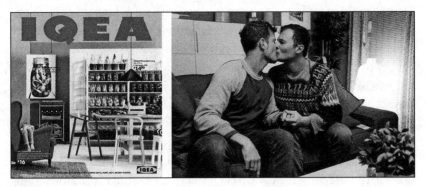

Figure 1.3. "IQEA." Photo by Alexander Kargaltsev.

on couches. Alternative publisher OR Books posts the "IQEA" catalog images online, helping to shed public light on Russia's persecution of gays and lesbians in the months leading up to the Winter Olympics in Sochi, Russia.[1]

May 28, 2014. On the day of multinational energy giant Chevron's annual shareholder meeting, the hashtag #AskChevron began trending on Twitter. Ostensibly a corporate-sponsored PR initiative to engage the public via social media—modeled after #AskJPM (JP Morgan), which infamously backfired—#AskChevron was in fact a case of "brandjacking." The activist group Toxic Effect had paid to promote the hashtag on

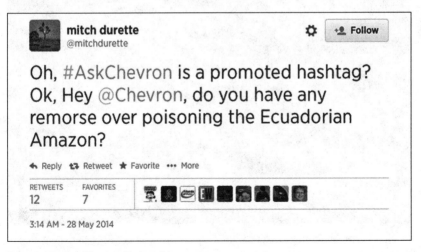

Figure 1.4. #AskChevron Twitter Jam.

Twitter, seeking to draw attention to Chevron's sordid record of environmental damage and malfeasance in Ecuador by inviting people to tweet their own questions to the corporation. Thousands responded, asking a variety of questions under the hashtag, including "What's your beef with the Earth?," "Are you the devil?," and "Can you tell me which country I should bribe & dump my toxins in? Larry Summers won't return my calls" (Abrams 2014).

April 10, 2015. Thousands of ghostly figures, chanting and carrying placards, marched in front of the Spanish Parliament in Madrid to protest the draconian new Citizen Safety Law, which prohibits gathering in front of Congress, assembling in public without a permit, and photographing or recording police. This was the first hologram demonstration in history, mounted by Holograms Por La Libertad, whose website invited people to upload their images, voices, and messages to participate virtually in the march.[2] The high-tech protest cleverly outflanked the authorities by publicly performing a hauntingly powerful message, but leaving no bodies to be arrested, charged, or fined.

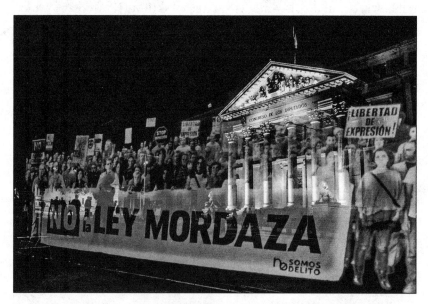

Figure 1.5. Virtual protest march in Madrid, Spain, on April 10, 2015. Photo by Reiner Wandler.

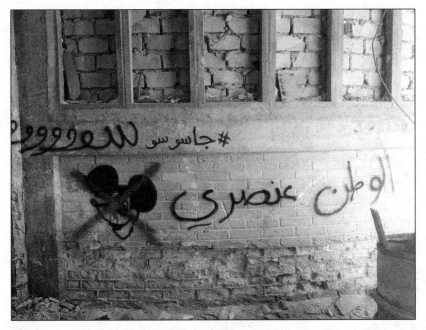

Figure I.6. "*Homeland* is racist" graffito, which appears on the series. Photo courtesy of the artists.

October 11, 2015. Tonight's episode of the American TV series *Homeland* includes scenes of a fictional refugee camp meant to be located in Lebanon, close to the Syrian border. As the protagonists wander through camp, we see graffiti in Arabic script on the walls—apparently symbols of the politically explosive atmosphere in the region. However, what the show's producers and most of *Homeland*'s audience fail to realize is that the Arabic slogans actually translate to "*Homeland* is racist," "The situation is not to be trusted," and "This show does not represent the views of the artists." The Berlin- and Cairo-based "Arabian Street Artists," originally hired by *Homeland*'s producers to lend an "authentic" look to the show's set, have subversively expressed their views about the hit series' "inaccurate, undifferentiated and highly biased depiction of Arabs, Pakistanis, and Afghans, as well as . . . the so-called Muslim world in general" (Amin, Kapp, and Karl 2015).

* * *

In each of these examples, activists have appropriated, reworked, and disseminated cultural symbols in order to contest meanings and challenge dominant forms of power. This book examines phenomena like these—creative acts of popular intervention performed by people seeking change, using whatever means and materials are at hand. We consider these actions instances of "culture jamming," a term that first came into widespread use in the early 1990s. "Culture jamming" commonly refers to a range of tactics used to critique, subvert, and otherwise "jam" the workings of consumer culture. These tactics include media pranks, advertising parodies, textual poaching, billboard appropriation, street performance, and the reclamation of urban spaces for noncommercial use. Using various forms of semiotic defamiliarization, culture jamming seeks to interrupt the flow of mainstream, market-driven communications—scrambling the signal, injecting the unexpected, jarring audiences, provoking critical thinking, inviting play and public participation.

Over the past few decades, techniques of culture jamming have transformed considerably as activists have come to adapt them to different contexts and deploy them via rapidly changing communication media. Whereas early jammers used spray paint and photocopiers, today most of them carry digital recording devices in their pockets and use social media platforms like Facebook or Twitter to aid in the logistical coordination of actions and the rapid dissemination of content. Activists today no longer confront a monolithic broadcast media behemoth that targets passive, unwitting audiences; rather, they operate within what Henry Jenkins (2006) has called "convergence culture," where top-down and bottom-up culture intersect and where media consumers are also media producers. Furthermore, the targets of culture jamming have expanded from advertising and consumerism to include numerous other social and political issues.

The essays, interviews, and creative work assembled in this book explore the shifting contours of culture jamming—plumbing its history, mapping its transformations, testing its force, and assessing its efficacy. While some might consider culture jamming passé, this volume argues for the concept's continuing relevance in our globalized, networked world. Culture jamming tactics have been employed in a variety of contexts in recent years, as our opening snapshots suggest; even given the

hegemonic power of global capital (and the governments that under-write it), people around the world are finding ways to resist and cre-atively intervene. Grassroots activists, artists, and ordinary citizens are reclaiming public space, spreading alternative messages, and fighting for democratic access to media channels. *Culture Jamming: Activism and the Art of Cultural Resistance* examines these actions in order to shed light on the possibilities for creative resistance in the twenty-first century.

Roots and Routes

Like most master terms, "culture jamming" is contested and open to multiple interpretations. One common definition frames culture jamming as essentially negative: jamming up or blocking the flow of commercial messages. Christine Harold, in her 2004 essay reprinted in this volume (chapter 2), calls this type of jamming sabotage, tracing the etymology of that term to "sabot," the wooden clogs worn in many European nations in the nineteenth century. She writes, "'Saboter,' then, meant . . . to 'botch,' presumably by throwing one's wooden shoes into the machinery. 'Sabotage' means literally to 'clog' with one's clogs." An alternative view, articulated by Mark LeVine in chapter 4, likens culture jamming to a musical jam session, where artists and activists gather to experiment with cultural forms and play with one another.[3] In this view, culture jamming is not merely *anti*-consumer capitalism, a critical or negating force; it is also a creative and constructive one, seeking artfully to invent new visions for the future. These two approaches, of course, need not be mutually exclusive: indeed, LeVine asserts that culture jam-ming should be "both critical and positive . . . perform[ing] an inherent critique of the existing system while also showing the way forward to a different future."

While the term "culture jamming" has a relatively short history, its philosophical roots and artistic/activist precursors wend back at least a century. An early version of the expression was coined by Negativland, the San Francisco–based experimental audio collage band whose record *Over the Edge, Vol. 1: Jamcon '84* included a track called "Crosley Bendix Reviews JamArt and Cultural Jamming." On the album, Negativland's Don Joyce (as faux radio commentator Crosley Bendix) discusses bill-board banditry, stating, "The studio for the cultural jammer is the world

at large. His tools are paid for by others—art with *real* risk." Joyce alludes to the covert alterations performed in the 1970s and early 1980s by underground groups including California-based Billboard Liberation Front and the Australian ensemble BUGA UP (Billboard Utilising Graffitists Against Unhealthy Promotion). The term "jamming" here was borrowed from the vernacular of CB (citizens band) radio, where it refers to the rogue practice of interrupting broadcasts and interfering with conversations.

In December of 1990, cultural critic Mark Dery launched the term into the mainstream with his *New York Times* article "The Merry Pranksters and the Art of the Hoax." Dery offered a first conceptual account of "cultural jamming" in his review of a new generation of media-savvy guerrilla artists—Robbie Conal, Jerry Johnson, and Joey Skaggs, as well as art collectives like Church of the SubGenius—who used semiotic appropriation, sociopolitical satire, and media hoaxes to articulate dissent. "Cultural jamming," explains Dery, "is artistic 'terrorism' directed against the information society in which we live." Dery's writings on the subject developed into his seminal essay, *Culture Jamming: Hacking, Slashing, and Sniping in the Empire of Signs*, published in 1993 as part of Open Magazine's Pamphlet Series and reprinted in this volume (chapter 1).[4]

Dery asserts that culture jamming is an "elastic category" that "accommodates a multitude of subcultural practices." He situates culture jamming on a historic continuum of artistic resistance, including premodern folk festivals, artistic movements of high modernity (Dada, Surrealism, Artaud's theater of cruelty), sociopolitical satire, and pop and appropriation art, William Burroughs's cut-up collage, Situationist *détournement*, alternative media practices, Yippie antics, and graffiti art. Describing renegade jammers, Dery writes, "Part artistic terrorists, part vernacular critics, culture jammers, like [Umberto] Eco's 'communications guerrillas,' introduce noise into the signal as it passes from transmitter to receiver, encouraging idiosyncratic, unintended interpretations." He also calls jammers "Groucho Marxists," highlighting their emphasis on play and having fun while attacking dominant ideologies.

In the early 1990s, Dery also published a series of articles in *Adbusters* magazine, the first of which was "Subvertising: The Billboard Bandit as Cultural Jammer." The Adbusters Media Foundation, founded in 1989 by Kalle Lasn and Bill Schmalz, was on a mission to "break the spell that

advertising has cast over our culture" and to protest the lack of demo-
cratic access to the mass media (Lasn and Schmalz 1989). Soon after
Dery introduced the term to Lasn and company, the Media Founda-
tion took up "culture jamming" as its signature catchphrase, dubbing
its website the "Culture Jammers' Headquarters." The advertising-free
Adbusters magazine featured parody ads and cultural critique and pro-
moted anti-consumer campaigns like Buy Nothing Day and TV Turnoff
Week. Circulation grew steadily through the 1990s, and the publication
won Canada's Magazine of the Year award in 1999. To this day, *Adbusters*
remains an important voice in the alternative scene of culture jammers
and critics; the magazine put out the initial call to "Occupy Wall Street"
on September 17, 2011, with a poster of a dancer balancing on the back of
the bronze Wall Street bull.

Drawing on material from the magazine, Lasn published a book-
length manifesto in 1999 titled *Culture Jam: The Uncooling of America*TM.
His book traces the origins of and philosophy behind *Adbusters*, framing
culture jamming as revolutionary praxis. Lasn opens with a bold proc-
lamation: "We call ourselves culture jammers. We're a loose global net-
work of media activists who see ourselves as the advance shock troops
of the most significant social movement of the next twenty years. Our
aim is to topple existing power structures and forge major adjustments
to the way we will live in the twenty-first century" (xi). Lasn's book is a
wake-up call seeking to jar readers out of their consumption-induced
stupors; a cry of rage against the colonization of our physical and mental
environments by marketing messages; a vehement critique of privately
owned, advertising-driven media and corporate personhood; and a de-
mand for returning democracy to the airwaves. The book also offers
instruction in culture jamming tactics, from small personal acts of re-
sistance, to petitioning the government, to "meme warfare."[5] Lasn's style
is brash and irreverent, and an insurgent ethos permeates the book from
the very beginning: its epigraph is Marshall McLuhan's proclamation
that World War III will be "a guerrilla information war with no division
between military and civilian participation" (McLuhan 1970, 66).

Another author from Canada, journalist Naomi Klein, published her
bestseller *No Logo: Taking Aim at the Brand Bullies* later that same year.
Klein's analysis of branding, globalization, labor abuses, and the anti-
sweatshop movement includes a chapter on culture jamming, which

she likens to "semiotic Robin Hoodism" (280). *No Logo* struck a chord with an audience that was growing more alarmed about the expanding power of multinational corporations and more critical of the neoliberal forces driving globalization. Klein argues that in the late twentieth century, multinational corporations based in the global North had largely shifted their energies from making products to building brands, and as such, brands had become a ripe target for attack. Indeed, many demonstrations of the anti-globalization "movement of movements" during the early years of the twenty-first century included both negative jams against brands and corporate capital and positive jams where people from various groups assembled in public spaces, collaborating in raucous, hopeful, carnivalesque "protestivals" (see St. John 2008).

The dramatic protests at the 1999 World Trade Organization meeting in Seattle, for instance, brought together a large and diverse coalition of activists, including labor unions, environmentalists, farmers, feminists, faith-based organizations, and advocates for fair trade, public health, and indigenous and human rights. Protestors not only physically jammed the streets with their bodies—singing, dancing, marching, some dressed as sea turtles and other fauna—but also took direct aim at corporate brands. Black bloc anarchists attacked global brands by vandalizing Seattle's Nike Town storefront and throwing a hammer through a Starbucks window.[6]

Subsequent antiglobalization protests occurred at meetings of the International Monetary Fund (IMF) and World Bank in Washington, DC, and Prague (2000), at the European Union summit in Gothenberg (June 2001), and at the G8 summit in Genoa (July 2001). These demonstrations involved culture jamming actions as well. Autonome a.f.r.i.k.a gruppe (2002), the anonymous guerrilla-communications collective based in Germany, describes how the Prague and Genoa protestors engaged in the "tactical distortion of signs":

> The hip-swinging fairies of the "Pink Block" not only managed to penetrate into the symbolic "heart of the beast" . . . they also created images that took the icon of the stone-throwing street fighter against the police to the point of absurdity. The warrior is a fighting woman in pink, she is a samba dancer. A year later in Genoa, it was Martians, UFOs, the U-NO men and women soldiers of the PublixTheatreCaravan, bikini girls, tire

men, and others that distorted and alienated the firmly fixed image of what a radical demonstration is supposed to look like and how it is to act. (3)

These creative jams confronted authority with imagination, subverting the stereotype of the angry, fist-waving protestor. As Steven Duncombe (2007) puts it, such "mass protests create temporary autonomous zones: a living, breathing, dancing imaginary form of a world turned upside down" (23).[7]

The most comprehensive scholarly account of culture jamming to date is Christine Harold's 2007 monograph *Our Space: Resisting the Corporate Control of Culture*, which expands upon her 2004 essay reprinted here. Harold describes culture jamming as an "insurgent political movement" that seeks to "undermine the marketing rhetoric of multinational corporations" in order to "rescue publics from being consumed by consumption" (xxv–xxvii). From her analysis of a wide range of culture jamming examples, Harold discerns three "rhetorical postures": sabotage, appropriation, and intensification. Sabotage seeks to block or jam the workings of consumer culture using parody and inversion; saboteurs are critical nay-sayers, and as such, wind up creating cynicism and perpetuating the very binaries they attack. Furthermore, Harold argues, sabotage is fundamentally limited in that it fails to "offer a new locus for the desires the market currently seems to satisfy—desires for community, identity, and beauty" (58). Appropriation, by contrast, is used by pranksters and pirates, and it works by "playfully and provocatively folding existing cultural forms in on themselves" (74). While pranking is less negative than sabotage, and does draw attention to the logics behind branding and marketing, Harold asserts that appropriation "still operates via an oppositional stance, a dialectic between the structures of capitalism and a mythical outside" (160).

Harold finds the greatest promise in a third posture, intensification—an idea she gleans from the Creative Commons project and other "open source" movements seeking to make intellectual and cultural work freely available for public collaboration. These projects do not assert or assume an outside space, removed from capitalism; rather, they creatively take up existing market concepts, like private property, and then intensify or amplify them in new ways. As such, intensification is

"not predicated on a dialectical relationship between publics and markets," and so it can offer possibilities for resistance and political action "*within* the logics of postindustrial capitalism" (xxvii).

This notion of intensification is also integral to Henry Jenkins's conception of convergence culture. Like Harold, Jenkins critiques the negative, pessimistic version of culture jamming; in 2006, he even suggested that "perhaps . . . the concept of culture jamming has outlived its usefulness. The old rhetoric of opposition and co-optation assumed a world where consumers had little direct power to shape media content and faced enormous barriers to entry into the marketplace, whereas the new digital environment expands the scope and reach of consumer activities" (215). To replace this oppositional model of jamming, in chapter 5 Jenkins proposes "cultural acupuncture," a term that suggests participation rather than pure resistance, and focuses on how people amplify, intensify, and redirect the circulation of messages.

Both the concept and practices of culture jamming, then, have transformed considerably since the term was first coined in the mid-1980s. This book examines those transformations in an effort to help map the varied and shifting terrain of contemporary activism. While social movements bridging the millennium still rely upon older rhetorical forms—oratory, broadsides, protest songs, marches, and assemblies—many also incorporate variations of culture jamming.[8]

Defining Culture Jamming's M.O.

Culture jamming tactics vary across different historical and geographic contexts. While culture jammers seek to accomplish a range of ends, there are several features common to most of their interventions. Here, we outline a core set of qualities that define culture jamming's modus operandi, illustrating not only what culture jamming *is*, but also what it *does*.

1. *Culture jamming appropriates*. Jammers typically retool existing cultural forms, poaching an image, corporate logo, advertisement, billboard, city wall, or retail space and transforming it into something new. Their raw materials are the images, sounds, landscapes, and habitual practices of late-modern consumer capitalism.[9] Lasn uses the metaphor of jujutsu to describe how culture jammers use the culture

industry's products and strategies against itself—for example, turning the cigarette-pushing Joe Camel into "Joe Chemo," or organizing flash mobbers to prostrate themselves in mock worship before a shrine-like display at a Toys 'R' Us store. As Leah Lievrouw (2011) puts it, "What makes culture jamming distinctive . . . is that it 'mines' mainstream culture to reveal and criticize its fundamental inequities, hypocrisies, and absurdities" (80).

This process of mining mainstream culture and of appropriating and then transforming texts was called *détournement* by Situationist International, a collective of radical intellectuals and avant-garde artists who critiqued the "society of the spectacle" during the 1960s.[10] *Détournement* has no exact English counterpart, but close translations include "detour," "diversion," "subversion," "hijacking," and "misappropriation" (Harold 2007, 7; McLeod 2011, 3). The French term captures the critical impulse to turn culture back on itself: as Lasn (1999) writes, "Literally a 'turning around,' *détournement* [for the Situationists] involved rerouting spectacular images, environments, ambiences and events to reverse or subvert their meaning, thus reclaiming them" (103). *Détournement* prompts a double-take by viewers, creating a kind of "perspective by incongruity": A hijacked billboard, for instance, not only attacks a specific brand, but prompts critical reflection upon the entire institution of advertising.[11] Street artist Banksy's query "What are you looking at?," painted on a wall opposite a security camera, turns the authoritative gaze back on itself, protesting the encroachment of surveillance into public spaces.[12]

Because culture jamming appropriates existing materials, it is often technically illegal, in that it violates laws governing copyright and ownership. As both Kembrew McLeod (2007) and Lawrence Lessig (2004) have documented, intellectual property law in the United States effectively criminalizes the appropriation, remixing, and disseminating of various cultural forms. Hence culture jamming interventions may risk legal sanction; however, they importantly work to protest the shrinking realm of the intellectual and cultural commons, challenging copyright law with assertions of "fair use."[13]

Christof Decker opens our Critical Case Studies section with his reading of 1970s compilation documentaries by the American filmmaker Emile de Antonio, focusing especially on the 1971 film *Millhouse: A White Comedy*. As Decker suggests, de Antonio's appropriative use of

audiovisual material anticipated culture jamming practices and created "a unique convergence of documentary representation and media activism." With his idea of a "national electronic archive," de Antonio envisioned free and open access to the realm of media culture—a notion that has today been partially realized with online platforms such as YouTube.

The legal challenges posed by appropriative art is also a central theme of Evelyn McDonnell's chapter on Shepard Fairey's *Hope* poster, which rose to iconic status during Barack Obama's 2008 presidential campaign. McDonnell traces the origins of Fairey's form of culture jamming to the bricolage aesthetic of the 1970s punk scene, Dadaism and the appropriation art of the 1950s, 1960s, and 1970s, and the "sampling" practices of rap music. Her analysis of the legal showdown between Fairey and the Associated Press provides insights into the struggles over "free use" and illustrates, as she puts it, "what can happen to culture jammers when they fly too close to the sun."

2. *Culture jamming is artful.* Another signature feature of culture jamming is that it is artful, in both senses of the word: it is typically clever and cunning, and also exhibits creative skill. Culture jammers play with form, creating works that are aesthetically pleasing or arresting, whether in visual, aural, or performative registers. Billboard jammers, for instance, don't just deface or obliterate commercial messages; rather, they execute clever visual or verbal puns. Many of *Adbusters'* subvertisements over the years have been created by graphic designers and advertising industry artists—some of whom have jumped the corporate ship, and others who still work at ad agencies but moonlight as covert jammers—so the parody ads have the same professional quality as the originals they mimic.

Most of the jammers featured in this volume are artists of various stripes: painters, musicians, filmmakers, photographers, graphic and web designers, actors. Their work merges art and activism, endeavoring to shift how we experience and interpret the world. As painter Paul Klee said, "Art does not reproduce what we see; rather, it makes us see" (quoted in D'Ambrosio 2013, par. 7). Historically, artists have been the vanguard of societies—pushing boundaries, challenging traditions, introducing new and experimental ways of thinking and being.

Forerunners to culture jamming include Dadaists and Surrealists, artists who attacked the very norms defining "art." Jammers also trouble

these boundaries, bringing art into the streets, and activism into museums. The Guerrilla Girls, featured in chapter 19, protest discriminatory practices of the Western art world, including the dearth of works by women and artists of color in museums. One of their most famous posters features a reclining woman, nude except for her snarling gorilla head mask, and pointedly asks: "Do women have to be naked to get into the Met. Museum? Less than 5% of the artists in the Modern Art sections are women, but 85% of the nudes are female."

In another artistic jam of a high culture institution, Banksy surreptitiously installed in London's British Museum a fake prehistoric painting depicting a caveman pushing a shopping cart: the sign hanging below read, "This finely preserved example of primitive art dates from the Post-Catatonic era" (BBC News 2005). Benedikt Feiten takes a closer look at Banksy's work in chapter 9. Feiten argues that Banksy, who secretly applies stencil-sprayed images in a variety of urban contexts, "transform[s] public space into a field for improvisation." More specifically, Banksy views his works as a way to "answer back" to the corporate (mis)use of public space as a site of one-way communication.

Other jammer artists also take their work to the streets, turning decaying building façades, fences and walls, homes and roofs into canvases. For instance, French "photograffeur" JR pastes giant portraits of people onto these urban surfaces. JR has mounted enormous images of Israeli and Palestinian people, side by side and making playful faces, on the Israeli West Bank Barrier; he has pasted faces of women on forty hillside homes in the Providencia favela in Rio de Janeiro. Michael LeVan, in chapter 8, calls this "facing," a "transformative practice in the face of poverty and oppression." "Through his images of faces," writes LeVan, "JR forces a confrontation with political complacency around the impact of poverty and economic globalization on people, communities, landscapes, and cities." Another effect that LeVan attributes to JR's practice of culture jamming is calling into question the professional system that is art, because JR installs his artworks in the public space—and, even more significantly, in underprivileged spaces—not in museums. Culture jamming, then, injects art into everyday spaces and routines, reclaiming them for the imagination.

3. *Culture jamming is often playful.* In confronting serious issues, culture jammers frequently use humor, pranks, and carnivalesque inver-

sions. Several critics writing about culture jamming note a distinction between the serious and the playful jammer; Naomi Klein (1999) frames this as a tension between "the hard-core revolutionary" and "the merry prankster" (283). The Yes Men certainly fit the latter category; they describe their form of intervention as "laughtivism" (see chapter 21). If culture jamming is fun to do, then it is more inviting to participants. If it uses humor and is funny to watch, then it is more engaging and appealing to audiences. Comedy disarms and opens the possibility for increased awareness and self-reflexivity.[14] Humor and play are also central to several interventions featured in the Culture Jammers' Studio section of this book. Andrew Boyd, for one, explains how the playful, ironic schtick of "Billionaires for Bush" helped access "the economic unconscious, or the mythic dimension of money."

Moritz Fink's essay (chapter 11) analyzes the popular animated comedy *The Simpsons*, which cleverly presents corporate satire "to a massive audience in a context normally saturated with advertising and product placements." Corporate satire, Fink argues, has long been a part of popular culture, going back to the magazine *Ballyhoo* in the first half of the twentieth century, and *MAD* magazine and wacky packs in the second. *The Simpsons* offers "gesture[s] of culture jamming in a context where we generally wouldn't expect [them]," Fink observes. As a wildly successful mainstay of broadcast television entertainment, *The Simpsons* complicates notions of culture jamming as genuinely countercultural or anticapitalist rhetoric, and also provides a prominent platform for the humorous lampooning of a dominant culture shaped by brands and corporations.

4. *Culture jamming is (often) anonymous.* Culture jammers generally do not seek personal fame and fortune. Most of them work covertly—behind masks or under cover of night, using a pseudonym or the anonymity provided by the Internet. Street artists JR and Banksy are infamous for their mysterious identities. Balaclavas obscure the faces of Pussy Riot band members, as well as that of Subcommandante Marcos, spokesperson and leader of the Zapatista movement in Chiapas, Mexico. Guy Fawkes masks, popularized by Alan Moore and David Lloyd's 1980s comics series *V for Vendetta*, are now a signature of the online hacktivist group Anonymous; these masks have also appeared in a variety of protests around the world (including Occupy, Arab Spring, anti-ACTA

protests in Europe, and antigovernment demonstrations in Bangkok). The Guerrilla Girls (2012), who wear gorilla masks and adopt names of famous female artists, explain the rhetorical force of anonymity:

> Sometimes you gotta speak out publicly, but sometimes it works even better to speak out anonymously. This has its disadvantages, like working your whole life without getting any credit, but it has lots of advantages, too. Our anonymity, for example, keeps the focus on the issues, and away from our personalities. Plus . . . you won't believe what comes out of your mouth while wearing a gorilla mask! (n.p.)

The anonymity afforded by masks and pseudonyms, then, not only emboldens activists by providing a modicum of protection from the authorities, it also puts the critique, not its authors, center stage.[15]

With this anonymity, culture jamming also calls into question the very notions of authority and authorship. A variation of the pseudonym deployed by jammers is the "multiple name," a collective identity through which anyone can perform an intervention under a common name. For example, the nom de plume "Luther Blissett," which first appeared in Bologna in 1994, has been used by numerous activists in Europe and North America (see Deseriis 2010). Multiple names establish a sense of collectivity by linking actions that may be distant in time or space and by inviting participation by others. Autonome a.f.r.i.k.a gruppe (1997) asserts that "as people enter into this history and take part in the practices that are linked with the multiple names, they actually become part of the imaginary and collective person. . . . The multiple name cancels out the separation between the individual and the collective" (n.p.). In chapter 3, Marco Deseriis provides a taxonomy of "three orders of the fake" that are characteristic of culture jamming; he explains that "mythmaking fakes," like the Luther Blissett Project, serve not so much to demystify or critique, but to "positively call a community, or a network of collaborators, into being."

5. *Culture jamming is participatory.* Jammers put a premium on sharing and collaboration. In contrast to many other artists, culture jammers invite imitation and often provide free materials and practical instructions to empower others to become jammers, too. According to this logic, anyone could be a "Banksy" by articulating dissent with a stencil

and can of spray paint. Many culture jamming groups provide resources online: one example is the Yes Men's "Yes Lab," which includes an Action Switchboard and instructions to help activists "create fun, meaningful, and movement-building projects around the issues we all care about."[16] In chapter 17, Kembrew McLeod explains that "in many ways, pranking and culture jamming are twisted versions of participatory democracy in action" because "pranking blurs the line between audience and observer. It invites people to engage in the spectacles that pranksters create."

Some culture jamming actions explicitly solicit participation by the public at large. Carrie Lambert-Beatty (2010) calls this particular type "invitational culture jamming" (102). An example of this highlighted by Lambert-Beatty is the Bubble Project, started in 2005 by designer Ji Lee. Jammers can download and print empty speech bubbles, then paste them on advertisements in their communities, inviting future passersby to write in the blank spaces. As the project's manifesto states:

> Our communal spaces are being overrun with ads. Train stations, streets, squares, busses, and subways now scream one message after another at us. Once considered "public," these spaces are increasingly being seized by corporations to propagate their messages. We the public, are both target and victim of this media attack. The Bubble Project instantly transform[s] these annoying corporate monologues into open public dialogues. They encourage anyone to fill them in with any expression, free from censorship. ("Manifesto" 2005, n.p.)

A prime benefit of invitational culture jamming is that "it connects like-minded people into real and virtual affinity groups" (Lambert-Beatty 2010, 101).

Our claim that culture jamming is participatory runs counter to Åsa Wettergren's (2003) assertion that culture jamming is "a strongly individualized form of resistance, engaging people who would avoid mass demonstrations or large manifestations" (38). While some jammers do act alone, their interventions often evoke public engagement and participation: one example of this is xtine burrough's Delocator.net, a user-driven database for finding locally owned coffee shops (see chapter 20).

The important question of whether culture jamming facilitates or hinders collective organizing is one taken up differently by authors in

this volume. Michael Serazio is rather skeptical, concluding that culture jamming is more stylistic and "cute" than revolutionary (chapter 10). Henry Jenkins, on the other hand, is more optimistic, arguing that collaborations forged around popular culture and fan affinities can provide on-ramps to political activism (chapter 5).[17] As his example of one fan community, the Harry Potter Alliance (HPA), shows, media activism increasingly assumes an inside perspective. Rather than condemning "the System" per se, it embraces some elements offered by the cultural industries while exposing and decrying others. Jenkins writes, "What the HPA calls 'cultural acupuncture' embraces a logic of participation rather than resistance; fan activists claim ownership over the materials of popular culture rather than disavowing them; and these new forms of attention-based advocacy take as a given the capacity to take collective action in order to call out issues that should be part of the society's larger political agenda."

6. *Culture jamming is political.* Culture jamming does political work in that it critically engages narratives of the dominant capitalist culture. At its most trenchant, culture jamming challenges existing structures of power, seeking to reveal hypocrisy and injustices, spark public outrage, and promote collective action.

Early culture jammers primarily targeted corporate branding and consumerism, fighting against the proliferation of billboards and shopping malls and the excessive branding of public places such as Times Square. Some of these interventions moved beyond critiquing overconsumption per se to contest political injustices embedded in specific products. For instance, in the early 1990s, the Barbie Liberation Organization (BLO) protested the sexist assumptions behind Mattel's talking Barbie doll, which said, "I love shopping!" and "Math class is hard." The BLO covertly swapped the voice boxes of Barbies with those of talking GI Joe dolls, and then returned them to stores. Unwitting customers took home Barbies who yelled, "Vengeance is mine!" and GI Joes who cooed, "Let's plan our dream wedding!" (see also Harold, chapter 2). In 2001, MIT graduate student Jonah Peretti placed an order for a personalized pair of Nike iD sneakers, which buyers could customize with their names, a short slogan, or graphic content. Peretti requested that the word "sweatshop" be emblazoned on his new Nikes—a clear jab at Nike's unethical labor practices. Nike rejected Peretti's order, claiming

that it contained "inappropriate slang"; Peretti retaliated by forwarding his e-mail exchange with Nike to friends and ultimately posting it on the Web. The story got picked up by the mainstream media, including NBC's *Today Show* and the *Wall Street Journal* (see Peretti 2001).

Later activists widened the culture jamming scope to target both corporate and political entities, seeking to draw public attention to a variety of political struggles. The Yes Men impersonate World Trade Organization officials or Dow Chemical employees to subvert government and corporate discourses from within (see chapter 21). A flash mob in Oakland, California, stages a song and dance routine in the frozen foods aisle attacking Whole Foods CEO John Mackey's opposition to national health care reform (see chapter 13). The Italian collective IOCOSE launches a parody e-mail spam campaign to protest the right-wing conservative turn by the Italian Democratic Party (see chapter 23). And the artist Paolo Cirio hacks into the Cayman Island Company Register website in order to "democratize" access to offshore corporate tax havens (see chapter 22). In chapter 15, Wazhmah Osman analyzes multiple culture jams protesting US drone strikes in Afghanistan and Pakistan by making innocent victims visible, thereby revealing the racist hypocrisy of the Western "white savior" complex and debunking the myth of the surgically clean, bloodless war. None of these examples involves semiotic play for its own sake: all are interventions with specific targets and clear political aims.[18]

In recent years, culture jamming aesthetics have also seeped into mainstream politics. As candidates, parties, and even nations embrace branding strategies, those brands become ripe targets for parody, satire, and *détournement*. In chapter 16, Anna Baranchuk examines how the feminist collective Pussy Riot attempted to jam Russia's post–Cold War nation branding efforts. She concludes that, while Pussy Riot's performances drew praise from Western onlookers, their jam largely failed for the Russian audience, in that it further deepened lines of political and generational division. In the United States, political culture jamming has been waged by television humorists Jon Stewart (host of *The Daily Show*) and Stephen Colbert (host of *The Colbert Report*),[19] as well as by folks at home with access to YouTube who create parodies of political ads or mash-up videos mocking candidates (see Warner 2007; Serazio 2012; Day 2011). Andrew Boyd's contribution to this

book (chapter 18) recounts the satirical performances of "Billionaires for Bush"; Kembrew McLeod explains in chapter 17 a prank in which his alter-ego, the RoboProfessor, confronted presidential candidate Michelle Bachman on the campaign trail about her homophobia. Culture jamming interventions—symbolically and sometimes quite literally—have migrated from the shopping mall and Times Square to the National Mall and Tahrir Square.

7. *Culture jamming operates serially.* In most cases, culture jamming occurs not as a singular, unique event, but as a series of related episodes. Just as Absolut Vodka's iconic series of advertisements is instantly recognizable, so, too, are *Adbusters'* parody ads: a bottle in the shape of a noose ("Absolute Hangover"); red chairs arranged in the outline of a bottle ("Absolute AA"); an absent bottle outlined in white chalk, like in a homicide scene ("Absolute End"). Reverend Billy's Church of Stop Shopping amphibiomorphic choir members transform into extinct Golden Toads over and over, descending on Chase Banks in New York, San Francisco, London, and elsewhere. This serial quality to culture jamming means that actions are repeatable—they can be taken up and reproduced easily by others, in different places, thus sustaining and rhizomatically expanding the reach of the particular campaign. A Pussy Riot member declared that the band "has nothing to worry about, because if the repressive Putinist police crooks throw one of us in prison, five, ten, fifteen more girls will put on colorful balaclavas and continue the fight against their symbols of power" (quoted in Baranchuk, chapter 16).

Related to seriality and repetition is the concept of "meme," which, though contested, also enjoys widespread use and recognition. Memes are small units of meaning that are easily repeated, copied, sometimes altered, and spread—such as Pepper Spray Everything Cop. Evolutionary biologist Richard Dawkins (1976) first introduced the term in his book *The Selfish Gene*, where he likens cultural transmission to genetic transmission and asserts that memes propagate themselves by "leaping from brain to brain" (192). This biological transmission metaphor also underlies the popular expression "going viral" to describe the phenomenon of a meme—or YouTube video, or other cultural tidbit—suddenly becoming wildly popular and spreading into public awareness, often via social media. Henry Jenkins critiques the viral conceptualization

of memes because it frames people as passive host organisms with no agency or critical capacities. He and co-authors Sam Ford and Joshua Green (2013) offer the notion of "spreadable media" to replace the infection and contamination metaphors; in their model, "audiences play an active role in 'spreading' content rather than serving as passive carriers of viral media" (21).

We agree that Dawkins's original definition of memes is problematic and that memes do spread thanks to actions by media users, rather than leaping spontaneously from brain to brain. That said, memes are still significant as units of cultural meaning that are immediately recognizable, can be appropriated and remade and spread, and often come to stand in metonymically for a larger argument or critique. Memes are especially important to understand as networked culture expands to become global in scope. Limor Shifman (2014) maintains that Internet memes play a "key role in contemporary formulations of political participation and cultural globalization" (171–72).

In this collection, Jack Bratich opens chapter 14 with a reading of "Occupy" as a meme. While the Occupy Wall Street protests of 2011 created the meme of "the 99%," the phrases "We are the 99%" and "99% versus the 1%" have outlived the OWS encampments and been deployed by activists, organizations, and even some elected officials. The seriality and repeatability of memes and other forms of culture jamming play an important role in garnering recognition and fostering participation.[20] OWS, Bratich argues, was not just another meme: "For one thing," he writes, "it mutated into a platform for other actions, even other memes (such as Pepper Spray Cop and . . . other Internet memes . . .). For another, the temporarily formed assembly mutated into something more enduring—a decentralized but resilient networked collective body." The memetic and serial qualities of culture jamming, then, help to foster participation and collaboration.

8. *Culture jamming is transgressive.* Jamming interventions transgress boundaries both spatial and normative. Culture jammers often infiltrate the spaces governed by consumer capital, violating expected rules of behavior and thus eliciting surprise, confusion, amusement, or even shock. In their interview here (chapter 24), Reverend Billy and Savitri D note that their incursions into Disney and Starbucks stores reveal how the range of acceptable behaviors in commercial spaces is very narrow in-

deed. Rebecca Walker (chapter 13) explains the profound impact of such spatial transgressions: "In a flash mob, participants break the norms of acceptable behavior and by doing so perform the dual function of (1) waking up their own participant bodies to the idea that other options for behavior exist and (2) reminding the audience of the mob of the absurd and arbitrary nature of so-called 'normal' behavior. To say it differently, the flash mob reminds us that we actually have a choice." Walker asserts that flash mobs, as new forms of culture jamming, "confound the corporation machine, intrigue passersby, and deterritorialize behavioral norms."

Several versions of the flash mob were deployed as part of the #BlackLivesMatter movement in the fall of 2014. Citizen protests had erupted in cities across the United States after a white police officer killed unarmed African American teenager Michael Brown in Ferguson, Missouri, on August 9. At a St. Louis Symphony concert in early October, several symphony-goers stood in the audience and sang out the Civil Rights song, "Which Side Are You On?" as banners reading "Racism Lives Here" and "Requiem for Michael Brown 1996–2014" unfurled from the balcony. In Oakland, California, and New York City, activists launched #BlackBrunch, peacefully entering the predominantly white spaces of trendy restaurants during weekend brunch hours and standing solemnly amidst the tables to read aloud the many names of African Americans killed by police. These interventions sparked mixed reactions: some observers stood in solidarity with the protestors, while others objected to being inconvenienced.

Performances like these transgress the unstated rules of decorum and propriety. Other jams are more irreverent and explicitly confrontational. In chapter 12, Tony Perucci explores an abrasively transgressive form of culture jamming he calls "ruptural performance," which resists legibility and often prompts the response, "What the f**k is that?" Perucci investigates innovative and sometimes perplexing culture jams executed by groups in Brazil, the United States, and Russia protesting media censorship, consumer capitalism, and corruption in electoral politics. These performances disrupt the onlooker's gaze by staging bizarre actions in unexpected places, drawing upon the theatrical traditions of Dada, Brecht, Artaud, and Abbie Hoffmann. Ruptural performance, Perucci explains, "jams up the meaning-making process itself. It willfully con-

fuses . . . and utilizes the very bafflement that ensues as a strategic advantage in challenging power."

Culture jamming is also transgressive in a legal sense, since it frequently disregards copyright law and private property ownership. The collaborative, anonymous, and appropriating qualities of culture jamming described above run counter to the individualistic, accumulative, zero-sum mentality driving corporate capitalism. Through various modes of trespassing private property, jammers press for fair use and promote the idea of the commons.

Finally, culture jamming in the twenty-first century is traversing national boundaries and growing into a global phenomenon. While jamming emerged first in the San Francisco Bay Area and Pacific Northwest, centers of both technological innovation and countercultural activism, it quickly spread overseas to other late-capitalist consumer societies in Europe and Australia. Since the turn of the millennium, culture jamming has traveled yet farther, partly in response to the global expansion of consumer capitalism and partly thanks to the rise of digital networks and proliferation of increasingly powerful mobile devices. In China, netizens engage in *e gao*, a popular form of fan-subbing and satirical media spoofs (Meng 2011). In Turkey in the summer of 2013, culture jammers contested the lack of media coverage of clashes between police and Gezi Park protesters with televisual memes (Tufecki 2013). In South Africa, a Rhodes student made parodic t-shirts that *détourned* South African Breweries' (SAB) slogan "America's lusty, lively beer, Carling Black Label Beer, Brewed in South Africa" into "Africa's lusty, lively exploitation since 1652, Black Labour White Guilt, No regard given worldwide" (Rens 2005, 21). In Brazil, street artists leveled poignant critiques against the social and economic impact of the 2014 FIFA World Cup; photos of murals that depict starving children next to symbols of the brave new sports world went viral on social media. In Mexico, the Zapatista Air Force attacked Mexican Army barracks in Chiapas with a fleet of paper airplanes, "which flew through and over the barbed wire of the military encampment, each carrying a discursive missile: messages and poems for the soldiers" (Lane 2003, 130). As a transgressive, boundary-blurring form of activism, culture jamming is constantly on the move—emerging in unexpected places, adapting to new contexts, inventing new modes of critique.

Critiques and Limitations

At its best, culture jamming is a creative and inventive mode of public engagement: it cultivates critical attitudes toward commercial culture and dominant institutions, and helps foster belief that the world can be different. That said, culture jamming is not a panacea, nor is it the best or only tool for achieving social change. Indeed, culture jamming has been both widely celebrated and roundly critiqued in the past few decades by academics, in the popular press, and even on the very pages of *Adbusters* magazine, in the letters submitted by readers (see Haiven 2007). Here we engage the most significant critiques of culture jamming—not necessarily to debunk or discredit them, but rather to understand why these critiques have emerged and address the assumptions behind them. Several contributors to this book take critical positions as well, noting where some culture jamming interventions have failed, challenging certain definitions of the term, and offering revisions to or departures from older conceptualizations. To be sure, culture jamming does have limitations and cannot by itself achieve the grand, revolutionary aims often proclaimed by its champions.

In fact, the revolutionary rhetoric in which culture jamming is sometimes couched is one source of dissension. For instance, Lasn's (1999) introduction to *Culture Jam* issues a fervent call to arms:

> We will strike by smashing the postmodern hall of mirrors and redefining what it means to be alive. We will reframe the battle in the grandest terms. The old political battles that have consumed humankind during most of the twentieth century—black versus white, Left versus Right, male versus female—will fade into the background. The only battle still worth fighting and winning, the only one that can set us free, is The People versus the Corporate Cool Machine. (xvi)

While this insurgent tone may quicken the pulse and stir readers' passions, it also invites visions of a full-fledged social movement fighting to achieve massive change. Taken literally, such a call for revolution seems overblown, and the People's Army feebly equipped, if its primary weapons are *détourned* billboards and subvertisements. Furthermore, in the passage above, Lasn sets up a stark binary, asserting the righteous

authenticity of "us" versus "them." This kind of dualistic framing—where culture jammers are rebel outsiders, attacking or evading the dominant spectacle staged by the Powers that Be—is problematic and has drawn considerable flak. Max Haiven (2007), for instance, critiques *Adbusters* for furnishing its followers "with the smug satisfaction of being 'outside' or 'knowingly critical' of (and thus no longer complicit with) consumer culture" (91).

Underlying this us/them, outsider/insider model is a conviction that authentic experience exists only *outside* of consumer capitalism and that people can (and should) access authenticity by rejecting television, advertisements, shopping. Valerie Scatamburlo-D'Annibale (2009) observes that "there is a conceptual murkiness in the way that [Lasn] and others employ the term [authenticity]—while the presumably 'inauthentic' spectacle is contrasted with some vaguely defined authentic gestures, exactly what constitutes the 'authentic' remains largely unarticulated" (226). "Authenticity" is a loaded term, particularly in late capitalist cultures where branding has come not only to dominate the marketing of consumer products, but also to inflect art, politics, religion, and even the crafting of our individual identities. In her book *Authentic™: The Politics of Ambivalence in a Brand Culture*, Sarah Banet-Weiser (2012) explores the complex invocations of authenticity in brand cultures, noting that formerly authentic spaces, like religion, are now increasingly branded and that authenticity *itself* has become a brand (11). Banet-Weiser suggests that we need to move beyond the reductive framing of "the authentic versus the fake, the empowered consumer versus corporate dominance" in order to understand the complex ways that brand cultures, as utopian spaces, are fundamentally ambiguous (13).

The insider/outsider binary is attacked by Joseph Heath and Andrew Potter (2004) in their fervent broadside against culture jamming, *Nation of Rebels: Why Counterculture Became Consumer Culture*. They contend that the very notion of counterculture is bunk and indict *Adbusters* for hypocritical posturing—for claiming to resist consumer culture while simultaneously peddling their own products, including the Blackspot sneaker, a logo-less shoe made using ethical labor practices. Heath and Potter assert that the revolutionary, antiestablishment attitude copped by jammers actually reflects the true spirit of capitalism and that counterculture "cool" has been used to sell products for decades. Countercul-

ture rebellion, they argue, is a sort of pseudo-rebellion, "a set of dramatic gestures that are devoid of any progressive political or economic consequences and that detract from the urgent task of building a more just society" (65). They conclude that culture jamming is both a cop-out and a dangerous distraction from the real and important—if less hip and "cool"—work of democratic political reform.

Heath and Potter (2004) also attack culture jammers and their ilk for treating "the system" as monolithic—but in the end, we find that these authors essentially do the same thing to "counterculture." They reductively paint jammers as individuals concerned primarily with image, who want to look hip by rejecting mainstream brands, but who remain beholden to consumer capitalism all the same: hippies driving VW buses and listening to Hendrix; hipsters buying Blackspots and feeling superior for dissing Starbucks. Certainly, traces of this ethos can be found in the pages of *Adbusters* and among some counterculture types, but Heath and Potter's caricature of counterculture fails to adequately capture the range of attitudes and actions that constitute culture jamming, as this collection demonstrates. Furthermore, Heath and Potter miss the rhetorical and political opportunities that flow from countercultural activism. Their critique of the Blackspot sneaker campaign, as Harold (2007) incisively puts it, "is unfortunate and unfair, *especially* given that their ultimate thesis is that countercultural calls for revolution distract people from more valuable incremental reforms. Their book is so set on disabusing the masses of the countercultural 'myth' that they fail to see that, in this case, *the myth sells valuable incremental reform*" (68). This point is an important one: the bold, brash, irreverent, and even revolutionary rhetoric of culture jamming can and does play a useful role in broader political movements.[21]

Several critics, Heath and Potter among them, note that culture jamming tactics have been deftly captured and redeployed by marketers, making it difficult if not impossible for culture jamming to maintain its critical bite. Michael Serazio's chapter in this book examines how one agency, Crispin Porter + Bogusky, has coopted the edgy, "anti-advertisement" attitudes of culture jamming and effectively channeled them back into ads. Such cooptation, however, need not signal the demise or ultimate impotence of culture jamming in toto: rather, it alters the field of signs available for appropriation, pushing

culture jammers to invent new tactics, to morph and adapt and spread in unpredictable ways.

The final and perhaps most significant weakness of culture jamming is the potential danger that it becomes an end in itself. Scatamburlo-D'Annibale (2009) ties this to "discourse radicalism," the idea that textual resistance—e.g., *détourning* a billboard or advertisement—becomes equivalent to, or a substitute for, political resistance (227). Some critics worry that culture jammers seeking authenticity outside of the consumer spectacle will simply retreat into that space of refuge, rather than struggle for structural political change. Or, in a related vein, that culture jamming will be used simply as a tool to encourage socially more "responsible" shopping—still a private act, still rooted in consumption.[22] Others hold that culture jamming lacks the serious Marxist class critique that drove the Situationists and that it is more stylistic than substantive. Worse yet, culture jamming might serve as a distraction, a steam-valve, or an obstacle to collective action.[23] As Henry Jenkins puts it in chapter 5, "Often, jammers have been accused of falling prey to a romance with resistance that locks them permanently outside the mechanisms of power through which lasting reforms might be won."

In response to these many critiques, several authors in this book offer new versions of culture jamming that recalibrate its activist potential for the twenty-first century. Michael LeVan offers a meditation on "facing"; Henry Jenkins proposes "cultural acupuncture." Jack Bratich advocates an ecological conceptualization of culture jamming rooted in polemology and the corporeal body politic, while Rebecca Walker suggests that "flash mobs" may be "the perfect platforms for culture jammers of the digital age, combining the power of live performance with the mass dissemination capabilities of the viral video." Mark LeVine champions a musical, "auratic" understanding of culture jamming as joyful hybridity, asserting that, "culture jamming is the best, and perhaps only, way to grasp and work through the unprecedented complexity of globalization and the problems it has generated."

* * *

While the actions featured in *Culture Jamming: Activism and the Art of Cultural Resistance* span several decades and many countries, we do not claim to provide a comprehensive survey of the full breadth of culture

jamming activism or scholarship. Rather, this project brings together manifestoes, new critical scholarship, and statements by culture jammers themselves in order to foster a rich and provocative exchange. We hope that this collaborative work offers useful tools with which to think (and act!) and that it will serve as a springboard for future studies of culture jamming interventions yet to be seen.

In the face of widening income inequality, deepening struggles over globalization and fair trade, increasing private encroachment on the public commons, and accelerating global warming and climate disruption, we draw hope and inspiration from the artists and activists around the world who dare to imagine a radically different world. As Kalle Lasn (2000) said in an interview with one of us at the turn of the millennium:

> If we dump this unsustainable consumer culture of ours, if we jam it into the ground and start creating a new culture from the bottom up, then who knows what that culture's going to be? It's up for grabs! That's the very nature of a culture—that nobody can predict in advance what it's going to be. At the moment we have this top-down culture, and we know what's in store if we keep that culture, but I like the unknown, the unpredictability of not being able to answer that question, of saying, "I don't know what it's going to be like, but it's gonna be fun finding out what kind of culture we'll make that has a non-commercial heart and soul." Of course, I think I know some of the contours of that new culture: it will be sustainable, have a true-cost marketplace, we'll be driving cars a lot less and probably using different kinds of foods. . . . But exactly how this new culture will pan out, nobody knows.

NOTES

1 See www.orbooks.com. OR Books is also publisher of *Gay Propaganda: Russian Love Stories*, co-edited by Masha Gessen and IKEA protest organizer Josef Huff-Hannon (2014). OR gets into the culture jamming act further by offering information and digital tools to help smuggle *Gay Propaganda* into Russia.

2 See the website at www.hologramasporlalibertad.org.

3 See also Branwyn (1997); Harold (2004); Harold (2007); Lambert-Beatty (2010); Fink (2012).

4 Dery (2010) notes that his Inner Grammarian prompted him to retool "cultural jamming" into "culture jamming." Today, the original pamphlet is available only

through second-hand retailers or on Ebay. In 2010, Dery relaunched the essay with a new introduction on his website, www.markdery.com.

5 Lasn (1999) explains: "A meme (rhymes with 'dream') is a unit of information (a catchphrase, a concept, a tune, a notion of fashion, philosophy or politics) that leaps from brain to brain. . . . Potent memes can change minds, alter behavior, catalyze collective mindshifts and transform cultures. Which is why meme warfare has become the geopolitical battle of our information age. Whoever has the memes has the power" (123). See also our discussion of memes below.

6 Kevin DeLuca and Jennifer Peeples (2002) argue that this "symbolic violence," directed at carefully selected property rather than at people, functions as an image event, or a mind bomb that provokes "the shock of the familiar made strange" (144).

7 Here, Duncombe (2007) invokes Hakim Bey's notion of "temporary autonomous zones," or TAZs.

8 A variety of these recent creative interventions are featured in the tactical manual *Beautiful Trouble: A Toolbox for Revolution* (Boyd and Oswald 2012) and its accompanying website, www.beautifultrouble.org.

9 This process of seizing and reassembling bits of culture was influenced by the Dadaists, who made collages by cutting up aesthetic artifacts and recomposing them in new, provocative forms, or transformed ordinary objects into "art" by putting them in museums (exemplary here is Marcel Duchamp's *Fountain* [1917]).

10 Guy Debord ([1967] 2014) describes the "society of the spectacle" as a new mode of social control wherein authentic experience is supplanted by representations of consumer capitalism. The spectacle, writes Debord, "is not a collection of images; it is a social relation between people that is mediated by images" (2). For the Situationists' concept of *détournement*, see Debord and Wolman ([1956] 2006), Debord ([1967] 2014, 109–10), and Marcus (1989).

11 Kenneth Burke ([1937] 1984) describes perspective by incongruity as a "method for gauging situations by 'verbal atom cracking.' That is, a word belongs by custom to a certain category—and by rational planning you wrench it loose and metaphorically apply it to another category" (308).

12 Zack Malitz (2012) argues that "*détournement* works because humans are creatures of habit who think in images, feel our way through life, and often rely on familiarity and comfort as the final arbiters of truth. Rational arguments and earnest appeals to morality may prove less effective than a carefully planned *détournement* that bypasses the audience's mental filters by mimicking familiar cultural symbols, then disrupting them" (28–29).

13 A prime example of this kind of protest is the Illegal Art show, put together by Carrie McLaren, publisher of *Stay Free!* Magazine. McLeod (2005) writes that the traveling show "won a small victory for freedom of expression' by committing repeated acts of copyright civil disobedience" (145–46).

14 Åsa Wettergren (2009) links the playful fun of culture jamming to Bakhtin's account of utopian laughter (6).

15 As Graham St. John (2008) puts it, "Collective 'masking up' attracts attention to one's cause (rather than one's self), contesting the field of appearances through a kind of tactical disappearance" (178).

16 See www.yeslab.org.

17 In a similar vein, Stephen Duncombe (2002) writes, "Because cultural resistance often speaks in a more familiar and less demanding voice than political dissent it makes this move even easier. In this way cultural resistance works as a sort of stepping stone into political activity" (6).

18 Unlike postmodern pastiche—that is, "blank parody" bereft of parody's critical impulse (Jameson 1984, 65)—culture jamming critically comments on the appropriated signs, filling them with new counter-meanings and engaging in a confrontation with the dominant capitalist culture.

19 Perhaps one of the best examples here is the Super PAC started by Colbert in 2011, "Americans for a Better Tomorrow, Tomorrow," which raised over $1 million. Colbert used the Super PAC to reveal the ludicrous loopholes and ambiguities in campaign financing after the 2010 US Supreme Court's *Citizens United v. Federal Election Commission* decision. When Colbert later decided to explore running for office (for "President of the United States of South Carolina"), he signed over control of the Super PAC to Jon Stewart, who then referred to it as "The Definitely Not Coordinating with Stephen Colbert Super PAC." Ultimately, Colbert's Super PAC was retired, and proceeds were donated to charities.

20 See Davi Johnson's (2007) case for the meme as a useful tool for analyzing the political effects of cultural discourses, and for engaging in geographically-oriented materialist criticism.

21 Vince Carducci (2006) argues that culture jamming interventions into consumption can lead to changes in practices of production. "By exposing the inconsistencies on the producer side of the leger," he writes, "culture jammers may in fact be the avant-garde of the evolution of consumer society, encouraging producers to conform to new consumer expectations in order to garner sales, and thereby continuing the development of socially conscious production in Western capitalism" (123).

22 See, for instance, Richard Gilman-Opalsky (2013).

23 Heath and Potter (2004) put this point most acerbically when they assert that "countercultural rebellion is not just unhelpful, it is positively counterproductive. Not only does it distract energy and effort away from the sort of initiatives that lead to concrete improvements in people's lives, but it encourages wholesale contempt for such incremental changes" (8).

REFERENCES

Abrams, Lindsay. 2014. "The Story behind #AskChevron: How a Group of Environmentalist Hijacked Twitter," Salon.com.

Amin, Heba, Caram Kapp, and Don Karl. 2015. "'Arabian Street Artists' Bomb Homeland: Why We Hacked an Award-Winning Series." *Heba Y Amin*, October 14. www.hebaamin.com.

Autonome a.f.r.i.k.a. gruppe. 1997. "All or None? Multiple Names, Imaginary Persons, Collective Myths." Republicart.net, translated by Aileen Derieg. www.republicart.net.

——. 2002. "Communication Guerilla: Transversality in Everyday Life?" Republicart.net, translated by Aileen Derieg. www.republicart.net.

Banet-Weiser, Sarah. 2012. *Authentic™: The Politics of Ambivalence in a Brand Culture*. New York: New York University Press.

BBC News. 2005. "Cave Art Hoax Hits British Museum." *BBC News*, May 19. news.bbc.co.uk.

Branwyn, Gareth. 1997. *Jamming the Media, A Citizen's Guide: Reclaiming the Tools of Communication*. San Francisco: Chronicle Books.

Bruner, Lane M. 2005. "Carnivalesque Protest and the Humorless State." *Text and Performance Quarterly* 25 (2): 136–55.

Burke, Kenneth. (1937) 1984. *Attitudes toward History*. 3rd ed. Berkeley: University of California Press.

Carducci, Vince. 2006. "Culture Jamming: A Sociological Perspective." *Journal of Consumer Culture* 6 (1): 116–38.

Cottle, Simon. 2011. "Transnational Protests and the Media: New Departures, Challenging Debates." In *Transnational Protests and the Media*, edited by Simon Cottle and Libby Lester, 17–40. New York: Peter Lang.

Cottle, Simon, and Libby Lester. 2011. "Transnational Protests and the Media: An Introduction." In *Transnational Protests and the Media*, edited by Simon Cottle and Libby Lester, 3–16. New York: Peter Lang.

D'Ambrosio, Antonino. 2013. "How the Creative Response of Artists and Activists Can Transform the World." *Nation*, January 28. www.thenation.com.

Dawkins, Richard. 1976. *The Selfish Gene*. Oxford, UK: Oxford University Press.

Day, Amber. 2011. *Satire and Dissent: Interventions in Contemporary Political Debate*. Bloomington: Indiana University Press.

Debord, Guy. (1967) 2014. *Society of the Spectacle*. Translated and annotated by Ken Knabb. Berkeley, CA: Bureau of Public Secrets.

Debord, Guy, and Gil J. Wolman. (1956) 2006. "A User's Guide to Détournement." In *Situationist International Anthology*, revised and expanded edition, edited and translated by Ken Knabb, 14–21. Berkely, CA: Bureau of Public Secrets.

DeLuca, Kevin Michael, and Jennifer Peeples. 2002. "From Public Sphere to Public Screen: Democracy, Activism, and the 'Violence' of Seattle." *Critical Studies in Media Communication* 19 (2): 125–51.

Dery, Mark. 1990. "The Merry Pranksters and the Art of the Hoax." *New York Times*, December 23. www.nytimes.com.

——. 1991. "Subvertising: The Billboard Bandit as Cultural Jammer." *Adbusters* 2 (1): 43–46.

——. 1993. *Culture Jamming: Hacking, Slashing and Sniping in the Empire of Signs*. Pamphlet no. 25. Westfield, NJ: Open Magazine.

——. 2010. "A Brief Introduction to the 2010 Reprint." October 8. markdery.com.

Deseriis, Marco. 2010. "Lots of Money Because I Am Many: The Luther Blissett Project and the Multiple-Use Name Strategy." *Thamyris/Intersecting* 21 (1): 65–94.

Dittmar, Linda, and Joseph Entin. 2010. "Jamming the Works: Art, Politics, and Activism." *Radical Teacher* 89 (Winter): 3–8.

Duncombe, Stephen. 2002. Introduction. In *Cultural Resistance Reader*, edited by Stephen Duncombe, 1–16. London: Verso.

——. 2007. *Dream: Re-Imagining Progressive Politics in an Age of Fantasy*. New York: New Press.

Fink, Moritz. 2012. "Digital *Détournement*: Jamming (with) the *Simpsons*-Banksy Intro, Johnnystyle." *Confessions of an Aca-Fan: The Official Weblog of Henry Jenkins*. www.henryjenkins.org.

Frakenstein, Marilyn. 2010. "Studying Culture Jamming to Inspire Student Activism." *Radical Teacher* 89 (Winter): 30–43.

Gilman-Opalsky, Richard. 2013. "Unjamming the Insurrectionary Imagination: Rescuing Détournement from the Liberal Complacencies of Culture Jamming." *Theory in Action* 6 (3): 1–34.

Guerrilla Girls. 2012. "Guerrilla Girls: The Masked Culture Jammers of the Art World." By Saba Gulraiz. *Art Etc.: News & Views*. www.artnewsnviews.com.

Gutierrez, Bernardo. 2013. "What Do Brazil, Turkey, Peru and Bulgaria Have in Common?" *Aljazeera*, September 7. www.aljazeera.com.

Haiven, Max. 2007. "Privatized Resistance: AdBusters and the Culture of Neoliberalism." *Review of Education, Pedagogy, and Cultural Studies* 29: 85–110.

Heath, Joseph, and Andrew Potter. 2004. *Nation of Rebels: Why Counterculture Became Consumer Culture*. New York: HarperCollins.

Jameson, Fredric. 1984. "Postmodernism; or, The Cultural Logic of Late Capitalism." *New Left Review* 146 (July/August): 59–92.

Jenkins, Henry. 2006. *Convergence Culture: Where Old and New Media Collide*. New York: New York University Press.

Jenkins, Henry, Sam Ford, and Joshua Green. 2013. *Spreadable Media: Creating Value and Meaning in a Networked Culture*. New York: New York University Press.

Johnson, Davi. 2007. "Mapping the Meme: A Geographical Approach to Materialist Rhetorical Criticism." *Communication and Critical/Cultural Studies* 4 (1): 27–50.

Klein, Naomi. 1999. *No Logo: Taking Aim at the Brand Bullies*. Toronto: Knopf.

Lambert-Beatty, Carrie. 2010. "Fill in the Blank: Culture Jamming and the Advertising of Agency." *New Directions for Youth Development* 125 (Spring): 99–112.

Lane, Jill. 2003. "Digital Zapatistas." *The Drama Review* 47 (2): 129–44.

Lasn, Kalle. 1999. *Culture Jam: The Uncooling of America™*. New York: Eagle Brook.

———. 2000. Interview by Marilyn Bordwell (DeLaure). August 3. Vancouver, BC.

Lasn, Kalle, and Bill Schmalz. 1989. "Statement." *Adbusters*. www.premiereissues.com.

Lessig, Lawrence. 2004. *Free Culture*. New York: Penguin.

Lievrouw, Leah. 2011. *Alternative and Activist New Media*. Cambridge, UK: Polity.

Malitz, Zack. 2012. "Tactic: Détournement/Culture Jamming." In *Beautiful Trouble: A Toolbox for Revolution*, edited by Andrew Boyd and Dave Oswald Mitchell, 28–31. New York: OR Books.

"Manifesto." 2005. The Bubble Project. www.thebubbleproject.com.

Marcus, Greil. 1989. *Lipstick Traces*. Cambridge, MA: Harvard University Press.

McLeod, Kembrew. 2007. *Freedom of Expression®: Resistance and Repression in the Age of Intellectual Property*. Minneapolis: University of Minnesota Press.

———. 2011. "Crashing the Spectacle: A Forgotten History of Digital Sampling, Infringement, Copyright Liberation, and the End of Recorded Music." In *Cutting across Media: Appropriation Art, Interventionist Collage, and Copyright Law*, edited by Kembrew McLeod and Rudolf Kuenzli, 164–77. Durham, NC: Duke University Press.

McLuhan, Herbert Marshall. 1970. *Culture Is Our Business*. New York: McGraw-Hill.

Meng, Bingchun. 2011. "From *Steamed Bun* to *Grass Mud Horse*: E Gao as Alternative Political Discourse on the Chinese Internet." *Global Media and Communication* 7 (1): 33–51.

Peretti, Jonah. 2001. "The Life of an Internet Meme: A History of the Nike Emails." Archived at www.shey.net.

Reed, T. V. 2005. *The Art of Protest: Culture and Activism from the Civil Rights Movement to the Streets of Seattle*. Minneapolis: University of Minnesota Press.

Rens, Andrew. 2005. "A Powerful, Symbolic Victory." *Rhodes Journalism Review* 25: 21.

Sandlin, Jennifer A., and Jennifer L. Milam. 2008. "'Mixing Pop (Culture) and Politics': Cultural Resistance, Culture Jamming, and Anti-Consumption Activism as Critical Public Pedagogy." *Curriculum Inquiry* 38 (3): 323–50.

Scatamburlo-D'Annibale, Valerie. 2009. "Beyond the Culture Jam." In *Critical Pedagogies of Consumption: Living and Learning in the Shadow of the "Shopocalypse,"* edited by Jennifer A. Sandlin and Peter McClaren, 224–36. London: Routledge.

Serazio, Michael. 2012. "'The Real Mitt Romney' Is Funny, but Is It Art?" *Atlantic*, September 26. www.theatlantic.com.

Shifman, Limor. 2014. *Memes in Digital Culture*. Cambridge, MA: MIT Press.

St. John, Graham. 2008. "Protestival: Global Days of Action and Carnivalized Politics in the Present." *Social Movement Studies* 7 (2): 167–90.

Tufekci, Zaynep. 2013. "It Takes a Quiz Show Host: #Occupygezi and Culture Jamming against Censorship Turkey." *Technosociology: Our Tools, Ourselves* (blog), June 5. www.technosociology.org.

Tyron, Chuck. 2009. *Reinventing Cinema: Movies in the Age of Media Convergence*. New Brunswick, NJ: Rutgers University Press.

Warner, Jamie. 2007. "Political Culture Jamming: The Dissident Humor of *The Daily Show with Jon Stewart.*" *Popular Communication* 5 (1): 17–36.

Wettergren, Åsa. 2003. "Like Moths to a Flame: Culture Jamming and the Global Spectacle." In *Representing Resistance: Media, Civil Disobedience, and the Global Justice Movement*, edited by Andy Opel and Donnalyn Pompper, 27–43. Westport, CT: Praeger.

———. 2009. "Fun and Laughter: Culture Jamming and the Emotional Regime of Late Capitalism." *Social Movement Studies* 8 (1): 1–15.

Definitions and Debates

1

Culture Jamming

Hacking, Slashing, and Sniping in the Empire of Signs

MARK DERY

I. The Empire of Signs

"My fellow Americans," exhorted John F. Kennedy, "haven't you ever wanted to put your foot through your television screen?"

Of course, it wasn't actually Kennedy, but an actor in "Media Burn," a spectacle staged in 1975 by the performance art collective Ant Farm. Speaking from a dais, "Kennedy" held forth on America's addiction to the plug-in drug, declaring, "Mass media monopolies control people by their control of information." On cue, an assistant doused a wall of TV sets with kerosene and flicked a match at the nearest console. An appreciative roar went up from the crowd as the televisions exploded into snapping flames and roiling smoke.

Minutes later, a customized 1959 Cadillac hurtled through the fiery wall with a shuddering crunch and ground to a halt, surrounded by the smashed, blackened carcasses of televisions. Here and there, some sets still burned; one by one, their picture tubes imploded, to the onlookers' delight. A postcard reproduction of the event's pyrotechnic climax, printed on the occasion of its tenth anniversary, bears a droll poem:

> Modern alert
> plague is here
> burn your TV
> exterminate fear
> Image breakers
> smashing TV
> American heroes
> burn to be free.

In "Media Burn," Ant Farm indulged publicly in the guilty pleasure of kicking a hole in the cathode-ray tube. Now, almost two decades later, TV's cyclopean eye peers into every corner of the cultural arena, and the desire to blind it is as strong as ever. "Media Burn" materializes the wish-fulfillment dream of a consumer democracy that yearns, in its hollow heart and empty head, for a belief system loftier than the "family values" promised by a Volvo ad campaign, discourse more elevated than that offered by the shark tank feeding-frenzy of *The McLaughlin Hour*.

It is a postmodern commonplace that our lives are intimately and inextricably bound up in the TV experience. Ninety-eight percent of all American households—more than have indoor plumbing—have at least one television, which is on seven hours a day, on the average. Dwindling funds for public schools and libraries, counterpointed by the skyrocketing sales of VCRs and electronic games, have given rise to a culture of "aliteracy," defined by Roger Cohen (1991) as "the rejection of books by children and young adults who know how to read but choose not to" (34). The dreary truth that two thirds of Americans get "most of their information" from television is hardly a revelation (McKibben 1992, 18).

Media prospector Bill McKibben (1992) wonders about the exchange value of such information:

> We believe we live in the "age of information," that there has been an information "explosion," an information "revolution." While in a certain narrow sense this is the case, in many important ways just the opposite is true. We also live at a moment of deep ignorance, when vital knowledge that humans have always possessed about who we are and where we live seems beyond our reach. An Unenlightenment. An age of missing information. (9)

The effects of television are most deleterious in the realms of journalism and politics; in both spheres, TV has reduced discourse to photo ops and sound bites, asserting the hegemony of image over language, emotion over intellect. These developments are bodied forth in Ronald Reagan, a TV conjuration who for eight years held the news media, and thus the American public, spellbound. As Mark Hertsgaard (1988) points out, the president's media-savvy handlers were able to reduce the

fourth estate, which likes to think of itself as an unblinking watchdog, to a fawning lapdog:

> Deaver, Gergen and their colleagues effectively rewrote the rules of presidential image-making. On the basis of a sophisticated analysis of the American news media—how it worked, which buttons to push when, what techniques had and had not worked for previous administrations— they introduced a new model for packaging the nation's top politician and using the press to sell him to the American public. Their objective was not simply to tame the press but to transform it into an unwitting mouthpiece of the government. (5)

During the Reagan years, America was transformed into a TV democracy whose prime directive is social control through the fabrication and manipulation of images. "We [the Reagan campaign staff] tried to create the most entertaining, visually attractive scene to fill that box, so that the cameras from the networks would have to use it," explained former Reagan advisor Michael Deaver. "It would be so good that they'd say, 'Boy, this is going to make our show tonight.' We became Hollywood producers" (quoted in "Illusions of News," 5).

The conversion of American society into a virtual reality was lamentably evident in the Persian Gulf War, a made-for-TV miniseries with piggybacked merchandising (T-shirts, baseball caps, Saddam toilet paper, Original Desert Shield Condoms) and gushy, *Entertainment Tonight*-style hype from a cheerleading media. When filmmaker Jon Alpert, under contract to NBC, brought back stomach-churning footage of Iraq under US bombardment, the network—which is owned by one of the world's largest arms manufacturers, General Electric—fired Alpert and refused to air the film. Not that Alpert's film would have roused the body politic: Throughout the war, the American people demanded the right not to know. A poll cited in the *New York Times* was particularly distressing: "Given a choice between increasing military control over information or leaving it to news organizations to make most decisions about reporting on the war, 57 percent of those responding said they would favor greater military control" (Jones 1991).

During the war's first weeks, as home-front news organizations aided Pentagon spin control by maintaining a near-total blackout on cover-

age of protest marches, Deaver was giddy with enthusiasm. "If you were going to hire a public relations firm to do the media relations for an international event," he bubbled, "it couldn't be done any better than this is being done" (quoted in "Illusions of News," 1990). In fact, a PR firm, Hill & Knowlton, *was* hired; it orchestrated the congressional testimony of the distraught young Kuwaiti woman whose horror stories about babies ripped from incubators and left "on the cold floor to die" by Iraqi soldiers was highly effective in mobilizing public support for the war. Her testimony was never substantiated, and her identity—she was the daughter of the Kuwaiti ambassador to the United States—was concealed, but why niggle over details? "Formulated like a World War II movie, the Gulf War even ended like a World War II movie," wrote Neal Gabler (1991), "with the troops marching triumphantly down Broadway or Main Street, bathed in the gratitude of their fellow Americans while the final credits rolled" (32).

After the yellow ribbons were taken down, however, a creeping disaffection remained. A slowly spreading rancor at the televisual *Weltanschauung*, it is with us still, exacerbated by the prattle of talk show hosts, anchorclones, and the Teen Talk Barbie advertised on Saturday mornings whose "four fun phrases" include "I love shopping" and "Meet me at the mall." Mark Crispin Miller (1987) neatly sums TV's place in our society:

> Everybody watches it, but no one really likes it. This is the open secret of TV today. Its only champions are its own executives, the advertisers who exploit it, and a compromised network of academic boosters. Otherwise, TV has no spontaneous defenders, because there is almost nothing in it to defend. (228)

The rage and frustration of the disempowered viewer exorcised in "Media Burn" bubbles up, unexpectedly, in "57 Channels (and Nothin' On)," Bruce Springsteen's Scorsese-esque tale of a man unhinged by the welter of meaningless information that assails him from every channel. Springsteen sings:

> So I bought a .44 magnum it was solid steel cast
> And in the blessed name of Elvis well I just let it blast

'Til my TV lay in pieces there at my feet
And they busted me for disturbin' the almighty peace.

Significantly, the video for "57 Channels" incorporates footage of a white Cadillac on a collision course with a wall of flaming TV sets, in obvious homage to "Media Burn." The ritual destruction of the TV set, endlessly iterated in American mass culture, can be seen as a retaliatory gesture by an audience that has begun to bridle, if only intuitively, at the suggestion that "power" resides in the remote control unit, that "freedom of choice" refers to the ever-greater options offered around the dial. This techno-voodoo rite constitutes the symbolic obliteration of a one-way information pipeline that only transmits, never receives. It is an act of sympathetic magic performed in the name of all who are obliged to peer at the world through peepholes owned by multinational conglomerates for whom the profit margin is the bottom line. "To the eye of the consumer," notes Ben Bagdikian (1989),

> the global media oligopoly is not visible. . . . Newsstands still display rows of newspapers and magazines, in a dazzling array of colors and subjects. . . . Throughout the world, broadcast and cable channels continue to multiply, as do video cassettes and music recordings. But . . . if this bright kaleidoscope suddenly disappeared and was replaced by the corporate colophons of those who own this output, the collage would go gray with the names of the few multinationals that now command the field. (819)

In his watershed work, *The Media Monopoly*, Bagdikian (1989) reported that the number of transnational media giants had dropped to twenty-three and was rapidly shrinking. Following another vector, Herbert Schiller (1987) considers the interlocked issues of privatized information and limited access:

> The commercialization of information, its private acquisition and sale, has become a major industry. While more material than ever before, in formats created for special use, is available at a price, free public information supported by general taxation is attacked by the private sector as an unacceptable form of subsidy. . . . An individual's ability to know the

actual circumstances of national and international existence has progressively diminished. (6)

Martin A. Lee and Norman Solomon (1990) level another, equally disturbing charge:

> In an era of network news cutbacks and staff layoffs, many reporters are reluctant to pursue stories they know will upset management. "People are more careful now," remarked a former NBC news producer, "because this whole notion of freedom of the press becomes a contradiction when the people who own the media are the same people who need to be reported on." (75)

Corporate ownership of the newsmedia, the subsumption of an ever-larger number of publishing companies and television networks into an ever-smaller number of multinationals, and the increased privatization of truth by an information-rich, technocratic elite are not newly risen issues. More recent is the notion that the public mind is being colonized by corporate phantasms—wraithlike images of power and desire that haunt our dreams. Consider the observations of Neal Gabler and Marshall Blonsky:

> Everywhere the fabricated, the inauthentic and the theatrical have gradually driven out the natural, the genuine and the spontaneous until there is no distinction between real life and stagecraft. In fact, one could argue that the theatricalization of American life is the major cultural transformation of this century. (Gabler 1991, 32)

> We can no longer do anything without wanting to see it immediately on video. . . . There is never any longer an event or a person who acts for himself, in himself. The direction of events and of people is to be reproduced into image, to be doubled in the image of television. . . . Today the referent disappears. In circulation are images. Only images. (Blonsky 1992, 231)

The territory demarcated by Gabler and Blonsky, lush with fictions yet strangely barren, has been mapped in detail by the philosopher Jean

Baudrillard. In his landmark 1975 essay, "The Precession of Simulacra," Baudrillard put forth the notion that we inhabit a "hyperreality," a hall of media mirrors in which reality has been lost in an infinity of reflections. We "experience" events, first and foremost, as electronic reproductions of rumored phenomena many times removed, he maintains; originals, invariably compared to their digitally enhanced representations, inevitably fall short. In the "desert of the real," asserts Baudrillard, mirages outnumber oases and are more alluring to the thirsty eye.

Moreover, he argues, signs that once pointed toward distant realities now refer only to themselves. Disneyland's Main Street, USA, which depicts the sort of idyllic, turn-of-the-century burg that exists only in Norman Rockwell paintings and MGM backlots, is a textbook example of self-referential simulation, a painstaking replica of something that never was. "These would be the successive phases of the image," writes Baudrillard, betraying an almost necrophiliac relish as he contemplates the decomposition of culturally defined reality. "[The image] is the reflection of a basic reality; it masks and perverts a basic reality; it masks the absence of a basic reality; it bears no relation to any reality whatever: it is its own pure simulacrum" (1983, 11).

Reality isn't what it used to be. In America, factory capitalism has been superseded by an information economy characterized by the reduction of labor to the manipulation, on computers, of symbols that stand in for the manufacturing process. The engines of industrial production have slowed, yielding to a phantasmagoric capitalism that produces intangible commodities—Hollywood blockbusters, television sit-coms, catchphrases, jingles, buzzwords, images, one-minute megatrends, financial transactions flickering through fiber-optic bundles. Our wars are Nintendo wars, fought with camera-equipped smart bombs that marry cinema and weaponry in a television that kills. Futurologists predict that the flagship technology of the coming century will be "virtual reality," a computer-based system that immerses users wearing headgear wired for sight and sound in computer-animated worlds. In virtual reality, the television swallows the viewer, headfirst.

II. Culture Jamming

Meanwhile, the question remains: How to box with shadows? In other words, what shape does an engaged politics assume in an empire of signs?

The answer lies, perhaps, in the "semiological guerrilla warfare" imagined by Umberto Eco (1986). "The receiver of the message seems to have a residual freedom: the freedom to read it in a different way. . . . I am proposing an action to urge the audience to control the message and its multiple possibilities of interpretation" (138, 143), he writes. "One medium can be employed to communicate a series of opinions on another medium. . . . The universe of Technological Communication would then be patrolled by groups of communications guerrillas, who would restore a critical dimension to passive reception" (143–44).

Eco assumes, a priori, the radical politics of visual literacy, an idea eloquently argued by Stuart Ewen, a critic of consumer culture. "We live at a time when the image has become the predominant mode of public address, eclipsing all other forms in the structuring of meaning," asserts Ewen (1990). "Yet little in our education prepares us to make sense of the rhetoric, historical development or social implications of the images within our lives." In a society of heat, light and electronic poltergeists—an eerie otherworld of "illimitable vastness, brilliant light, and the gloss and smoothness of material things" (76)—the desperate project of reconstructing meaning, or at least reclaiming that notion from marketing departments and PR firms, requires visually literate ghostbusters.

Culture jammers answer to that name. "Jamming" is CB slang for the illegal practice of interrupting radio broadcasts or conversations between fellow hams with lip farts, obscenities, and other equally jejune hijinks. Culture jamming, by contrast, is directed against an ever more intrusive, instrumental technoculture whose operant mode is the manufacture of consent through the manipulation of symbols.

The term "cultural jamming" was first used by the collage band Negativland to describe billboard alteration and other forms of media sabotage. On *Jamcon '84* (Negativland 1985), a mock-serious band member observes, "As awareness of how the media environment we occupy affects and directs our inner life grows, some resist. . . . The skillfully reworked billboard . . . directs the public viewer to a consideration of the

original corporate strategy. The studio for the cultural jammer is the world at large."

Part artistic terrorists, part vernacular critics, culture jammers, like Eco's "communications guerrillas," introduce noise into the signal as it passes from transmitter to receiver, encouraging idiosyncratic, unintended interpretations. Intruding on the intruders, they invest ads, newscasts, and other media artifacts with subversive meanings; simultaneously, they decrypt them, rendering their seductions impotent. Jammers offer irrefutable evidence that the Right has no copyright on war waged with incantations and simulations. And, like Ewen's cultural cryptographers, they refuse the role of passive shoppers, renewing the notion of a public discourse.

Finally, and just as importantly, culture jammers are Groucho Marxists, ever mindful of the fun to be had in the joyful demolition of oppressive ideologies. As the inveterate prankster and former Dead Kennedy singer Jello Biafra (1987) once observed, "There's a big difference between 'simple crime' like holding up a Seven-Eleven, and 'creative crime' as a form of expression. . . . Creative crime is . . . uplifting to the soul. . . . What better way to survive our anthill society than by abusing the very mass media that sedates the public? . . . *A prank a day keeps the dog leash away!*" (64).

Jamming is part of a historical continuum that includes Russian samizdat (underground publishing in defiance of official censorship); the anti-fascist photomontages of John Heartfield; Situationist *détournement* (defined by Greil Marcus [1989] in *Lipstick Traces* as "the theft of aesthetic artifacts from their contexts and their diversion into contexts of one's own devise" [168]); the underground journalism of 1960s radicals such as Paul Krassner, Jerry Rubin, and Abbie Hoffman; Yippie street theater such as the celebrated attempt to levitate the Pentagon; parody religions such as the Dallas-based Church of the Subgenius; workplace sabotage of the sort documented by *Processed World*, a magazine for disaffected data-entry drones; the ecopolitical monkeywrenching of Earth First!; the random acts of Artaudian cruelty that radical theorist Hakim Bey (1991) calls "poetic terrorism" ("weird dancing in all-night computer banking lobbies . . . bizarre alien artifacts strewn in State Parks" [113]); the insurgent use of the "cut-up" collage technique proposed by William Burroughs (1979) in "Electronic Revolution" ("The control of the

mass media depends on laying down lines of association. . . . Cut/up techniques could swamp the mass media with total illusion" [126, 132]); and subcultural bricolage (the refunctioning, by societal "outsiders," of symbols associated with the dominant culture, as in the appropriation of corporate attire and *Vogue* model poses by poor, gay, and largely non-white drag queens).

An elastic category, culture jamming accommodates a multitude of subcultural practices. Outlaw computer hacking with the intent of exposing institutional or corporate wrongdoing is one example; "slashing," or textual poaching, is another. (The term "slashing" derives from the pornographic "K/S"—short for "Kirk/Spock"—stories written by female *Star Trek* fans and published in underground fanzines. Spun from the perceived homoerotic subtext in *Star Trek* narratives, K/S, or "slash," tales are often animated by feminist impulses. I have appropriated the term for general use, applying it to any form of jamming in which tales told for mass consumption are perversely reworked.) Transmission jamming, pirate TV and radio broadcasting, and camcorder counter-surveillance (in which low-cost consumer technologies are used by DIY muckrakers to document police brutality or governmental corruption) are potential modus operandi for the culture jammer. So, too, is media activism such as the cheery immolation of a mound of television sets in front of CBS's Manhattan offices—part of a protest against media bias staged by FAIR (Fairness and Accuracy in Reporting) during the Gulf War—and "media-wrenching" such as ACT UP's disruption of *The MacNeil/Lehrer Newshour* in protest of infrequent AIDS coverage. A somewhat more conventional strain of culture jamming is mediawatch projects such as Paper Tiger Television, an independent production collective that produces segments critiquing the information industry; Deep Dish TV, a grassroots satellite network that distributes free-thinking programming to public access cable channels nationwide; and Not Channel Zero, a collective of young African American "camcorder activists" whose motto is "The Revolution, Televised." And then there is academy hacking—cultural studies, conducted outside university walls, by insurgent intellectuals.

Thus, culture jamming assumes many guises; let us consider, in greater detail, some of its more typical manifestations.

Sniping and Subvertising

"Subvertising," the production and dissemination of anti-ads that deflect Madison Avenue's attempts to turn the consumer's attention in a given direction, is a ubiquitous form of jamming. Often, it takes the form of "sniping"—illegal, late-night sneak attacks on public space by operatives armed with posters, brushes, and buckets of wheat paste.

Adbusters, a Vancouver-based quarterly that critiques consumer culture, enlivens its pages with acid satires. "Absolut Nonsense," a cunningly executed spoof featuring a suspiciously familiar-looking bottle, proclaimed: "Any suggestion that our advertising campaign has contributed to alcoholism, drunk driving or wife and child beating is absolute nonsense. No one pays any attention to advertising." Ewen, himself a covert jammer, excoriates conspicuous consumption in his "Billboards of the Future"—anonymously mailed Xerox broadsides like his ad for "Chutzpah: cologne for women & men, one splash and you'll be demanding the equal distribution of wealth." Guerrilla Girls, a cabal of feminist artists that bills itself as "the conscience of the art world," is known for savagely funny, on-target posters, one of which depicted a nude odalisque in a gorilla mask, asking, "Do women have to get naked to get into the Met. Museum?" Los Angeles's Robbie Conal covers urban walls with the information age equivalent of Dorian Gray's portrait: grotesque renderings of Oliver North, Ed Meese, and other scandal-ridden politicos. "I'm interested in counter-advertising," he says, "using the streamlined sign language of advertising in a kind of reverse penetration" (Conal 1990). For gay activists, subvertising and sniping have proven formidable weapons. A March 1991 *Village Voice* report from the frontlines of the "outing" wars made mention of "Absolutely Queer" posters, credited to a phantom organization called OUTPOST, appearing on Manhattan buildings. One, sparked by the controversy over the perceived homophobia in Silence of the Lambs, featured a photo of Jodie Foster, with the caption: "Oscar Winner. Yale Graduate. Ex-Disney Moppet. Dyke." Queer Nation launched a "Truth in Advertising" postering campaign that sent up New York Lotto ads calculated to part the poor and their money; in them, the official tagline, "All You Need Is a Dollar and a Dream" became "All You Need Is a Three-Dollar Bill and a Dream." The graphics collective Gran

Fury, formerly part of ACT UP, has taken its sharp-tongued message even further: A super slick Benetton parody ran on buses in San Francisco and New York in 1989. Its headline blared "Kissing Doesn't Kill: Greed and Indifference Do" over a row of kissing couples, all of them racially mixed and two of them gay. "We are trying to fight for attention as hard as Coca-Cola fights for attention," says group member Loring Mcalpin. "If anyone is angry enough and has a Xerox machine and has five or six friends who feel the same way, you'd be surprised how far you can go" (quoted by Jacobs 1991, 91–92).

Media Hoaxing

Media hoaxing, the fine art of hoodwinking journalists into covering exhaustively researched, elaborately staged deceptions, is culture jamming in its purest form. Conceptual con artists like Joey Skaggs dramatize the dangers inherent in a press that seems to have forgotten the difference between the public good and the bottom line, between the responsibility to enlighten and the desire to entertain.

Skaggs has been flimflamming journalists since 1966, pointing up the self-replicating, almost viral nature of news stories in a wired world. The trick, he confides, "is to get someone from an out-of-state newspaper to run a story on something sight unseen, and then you Xerox that story and include it in a second mailing. Journalists see that it has appeared in print and think, therefore, that there's no need to do any further research. That's how a snowflake becomes a snowball and finally an avalanche, which is the scary part. There's a point at which it becomes very difficult to believe anything the media tells you" (Skaggs 1990).

In 1976, Skaggs created the Cathouse for Dogs, a canine bordello that offered a "savory selection" of doggie Delilahs, ranging from pedigree (Fifi, the French poodle) to mutt (Lady the Tramp). The ASPCA was outraged, the *Soho News* was incensed, and ABC devoted a segment to it, which later received an Emmy nomination for best news broadcast of the year. In time, Skaggs reappeared as the leader of Walk Right!, a combat-booted Guardian Angels-meet-Emily Post outfit determined to improve sidewalk etiquette, and later as Joe Bones, head of a Fat Squad whose tough guy enforcers promised, for a fee, to prevent overweight

clients from cheating on diets. As Dr. Joseph Gregor, Skaggs convinced UPI and New York's WNBC-TV that hormones extracted from mutant cockroaches could cure arthritis, acne, and nuclear radiation sickness.

After reeling in the media outlets that have taken his bait, Skaggs holds a conference at which he reveals his deception. "The hoax," he insists, "is just the hook. The second phase, in which I reveal the hoax, is the important part. As Joey Skaggs, I can't call a press conference to talk about how the media has been turned into a government propaganda machine, manipulating us into believing we've got to go to war in the Middle East. But as a jammer, I can go into these issues in the process of revealing a hoax" (Skaggs 1990).

Audio Agitprop

Audio agitprop, much of which utilizes digital samplers to deconstruct media culture and challenge copyright law, is a somewhat more innocuous manifestation. Likely suspects include Sucking Chest Wound, whose *God Family Country* ponders mobthink and media bias; the Disposable Heroes of Hiphoprisy, who take aim in "Television, the Drug of the Nation" at "happy talk" newscasts that embrace the values of MTV and *Entertainment Tonight*; Producers for Bob, whose pert, chittering dance tracks provide an unlikely backdrop for monologues about "media ecology," a McLuhan-inspired strategy for survival in a toxic media environment; and Chris Burke, whose *Oil War*, with its cut-up press conferences, presidential speeches, and nightly newsbites, is pirate C-Span for Noam Chomsky readers. Sucking Chest Wound's Wayne Morris speaks for all when he says, "I get really angry with the biased coverage that's passed off as objective journalism. By taking scraps of the news and blatantly manipulating them, we're having our revenge on manipulative media."

Billboard Banditry

Lastly, there is billboard banditry, the phenomenon that inspired Negativland's coinage. Australia's BUGA UP stages hit-and-run "demotions," or anti-promotions, scrawling graffiti on cigarette or liquor ads. The

group's name is at once an acronym for "Billboard-Utilising Graffitists Against Unhealthy Promotions" and a pun on "bugger up," Aussie slang for "screw up."

In like fashion, African American activists have decided to resist cigarette and liquor ads targeting communities of color by any means necessary. Describing Reverend Calvin Butts and fellow Harlem residents attacking a Hennesey billboard with paint and rollers, *Z magazine*'s Michael Kamber reports, "In less than a minute there's only a large white blotch where moments before the woman had smiled coyly down at the street" (quoted in Goldstein 1991, 48). Chicago's Reverend Michael Pfleger is a comrade-in-arms; he and his Operation Clean defaced— some prefer the term "refaced"—approximately one thousand cigarette and alcohol billboards in 1990 alone. "It started with the illegal drug problem," says Pfleger. "But you soon realize that the number-one killer isn't crack or heroin, but tobacco. And we realized that to stop tobacco and alcohol we [had] to go after the advertising problem" (quoted in Ferman 1991, 41).

San Francisco's Billboard Liberation Front, together with Truth in Advertising, a band of "midnight billboard editors" based in Santa Cruz, snap motorists out of their rush hour trances with deconstructed, reconstructed billboards. In the wake of the Valdez disaster, the BLF reinvented a radio promo—"Hits Happen. New X-100"—as "Shit Happens—New Exxon"; TIA turned "Tropical Blend. The Savage Tan" into "Typical Blend. Sex in Ads."[1]

Artfux and the breakaway group Cicada Corps of Artists are New Jersey–based agitprop collectives who snipe and stage neo-Situationist happenings. On one occasion, Artfux members joined painter Ron English for a tutorial of sorts, in which English instructed the group in the fine art of billboard banditry. Painting and mounting posters conceptualized by English, Artfux accompanied the New York artist on a one-day, all-out attack on Manhattan. One undercover operation used math symbols to spell out the corporate equation for animal murder and ecological disaster: A hapless-looking cow plus a death's-head equaled a McDonald's polystyrene clamshell. "Food, Foam and Fun!" the tagline taunted. In a similar vein, the group mocked "Smooth Joe," the Camel cigarettes camel, turning his phallic nose into a flaccid penis and his sagging lips into bobbing testicles. One altered billboard ad-

jured, "Drink Coca-Cola—It Makes You Fart," while another showed a seamed, careworn Uncle Sam opposite the legend, "Censorship is good because————!"

"Corporations and the government have the money and the means to sell anything they want, good or bad," noted Artfux member Orlando Cuevas in a *Jersey Journal* feature on the group. "We . . . [are] ringing the alarm for everyone else."

III. Guerrilla Semiotics

Culture jammers often make use of what might be called "guerrilla" semiotics—analytical techniques not unlike those employed by scholars to decipher the signs and symbols that constitute a culture's secret language, what literary theorist Roland Barthes called "systems of signification." These systems, notes Barthes (1968) in the introduction to *Elements of Semiology*, comprise nonverbal as well as verbal modes of communication, encompassing "images, gestures, musical sounds, objects, and the complex associations of all these" (9).

It is no small irony—or tragedy—that semiotics, which seeks to make explicit the implicit meanings in the sign language of society, has become pop culture shorthand for an academic parlor trick useful in divining the hidden significance in *Casablanca*, Disneyland, or our never-ending obsession with Marilyn Monroe. In paranoid pop psych such as Wilson Bryan Key's *Subliminal Seduction* (1991), semiotics offers titillating decryptions of naughty advertising. "This preoccupation with subliminal advertising," writes Ewen, "is part of the legendary life of post–World War II American capitalism: the word 'SEX' written on the surface of Ritz crackers, copulating bodies or death images concealed in ice cubes, and so forth" (26). Increasingly, advertising assumes this popular mythology: A recent print ad depicted a cocktail glass filled with ice cubes, the words "Absolut vodka" faintly discernible on their craggy, shadowed surfaces. The tagline: "Absolut Subliminal."

All of which makes semiotics seem trivial, effete, although it is an inherently political project. Barthes "set out . . . to examine the normally hidden set of rules, codes and conventions through which meanings particular to specific social groups (i.e. those in power) are rendered universal and 'given' for the whole of society" (Hebdige 1979, 9). Marshall

Blonsky (1992) has called semiotics "a defense against information sickness, the 'too-muchness' of the world" (231), fulfilling Marshall McLuhan's (1964) prophecy that "just as we now try to control atom-bomb fallout, so we will one day try to control media fallout" (267). As used by culture jammers, it is an essential tool in the all-important undertaking of making sense of the world, its networks of power, the encoded messages that flicker ceaselessly along its communication channels.

This is not to say that all of the jammers mentioned in this essay knowingly derive their ideas from semiotics or are even familiar with it, only that their ad hoc approach to cultural analysis has much in common with the semiotician's attempt to "read between the lines" of culture considered as a text. Most jammers have little interest in the deliria that result from long immersion in the academic vacuum, breathing pure theory. They intuitively refuse the rejection of engaged politics typical of postmodernists like Baudrillard, a disempowering stance that too often results in an overeagerness for ringside seats at the *Gotterdämmerung*. The *L.A. Weekly*'s disquieting observation that Baudrillard "loves to observe the liquidation of culture, to experience the delivery from depth" calls to mind Walter Benjamin's pronouncement that mankind's "self-alienation has reached such a degree that it can experience its own destruction as an aesthetic pleasure of the first order" (Davis 1990, 54). Jammers, in contrast, are attempting to reclaim the public space ceded to the chimeras of Hollywood and Madison Avenue, to restore a sense of equilibrium to a society sickened by the vertiginous whirl of TV culture.

IV. Postscript from the Edge

The territory mapped by this essay ends at the edge of the electronic frontier, the "world space of multinational capital" (Jameson 1991, 54) where vast sums are blipped from one computer to another through phone lines twined around the globe. Many of us already spend our workdays in an incunabular form of cyberpunk writer William Gibson's (1984) "cyberspace," defined in his novel *Neuromancer* as "a consensual hallucination experienced daily by billions of legitimate operators.... A graphic representation of data abstracted from the banks of every computer in the human system" (51). The experience of computer scientist W. Daniel Hillis (1992), once novel, is becoming increasingly familiar:

When I first met my wife, she was immersed in trading options. Her office was in the top of a skyscraper in Boston, and yet, in a very real sense, when she was at work she was in a world that could not be identified with any single physical location. Sitting at a computer screen, she lived in a world that consisted of offers and trades, a world in which she knew friends and enemies, safe and stormy weather. For a large portion of each day, that world was more real to her than her physical surroundings. (13)

In the next century, growing numbers of Americans will work and play in artificial environments that exist, in the truest sense, only as bytes stored in computer memory. The explosion of computer-based interactive media seems destined to sweep away (at least in its familiar form) the decidedly *non*-interactive medium that has dominated the latter half of this century: television. Much of this media may one day be connected to a high-capacity, high-speed fiber optic network of "information superhighways" linking as many homes as are currently serviced by the telephone network. This network, predicts computer journalist John Markoff (1993), "could do for the flow of information—words, music, movies, medical images, manufacturing blueprints and much more—what the transcontinental railroad did for the flow of goods a century ago and the interstate highway system did in this century" (1).

The culture jammer's question, as always, is: Who will have access to this cornucopia of information, and on what terms? Will fiber-optic superhighways make stored knowledge universally available, in the tradition of the public library, or will they merely facilitate psychological carpet-bombing designed to soften up consumer defenses? And what of the network news? Will it be superseded by local broadcasts, with their heartwarming (always "heartwarming") tales of rescued puppies and shocking (always "shocking") stories of senseless mayhem, mortared together with airhead banter? Or will the Big Three give way to innumerable news channels, each a conduit for information about global, national, and local events germane to a specific demographic? Will cyberpunk telejournalists equipped with Hi-8 video cameras, digital scanners, and PC-based editing facilities hack their way into legitimate broadcasts? Or will they, in a medium of almost infinite bandwidth and channels beyond count, simply be given their own airtime? In short, will the electronic frontier be worm-holed with "temporary autono-

mous zones"—Hakim Bey's (1991) term for pirate utopias, centrifuges in which social gravity is artificially suspended—or will it be subdivided and overdeveloped by what cultural critic Andrew Ross (1995) calls "the military-industrial-media complex"? (163) William Gibson, who believes that we are "moving toward a world where all of the consumers under a certain age will . . . identify more . . . with the products they consume than . . . with any sort of antiquated notion of nationality," is not sanguine. In the video documentary *Cyberpunk*, he conjures a minatory vision of what will happen when virtual reality is married to a device that stimulates the brain directly. "It's going to be very commercial," he says. "We could wind up with something that felt like having a very, very expensive American television commercial injected directly into your cortex" (quoted in Trench 1990, n.p.).

"For Sale" signs already litter the unreal estate of cyberspace. A *New York Times* article titled "A Rush to Stake Claims on the Multimedia Frontier" prophesies "software and hardware that will connect consumers seamlessly to services . . . [allowing them] to shop from home" (Fisher 1993), while a *Newsweek* (1993) cover story on interactive media promises "new technology that will change the way you shop, play and learn" (the order, here, speaks volumes about American priorities). Video retailers are betting that the intersection of interactive media and home shopping will result in zillions of dollars' worth of impulse buys: zirconium rings, nonstick frying pans, costumed dolls, spray-on toupees. What a *New York Times* author cutely calls "Communicopia" ("the convergence of virtually all communications technologies") may end up looking like the Home Shopping Network on steroids.

But hope springs eternal, even in cyberspace. Jammers are heartened by the electronic frontier's promise of a new media paradigm—interactive rather than passive, nomadic and atomized rather than resident and centralized, egalitarian rather than elitist. To date, this paradigm has assumed two forms: the virtual community and the desktop-published or online 'zine. ("'Zine," the preferred term among underground publishers, has subtly political connotations: grassroots organization, a shoestring budget, an anti-aesthetic of exuberant sloppiness, a lively give-and-take between transmitters and receivers, and, more often than not, a mocking, oppositional stance vis-à-vis mainstream media.) Virtual communities are comprised of computer users

connected by modem to the bulletin board systems (BBS's) springing up all over the Internet, the worldwide metanetwork that connects international computer networks. Funded not by advertisers but by paid subscribers, the BBS is a first, faltering step toward the jammer's dream of a truly democratic mass medium. Although virtual communities fall short of utopia—women and people of color are grossly underrepresented, and those who cannot afford the price of admission or who are alienated from technology because of their cultural status are denied access—they nonetheless represent a profound improvement on the homogenous, hegemonic medium of television.

On a BBS, any subscriber may initiate a discussion topic, no matter how arcane, in which other subscribers may participate. If the bulletin board in question is plugged into the Internet, their comments will be read and responded to by computer users scattered across the Internet. Online forums retire, at long last, the Sunday morning punditocracy, the expert elite, the celebrity anchorclones of network news, even the electronic town hall, with its carefully screened audience and over-rehearsed politicians. As one resident of a San Francisco–based bulletin board called the WELL noted,

> This medium gives us the possibility (illusory as it may be) that we can build a world unmediated by authorities and experts. The roles of reader, writer, and critic are so quickly interchangeable that they become increasingly irrelevant in a community of co-creation. (Knutson 1993)

In like fashion, ever-cheaper, increasingly sophisticated desktop publishing packages (such as the software and hardware used to produce this pamphlet) ensure that, in a society where freedom of the press—as A. J. Leibling so presciently noted—is guaranteed only to those who own one, multinational monoliths are not the only publishers. As Gareth Branwyn (1992), a one-time 'zine publisher and longtime resident of virtual communities, points out,

> The current saturation of relatively inexpensive multimedia communication tools holds tremendous potential for destroying the monopoly of ideas we have lived with for so long. . . . A personal computer can be configured to act as a publishing house, a broadcast-quality TV studio, a

professional recording studio, or the node in an international computer
bulletin board system. (1–2)

Increasingly, 'zines are being published online, to be bounced around
the world via the Internet. "I can see a future in which any person can
have a node on the net," says Mitch Kapor, president of the Electronic
Frontier Foundation, a group concerned with free speech, privacy, and
other constitutional issues in cyberspace. "Any person can be a pub-
lisher. It's better than the media we now have" (quoted in Sterling 1992,
298).

Devil's advocates might well argue that *Festering Brain Sore*, a fanzine
for mass murderer aficionados, or the WELL topic devoted to "armpit
sex" are hardly going to crash the corporate media system. Hakim Bey
(1991) writes, "The story of computer networks, BBS's and various other
experiments in electro-democracy has so far been one of hobbyism for
the most part. Many anarchists and libertarians have deep faith in the
PC as a weapon of liberation and self-liberation—but no real gains to
show, no palpable liberty" (113).

Then again, involvement in virtual communities and the 'zine scene
is rapidly expanding beyond mere hobbyism: as this is written, approxi-
mately 10 million people frequent BBS's, and an estimated ten thousand
'zines are being published (seventy alone are given over to left politics of
a more or less radical nature). These burgeoning subcultures are driven
not by the desire for commodities but by the dream of community—
precisely the sort of community now sought in the nationally shared ex-
perience of watching game shows, sitcoms, sportscasts, talk shows, and,
less and less, the evening news. It is this yearning for meaning and cohe-
sion that lies at the heart of the jammer's attempts to reassemble the frag-
ments of our world into something more profound than the luxury cars,
sexy technology, and overdesigned bodies that flit across our screens.
Hackers who expose governmental wrongdoing, textual slashers, wheat-
paste snipers, billboard bandits, media hoaxers, subvertisers, and unan-
nounced political protestors who disrupt live newscasts remind us that
numberless stories go untold in the daily papers and the evening news;
that what is *not* reported speaks louder than what is. The jammer insists
on *choice*: not the dizzying proliferation of consumer options, in which
a polyphony of brand names conceals the essential monophony of the

advertiser's song, but a true plurality, in which the univocal world view promulgated by corporate media yields to a multivocal, polyvalent one.

The electronic frontier is an ever-expanding corner of Eco's (1987) "universe of Technological Communication . . . patrolled by groups of communications guerrillas" bent on restoring "a critical dimension to passive reception" (144). These guerrilla semioticians are in pursuit of new myths stitched together from the fabric of their own lives, a patchwork of experiences and aspirations that has little to do with the depressive stories of an apolitical intelligentsia or the repressive fictions of corporate media's Magic Kingdom. "The images that bombard and oppose us must be reorganized," insist Stuart and Elizabeth Ewen (1976). "If our critique of commodity culture points to better alternatives, let us explore—in our own billboards of the future—what they might be" (282). Even now, hackers, slashers, and snipers—culture jammers all—are rising to that challenge.

NOTE

1 [In his 2010 revision, Dery added here: "Inspired by a newsflash that plans were underway to begin producing neutron bombs, a Seattle-based trio known as SSS reworked a Kent billboard proclaiming 'Hollywood Bowled Over By Kent III Taste!' to read 'Hollywood Bowled Over By Neutron Bomb!,' replacing the cigarette pack with a portrait of then-President Ronald Reagan."—Eds. See also the Introduction to this volume, n. 4.]

REFERENCES

Bagdikian, Ben. 1989. "Lords of the Global Village." *Nation*, June 12, 819.

Barthes, Roland. 1968. Introduction to *Elements of Semiology*, translated by Annette Lavers and Colin Smith, 9–12. New York: Hill & Wang.

Baudrillard, Jean. 1983. "The Precession of Simulacra." In *Simulations*, translated by Phil Beitchman and Paul Foss, 179. New York: Semiotext(e).

Bey, Hakim. 1991. *T.A.Z.: The Temporary Autonomous Zone*. New York: Autonomedia.

Biafra, Jello. 1987. Interview by Vivian Vale and Andrea Juno in *Pranks!*, edited by Vivian Vale and Andrea Juno, 59–64. San Francisco: V/Search.

Blonsky, Marshall. 1992. *American Mythologies*. New York: Oxford University Press.

Branwyn, Gareth. 1992. "Jamming the Media." In *Black Hole*, edited by Carolyn Hughes, 1–2. Baltimore: Institute for Publications Design, Yale Gordon College of Liberal Arts, University of Baltimore.

Burroughs, William S. 1979. "The Electronic Revolution." *Ah Pook Is Here and Other Texts*. New York: Riverrun Press.

Cohen, Roger. 1991. "The Lost Book Generation." *New York Times*, "Education Life" Supplement, January 6, 34.

Conal, Robbie. 1990. Interview by Mark Dery.

Davis, Mike. 1990. *City of Quartz: Excavating the Future in Los Angeles*. New York: Verso.

Eco, Umberto. 1986. "Towards a Semiological Guerrilla Warfare." In *Travels in Hyperreality*, translated by William Weaver, 135–44. San Diego: Harcourt Brace Jovanovich.

Ewen, Stuart. 1990. "Living by Design." *Art in America* (June): 76.

———. 1991. "Desublimated Advertising." *Artforum* (January): 26.

Ewen, Stuart, and Elizabeth Ewen. 1976. *Channels of Desire: Mass Images and the Shaping of American Consciousness*. New York: McGraw-Hill.

Ferman, David. 1991. "Pastor Leads War on Billboards." *Adbusters* (Fall/Winter): 41–42.

Fisher, Lawrence M. 1993. "A Rush to Stake Claims on the Multimedia Frontier." *New York Times*, May 30. www.nytimes.com.

Gaber, Neal. 1991. "Now Playing: Real Life, the Movie." *New York Times*, October 20, sec. 2.

Gibson, William. 1984. *Neuromancer*. New York: Ace.

Goldstein, Harry. 1991. "Billboard Liberation: Talking Back to Marketers by Taking Outdoor Advertising into Your Own Hands." *Utne Reader* (November/December): 46–48.

Hebdige, Dick. 1979. *Subculture: The Meaning of Style*. London: Methuen.

Hertsgaard, Mark. 1988. *On Bended Knee: The Press and the Reagan Presidency*. New York: Farrar, Straus & Giroux.

Hillis, Daniel W. 1992. "What Is Massively Parallel Computing?" *Daedalus* (Winter): 13.

"Illusions of News." 1990. *The Public Mind with Bill Moyers*, episode 3. Washington, DC: PBS.

Jacobs, Karrie. 1990. "Metropolis" (July/August 1990). Reprinted in *Utne Reader* (March/April 1991): 91–92.

Jameson, Fredric. 1991. *Postmodernism: or, The Cultural Logic of Late Capitalism*. Durham, NC: Duke University Press.

Jones, Alex S. 1991. "Poll Backs Control of News." *New York Times*, January 31, C24.

Kissinger, Beth. 1991. "Guerrilla Arts Group Invades Billboards." *Jersey Journal*, (May/June 1991).

Knutson, William Rolf. 1993. E-mail message to the author, March 25.

Lee, Martin A., and Norman Solomon. 1990. "Anti-Hero: What Happens When Network News Is Owned and Sponsored by Big Corporations That Need to Protect Their Own Interests?" *Spin* 6 (4): 75.

Marcus, Greil. 1989. *Lipstick Traces*. Cambridge, MA: Harvard University Press.

Markoff, John. 1993. "Building the Electronic Superhighway" *New York Times*, January 24, sec. 3.

McKibben, Bill. 1992. *The Age of Missing Information*. New York: Random House.

McLuhan, Herbert Marshall. 1964. *Understanding Media: The Extensions of Man*. New York: Signet.

Miller, Mark Crispin. 1987. "Deride and Conquer." In *Watching Television*, edited by Todd Gitlin, 183–228. New York: Pantheon.

Negativland. 1985. *Over the Edge Vol. 1: Jamcon '84.* SST Records. Audio-cassette.

Newsweek. 1993. "Interactive: A New Technology that Will Change the Way You Shop, Play and Learn. A Million Dollar Industry (Maybe)." May 31.

Ross, Andrew. 1995. *The Chicago Gangster Theory of Life: Nature's Debt to Society.* London: Verso.

Schiller, Herbert I. 1987. "Information: Important Issue for '88." *Nation*, July 4–11, 6.

Sechehaye, Marguerite. 1968. *Autobiography of a Schizophrenic Girl.* New York: Grune & Stratton.

Skaggs, Joey. 1990. Interview by Mark Dery.

Sterling, Bruce. 1992. *The Hacker Crackdown: Law and Disorder on the Electronic Frontier.* New York: Bantam.

Trench, Marianne, dir. 1990. *Cyberpunk.* New York: Intercon. Videocassette (VHS), 60 min.

2

Pranking Rhetoric

"Culture Jamming" as Media Activism

CHRISTINE HAROLD

Pranks aren't reactive like acts of revenge. They don't punish,
they provoke. . . . Revenge is a science, pranking is an art.
—Reverend Al, of the Cacophony Society pranking group

Illusion is a revolutionary weapon.
—William Burroughs

In late 2003, *Adbusters*, the activist magazine known for its parodic "sub-
vertisments" and scathing critiques of consumer culture, launched its
most ambitious anti-branding campaign yet. Its "Blackspot" sneaker, an
unassuming black canvas shoe, with a large white spot where one would
expect a corporate logo, is intended to "uncool" sportswear giant Nike
by offering an ethically produced alternative to the Nike swoosh. The
magazine's first goal is to challenge Nike's controversial CEO by way of
a full-page ad in the *New York Times* declaring:

> Phil Knight had a dream. He'd sell shoes. He'd sell dreams. He'd get rich.
> He'd use sweatshops if he had to. Then along came the new shoe. Plain.
> Simple. Cheap. Fair. Designed for only one thing. Kicking Phil's ass. The
> Unswoosher. ("Blackspot" 2004)

Adbusters is also encouraging its readers to help spread the "Blackspot
virus" by graffiti-ing black spots on Niketown windows and displays across
the United States and Canada. Although it remains to be seen whether
the campaign will, as *Adbusters* hopes, "set a precedent that will revo-
lutionize capitalism" ("Blackspot" 2004), to date well over two hundred

independent shoe stores and four thousand individuals have placed orders for the shoes, and Blackspot was featured in the *New York Times Magazine*'s special "Year in Ideas" issue as one of the "best ideas of 2003."

Adbusters is at the forefront of an insurgent political movement known loosely as "culture jamming." This movement seeks to undermine the marketing rhetoric of multinational corporations, specifically through such practices as media hoaxing, corporate sabotage, billboard "liberation," and trademark infringement. Ad parodies, popularized through magazines such as *Adbusters* and *Stay Free!* and countless websites, are by far the most prevalent of culture jamming strategies. Ad parodies attempting to serve as rhetorical x-rays, revealing the "true logic" of advertising, are a common way for so-called "subvertisers" to talk back to the multimedia spectacle of corporate marketing. An *Adbusters* parody of Calvin Klein's "heroin chic" ads of the mid-1990s, for example, features a female model hunched over a toilet, vomiting, presumably to maintain her waifish figure. The ad tells viewers that women are dissatisfied with their own bodies because "the beauty industry is the beast." In another, Joe Chemo, a cancer-ridden cartoon camel, derides the infamous Joe Camel campaign, and a Tommy Hilfiger spoof depicts his customers as sheep, wanting only to "follow the flock." The Gap's infamous appropriation of the likenesses of counterculture heroes Jack Kerouac and James Dean to sell khaki pants inspired a similar response from the adbusting community. To the Gap's claim that "Kerouac wore khakis," a group of Australian subvertisers responded with the likeness of another twentieth-century icon who wore khakis as well—Adolf Hitler. As such, Gap khakis were recoded as a means not to rugged individuality but genocidal totalitarianism—the conformist impulse writ large.

Ad parodies such as these might be categorized as a strategy of rhetorical sabotage, an attempt to impede the machinery of marketing. *Adbusters*' own "culture jammer's manifesto," for example, declares: "We will jam the pop-culture marketers and bring their image factory to a sudden, shuddering halt" (Lasn 1999, 128). The industrial imagery here is telling. It invokes the most traditional target of sabotage—the factory. Historically, sabotage, or monkeywrenching, has been a dominant oppositional response to industrial power. The word "sabotage," according to *Merriam-Webster's Dictionary* (2012), emerged in Europe around 1910, at the height of the Industrial Revolution. Indeed, it is a term that is

inextricably linked to industrial capitalism. The first definition of sabotage offered in *Webster's* is the "destruction of an employer's property or the hindering of manufacturing by discontented workers." *Webster's* explains that the word comes from "sabot," the name for the wooden shoes worn in many European countries in the nineteenth century. "Saboter," then, meant "to clatter with sabots" or to "botch," presumably by throwing one's wooden shoes into the machinery. "Sabotage" means literally to "clog" with one's clogs.

I suggest that while the advertising sabotage articulated by *Adbusters* is not without some rhetorical value, it does little to address the rhetoric of contemporary marketing—a mode of power that is quite happy to oblige subversive rhetoric and shocking imagery. Indeed, parody and irony are the dominant motifs of many successful mass-marketing campaigns. Through a kind of nudge-and-wink knowingness, Madison Avenue culture jammers make every effort to subvert traditional advertising tropes—selling, as cultural critic Thomas Frank (1997) has put it, edgy brands as tickets to the rhetorical "lynching" of consumerism. As Fredric Jameson (1991) has famously argued, the cultural logic that accompanies this era of late capitalism is defined by a codification of the eccentric modernist styles of resistance. For example, contemporary advertising is teeming with the language of revolution. But, as Jameson (1991) points out, these flagrantly rebellious styles "ostentatiously deviate from a norm which then reasserts itself, in a not necessarily unfriendly way, by a systematic mimicry of their willful eccentricities." In other words, parody becomes one of many social codes—codes that are as available to the capitalist as they are to the artist—and, as such "finds itself without vocation" (16) as a rhetoric of protest in late capitalism.

Further, I want to suggest that despite its deconstructive sensibility, parody, an example of what Mikhail Bakhtin (1984) would describe as turning the world upside down, perpetuates a commitment to rhetorical binaries—the hierarchical form it supposedly wants to upset. The frustration expressed by *Adbusters'* readers (if the magazine's often scathing letters section is any indication) implies that being told what is best for them is no more welcome coming from *Adbusters* than it is coming from advertisers. This may be, in part, because the parodic form neglects what literary theorist Jeffrey Nealon (1993) calls the "crucial operation" of deconstruction, *reinscribing* oppositions (30)—for ex-

ample, health/sickness or authenticity/conformity—back into a larger textual field. Hence parody, as negative critique, is not up to the task of undermining the parodist's own purchase on the Truth as it maintains both a hierarchy of language and the protestor's role as revealer. Parody derides the *content* of what it sees as oppressive rhetoric, but fails to attend to its *patterns*.

In this essay, I explore the rhetorical strategies of an alternative sort of culture jammer—the prankster—who resists less through negating and opposing dominant rhetorics than by playfully and provocatively folding existing cultural forms in on themselves. The prankster performs an art of rhetorical jujitsu, in an effort to redirect the resources of commercial media toward new ends. In what follows, I first detail the theoretical frame through which I engage the political art of culture jamming, including why, specifically, the prankster's ethic may offer a more compelling response than parody to contemporary cultural and economic forces. Second, in an effort to explore pranking in action, I offer three contemporary case studies of radical and mainstream efforts to hijack popular media forms: the culture jamming collective ®™ark (pronounced "artmark"); the San Francisco–based Biotic Baking Brigade; and the American Legacy Foundation's INFKT Truth campaign. Finally, I conclude by suggesting that although pranking strategies do perform the Aristotelian notion of exploiting available means, for them to be fully imagined as rhetoric, rhetoric itself may have to be somewhat recalibrated in its role as a mass-mediated political art. As I will discuss, although culture jamming should not be seen as a replacement for more traditional modes of civic engagement, the playful and disruptive strategies of the prankster have much to offer social justice movements in the so-called "post-industrial" era.

Intensifying Media Forms: A Theory of Culture Jamming

The term "culture jamming" is based on the CB slang word "jamming" in which one disrupts existing transmissions. It usually implies an interruption, a sabotage, hoax, prank, banditry, or blockage of what are seen as the monolithic power structures governing cultural life. Like Umberto Eco's (1986) "semiological guerrillas" (135), culture jammers seek to "introduce noise into the signal" that might otherwise obliterate alternatives to it (Dery 1993, 7). Culture jamming is usually described

as a kind of "glutting" of the system; it is an amping up of contradictory rhetorical messages in an effort to engender a qualitative change. In this sense, jamming need not be seen only as a damming or a stopping of corporate media, as *Adbusters'* monkeywrenching imagery implies. Rather, it may be more useful to consider jamming as an artful proliferation of messages, a rhetorical process of intervention and invention, which challenges the ability of corporate discourses to make meaning in predictable ways.

Many contemporary culture jammers describe themselves as political heirs to the Situationists, a group of avant-garde artists who flourished in 1950s and 1960s Europe. The Situationists were committed to detouring preexisting political and commercial rhetorics in an effort to subvert and reclaim them. For the Situationists, led by *Society of the Spectacle* author Guy Debord, everyday life was being overrun by the Spectacle, a novel mode of social domination in which the industrial age's coercive manual labor was replaced by capitalism's deceitful promise of fulfillment through entertainment and consumption. Their main strategy, *détournement*, was an effort to "devalue the currency of the Spectacle" (Lasn 1999, 108), which they claimed had kidnapped authentic life. Examples include everything from rewording conversations between popular comic strip characters, to reworking the sign on a storefront, to making subversive collages out of familiar commercial and government images. *Détournement* can be translated as "detour" or "diversion" but other, more subtle meanings in the French include "hijacking," "embezzlement," "corruption," and "misappropriation" (Sadler 1999, 17). Although many ad parodists, such as those at *Adbusters*, see themselves as carrying the revolutionary mantle of the Situationists, Debord and his comrades were decidedly opposed to parody as an effective rhetorical strategy, because it maintained, rather than unsettled, audiences' purchase on truth.

As I have mentioned, a major limitation of the adbuster's reliance on parody as a revelatory device is that this device has been enthusiastically embraced by marketers as well. This insistence on revealing a hidden truth also becomes a problem for other reasons. Such an insistence disallows a forceful response to what it faces because it can only *react*. It is a rhetoric that resentfully tells its audience, "Things are not as they should be," without affirming possible alternatives. Saying no is itself an

often satisfying alternative, but it is hardly one on which to build a lasting political movement.

The no-sayer is, in essence, yoked in a dialectic tug of war with the rhetoric he or she seeks to negate. *Adbusters*' Blackspot sneaker campaign, for example, may be more proactive than its subvertisements (*Adbusters* is, for example, proposing to build a "clean" factory in China should the campaign succeed), but the rhetorical message is similar. It is mobilized, first and foremost, by a desire to "kick Phil's ass." Second, then, because the no-sayer has not challenged the essential form of the binary, the no-sayer can never negate adequately by his or her own dialectical standards. A rhetoric that is defined by negation must always encounter more boundaries that must be overcome. More transgression is always required, which inevitably produces more cynicism and resentment. Certainly, saying no is sometimes a crucial political strategy. However, I suggest that asceticism may not be an effective intervention into the scintillating world of consumer culture; and ironically, by ardently pursuing the authentic realm "out there," one plays one's role as consumer in the fullest possible sense, endlessly chasing after something just beyond reach.

Finally—and most crucial for the discussion of pranking that follows—whereas parody may have significant impact in certain rhetorical situations, it should not be seen as a transhistorical category that is inherently subversive, primarily because capitalism itself is not a transhistorical system. It is constantly taking new shapes and producing different kinds of effects. A specific conversation between two theorists of contemporary capitalism, Michel Foucault and Gilles Deleuze, offers a productive model through which to conceptualize the political practices of culture jamming (Deleuze 1990). Foucault and Deleuze conceived contemporary capitalism as undergoing a shift from *disciplinarity* to *control*. Under disciplinary societies, most famously theorized by Foucault, previously feudalist modes of production were brought together, organized, and confined in order to maximize efficiency and profit. Disciplinary societies operate primarily through the confinement and atomization of individuals (for example, through the familiar models of the prison, the classroom, or the factory). This was the mode of power most appropriate to a Fordist world in which assembly-line style production was the most efficient way for capital to expand. Fordism re-

quired a certain level of *standardization* to function. Workers were more or less interchangeable, and labor practices were repeated with as little variation as possible. Concurrently, the advertising industry emerged to standardize the consumers who would make up the markets for these newly mass-produced products.

Deleuze (1990) pursues Foucault's acknowledgement late in his career that the West is now undergoing a transformation from the disciplinarity necessary for an industrial economy to a service economy organized, in part, through the increased control of consumer desires. Control societies do not operate through the confinement and silencing of individuals but "through continuous control and communication" (174). That is, people are not denied access to information and knowledges but are granted ever greater access to them through the opening up of technologies and the hybridization of institutions. However, what might appear as new freedoms also enable business to increasingly modulate every aspect of life. I suggest that the proliferation of the rhetoric of consumerism, in part, marks this shift from discipline to control. Because of this emerging shift from disciplinarity (which spotlights the political rhetoric of the nation-state) to control (which increasingly relies on the visual rhetoric of the market), the opportunities for political protest have shifted as well.

At least two modes of intervention or resistance emerge out of and in response to the logics of disciplinarity and control—sabotage and appropriation. I loosely affiliate sabotage with disciplinarity and appropriation with control. However, I want to be careful, here, to complicate any neat distinction between the two. Although appropriation may be increasing in the face of greater control, both strategies continue to function in response to similar problems by deploying different tools. As Deleuze (1990) has suggested, disciplinarity does not disappear with the emergence of control. Control is an intensification, rather than a replacement, of discipline.

Media pranksters, an increasingly active type of consumer activist, prefer affirmation and appropriation to opposition and sabotage. Whereas the culture jammer as saboteur opposes commercialism through revelatory rhetoric such as parody, pranksters can be seen as comedians, as playful explorers of the commercial media landscape. In

the third essay of *On the Genealogy of Morals*, Nietzsche (1989) argues that the ascetic ideal, that resentful no-saying of the first order, "has at present only *one* kind of real enemy capable of *harming* it: the comedians of this ideal—for they arouse mistrust of it" (160). Unlike the ascetic, the comedian is not interested in revenge or "bringing the people to consciousness" as if she can use her comedy to expose the truth or push the limits of power until they reveal their true logic. These are the goals of the parodist, not the comedian. To reveal, one must stand in a familiar place and know just what is behind the spectacular curtain. In contrast, the comedian is something of a surfer with no firm, knowable ground on which to stand. Rather, she learns to navigate a force that is already in motion and will continue to be in motion long after she has passed. Whereas parodists attempt to change things in the name of a presupposed value, comedians diagnose a specific situation and try something to see what responses they can provoke.

Legendary New York performance artist and media hoaxer Joey Skaggs has been provoking people for over three decades. Since 1966, Skaggs has been putting people on, using the news media's own insatiable appetite for sensational images as his canvas. Skaggs says of his work:

> I had concepts that I thought would make a statement. *I was using the media as a medium.* Rather than sticking with oil paint, the media became my medium; I got involved with the phenomenon of the media and communication as my art. (Skaggs 1987, 36; emphasis added)

Skaggs's most famous and widely disseminated "image event" (DeLuca 1999) was his 1976 "Cathouse for Dogs," a phony doggie brothel in a makeshift storefront where one could supposedly have one's dog sexually "serviced." To begin, Skaggs simply issued press releases and ran the following advertisement in the *Village Voice*:

CATHOUSE FOR DOGS
Featuring a savory selection of hot bitches. From pedigree (Fifi, the French Poodle) to mutts (Lady the Tramp). Handler and vet on duty. Stud and photo service available. No weirdos, please. Dogs only. By appointment. Call 254–7878.

On the face of it this silly prank hardly seems the kind of thing that would garner much reaction save from a few perverts or curious thrill-seekers. However, Skaggs's "Cathouse for Dogs" received more attention than even he imagined it would. Several New York television stations sent camera crews, the *Soho News* ran a piece, and the ASPCA, the Bureau of Animal Affairs, and the NYPD vice squad, as well as the Mayor's office, all campaigned to put Skaggs out of business.

His greatest exposure, though, came by way of an *ABC News* interview. With little more than some footage of mating dogs and an interview with Skaggs, ABC produced a standard "wrap-around" news piece—interview-footage-interview—and aired it in a larger story about animal abuse. Skaggs's hoax quickly spread, earning him international media attention as well as a lawsuit from the ASPCA. Skaggs is careful to point out that his production was purely rhetorical:

> I didn't want customers—it was never my intent to defraud or deceive people for money. Deceit—yes, fraud—no. . . . An artist is much different from a con-man. I am a con-man, but I'm a con-fidence, con-ceptual, con-artist. That's different. (Skaggs 1987, 40)

Artistic intentions aside, that year, Skaggs was subpoenaed by the Attorney General's office for "illegally running a cathouse for dogs." Meanwhile, ABC's documentary piece featuring Skaggs's cathouse was nominated for an Emmy as "best news broadcast of the year" (Skaggs 1987, 40)! Facing criminal charges, Skaggs publicly revealed his cathouse as a hoax. Facing professional humiliation, the ABC journalists never retracted their story, despite Skaggs's revelation.

Skaggs's hoax illustrates an important characteristic of the media. It functions, in his words, as something of a "telephone game" in which meaning and content mutate with each repetition:

> In this day and age, with electronic telecommunications instantaneously darting around the globe and people feeding off everyone else's network of nerve endings, a misspelled word or a misplaced exclamation mark can totally change what is being said. And it's almost impossible to determine where the accidental change came from. And that's on a mild level. It's even *intentionally* done. Governments are doing it, corporations

are doing it. Individuals within the media itself are doing it, and people like myself are doing it to make sociopolitical commentaries [about the irresponsibility of the news media]. (Skaggs 1987, 40–41)

As Skaggs suggests, his strategy is not uniquely his own, the domain only of the political subversive. Rather, he observes that unpredictable differentiation is an unavoidable effect as texts are disseminated across the mediascape. Messages and images mutate as they migrate through the vast variety of media outlets, until questions of source and original intent cease to matter. As he notes, governments and corporations often sponsor disinformation campaigns, using the media to start rumors or deflect the public's attention from potential scandals. Indeed, thanks to ABC's professional constraints, Skaggs's cathouse for dogs remains on the record as historical "fact."

Skaggs's cathouse for dogs event—as well as his many others, which included a "celebrity sperm bank" and a Thanksgiving world hunger performance piece—is noteworthy because it exemplifies pranking as a strategic mode of engagement with commercial media and consumer culture in general. Skaggs's project clearly functions as a prank in its most familiar sense: a trick, a practical joke, or a mischievous act. This is a prank in the mundane sense of tying a classmate's shoelaces together under the desk, or short-sheeting a bed. A prank affords the prankster a certain "gotcha!" pleasure at having pulled one over on an unsuspecting party. But, more importantly for our purposes here, Joey Skaggs's prank—as well as the others I will discuss shortly—also illustrates two alternative senses of the word: (1) In Middle English, to prank was to add a stylistic flourish as to one's dress: to deck, or adorn as in "to dress, or deck in a gay, bright, or showy manner; to decorate; to deck oneself *out*, dress oneself *up*"; (2) prank can also mean a fold, or a "pleat, as in the figurative sense of 'wrinkle'" (Vale and Juno 1987, n.p.). These alternative senses of prank are imperative for this discussion of culture jamming. In neither alternative is a prank an act of dialectical opposition. In the first alternative sense, as in to "deck in a showy manner," a prank is a *stylistic exaggeration*. It is a kind of *layering up* of adornment in a conspicuous way that produces some sort of qualitative change. Prank, in this sense, is an augmentation of dominant modes of communication that interrupts their conventional patterns. In the second alterna-

tive sense, a prank is a wrinkle, or a fold. Like a fold, a prank can render a qualitative change by turning and doubling a material or text. This qualitative change is produced not through the addition of novelty, but through reconfiguration of the object itself. For analytical purposes, let us continue to stretch and layer the meaning of prank to include a folding over of mass-mediated rhetoric. Dominant texts are wrinkled, they are folded, they ravel and unravel as a result of these stylistic layerings. In the case studies that follow, I will play with these alternative senses of prank—adornment and folding—in an attempt to describe the rhetorical possibilities of media pranking.

While we are playing with definitions, however, let us consider another: I propose an alternative sense of jamming itself. Ultimately, if marketing is, as Deleuze (1990) suggests, "now the instrument of social control" (181), then perhaps activists must better learn to play and manipulate that instrument. Rather than approach jamming as simply a monkey-wrenching or opposition to marketing rhetoric, as the activists at *Adbusters* might have it, perhaps activists might approach it as well-trained musicians do music—as a familiar field on which to improvise, interpret, and experiment.

Earlier, I discussed the etymological roots of sabotage (literally, throwing one's clogs into the machinery) in the Industrial Revolution. This is a response to a disciplinary model of power that ad parodists continue to practice, despite the waning of the factory as both the symbolic and material engine of the contemporary marketplace. However, in what is little more than a side note in its definition of sabotage, *Webster's* states that, in addition to referring to wooden shoes, "sabot" also denotes "a thrust transmitting carrier," or a kind of "launching tube." This second definition provides a compelling alternative sense of the concept of sabotage. As we have seen, in its monkeywrenching version, sabotage implies destruction or the stopping and hindering of flows through the introduction of an outside element. Put simply, it is a clogging. However, in the word's second sense, as a launching tube, sabotage also implies a channeling, or a transmission of energy or resources through a conduit. This implies that resistance can also enable and direct energy flows rather than merely thwart them. With this in mind, one's rhetorical tools need not come from outside at all, as an oppositional model might in-

sist. Further, as the invocation of tube and carrier implies, and as we have seen from the previous examples of culture jamming, sabotage is not a chaotic, shapeless, anarchic practice, but one that is restrained and shaped by the machinery from which it emerges; without the transmitting carrier, no thrust. In other words, constraints can be seen as immanent to those flows that seek to transform them.

Jamming, in this second, interpretive sense, requires both practice and knowledge of one's instrument as well as a dynamic exchange among a community of agents. Jamming, although it often implies a free-form chaos, requires knowledgeable and disciplined players to work. Recall, for example, Joey Skaggs's description of the work he put into his cathouse for dogs. He painstakingly set up an image event that would appeal to the needs of the televisual news media. He employed the strategies of a television producer in an effort to fold the medium over on itself. As Skaggs suggests, the broadcast media itself is his canvas. And Skaggs knows the contours of his canvas well:

> First there's the hook, when I do the performance; next, I document the process of miscommunication, or how the media twists the content and meaning of the message; finally, I talk about the serious issues underlying the performance piece. The media often trivialize the third stage by saying "Oh, he's a hoaxter, he has an ego problem, he wants attention, etc." (Quoted in Frauenfelder and Branwyn 1995, 40–41)

Skaggs's strategies do not oppose dominant modes of power; they utilize them. As he suggests, "You're already being pranked every day. If you think *I'm* the prankster, you are sadly mistaken" (quoted in Frauenfelder and Branwyn 1995, 41).

To jam as a musician does is to interpret an existing text. I do not mean here, interpret as in trying to make one word correspond directly to its equivalent as one does when translating a text from one language to another, where the interpreter is obliged to make the translation as correct as possible. Rather, I mean interpret in its sense as appropriation, as when a group of jazz musicians appropriate an existing piece of music or a set of chord progressions and, in doing so, produce a new interpretation. This interpretation does not necessarily correspond to

anything outside itself. It does not fail or succeed at representing an original. However, it does contain familiar textual residues. Jamming as appropriation, in these ways, differs from jamming as sabotage.

Pranking as Rhetorical Appropriation

This section focuses on three contemporary examples of media pranking. The first two, the Barbie Liberation Organization and the Biotic Baking Brigade, typify much pranking activism: both are protean collections of activists temporarily stealing the limelight of the mainstream organizations or leaders they target. Both can easily be categorized as engaging in guerrilla media strategies in the terms described above. The third example, the American Legacy Foundation's Truth campaign, an official organization's attempt to thwart teen smoking, maintains a guerrilla aesthetic and ethic but differs from the others in terms of its scope and resources. Unlike the other examples, which operate on shoestring budgets and the media savvy of activists, the Truth campaign is well funded by court-ordered tobacco industry dollars. It is the result of a successful hybrid of traditional legal advocacy and a deployment of the comedic sensibility of the prankster.

Hacking Gender: °™ark and the Barbie Liberation Organization

In 1989, a group of culture jammers known only as the Barbie Liberation Organization (BLO) pranked the infamously litigious Mattel Corporation through its most prized brand: Barbie. Barbie and Hasbro's military action figure GI Joe are notorious for reinforcing unrealistic, even dangerous, gender stereotypes. But for the BLO, Mattel's Teen Talk Barbie proved to be the last straw. The doll, enhanced with a computer chip "voice box," was programmed to giggle random phrases when a button on her back was pressed. Mattel's chosen phrases included: "Math class is tough!," "I love shopping!," and "Will we ever have enough clothes?" ("Culture Jammer's Encyclopedia" n.d.). In response, the Manhattan-based BLO organized a prank that continues to generate discussion on feminist and culture jamming websites. Taking advantage of the mechanical similarities between Teen Talk Barbie and her male counterpart Talking Duke GI Joe, the BLO purchased hundreds of each doll

from local stores, took them home and switched their voice chips. At the height of the Christmas shopping season, they returned the dolls to stores so they could be resold to unknowing shoppers. When children opened their toys on Christmas morning, instead of Barbie chirping cheerful affirmations of American girlishness, she growled, in the butch voice of GI Joe: "Eat lead, Cobra!," "Dead men tell no lies!," and "Vengeance is mine!" Meanwhile, Joe exclaimed: "Let's plan our dream wedding!"

The rhetorical message of the Great Barbie Hack may be somewhat obvious. The sheer dissonance created by hearing gender inappropriate voices and sentiments may have made absurd otherwise normalized gender norms. As one BLO operative put it: "Our goal is to reveal and correct the problem of gender-based stereotyping in children's toys" (quoted in Greenberg 1994, par. 5). Another told the *New York Times*: "We are trying to make a statement about the way toys can encourage negative behavior in children, particularly given rising acts of violence and sexism" (Dery 1994, par. 5). Political goals aside, the dolls have become something of a collector's item. As another BLO member jokingly told National Public Radio's Scott Simon, the BLO is good for business:

> Nobody wants to return [the dolls]. . . . We think that our program of putting them back on the shelves [benefits] everyone: The storekeepers make money twice, we stimulate the economy, the consumer gets a better product and our message gets heard. (Dery 1994, par. 9)

It also may have confused and upset children on Christmas morning. But not seven-year-old Zachariah Zelin who received one of the altered GI Joes. When asked "whether he wanted Santa to take back the feminine Joe, he responded sharply 'No way. I love him. I like everything about him'" reports one Associated Press writer (Greenberg 1994, par. 13).

What was truly inspired about the BLO was their media savvy. Each "hacked" doll had a sticker on its back urging recipients "Call your local TV news," ensuring television journalists would have real disgruntled families to interview for their reports ("Culture Jammer's Encyclopedia" n.d.). Further, the group later utilized the new medium of the Internet to disseminate detailed instructions on how to perform such hacks, complete with pictures and diagrams, enabling others to perpetuate

the practice. The BLO claims to have inspired similar hacks in Canada, France, and England. Finally, using a strategy increasingly popular with media activists, the BLO produced its own prepackaged news pieces to be distributed to content-hungry local television stations. The video documentaries showed doll hackers at work, "post-op" Barbies and Joes, and interviews with BLO members explaining their project. The videos were sent out to television stations complete with press releases explaining what BLO had done and why.

When reporters asked the toy manufacturers for their reaction, one Hasbro spokesman simply called the attack "ridiculous." Another was amused, but nonplussed: "This will move us to have a good laugh and go on making more GI Joes. Barbie dolls and GI Joes are part of American culture." Mattel officials downplayed the attack, saying they had received no complaints from consumers (Greenberg 1994, par. 10).

The BLO was the first and most prominent culture jamming project funded by °¨ark, something of a culture jamming clearing house that has modeled itself after a corporation. Although its actual numbers are somewhat uncertain, according to the group's website:

> °¨ark is a brokerage that benefits from "limited liability" just like any other corporation; using this principle, °¨ark supports the sabotage (informative alteration) of corporate products, from dolls and children's learning tools to electronic action games, by channeling funds from investors to workers for specific projects grouped into "mutual funds." ("Frequently Asked Questions" 2000, par. 7)

°¨ark exploits rather than condemns a corporate luxury that rankles many culture jammers—a corporation's ability to skirt certain legal restrictions that individuals are obliged to heed. As a private corporation, the group enables activists and investors to participate in illegal product tampering without much personal risk. As the group describes its mission: "°¨ark is indeed just a corporation, and it benefits from corporate protections, but unlike other corporations, its 'bottom line' is to improve culture, rather than its own pocketbook; it seeks *cultural* profit, not financial" (par. 8).

°¨ark spokesperson Ray Thomas argues that many people still think of power in "the old terms"—that is, government power. His group seeks to

make explicit the increasing power of corporations: "They are so adaptable, and they're so organic that it's hard to speak of any one corporation as the enemy. It's more the system that allows tremendous abuse" (quoted in "How to Make Trouble" 1998, n.p.). Rather than attempting to dismantle the corporate power system, Thomas and the other activists at ®™ark exploit it; they observe the "adaptable" and "organic" nature of corporations and approach it as fertile soil for rhetorical and political appropriation. As one Australian journalist notes, ®™ark has "cleverly aped the structures and jargons of a financial institution, even down to a smarmingly corporate-sounding promotional video" (quoted in "How to Make Trouble" 1998, n.p.). Opening with warnings from Abraham Lincoln about unfettered corporate power, the aforementioned video— "Bringing It to You!"—offers viewers a history of the corporation and rehearses ®™ark's style of corporate sabotage. In the spirit of pranking as I want to conceive it here, ®™ark folds and augments the corporate model in a way that offers new dimensions for rhetorical invention.

Pie Crimes and Misdemeanors: The Biotic Baking Brigade

In 1998, Nobel Prize–winning economist Milton Friedman (along with conservative California governor Pete Wilson, multimillionaire Steve Forbes, and former secretary of state under Ronald Reagan, George Schultz) was attending a conference on the benefits of privatizing public education. As Friedman was greeting well-wishers, a young man emerged from the crowd, exclaiming "Mr. Friedman, it's a good day to pie!" and heaved a coconut crème pie into the face of the famous Chicago-school economist. With that, the Biotic Baking Brigade (BBB) executed the first of what would be many successful missions: publicly delivering pies to "pompous people." Since its inception, BBB victims have included Microsoft founder Bill Gates, CEO of genetic engineering giant Monsanto Robert Shapiro, Chevron CEO Kenneth Derr, San Francisco Mayor Willie Brown, and World Trade Organization Chief Renato Ruggiero.

When reporting the public pieing of Mayor Willie Brown (who had just mandated a city-wide sweep of the homeless), a confused San Francisco anchorman asked: "Is it funny? Is it some kind of statement? A physical assault?" ("The Pie's the Limit" 1999). The BBB is consis-

tently ready with pointed answers for journalists asking the inevitable question—"Why?" In the case of Milton Friedman, for example, BBB "special agent" Christian Parenti said:

> Milton Friedman is the chief architect of neo-liberal economics. [His] particular brand of economics further allows multi-national corporations to rape the land, to plunder social systems . . . to prevent any type of popular resistance to occur. So, even though Milton Friedman may seem like a strange target, like just some fuddy-duddy old geek, the man is like a purveyor of an ideological poison that is central to the kinds of policies and politics that are threatening the health of the planet and threatening the interests of common people all over the planet. (Quoted in "The Pie's the Limit" 1999)

A pie in the face of Milton Friedman becomes what rhetoricians would call a *synecdoche*; it is an easy visual short hand for a whole host of grievances against globalization's prevailing economic ideology.

The BBB's Rahula Janowski explains the logic behind the group's choice of "weapon": "Pie is an example that you don't have to revere someone just because they're more powerful than you. . . . Pie is the great equalizer. How wealthy and powerful are you with pie dripping off your face?" Janowski points out that many CEOs and other powerful people do not often put themselves in situations where they hear dissent. So the BBB seeks them out in public fora, often where the target is giving a speech in some controlled, formal environment:

> It's a message of "we know who you are and we don't agree with what you're doing." And it also puts a face on that dissent. Here's this person and they're willing to come right up and put the pie in your face. Like, "we *really* don't like what you're doing." (Quoted in "The Pie's the Limit" 1999)

Importantly, the face that gets disseminated throughout the mediascape is not that of an angry protestor, as is often the case, but the often well-known face of a captain of industry. The face of Bill Gates is a familiar image for evening news audiences; however, after being pranked by the BBB, its ability to convey authority and influence is momentarily disenabled.

Although their message is clearly one that opposes the ideologies and practices of their targets—genetic engineering, neoliberal economics, clear-cutting of redwoods, corporate monopolies—their tactic of choice, pie-throwing, expresses that opposition in such a way that makes it difficult for targets to respond or audiences to understand in traditional ways. As one BBB agent, Rosie Rosebud, explains: "A clown, a comedian, is someone who can laugh at themselves, they can laugh at society, and their rulers" (quoted in "The Pie's the Limit" 1999). The BBB's rhetoric, when its agents speak to reporters, is clearly oppositional in nature, but it is their comedic posture and creation of spectacular images that get them the interviews in the first place.

The BBB understands well how to get its agenda into newspapers and television broadcasts. Unlike *Adbusters*, the BBB does not remain resentfully on the outside, denied access to what Kevin DeLuca and Jennifer Peeples (2002) call the "public screen" by the commercial media. Instead, they hijack events that are already orchestrated for television—public speeches, rallies, meet-and-greets, and so on. They know that the image of a famous politician or captain of industry getting a pie in the face is so striking that the image-hungry media cannot help but cover it. Bill Gates with lemon meringue dripping from his nose *will* make the five-o'clock news. Unlike its more ascetic counterparts, the BBB does not condemn the news; it makes it by cooking up tasty images for the Spectacle to consume. As San Francisco prankster Mark Pauline puts it in another context:

> The media can never deny coverage to a good spectacle. No matter how ridiculous, absurd, insane or illogical something is, if it achieves a certain identity as a spectacle, the media has to deal with it. They have no choice. They're hamstrung by their own needs, to the extent that they're like a puppet in the face of such events. (Pauline 1987, 14)

Again, BBB agents are always on hand to offer journalists a quick interpretive sound bite, such as "Monsanto CEO Robert Shapiro is the Pinochet of the food world [so] he's gotten his just desserts!" But the image of the powerful being pied says more than a spoken message ever could. As Janowski explains: "The American public understands the impact of the message that is put forth by a pie. I mean, I think

of the Three Stooges. Think of the Marx Brothers. It's *very, very plain* what's happening when a pie is delivered" (quoted in "The Pie's the Limit" 1999). A pie in the face becomes a powerful rhetorical symbol that requires little explanation. Agent "Salmonberry" puts it most succinctly: "I think the history of pie-throwing shows that it's a form of visual *Esperanto*. It's a universal language. Everyone understands the pie in the face. [It's about] taking their spectacle and just spinning it around. It allows people to have a laugh at the expense of the rich and powerful and otherwise unaccountable" (quoted in "The Pie's the Limit" 1999). The BBB, then, mobilizes two familiar but dissonant visuals—a sober public speaker and a pie in the face—and by joining them, produces a kind of political jujitsu, using the power of the broadcast media toward its own ends.

To ensure its images make the news, the BBB sends its own camera operators on missions. In some cases, as with the pieing of Chevron CEO Kenneth Derr, the news media cannot be counted on to capture the moment on video. Like the Barbie Liberation Organization, the Biotic Baking Brigade happily provides budget-strapped local news stations with ready-made video packages, complete with interviews and images. This is a strategy often used by corporate advertisers hoping to create a "buzz" around a new product. Advertisers regularly offer pre-produced marketing stunts packaged as news features (known in the PR world as "video press releases"), which local news stations can easily queue up for broadcast. Result: free content for the station and free advertising for the corporation. Media pranksters like those in the BLO or the BBB just borrow that strategy, turning the media's love of images over on itself and creating a venue for issues that the commercial media often ignore. Further, BBB agents, despite their somewhat militant politics, are always clean cut, articulate, and wear a sly smile. Hence, they are not easily dismissed as militant hippie radicals creating anarchy. They realize that they, too, must look the part for broadcast television if they are to gain access to it. As BBB agents are always sure to tell reporters, civil disobedience is "as American as apple pie."[1]

INFKT Truth: Pranking Big Tobacco

One of the most successful models of media pranking comes in the form of an institutionally sanctioned public service campaign: the American Legacy Foundation's INFKT Truth campaign. Funded with more than $100 million of tobacco money per annum ("Arnold Faces Anti-Smoking Challenge" 2002) after the 1998 "master settlement" agreement between tobacco companies and forty-six states, the impeccably produced television, print, radio, and web campaign, distinguished by a bright orange background and the cyber-style font and graphics popular in rave and gaming culture, Truth seeks to mobilize young people against Big Tobacco. As its use of the phonetic device "INFKT" implies, the Truth campaign encourages young people to infect their peers with knowledge about how the tobacco industry markets to children.

Unlike Nancy Reagan's "Just say no" campaign, which was, by most accounts, a dismal failure in the 1980s, Truth invites young people to assume a subversive posture that is far more active than just impotently saying no to tobacco. An underlying assumption of INFKT Truth is that Nike's provocation to "just do it" has proven far more compelling to young people than Reagan's message of abstinence could ever be. In an article about teen anti-smoking campaigns, one Scottish newspaper sarcastically asks: "Would you embrace a drug-free lifestyle on the advice of an emaciated former actress with concrete hair and a designer clothes habit many times more expensive than the average teenager's dope habit?" (Harris 1996, 14). Whereas the "just say no" admonishment came from the First Lady, an unmistakable symbol of the establishment, the Truth campaign takes seriously young people's antiauthoritarian attitudes and positions itself with them. Rather than asking teenagers to correct their own individual behavior, Truth encourages a critical analysis of tobacco as an industry.

Before the American Legacy Foundation launched its Truth campaign in 2000, the most prominent voice against underage smoking was the tobacco industry itself, forced by a series of courtroom battles to sponsor anti-smoking public service announcements. At first blush, these tobacco-sponsored announcements seemed well-intentioned, but their rhetoric was so out of touch with the tropes of so-called "Generation Y" that they seem purposefully ineffective. Take, for example, tobacco giant

Lorillard's "Tobacco is Wacko (if you're a teen)" campaign that supposedly sought to discourage kids from picking up the habit. First, let us assume that for most of today's teens and "tweens," as the market has so cleverly labeled pre-adolescents, "wacko" is probably not on the slang radar. More importantly, Lorillard neglects the fact that being "outside the box," "on the edge," "Xtreme" or, okay, even slightly "wacko" is exactly what is understood as cool for today's kids. Other advertisers pursuing the volatile teen market have known this for some time. Although even the most cursory analysis of market-produced rebellion shows that kids are encouraged to rebel symbolically in a mass-produced way—by purchasing the latest "edgy" product—kids at least want to feel that they are choosing not to run with the herd when buying this or that brand of widget.

On the face of it, then, it might seem that Lorillard misses what proves effective with the youth market when it states that it is wacko (read: edgy) to smoke cigarettes. Although it hopelessly fudges the vernacular of today's teens, it perpetuates the aura that makes smoking so sexy to kids in the first place. Smoking is what distinguishes you from the pack. It is what makes you a rebel. In this light, Lorillard's choice of the outdated "wacko" is clearly not misguided at all. In fact, it is most likely that the company's court-ordered anti-smoking campaign was ineffective by design. As one anti-tobacco website puts it:

> The tobacco industry favors only measures that are known not to work well and may even be counter-productive—such as age-related restrictions, retailer schemes, exhortation from parents and teachers, and "finger wagging" messages that smoking is only for grownups. These methods deflect attention away from the industry, are difficult to enforce, and present cigarettes as a "forbidden fruit" reserved for adults—exactly what most young people aspire to be! ("Exposing the Truth" 2001, par. 6)

Indeed, the outdated choice of "wacko" makes the "Don't Smoke" message all the more unhip, which leaves tobacco products untainted by any odor of unfashionability. In all, the tobacco industry spent a lot of money to tell kids that more than anything else, its product makes you a rebel, which is precisely the message sent by every other successful youth marketer.

In contrast, the Truth campaign does not just tell kids not to smoke. In fact finger-waving messages never appear in its literature or imagery at all. Instead, Truth encourages young people to become culture jammers, or pranksters, themselves, and even provides them with the tools to do it. The Truth campaign is successful because it maximizes a truism in contemporary marketing: kids want to feel like they are "sticking it to the man" even if "the man" provides them the tools with which to do so. One of the group's slogans makes its nonconformist posture clear: "Join Truth now! But, don't think of it as 'joining' something." Whereas the tobacco industry's pseudo-attempt to curb teen smoking continues to afford the smoker the rebellious subject position, Truth flips that equation. In the Truth campaign, the non-smoking teen is the rebel, and tobacco executives, rather than parents and teachers, represent "the man." By rehearsing a series of pranks instigated by ordinary teenagers, Truth offers kids a new mode of agency in relation to tobacco advertising. It is an agency that is born of engaged mischief and hip rebellion rather than no-saying and abstention.

For example, one series of magazine ads provides kids with an incredibly simple way to become anti-tobacco activists. In several popular teen magazines, the group took out double-page spreads featuring Truth's trademark orange background and bold white letters. One spread read, "CIGARETTE SMOKE HAS ARSENIC," and the other, "AMMONIA IS ADDED TO CIGARETTES." On the following page is a picture of bookstores, magazine stands, and grocery store checkouts with magazines opened to these Truth "billboards." The demonstrative ads urge readers to "Spread the knowledge. Infect truth." Not only does Truth provide mini billboards inside teen magazines, it also shows contexts in which those billboards might be displayed. In doing so, it provides young people with a quick and easy way to protest, to feel as if they are committing a subversive act, however small and temporary.

In another magazine campaign, Truth provides stickers in the shape of blank conversation bubbles as in a comic strip. Next to the free stickers is a picture of a Marlboro Man advertisement "augmented" by one of the stickers. In this case, someone has written: "When I get tired of counting cow patties, I like to count the 4,000 chemicals in cigarette smoke." The bubbles are outlined in the familiar Truth orange but are otherwise just blank slates, ready for kids to contribute their own mes-

sages to the vast sea of advertising. In short, it demonstrates an easy way for kids to hijack the advertisements that so saturate their landscape. As tobacco giant R. J. Reynolds itself is aware, the visual vocabulary of comic books appeals to kids. In a 1973 memo on how to better market its Camel cigarettes to young people, an R. J. Reynolds executive wrote, "Comic strip type copy might get a much higher readership among younger people than any other type of copy" ("Tobacco Facts" n.d.). The company put this wisdom to use years later in its controversial Joe Camel campaign. In response, Truth launched its bubble campaign, folding Tobacco's enthusiasm for the rhetorical power of comic book imagery over on itself and, in doing so, allowing kids to participate in the construction of a new narrative.

The Truth bubble campaign borrows a common mode of *détournement* employed by the Situationists who often revised the dialogue in popular comic strips as a venue for their own subversive messages. As Situationist René Viénet ([1967] 2006) argued, "Comic strips are the only truly popular literature of our century" (275) and as such were a potentially powerful vehicle for rhetorical intervention. The Situationists hijacked existing comics, but they also borrowed the familiar dialogue bubbles that had become part of the popular vernacular as vehicles for revision in other venues. Viénet writes: "It is also possible to detourn *any* advertising billboards—particularly those in subway corridors, which form remarkable sequences—by pasting over pre-prepared placards." Anticipating terminology popular with contemporary culture jammers, he described the practice as "guerrilla" media warfare (274). In this spirit, the Truth campaign, in effect, trains young people to practice their own brand of Situationism, by confiscating a small space from commercial advertising and using it as a site for rhetorical invention. The goal to reclaim public space from the increasing "contamination" of commercial messages is shared by many culture jammers—billboard liberators, graffiti artists, and hackers, for example—but these practices usually require a criminal act, defacing private property. The Truth bubble strategy is no different in that it is, in effect, encouraging young people to vandalize a corporation's property. But, unlike other culture jammers who readily embrace their role as cultural guerrillas, Truth's suggested hijack is noteworthy in that it comes from a government-regulated organization working with legally granted tobacco money.

The content of the Truth campaign's rhetoric is not fundamentally different from the *Adbusters'* strategy of negative critique. What differentiates the two is the form of their rhetorical strategy. Unlike the magazine's Joe Camel parody, Joe Chemo, which critiques cigarette smoking and the ads that promote it, Truth unabashedly appropriates the rhetorical tropes of branding; it taps into the language of the market. Its signature color orange, its use of white asterisk pop-ups to connote a virus spreading, and its digital font are consistent in its magazine, television, and Internet campaigns. In effect, Truth is an excellent example of good brand management. The current INFKT Truth campaign experiments with a mode of rhetoric that is not grounded in the proclamations of any individual speaking subject. It promotes a kind of word-of-mouth dissemination of arguments against the tobacco industry. As such, it capitalizes on what may be two favorite pastimes of many teens: rebellion and gossip.

Conclusion: Pranking Rhetoric in the Commercial Mediascape

The title of this essay, "Pranking Rhetoric," was carefully chosen. On one hand, it names a category of rhetorical action: pranking. On the other, it articulates an underlying premise of this analysis. That is, in order to consider pranking as rhetoric, rhetoric itself must be, well, pranked. And, here, I mean "prank" in all its forms: to trick, but also to fold, and to adorn. The practices discussed in this essay—pranks, hoaxes, *détournements*— are not explicitly persuasive, if we understand persuasion as a targeted change in meaning structures. As I have suggested, they do not necessarily rely on that "aha!" moment when an audience becomes conscious of some new insight. Also, their effectiveness does not depend on the ethos or charisma of a specific rhetoric. Hence, they fall outside the expectations of what conventionally qualifies as effective rhetoric. Clear arguments do often follow pranks—as in the Biotic Baking Brigade's critique of neoliberal economics—but those arguments are translations of pranks. They do not account for the power of the pranks themselves. One might even argue that such translations dilute the rhetorical power pranks have to confuse and provoke. In other words, attaching an explicit argument, making a prank make sense, may undermine what is unique about pranking's signifying rhetoric in the first place.

The mass-mediated pranks and hoaxes discussed here do not oppose traditional notions of rhetoric, but they do repattern them in interesting ways. Media pranksters undermine the proprietary authority of rhetoric by hijacking its sanctioned venues, as does the Biotic Baking Brigade. Hoaxes challenge rhetoric's relationship to truth (either the art's "misuse" as a tool for propaganda, or its "correct use" in revealing facts to audiences), because they produce rhetorical effects that have little to do with facts or evidence, as in Joey Skaggs's cathouse for dogs. In general, pranking has the potential to unravel rhetoric's continued reliance on individual auteurs (be they presidents or protestors) because a prank's source is often impossible to locate and, ultimately, irrelevant to its political impacts.

Traditionally, communication has largely been conceived in industrial, Fordist terms. Arguments are systematically and rationally assembled. Messages move teleologically toward an end product—persuasion. Perhaps the strategies of pranking and branding (its commercial counterpart) may have something to teach communication scholars. As North America moves into an economy driven as much by information and marketing as the production of tangible goods, it becomes all the more crucial that communication scholars attend to the battles being waged over commercialization. A basic tenet of both the marketing and prankster world is that ideas and innovations spread less like widgets coming off an assembly line than like viruses in an ecosystem (see, for the most prominent example, Rushkoff 1996). Indeed, viruses *communicate* diseases, yet they cannot be said to possess intentions nor progress teleologically, as a factory model might imply.

Vivian Vale and Andrea Juno (1987), in *Pranks!*, their edited collection of interviews with political pranksters, acknowledge that pranking can often be funny, even trivial. However, they remind us that pranks can also pose a "direct challenge to all verbal and behavioral *routines*, and [undermine] the sovereign authority of words, language, visual images, and social conventions in general" (n.p.). Contemporary commercial culture depends upon consumers having somewhat routinized responses to words and images; however, these responses need not be completely homogenous. Indeed, it is the protean, polysemic nature of brands that allows them to be disseminated globally, across individuals and cultures. For example, Nike's swoosh may signify "self-discipline" to

one person and "liberty" to another; and it is likely that the Nike corporation does not much care how people interpret it as long as they keep buying Nike products. This is the viral power of the brand—its ability to provoke through sheer replication of form.

Pranking—as intensification, augmentation, folding—is conceptually and practically quite different from how we often consider rhetorics of protest. Pranking is often comedic, but not in a satirical, derisive sense that prescribes a "correct" political position. It takes the logic of branding seriously. As the famous rallying cry of Nike CEO Phil Knight— "Brands! Not products!"—illustrates, successful brands are not limited to a closed system of representation. The swoosh has the capacity to signify much more than sneakers, or even products, and that is just the way Nike wants it. Nike understands that in an age when the factory has largely been moved overseas, it is now in the business of producing something much more profitable than sportswear: its product is seductive imagery and the loyal consumers it attracts.

As I have argued throughout, pranking repatterns commercial rhetoric less by protesting a disciplinary mode of power (clogging the machinery of the image factory) than by strategically augmenting and utilizing the precious resources the contemporary media ecology affords. In doing so, pranksters, those comedians of the commercial media landscape, make manifest Michel Foucault's (1983) observation that one need not be sad to be militant. Rather than using political action to discredit a line of thought (as the parodist might have it), Foucault urges us to "use political practice as an *intensifier* of thought, and analysis as a multiplier of the forms and domains for the intervention of political action" (xii).[2] Culture jamming multiplies the tools of intervention for contemporary media and consumer activists. It does so by embracing the viral character of communication, a quality long understood by marketers. So-called "cool hunters," for example, employ the tools of anthropologists who engage in "diffusion research" to determine how ideas spread through cultures. These marketers, like their anthropologist counterparts, have learned that people tend to adopt messages less in response to rational arguments than through exposure and example (Gladwell 1997). Activists with a prankster ethic, such as those promoting the INFKT Truth campaign, capitalize on this capacity of ideas to multiply and disseminate like viruses. Further, although *Adbusters'*

campaign to spread the Blackspot virus may still promote oppositional content, its embrace of the viral form indicates the group's advertising savvy. Tellingly, the magazine's focus on advertising parodies has waned in recent years.

It is important to note that the opportunities offered by culture jamming should not be seen as supplanting other, more traditional modes of engagement that continue to produce powerful rhetorical and political effects. Culture jamming—largely a response to consumerism and corporate power—may not be as productive in rhetorical situations that call for legal or policy interventions, for example. Further, culture jamming may be an effective strategy for engaging corporations that rely heavily on positive public relations, but may do little in the face of those that benefit from working beneath the public's radar. For these reasons, it may be most helpful to take seriously culture jamming, and pranking in particular, as important components of rhetorical hybrids, collections of tools that activists and scholars can utilize when intervening in the complex world of commercial discourse.

Finally, whereas ad parodies and satire offer up alternative interpretations of marketing rhetoric, pranks potentially upset the obligation of rhetoric to *represent* at all. Pranks intensify the polysemic quality of the signs on which marketing campaigns rely. They exacerbate the slippage in the signification process in such a way that polysemy may no longer serve the corporate author's effort to spread its ultimate message: buy! As Vale and Juno (1987) write, pranks

> attack the fundamental mechanisms of a society in which all social/verbal intercourse functions as a means toward a future *consumer exchange*, either of goods or experience. It is possible to view *every* "entertainment" experience marketed today either as an act of consumption, a prelude to an act of consumption, or both. (Introduction, n.p.)

In response to the increasing rhetorical prominence of marketers, whom Deleuze (1990) describes as "the arrogant breed who are our masters," pranks enact his insistence that "we've got to hijack speech. Creating has always been something different from communicating. The key thing may be to create vacuoles of non-communication, circuit breakers, so we can elude control" (175). In this sense, pranks—precisely because they

border on the nonsensical—reconfigure the very structures of meaning and production on which corporate media and advertising depend. Pranking—by layering and folding the rhetorical field—addresses the *patterns* of power rather than its *contents*. It does so by taking its cue, in part, from the incredible success of commercial rhetoric to infect contemporary culture.

NOTES

1 The phrase is reminiscent of Black Panther leader Huey Newton's famous phrase: "Violence is as American as cherry pie."

2 In his preface, Foucault is interpreting the themes of Gilles Deleuze and Félix Guattari (2000).

REFERENCES

"Arnold Faces Anti-Smoking Challenges." 2002. *Adweek*, January 28.

Bakhtin, Mikhail M. 1984. *Rabelais and His World*. Translated by Helene Iswolsky. Bloomington: Indiana University Press.

"Blackspot." 2004. www.blackspotsneaker.org.

Branwyn, Gareth. 1997. *Jamming the Media, A Citizen's Guide: Reclaiming the Tools of Communication*. San Francisco: Chronicle Books.

Burroughs, William S. 1998. "Word Virus." In *Electronic Revolution*, edited by James. Grauerholz and Ira Silverberg, 294–313. New York: Grove Press.

"Culture Jammer's Encyclopedia." N.d. Sniggle.com. www.sniggle.net.

Deleuze, Giles. 1990. *Negotiations*. New York: Columbia University Press.

Deleuze, G., and Félix Guattari. 2000. *Anti-Oedipus: Capitalism and Schizophrenia*. Minneapolis: University of Minnesota Press.

DeLuca, Kevin M. 1999. *Image Politics: The New Rhetoric of Environmental Activism*. New York: Guilford Press.

DeLuca, Kevin M., and Jennifer Peeples. 2002. "From Public Sphere to Public Screen: Democracy, Activism, and the 'Violence' of Seattle." *Critical Studies in Media Communication* 19 (June): 125–51.

Dery, Mark. 1993. *Culture Jamming: Hacking, Slashing and Sniping in the Empire of Signs*. Pamphlet no. 25. Westfield, NJ: Open Magazine.

———. 1994. "Hacking Barbie's Voice Box: 'Vengeance Is Mine!'" Levity.com. www.levity.com.

Eco, Umberto. 1986. "Towards a Semiological Guerrilla Warfare." In *Travels in Hyperreality*, translated by William Weaver, 135–44. San Diego: Harcourt Brace Jovanovich.

"Exposing the Truth: Tobacco Industry 'Anti-Tobacco' Youth Programs." 2001. Essentialaction.org. www.essentialaction.org.

"The Ethical Sneaker." 2003. *New York Times Magazine*, December 14.

Frank, Thomas. 1997. "Why Johnny Can't Dissent." In *Commodify Your Dissent: Salvos from "The Baffler,"* edited by Thomas Frank and Matt Weiland, 31–45. New York: Norton.

Frauenfelder, Mark, Carla Sinclair, and Gareth Branwyn, eds. 1995. *The Happy Mutant Handbook*. New York: Riverhead Books.

"Frequently Asked Questions." 2000. ®ark. www.rtmark.com.

Gladwell, Malcolm. 1997. "The Coolhunt." *New Yorker*, March 17. www.gladwell.com.

Greenberg, Brigitte. 1994. "The BLO—Barbie Liberation Organization—Strikes." *Unit Circle Magazine*. www.etext.org.

"Hacking Barbie with the Barbie Liberation Organization." N.d. *Brillomag*. www.brillomag.net.

Harris, Gillian. 1996. "Just Say No to the Preaching and Scaremongering." *Scotsman*, January 16.

"How to Make Trouble and Influence." 1998. Australian Broadcasting Corporation. www.abc.net.

Jameson, Fredric. 1991. *Postmodernism: or, The Cultural Logic of Late Capitalism*. Durham, NC: Duke University Press.

Lasn, Kalle. 1999. *Culture Jam: The Uncooling of America*™. New York: Eagle Brook.

Merriam-Webster's Collegiate Dictionary. 2012. 11th ed. Springfield, MA: Merriam-Webster.

Nealon, Jeffrey T. 1993. *Double Reading: Postmodernism after Deconstruction*. Ithaca, NY: Cornell University Press.

Nietzsche, Friedrich. 1989. *On the Genealogy of Morals and Ecce Homo*, translated by Walter Kaufmann. New York: Vintage.

Pauline, Mark. Interview by Vivian Vale and Andrea Juno. In *Pranks!*, edited by Vivian Vale and Andrea Juno, 6–17. San Francisco: V/Search.

Rushkoff, Douglas. 1996. *Media Virus! Hidden Agendas in Popular Culture*. New York: Ballantine.

Sadler, Simon. 1999. *The Situationist City*. Cambridge, MA: MIT Press.

Skaggs, Joey. 1987. Interview by Andrea Juno. In *Pranks!*, edited by Vivian Vale and Andrea Juno, 36–50. San Francisco: V/Search.

The Pie's the Limit! A Documentary on the Global Pasty Uprising. 1999. San Francisco: Whispered Media. Video recording. archive.org.

"Tobacco Facts." N.d. www.tobaccofacts.org.

Vale, Vivian, and Andrea Juno. 1987. Introduction. In *Pranks!*, edited by Vivian Vale and Andrea Juno, n.p. San Francisco: V/Search.

Viénet, René. (1967) 2006. "The Situationists and the New Forms of Action against Politics and Art." In *Situationist International Anthology*, revised and expanded edition, edited and translated by Ken Knabb, 273–77. Berkeley: Bureau of Public Secrets.

3

The Faker as Producer

The Politics of Fabrication and the Three Orders of the Fake

MARCO DESERIIS

Whether it takes the form of a forged artwork or manuscript, the fake of the modern age is haunted by its double—the unique mark of a supposedly inimitable author. Whereas until the Renaissance the imitation of ancient artworks was a tribute to the classical ideal of beauty, the separation between art and craft that began with the Renaissance laid the ground for the imitation of the art of individual masters. Indeed, without the modern art market's need to discriminate between copies and originals, the development of a parallel lineage of art forgers would have not been possible. From Giovanni Bastianini's mid-nineteenth-century fake Renaissance sculptures, to Han van Meegeren's astounding Vermeers of the 1930s, to Elmyr de Hoyr's tireless fabrication of Picassos, Matisses, and Modiglianis in the 1950s, the modern forger has thus come to inhabit at least two traditions: that of the masters he seeks to imitate and that of the master imitators who have preceded him (Radnóti 1999).

Such duplicity is inscribed in the ambiguous nature of the term "forgery," whose etymology can be traced back to Latin words such as *faber* (smith and falsifier), *fabrica* (workshop, but also ruse, trick, artifice), and *fabricare* (to fabricate). Thus, if every *artifact* might be said to conceal an *artifice*, it is because craftsmanship and forgery have always been intimately connected. With the Industrial Revolution, however, the relationship between creation and imitation undergoes a dramatic shift as the industrial commodity—what Jean Baudrillard (1993) calls the "second-order simulacrum"—no longer refers back to an original. The rise of cybernetics and networked computing increases the power of reproduction over production, of that which is precoded over that which has yet to be codified.

Thus, if forging presupposes the individual mastery of a techne, mechanical and digital means of reproduction transform the art of imitation from an individual skill to a generalized condition. As all signs become potentially reproducible by anybody by the click of a mouse, the political and ontological status of the fake also changes. Does it still make sense to read the fake as an exemplary critique of bourgeois notions of originality and novelty, when the novel and the original are increasingly under assault? In this essay, I am going to argue that while fakes continue to interrogate the status of the original—and thus, by extension, of the protocols that validate originality—their political function needs to be rethought vis-à-vis the post-scarce information regime of the digital age. In particular, in the current media environment, fakes and media pranks retain a critical edge when they set the conditions for the cooperative production and simulation of authoritative forms of discourse.

The notion that cultural production should not be judged only for its semantic aspects but also and foremost for its ability to mobilize others was first articulated by Walter Benjamin ([1934] 1986) in a renowned essay titled "The Author as Producer." In this text, Benjamin argues that a truly progressive author not only shows "the correct political tendency" but is aware of her own position in the relations of production. This means that the author cannot stop at generating a progressive or even revolutionary thought, but must consider how her literary production might be "able first to induce other producers to produce, and second to put an improved apparatus at their disposal. And this apparatus is better the more consumers it is able to turn into producers—that is, readers or spectators into collaborators" (233).

Thus, as early as 1934, Benjamin offered a materialist reading of media as means of production and organization that anticipated in many ways the participatory and collaborative media of our time. And yet, in spite of Benjamin's groundbreaking work, progressive and Marxist media theorists have generally failed to grasp the emancipatory and revolutionary potential of modern media. With the exception of the productivist and factographic experiments of the Soviet avant-garde in the 1920s, Bertolt Brecht's ([1932] 1964) theory of radio, and Hans Magnus Enzensberger's ([1970] 2000) analysis of the mobilizing power of electronic media, the Marxist media theory of the twentieth century has been strangely

dominated by an Orwellian strand that runs from Theodor Adorno and Max Horkheimer ([1947] 2002) to Guy Debord ([1967] 2014), Jean Baudrillard ([1981] 1995), and the French collective Tiqqun (2001). These authors have read the culture industry, the mass media, and even the Internet as the ultimate expression of capitalist standardization, domination, and ideology. This interpretation has been reinforced by empirical and critical studies that have noted how the concentration of ownership in the media industry poses a serious threat to a democratic public sphere (Schiller 1991; McChesney 1999; Bagdikian 2000).

Against this Orwellian strand, this essay attempts to reconnect the fake to a participatory theory of media by detaching it from negative connotations such as the inauthentic, the replica, and the simulacrum. It attaches it instead to three positive qualifiers: the subliminal, the subversive, and the mythmaking—identified here as "the three orders of the fake."

On a first level, because they have to appear credible to journalists, media fakes put to test the professional standards and fact-checking procedures of media organizations. I refer to these fakes as *subliminal* for their ability to operate below the conscious threshold of perception of the media and to expose the often invisible mechanisms of inclusion and exclusion that underpin the discourse of the media. On a second level, fakes can expose the intimate connection between various forms of institutional power and what Paul Lazarsfeld and Robert Merton (1948) termed the "status conferral function" of mass media. By defying an institution's ability to control the unity of its public performances, *subversive fakes* force it to restore the shaken order of the discourse through official disavowals, apologies, or legal threats. Finally, on a third level, media pranksters can open their own stunts to the participation of many. I describe these fakes as *mythmaking* for their ability to inspire diffused participation in a layered narrative that is open to several kinds of contributions.

Before proceeding any further, I shall add two important provisos. From now on, I will refer to some media fakes as media pranks or media hoaxes. While these terms are not always interchangeable, the hoaxes and pranks analyzed in this context involve a great deal of dissimulation and mimicry, that is, the ability of their executors to disguise themselves as someone else. Second, the three orders of the fake are not meant to

designate three distinct *categories*. Rather they describe features that range from the simple to the complex. In fact, whereas it can be argued that all fakes are subliminal in that they have to pass a credibility test, only some fakes threaten power and its symbolism, and only a few require the participation of many. In this respect, the subliminal, the subversive, and the mythmaking are not mutually exclusive. Rather these qualifiers designate different degrees or orders of complexity, which can sometimes coexist within the same object of study.

Subliminal Fakes

Although media fakes may be as old as the media themselves, the 1960s is the decade when the first generation that had grown up with television began to express a systematic critique of media coverage on a variety of pressing social and political issues. In an influential essay titled "Towards a Semiological Guerrilla Warfare," Umberto Eco (1986) identified in new countercultural subjectivities, such as "hippies, beatniks, new Bohemias, student movements," the first manifestations of this emerging critical consciousness. The Italian semiotician noted how these "communication guerrillas" did not reject mass communication tout court, but worked for "the constant correction of perspectives, the checking of the codes, the ever-renewed interpretation of mass messages" through the very use of "the means of the technological society (television, press, record companies)" (143–44). Eco went as far as saying that rather than concerning themselves with occupying "the chair of the Minister of Information" or of the *New York Times*, politicians and educators should aim at "occupying the chair in front of every TV set" so as to shift the terrain of struggle from the strategic control of information sources to a diffused "guerrilla warfare" for the control of interpretation (142).

The notion that the critical interpretation of media messages is itself a form of intervention did not belong only to the counterculture. In the same years as alternative media were emerging, a few media pranksters expressed a critique-in-action of mass media that exploited the very channels it was aimed at. Such is the case of Alan Abel and Joey Skaggs, two of the better-known media pranksters in the United States. Both Abel and Skaggs staged pranks and media stunts that often shared the

libertarian and critical ethos of the counterculture. Yet, as we shall see, their ability to produce stories that were highly newsworthy exposed their pranks to the risk of being recuperated by the media circus, thereby blunting, at least in part, their critical edge.

Born in 1930, Alan Abel has schemed and executed, along with his wife, Jeanne, and a small circle of accomplices, dozens of hoaxes that mix humor and social commentary. The first was the Society for Indecency to Naked Animals (SINA), one of the more elaborate hoaxes of all times. On May 27, 1959, a man named G. Clifford Prout (in reality Abel's friend and actor Buck Henry) appeared as president of the SINA on NBC's *Today Show* to advocate the clothing of all animals' genitalia. By coining catchy slogans such as "Don't ever forget, a nude horse is a rude horse" and "Decency today means morality tomorrow," Prout's appearance generated a massive public response. SINA stirred such controversy that Prout's character kept haunting the media for several years. Finally, during an appearance on CBS's *Evening News with Walter Cronkite* some CBS employees recognized that Prout was actor Buck Henry. This brought a formal end to the hoax, which was officially uncovered by *Time* magazine in 1963. As Abel was praised as a genius hoaxer, he exploited the media attention to present the hoax as a satire on US postwar prurient moralism and censorship (Abel 1970).

In the following decades, Abel continued staging numerous hoaxes. These included the "Sex Olympics," an international sex competition wherein couples were supposed to compete for climax in front of an audience (1971);[1] the "Omar's School for Beggars," a professional school of panhandling for the unemployed run by an Arab American man (1975–1983); the publication of his own obituary in the *New York Times* (1980); the orchestration of a mass fainting in the sitting audience of the *Donahue Show* (1985); the staging of a fake $35 million lottery win bash (1992); the presentation of himself as the man with the smallest penis in the world in the HBO documentary *Private Dicks* (1999); a national campaign to ban breastfeeding (2000–2005); and many others.[2]

As one follows Abel's multiple TV stunts over the course of five decades, it is easy to note that the media kept inviting him even *after* his hoaxes were exposed. Far from being embarrassed for their own lack of judgment, TV producers understood that Abel's personas *worked*, and as such deserved airtime regardless of—or perhaps precisely because

of—their fictional character.[3] In other circumstances, Abel was coopted for his writing skills. As he explains in an interview with Andrea Juno, the mass fainting at the *Donahue Show* had been in fact solicited by one of Donahue's assistants:

> I used to write material for Phil Donahue when he was a talk show host back in Dayton, Ohio. Phil went on to Chicago where he remained for eighteen years. Then in 1985 he moved to New York. I got a call from one of his assistants who said, "It's very important that Phil's new show gets good ratings in New York. Why don't you come up with some media stunt, and if it *works*, and doesn't kill anybody or hurt anyone, you'll be well-paid." I thought about it and came up with this idea. I got a headline in the New York *Post* and the wire services picked up the story: "Entire Studio Audience Flees Donahue Show!" Donahue was very upset when he found out that it was a hoax, *but* his ratings started going up so he mellowed. (Abel 1987, 106)

Pranksters' occasional complicity with media professionals is also evident in some of the media stunts organized by Joey Skaggs. A former beatnik of the New York Lower East Side, Skaggs debuted as a self-styled "conceptual artist" in the 1960s. His first stunts included street performances such as the organization of a hippie sightseeing bus tour in Queens (an ironic twist on the then common practice among suburbanized New Yorkers of touring the Lower East Side in search of hippies to photograph); the installment of a Native American crucifix on the altar of St. Patrick's Cathedral; and a simulated US Army attack on a life-size replica of a Vietnamese village representing the Nativity in Central Park.

In the 1970s, Skaggs began paying more attention to the media effects of his interventions. In 1976, he posted a classified ad in the *Village Voice* that publicized a bordello for sexually frustrated dogs. The "Cathouse for Dogs" offered "a savory selection of hot bitches," which were artificially induced into a state of heat by a drug called Estro-dial. As journalists began investigating the announcement, Skaggs hired twenty-five actors and fifteen dogs to provide them with physical evidence of the actual existence of the bordello. One evening, journalists were invited to witness how customers had to fill out a questionnaire on their dogs' medical history and sexual preferences in the presence of a phony

veterinarian while Skaggs lectured them on dog copulation technique (Skaggs 1987, 39–40).

As the news begun mounting—stirring a real campaign to close down the bordello—a journalist from the local *Soho Weekly News* covered the story twice. "During the second interview, a week after the first article had appeared, the writer suspected it was a hoax. *But it was such a good story*, [that] he complied with Skaggs' request to continue the ruse" (Skaggs 1997a; emphasis added). This allowed the news to snowball from the local press to the national and international media.[4] When Skaggs was finally subpoenaed by the office of the Attorney General for illegally running a cathouse for dogs, he held a press conference in which he unveiled the hoax.

Skaggs (1997b) describes himself as a conceptual artist "who uses the media as his medium to make a statement."[5] Like Alan Abel's, Skaggs' pranks are double-edged swords. On the one hand, they have a demystifying function—that is, they reveal the mechanisms whereby some facts are turned into news even when their truthfulness is dubious. On the other hand, these stunts have a positive function in that they stir public debate over controversial issues that would otherwise receive little media coverage.

In one sense, then, hoaxers and media are foes. Since the media are understandably embarrassed after being fooled, they tend not to retract, or to give retractions very low visibility. That is why the denouement is the most delicate moment of the hoax. Skilled hoaxers such as Skaggs and Abel usually pull the plug when a story has reached its zenith so that the media can hardly avoid a retraction. Another tactic used by hoaxers is to exploit the competition internal to the media system by informing some media outlets that their competitors have been duped.

And yet, pranksters and journalists are not always opponents. Because media pranks have a high entertainment value, media producers can become a hoaxer's best allies. In fact, even when complicity is not overt, a journalist or an editor who omits fact-checking sets aside a basic deontological principle for a story that is *too good to be fake*. Within an increasingly saturated media environment, journalists tend to select the stories that are more likely to be aired or published, when they do not fabricate them themselves.[6] Furthermore, the dominance of commercial television in the United States and of the tabloid press in the United

Kingdom and other European countries (where public broadcasting has partly contained the expansion of commercial networks) has significantly lowered journalistic standards. In the age of the seemingly unstoppable rise of infotainment, soft news, and celebrity culture, facts are routinely sacrificed to narrative or, in the best-case scenario, are framed in a dramatic or entertaining fashion around "human interest" stories (Langer 1998).

In this context, it is no surprise if pranks à la Abel and Skaggs rarely miss their mark. Since those hoaxes provide the media with living personifications of amusing and dramatic stories, newsmakers can hardly ignore them. At the same time, the hoaxer's ethical position should not be confused with that of ratings-obsessed TV producers and con journalists in search of notoriety. In spite of some collusions, by and large media pranksters remain external to the media apparatus as their ethical commitment lies in unveiling how media often fail to fact-check and apply the very standards that should make them trustable.

In order to disentangle this apparent contradiction between the demystifying function of hoaxes and the dangerous liaisons between hoaxers and media producers, I term this typology of fakes *subliminal*. In psychology the term (from the Latin *sub limen*) indicates a stimulus operating below the threshold of conscious perception.[7] Likewise, as noted in the introduction, subliminal fakes operate below the media conscious threshold of perception as they challenge the media's ability to discriminate between reality and fiction, truth and fabrication. By producing enough sensible evidence and background information to turn a pseudo-event into a "fact," subliminal fakes probe the set of criteria that should guarantee the truthfulness of media narratives.[8]

Sometimes, failure to implement these standards can seriously damage news organizations, especially in the case of institutions whose reputation derives from their reliability. But with the rise of commercial media and infotainment, the media's presumed function to discriminate between reality and fiction tends to give way to modes of presenting the news in which the two are increasingly blended. Thus, if in the 1960s and 1970s subliminal fakes revealed something about the inner workings of the media machinery, the rampant dramatization of news has made it increasingly difficult for these media stunts to yield any critical knowledge other than *registering* a shift in news values toward drama,

entertainment, and sensationalism. This does not mean that pranks in the vein of Abel and Skaggs have become useless. But certainly their critical edge was much sharper in a media landscape wherein the power of media was very much attached to their *presumed* impartiality and objectivity.

Subversive Fakes

To consider how the politics of fabrication might still be effective in the age of infotainment, I will now turn to a typology of fakes whose character is more overtly political. The ultimate purpose of those fakes, which I describe as *subversive*, is to undermine the Foucauldian order of the discourse—that is, the complex of invisible discursive structures that legitimates both the speakers and the kinds of enunciations that are allowed in the public sphere of communication (Foucault 1969; Autonome a.f.r.i.k.a gruppe, Blissett, and Brunzels 1997). By usurping the position of a powerful subject and sending a blatantly absurd, irreverent, or revealing message, subversive fakes undermine power's ability to control the unity and coherency of its public performances. As we shall see, this usually forces power to restore the shaken order of the discourse through an official disavowal.

Similar to subliminal fakes, the origin of these fakes lies in the creative fringes of the 1960s and 1970s counterculture. Conceived and executed by art-activists such as the Situationists, the Dutch Provos, the Yippies in America, the Italian Indiani Metropolitani, the Kommune 1 and Spass-Guerrilla in West Germany, and, later on, the Polish Orange Alternative, these interventions ranged from staging of surreal press conferences and street performances to the announcement of imaginary events to the forgery of seemingly official government documents. For instance, in the late 1970s, the Italian satirical magazine *Il Male* (The evil) printed and distributed tens of thousands of fake copies of Italian newspapers that announced (and sometimes anticipated) historic events such as the end of the so-called "historic compromise" between the Italian Communist Party and the Democratic Christians, the reunification of Germany, the collapse of the Communist regime in Poland, the annulment of the 1978 final of the World Cup, and the arrest of comic actor Ugo Tognazzi as head of the Red Brigades (Vincino 2007).

The spy wars and the suspicious climate of the Cold War also invited the dissemination of false reports and anonymous dossiers. One such renowned case is the "Report from Iron Mountain", a 1967 forged US government memo that explained how permanent war was a necessary condition of social order and state power. Likewise, the *Truthful Report on the Last Chances to Save Capitalism in Italy*, a 1975 political pamphlet signed by Censor, a pretended bourgeois intellectual (who was in fact the Italian Situationist Gianfranco Sanguinetti), persuasively argued that the only chance to save capitalism in Italy was to open the government to the participation of the Communist Party (Autonome a.f.r.i.k.a. gruppe 1997). Both publications sparked huge public debates and endless speculations about the identity of their authors.

In 1976, the Italian autonomist, "Mao-Dadaist" collective A/Traverso (Collettivo A/Traverso 2002) summarized this strategy of undermining power's self-legitimation through fake speech acts in a text significantly titled "False Information May Produce Real Events":

> It is necessary to take the place of (self-validating) power, and speaking with its voice. Emitting signs with the voice and tone of power. False signs. We produce false information that expose what power hides, and that produce revolt against the force of the discourse of order. (Collettivo A/Traverso 2002, 59, author's translation)

Thus, besides their more overt political content, subversive fakes differ from subliminal fakes in that their primary targets are not only the inner workings of the media, but *the discourse of power as such*. One of the key functions of modern media is, in fact, to amplify economic, political, religious, and military authorities. Such authorities derive their legitimacy first and foremost from the material and normative structure of their own institutions. As Pierre Bourdieu (1991) points out, "to be able to give an order, one must have a recognized authority over the recipient of that order," so that while in theory a soldier can give an order to his superior, in practice he is not authorized by the military institution to do so (73). Yet while the media cannot *create* symbolic power—insofar as such power is rooted in an institutional structure—they can surely extend its reach beyond its originating context. Conversely, when an impostor usurps such power, his action can have unforeseen

consequences for the entire order of discourse—that is, not only for the reputation of a media outlet but also for the institutions affected by the prank.

This is particularly true in the networked society, where authoritative forms of discourse and symbolic power are more exposed to unauthorized appropriations than in the industrial information society. As Yochai Benkler (2006) has noted, the networked information economy drastically reduces the amount of physical capital that is necessary to participate in the public sphere of communication. Thus contemporary culture jammers can "emit signs with the tone and voice of power" (to use the words of A/Traverso) without having to mobilize the human and financial resources that are necessary for broadcasting a TV or radio show or printing and distributing a newspaper.

Cyber-squatting for political purposes provides an exemplary case study. Since the 1990s, US culture jamming groups ®TMark and the Yes Men have registered and operated dozens of seemingly official websites of corporations, institutions, and politicians. After creating spoof websites of the Shell corporation, George W. Bush, and Rudolph Giuliani, in 1999 ®TMark begun operating gatt.org, a clone of the official website of the World Trade Organization, which contained critical information about the institution that oversees international trade. This forced the WTO to issue a press release about a misleading website (gatt.org) purporting to be the official WTO site (wto.org). The warning was quickly appropriated by gatt.org, which accused wto.org of being the misleading website.[9] The spiral of disavowals and counter-disavowals—combined with the huge exposure obtained by gatt.org in the days of the anti-WTO street protests in Seattle—showed how the jammers' fake website and witty press releases gave them an edge over the serious and increasingly embarrassed responses of an institution that had no power to silence its opponent.[10]

®TMark has coined the expression "tactical embarrassment" to describe the technique of forcing a target institution to disown the statements made by a fake spokesperson and of exploiting the official disavowal to increase media exposure. This technique was further refined after the year 2000 when ®TMark handed over gatt.org to the Yes Men, an offshoot of the group, which kept managing the website in the following years. By responding to incoming e-mails and invitations from journalists and

conference organizers who had mistaken gatt.org for wto.org, the Yes Men were able to present themselves as WTO spokespersons in various international conferences and even on TV. In the early 2000s, the group gave a series of fake lectures that took neoliberal arguments to the extreme by cheerfully proposing sinister solutions to global problems such as famine, oil shortages, and global warming (Yes Men 2004).[11]

In the following years, the Yes Men extended this tactic to other websites and began targeting corporations with a questionable environmental record. In 2004, after creating DowEthics.com—a spoof website of the Dow Chemical corporation—the group was able to send one of its representatives to a *BBC World News* program dedicated to the twentieth anniversary of the explosion of the Union Carbide chemical plant in Bhopal, India. The phony Dow spokesperson announced that his company (which had acquired Union Carbide in 2001) was now ready to "accept full responsibility" for the disaster that had caused thousands of casualties and was in the process of liquidating Union Carbide to "fully compensate" the families of the victims and clean up the plant site. The news immediately hit the financial market where "Dow's share price fell 4.2 percent in twenty-three minutes, wiping two billion dollars off its market value" ("Yes Men Hoax," 2004). This forced Dow to make an immediate disavowal and BBC to retract and apologize to its viewers—a combined intervention that restored the value of the Dow equities. Within a few hours, a DowEthics press release issued by the fake Dow website underscored how the Dow shareholders had nothing to be worried about because the company would have *not* acted ethically unless forced by law. This final announcement clarified the sense of the hoax: to demonstrate the impossibility for a corporation of the size of Dow to be responsible toward anything other than its bottom line.[12]

Both gatt.org and DowEthics.com illustrate well how two spoof websites that require limited resources to be managed can undermine the entire order of discourse. In particular, the false BBC announcement showed that reputable media are not always reliable, that their statements can have immediate reality effects, and that social responsibility and financial power are effectively divorced, as the latter rewards only those actions that are economically sound. In this respect, subversive fakes are multipurpose devices that undermine the order of discourse by setting in motion a chain of reactions whose consequences are hardly predictable.

Mythmaking Fakes

If the primary function of subversive fakes is to expose the order of the discourse, occasionally such fakes take the form of performances that require the participation of many. These *mythmaking* fakes do not have a merely demystifying function; they also positively call a community, or a network of collaborators, into being.

An exemplary case of radical mythmaking is the Luther Blissett Project. In the 1990s, hundreds of activists from Italy and other European countries shared the nom the plume "Luther Blissett" to author political essays and novels, conduct experimental urban drifts, fabricate artists and artworks, and organize a variety of media pranks (Deseriis 2015, 127–64). The attribution of these interventions to Luther Blissett was meant to cultivate the myth of a folk hero of the information age, whose persona allowed cultural producers to reclaim a social wage while renouncing their individual intellectual property rights. In this respect, as former member of the Luther Blissett Project Roberto Bui points out, the media pranks were functional to the creation of a myth that would enable different groups and generations of activists to recognize each other:

> Mythopoesis is the social process of constructing myths, *by which we do not mean "false stories,"* we mean stories that are told and shared, re-told and manipulated, by a vast and multifarious community, stories that may give shape to some kind of ritual, some sense of continuity between what we do and what other people did in the past. A tradition. In Latin the verb "tradere" simply meant "to hand down something," it did not entail any narrow-mindedness, conservatism or forced respect for the past. Revolutions and radical movements have always found and told their own myths. (Quoted in Wu Ming 2002, 1; emphasis added)

Whereas the participants in Luther Blissett relied by and large on the Internet to plan and coordinate their ruses, the power of media to mobilize communities of activists and practitioners long predates the Internet. Such power was perfectly understood by Abbie Hoffman (1968) in the late 1960s, when he recognized that the founding of the Yippies party and the development of a model for an alternative society

"required the construction of a vast myth, for through the notion of myth large numbers of people could get turned on and, in that process of getting turned on, begin to participate in Yippie!. . . . Precision was sacrificed for a greater degree of suggestion" (102).

Hoffman (1968) cites Georges Sorel's myth of the general strike and Marshall McLuhan's emphasis on the participatory character of electronic media as sources of inspiration for his idea of mythmaking.[13] Answering a question about the famous 1967 rally in which the Yippies surrounded and tried to "levitate" the Pentagon through their psychic power, McLuhan mentioned the role that false information plays in mythmaking: "Myth means putting on the audience, putting on one's environment. . . . Young people are looking for a formula for putting on the world—*participation mystique*" (quoted in Hoffman 1968, 103). Drawing on McLuhan, Hoffman underscores the crucial function that media play in mythmaking. Explaining how the Yippies generally encouraged journalists to lie, rather than telling the truth about their own activities, Hoffman acutely points out that "when newspapers distort a story, they become participants in the creation of a myth. We love distortions. . . . It's a very important point. Distortion is essential to mythmaking" (65).

Distortion or outright fabrication are essential to mythmaking because by saying what cannot be said in the public sphere in a dramatic or entertaining fashion, mythmakers invite journalists to pass on a story that would remain otherwise untold. In this respect, Hoffman's (1968) suggestion that journalists may be relays of a story whose multiple versions form an open, rewritable myth, allows us to bypass the apparent contradiction between the demystifying function of fakes and their more positive, imaginative side. If the journalist is also a potential mythmaker and co-conspirator, then the question is no longer how to dupe him, but how to allure him into reporting a story whose value resides primarily in its "organizing function," or, as Benjamin ([1934] 1986) wrote, in its ability to turn "consumers into producers—that is, readers or spectators into collaborators" (233).

Such considerations become all the more relevant if applied to decentralized and distributed media such as the Internet. Because the networked information economy reduces the cost of access to the public sphere of communication, mythmakers can use a range of media to tell stories that have both an imaginative and a pragmatic function. On the

one hand, networked media allow mythmakers to exert greater control over the production and circulation of their stories. On the other hand, because these stories are produced collaboratively, they often contain a set of pragmatic rules (the HowTos) that are handed down through the very same media.

To illustrate this concept, I will consider how the Yes Men combine the denotative and pragmatic aspects of storytelling by producing projects that operate on multiple levels. While the group's impersonations and surreal lectures are usually announced through press releases that are immediately reported by mainstream media, the Yes Men have incorporated many of their stunts in three feature films: *The Yes Men* (2004), *The Yes Men Fix the World* (2009), and *The Yes Men Are Revolting* (2015). Independently produced and distributed, these movies have allowed the group to tell its own stories without having to rely on external relays such as journalists and traditional media, which, however, do play a role *in* them.

Returning to a traditional medium such as film has another consequence—namely, the multiplication of audiences. In fact, a spectator of a Yes Men film is invited to assess the reaction of the corporate audiences attending their lectures, who also star as unknowing characters in the story. Because those who should be in charge of providing solutions to world problems like global warming and social inequality routinely fail to produce them, the movie viewer herself is invited to assume the ethical stance of searching for solutions. In order to prompt the audience to assume such position—that is, to *transform film spectators into collaborators*—the Yes Men articulate the pragmatics of their storytelling through a variety of media and venues. For example, the group releases online tool kits for tactical embarrassment and "identity correction," which reveal the behind-the-scenes of their stunts.[14] And it has launched the Yes Lab, a New York–based laboratory that offers training to activist organizations and students.[15]

The practical knowledge shared at the Yes Lab includes tips for social engineering as well as technical support on how to run spoof websites. In the early 2000s, along with Internet artist Amy Alexander, the Yes Men created Reamweaver, an ad hoc software for the management of mirror websites that allowed them to keep their spoof web sites always updated and faithful to the original. Drawing inspiration from Reamweaver, in

2008 the Italian artist duo Le Liens Invisibles (The Invisible Connections) released another piece of software called "A Fake Is a Fake," which enabled users to forge and parody authoritative themes such as those of nytimes.com, whitehouse.gov, figaro.fr, repubblica.it, and run them on any Wordpress site. Like Reamweaver, A Fake Is a Fake was freely available for download, along with tips on how to use it.[16]

In November 2008, one week after the US presidential elections, the Yes Men and Le Liens Invisibles published a fake online special edition of the *New York Times*, which announced the end of the wars in Iraq and Afghanistan, the indictment of former President George W. Bush on treason charges, the approval of a publicly funded national health insurance program, and so forth.[17] Postdated July 4, 2009, the special edition was written by several dozens of contributors, printed in eighty thousand copies, and distributed by hundreds of volunteers in New York City who had been mobilized through the Yes Men mailing list. The experiment was repeated in October 2009, with a fake special edition of the *New York Post* entirely dedicated to climate change and environmental activism.[18] In the same month, the Yes Men also staged a fake press conference at the National Press Club in Washington, DC, where they spoke on behalf of the US Chamber of Commerce, exposing its staunch anti-environmental record. In this circumstance, the presence of fake journalists at the event duped several major news organizations.[19]

These collaborative interventions show that contemporary media pranksters can fabricate not only a story but an entire media outlet. If in the age of broadcast media a fake story still had to be selected by professionals in order to be consecrated as news, in the age of networked media culture jammers can appropriate authoritative forms of discourse without the formal validation of mainstream media. Media theorist Henry Jenkins (2006) has argued that culture jammers no longer need to forge and parody mainstream media as the Internet allows them to produce their own media.[20] Yet my wager is that culture jammers are not merely interested in telling alternative stories. Rather, by tapping into the symbolic capital accumulated by mainstream media, culture jammers open up such capital to a variety of uses and possibilities. Guy Debord ([1967] 2014) once wrote that "the modern spectacle depicts what society *could deliver*, but in so doing it rigidly separates what is *possible* from what is *permitted*" (9; emphases in the original). When the *Times'* readers (or a

part of them) come together not only to read "All the News that Fits to Print" but also to produce "All the News We Hope to Print," they restore the sense of possibility that is constantly suppressed by "spectacular" (read: mainstream) media.

From this angle, Benjamin's idea of the author as producer and organizer allows us to read the mythmaking fake as a productive machine in its own right. Mythmaking fakes express the ability to hack into the symbolic capital that has been accumulated by an institution and return this capital to the social field. It is through such hack—understood here in the etymological sense of performing a cut—that the community redefines the relationship to itself and to the information environment in terms of possibilities rather than restrictions. This productive function of the fake, I would like to suggest, is what enables the unfolding of the virtual dimension of information or its expression as difference rather than repetition (Wark 2004). After all, talk shows, reality shows, and so-called interactive television all revolve around a controlled participatory mystique that seduces spectators with the illusion of agency. The question then is how to remove those controls to truly disclose the production of information to social praxis—that is, to a whole range of possibilities that are invariably suppressed by the heteronomous voices that tell us our identity. My contention is that this search for the true wealth of information can be better pursued once we cease considering the fake as a simple manifestation of skepticism and disbelief, a sudden blackout in the order of the discourse, and we begin analyzing it as a productive machine in its own right.

NOTES

1 The Sex Olympics were a guerrilla-marketing ruse to promote *Is There Sex after Death?*, a mockumentary about the sex revolution produced and directed by the Abels in 1971 and whose distribution had incurred in various forms of censorship.

2 A complete and updated list of Abel's hoaxes is available at www.alanabel.com.

3 Jennifer Abel's documentary *Abel Raises Cain* (2006) shows how her father kept performing the role of Omar the Beggar on TV at least until 1987, even though the hoax had been exposed several years earlier. In some circumstances, TV hosts seem to doubt Abel's real identity. Sometimes they even accuse him of being a phony, but it is precisely this uncertainty that makes the shows interesting and entertaining.

4 WABC TV produced a documentary, nominated for the Emmy Awards, that featured images shot during the night in the cathouse by Alex Bennett, a producer

from a New York cable TV station, who, like his colleague from the weekly magazine, had smelled something but "gleefully went along with the hoax" (Skaggs, 1997a, n.p.).

5 Joeyskaggs.com lists most of Skaggs's hoaxes. Among them are "Metamorphosis," a miracle pill supposedly extracted from a "superstrain" of cockroaches, which cured arthritis, acne, and menstrual cramps, and immunized against nuclear radiations (1981); the "Fat Squad," a commando unit that would make overweight customers strictly adhere to their diet by physically restraining them from eating (1986); and the "Solomon Project," a distributed computing program that would eliminate the need for (biased) juries in courtrooms (1995).

6 Countless examples could be made of stories that are cooked, blown up, or fabricated to be "stickier" than others. Renowned is the case of Stephen Glass, a twenty-five-year-old reporter for the *New Republic* who published at least twenty-seven stories between 1995 and 1998 that contained fabricated quotations, sources and events. Significantly, after he was fired from *TNR* Glass became a celebrity: he was invited to various TV shows, his story was turned into a film titled *Shattered Glass* (2003), and he wrote the autobiographical novel *The Fabulist*.

7 In the 1950s and 1970s, bestsellers such as Vance Packard's (1957) *The Hidden Persuaders* and Brian Wilson Key's (1973) *Subliminal Seduction* linked the term "subliminal" to advertising in the public imagination. The public outcries over the possible insertion of hidden messages in commercials to entice consumers to buy specific products and manipulate an unknowing audience reactivated the panics generated by the hypodermic needle theory of media effects in the 1930s. However, after controlled laboratory experiments demonstrated that subliminal messages rarely inform decisions and guide actions, the term acquired a more general connotation to indicate a not fully conscious perception of a stimulus.

8 Daniel Boorstin (1971) has defined a "pseudo-event" as an event that is "not spontaneous," but "planned, planted and incited." According to the American historian, the success of a pseudo-event such as a press conference or a PR campaign is measured by how widely it is reported so that "the question 'Is it real?' is less important than 'Is it newsworthy?'" (11). This is to say that in staging fictional media events, pranksters share something with PR professionals, political consultants, and marketing experts. Yet if the techniques might be similar, the motivations and ethos are at odds, as pranksters do not profit from their stunts and in some cases risk legal prosecution.

9 The WTO press release is available at www.wto.org, and *™ark's response is available at www.rtmark.com.

10 Some of the press generated by gatt.org is archived at www.rtmark.com.

11 In 2001, at a textile conference in Tampere, Finland, the fake WTO representative unveiled the "Management Leisure Suit," a golden suit whereby managers can control remote factory workers twenty-four hours a day through a monitor displaying their activities inside a three-foot phallus attached to the suit. In 2002,

the group proposed to recycle the body waste of McDonald's consumers as a solution to alleviate starvation problems in third-world countries before an audience of college students in Plattsburgh, New York. The Yes Men's stunts as WTO representatives were popularized in a 2004 documentary directed by Chris Smith, Dan Ollman, and Sarah Price, which was distributed in the United States and various European countries. The pre-2010 Yes Men stunts are archived on the Yes Men's web site at www.theyesmen.org.

12 See "Dow 'Help' Announcement Is Elaborate Hoax," Dowethics.com, December 3, 2004, www.dowethics.com. The behind-the-scenes of the BBC stunt is documented in the the Yes Men's second feature film, *The Yes Men Fix the World* (2009; self-produced, distributed by United Artists).

13 For Sorel ([1908] 1999), the general strike was not aimed at reaching immediate and concrete objectives such as higher salaries or better working conditions. Rather the general strike was a nonnegotiable movement for the abolition of all class differences whereby the working class could forge its own revolutionary consciousness. As such, the myth of the general strike was a form of politics that prefigured the entire socialist project.

14 For example, the launch of their second feature film was accompanied by the *Fix the World Challenge*, a Wordpress blog (now offline) that offered a series of tutorials for aspiring Yes Men on how to "create a ridiculous spectacle," "crash a fancy event," "correct an identity online," "hijack a conference," and so forth. Users were invited to log into the blog and join online groups for planning and coordinating their own stunts.

15 The Yes Lab is hosted by the Hemispheric Institute at New York University, www.yeslab.org.

16 Both software are no longer available. Documentation of both projects is available at www.rtmark.com and www.lesliensinvisibles.org.

17 The "edition" can be seen at www.nytimes-se.com.

18 The "edition" can be seen at www.nypost-se.com.

19 See Lisa Lerer and Michael Calderone, "CNBC, Reuters fall for climate hoax," *Politico*, October 19, 2009. www.politico.com; and Anne C. Mulkern and Alex Kaplun, "Fake Reporters Part of Climate Pranksters' 'Theatre.' " *New York Times*, October 20, 2009, www.nytimes.com. For an analysis of the hoax as a form of appropriation art, see Nate Harrison (2012). The US Chamber of Commerce initially sued the Yes Men for trademark infringement, but then dropped the charges in January 2013.

20 In *Convergence Culture*, Jenkins (2006) erroneously identifies culture jamming with a form of cultural resistance that is an alternative to mainstream media rather than entirely dependent on it: "Too many critical pessimists are still locked into the old politics of culture jamming," he writes. "Resistance becomes an end in and of itself rather than a tool to ensure cultural diversity and corporate responsibility. The debate keeps getting framed as if the only true alternative were to opt out of media and live in the woods, eating acorns and lizards and reading

only books published on recycled paper by small alternative presses" (248–49). First, it is unlikely that culture jammers would preach offline romanticism. Rather it is their fascination with media that prompts them to appropriate the media's symbolic power. Second, Jenkins does not even consider that jammers may have desires and objectives that go beyond ensuring "cultural diversity and corporate responsibility."

REFERENCES

Abel, Alan. 1970. *Confessions of a Hoaxer*. Toronto: Macmillan.

———. 1987. Interview by Andrea Juno in *Pranks!*, edited by Vivian Vale and Andrea Juno, 103–9. San Francisco: V/Search.

Adorno, Theodor W., and Max Horkheimer. (1947) 2002. *Dialectic of Enlightenment: Philosophical Fragments*. Edited by Gunzelin Schmid Noerr. Translated by Edmund Jephcott. Stanford, CA: Stanford University Press.

Autonome a.f.r.i.k.a. gruppe, Luther Blissett, and Sonja Brünzels. 1997. *Handbuch der Kommunikationsguerrilla. Jetzt helfe ich mir selbst*. Hamburg: Verlag Libertäre Assoziation.

Bagdikian, Ben Haig. 2000. *The Media Monopoly*, 6th ed. Boston: Beacon Press.

Baudrillard, Jean. (1976) 1993. *Symbolic Exchange and Death*. London: Sage.

———. 1995. *Simulacra and Simulation*. Ann Arbor, MI: University of Michigan Press.

Benjamin, Walter. (1934) 1986. "The Author as Producer." In *Reflections: Essays, Aphorisms, Autobiographical Writings*, edited and with an introduction by Peter Demetz, 220–38. New York: Schocken Books.

Bilchbaum, Andy, Mike Bonanno, and Bob Spunkmeier. 2004. *The Yes Men: The True End of the World Trade Organization*. New York: Disinformation Press.

Boorstin, Daniel J. 1971. *The Image: A Guide to Pseudo-Events in America*. New York: Athenaeum.

Bourdieu, Pierre. 1991. *Language and Symbolic Power*. Cambridge, MA: Harvard University Press.

Brecht, Bertolt. (1932) 1964. "The Radio as an Apparatus of Communication." In *Brecht on Theatre: The Development of an Aesthetic*, edited and translated by John Willett, 51–52. New York: Hill & Wang.

Debord, Guy. (1967) 2014. *Society of the Spectacle*. Translated and annotated by Ken Knabb. Berkeley, CA: Bureau of Public Secrets.

Deseriis, Marco. 2015. *Improper Names: Collective Pseudonyms from the Luddites to Anonymous*. Minneapolis: University of Minnesota Press.

Eco, Umberto. 1986. "Towards a Semiological Guerrilla Warfare." In *Travels in Hyperreality*, translated by William Weaver, 135–44. San Diego: Harcourt Brace Jovanovich.

Enzensberger, Hans Magnus. (1970) 2000. "Constituents of a Theory of the Media." In *Media Studies: A Reader*, edited by Paul Marris and Sue Thornham, 68–91. New York: New York University Press.

Foucault, Michel. 1977. "What Is an Author?" In *Language, Counter Memory, Practice: Selected Essays and Interviews by Michel Foucault*, edited and translated by Donald F. Bouchard, 113–38. Ithaca, NY: Cornell University Press.

———. 1972. "The Discourse on Language." In *The Archeology of Knowledge and The Discourse on Language*, translated by A. M. Sheridan Smith, 215–37. London: Tavistock.

Hall, Stuart. 1993. "Encoding/Decoding." In *The Cultural Studies Reader*, edited by Simon During, 163–73. London: Routledge.

Harrison, Nate. 2012. "Appropriation Art, Subjectivism, Crisis: The Battle for Fair Uses." In *Media Authorship*, edited by Cynthia Chris and David Gerstner, 56–71. New York: Routledge.

Hoffman, Abbie. 1968. *The Revolution for the Hell of It*. New York: Avalon.

Jenkins, Henry. 2006. *Convergence Culture: Where Old and New Media Collide*. New York: New York University Press.

Key, Brian Wilson. 1973. *Subliminal Seduction: Ad Media's Manipulation of a Not So Innocent America*. New York: Signet Books.

Langer, John. 1998. *Tabloid Television: Popular Journalism and the "Other News."* London: Routledge.

Lazarsfeld, Paul F., and Robert K. Merton. (1948) 2004. "Mass Communication, Popular Taste, and Organized Social Action." In *Mass Communication and American Social Thought: Key Texts, 1919–1968*, edited by John Durham Peters and Peter Simonson, 230–42. Lanham, MD: Rowman & Littlefield.

McChesney, Robert. 1999. *Rich Media, Poor Democracy: Communication Politics in Dubious Times*. Champaign: University of Illinois Press.

McCombs, Maxwell, and Donald Shaw. 1972. "The Agenda-Setting Function of Mass Media." *Public Opinion Quarterly* 36 (2): 176–87.

Ong, Walter J. 1982. *Orality and Literacy: The Technologizing of the Word*. London: Methuen.

Packard, Vance. 1957. *The Hidden Persuaders*. New York: David McKay.

Radnóti, Sándor. 1999. *The Fake: Forgery and Its Place in Art*. Translated by Ervin Dunai. Lanham, MD: Rowman & Littlefield.

Schiller, Herbert I. 1991. *Culture, Inc.: The Corporate Takeover of Public Expression*. Oxford: Oxford University Press.

Skaggs, Joey. 1987. Interview by Andrea Juno. In *Pranks!*, edited by Vivian Vale and Andrea Juno, 36–50. San Francisco: V/Search.

———. 1997a. "The Cathouse for Dogs." www.joeyskaggs.com.

———. 1997b. "Artist's Manifesto (Dogma)." www.joeyskaggs.com.

Sorel, Georges. 1999. *Reflections on Violence*. Cambridge, UK: Cambridge University Press.

Tiqqun. 2001. "L'Hypothèse cybernétique." In *Tiqqun: Organe de liaison au sein du Parti imaginaire—Zone d'opacité offensive*, 40–83. Les Belles-Lettres: Self-published.

Vincino. 2007. *Il Male, 1978–82: I Cinque anni che cambiarono la satira*. Milan: Rizzoli.

Wark, McKenzie. 2004. *A Hacker Manifesto*. Cambridge, MA: Harvard University Press.

Wu Ming 1. 2002. "Why Not Show Off about the Best Things? A Few Quick Notes on Social Conflict in Italy and the Metaphors Used to Describe It." www.wumingfoundation.com.

"Yes Men Hoax on BBC Reminds World of Dow Chemical's Refusal to Take Responsibility for Bhopal Disaster." *Democracy Now!*, December 6, 2004. www.democracynow.org.

4

Putting the "Jamming" into Culture Jamming

Theory, Praxis, and Cultural Production during the Arab Spring

MARK LEVINE

I will never forget the first time I read the words "culture jamming," in a galley for Naomi Klein's (1999) seminal *No Logo*: "Culture jamming baldly rejects the idea that marketing . . . must be passively accepted as a one-way information flow," she wrote (281). Brilliant!, I thought. Corporations want communication to be one-way unless they can control or at least direct the consumer's response toward purchasing and consuming their product. Klein continued: "The most sophisticated culture jams are . . . interceptions—counter-messages that hack into the corporation's own method of communication to send a message starkly at odds with the one that was intended" (281).

This I didn't get. I'd been a professional musician for a dozen years when I read those words. You're not supposed to intercept someone's message in a jam; you're supposed play in synchrony with it, harmonize with it, help expand it, even amplify it. Exactly the opposite of the definition Klein had offered. But then I understood that for Klein culture jamming didn't mean bringing cultures together to jam, something I'd been trying to do most of my musical life. For anticorporate globalization activists, it meant the much more literal jamming of messages into and against corporate advertising in order to subvert its intended meaning. The Marlboro Man's face painted over by a skull and crossbones; "Philosophy Barbie"; Reverend Billy leading his "Church of Stop Shopping" in an anti-neoliberal gospel sing-a-long. As *Adbusters* (n.d.), the main institutional home of culture jamming, declares on the homepage at www.adbusters.org: "We are a global network of culture jammers and creatives working to change the way information flows, the way corporations wield power, and the way meaning is produced in our society."

I loved the idea of culture jamming that Klein and *Adbusters* put forth and that early culture jammers had been practicing with their often wildly creative subversions of classic advertising. But this type of jamming is most definitely not as useful—or as fun, I thought—as the type of "culture jamming" the term first evoked for me: bringing artists from different cultures together to create new forms of culture that were not merely hybrids of existing forms and practices, but something new, greater than the sum of their parts. Indeed, given that the term was coined by a band, Negativland, it seemed that musical jamming should be embedded into the core meaning of the concept.

Not merely for aesthetic reasons but also for political ones, I knew from years of traveling around the Middle East and Africa, jamming with musicians, and working with activists and scholars from other cultures that these kinds of musical jams were crucial to the creation of what Manuel Castells (1996) has termed "project identities"—open, pluralistic, tolerant, and future-oriented identities, rather than the kinds of "resistance" identities that were the best possible outcome of the negative practice represented by the culture jamming Klein was encouraging.

On the other hand, it was also clear that just bringing people together who do not normally collaborate would not, by itself, produce politically salient and powerful art. What was needed was to encourage jamming that was both critical and positive, that performed an inherent critique of the existing system while also showing the way forward to a different future. Artists alone cannot achieve this. Or at least few can. And activists and critical scholars can rarely touch people at their core as can—or at least should—great art.

As someone who has spent his professional life as a scholar, activist, and artist, I thought it natural to try to create a kind of "culture jamming" in which artists, activists, and scholars could come together in discussion and performance, where ideas and critique could be shared and developed as part of the process of creating new, critically engaged art. From the perspective of the worlds of art, academia (and to a similar extent, journalism), and activism—all of which must operate in some sort of harmony in order to achieve common ends—culture jamming is the best, and perhaps only, way to grasp and work through the unprecedented complexity of globalization and the problems it has generated. That is, we must approach those with whom we are working, dialogu-

ing, or struggling in the same way that a great musician would approach sharing the stage with an equally accomplished peer—think Carlos Santana welcoming Eric Clapton to the stage, or Chuck D trading rhymes with KRS-One. Such jams require several elements to succeed. First, all the participants must share the same extremely high skill level. Second, while clearly possessing both extreme self-confidence and strong egos, they must be utterly selfless and accommodating. Third, and related to the first two, they must be able to listen and attenuate their approach to the music based on the smallest, sometimes subliminal cues from other musicians—not merely their famous friends, but the rest of the band as well. Fourth, they need to display what, riffing on the work of the great Frankfurt School critic Herbert Marcuse (1965), could be described as "repressive tolerance" toward the dominant (neo)liberal discourse of "tolerance" and "diversity," which in fact seek to impose tolerance by the majority of people toward the policies of those in political and economic power (however much their impact is inimical to their interests), while attempting to discredit and push to the margins views which truly challenge existing systems. Marcuse advocated both intolerance toward this faux tolerance of the dominant system and real tolerance toward the kinds of revolutionary views that truly challenge the system.

As anyone who has ever shared the stage with top-level musicians will attest, creativity and risk-taking are a necessity, but musical chauvinism, amateur behavior or performance, and ego that exceeds ability are in no way tolerated. These positive attitudes and states—or rather, presence—of mind are crucial for culture jamming in its broader, activist sense to succeed. Their absence has doomed any number of progressive movements, from the Students for a Democratic Society to the Socialist Workers Party to the post-9/11 global peace and justice movement; their presence made the early victories of the Arab and then Global Spring, in Tunisia, Cairo, London, or New York, possible.

Expanding Theory and Praxis

From the inception of the term in the mid-1980s, culture jamming has been concerned not only with how information is created and disseminated, but also with who controls its production and circulation, and whether and how critical voices can establish and maintain a presence

in these networks. Jamming has, in fact, been deeply connected to critical theory from the start, "go[ing] to the heart of critical social, political economic and media theory, including struggles over ideological and cultural hegemony" (Nomai 2008, 36).

Before we can explore the critical roots and connections of culture jamming, an even more basic concept must be clarified, that of culture itself. Long considered one of the most complex and over-determined words in the English language (and certainly no less so in most other tongues), "culture" has traditionally been defined in essentialist and un-changing terms—the "great" books, art, or literature of a society that bears little relationship to the practices that define peoples' identities and sentiments on the ground.

Inspired by the seminal trajectories of Gramsci, Benjamin, Adorno and the Frankfurt School tradition, Foucault, Deleuze, Agamben, Bhabha, and Butler, and following the tracks put down by the emergence of disciplines such as cultural studies, performance studies, and world history, we need instead to understand culture as representing a constantly changing process of identity formation and performance. That is, culture is inherently performative—it does not exist outside of its performance by individuals and groups, in everyday life as well as publicly consumed spectacles and products. It is a negotiation process that involves disciplining, resistance, and contestation, whose borders remain fluid and permeable regardless of how rigidly they are imagined.

Culture is also inherently transnational and translational, colonizing and colonized, "othering" and "othered," part survival strategy and part "expedient" invention that continuously redefines our identities. Indeed, in the global era, politics and economics become globalized to the extent that they are "culturalized," that is, transacted through cultural symbols.[1] Yet if culture has become a "crucial key" (as the United Nations described it) to solving our world's myriad crises, in the dominant neoliberal version of globalization, "culture" can mean only corporate-led, consumer-driven culture: a combination of addiction and fanatical religion that is as hard to break or walk away from as crack or your mother's church.

Indeed (and it is sadly paradoxical at that), culture has become depoliticized and commodified at precisely the moment that it has become the defining mechanism of political and economic interaction and the

engine of global integration. This process has occurred just as the specific conditions of production and distribution have allowed for an unprecedented decommodification and return of what Walter Benjamin ([1936] 1968) termed its "aura," to great potential effect. As it happened, however, the resulting homogenized, consumerist culture has made it all the more difficult to produce critical art that can reach the majority of Americans, or anyone else for that matter—a disconnect that urgently needs to be better understood and repaired.

The neoliberal challenges to cultural autonomy, specificity, and political agency constitute the theater of battle, as it were, in which culture jamming operates. If jammers are to do more than just wield "guerrilla semiotics" or wage "semiological guerrilla warfare" (as Eco [1986] described it, building on the subversive semiological tradition of Barthes[2]); if culture jamming is to move beyond serving merely as a deliberately distorted "mirror" to refract an already distorted reality back on the public in a clearer form; if jammers are to achieve "new way[s] of conceiving the world [and] modifying popular thought and mummified popular culture," as Gramsci (1971, 471) called for from his dark prison cell, and move beyond a war of resistance and position toward systematic change and a truly revolutionary "war of maneuver"—then jamming needs to become much more music-like in its method and transcendent in its goals, even as its politics remains deeply and immanently critical of the existing order (Berry 1995).

Empathy, Aesthetic Embeddedness, and Revolutionary Jamming

The history of the artistic and musical avant-gardes of the twentieth century offer us instruction on the limits of culture jamming as it is normally understood and practiced. We can see, or rather hear, these limits in the music of Schoenberg and Berg, driven by the tension between "continual construction and perpetual decay, life and death" (Adorno quoted in Mason 2013, par. 3). We find them in the Dadaists with their "shock art," Surrealists with their atemporal and spatially incongruent visual juxtapositions, and Situationists with their immanently critical détournement—surely the most direct inspiration for culture jamming. And we see them in the hippies with their "cool" challenges to political and sexual mores (already conquered by capital at their moment of

conception) and the punkers with their deliberate trashing of musical norms and hierarchies.

Within the arsenal normally deployed by culture jammers, we experience these limits in tactics such as sniping, subvertising, media hoaxing, audio agitprop, and billboard banditry (Dery 1993). All these practices—or better, performances—certainly have helped to deconstruct media culture, challenge ideologies and intentions, and even test laws underlying industrialized and mass distributed cultural production. But their limits are exposed by their failure to move their societies meaningfully closer toward revolutionary change than they were before—they have not, as Toni Cade Bambara (1983) describes the function of great art, "ma[d]e the revolution irresistible" (viii). For all their aesthetic power and political acuity, they don't have enough power to take on the "creative dark matter" or energy that both holds the broader system together, yet normally operates in the shadows. As with any subgenre breaking into the mainstream, to effect radical change in behaviors and not just attitudes, the jamming movement needs to create certifiable "hits"—new narratives, identities, and politics—which can engage and ultimately enlist enough people to its cause fundamentally to change the status quo.

There are several issues to consider when exploring this failure. The first is the nature of the various media involved in culture jamming. While the most well-known and successful subversions have been visual (not surprising, given the immediate impact of subverted advertising images or slogans on the viewer, compared with the time commitment necessary to read through a long text, listen to a song, or watch a film), music, in my opinion, is the art form most suited to culture jamming because it both reaches the most people and by its very nature creates community in ways that other forms of art do not.[3] Music is, of all the creative arts, the one that has the strongest ability to create empathy between people who otherwise might not interact or relate to each other, both through its power to create shared "embodied experiences"—the most direct form of aesthetic embeddedness—and through the way it speaks to multiple audiences, and in so doing enables them to begin previously unreachable conversations.[4]

Empathy is perhaps the most important element of the concept of culture jamming I am articulating here and is crucial to the creation,

visibility, and expansion of the new types of aura I described above as being enabled by the uncommodified digital production and circulation of music and related arts. Building on the work of philosopher Emmanuel Levinas, I argue that empathy depends on a radical recognition of the other, and in particular of those others who are most immediately threatening to you. It involves a kind of hospitality that demands one give up significant control over what one already possesses, a kind of sharing and erasure of hierarchies that, as I explained above, is a sine qua non for any true jam in the musical sense because it is the sine qua non for truly open and free communication and dialogue. Without empathy, you can't create new levels of solidarity, and without solidarity between previously disparate and even antagonistic groups, there can be no true revolution (see Levine 2005, chap. 7–9).

The problem is that it is very difficult to create empathy from culture jamming conceived of in its usual, more purely critical sense. Indeed, the very "immanence" of the critique embedded in the best traditional culture jams is precisely what makes them difficult to use as the basis of a new, positive identity. The intensity and "negativity" of the criticism is aimed at breaking an existing chain of signification, not creating new bonds.[5]

Ethnomusicologist Philip Bohlman (2002) provides an important clue to helping us understand why music has this transformative power with his notion of "aesthetic embeddedness." Specifically, he argues for the unique ability of music to extend its impact far beyond the cultural realm where it is first felt because more than any other cultural product, music is aesthetically embedded within—that is, it reflects and even amplifies—the larger social, political, and economic dynamics of a society. By this, I mean that music is both intensely shaped by political dynamics and in turn shapes them: for instance, folk music and hip-hop were shaped by the politics of their times, but in reflecting and commenting on social issues, they also helped to shape the larger political scenes. Conversely, political and economic power inevitably have "an aesthetic property" that the most socially relevant music in a society amplifies in order to move its listeners to action. Indeed, music specifically "affords power to those who search for meaning" (14). That is, its amplifying power makes it an important tool in struggles to achieve social and political hegemony. The role of revolutionary music in challenging

the legitimacy and power of the anciens régimes in the Arab uprisings (which I discuss in more detail below) is the latest and among the clearest examples of how this process functions.

Crucially for our purposes, Bohlman (2002) sees the much-abused genre of world music, which we can define as ostensibly indigenously created and performed non-Western music marketed largely to Western audiences, as epitomizing the dual power of music to embed and be embedded; not merely as an autonomous object, but rather to "effect change, to transform text, narrative and ritual into meaning" (13). This dual power has rarely been more present than during the post-2010 revolutionary protests across the Arab world, which in countries such as Tunisia and Egypt witnessed key leadership positions arise among the "revolutionary youth" activists whose road to political activism began as members of subcultures such as the region's much abused heavy metal scenes, one of the most important yet least understood or accepted genres of "world music."

Jamming and the Return of the Aura of Music—and Protest

Above I referred to Toni Cade Bambara's (1983) declaration that the duty of the radical artist is to make revolution irresistible (viii). Culture jamming can do no less if it is to be considered a tool of revolution rather than merely critique. This raises the question, however, of what kind of artistic/aesthetic production can motivate people to risk everything—indeed make it well-nigh impossible for them not to—for the chance fundamentally to change the system in which they live. I argue that the key to art, and music specifically, fulfilling this duty of motivating large numbers of people to risk their freedom and even life to support revolutionary change is the return of the aura to the work of art, which as Benjamin argues was lost as artistic production and circulation became industrialized, commodified, and commercialized in the technological age.

With modern mass production and circulations of art—Benjamin calls it "mechanical" or "technological"—"the aura" that previously had given art such aesthetic, and thus social, power disappeared. The aura of pre-"mechanized" art was created by its perceived singularity and irreplaceable value, which owed precisely to the fact that it was impossible

to replicate exactly and distribute most artistic products in a commodi-fied manner (literature and poetry, which could be mass printed and sold, were the obvious exceptions). For Benjamin, the disappearance of the aura of art with the development of technologies for mass reproduc-tion and commodified distribution was a positive development because it allowed for artistic production that no longer ritualistically served ex-isting power structures and thus could enable new and even revolution-ary visions of the future.

Benjamin's friend and colleague Theodor Adorno was profoundly influenced by the notion of the aura developed in Benjamin's semi-nal "The Work of Art in the Age of Mechanical Reproduction" (1936). But Adorno saw the process more negatively: for him, mass-produced, commodified cultural production led to the creation of a "culture in-dustry." Far from challenging the power of capital and its ideologies, the culture industry imposed an artificial aura, the "aura of style," upon cultural production, which had unprecedented power to reinforce the hegemonic ideology of the system (in this case emerging consumer cap-italism). In Adorno's words, this process constituted a "stereotyped ap-propriation of everything for the purpose of mechanical reproduction that eliminated every unprepared and unresolved discord" (Adorno and Horkheimer [1947] 2007, 100).

In response to the dominant, highly ideological form of artistic pro-duction, revolutionary art (the most important example of which, for Adorno, was music) must highlight, not resolve, the political, economic, and cultural discord that lurks beneath the portrayal of a harmonious society. Such art must become "immanently critical," as explained above, if it is to enable greater human freedom. But revolutionary art, and the culture jamming that would produce it, cannot stop with merely high-lighting or heightening discord; it has to take the next step and promote a vision, a path and a method to create a new kind of accord between the people who must act in concert if the system is to be seriously chal-lenged. Here it must be recognized that Adorno, like Marx before him, did not place much faith in the masses, which is why he so distrusted commercial/popular culture. Musically inspired culture jamming must move beyond this inherently elitist myopia within Marxist-inspired cri-tiques of popular culture and politics, even as it recognizes and navigates through the reality that activists, like all great artists, are always at the

avant-garde of social and political change. Egyptian revolutionary singer Ramy Essam's (2011) explanation of his role in the revolution is applicable to other revolutionary artists and activists alike: "I listen to the people and take their most powerful and important feelings and desires and try to put them in the most powerful and succinct way, and then give it back to them to help motivate them and give them hope and strength."

In this process, the rise of new digital technologies—which enable the low-cost, do-it-yourself production of professional-sounding recordings by anyone with the requisite talent and a computer, along with unlimited and free circulation of these recordings to anyone through the Internet—has returned the aura to music (or at least to the styles of music, such as hip-hop and various forms of rock, that have been the most prominent and important in the Arab uprisings). That is, it has enabled music to connect to and move people in the ways necessary to encourage and sustain revolutionary action. As Bart Cammaerts (2007) points out, politicians and governments have also understood the power of the free and unlimited distribution of content on the Internet to facilitate the creation of auras of authenticity around their "products."

"Mechanical" reproduction and commodified distribution necessitated the development of a "culture industry," and with the incorporation of cultural production and distribution into capitalist networks and control, the resultant art as well as its consumption could not help but reinforce the system's ideology, and serve as one of the most powerful weapons in capital's—especially late, post-industrial capital's—ideological and hegemony-producing arsenal. But with low-cost digital production capabilities and products that can be endlessly circulated for free, the necessary link between large-scale circulation and distribution of cultural products and commodification was broken. This break enabled the decommodification of music in the context of unlimited circulation, which moved such artistic production away from the "aura of style" Adorno feared would take over mass-produced and circulated art (Adorno and Horkheimer [1947] 2007), while enabling an aesthetic of uniqueness and immediacy that was central, in Benjamin's ([1936] 1968) view, to the production of the aura before the industrialized commodification of artistic production. Specifically, the rise of "DIY" (do-it-yourself) musical scenes like heavy metal, punk, hip-hop, and other "alt" popular music styles involved the creation of subcultures that were

inherently (if only latently at the start) subversive and countercultural. Moreover, these scenes were composed in good measure of "outsiders" and others who were marginalized in their societies, as well as of participants in the scenes who had high levels of new media-related skills (coding, hacking, developing websites, digital musical production, and so on) and experience in organizing at the underground level to spread their music. Finally and most importantly, these scenes survived and indeed thrived on face-to-face gatherings where music was intensely, viscerally, and ritualistically shared, and where shared experiences led to solidarities, which strengthened the power of the music.

The combination of dynamics described here is what led to the return of the "aura" of music, by which I mean that music once again served as a "ritualistic" (to use Benjamin's [1936] term) condenser and amplifier of solidarities and identities—but it was now, at least potentially, free of servitude to the capitalist market and its attendant political and ideological systems. This aura, which we could see glimpses of during the height of the hippie era and then again with the birth of punk and hip-hop (all three of which were deeply grounded in broader political-economic conflicts), has the power to attract more people and help inspire and disseminate alternative identities and visions of the future of society.

In the advanced capitalist countries of North America, Europe, and Asia, such auratic scenes ultimately cannot compete with the hyper-commodified and politically dominant forms of cultural production and distribution generated and controlled by the commercial entertainment industries, even as the work of revolutionary artists helps sustain and even grow progressive communities. But in the Middle East, North Africa, and other parts of the developing world, such auratic scenes have greater possibility to encourage participation in movements for systemic and even revolutionary change.[6]

Music, Global Youth, and the Road to Revolution

Ultimately, what I'm arguing is that for culture jamming to fulfill its liberatory potential, it has to generate the kind of aura discussed above, one that can develop only when the jams are as musical as they are critical. In my book *Why They Don't Hate Us*, where I first wrote about culture

jamming in depth, I argued that a true culture jam would be a combination roundtable and performance bringing together an international (or at least multicultural) group of artists, scholars, and activists who do not normally have the chance to be in dialogue with each other, let alone with an audience (LeVine 2005). The first jams I did occurred in New York, in Philadelphia, and Los Angeles as part of the 2000 "Shadow Conventions" and in Prague at the "S26" anti-IMF protests of September 2000; it quickly became clear to me, though, that culture jamming would be far more powerful in the Middle East and larger Arab/Muslim world than in the United States or Europe, at least in the early years of the post-9/11 era.

At this time I was inspired specifically by the creativity of Arab DJs and producers who, unbeknown to most of the Euro-American public or even artists, were creating incredibly powerful and original hybrids of so-called "Western" and "Arab" styles. Specifically, if you traveled to any *souk*, or market, in the Arab world in the late 1990s and early 2000s looking for good dance music, you'd find various CD series with titles like *The Orient Beats Back* or *Arabica 2000* (or 2001, 2002, and so on). With their mixing and hybridization of often improbable combinations such as Arab dance remixes of classic Pink Floyd songs, these collections pointed to an emerging globalized cultural aesthetic geography in which the Muslim world was in many ways well ahead of the West. Rock 'n' roll, as well as disco, country, funk, and most other styles of American popular music, have a long history in the region. So the existence of these compilations did not surprise me as much as their innovative aesthetics and production, how artists were creating new hybrids of so-called Eastern and Western styles and sounds that were not yet imagined in the supposedly more "advanced" West.

But what really helped me understand the revolutionary potential of music was my discovery of the region's vibrant if often repressed heavy metal scenes. Despite its origins far removed from the indigenous musical traditions of the Middle East and North Africa, heavy metal became increasingly popular in the 1990s across the region—so much so that governments began serious crackdowns in the latter half of the decade (epitomized by the Satanic Metal scares in countries like Egypt, Jordan, Lebanon, Iran, and Morocco). As I began to research the scenes and befriend musicians and fans across the region, it became clear that the

metal scenes were not merely subcultures looking for autonomy and freedom from the dominant patriarchal and oppressive structures; they were also potential "countercultures" in which radically new identities were being articulated and new tools of activism—the Internet, wide-scale digital sharing, DIY distribution and organizing—were being used.

While in countries like Egypt the scenes remained underground after the Satanic Metal affairs until the latter half of the 2000s, in Morocco something amazing happened. When a Satanic scare in which fourteen metalheads were arrested occurred in 2003, the metal community put all the skills they had learned through organizing and developing the scene to political and social use. They started an international campaign to free their jailed comrades using e-mail and other Internet platforms to spread the word; they organized demonstrations and even concerts in front of the court house where the alleged "Satanists" were tried; and they so shamed the government that, in perhaps the only case of a youth movement directly challenging a regime and winning before the Arab Spring, they ultimately succeeded in having the convictions against the metalheads overturned, after which the popularity of the scenes grew immensely.

The manner in which Moroccan metalheads took on their government and won was a template for the kind of activism that would characterize the Arab Spring. Three years later, in 2005, it would become more evident in Egypt with the founding of the Kefayyah movement (one of the first directly political youth-inspired movements in Egypt, which was an early adopter of social media), which included many metal fans in its ranks, and soon after that in Tunisia, where activists were also very involved in the country's music scene. When the political explosions in Tunisia and Egypt finally occurred in 2010 and 2011, I discovered that key leaders of the revolutionary movements were my friends from the metal scene.

The transition from musical to political activist was both natural and necessary. Indeed, the discourse of "dignity," "freedom," "bread," and "social justice" had been developed as much in the lyrics of local rock and rap songs as in the directly political discourse of more established activists.[7] In fact, it often turned out that the musicians were at the same time activists and intellectuals (if not formally trained scholars in their own right). Without necessarily doing so consciously, they themselves

consolidated the function of artists, scholars, and activists. In so doing they helped encourage the most powerful culture jams seen in decades with the massive street protests that occurred in Tunisia, Egypt, and then across the region.

Tahrir and the Search for the Perfect Jam

One can see the dynamic described here engaged in by well-known "revolutionary artists" such as Tunisian rapper El Général and Egypt's "singer of the revolution," Ramy Essam. Though these two signal artists should not be considered *the* definitive revolutionary artists—most every engaged artist I have met in Tunisia or Egypt is at the same time a well-informed and increasingly polished "public intellectual"—their experiences, especially Essam's, exemplify the power of culture jamming to effect true social change.

If I had had any doubts about the power of music to move revolutionary masses, they melted away the moment I first entered Midan Tahrir in the midst of the eighteen-day protest that ultimately forced Hosni Mubarak from power in early February 2011. Music was literally everywhere: people were chanting, singing into megaphones, playing drums, blowing horns. The Midan was rung with makeshift stages where some of Egypt's best known musical groups and other, suddenly famous musicians played day and night.

But it wasn't just that Tahrir was an incredibly musical space. It was that, as in Tunisia only weeks before, music was at the forefront of the revolution. In Tunisia it was the young and relatively unknown rapper El Général who helped move thousands of people into the streets with his song "Rais LeBled" (President of the country), which, in the form of a Dear Mr. President missive, offered one of the most powerful and irrefutable critiques of a political leader ever put to music. With the insight of a scholar and the allusiveness of a poet, El Général offered Tunisians a powerful yet concise summary of the entire range of betrayals by their leader and the perfect rationale for screaming "Dégage!" (Leave!) at the top of their collective lungs until President Ben Ali fled the country.

A similar process occurred in Egypt, as epitomized by the experience of Ramy Essam, considered the "singer of the Egyptian revolution." Essam was a largely unknown metalhead turned aspiring pop star

from Mansoura, a town about 120 kilometers north of Cairo, when he watched Tahrir explode into fighting on January 28, 2011. By February 1, he could sit by no more, and with little more than his acoustic guitar and a sleeping bag, he headed to Tahrir; within another twenty-four hours he had written what became quite literally the anthem of the revolution, titled "Irhal!" or "Leave!"

When I first heard "Irhal," late at night in my kitchen in California, it was on a YouTube video that had only about three hundred views. (By the time I met Essam a few days later and twelve thousand kilometers to the east, the number of views had reached the tens of thousands.) I write "heard" rather than "saw" because Essam was nowhere in the video, which was shot in an almost completely darkened Tahrir and focused on the crowd, not the stage. All I heard was the anger and the massive groove of the song, which was so powerful despite being just an acoustic guitar rhythm and Essam's voice that I immediately called my producer and we put a bass line and funk drum groove underneath in order to create a danceable hip-hop version of the song that could be remixed by other politically inclined artists.

Given the angry force of "Irhal," I was shocked when I met Essam in Tahrir and found him all smiles. In fact, Essam has never stopped smiling, despite being tortured, tear-gassed, shot at, accused of every crime imaginable by the government, and perhaps worst, failing to get a decent night's sleep during the last two years. It was joy that kept Essam playing "Irhal" dozens of times a day, from 10:00 a.m. until 3:00 a.m., during the eighteen days of protest in Tahrir, and every time Tahrir has been occupied since then. Essam's remark about his function within the broader revolution, to take what people are feeling most deeply and put it into words that can speak to everyone continuously, is crucial here. Essam was not alone in this endeavor; other revolutionary artists— such as folklore ensemble Tanboura, hip-hop artists MC Amin, Arabian Knightz, and Ramy Donjewan, and rock/pop groups Eskandarella, Massar Egbari, and Wust al-Balad—all played similar roles.

There are two key aspects of Essam's story that are informative for our understanding of culture jamming. The first is that beyond writing and singing music that captured the spirit of the revolution, Essam himself quickly became a public intellectual at the forefront of debating Egypt's future, constantly meeting and working with activists at the street level.

He slept in Tahrir every day during the occupation, and he appeared routinely on television. He not only represented the views of the revolutionary youth to the wider public, but also worked to bring the broader Egyptian public toward the revolutionary movement.[8]

Equally as important, he and other artists have laid aside any notion of genres or boundaries in pursuit of the perfect revolutionary jam. Hip-hop blends with traditional music, metalheads like Essam write Bob Dylanesque anthems, folklore groups like Tanboura reawaken old resistance songs to use against new oppressors, and everyone adopts the words of revolutionary poets and singers of previous generations, such as Sheikh Imam and Fouad Negm. This linking together of disparate forms from various periods provides greater legitimacy to the newer artists and forms, while reinscribing into their music cultural codes and products that had either fallen into disuse or been appropriated by the regime (as was folkloric music and mainstream Egyptian pop).

Joy amidst the Tear Gas

It is easy to smile in the midst of a liminal revolutionary moment, when society has clearly reached a tipping point and is breaking free of an old order and opening up new possibilities for the future. In Tunisia or Egypt, you can hear the transformation of the revolutionary music at the moment of the revolutionary break, away from the anger and dissonance of "Rais LeBled" or "Irhal" and toward songs that reveal a "joyful hybridity" of styles, cultures, even languages that reflect precisely the kind of project identity I earlier described as being the sine qua non for moving from resistance toward revolutionary change. Such an attitude, while not explicitly theorized by the artist-activists, is very similar to the attitudes and practices of the Seattle generation of anticorporate globalization protesters, who from the seminal Seattle protests of late 1999 through the violence of Genoa in July 2001, and even in the height of the post-9/11 hysteria, practiced what guerrilla artist Robbie Conal (2003) described as "ferocious joy" coupled with the creation of carnival and "revelious" atmospheres as central ingredients of these protests.[9]

One of Adorno's ([1962] 1988) many insights into the ambiguous role of music within national cultures was that "a country's music has become a political ideology by stressing national characteristics, appearing

as a representative of the nation and everywhere confirming the national principle. . . . Yet music, more than any other artistic medium, expresses the national principle's antinomies as well" (155). The joyful hybridity exemplified by some of the best musical production by revolutionary artists, such as Essam or Tunisian hip-hop crew Armada Bizerta, reveals that talented artists can create an incredible variety of sonic tapestries to match and help shape the national mood—from dissonant anger to joyful creativity—as the political and cultural situation on the ground changes. Their flexibility, which is both a producer and a product of the hybridity of their art, is key to their functioning as the kind of immanent critique Adorno and other critical theorists hoped would be able to "reliquify" the "congealed," ideologically bounded identities imposed by authoritarian regimes on their citizens. That is, they could produce simultaneous art that supports Castells's (1996) notion of resistance and project identities, helping to de- and reconstruct core communal identities (religious, national, gender, kinship) whose manipulation was for decades a core strategy for maintaining the ambiguities, yet power, of authoritarian domination.

These artists have not only helped reshape their own political and aesthetic cultures; they have also opened new perspectives and pathways for their peers in Europe, the United States, and elsewhere to creatively deploy the full vocabulary of global cultural production to help shake up and uncongeal political and economic systems that are experiencing unprecedented moments of vulnerability. Despite all the setbacks they have faced, the culture jammers of the Arab world are providing a seminal example of how to create and sustain revolutionary movements against previously all-powerful systems, and to do so in a manner that, however fitfully, at least points the way forward for societies trapped for decades in webs of authoritarian rule, and, by extension, for the rest of us as well.

Postscript, May 2015

Since this book went into production, the situation in Egypt became far more repressive and ultimately Ramy Essam left to take up a multiyear study and performance residency in Sweden. Other highly political artists like Moroccan rapper El Haqed (L7a9ed, the Enraged One) have been forced to leave their countries for uncertain futures as political

exiles. Artists across the Arab world continue to face often severe repression, including physical attacks and imprisonment. Nevertheless, whether the revolutionary artists discussed here are abroad or in a jail cell, their music remains at the heart of ongoing attempts to press for greater democracy and freedom across the Arab world.

NOTES

1 I develop this theory of culture fully in LeVine (2005), chapters 1–5; see also Tomlinson (1999).

2 Eco here is building on Barthes's (1982) seminal work in *Empire of Signs*.

3 Film can also create incredibly powerful sets of shared experiences; but while great films have captured the "spirit" of a generation (e.g., *Easy Rider*) or viciously deconstructed the larger system (e.g., *Natural Born Killers*), even the most critical films had the power both to offer an alternative vision and help lead people to its realization, which is at the heart of culture jamming.

4 See DeChaine (2002) for the notion of embodied experience as it relates to music.

5 Immanent critique returns to the Hegelian turn on Kant's transcendentalism and then Marx's reshaping of Hegel's dialectic to focus on the processes and ideologies immanent *within* material history. It became a cornerstone of "critical theory" as developed by the Frankfurt School; the imagination of immanent critique as ultimately and endlessly "negative"—meaning, there is no possibility of a positive (and inevitably ideological) synthesis—was developed by Adorno (2007) in his magnum opus, *Negative Dialectics.*

6 In research with my colleague Bryan Reynolds, I described this process as involving the creation of what we term "theater of immediacy"; that is, cultural (often, but not necessarily artistic) creation and performance for an intended audience that is not merely emergent but "emurgent" (emergent + urgent): developing rapidly and in the context of intense sociopolitical struggle that destabilizes and even reconfigures previously dominant, congealed structures and networks of power and identity (see LeVine and Reynolds 2016).

7 Examples of these lyrics can be found in LeVine (2008).

8 The fact that he was brutally tortured by security forces during the second wave of revolutionary protests, in March 2011, only increased his bona fides.

9 For a description of such practices see Notes from Nowhere (2003); for Conal's description of ferocious joy, see the concert film *A Night of Ferocious Joy* (2003).

REFERENCES

Adorno, Theodor W. (1962) 1988. *Introduction to the Sociology of Music*. Translated by E. B. Ashton. New York: Continuum.

———. (1966) 1973. *Negative Dialects*. Translated by E. B. Ashton. New York: Continuum.

Adorno, Theodor W., and Max Horkheimer. (1947) 2007. *Dialectic of Enlightenment: Philosophical Fragments*. Edited by Gunzelin Schmid Noerr. Translated by Edmund Jephcott. Palo Alto, CA: Stanford University Press.

Bambara, Toni Cade. 1983. Foreword to *This Bridge Called My Back: Writings by Radical Women of Color*, 2nd ed., edited by Cherrie Moraga and Gloria Anzaldua, vi–viii. Latham, NY: Kitchen Table: Women of Color Press.

Barthes, Roland. 1983. *Empire of Signs*. Translated by Richard Howard. New York: Hill & Wang.

Benjamin, Walter. (1936) 1968. "The Work of Art in the Age of Mechanical Reproduction." In *Illuminations*, edited and introduced by Hannah Arendt, translated by Harry Zohn, 217–52. New York: Harcourt, Brace and World.

Berry, Collin. 1995. "The Letter U and the Numeral 2." *Wired Digital, Inc.* 3 (1). www.wired.com.

Bohlman, Phillip. 2002. *World Music: A Very Short Introduction*. Oxford, UK: Oxford University Press.

Cammaerts, Bart. 2007. "Jamming the Political: Beyond Counter-Hegemonic Practices." *Continuum: Journal of Media & Cultural Studies* 21 (1): 71–90.

Castells, Manuel. 1996. *The Power of Identity*. London: Blackwell.

DeChaine, Robert. 2002. "Affect and Embodied Understanding in Musical Experience." *Text and Performance Quarterly* 22 (2): 79–98.

Dery, Mark. 1993. *Culture Jamming: Hacking, Slashing and Sniping in the Empire of Signs*. Pamphlet no. 25. Westfield, NJ: Open Magazine.

Eco, Umberto. 1986. "Towards a Semiological Guerrilla Warfare." In *Travels in Hyperreality*, translated by William Weaver, 135–44. San Diego, CA: Harcourt Brace Jovanovich.

Essam, Ramy. 2011. Discussion with the author. Cairo, Egypt, December 5.

Gramsci, Antonio. 1971. *Selections from the Prison Notebooks*. Edited and translated by Q. Hoare and G. Nowell-Smith. New York: International Publishers.

"Home Page." N.d. *Adbusters*. www.adbusters.org.

Klein, Naomi. 1999. *No Logo: Taking Aim at the Brand Bullies*. Toronto: Knopf.

LeVine, Mark. 2005. *Why They Don't Hate Us: Lifting the Veil on the Axis of Evil*. Oxford, UK: Oneworld Publications.

———. 2008. *Heavy Metal Islam: Rock, Resistance and the Struggle for the Soul of Islam*. New York: Random House.

LeVine, Mark, and Bryan Reynolds. 2016. "Theater of Immediacy: Performance Activism and Art in the Arab Uprisings." In *Islam and Popular Culture*, edited by Karin van Nieuwekerk, Mark LeVine, and Martin Stokes, 58–77. Austin: University of Texas Press.

Marcuse, Herbert. 1965. "Repressive Tolerance." In *A Critique of Pure Tolerance*, by Robert Paul Wolff, Barrington Moore Jr., and Herbert Marcuse, 81–118. Boston: Beacon Press.

Mason, Moya K. 2013. "Theodor Adorno's Theory of Music and Its Social Implications." Moyak.com. www.moyak.com.

A Night of Ferocious Joy. 2003. DVD. Directed by David Zeiger. Los Angeles: Displaced Films.

Nomai, Afsheen J. 2008. "Culture Jamming: Ideological Struggle and the Possibilities for Social Change." PhD diss., University of Texas at Austin.

Notes from Nowhere. 2003. *We Are Everywhere: The Irresistible Rise of Global Anticapitalism*. London: Verso Books.

Tomlinson, John. 1999. *Globalization and Culture*. Chicago: University of Chicago Press.

5

From Culture Jamming to Cultural Acupuncture

HENRY JENKINS

Mark Dery's (1993) *Culture Jamming: Hacking, Slashing and Sniping in the Empire of Signs* begins with a question posed by the John F. Kennedy character in Ant Farm's 1975 spectacle "Media Burn": "Haven't you ever wanted to put your foot through your television screen?" Read retrospectively, Dery's essay captures a moment of transition—beginning with an emphasis on television's dominance over the contemporary media landscape and ending with speculations about how networked computing might pave the way for a future that Dery hopes will be "interactive rather than passive, nomadic and atomized rather than resident and centralized, egalitarian rather than elitist" (14), even if he fears otherwise. The Net, Dery speculated, might become the corrective to broadcast networks: "Jammers . . . are attempting to reclaim the public space ceded to the chimeras of Hollywood and Madison Avenue, to restore a sense of equilibrium to a society sickened by the vertiginous whirl of TV culture" (13).

Dery's culture jammers imagine the American public as entertaining itself to death and themselves as a vanguard army of organic intellectuals and grassroots activists who deploy underground channels of communication to enlighten the masses (through more or less the same means that the broadcast networks used to disempower them). The culture jamming model sees mass media as possessing powers that border on mind control but also as being susceptible to disruption by the most basic acts of the subversive imagination. The early culture jammers were—as a rule—antitechnological, seeking the authenticity of wheat paste and spray paint over the slick, corporate imagery associated with television, yet Dery ends his essay with a hint of cyber-utopianism. Drawing on Howard Rheingold's (1993) then-new concept of "virtual community," Dery wrote about the ideals that would inform the first

generation of cyberactivists, whose "burgeoning subcultures are driven not by the desire for commodities but by the dream of community." A more democratic culture, he suggested, would reward a popular "yearning for meaning and cohesion" as "the univocal world view promulgated by corporate media yields to a multivocal, polyvalent one" (16).

Revisiting the essay today requires us to acknowledge that we live in very different times. Dery offers two competing visions for the digital realm—one in which networked communications enhances grassroots power and the other where corporate control and consumer manipulation extend into these new media formats. As subsequent generations have discovered, this was not an either-or choice. Both developments have occurred, resulting in more complex sets of struggles between corporate and grassroots media. In such a context, do we want to throw a spanner in the works, or do we want to deploy the machinery toward our own ends? To what degree is the concept of "culture jamming" itself dependent upon arguments that are specific to particular media systems (broadcasting, networking, and so on)?

Today's change-makers are, if anything, even more strongly invested in appropriating and remixing content from "the empire of signs"; they are still holding corporations accountable for unhealthy impacts on our lives, but contemporary remix artists and activists have very different means of getting their messages out to the world and very different models for how to motivate popular support for their causes than were available to Dery and his contemporaries. Today, we are unlikely to say, as Dery asserted twenty years ago, that "our lives are intimately and inextricably bound up in the TV experience" (1). Networked computing did not, as Dery predicted, "sweep away" television; rather, grassroots media operate in a complex set of relationships with corporatized media. Much like their predecessors, contemporary activists seek to bring about social change through any media necessary; they simply have access to a broader array of media platforms and practices than before.

How we negotiate this space between corporate and grassroots media is a much bigger question than can be fully addressed in a short provocation. So, after a brief sketch describing new research into participatory politics more generally, I am going to focus primarily on one specific activist group, the Harry Potter Alliance, and one specific campaign, "Not in Harry's Name," which pressured Warner Brothers (WB) to disclose

whether the chocolate contracts associated with their Harry Potter license are produced by Fair Trade companies. I do so with the acknowledgment that no single group, network, movement, or cause can illustrate today's broad range of models for thinking about how activists might engage with popular culture or promote change through grassroots media tactics. My hope is to explore the assumptions about media, activism, and social change driving the Harry Potter Alliance's concept of "cultural acupuncture" as compared to the 1990s-vintage "culture jamming" approach. Put in the broadest possible terms, both seek to "hijack" the "signs" of popular culture, but where classic culture jammers sought to disrupt or block the flow, these new activists seek to redirect circulation through their cultural acupuncture. In part, this shift in terminology reflects the fact that today's activists have much greater capabilities to get their messages out and much greater potential to impact the agenda of the mainstream media. That said, the essay will conclude with some reservations about these new models of attention-based activism. Going back to Dery (1993), we still want to ask, "Who will have access to this cornucopia of information, and on what terms?" (13).

From *No Logo* to *Beautiful Trouble*

Naomi Klein's (1999) book *No Logo* describes culture jamming as having been reborn through the use of "newly accessible technologies that have made both the creation and circulation of ad parodies immeasurably easier" (285). Quoting Jorge Rodriquez de Gerada, an activist who she claimed worked in the advertising industry by day and deployed its techniques to challenge corporate power by night, Klein notes that the culture jamming movement had moved rapidly "from low-tech to medium-tech to high-tech" (285) in its tactics and worldview; activists, such as those involved in the antiglobalization movement, were now developing independent communication channels to circulate their messages more powerfully and more widely than before. Access to desktop publishing and image manipulation software, Klein argues, allowed the culture jammers to create anti-advertisements "designed to mesh with their targets, borrowing visual legitimacy from advertising itself" (285), rather than having to resort to using magic markers or spray paint cans to deface billboards. New computing technologies not only enabled

jammers to produce professional quality images; they also fundamentally shifted the very practices of organizing. As Klein writes:

> The Net is more than an organizing tool—it has become an organizing model, a blueprint for decentralized but cooperative decision making. It facilitates the process of information sharing to such a degree that many groups can work in concert with one another without the need to achieve monolithic consensus (which is often impossible, anyway, given the [heterogeneous] nature of activist organizations). And because it is so decentralized, these movements are still in the process of forging links with their various wings around the world, continually surprising themselves with how far unreported little victories have traveled, how thoroughly bits of research have been recycled and absorbed. (396)

Alongside Klein's strong critique of multinational corporations and their labor, environmental, media, and branding practices, then, came a strong advocacy for grassroots media power. When reading Dery and Klein, we have no doubt what they were for, rather than simply knowing what they were fighting against; both ultimately left us better informed and more empowered.

More than a decade later, the new forms of media power and political organization that Klein envisioned for grassroots groups have become much more widespread; several generations of activists have tested these approaches, developed best practices, and routinized much of what once seemed radical and transformative. Consider, for example, the vision for social change offered by *Beautiful Trouble: A Toolbox for Revolution*:

> From the Arab Spring to the American Fall and beyond, a new global people's movement is being born. The impossible suddenly seems possible, and all around the world ordinary people are trying out new tools and tactics to win victories where they live. In the shadow of austerity and ecological crisis, the urgency of this political moment demands resources that will transform outrage into effective action. *Beautiful Trouble* is a toolbox for the next revolution. (Boyd and Mitchell 2012, par. 1)

A great illustration of the state of the art in contemporary digitally enhanced activism, the collection entitled *Beautiful Trouble* is a printed

book, produced by alternative publisher OR Books, and distributed in both hard copy and digital format through Amazon; *Beautiful Trouble* is also a website, which makes much of the book's content available for free and through open-source, in an interactive form; and *Beautiful Trouble* maintains a network of veteran activists who travel to college campuses, union halls, and hacker spaces, training what they describe as "the next generation of change-makers." The encyclopedic book/ website offers accounts of thirty-plus examples of grassroots activism, often written by those who were deeply involved in their planning and execution, and also explains core concepts and tactics that cut across these various movements. While most of the current contributors are North American, they represent a coalition of diverse interests, as Klein's earlier discussion of networked politics might suggest, collaborating to provide a more robust infrastructure through which to struggle for social justice. Readers are encouraged to contribute their own entries or simply to help spread the word through social media.

Culture jamming tactics, such as *détournement*, are still part of this toolbox for change, updated to reflect the capacity for networked communities to rapidly produce and circulate "memes" in response to current events. This is what occurred, for instance, when thousands re-mixed and spread across the web the image of University of California, Davis, police lieutenant John Pike pepper-spraying student protestors in the Occupy movement. As activist Zack Malitz (2012) notes in *Beautiful Trouble*, "These images, and other *détournements* of 'pepper spray cop,' are some of the most visible critiques of police brutality in recent American history" (par. 5).

While earlier culture jammers felt they could remain on the outside looking in, often exempting themselves from the culture of consumption they were critiquing, these new activists stress the importance of under-standing the power of popular mythology before deploying it. Malitz (2012), writing about *détournement* in *Beautiful Trouble*, talks about the importance of cultural "fluency": "The better you know a culture, the easier it is to shift, repurpose, or disrupt it. To be successful, the media artifact chosen for *détournement* must be recognizable to its intended audience. Further, the saboteur must be familiar with the subtleties of the artifact's original meaning in order to effectively create a new, criti-cal meaning" (par. 8). Stephen Duncombe (2012b), another contributor,

warns that activists cannot afford to ignore the reactionary dimensions of popular texts, lest they reproduce them in the process of circulating their counternarratives. Yet, they also must not remain aloof from the desires and fantasies that motivate investments in these texts in the first place. Duncombe argues that political truths must be "communicated in new and compelling ways that can be passed from person to person, even if this requires flights of fancy and new mythologies" (par. 8). For him, achieving these goals involves learning from Hollywood, the games industry, and Madison Avenue.

Above all, *Beautiful Trouble*'s contributors argue that in a world where more and more people have the skills and capacities to produce and circulate their own media, grassroots movements, at least those worthy of their name, must encourage active and collective participation. Drawing a comparison to the difference between watching and joining a drum circle, Steve Lambert (2012) explains, "One way to reach your audience is to entice them to become participants by expanding the creative part of the action to include as many as possible. Come up with ways for observers to meaningfully involve themselves, instead of expecting them to stand mute before your expressive outbursts of creativity" (par. 5). Rather than seeing *détournement* as an avant-garde artistic and political practice, these writers want to enable more and more people to rewrite and recirculate media content on an ongoing basis in ways that contribute to the larger movement and yet are personally meaningful as well.

Participatory Politics

These twenty-first-century activists reflect the tendency among American youth toward what researchers working with the MacArthur Foundation describe as "participatory politics." Using both quantitative surveys and qualitative field research, the Youth and Participatory Politics research network (of which I am a member) is documenting and interpreting the political lives of American youth as they negotiate the opportunities and risks represented by the current media landscape. Joseph Kahne and Cathy Cohen (forthcoming) offer this definition of participatory politics:

> These practices are focused on expression and are peer based, interactive, and nonhierarchical, and they are not guided by deference to elite

institutions. . . . The participatory skills, norms, and networks that de-
velop when social media is used to socialize with friends or to engage
with those who share one's interests can and are being transferred to the
political realm. . . . What makes participatory culture unique is not the
existence of these individual acts, but that the shift in the relative preva-
lence of circulation, collaboration, creation, and connection is changing
the cultural context in which people operate.

Everyday experiences within a more participatory culture shift expec-
tations about what constitutes politics and what kinds of change are
possible. Right now, young people are significantly more likely to par-
ticipate in everyday cultural or recreational activities than political
activities. For many young people, now and historically, there's a hurdle
to entering politics. They are often not "invited" to participate, and they
may not see rich examples of activists in their immediate environment.
Those activist groups that have been most successful at helping young
people find their civic voices often have done so by tapping into partici-
pants' interests in popular and participatory culture. Cohen et al. (2012)
found that youth who were highly involved in interest-driven activities
online were five times as likely as those who weren't to engage in partici-
patory politics, and nearly four times as likely to participate in the forms
of institutional politics measured in their survey.

While this research is focused on the United States, such trends have
global implications. Linda Herrera (2012), for example, interviewed
young Egyptian activists in order to map the trajectory of their involve-
ment with digital media prior to becoming revolutionaries. For many,
their point of entry to interacting with media online was through rec-
reational use: downloading popular music, gaming, trading Hollywood
movies, or sharing ideas through online discussion forums and social net-
working sites. Mundane involvements in participatory culture exposed
them to a much broader range of ideas and experiences than allowed
within mainstream Egyptian culture, encouraged them to acquire skills
and discover their personal voices, and enabled them to forge collective
identities and articulate their hopes for the future.[1] As Herrera concludes,
"Their exposure to, and interaction with, ideas, people, images, virtual
spaces, and cultural products outside their everyday environments led to
a substantial change in their mentality and worldview" (343).

Some theorists have used the term "latent capacity" to describe the ways that everyday online activities help participants build skills and acquire social capital that can be deployed toward political ends "when the time comes." Cohen et al. (2012) identify an enormous amount of "latent capacity" within the contemporary American youth they survey (altogether, more than 3,000 respondents, 15 to 25 years in age). The overwhelming majority of American youth across races—Asian American (98 percent), Latino (96 percent), white (96 percent), and black (94 percent)—have access to a computer that connects to the Internet. Seventy-six percent of youth spread messages, share status updates, or chat online on a weekly basis (and roughly 50 percent engage in these practices on a daily basis). Overall, 58 percent of youth share links or forward information through their online social networks at least once a week. Most youth do not translate these practices into political participation, but a growing number do. Fifty-one percent of young people had engaged in at least one act of participatory politics during the twelve months prior to the survey. Moreover, the distribution of these practices is surprisingly consistent across racial categories when compared to more traditional kinds of institutional political activity, such as voting, petitioning, or boycotting.

These new digital media platforms and practices potentially enable forms of collective action that are difficult to launch and sustain under a broadcast model, yet these platforms and practices do not guarantee any particular outcome. They do not necessarily inculcate democratic values or develop shared ethical norms. They do not necessarily respect and value diversity, do not necessarily provide key educational resources, and do not ensure that anyone will listen when groups speak out about injustices they encounter. In his critique of the concept of participatory culture and politics, James Hay (2011) writes, "It would be too simplistic to generalize blogging, photo-shopping and social networking (media revolution) as the condition for an enhanced democracy" (666). So, the challenge is to identify the mechanisms that help young people move from being socially and culturally active to being politically and civically engaged.

Our Media, Activism and Participatory Politics research team at the University of Southern California has been developing case studies across a range of different movements—interviewing young activists,

following their media productions, observing their social interactions, and otherwise attempting to understand the processes by which they recruit, train, motivate, and mobilize their participants. We tend to pay close attention to younger participants who are entering the political sphere for the first time. (In truth, there was also a strong generational dimension to the 1980s culture jammers Dery discusses or the indie media activists that Klein documents, though they were less likely to acknowledge age per se as a factor in the choice of tactics they deployed.) Writing about the Harry Potter Alliance and the Nerdfighters (two of our cases), Neta Kligler-Vilenchik (2013) describes the processes of "translation" through which these organizations tap the cultural fantasies and social connections young people feel toward forms of popular culture franchises for launching political awareness campaigns. In particular, she stresses three dimensions of these groups—their creative deployment of shared mythologies, their encouragement of grassroots media production and circulation, and their willingness to provide a space where political conversations are accepted as a normal part of the group's activities—which contribute to their ability to bridge members' cultural and political interests. Many young people report that they find the language through which we conduct "politics" both exclusive (in that it makes sense only if you are already enmeshed in its frame of reference) and repulsive (in that it encourages partisan bickering). On the other hand, the use of pop culture references, an appeal to shared rather than conflicted values, and an emphasis on embedding political discourse in everyday social interactions help young people to navigate the often-difficult transition into civic engagement. In part because of this, the Harry Potter Alliance is one of the case studies featured in *Beautiful Trouble*, and its founder, Andrew Slack, is one of the contributors.

The Harry Potter Alliance, Cultural Acupuncture, and Fan Activism

Established in 2005 at the peak of the hype and hysteria around J. K. Rowling's best-selling children's book series, the Harry Potter Alliance has, by its own estimate, mobilized more than 100,000 youth in 90 chapters worldwide (thought mostly in the United States), who are engaged in various forms of human rights activism (Jenkins 2012). As Neta

Kligler-Vilenchik and Sangita Shresthova (2013) explain, "The organization . . . connects fans through campaigns and calls to action, a loosely knit network of chapters, and an online presence that includes discussion forums, a well-designed national website, and a presence on wide ranging social media platforms. There is a core leadership and staff at the national level, but also a constant give and take with local leadership and chapters" (49). Among the HPA's successes has been donating more than 100,000 books to local and international communities, registering approximately 1,100 voters through Harry Potter–themed "Wizard Rock" concerts across the country, and raising more than $123,000 in partnership with Partners in Health in Haiti in a two-week period (altogether, five cargo planes' worth of supplies). Through the years, HPA's efforts have addressed such diverse issues as marriage equality, immigrant rights, labor issues, environmentalism, teen suicide, and food justice, thereby demonstrating the capacity to move beyond a single-issue focus while maintaining and growing its base of support. As the organization's website explains, "Our mission is to empower our members to act like the heroes that they love by acting for a better world. . . . Our goal is to make civic engagement exciting by channeling the entertainment-saturated facets of our culture toward mobilization for deep and lasting social change" (quoted in Kligler-Vilenchik and Shresthova 2013, 50).

Slack (2010) and his supporters call this approach "cultural acupuncture":

> Cultural acupuncture is finding where the psychological energy is in the culture, and moving that energy towards creating a healthier world. . . . A marketing campaign that goes beyond the importance of a brand of soap and instead focuses on a brand of becoming something bigger than ourselves, something that matters because it speaks to the higher nature of who we truly are on this interdependent planet, where each one of us plays an indispensable role. (Par. 4–6)

Recognizing that the news media was more apt to cover the launch of the next Harry Potter film than genocide in Darfur, Slack saw the HPA as a way to identify key cultural pressure points, thus redirecting energy toward real-world problems. Pinning political and social causes to Harry Potter works because this content world has a large following, is familiar

to an even larger number of people, has its own built-in mechanisms for generating publicity, and is apt to attract many subsequent waves of media interest. Harry Potter constitutes a form of cultural currency that channels fans' emotional investments and wider public interest in ways that can carry HPA's messages to many who would not otherwise hear them.

The issues that motivate Slack (2012)—including a deep skepticism about Madison Avenue manipulation and about the ways media concentration constrains and distorts the kinds of information we need to act meaningfully and collectively as citizens—are more or less the same ones that motivated Dery's (1993) culture jammers. Yet Slack has turned their core metaphor on its head. Cultural acupuncture seeks to reshape and redirect circulation, rather than block or jam the flow.

From the start, the culture jamming movement operated from what Klein (1999) described as an "outsider stance" (283), seeing popular culture largely as the debased product of the culture industries. As Klein notes, a jammer's self-perceptions as empowered and resistant "cannot be reconciled with a belief system that regards the public as a bunch of ad-fed cattle, held captive under commercial culture's hypnotic spell" (304). The movement's contempt for the masses is perhaps best summarized by *Adbusters* graphics from the early 1990s depicting consumers as pigs slurping up slop, as pale-faced zombies hypnotized by the glow of the television screen, or as slack-jawed supplicants with brand logos tattooed across their bodies. Even the more recent reframings of culture jamming found in *Beautiful Trouble*, such as Duncombe's (2012a), still largely embrace that outsider perspective, seeing activists as people who will need to immerse themselves in other people's popular culture before they can learn to appeal to a broader public. Writes Duncombe, "You may not like or be familiar with Nascar, professional sports, reality TV and superheroes, but they are all fertile arenas of culture to work with. It may take an open mind and a bit of personal courage, but it behooves us to immerse ourselves in, learn about and respect the world of the cultural 'Other'—which, for many of us counter-culture types, ironically, is mass culture" (par. 6). While Dery (1993) celebrated culture jammers as "Groucho Marxists" seeking "joyful demolition of oppressive ideologies" (7), culture jammers have, in practice, been more often plain ol' grouchy Marxists. Their critiques are tone deaf; they have not respected (or even

understood) the much more multivalent relationship many youth enjoy with the popular culture they often use to express their identities or make sense of the world.

Dery sought, at times, to extend his culture jamming model to include forms of fan cultural production. However, from the start, the fit was an uncomfortable one for all involved. Fan cultural production is motivated by both fascination and frustration, which is only partially captured by accounts that read it purely in terms of resistance. Dery sympathetically quotes Mark Crisipin Miller (1987): "Everybody watches it [TV], but no one really likes it. . . . TV has no spontaneous defenders, because there is almost nothing in it to defend" (3). Given such a starting point, how would fans, for instance, fit into this picture? Later, though, paying tribute to my own notion of "textual poaching" (Jenkins 1992), Dery acknowledges that fan fiction writers, especially those writing homoerotic "slash" stories about Kirk and Spock (then the most visible example), worked from "feminist impulses"; Dery proposes at one point that the term "slashing" might be productively extended to "any form of jamming in which tales told for mass consumption are perversely reworked" (8). The term "perverse" here is doubly problematic, first because it is such a loaded concept when applied to homoeroticism, and second because the fans themselves did not necessarily feel that they were "perversely reworking"—or imposing "subversive meanings" on—the texts that they loved. Rather, they saw themselves as recovering the homoerotic subtext within mass media's construction of homosocial relations, seeking textual evidence to support their interpretations and to ground their own erotic fantasies about the characters.

While Dery sees culture jammers as directing their creative efforts "against" the culture industries, fans often seek to reform from within, even when they also recognize themselves as operating on the margins of the intended audience for their favorite programs. While Dery's culture jammers deconstruct popular narratives, "rendering their seductions impotent" (7), textual poachers reconstruct, rewrite, and remix them: they are seeking to draw out themes that are meaningful for them, even as they also often end up critiquing corporate, patriarchal, and homophobic ideologies that fans feel damage the integrity of their shared mythologies. While Dery's culture jammers often deploy metaphors of "disenchantment," seeking to awaken a public being fed nothing but

dreams to the reality of the world's problems, textual poachers—as Slack (2013) explained recently—contend that "fantasy is not an escape from our world, but an invitation to go deeper into it." Of course, in practice, it may be more difficult to maintain such a strong distinction. Culture jammers, as Klein (1999) notes, often worked within the advertising industries they were seeking to dismantle. Meanwhile, many fans—especially female, minority, and queer fans—feel excluded from the ways fan culture gets depicted within mainstream media or the ways that fans are addressed by industry insiders, even at a time when fan participation and engagement have been more fully incorporated into the business models informing entertainment franchises.

Slack's (2010) cultural acupuncture starts from the premise that there is power and meaning in stories such as Harry Potter, which have been embraced by significant numbers of people around the world. As Slack seeks to translate the core insights from his organization's success for a broader range of activists in *Beautiful Trouble*, he states frankly, "Meet people where they're at, not where you want them to be. . . . Remember to speak your group's language and start with the values they would most readily respond to" (par. 8). As a community organizer working within the fan community, Slack's efforts start by fully and unambiguously embracing the core values of the Harry Potter narratives and then deploying them as a conceptual frame through which to translate real-world concerns for his young supporters.

Slack (2012) has developed a theory of creative mythology that operates on at least three levels: the personal narratives of supporters (including, for example, his own stories of growing up within a divorced family, surviving a depressed father, struggling with issues of self-esteem, and confronting high school bullying); the collective narratives of the community (such as their history of conflicts and collaborations with "the Powers that Be" that control the future of the narratives that matter to them); and the mythological narrative in which they are invested (in this case, Rowling's stories about how Harry and his Hogwarts classmates formed "Dumbledore's Army" to challenge evil in their society). One of the HPA's strengths is its ability to move smoothly among these three levels of analysis, often using metaphors from the books to explain real-world issues (say, the closeting of werewolves to talk about other forms of discrimination) or tapping into the infrastructure of fandom to rally

support behind HPA campaigns (for example, using Quidditch Matches, Wizard Rock concerts, film openings, or fan conventions as opportunities to register people to vote or soliciting signatures on petitions).

More recently, Slack (2013) has sought to expand the HPA's reach to a range of other fandoms under the banner of "Imagine Better." In a talk delivered at the TEDxYouth conference in San Diego in 2013, Slack constructs a composite mythology (framed around the concept of "orphans" versus "empires"), stitching together themes and images from, among other popular culture narratives, *The Wizard of Oz, Hunger Games, Doctor Who, Star Wars, Superman, Batman, Once Upon a Time,* and *The Lion King*—each of which, he suggests, explores how people who feel locked outside the system can nevertheless overcome powerful foes and change the world. Reaching his crescendo, the energetic Slack calls for his enthralled audience (which is, by this point, engaging him in call-and-response) to join forces in creating "a Dumbledore's army for our world, a fellowship of the ring, a rebel alliance" that might fight for social justice and human rights.

For these young fans, the Harry Potter narratives are not just books they read or films they watch; they represent, on the personal level, landmarks by which they measure their own passage from childhood to adulthood and, on the collective level, shared experiences of meaning-making, creative expression, and sociality. When culture jammers sought to *détourn* advertisements, they often spoke of brand icons as shiny yet empty signifiers into which they could insert their own meanings. At most, jammers sought to "decrypt" the hidden implications of those brand messages. For fans, though, these mythologies run deep, with many levels of meaning and affect that need to be respected and valued. It matters to these fans that Rowling herself once worked for Amnesty International, that she has advocated for the role of empathy and imagination in human rights struggles, and that her books have such strong and overt themes of prisoner rights and respect for diversity (Jenkins 2012).

HPA members are, in short, still acting as fans even as they are also acting as activists. For the purposes of this discussion, "fan activism" refers to forms of civic engagement and political participation that emerge from within fan culture itself, often in response to the shared interests of fans, often conducted through the infrastructure of existing fan practices and relationships, and often framed through metaphors drawn

from popular and participatory culture. Historically, fan activism has been understood through an almost exclusively consumerist lens, focusing on fan efforts to keep favorite programs on the air. Such examples have been sometimes used as a demonstration of the ways that a growing number of interest groups are using tools such as petitions, which were designed to serve political purposes, toward nonpolitical ends. Yet, even these fan efforts are often struggles over representation—both in terms of what does or does not get included within textual representations and in terms of whose interests do or do not get reflected in the marketplace. However, in a growing number of cases, fan activism *is* being deployed toward explicitly political ends.

Not in Harry's Name

To better understand the mechanisms through which the HPA enables fan activism, let's examine a specific campaign, "Not in Harry's Name," which aimed to help motivate young participants to engage in actions directed against the very corporation, Warner Brothers, that produces the Harry Potter franchise. Fan activists have often been accused of doing nothing more than fighting for their right to consume. Here, however, these fans were deploying their roles as consumers (including threats of boycotts) in the name of ethical production practices. The central issue in this campaign concerned whether chocolate frogs (and other confections) produced and sold by Warner Brothers at the Harry Potter attraction at Universal's Island of Adventure theme park were produced under Fair Trade conditions. As the group explains, much of the cocoa grown in West Africa for use in commercial chocolate is made using underpaid—and, in some cases, enslaved—child labor. Complicity in such practices is part of what allows American-based manufacturers to sell chocolate products at such low prices in the global North. Fair Trade organizations have demanded greater transparency about chocolate contracts in order to allow consumers to make meaningful choices about whether they want to contribute to these exploitative labor conditions or join the larger efforts toward corporate transparency and accountability that Klein discusses in *No Logo*. Concerned about what was being done by Warner Brothers "in Harry's name," the HPA partnered with Free2Work to investigate Behr's Chocolate, the company contracted to

produce the chocolate frogs. The project revealed that Behr's did not post any information about the choices they made regarding where and how they contract their labor, resulting in a "failing grade."

The HPA saw the issue of who produces "chocolate frogs" as a powerful focal point for educating their young supporters about the issues of fair trade and corporate transparency. As Lauren Bird (2013), a young HPA staff member, explained in a videoblog, HPA supporters felt directly implicated in these suspect labor practices deployed to produce the candy their community consumes:

> We chose Harry Potter chocolate because that chocolate comes with a story that is not only near and dear to our hearts but is a story about justice and equal rights. Plus, it is chocolate being sold primarily at a theme park for kids. It is pretty disturbing to think that the chocolate these kids are eating at this magical, wonderful place was possibly coercively made by kids like them in another part of the world. . . . We are Harry Potter fans. That means that this chocolate matters more to us than whether Snickers Bars are ethically made. But this also means we're going up against our heroes, the people behind the story. (Thehpalliance, 2013)

Bird discusses openly the fans' ambivalence about launching this campaign, especially the HPA leadership's uncertainty about publically calling out a studio whose goodwill they depend on for other work they do. Yet, wearing black-rimmed glasses (reminiscent of Harry Potter) and a fan-themed t-shirt, Bird insists that fans have a right—and an obligation—to call out corporate media for what's being done "in Harry's name."

In the campaign's first phases, the HPA attracted more than sixteen thousand signatures on a petition calling for Warner Brothers to make all Harry Potter chocolate Fair Trade. In order to stress the effort's grassroots nature, they had more than two hundred members send along pages of signatures. Even this tactic was motivated through references to the core texts: "Remember what happened when Uncle Vernon tried to ignore Harry's Hogwarts letters? More letters showed up. This is exactly what we're going to do" (Harry Potter Alliance 2012a).

The studio responded to the HPA petition by (some would say patronizingly) reassuring their fans that they cared deeply about the Fair Trade issue, that they were complying with all operative international

laws and their own internal standards, and that they had investigated the companies producing their chocolate and were satisfied with their labor practices. Everything here was consistent with the corporate rhetoric Klein (1999) dissected in her book:

> If any busybody customer wanted to know how their products were made, the public-relations department simply mailed them a copy of the code, as if it were the list of nutritional information on the side of a box of Lean Cuisine. . . . Codes of conduct are awfully slippery. Unlike laws, they are not enforceable. And unlike union contracts, they were not drafted in cooperation with factory managers in response to the demands and needs of employees. (430)

Companies often obscure the labor that generates commodities behind brand mythologies. Klein calls for anticorporate activists to explicitly link the brand to the conditions within the factories where its products are manufactured.

Rather than accepting the company's self-representations at face value, the HPA demanded that the studio release its own internal report. This time, the group gathered more than sixty thousand signatures on their petition and, in the process, brought much greater media coverage to the issue. As Slack explains:

> For fifteen months, we have given WB every possible opportunity to partner with us by making all Harry Potter chocolate Fair Trade. They have turned down each of those opportunities because they underestimate us. It's now a matter of time before the entire world sees that fans of the Harry Potter series are responsibly advocating for children while the leaders of WB are acting irresponsibly. If the research they cite exists then they should be able to produce it. They should have nothing to hide. (Harry Potter Alliance 2012b, par. 3)

For more than four years, Warner Brothers remained nonresponsive, choosing to sit out the storm of bad publicity rather than open up their labor practices and subcontracts to closer public scrutiny.

Throughout these efforts, the HPA employed tactics that playfully evoked the content world or otherwise played upon shared knowledge

of the fan community. Rather than seeing the licensed candies as mere commodities, the HPA evaluates them according to their meaningfulness within the content world. Chocolate has magical powers in Rowling's narrative—serving, for example, to alleviate some of the symptoms of Dementor attacks; thus, the HPA playfully asked whether chocolate produced under such dubious circumstances might still carry these beneficial effects. They also frequently link their struggles against child labor to Hermione's efforts to stop the enslavement of elves within the wizarding world.

Studios have long sent fans cease-and-desist letters protesting unauthorized use of intellectual properties and shutting down websites or removing videos or fan fiction. Drawing on this history, HPA encouraged fans to draft and send their own cease-and-desist letters, accusing the studio of inappropriate use of their shared mythology. In Rowling's novels, Howlers are blood-red letters sent within the wizarding community to signal extreme anger and embarrass the receiver. The sender's voice is amplified to a deafening volume, and then the letter combusts. HPA urged fans to record their own video Howlers to send to the studio executives, signaling their extreme disapproval of their continued silence about the report. The videos often included an HPA-produced bumper sequence showing an Owl delivering a letter in a red envelope and then closing with the image of the letter bursting into flames. Perhaps most intriguingly, the HPA contracted with a Fair Trade chocolate company to produce and market (through the HPA's website) their own chocolate frogs, complete with wizard cards, as a means of demonstrating that such products could be produced without relying on companies with exploitative working conditions.

Such tactics illustrate the ways that the Harry Potter content world has functioned within the HPA as what Ashley Hinck (2012) calls "a public engagement keystone," that is, as "a touch point, worldview, or philosophy that makes other people, actions, and institutions intelligible" to participants (par. 5). Writing about the HPA's initial efforts to rally fans against genocide in Darfur, Hinck praises their ability to tap into the fandom's core competencies, offering opportunities for meaningful discussion, interpretation, and deliberation fundamental to any form of civic engagement. Lori Kido Lopez (2011) has made similar claims in regard to the Racebending movement, another example of fan

activism that was organized to call out Hollywood's racially biased casting practices, specifically in regard to *Avatar: The Last Airbender* but later around many other productions as well. Writes Lopez, "Some of the organization's strongest and most effective tactics rely on the skills developed as members of the fan community: honing their arguments through community discussions, producing and editing multimedia creations, educating themselves about every facet of their issue, and relying on their trusted networks to provide a database of information" (432).

The HPA has also tapped into their larger networks of affiliations and associations in order to expand their communications capacity. Building on relationships fostered across many Harry Potter fan conventions, HPA members have solicited and gained support from a number of the films' cast members, including Evanna Lynch (Luna Lovegood), Natalia Tena (Nymphadora Tonks), Mark Williams (Arthur Weasley), Jason Issacs (Lucius Malfoy), Scarlett Byrne (Pansy Parkinson), and Christian Coulson (Tom Marvolo Riddle). The HPA has also collaborated with the Nerdfighters, an informal online community created around Hank and John Green—collectively known as the Vlogbrothers. (It is significant to note that John is also a popular Young Adult novelist, authoring books such as *Paper Towns* and *The Fault in Our Stars*.) As Kligler-Vilenchik (2013) notes, the Nerdfighters have proven especially effective at short-term mobilization efforts through their active presence on YouTube, which enables them to tap a larger, more dispersed, more loosely affiliated membership for quick-turnaround and low-involvement activities. And the HPA has solicited videos from a range of other popular YouTube personalities as well, including many who are well known within the Harry Potter and *Glee* fandoms. While these videos tend to draw only a few thousand or even a few hundred views, the range of different groups and individuals producing and circulating "Not in Harry's Name" videos has dramatically expanded public awareness. The HPA could not have afforded to buy advertising to reach this many people and could probably not have attracted mainstream media coverage without first demonstrating their ability to gain this level of popular support.

In the end, the young fans won. In December 2014, Warner Brothers spokespeople issued a statement announcing that by the end of 2015, they will have converted 100 percent of their product to contain chocolate produced according to Fair Trade standards, and they publicly ac-

knowledged the role that the HPA's "Not in Harry's Name" campaign played in their "discussions on this important issue" (Rosenberg 2015). In this case, the fans had functioned as the conscience of a corporation, which, after four years of resistance, finally gave ground to their demands. Matt Maggiacomo (2015), currently the executive director of the Harry Potter Alliance, issued a statement proclaiming the group's success:

> Warner Bros.' agreement to transition to 100% fair trade or UTZ certification for all Harry Potter chocolate products was a huge, resounding, and unprecedented victory for fan activism. . . . It's nearly impossible to quantify just how much time and effort have been poured into this campaign to remove child labor and slavery from Harry Potter chocolate sourcing. . . . Because of this campaign:
>
> - A major corporation has committed to removing child labor and slavery from the sourcing of a vastly popular commodity.
> - Fair trade chocolate frogs will be available to over thirty-four million people per year who visit Universal Orlando.
> - The morals of J. K. Rowling's Harry Potter series are being upheld by the companies that profit from its popularity.
>
> With the success of Not in Harry's Name, we've demonstrated what fan activism can do.

For many outside the HPA, "Not in Harry's Name" had felt like a Children's Crusade: idealistic, naive, and doomed to painful failure. At various points along the way, the organizers considered how they might back away from what was an effort that consumed massive human resources and seemed to have no end in sight. Many of us had agreed that the success of the campaign came in educating so many people about the issues of Fair Trade, whether or not they moved corporate policy. But, their sustained efforts, together with those of a range of other partners (including the antislavery organization, Walk Free), and their ability to gain the support of J. K. Rowling, made it possible for the HPA to keep the heat on WB throughout this prolonged period. So, whatever else you want to say about cultural acupuncture—in this case, it worked.

The Limits of Attention-Based Activism

Might the HPA's actions be considered a contemporary form of culture jamming? If Dery saw "slashers" as culture jammers, then the HPA certainly belongs under his rather broad definition. However we need to differentiate among the different emotional valences associated with various strategies for appropriating and reinscribing popular mythologies for political ends. The HPA relies on fans' insider feelings of being a central part of the Harry Potter experience, just as Adbusters' jammers embrace their "outsider status." *Beautiful Trouble* describes other contemporary campaigns that fall somewhere in between. For example, Mark Read (2012) reports on the ways that Occupiers constructed their own Bat Signal to call the 99% into action and projected it against the side of a New York City high-rise office building: "The heroes in masks and on the screen are not just corporate cash cows; they also frequently represent values subversive to the very corporations that profit from them. Exploit these contradictions" (par. 11). One can imagine that the Occupiers had differing degrees of familiarity and comfort with the superhero genre, even as they took glee in deploying its imagery to dramatize their cause. For the Occupiers, the message was not that they should rely on millionaire playboys or masked vigilantes to solve their problems but rather that the 99% should take collective action to right the wrongs being caused by the unequal distribution of wealth. What the HPA's chocolate frogs and Occupy's Bat Signal share is a desire to harness popular culture as a set of shared cultural references that will be easily understood by those who they want to participate in their movements and that may have some novelty in dramatizing the issues for those who have not been reached through previous campaigns. We can see these efforts as responsive to the contours of the contemporary attention economy and to the affordances of a world where grassroots networks and their allies have greater capacities to circulate content outside of corporately controlled media (Jenkins, Ford, and Green 2013).

We still have a lot to learn about what attention-based advocacy looks like—its ethical norms, its effectiveness, its sustainability. As I close this provocation, I want to call attention to some important critiques that have been raised against attention-based activism more generally. The first comes from Ethan Zuckerman (2012), the director of MIT's Center

for Civic Media, who was responding to the highly visible Kony 2012 campaign launched by Invisible Children in 2012 to call out Ugandan warlord Joseph Kony for the abduction and forced enlistment of child soldiers. Zuckerman reviews a range of different criticisms leveled against the video from human rights activists and policy think tanks, stressing that the video gained broad and rapid circulation by grossly oversimplifying the complexities of the conditions as experienced in Africa and creating heroic roles for Western activists at the expense of denying the agency of Africans working to change their own conditions. Zuckerman muses, "I'm starting to wonder if this is a fundamental limit to attention-based advocacy. If we need simple narratives so people can amplify and spread them, are we forced to engage only with the simplest of problems? Or to propose only the simplest of solutions?" (par. 34).

Such concerns should resonate with HPA supporters and critics alike: Can complex issues like child slavery be reduced to the contours of a best-selling series of children's books? Is there a point where the activist has to push the fantasies aside and deal in a much more nuanced way with real-world conditions? Can popular mythology serve as a means of translation from cultural to political engagement without also limiting the range of problems that can be addressed or the tactics that we deploy to address them? Are chocolate frogs, when everything is said and done, the best lever for going after a complex problem like child slavery in West Africa? Zuckerman ends his blog post by asking how we might understand the pushback and conversation Kony 2012 provoked: simple starting points might lead to deeper, more informed discussions, precisely because they grab the attention and prick the conscience of a large number of people. Similarly, I've seen some pretty productive debates about whether Harry Potter is an appropriate vehicle for dealing with child slavery, debates that push participants to dig deeper, read more, and ask harder questions about an issue that might have gained only passing attention otherwise.

A second set of concerns with attention-based advocacy surfaced in an essay published on the *Huffington Post* by Michelangelo Signorile (2012), a longtime queer activist and talk-show host. Signorile was responding to the success and limits of a grassroots effort by networked activists to call out the fast food chain, Chick-Fil-A, for their owners' financial support for homophobic organizations. Signorile argues that

the campaign's participatory approach made it easy to join but difficult to control its messaging. Even as GLBT activists sought to hijack a corporate brand to put a face on homophobia, they eventually lost control over what their efforts meant: "Our enemies distorted our message and reframed the story. . . . How did we allow it to happen? Because there was no coordinated effort on our side. The controversy was largely driven by blogs, social media and very loosely organized grass-roots activists, with no coordinated leadership" (par. 4–5). *Détournement* has historically described tactics used by the weak against the powerful. However, in today's age of networked publics, where grassroots communications practices are being deployed on the political Right and the political Left, there is often a race to assert who represents the underdog in any political struggle. For Signorile, the distributed framing of issues within a networked public is always going to be less coherent than the communication strategies of organizations (including corporations) that speak with one voice. The HPA carefully walks this line, creating mechanisms through which local chapters may initiate actions but also providing a national leadership to frame these issues into a coherent message and maintain a united front against targets like Warner Brothers.

Finally, there are legitimate concerns that the medium may drown out the message. As Klein (1999) writes about culture jamming more generally, "For years, we in this movement have fed off our opponents' symbols—their brands, their office towers, their photo-opportunity summits. We have used them as rallying cries, as focal points, as popular education tools. But these symbols were never the real targets; they were the levers, the handles" (458). Part of what makes fan activism a risky approach is that it starts with a community that is more invested than most in the core mythology. In valuing their relationship to this popular narrative, the HPA offers a safe space from which to venture into politics but, at the same time, provides a refuge into which supporters can escape if and when they tire of the hard work of bringing about social change. The ability to move rapidly from issue to issue is part of what makes the HPA effective for rapid mobilization (and the Nerdfighters even more so), but it also represents a form of privilege not enjoyed by traditional kinds of civil rights groups whose members are deeply implicated in struggles to improve their own living and working conditions. Of course, other forms of culture jamming are not exempt

from such charges. Often, they tap into brands in which they have limited investment, simply because they offer the most readily available resources from which to make their statements. Often, jammers have been accused of falling prey to a romance with resistance that locks them permanently outside the mechanisms of power through which lasting reforms might be won.

Read through this lens, we might see Dery's culture jammers as speaking to us from an earlier moment in the historic evolution of attention-based advocacy: the jammers seek to cut through the clutter of an increasingly mediated culture, to use the power of mass media against itself. They saw *détournement* as a means of generating new images through which to dramatize political struggles; their efforts to build alternative communication channels and processes helped to pave the way for today's participatory politics.

Culture jamming tactics were premised on limited access to communication resources and thus the need to disrupt the power of mass media. Culture jamming is the tactic of those who see themselves as always trapped on the outside looking in, not those who believe they can effectively change the core values of their society. More recent forms of attention-based advocacy take a different shape in part because of the expanded range of media options available to those who want to have their messages heard. What the HPA calls "cultural acupuncture" embraces a logic of participation rather than resistance; fan activists claim ownership over the materials of popular culture rather than disavowing them; and these new forms of attention-based advocacy take as given the capacity to take collective action in order to call out issues that should be part of the society's larger political agenda. The challenges confronting these forms of activism are also byproducts of the expanded speed and scope of their communication capacity: How can we generate messages that circulate broadly but encourage deeper reflection? How can we maintain control over our messages in a world where grassroots media can be remixed and redefined alongside mass media content? And how do we deal with the seductions of networked communication, where circulation can become an end unto itself, and where the medium can swamp the message?

NOTE

1 See Mark Levine, chapter 4 in this volume.

REFERENCES

Bird, Lauren. 2013. "When Our Heroes Fail." YouTube video posted by thehpalliance, January 31. www.youtube.com.

Boyd, Andrew, and Dave Oswald Mitchell, eds. 2012. *Beautiful Trouble: A Toolbox for Revolution*. New York: OR Books. eBook.

Cohen, Cathy, Joseph Kahne, Benjamin Bowyer, Ellen Middaugh, and Jon Rogowski. 2012. *Participatory Politics: New Media and Youth Political Action*. Oakland, CA: Youth and Participatory Politics Research Center. eBook.

Dery, Mark. 1993. *Culture Jamming: Hacking, Slashing and Sniping in the Empire of Signs*. Pamphlet no. 25. Westfield, NJ: Open Magazine.

Duncombe, Stephen. 2012a. "Principle: Know Your Cultural Terrain." In *Beautiful Trouble: A Toolbox for Revolution*, edited by Andrew Boyd and Dave Oswald Mitchell. New York: OR Books. eBook.

———. 2012. "Theory: Ethical Spectacle." In *Beautiful Trouble: A Toolbox for Revolution*, edited by Andrew Boyd and Dave Oswald Mitchell. New York: OR Books. eBook.

Harry Potter Alliance. 2012a. "Letters from Everyone: Not in Harry's Name, Continued." AurorBrigade.org, January 24. www.aurorbrigade.org.

———. 2012b. "Warner Bros. Receives Hundreds of Letters Illustrating the More than 16,000 Signatures of HP Fans." HarryPotterAlliance.org, February 13. www.thehpalliance.org.

Hay, James. 2011. "'Popular Culture' in a Critique of the New Political Reason." *Cultural Studies* 25 (4–5): 659–84.

Herrera, Linda. 2012. "Youth and Citizenship in the Digital Age: A View from Egypt." *Harvard Educational Review* 82 (3): 333–52.

Hinck, Ashley. 2012. "Theorizing a Public Engagement Keystone: Seeing Fandom's Integral Connection to Civic Engagement through the Case of the Harry Potter Alliance." *Transformative Works and Cultures* 10, edited by Henry Jenkins and Sangita Shresthova. www.journal.transformativeworks.org.

Jenkins, Henry. 1992. *Textual Poachers: Television Fans and Participatory Culture*. New York: Routledge.

———. 2012. "'Cultural Acupuncture': Fan Activism and the Harry Potter Alliance." *Transformative Works and Cultures* 10, edited by Henry Jenkins and Sangita Shresthova. www.journal.transformativeworks.org.

Jenkins, Henry, Sam Ford, and Joshua Green. 2013. *Spreadable Media: Creating Value and Meaning in a Networked Culture*. New York: New York University Press.

Kahne, Joseph, and Cathy Cohen. (Forthcoming). "Youth, New Media, and Participatory Politics." In *Youth, New Media and Citizenship*, edited by Danielle Allen and Jennifer Light. Cambridge, MA: MIT Press.

Klein, Naomi. 1999. *No Logo: Taking Aim at the Brand Bullies*. Toronto: Knopf.

Kligler-Vilenchik, Neta. 2013. "Fan Communities 'Decreasing World Suck': Mechanisms of Translation toward Participatory Politics." Working Paper, MacArthur Youth and Participatory Politics Network, "Media, Activism and Participatory Politics" Project, Annenberg School for Communication and Journalism, University of Southern California, Los Angeles. ypp.dmlcentral.net.

Kligler-Vilenchik, Neta, and Sangita Shrethova. 2013. "The Harry Potter Alliance: Connecting Fan Interests and Civic Action." In *Connected Learning: An Agenda for Research and Design*, by Mizuko Ito, Krist Gutierrez, Sonia Livingstone, Bill Penuel, Jean Rhodes, Katie Salen, Juliet Schor, Julian Sefton-Green, and S. Craig Watkins, 49–53. Irvine, CA: Digital Media and Learning Research Hub. eBook.

Lambert, Steve. 2012. "Principle: Nobody Wants to Watch a Drum Circle." In *Beautiful Trouble: A Toolbox for Revolution*, edited by Andrew Boyd and Dave Oswald Mitchell. New York: OR Books. eBook.

Lopez, Lori Kido. 2011. "Fan Activists and the Politics of Race in *The Last Airbender*." *International Journal of Cultural Studies* 15 (5): 431–45.

Maggiacomo, Matt. 2015. "You've Proved What Fans Can Achieve. What Next?" Mailing to the membership of the Harry Potter Alliance, January 15.

Malitz, Zack. 2012. "Tactic: Detournement/Culture Jamming," In *Beautiful Trouble: A Toolbox for Revolution*, edited by Andrew Boyd and Dave Oswald Mitchell. New York: OR Books. eBook.

Miller, Mark Crispin. 1987. "Prime Time: Deride and Conquer." In *Watching Television*, edited by Todd Gitlin, 183–228. New York: Pantheon.

Read, Mark. 2012. "Case Study: 99% Bat Signal." In *Beautiful Trouble: A Toolbox for Revolution*, edited by Andrew Boyd and Dave Oswald Mitchell. New York: OR Books. eBook.

Rheingold, Howard. 1993. *The Virtual Community: Homesteading on the Electronic Frontier*. New York: Harper Collins.

Signorile, Michelangelo. 2012. "Chick-Fil-A: Were the Protests a Big Fail? And Where Do We Go from Here?" *Huffington Post*, August 6. www.huffingtonpost.com.

Slack, Andrew. 2010. "Culture Acupuncture and a Future for Social Change," *Huffington Post*, July 2. www.huffingtonpost.com.

———. 2012. "Case Study: The Harry Potter Alliance." In *Beautiful Trouble: A Toolbox for Revolution*, edited by Andrew Boyd and Dave Oswald Mitchell. New York: OR Books. eBook.

———. 2013. "Orphans vs. Empires." YouTube video posted by TEDxYouth@San Diego, January 17. www.youtube.com.

Zuckerman, Ethan. 2012. "Unpacking Kony 2012." . . . *My Heart's in Accra*, March 8. www.ethanzuckerman.com.

PART II

Critical Case Studies

6

Radical Scavenging Revisited

Emile de Antonio and the Culture Jamming of Compilation Film

CHRISTOF DECKER

The Bill of Rights was written with a quill pen and beauti-
fully, so that every word of it needs to be made operational
today. More views, more access, more community control,
less corporate profit. One specific need: a national elec-
tronic archive where nothing is thrown away because it costs
money to store it (our history), whose retrieval and indexing
systems are electronic and instant, where everything is made
available for us for use, free.
—Emile de Antonio (1971)

Emile de Antonio made his case for a "national electronic archive," which
could be accessed and used for free, in the early 1970s. At this historical
moment, the importance of the legacy of television as an audiovisual
archive with national significance was not widely recognized. De Anto-
nio was considered to be a radical documentary *film*maker, yet much of
the material for his compilation films had come from television archives,
such as the footage of the Army-McCarthy hearings that formed the
basis for the widely acclaimed, critical investigation of Senator Joseph
McCarthy in *Point of Order* (1964).[1] De Antonio was keenly aware of
a shift taking place in American culture, which linked the aspiration
of gaining political power with the process of image-making. Televi-
sion as an institution was crucial in this development. Aesthetically,
TV once seemed to be of little interest, but it was amassing an audio-
visual archive of contemporary life that de Antonio considered to be
invaluable. However, as he pointed out, the networks were discard-
ing this footage because it was too costly to store. In contrast to their

practice of destroying "the raw history of our country, and our world and our times" (Firestone 2000, 257), de Antonio's vision of a "national electronic archive" called for a democratic notion of access and use: It was the dream of the compilation artist hoping to draw on any material available to create alternative interpretations of the country's history.

One might argue that de Antonio's vision was realized with the advent of the Internet and websites such as YouTube or Flickr. Mark Dery (1993), in his influential essay on culture jamming, mentioned the promises of the Internet for less passive and more interactive modes of communication, and since the early 1990s the Internet has indeed grown into an incredibly rich field of exchange, making available a vast array of audiovisual images, clips, and files. Yet, arguably, it has not turned into the democratic and noncommercial space of access and use that de Antonio had envisioned. My focus in this essay will lie on compilation films from the predigital era. In the realm of moving images, the reediting and recompiling of archival or "found" footage can be seen as the primary form of using material in a deconstructive and mocking spirit that has come to be called "culture jamming." I argue that the history of compilation films represents an important reference point for the emergence of culture jamming in the late twentieth century. In particular, the 1960s and 1970s marked an influential stage in the transition toward a critical as well as a playful practice of working with archival footage.

My case in point will be *Millhouse: A White Comedy*, Emile de Antonio's satirical attack on Richard M. Nixon from 1971, which is a prime example of an aesthetic practice of "radical scavenging" that de Antonio championed in his work—"revisiting existing footage to construct out of it an alternative and maybe even directly oppositional narrative from that which it inherently possesses" (Bruzzi 2000, 24). De Antonio assembled audiovisual material from different (legal and illegal) sources documenting Richard M. Nixon's political career, and he rearranged it to playfully undermine the documentary genre of the political biography as well as to damage the public image of the president as the most important representative of the political establishment. Practicing culture jamming *avant la lettre*, de Antonio established a mode of using preexisting footage that combined a critical reexamination of the dominant meanings and ideologies encoded in the material with the playfulness of comic effects to create a unique convergence of documentary representation and media activism.

On the History of Assembling "Found Footage"

The practice of re-editing existing footage goes back to the earliest days of cinema, when exhibitors in nickelodeons would change the order of films to be shown or assemble the most exciting and spectacular scenes from a film.[2] In the political and aesthetic modernist avant-garde movements in Europe or North America, this practice was likewise employed, albeit to different ends. Some filmmakers were interested in bringing out new and hitherto undetected formal qualities; others used the footage from newsreels and other sources to make political arguments (Arthur 1999). The Second World War was instrumental in professionalizing the rhetorical uses of found, stock, or captured footage as "semiotic attack" and propaganda. Fascist leaders, most notably Adolf Hitler and Benito Mussolini, were ridiculed in films by Len Lye and Alberto Cavalcanti, who re-edited captured enemy films; on the other side of the Atlantic, Frank Capra supervised the *Why We Fight* series—seven films drawing on all kinds of sources including Hollywood fiction films and explaining (as well as promoting) US reasons for entering and fighting the war. Jay Leyda's (1964) seminal study *Films Beget Films*, in particular his comprehensive filmography, underlines the rich and complex pre-1960s history of assemblage and compilation films, which here can be mentioned only in passing.

In its most basic form, the making of compilation films, videos, or digital files consists of two phases. First, the maker gathers existing footage from fiction, nonfiction, industrial, governmental and science films, or from television coverage, newsreels, art projects, web cams, home movies, and various other sources. Then he or she takes it apart and reassembles individual scenes, images, sequences, and sounds to create a new audiovisual object. The unity and wholeness of pre-existing footage is thus destroyed, and from this act of creative—sometimes joyful, sometimes aggressive—destruction, or "surgical operation" (de Greef 1992, 81), emerges a new object of meaning. The compilation aesthetic, more than anything else, acknowledges that the crucial stage of creating audiovisual meaning lies in the process of assembling individual fragments into a larger whole and thus in the practice of selecting fragments and editing them into a network of relationships.

As many authors have pointed out, the new object emerging from this act of creative destruction—or as William C. Wees (1992) puts it, from

this assemblage of "visual quotations that have been ripped out of con-text" (47)—may have various functions.[3] In mainstream television re-portage, using archival footage usually serves to illustrate what the verbal logic (in voice-over narration) establishes as the dominant interpretation of visual historical or political events. In more experimental works, the process of re-editing existing footage inevitably includes reflecting about the origins and status of this footage. In Bruce Conner's (1958) *A Movie*, for example, old Hollywood films (among many other sources) are play-fully reassembled to highlight the conventions of fictional storytelling and continuity editing by combining chase scenes from different genres. The new film, then, not only creates humorous and surprising juxtapo-sitions of shots that play with audience expectations; at a more abstract level, its deconstructive form also invites a reflection on the prevailing norms of storytelling and entertainment. For works of nonfiction, this critical function of interrogating the "essence" of the archival or found footage—in particular its mode of production, institutional context, style, and rhetorical claims—is an important element of compilations. Reflexivity implies that a new assemblage may investigate the "embedded ideology in extant materials" (Arthur 1999, 62) and, as William C. Wees (1992) has argued, this suggests that compilation films have the potential "to critique, challenge, and possibly subvert the power invested in images produced by, and distributed through, the corporate media" (39).[4]

The desire for, and delight in, playfully taking existing aesthetic ob-jects apart to use them for a "semiotic attack" has characterized the his-tory of compilation movements from both the formal and the political avant-garde. Many of its artists and activists—in movements such as Surrealism or Dada—may be seen as culture jammers *avant la lettre*, who, as Carrie Lambert-Beatty (2010) writes, "combine incisive ideologi-cal critique with distinctly playful action" (101). They often created their work from a culturally marginalized, nonindustrial "outsider" position, giving expression to an oppositional or subcultural point of view. And they shared, indeed in many cases shaped, the antiauthoritarian stance of rewriting and redefining official mainstream symbols against the domi-nant culture. Willem de Greef (1992) aptly summarizes the pleasure of dehierarchizing the process of media communication: "By abandoning the original hierarchies between images, an originally intended mean-ing can be subordinated by a derived, opposed or hidden logic; implicit

meanings and dimensions can be brought to the forefront: Found foot-age celebrates the triumph of the illogical, of libido and anarchy" (79).

In terms of its artistic strategies, subcultural practices, and political functions, the long history of compilation film (particularly since the 1950s) can be seen as an important phase in the historical development of culture jamming. And yet, the story of the compilation genre's poten-tial to challenge powerful media institutions and their ability to shape the public sphere aesthetically and ideologically is more complicated. The growing number of compilation films, particularly in the field of documentary, has managed to cast doubt on the evidentiary status of sounds and images. It has made the notion of audiovisual history more complex both by implying that "a piece of archive material becomes a mutable rather than a fixed point of reference" (Bruzzi 2000, 12) and by casting doubt on the historical "truths" it purportedly reveals. Further-more, the emphasis on the notion of "found footage" in the compilation discourse also tends to overrate and romanticize its own contestatory power. Apart from footage that is literally "found"—such as home mov-ies hidden in a forgotten trunk—many restrictions apply to accessing, obtaining, and using archival material (Beattie 2004, 125–45). The cul-tural arena in which the subversive practice of re-editing takes place is therefore delimited by commercial, legal, and political barriers that may or may not be affected by local acts of culture jamming.

The questions at the core of this practice—who may access what type of archival material and use it at what price and for what purposes?—were precisely what concerned Emile de Antonio, who was not just a radical filmmaker but a shrewd businessman. With his "national elec-tronic archive," he envisioned open and free access to everything the television networks were putting into their archives. Yet the reality in the late 1960s was different, and inherently paradoxical. For *Millhouse: A White Comedy*, de Antonio chose two approaches to obtain his archi-val footage: On the one hand, he drew on material that had been stolen from an NBC archive; on the other, he approached "rich liberals" to fi-nance his film, thus enabling him to officially buy stock footage from the networks (Weiner 1971, 7).[5] The making of his film therefore required either illegal acts of stealing footage or participating in the commercial acquisition of audiovisual material—both of which diametrically op-posed de Antonio's utopia of free access and use.

The President as an Object of Satire

Emile de Antonio has variously been described as a "courageous maverick," a "colorful and indefinable radical" (Wexler 2000, xii), and a "self-described anarchist" (Rosenbaum 2000, 341). He called himself a "Marxist social critic of the existing social system" (Weiner 1971, 14) and almost single-handedly came to define a partisan form of documentary filmmaking. About *Millhouse*, he said, "There was never any pretense of objectivity," adding, "I'm proud of my point of view and I flaunt it" (quoted in O'Brien 2000, 241). This stance of media activism distinguished him from the 1960s movements of observational or direct cinema, which de Antonio loathed. It established him as a "culture jammer" whose provocative and outspoken attitude paved the way for more popular—and populist—on-camera performances of documentary filmmakers. In 1989, Michael Moore, the most influential and notorious of these younger generation of filmmakers, appeared on-screen in his first successful film, *Roger and Me*. While de Antonio made his last film, *Mr. Hoover and I*, in the same year, also appearing on-screen, he chose a very different, direct and personal form of addressing the camera. He died a few months after the film's completion.

De Antonio called his style of assembling archival footage "radical scavenging" (Weiner 1971, 3). It consisted of looking at hundreds of hours of television material in order to, as Bernard Weiner (1971) puts it, "locate the one short sequence necessary for the development of the didactic message" (3). De Antonio (2000) was convinced that the "audiovisual history of our time is the television outtake" (350), but he saw it as a contested object of competing historical interpretations that had to be rearranged since the networks were biased and driven by their financial interests. In typical provocative fashion, he stated in an interview from the early 1970s: "The true castrati of our age are the networks who can't afford to offend the sponsors" (O'Brien 2000, 241). De Antonio shared the desire of avant-garde filmmakers such as Bruce Conner to interrogate the nature and origins of archival footage.[6] Yet, as a documentary filmmaker and social critic, he was ultimately less concerned with aesthetic considerations and more interested in the question of how the re-editing and assemblage of television (and film) outtakes could be used for the construction of alternative histories.

To be sure, the history of the documentary genre up to the 1960s had been shaped by movements of social critique, but with *Millhouse* the spirit and practice of culture jamming compilations entered the American scene. The film attempted to reframe and resemanticize footage that the mainstream media had shot of Richard M. Nixon, such as news conferences and party conventions, and thus turn the media messages against themselves. And it did so by means of satire and comic juxtapositions—a new development in the American context. Nixon had been a prominent target for famous political cartoonists such as Herb Block and David Levine. The cultural climate in the 1960s was generally characterized by new forms of satire that were "more direct, more savage, and more explicitly cruel, without fear of censorship, stigma, or punishment" (Whitefield 1985, 114). Thus de Antonio's combination of playfulness, humor, and critique constituted one of the first instances of culture jamming against the "discourses of sobriety" (Nichols 1991, 4) of American documentary film. As de Antonio stated upon its release, "The Nixon film is, I think, the first attempt at a real documentary comedy" (Weiner 1971, 4).

Because *Millhouse* was an early popular example of culture jamming in the presumably "serious" genre of documentary film, de Antonio was also taking real risks. As Jonathan Rosenbaum (2000) observes, the film "had the nerve to shower Nixon with abuse and scorn when he was at the height of his power as president" (336). De Antonio knew he was under surveillance by the FBI (in *Mr. Hoover and I* he recalls his long struggle with the government agency), and although the comedy did not lead to his inclusion on Nixon's infamous "enemies list," de Antonio was clearly identified as a political opponent and subsequently harassed by the White House. Nixon and his aides leaked embarrassing information, presumably from FBI files, on de Antonio to the press, as well as initiating IRS investigations of Daniel Talbot's New Yorker Films Theater where the film was being shown (Lewis 2000).[7]

An Attempt to Attack the "System"

Although the production background of *Millhouse* is shrouded in "subversive mystery," it seems certain that de Antonio obtained some of the archival footage illegally from "anonymous sympathizers" (Kellner

and Streible 2000, 42, 43), while the majority—70 percent in his own assessment—had been legitimately acquired from television archives.[8] The film followed the basic structure of Nixon's memoir *Six Crises* (1962) and provided a wealth of biographical details interspersed with achronological "flashbacks." It ended on a critical indictment of Nixon as a war president. At the height of the anti–Vietnam War protests, Nixon appeared to be an arrogant and hypocritical representative of the political elite, oblivious to the younger generation and its demands for peace. Contemporary reviewers found the film to be partly confusing and "hastily patched together" (Weiner 1972, 113), yet in this new mode of jamming the documentary form de Antonio was juggling with three different ambitions: to sketch the biography of a typical representative of the political establishment during the Cold War, to satirically deflate a public image created by television, and to intervene in the ongoing struggle over the Vietnam War. The result was a "scathing satirical attack" and "mischievous portrait" (Kellner and Streible 2000, 42) which sympathetic reviewers felt sometimes descended "to the level of easy derision" (Cocks 2000, 243), and hostile reviewers regarded as "an insult to the intelligence" (Buckley 2000, 245).

De Antonio's way of undermining and playing with the rhetorical conventions of documentary biography by means of comedy had clearly hit its mark. Despite negative criticism from both conservative and liberal reviewers, the film was widely seen. Indeed, as Bernard Weiner's (1972) review indicates, it was a popular success, a "smash hit" that was "playing to packed houses in at least 30 major cities" (113).[9] At the same time, de Antonio was trying to counter the prevailing notion that it was primarily a personal attack on the president. He saw Nixon as a representative of the larger forces at work in American politics and tried to emphasize the more general implications of the biographical approach. As he stated, "This film attacks the System, the credibility of the System, by focusing on the obvious and perfect symbol for that System" (Weiner 1971, 4). De Antonio used Nixon's middle name "Milhous" for the film's title, but deliberately changed it to "Millhouse" to conjure up more general connotations of a political mill grinding away (Lewis 2000, 133). He added the subtitle of "A White Comedy," probably to suggest the comic degeneration of the White House or the whiteness, the "WASPishness," of the ruling class. But despite these efforts it was obvious that

his film was primarily a caricature of the reigning president, and thus in tune with a widespread trend of ridiculing political leaders in the late 1960s.[10]

In this "new climate of creative irreverence" (Lewis 2000, 118), the film engaged in a political and historical analysis depicting Nixon as a crucial protagonist of the Cold War as well as a curiously unsympathetic individual who nevertheless managed to have several political comebacks. De Antonio presented Nixon not only as a cunning and ruthless politician who had built his career on anti-Communism, but also as a self-made man in the tradition of Horatio Alger: full of ambition, upwardly mobile, yet driven to desperate measures by the will to succeed. Famously, the film opened with the placing of Nixon's wax figure in Madame Tussauds and the final addition of its head. This not only highlighted the act of constructing a figure—literally in the wax museum, figuratively through the public image of the politician and the construction of a film biography; it also introduced one of the recurring themes of Nixon as a bland character with no personality and a 'waxen' appearance. He had been in politics since the 1940s and was now made to look like a relic from a bygone era. In line with this opening, de Antonio proceeded to use comic techniques that treated Nixon more like a type than an individual and highlighted the generational divide.

Techniques of Culture Jamming in *Millhouse*

One technique of culture jamming on which *Millhouse* drew was a critical form of "underground intertextuality" (James 1989, 140–43). De Antonio employed it to stress the generation gap and to present Nixon as an anachronistic politician trapped in the past of the Cold War and the dated images of American popular culture. In one scene, as Nixon was addressing the audience of the Republican Party on his nomination for the presidential election in 1968, he promised to "win for Ike" (Dwight D. "Ike" Eisenhower was hospitalized at the time). De Antonio immediately cut to a deathbed scene from the 1940 Warner Brothers' production *Knute Rockne, All American* in which the former American football player and coach Knute Rockne calls out to "win one for the Gipper," while George Gipp, one of the team's players, is dying. As this juxtaposition implies, Nixon took his cues from the history of sports and

old movies (a technique perfected in the 1980s by the actor who played George Gipp in 1940, Ronald Reagan).

Other sections of the film supported the notion of a generation gap, too. For instance, the opening credits included a photograph of Nixon hanging a coat over his wife Pat's shoulder, with both of them smiling into a mirror while "A White Comedy" was superimposed in an ornate and old-fashioned typeface (figure 6.1). Another public relations photograph showed the Nixon family on bicycles in Washington, the young congressman smiling, while a superimposition announced, "Millhouse goes to Washington," a reference to Frank Capra's depiction of a naive and idealistic politician from the 1930s, Jefferson Smith (played by James Stewart), in *Mr. Smith Goes to Washington* (1939). What followed was a sequence on Nixon's role in the hearings of the House Un-American Activities Committee, in particular his strict anti-Communist stance in the questioning of Alger Hiss. Nixon modeled himself on public images of optimism and youthfulness, yet, as the transition implied, he acted like the old deceitful elite in Capra's dystopian vision of Washington.

The effect of these examples was to paint Nixon as a representative of the old (white) establishment who, in the late 1960s, appeared hopelessly out of date and out of touch with the younger generation. One particular aspect of this gap, the dominant visual "whiteness" of the political rulers, was ruptured by de Antonio on the soundtrack. At the Republican National Convention, Nixon's speech on the progress and order of the "American Revolution" was intercut with Martin Luther King's voice speaking passages from his "I Have a Dream" speech. Briefly de Antonio cut to "battle footage" which showed violent protests and street fights between the police and demonstrators. The accompanying voice-over was the African American radio announcer Milton "Butterball" Smith describing what happened during the riots that accompanied the 1968 convention. Toward the end of the film, the black peace activist Dick Gregory was (visually) seen addressing the crowd at a demonstration, but for the most part the "whiteness" of the political establishment that Nixon represented was subverted by brief interruptions of black voices only in audio.

A second technique in de Antonio's film was to reveal the credibility gap that Nixon's career seemed to signify by creating comic juxtapositions. As Whitfield (1985) indicates, from his earliest days as a congressman, Nixon's style and personality had provoked political caricatures of his

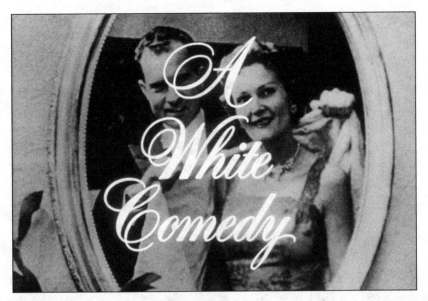

Figure 6.1. "A White Comedy" in old-fashioned typeface from the opening sequence of *Millhouse*.

"priggishness and stiffness that invited deflation" (120). Similarly, de Antonio highlighted the awkward poses of Nixon's public persona for comic effect. Several scenes showed him smiling broadly and rapidly raising his hands in a typical, yet curiously mechanical and artificial, gesture of triumph and thankfulness. This was juxtaposed with a David Levine cartoon of the same gesture in which Nixon had grotesquely shortened arms that reduced his overblown posture, and a literally faceless vice president Spiro Agnew stood at his side (de Antonio also used this cartoon for the advertising campaign of the film). Furthermore, to reveal the "unoriginal quality of Nixon's political rhetoric" (Lewis 2000, 136) and to emphasize the doubts over his sincerity and credibility, de Antonio assembled material, without major changes or comic exaggerations, that evidenced Nixon's repeated attempts to shape his public persona. As Kellner and Streible (2000) put it, "To simply show Nixon performing politically was enough" (44), and the image emerging from these scenes was that of a political hustler using television to mislead the public.

The most important segment in this respect was the "Checkers speech" from 1952, which was included in the first third of the film.

Figure 6.2. Scenes from the "Checkers speech" with an added iris-like frame.

While a candidate for the vice presidency in 1952, Nixon had been charged with unethical practices in the financing of his political work and decided to address the American public via television to explain his actions. Although Nixon professed to answer the attacks on his person with "honesty and integrity" in the broadcast, his gestures and performance style gave him a hypocritical and unbelievable air. Using conventional postures like half-raised hands to appeal to his audience, he came across as a bad actor. Nixon's wife sat next to him in an armchair, creating the peculiarly hybrid setting of a television studio, office, and model home, while Nixon went on to give a "complete financial history" of his family before switching to the more conventional political rhetoric of driving the "crooks" out of Washington. During the course of his speech, Nixon smugly defended his right to keep one particular gift: a black and white dog his children had named "Checkers."

As Lewis (2000) points out, in the early 1950s, "The Checkers speech was television genius," and it "saved Nixon's career" (134). Yet, in the 1970s, given the anachronistic look of footage from the 1950s, it was

sure to draw laughs. In this instance, then, de Antonio's jamming lay in the clash of political and cultural connotations encoded in the archival material. By combining footage from the beginnings of television campaigning with scenes from later decades and sequences discussing the manipulation of televised debates, de Antonio could ridicule Nixon's public persona and point to his long history of trying to use television to his personal advantage.

Of even greater urgency, however, was the Vietnam War, and another element in *Millhouse* to be considered through the culture jamming lens was the creation of hybrid ruptures. The final minutes of the film included a brief "flashback" to the history of US involvement in Indochina and footage from peace demonstrations. In contrast to the comic variations on the generation and credibility gaps, here de Antonio decided to create subversive counterpoints by implying that Nixon's rhetoric was cloaking the imperialist interests of the American government. One passage in particular stands out. While Nixon was giving a speech stating that the United States was not gaining anything from its actions in Vietnam and that even as the most powerful nation, it had refrained from conquest and domination, a scroll appeared superimposed over his face (figure 6.3). Titled "The US in SE Asia," it listed more than eighty companies and economic interests that appeared to be profiting from the

Figure 6.3. "The US in SE Asia," the superimposed scroll in the final sequence of *Millhouse*.

war. Conservative reviewers like William F. Buckley, Jr., were enraged by this insinuation, yet it was clearly de Antonio's most explicit non-comic technique of jamming with archival footage. He included Nixon's official statement that the United States was primarily interested in "peace and freedom" in Vietnam, but used the subversive technique of writing over the top of the president's face to create an irrevocably hybrid image. It was an image of rupture and disjunction that juxtaposed the dominant political discourse, authorized by the iconic image of the president addressing the public, with the counterhistorical claims of its opponents.

Evaluating the Efficacy of Culture Jamming

Emile de Antonio's early form of culture jamming in *Millhouse* belonged to a larger social and cultural movement aiming for empowerment of disfranchised groups in the 1960s and 1970s. The film had primarily a political motivation, yet the ultimate political efficacy of its practice was sometimes viewed critically. In his review, Bernard Weiner (1972) remarked that de Antonio's "essentially anarchistic outrage at the American political process" (113) kept intruding on Nixon's portrait. In a similar vein, reviewing de Antonio's work after he had died, Jonathan Rosenbaum (2000) suggested that his films were probably "more meaningful as potent contemporary gestures than as lasting works of art" (336). One assumption about culture jamming, then, is that it may be merely a gesture, a brief but essentially fleeting expression of political or moral outrage.

Undeniably, many practices of comic or subversive jamming in de Antonio's film seem to be addressing a young countercultural audience that was able to share and delight in his sense of "outrage." The film was designed as an intervention into an ongoing political conflict over the Vietnam War and the build-up to the general election of 1972 in which Nixon was going to run. Yet from today's perspective, the historical assessment of what may have appeared like a "gesture" at the time and its significance as an instance of media activism has changed. To garner attention as an explicitly political film, *Millhouse* made strong, partially overblown statements. But, as my analysis has shown, de Antonio was also making a collage of different materials and voices, which intervened creatively in the aesthetic tradition of compilation films, and he pre-

sented a historical interpretation that went beyond the current moment and is still relevant today. For instance, Michael Moore's widely seen documentary *Fahrenheit 9/11* (2004) developed a very similar argument about the United States having entered the Iraq War due to strong economic interests in a specific geopolitical region, and it also engaged in similar techniques of ridiculing President George W. Bush.

A related concern with culture jamming has been that it does not reach the people whose attitudes and opinions would have to be changed to effect genuine political transformations, even though it may find large audiences by being critical and entertaining at the same time. As Carrie Lambert-Beatty (2010) asks, "Do small, symbolic rebellions really contribute to social change, or do they merely let off steam that might otherwise propel more practical endeavors?" (101). In a similar vein, Douglas Kellner and Dan Streible (2000) assert that the final segments of *Millhouse* with sections on Vietnam and the peace demonstrations merely "preach to the converted" (45).

Just like the claim that culture jamming may simply represent a "gesture," the assessment that it is only preaching to the choir is often made in hindsight, when the political battles have been fought and a new historical consciousness supersedes an earlier, seemingly more naive point of view. We should keep in mind, however, that at the time de Antonio released his film, the Watergate scandal was still to come. Culture jamming may therefore seem outmoded from a later stage but at the time of its production, the political goals—as seen in public demonstrations for peace—probably needed to be reaffirmed, and preaching to the converted was an important aspect of consciousness raising or of supporting political activists (see Bratich, chapter 14). Evaluating the efficacy of culture jamming, therefore, requires close attention to the synchronic field of cultural relations rather than the diachronic relationships that are usually called upon to gauge the value of "classic" or timeless works of art.

A final reservation about culture jamming to be mentioned here is that its creative energies and aesthetic objects may be seized by its opponents and used for the wrong ends. To be sure, this was a constant debate in the avant-garde movements of modernism and postmodernism, but in a culture increasingly dominated by advertising and public relations, the danger that "the very entities culture jammers are trying to

fight can take up their techniques and ideas so easily" (Lambert-Beatty 2010, 111) may pose an even greater threat. If the creativity of culture jamming can be modified for yet another stage in the commodification of culture, its dissenting energies may be appropriated and its political efficacy thwarted (see Serazio, chapter 10). To avoid falling into this trap, de Antonio's technique of radical scavenging and assemblage was not just predicated on "jamming" with archival footage or television out-takes, but also attempted to find ways of using the material that could not be easily appropriated by mainstream media.

In more than any other passage in *Millhouse*, this aspiration lay at the center of the hybrid audiovisual image of Nixon proclaiming America's nonimperialist, peaceful intentions in Vietnam and the superimposed list of companies written over his face. It condensed de Antonio's claim of imperial expansionism cloaked by the official rhetoric of peace and thereby expressed an alternative, materialist con-ception of historical change—a counterhegemonic historical point of view. In this case, then, trying to create cultural forms that could not be easily appropriated for commercial purposes relied upon an unmis-takable oppositional interpretation of history that was encoded in the visual superimposition of text and image and was sure to be rejected by the media establishment. De Antonio's unique form of "democratic didacticism" (Beattie 2004, 135) in *Millhouse: A White Comedy* may serve, therefore, as an important example of jamming *and* resisting, of playfulness *and* risk taking in a critical interrogation of archival footage as the audiovisual history of its time. It emerged in the specific political constellation of the late 1960s and early 1970s, particularly the culmination of the Vietnam War and the legacy of the Cold War, yet it should be acknowledged as a bold and courageous instance of media activism that marked a significant transition in the history of compilation film.

NOTES

1 De Antonio's first film developed from a close collaboration with Daniel Talbot who was running the New Yorker Films Theater and had the initial idea of using the television footage; see his reminiscences in Talbot (2006).

2 On the various practices of producers or exhibitors editing films in the early period of cinema, see Musser (1990).

3 On the theory and history of compilation films see Beattie (2004, 125–45); Bruzzi (2000, 11–39); Arthur (1999); Peterson (1992); Peterson (1994); Wees (1992); de Greef (1992); Decker (2012).

4 On the notion of inscribing power relations into the film material, see James (1989, 3–28).

5 For an extended discussion of the production background, see Kellner and Streible (2000, 42–48); Lewis (2000, 113–54).

6 On the history of assemblage art and West Coast filmmaking, see Peterson (1986).

7 Randolph Lewis (2000) claims that de Antonio "was not technically on the enemies list, though he believed his name appeared there" (151).

8 See O'Brien (2000); Kellner and Streible (2000, 42–48); Lewis (2000, 113–54).

9 Lewis (2000, 113–54) gives a detailed description of the successful theatrical runs of the film.

10 See Whitfield (1985) for a more extended discussion of Nixon and other presidents as targets of satire.

REFERENCES

Arthur, Paul. 1999. "The Status of Found Footage." *Spectator* 20 (1): 57–69.

Beattie, Keith. 2004. *Documentary Screens: Non-Fiction Film and Television*. Houndsmills: Palgrave Macmillan.

Bruzzi, Stella. 2000. *New Documentary: A Critical Introduction*. London: Routledge.

Buckley, William F., Jr. 2000 (1971). "Leave Your Wits at the Entrance." In *Emile de Antonio: A Reader*, edited by Douglas Kellner and Dan Streible, 245–48. Minneapolis: University of Minnesota Press.

Cocks, Jay. 2000 (1971). "Minor Surgery." In *Emile de Antonio: A Reader*, edited by Douglas Kellner and Dan Streible, 243–44. Minneapolis: University of Minnesota Press.

De Antonio, Emile, dir. 1964. *Point of Order*. New York: New Yorker Films.

———, dir. 1971. *Millhouse: A White Comedy*. New York: New Yorker Films.

———, dir. 1989. *Mr. Hoover and I*. Denver: Turin Film Corporation.

———. 2000 (1971). "Some Discrete Interruptions on Film, Structure, and Resonance." In *Emile de Antonio: A Reader*, edited by Douglas Kellner and Dan Streible, 350–53. Minneapolis: University of Minnesota Press.

De Antonio, Emile, and Albert Maher. 2000 (1968). "Chasing Checkers by Richard M. Nixon." In *Emile de Antonio: A Reader*, edited by Douglas Kellner and Dan Streible, 348–49. Minneapolis: University of Minnesota Press.

De Greef, Willem. 1992. "The Found Footage Film as an Art of Reproduction." In *Found Footage Film*, edited by Cecilia Hausheer and Christoph Settele, 77–89. Lucerne: Viper/Zyklop Verlag.

Decker, Christof. 2012. "Image History: Compilation Film and the Nation at War." In *Screening the Americas: Narration of Nation in Documentary Film*, edited by Josef Raab, Sebastian Thies, and Daniela Noll-Opitz, 307–24. Trier: WVT.

Dery, Mark. 1993. *Culture Jamming: Hacking, Slashing and Sniping in the Empire of Signs*. Pamphlet no. 25. Westfield, NJ: Open Magazine.

Firestone, Cinda. 2000 (1972). "'The Real History of Our Times Is on Film': Filmmaker Emile de Antonio Talks about Nixon, the '50s, and Now." In *Emile de Antonio: A Reader*, edited by Douglas Kellner and Dan Streible, 252–57. Minneapolis: University of Minnesota Press.

James, David E. 1989. *Allegories of Cinema. American Film in the Sixties*. Princeton, NJ: Princeton University Press.

Kellner, Douglas, and Dan Streible. 2000. "Introduction Emile de Antonio: Documenting the Life of a Radical Filmmaker." In *Emile de Antonio: A Reader*, edited by Douglas Kellner and Dan Streible, 1–84. Minneapolis: University of Minnesota Press.

Lambert-Beatty, Carrie. 2010. "Fill In the Blank: Culture Jamming and the Advertising of Agency." *New Directions for Youth Development* 125 (Spring): 99–112.

Lewis, Randolph. 2000. *Emile de Antonio: Radical Filmmaker in Cold War America*. Madison: University of Wisconsin Press.

Leyda, Jay. 1964. *Films Beget Films*. London: Allen and Unwin.

Musser, Charles. 1990. *The Emergence of Cinema: The American Screen to 1907*. Berkeley: University of California Press.

Nichols, Bill. 1991. *Representing Reality. Issues and Concepts in Documentary*. Bloomington: Indiana University Press.

O'Brien, Glenn. 2000 (1972). "Interview with Emile de Antonio, Director of *Millhouse*." In *Emile de Antonio: A Reader*, edited by Douglas Kellner and Dan Streible, 237–42. Minneapolis: University of Minnesota Press.

Peterson, James. 1986. "Bruce Conner and the Compilation Narrative." *Wide Angle* 8 (3–4): 53–62.

———. 1992. "Making Sense of Found Footage." In *Found Footage Film*, edited by Cecilia Hausheer and Christoph Settele, 55–75. Luzern: Viper/Zyklop Verlag.

———. 1994. *Dreams of Chaos, Visions of Order: Understanding the American Avante-Garde Cinema*. Detroit, MI: Wayne State University Press.

Rosenbaum, Jonathan. 2000 (1990). "The Life and File of an Anarchist Filmmaker." In *Emile de Antonio: A Reader*, edited by Douglas Kellner and Dan Streible, 335–42. Minneapolis: University of Minnesota Press.

Talbot, Daniel. 2006. "Fact and Fantasy in the Making of *Point of Order*." *Cineaste* 31 (3): 18–20.

Wees, William C. 1992. "Found Footage and Questions of Representation." In *Found Footage Film*, edited by Cecilia Hausheer and Christoph Settele, 37–53. Lucerne: Viper/Zyklop Verlag.

Weiner, Bernard. 1971. "Radical Scavenging: An Interview with Emile de Antonio." *Film Quarterly* 25 (1): 3–15.

———. 1972. "*Millhouse: A White Comedy*." *Sight and Sound* 41 (2): 112–13.

Wexler, Haskell. 2000. Foreword to *Emile de Antonio: A Reader*, edited by Douglas Kellner and Dan Streible, xi–xiii. Minneapolis: University of Minnesota Press.

Whitfield, Stephen J. 1985. "Richard Nixon as a Comic Figure." *American Quarterly* 37 (1): 114–32.

7

Never Mind the Bollocks

Shepard Fairey's Fight for Appropriation, Fair Use, and Free Culture

EVELYN MCDONNELL

Every sk8ter boi with a Clash album and a can of spray paint wants to change the world. In late January 2008, Shepard Fairey may have done just that. He decided to create something he had never, in some twenty years of producing stickers, murals, T-shirts, prints, stencils, tags, and canvases, made before: a poster endorsing a popular political candidate.

Since Barack Obama was not exactly available to pose for some grassroots graphic artist, Fairey found a photo of the senator online. With a couple mouse clicks, he copied a shot taken by Mannie Garcia in 2006 for the Associated Press (AP). Then he turned a news photo into a propagandist art statement. Fairey replaced the natural tones of the photo with the strong lines and bold colors of Russian Constructivist art. He added oversized cartoon hatch-mark shadings in the style of Roy Lichtenstein. Across the bottom, he wrote: "Progress." In later iterations, he changed "Progress" to "Hope."

Fairey's Obama "Hope" poster is the most iconic, widely seen work of art in recent history. Its bold, dignified profile succinctly communicated both patriotism and change better than any other single image in a mediagenic campaign. "Hope" captured and helped enable a historic moment. And it got its maker, a longtime street artist, prankster, and political activist who was already one of the most widely known culture jammers, into a heap of trouble—a serious legal jam. In 2009, Fairey and the AP sued each other over the artist's use of Garcia's photo. "Hope" may not have merely helped the United States elect its first African American president; it also became a test case for and raised public awareness of one of the most important issues of the digital age: intellectual property.

Fairey's lawsuits with the Associated Press (which were settled out of court in January 2011 in a confidential agreement) highlighted the changing rules of intellectual property. This culture jam provided a case study in what media studies scholars Henry Jenkins et al. (2006) have described as the New Media Literacy of appropriation—a cultural form explicitly borrowing from another as a means of commenting and paying tribute. In 2006, the MacArthur Foundation funded a $50 million study of digital culture and learning. In a 2006 white paper written under funding from that study, Jenkins et al. identify the skills that are enabled by new media and explore how they might be implemented in classrooms. Appropriation is one of these main skills. "The digital remixing of media content makes visible the degree to which all cultural expression builds on what has come before," the authors write. "Appropriation is understood here as a process by which students learn by taking culture apart and putting it back together" (32).

The disruption/eruption of an underground artist into mainstream and commercial ideology is also an example of what Jenkins (2006) calls "convergence culture," which is marked by "a cultural shift as consumers are encouraged to seek out new information and make connections among dispersed media content" (3). The story of the "Hope" poster is the story of divergence as well—of increasingly closed copyright law deviating from increasingly open-sourced public practice. In this case, the law and mainstream media aligned themselves against market capitalism and anarchist street culture.

A close analysis of the Fairey-AP battle—or what could be called the case against "Hope"—provides key insights into the status of appropriation, fair use, free culture, and engaged citizenry during the first decade of the twenty-first century. The case illustrates what can happen to culture jammers when they fly too close to the sun—or the global media spotlight. The battle may have been a strategic turning point in what Harvard professor Lawrence Lessig (2005) has called the war against free culture. "There is no good reason for the current struggle around Internet technologies to continue" he writes. "There will be great harm to our tradition and culture if it is allowed to continue unchecked. We must come to understand the source of this war. We must resolve it soon" (11). By studying Fairey's tactics of appropriation, we take another step toward understanding that war. Lessig may be optimistic in saying that

understanding can lead to resolution, but it can certainly inform further activism and creativity.

The case *for* "Hope" indicates that the aesthetics of culture jamming—of street artists, punk, and Pop Art—are no longer confined to outsider practices. Fairey's creation didn't just go "all-city," the goal of 1970s graffiti artists; it went all-world. As communications scholar Sarah Banet-Weiser (2012) has said of Fairey's success, "The cultural capital of the street is now invaluable in the world of mainstream branding" (122). What does it mean when a once-subversive art style becomes the defining propaganda tool of the winning presidential campaign of one of the world's most powerful nations? A skateboard punk from middle America helped the first black American president get elected, and got a shitload of legal and PR trouble for his efforts.

Anarchy in the Public Domain

Fairey's use of Garcia's image, and the entire New Media Literacy (NML) conception of appropriation, have historical precedents in the cultural traditions in which the artist was steeped: punk, collage, street art, and Pop Art. Frank Shepard Fairey grew up in Charleston, South Carolina. He discovered punk rock and skateboard subculture as a teenager. "The Sex Pistols changed my life," he said in an interview with this writer in November 2009. "That was the gateway band for me."[1]

The Sex Pistols, the English band that sang about "Anarchy in the UK" in a music driven by over-amped guitars and Johnny Rotten's sarcastic snarl, were Fairey's gateway out of conservative Southern culture and into a global youth subculture characterized by rebellion against mainstream and corporate values. "There's not a lot of progressive culture there," he has said of his hometown. "I got into the skateboarding and punk life. That opened my eyes to political and social critique: How art could work with things that are political" (Fairey 2009a).

The cover of the band's 1977 debut album, *Never Mind the Bollocks, Here's the Sex Pistols*, was designed by English artist Jamie Reid. Reid did for punk music what Fairey would later do for the Obama campaign, providing a distinctive iconography, in this case made out of cut-up, xeroxed images and ransom-note-style lettering. In one famous piece, he put a safety pin through the lip of a reproduction of a photograph

of Queen Elizabeth II, providing a visual complement to the Pistols' song "God Save the Queen" (figure 7.1). Reid's irreverent mash-ups were clearly instances of the public defacing of hegemonic corporate images, and subsequent punk bands and culture jammers such as Negativland were undoubtedly influenced by his collages. Like the Pistols' music, Reid's art provoked the establishment and stirred up a youth cultural movement—punk—that years later would reach a young Fairey in the American South. Still, as far as I can tell, Reid was not sued by royal photographer Peter Grugeon for his appropriation.[2]

There was a purpose to this playfulness. Do-it-yourself—the notion that culture should actively be in the creative hands of the people, not just something produced by corporations and consumed by a passive audience—was a guiding ethos of punk. In reaction to the showy musicianship of art-rock, such bands as the Clash advocated the notion that music be simplified and demystified, so that anyone could play it. In a similar vein, cut-up art like Reid's is a way to claim images that permeate public spaces (the queen's face was omnipresent in 1977 England, the year of the Silver Jubilee), assert individual expression over them (the safety pin), and make them public domain (Reid's image was stickered around town). Through media bricolage, Reid and other punk 'zine creators asserted individuals' rights to exploit and manipulate commercial imagery, since commercial imagery exploits and manipulates the public. They were appropriating, creating visual remixes and mash-ups, culture jamming—long before those were digital-culture buzzwords.

Fairey was also inspired by another musical subculture of the 1970s: hip-hop. Graffiti is considered one of the four main elements of hip-hop—the other three being DJing, breakdancing (or B-boying), and rapping (Chang 2005). Like punk cut-up art, graffiti is also an assertion of the individual's right to self-expression in the public domain, with the legal concept of public domain meant quite tangibly—on subway cars and abandoned buildings. The art of spray-painting tags (aliases of graffiti artists) and street murals exploded during New York's fiscal crisis of the 1970s, as colorful balloon letters and stylized characters proliferated on subway cars and abandoned buildings. Such practitioners as Futura 2000, Rammellzee, Lady Pink, Revs, Cost, and Claw became famous for going "all-city" (Shapiro 2005). Street artists Keith Haring and Jean-

Figure 7.1. "God Save the Queen." Image by Jamie Reid, courtesy of John Marchant Gallery UK. Copyright Sex Pistols Residuals.

Michel Basquiat also crossed over into the world of fine art, becoming celebrities of the Downtown scene of the 1980s.

Art student Fairey witnessed this work all around him on a 1989 visit to New York. "I saw graffiti in risky places that gave me new respect for the dedication of the writers," he writes in *Obey: Supply and Demand: The Art of Shepard Fairey*. "Stickers and tags coated every surface in New York City. I left the city inspired" (Fairey et al. 2009, 18).

The graphic creation that first made Fairey famous in underground circles was a punk sticker, in the spirit of "God Save the Queen." While he was a student at the Rhode Island School of Design in 1989, Fairey made a stencil of plus-sized wrestler and actor Andre the Giant and added the words "Andre the Giant Has a Posse," plus his height and weight. He plastered the stickers around Providence. One day a local weekly, the *Nice Paper*, took note. Soon, the Andre campaign spread to nearby Boston and New York. Fairey sent stickers to friends who put them up wherever they lived. He advertised in punk magazines and sold the stickers by mail order for five cents each. Within seven years, he had printed and distributed a million of these Andre stickers. Fairey also made posters and stencils. André René Roussimoff died in 1993, but he and his make-believe posse were ubiquitous on urban street lamps and walls for years afterward (Fairey et al. 2009).

In the 1990s, Fairey altered the image of Andre due to concerns over intellectual property (Whittaker 2008). The face morphed into a bold graphic abstraction, and the caption read simply "Obey" or "Giant." The forced change actually enabled Fairey's art to become more sophisticated and distinctive—in fact, Fairey has written that he initiated the shift because he had become fascinated with the agit-prop art of Russian Constructivism (Fairey et al. 2009, 35). The style that was to become world-famous with "Hope" was already apparent in the "Obey Giant" series of 1995.

Appropriation was not only a tool of punk and street art. Reclamation and transformation of commercial or public images also came to be accepted in the highbrow art world of museums and galleries in the twentieth century. With his famous urinal sculpture of 1917, Marcel Duchamp, along with the Dadaists, was at the vanguard of conceptual installation art. Robert Rauschenberg's work of the 1950s mixed found objects and images. In the 1960s, Andy Warhol made brightly colored

Figure 7.2. Shepard Fairey's "Obey" icon.

silkscreens of Campbell's soup cans, Marilyn Monroe, and Elvis Presley. In the 1970s Richard Prince rephotographed commercial shots of Marlboro Men and Brooke Shields. As with Reid, these artists prefigured the ideas and even methods of such future culture jammers as *Adbusters*.

Such appropriative art has been both highly successful—a Prince work sold for $1.2 million in 2005—and controversial—he was sued over the Shields shot and reportedly settled out of court for a small fee (Kennedy 2007). Still, appropriation has become widely accepted as an artistic practice. In 2009, Miami's Rubell Family Collection launched an exhibit called "Beg Borrow and Steal" that featured seventy-four artists, including Mike Kelley, Rashid Johnson, David Hammons, Paul McCarthy, and Sherrie Levine, all engaged in various forms of mimicry. "Artists are acting as cultural curators; through their work they're recurating history and recontextualizing it," said Jason Rubell, one of the exhibit's curators. "They're appropriating and reassessing imagery that came before" (pers. comm.).

In the same way that Reid and the punks utilized it, appropriation by fine artists may be an effective tool against mass media bombardment, a way of reclaiming public space from corporate control. "There's an enormous difference between imitation and appropriation," said Rene Morales, a curator at the Miami Art Museum, which co-produced an installation by Fairey in December 2009. "Appropriation is a creative act; it's become one of the most effective ways to make art in a media-saturated word" (pers. comm.).

The works of Rauschenberg, Warhol, Prince, and others influenced Fairey. In a sense, they pioneered a core technique of culture jammers, taking ubiquitous commercial icons and repurposing them for their own artistic purposes. "My favorite artists are people like Jamie Reid and Rauschenberg and Warhol, who incorporated existing art work in their work but did it in a way that made something that wasn't very special incredibly special," Fairey said.

To those who decry lack of originality in Fairey's work, the artist agrees. "The idea of originality is pretty ridiculous. It's virtually impossible to be original. Language is based on reference. To me as a visual artist, I use reference in my work all the time, both images that have a specific connotation and styles that have a specific connotation." For instance, in the "Obey Giant" artworks, Fairey wrote "Obey" in red capital

letters. This was his homage to 1990s art star Barbara Kruger, whom he calls "the most political, outspoken artist" of that time. "I liked her work and I thought that if I used that style, people were going to wonder what I was trying to say. I think she understood she should be flattered."

Russian Constructivism, Reid, Warhol, Kruger: The artistic influences on Fairey's work are clear. He is as unapologetically derivative in his image choices as in his methods. He doesn't draw or paint the central figures of his pieces. He uses images created by others, either by photographers with whom he is collaborating or images he finds online, or at agencies that sell stock photos, or that are already well known (such as his series on famous musicians). "There's no shortage of images," he said with a twinkle of ironic mischief. "It's just that there's an abundance of lawyers as well."

Whereas Prince simply rephotographed some of his most famous pieces, without modification, Fairey alters, sometimes radically, the works he appropriates, with exacto knives, computer tools, or by hand illustrating them. He defends his methods philosophically:

> I'm biased to my own idea that images are abundant but making them special is what's important. Looking at how to distill what will make something iconic is what I think my skill is. There's some people who have great brush strokes and others who come up with cool color combinations. This is my skill, and whether the law said it's okay or not, it's what my skill is. . . . There's a huge debate with new technology about what constitutes legitimate art. Does it have to be done with a paintbrush or with your hands? I enjoy illustrating with my hands. But really, your eyes make the art. You make the decisions by looking at things and transferring what you want to do in any number of ways, whether it's with your hands or digitally or with photography. The end result is what's important. You may be Jeff Koons and have fabricators build it and never touch it. That to me is what art's about: Whether that end result, however you got there, affects people and said what you wanted to say.

Computers help artists like Fairey turn creation into a hands-off, eyes-on experience. Digital technology is radically changing the way the arts are made, transmitted, communicated, marketed, taught, learned, and controlled. The art of cutting, pasting, and remixing—whether in Garage

Band, word-processing software, Photoshop, iMovie—is now intrinsic to digital culture's transformative power. "The Internet has unleashed an extraordinary possibility for many to participate in the process of building and cultivating a culture that reaches far beyond local boundaries," Lessig (2004) writes. "That power has changed the marketplace for making and cultivating culture generally, and that change in turn threatens established content industries" (9).

Jenkins and his collaborators recognized the importance of remixing for youth accustomed to digital tools and named it the New Media Literacy "appropriation" in their 2006 MacArthur Foundation report. "Appropriation may be understood as a process that involves both analysis and commentary," they wrote. "Sampling intelligently from the existing cultural reservoir requires a close analysis of the existing structures and uses of this material; remixing requires an appreciation of emerging structures and latent potential meanings" (Jenkins et al. 2006, 33).

Fairey's "Hope" poster is a definitive example of appropriation. Fairey was engaged in the essential appropriative processes of analysis and commentary when he remixed Garcia's photo, an image grabbed "from the existing cultural reservoir" (in this case, the Associated Press). Saturating the black and white pixels with bold primary colors, he verbalized latent meanings: "Progress," "Hope."

The Clampdown

Appropriation may be recognized and respected by artists, punks, rappers, scholars, and educational foundations. But it is also at the center of a legal battleground. As an artist who was sued for copyright infringement, Fairey followed in the footsteps of Richard Prince and rappers 2 Live Crew. But he was the first artist to engage in litigation with a news giant during a time when Internet communication technologies had fundamentally shaken traditional media roles and economic models.

Intellectual property (IP) law is complicated, to say the least. As Jessica Litman (2006) quips, "Copyright law questions can make delightful cocktail-party small talk, but copyright law answers tend to make eyes glaze over everywhere" (13). Essentially, the law in America historically seeks a balance between the need to guarantee creators and inventors a financial incentive to create and invent and the right of the public at

large to participate in the free exchange of ideas. The overall goal, as stated in the Constitution, is "to promote the Progress of Science and useful Arts." Intrinsic to that progress and free expression, certain uses of copyrighted material are protected as fair use. Legal scholar Paul Goldstein (2003) explains that "the Copyright Act allows the copying of copyrighted material if it is done for a salutary purpose—news reporting, teaching, criticism are examples—and if other statutory factors weigh in its favor" (15).

Determining what use is fair has often been settled by litigation and involved unlikely defendants. The Miami bass group 2 Live Crew took their fight for the right to appropriate all the way to the Supreme Court. In 1990 music publishers Acuff-Rose sued the salacious rappers for sampling the Roy Orbison song "Oh, Pretty Woman," to which they owned the rights. The lawyers for 2 Live Crew defended the use as an act of parody and therefore an example of fair use. The Supreme Court agreed: "The goal of copyright, to promote science and the arts, is generally furthered by the creation of transformative works," wrote Justice David Souter in a decision that would later have ramifications for Fairey (quoted in Goldstein 2003, 27). But other artists who have used samples have not successfully claimed the parody fair use defense and lost their cases. Since the rapper Biz Markie was forced to remove a track from his 1991 album *I Need a Haircut*, musicians have repeatedly been sued over royalties. When it comes to digital culture and pop music, jurists and legislators tend to side with multimedia corporations in cases that are changing the rules of intellectual property. The courts shut down music distribution systems Napster and MP3.com in 2001 and issued restrictive, expensive licensing rules that effectively silenced Internet radio for a time. Lessig (2004), the founders of the Electronic Frontier Foundation, and others have documented and contested this erosion of free culture. "In the middle of the chaos that the Internet has created, an extraordinary land grab is occurring," Lessig writes. "The law and technology are being shifted to give content holders a kind of control over our culture that they have never had before. And in this extremism, many an opportunity for new innovation and new creativity will be lost (181).

Litman (2006) refers to this land grab by the vested interests of media conglomerates as the "Copyright Wars." "If current trends continue unabated," she writes, "we are likely to experience a violent col-

lision between our expectations of freedom of expression and the enhanced copyright law" (14). It was into this legal battleground that Shepard Fairey strode with seemingly noble intentions, but headed for a showdown.

"Hope"

Since the early days of the "Obey" stickers, Fairey's work had become increasingly political. Influenced by punk and Constructivism, he unabashedly referred to his work as propaganda. As his political convictions deepened, he went from being a culture jammer, poking holes in consumerist culture, to a political commentator and activist, bringing culture jamming aesthetics to electoral campaigns. During the 2004 election Fairey made a series of posters attacking George W. Bush and the war on Iraq; he also created posters for the presidential campaign of consumer-rights advocate Ralph Nader.

For the 2008 election, he decided to take a different tack:

> I'd spent a lot of time criticizing the Bush administration, the war in Iraq—things I unfortunately didn't have enough power to prevent but I could at least try to dissuade people from making the same mistakes again. A lot of people really respond to negative images because venting is cathartic. I had started to think about why my anti-Bush images and other people's anti-Bush images had not kept Bush from being reelected in 2004. Maybe it makes more sense to support rather than oppose. And I looked at Obama as the unique opportunity to endorse a mainstream candidate. . . . The ceiling to a lot of the rebel culture and the real activism and quasi-activism was these people are glad to talk but don't do anything to engage in this process enough to make an actual difference. I said I'm going to engage in this process. One of the most compelling things was having a two-and-a-half-year old and being about to have another baby. And thinking it's far more important to have them not growing up under McCain than for me to maintain my brand as anti-mainstream.

So in January 2008, as Obama was emerging as a front runner in the Democratic race but before the Super Tuesday primaries, Fairey made the "Progress" poster.

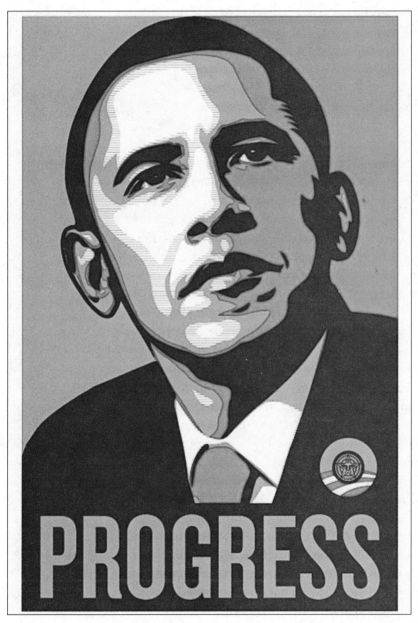

Figure 7.3. Shepard Fairey's "Obama Progress."

> I made the Obama poster just like I made any other poster. The week before it was a ballot box with a speaker on the front saying, "Engage in democracy, vote." To me it was just another political image. . . . I had no idea it was going to be such a hit.

Fairey intentionally created a piece that reached beyond the grassroots cultures that had been his comfortable home.

> I did purposefully try to make it something that I thought could cross over that would have enough appeal to my fan base to stylistically work for them and also not be quite as edgy or threatening. And not in any way to be ironic, to be sincere. And patriotic. My feeling was that all my friends are already going to vote for Obama. The person that hopefully this image will appeal to is the person who's on the fence. It needs to be something that's nonthreatening. Something—this sounds really corny—but something that would maybe be hopeful and inspirational.

Fairey originally did with the "Progress" poster what he had done with its predecessors: He made a limited print run of three to four hundred that he sold, then used the money to make more posters to distribute for free. Oprah Winfrey and Michelle Obama held a rally at the University of California, Los Angeles, at which he gave away ten thousand copies. In the meantime, Fairey had been in contact with people inside the Obama campaign, who liked the artwork but preferred it carry a different textual message. "Hope" and "Change" were the keywords they were trying to promote, Fairey said. So he made a new version for the campaign.

"I chose 'hope' because I think a lot of people are complacent and apathetic because they feel powerless," he said. "The first thing to motivate people to action is a level of optimism that their actions will make a difference. Hope is important because so many people feel hopeless."

The rest, as the saying goes, is history. Fairey's artful yet simple, dramatically chromatic message struck a chord. He made the "Hope" poster available as a free download on his website, with the condition that any proceeds from sales go to the Obama campaign. Soon, "Hope" was everywhere, a powerful illustration of the way in which the Internet enables networked communication. Fairey received a letter of thanks from

the presidential candidate on February 22, 2008, that said in part: "The political messages involved in your work have encouraged Americans to believe they can help change the status-quo" (quoted in Fairey et al. 2009, 273). On January 17, 2009, the Smithsonian unveiled a mural based on "Hope."

For the art's maker, the experience, at that point, was a positive lesson in civic engagement. Fairey said:

> I'm proud of the image. I put all the money from it back into making more posters, giving money to the campaign, organizing the Manifest Hope art shows. It was all related to supporting Obama. There was no goal for personal gain. Of course publicity wise, it was great for me. I'm very fortunate that I'm doing that well in my career that I can dedicate that much time to supporting a candidate and not have to have an ulterior motive, like the ambassadorship to Puerto Rico. It was something that was really heartfelt and I'm really glad Obama's president.

Backlash

"Hope" catapulted the already successful Fairey to a level of notoriety enjoyed by few contemporary artists. Needless to say, he had backed the right horse: He drew the official 2009 inaugural poster for Obama. He was the subject of numerous articles and was commissioned by Levi's to design a line of jeans. He was hired to draw covers of *Time* and *Rolling Stone*. The style of the "Hope" poster was itself widely appropriated and parodied (more on that later). But with fame comes friction.

In February 2009, the prestigious Institute of Contemporary Art in Boston debuted an exhibition of Fairey's work. The show had been scheduled before "Hope," the artist said. But of course, the opening got a lot more attention as a result of Fairey's heightened profile. Not all of this attention was positive, though. The night of the opening, Fairey was arrested by Boston police for acts of vandalism related to Fairey's public admission that he had performed numerous acts of street art during his lifetime, including when he lived in nearby Providence. "The Boston arrest was a lot of different things converging," he said. "I made the mistake of being very candid about my practice as a street artist. The Boston police said that's an affront to the Commonwealth."

Fairey had been arrested for vandalism before. But he had never en-gaged in legal battle with a large corporation for copyright infringement. Actually, it was the artist who, after several months of communications with AP lawyers, threw down the formal legal gauntlet: On February 9, 2009, with the Stanford University Fair Use Project as his legal team, he filed suit in US District Court in New York to vindicate his rights to the image of Obama. The AP, saying in a statement that it was disappointed that Fairey had broken off negotiations over the Garcia image, filed a countersuit. What the AP called "negotiations," Fairey had seen as legal threats.

Fairey's case centered on fair use. The suit argued that Fairey "altered the original with new meaning, new expression, and new messages," and did not create the art for commercial gain; that he "used only a portion of the Garcia Photograph, and the portion he used was reasonable in light of Fairey's expressive purpose"; and that his use "imposed no sig-nificant or cognizable harm to the value of the Garcia Photograph or any market for it or any derivatives; on the contrary, Fairey has enhanced the value of the Garcia photograph beyond measure."[3]

In response, the AP argued that Fairey's use of the photograph was substantial and not transformative: "The Infringing Works copy all the distinctive and unequivocally recognizable elements of the Obama Photo in their entire detail, retaining the heart and essence of The AP's photo, including but not limited to its patriotic theme."[4] It also charged that as of September 2008, Fairey had made $400,000 off the image. In a statement available on the AP website, spokesman Paul Colford said the organization was itself acting in defense of creators: "AP believes it is crucial to protect photographers, who are creators and artists. Their work should not be misappropriated by others."[5]

In October 2009, there was a significant, but troubling, development in the case. Fairey admitted that he had misstated which Garcia photo he had originally used for the poster. Instead of a photo in which Obama was shown next to actor George Clooney, he used a photo of Obama's face alone. He also admitted that he had altered evidence to cover up his misstatement. Fairey's lawyers resigned from the case; he replaced them with new counsel. Fairey said he was initially mistaken about the source and then, embarrassed, tried to hide his mistake. "I made some poor decisions that I can only blame myself for," he told me.

The change in source affected one tenet of his fair use argument: that he "used only a portion of the Garcia Photograph, and the portion he used was reasonable in light of Fairey's expressive purpose." The artist's misstatements may have kept the case from going to the Supreme Court and setting a legal precedent. At the urging of a judge, Fairey and the AP settled out of court at the start of 2011, with an undisclosed financial settlement; neither party surrendered its view of the law. In 2012, Fairey pleaded guilty to criminal charges of destruction of evidence and was sentenced to three hundred hours of community service.

Does Shepard Have a Posse?

Even before Fairey's admitted lie, he had a credibility issue. The Internet is full of Shepard-haters: Diehard punks and radical left-wingers accuse Fairey of selling out, not just because he created ad campaigns for Levi's and Saks Fifth Avenue, but also because of the Obama posters. Sarah Banet-Weiser has critiqued Fairey and other street artists, such as Banksy, as being peddlers of their own brands, the ultimate creative entrepreneurs in a neoliberal postcapitalist apocalypse world. He's a copycat, critics say: One website is dedicated to listing the artists and works Fairey has allegedly plagiarized. Undoubtedly some of these attacks come from artists who are jealous of his success. Others, like Banet-Weiser, have fairly well thought-out critiques. When I wrote an article on Fairey for the *Miami Herald* in November 2009, it quickly accrued comments both from kneejerk radicals and reasoned liberals troubled by Fairey's questionable integrity. Sometimes, it seems as if Fairey has a posse—one that's out to hang him.

The criticisms that have the most disturbing implications for the artist's reputation are the charges that while Fairey unapologetically appropriates, he has been litigious toward people who have in turn appropriated his work. For instance, in 2008 he sent a cease and desist letter to Baxter Orr, an Austin artist and art dealer who had made a version of Fairey's iconic "Obey" image with a surgical mask on it (apparently a reference to the SARS epidemic that had killed almost one thousand worldwide). Orr told the *Austin Chronicle*, "It's ridiculous for someone who built their empire on appropriating other people's images. Obey Giant has become like Tide and Coca-Cola" (quoted in Whittaker 2008).

When questioned about this, Fairey offered a somewhat torturous explanation of his actions. He said he was upset because Orr had been profiting off the artist's work by buying posters cheaply from Fairey's website—in true punk rock fashion, Fairey keeps prices for his work low—then flipping them for a substantial profit. Since this practice is only unethical, not illegal, Fairey went after the "parasite" (Fairey's term for Orr) over IP infringement instead. Fairey also complained that Orr, who later made the disturbing "Dope" poster parodies of Obama as a cokehead, had publicly bragged about his actions and needled Fairey. Fairey said the letter was a mistake. "I didn't think about how it looked hypocritical. I was operating out of anger and frustration."

One could argue that Fairey's admitted "mistakes" make him human. My personal assessment is that as a white kid from South Carolina, Fairey will always be an outsider in the outsider worlds of punk and hip-hop. This makes him both insecure and vulnerable to attacks from those who consider themselves insider purists (like Orr). I think Fairey considers the current, constrictive rules of copyright law a burdensome and unreasonable hindrance to the cultural practices to which he, and increasingly many new media workers, are accustomed, and that he felt therefore above the law when it came to admitting the source of the Obama image. His hypocritical defense of his own intellectual property against another's culture jamming both reveals his ego and shows just how complicated the politics of appropriation can be. Even those who see copyright law as being intrusive may see it as also necessary, especially when it comes to their own works.

Fairey is much more careful about attribution and appropriation since the AP skirmish. He undertook a project on American pioneers in art, music, and culture, starting with Rauschenberg associate Jasper Johns—thus saluting some of the figures others have accused him of stealing from. On his website, he carefully notes the Johns image is by photographer Michael Tighe ("Jasper Johns" 2009). He increasingly collaborates with photographers; a 2013 print of rocker Joan Jett is a Shepardiziation of a Chris Stein photo, for instance.

"I'm not trying to steal people's images and exploit them," Fairey said. "I feel like anything I make, I'm adding new value that doesn't usurp the value of the original. At the same time I don't want people to feel taken advantage of, so if I can make it be mutually beneficial, I will. This has

never been about me trying to be selfish or greedy about the art I make. I try to use my art for good causes. Almost every print I do has some philanthropic element."

Free Speech + Free Culture = Democracy

Lessig and Litman have both documented at length how the companies that are able to buy the most lawyers and legislators are currently winning the copyright wars. The AP said it was out to defend the rights of creators, but Mannie Garcia, the creator of the Obama photo, has both contested the organization's ownership of the image and said he thought Fairey's use of it had been a mostly positive experience:

> I don't condone people taking things, just because they can, off the Internet. But in this case I think it's a very unique situation. . . . If you put all the legal stuff away, I'm so proud of the photograph and that Fairey did what he did artistically with it, and the effect it's had. (Quoted in Kennedy 2009)

Copyright wars are not being waged by creators against other creators. They are being waged by the companies who have purchased the rights from the creators and are now cynically fighting to control creativity. But copyright law was invented precisely to counter such monopolization, when British Parliament passed the Statute of Anne to break the stranglehold booksellers had on literature. Today's corporate media is every bit as powerful as those eighteenth-century word lords.

Many scholars who are closely studying the way new media is redefining cultural practices have regarded the AP-Fairey case as an important landmark. Jenkins argues that images of public figures should be seen as particularly fair game for culture jammers and remixers, as the art of Reid and Prince has already put into practice. "Artists—whether professional or amateur—need to be able to depict the country's political leadership and in almost every case, they are going to need to draw on images of those figures which come to them through other media rather than having direct access," said Jenkins. "The question, then, boils down to what relationship should exist between the finished work and the source material. And my sense is that Fairey's art was trans-

formative in that it significantly shifted the tone and meaning of the original image. . . . The mythic power comes from what Fairey added to the image—not from any essential property of the original, which was workmanlike photojournalism" (pers. comm.).

The most disturbing ramification of the case against "Hope" may be its chilling impact on free speech and civic engagement, the backbones of democracy. Media organizations such as the AP have seen their revenues shrink as readers move from print to digital and mobile platforms, and they have watched as their content disperses over the web—with little or no recompense. The news company tried to make an example out of Fairey (they have also fought aggregators such as Google News). The skateboard punk artist sought a new, wider audience with "Hope"—he got it, but he also got dragged through the legal and PR mire. If Fairey were to consider making the Obama poster now, he might not simply license the photograph; he might remain silent all together. "I still don't regret it, though I'm a lot closer to regretting it than I ever thought I would be," he said in 2009. "It's such a nightmare that I'm going through. It's been really hard on my family."

Fairey's art makes sense—not just to punks, rappers, and culture jammers, but also to every Harlem Shaker who finds a thriving creative environment in the frontier world of the Internet. Appropriation is part of how they create and communicate every day. "[Fairey] embodies this new dispersed, grassroots, participatory culture about as well as any contemporary figure," said Jenkins. "The battle between AP and Fairey is an epic struggle between the old media and new-media paradigms, a dramatization of one of the core issues of our times" (pers. comm.).

In *Free Culture*, Lessig (2004) argues that the divergence between copyright law and public practice is turning regular citizens into outlaws and thus undermining the rule of law. The Harvard scholar and founder of Creative Commons publicly backed Fairey in his fight with the AP. Fairey probably didn't exactly mean to launch a grenade into this legal battleground when he created the most populist, crossover work of his life. But since his entire oeuvre is rooted in culture jamming practices, perhaps he couldn't help but be a guerrilla.

The "Hope" poster won its first objective: Barack Obama was elected president on November 4, 2008. It also made Shepard Fairey a celebrity. And though *Fairey et al v. The Associated Press* was an inconclusive legal

battle, it was a highly public skirmish in the copyright wars that challenged the way we both think about and litigate cultural creation in the twenty-first century. GIFs, memes, viral videos, parody videos, literal videos, fan fiction, modding—most Internet discourse is cannibalistic to some degree: It involves taking something that has been made before, and finding new meanings by reworking it. If an accomplished artist has his hands royally slapped for creating something as clearly iconic as the Obama campaign poster, what does that mean for the ten-year-old future Shepard Fairey posting videos of himself playing Grand Theft Auto on YouTube? The "Hope" case raised public awareness of how easily technology allows people to appropriate other works with a few clicks of a mouse and to question not only when that is legal, but when it is ethical, when it is transformative, when it is fair use, and when it is art.

NOTES

1 This and all subsequent quotations from Fairey that are not cited in notes are from an in-person interview conducted by Evelyn McDonnell (see Fairey 2009b).

2 "Sex Pistols Artwork," SexPistolsOfficial.com, www.sexpistolsofficial.com.

3 *Shepard Fairey and Obey Giant Art v. The Associated Press*, Complaint for Declaratory Judgment and Injunctive Relief, 11, docs.justia.com.

4 *Shepard Fairey and Obey Giant Art v. The Associated Press*, Answer, Affirmative Defenses, and Counterclaims of Defended, The Associated Press, 10, docs.justia. com.

5 Paul Colford, "AP Statement on Shepard Fairey Lawsuit," Associated Press, February 9, 2009, web.archive.org.

REFERENCES

Banet-Weiser, Sarah. 2012. *Authentic™: The Politics of Ambivalence in a Brand Culture*. New York: New York University Press.

Chang, Jeff. 2005. *Can't Stop Won't Stop: A History of the Hip-Hop Generation*. New York: Picador.

Colford, Paul. 2009. "AP Statement on Shepard Fairey Lawsuit." *AP*, February 9. www. ap.org.

Fairey, Shepard. 2009a. "Art, Culture, Politics: A Conversation with Shepard Fairey." Q & A with Sarah Banet-Weiser, Norman Lear Center Annenberg, University of Southern California, Los Angeles, November 4, 2009.

———. 2009b. Interview by Evelyn McDonnell, November 18, 2009.

Fairey, Shepard, et al. 2009. *Obey: Supply and Demand; The Art of Shepard Fairey*. Berkeley, CA: Gingko Press.

Goldstein, Paul. 2003. *Copyright's Highway: From Gutenberg to the Celestial Jukebox*. Stanford, CA: Stanford University Press.

"Jasper Johns." 2009. Obeygiant.com, December 10. www.obeygiant.com.

Jenkins, Henry. 2006. *Convergence Culture: Where Old and New Media Collide*. New York: New York University Press.

Jenkins, Henry, Katie Clinton, Ravi Purushotma, Alic J. Robinson, and Margaret Weigel. 2006. *Confronting the Challenges of Participatory Culture: Media Education for the 21st Century*. Chicago: MacArthur Foundation.

Kennedy, Randy. 2007. "If the Copy Is an Artwork, What's the Original?" *New York Times*, December 6.

———. 2009. "Artist Sues the A.P. over Obama Image." *New York Times*, February 9.

———. 2011. "Shepard Fairey and the A.P. Settle Legal Dispute." *New York Times*, January 12.

Lessig, Lawrence. 2004. *Free Culture*. New York: Penguin.

Litman, Jessica. 2006. *Digital Copyright*. Amherst, NY: Prometheus.

Sex Pistols. 1977. *Never Mind the Bollocks, Here's the Sex Pistols*. Warner Bros., compact disc.

Shapiro, Peter. *The Rough Guide to Hip-Hop*. London: Penguin.

Whittaker, Richard. 2008. "Artist Cage Match: Fairey vs. Orr." *Austin Chronicle*, May 16.

8

Facing

Image and Politics in JR's Global Street Art (2004–2012)

MICHAEL LEVAN

The face is the only location of community, the only possible city.
—Giorgio Agamben (2000)

Faces. Huge faces. Giant portraits of everyday people, making faces, pasted on the faces of buildings, walls, bridges, and vehicles of global urban life. Mostly uninvited faces, made somehow more inviting by their illegal surfacing. Defacing, refacing, and effacing the city, French artist JR faces the world as a grand installation space. Employing a kind of culture jamming via encounter, portraiture, and wheat-pasting, JR is the anonymous face of a global, altermodern, critical art project.

In this essay, I consider the ways that JR's street art exhibits a particular mode of culture jamming that I call *facing*. Through his images of faces, JR forces a confrontation with political complacency around the impact of poverty and economic globalization on people, communities, landscapes, and cities. His giant photos reface urban surfaces as singularities of expression: the images force contact with oppression, suffering, and globalization—but do so unexpectedly with laughter, grimaces, and looks. JR's images deface the architecture of exclusion that produces the people and places without a part in the order of art and politics by giving a face to it and making us *face* that face. Facing is always multiple. Facing is simultaneously a performance of image, of surface, and of relationship, all taking place at the intersections of aesthetics, politics, memory, and place. I explore the role of facing in JR's work in terms of the event-oriented and serial nature of his projects, of the images themselves (their lives lived between ephemerality and recirculation, the role of expressive contact, and their occasional

Figure 8.1. *Wrinkles of the City: La Havana*, Alfonso Ramón Fountain, Batista, Cuba, 2012. Photograph by JR, used with permission of the artist.

deployment as partial images), and of the surfaces on which the giant photos are affixed.

JR has had a quick rise to fame in the art world and beyond, earning accolades for his enigmatic, transformative, and participatory art. At age twenty-seven, he was chosen for the 2011 TED Prize, with its $100,000 award and "one wish to change the world." With the prize money, he initiated a project called Inside Out, a "global art project transforming messages of personal identity into works of art" ("Inside Out," n.d.)[1] in which people express themselves in black-and-white self-portraits that are printed as posters to be wheat-pasted in public spaces. Anyone with computer access can participate through insideoutproject.net, and photobooth installations for the same purpose were staged at galleries in France, Abu Dhabi, and jointly in Israel and Palestine. Portraits, as well as photographs of the pastings in situ, are found, with ongoing documentation, on the project website and JR's Facebook and Instagram feeds. He resists labels, he remains anonymous, he challenges aesthetic and political norms, and he spurs thought. He delivers a blow to the face

of global media representation, economic oppression, and conditions of life that would preclude dignity.

To consider facing as a style of culture jamming—that is, to explore how it bends, detours, disrupts, and distends hegemonic cultural norms by using the very media and material of those norms—I focus mainly on JR's works that contribute to his multisite projects *28 Millimeters* and *Wrinkles of the City*. On the face of it, JR's work seems simple: take a picture of someone, blow it up, and paste it on a large urban surface. Do it without official permission, and it is guerrilla street art. Do it in Parisian ghettos, *favelas* in Rio, or slums in Nairobi, and it becomes a transformative practice in the face of poverty and oppression. Do it on prestigious museums like the Tate Modern, and it becomes an agent of change. The method may be simple, but accounting for it reveals complex layers of critique woven into the multiple performances of facing.

JR works face to face with strangers, listening to the stories of the people he visits and photographs. With the help of friends and the residents in the communities where the works are produced, he pastes large photos of faces onto buildings, barricades, roofs, trains, bridges, busses, and industrial vehicles like garbage trucks. The large, close-shot black-and-white images shout out in the visual code of attention normally monopolized by advertising. They are thus "in your face." JR's projects present faces of the global multitude—of those who usually do not count, in places that usually do not count—while transforming the faces of cities into temporary art galleries and communities of participants into curators and critics. As JR describes it, his work "mixes art and act. It talks about commitment, beauty, freedom, identity, and limit" (quoted in Lichfield 2008). Part traveler, part artist, part vandal, JR refashions the world as an infinite gallery.

JR's quasi-anonymity—he goes only by his initials—makes it a little easier for him to pursue the clandestine work of illegal street art. It also allows for a streamlined biography. The basic story is that he was raised in the suburbs of Paris in a middle-class family of mixed Eastern European and North African origins. By fifteen he was hanging out with graffiti artists and tagging in the streets. At seventeen, in 2000, he found a cheap camera on the metro, started taking photos of local graffiti and friends, and began pasting photocopies and paper prints of them on

walls around the city. He has called himself a "photograffeur," an "artivist," a person who pastes posters, and "an all-surface wallpaper man that retired to become a printer" (quoted in Michaels 2011, n.p.). These changing and often facetious labels, coupled with his desire to remain anonymous, is a strategy JR uses to keep the focus on the projects themselves, the people he photographs, the places they live, the communities that live among and help produce the works, and all of the conversations and questions that the work engenders. As he said in a 2009 interview with Ed Caesar, "knowing my full name would add nothing."

Almost all of JR's work is interventional, critical, and questioning. A common theme brings together media representation, social justice, and dignity. In 2004, for example, JR began what would become the first of his *28 Millimeters* projects, *Portrait of a Generation*. For this project, JR went to Le Bosquet in Montfermeil, a Paris suburb known for crime, poverty, and its large population of African immigrants. JR took portraits of young residents of the area he was friendly with and pasted large posters of the photos back in the neighborhoods where they lived. Making unauthorized (that is, illegal) use of spaces to present art with a political and social message is a practice common to culture jamming. So is the effect of the photos: questioning boundaries by drawing attention to the often invisible, taken-for-granted fact of the boundaries themselves. The subjects of these photos were ordinary residents. Larger than life images tend to be reserved for models and celebrities. Thus, the scale of images often marks a boundary between fame and ordinariness. JR casts ordinary people at extraordinary scales, a procedure that takes to task both the concept of fame as a commodification of a person's image and the general political oblivion of ordinary people. But given that the subjects were young black immigrants, the work also makes a point that these young men are cut off and alienated from the very category of ordinary. They are rendered invisible through prejudice. They are not supposed to appear at all. By pasting their faces back in their own neighborhoods, JR highlighted the singularity of people known to much of France only as a part of a vague, nameless, faceless horde to be feared.

The most famous image from this period is *Ladj Ly*, a photo of several black youths in front of a decaying ghetto backdrop of boarded-up buildings covered with spray paint. One subject is in the foreground, raising what viewers expect (based upon habituated consumption of

Figure 8.2. *28 Millimeters: Portrait of a Generation, Ladj Ly*, Les Bosquets, Montfermeil, 2004. Photograph by JR, used with permission of the artist.

media representations) is a rifle or an automatic weapon of some sort. What one realizes, first with surprise and then with embarrassment, is that the young man is actually holding a video camera. Illuminated here is a system of visual images dominated by what Gilles Deleuze (1986) calls clichés: "these floating images, these anonymous clichés, which circulate in the external world, but which also penetrate each one of us" (208). The photo works first to illuminate the visual clichés of prejudices: we see how we see them. It then suggests something more powerful, a reappropriation of the media gaze itself, and a reversal of the order of viewing: We see you seeing us; we see how you see us. But, of course, a viewer of this image would have had to be in Montfermeil in 2004 to have seen it. When there were riots in the Paris suburbs in 2005, however, wider viewership arrived via the French media coverage of the event, and JR's photographs were broadcast as a backdrop to burning cars and other images of violence. By 2008, JR would be invited to paste a mammoth version of *Ladj Ly* on the side of the Tate Modern in London.

JR returned to Le Bosquet in 2006 with his camera and its 28-millimeter lens, the only lens he had at the time. "With that lens, you have to be as close as 10 inches from the person. So you can only do it with their trust" (JR 2011), he explains. To take a portrait with a 28-millimeter lens, photographer and subject have to inhabit intimate space together, be in close contact with each other. They have to be face-to-face to make a picture of a face. This gesture of facing flies in the face of typical media practices, where images are captured from afar with long lenses and the apparent objectivity of distance. By contrast, the intimacy of contact that is part of the process of taking these photos is a performance of trust, what Alphonso Lingis (2004) calls "the most joyous kind of bond with another living being" (x), and a revelation of singularity. JR asked the young men being photographed to make scary faces, diverting the clichés of media representations from danger to humor by way of hyperbolic poses, "in close-up, grimacing like the extra-terrestrials that most Parisians assume they are" (Lichfield 2008). Allowing the men to "play the caricatures of themselves" (JR 2011) gives them not only agency in how they are represented in the photos, but also agency in reappropriating and responding to their distorted media representations. In effect, this is similar to one of the earliest forms of culture jamming, what Mary Louise Pratt (2008) calls, in the context of seventeenth-century European colonialism, autoethnography: "instances in which colonized subjects undertake to represent themselves in ways that engage with the colonizer's terms" (9). By taking hold of the very forms of representation offered by news media and branding, facing is both resistance and reply to the codes of representation coming from the outside. To make the gesture more pointed and poignant, JR posted this round of images not on the surfaces of Le Bosquet but across bourgeois neighborhoods of Paris. He created a milieu of encounter as an exposition of the relationality of fear. In a facing gesture aimed at reversing the anonymity and invisibility that is partly constitutive of this fear and prejudice, JR included the names, ages, and building numbers of the people in the photos.

JR attributes much of this kind of fear and prejudice to the practices of, and visual system created by, the global news media, and most of his projects are inspired by a curiosity to visit places that have been painted in a grim light. This curiosity has taken him to Jerusalem, Ramallah,

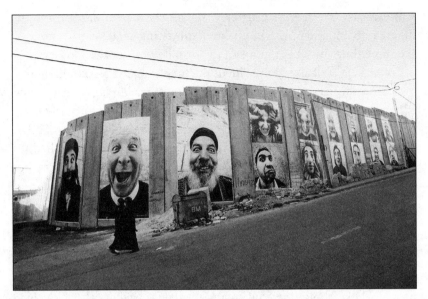

Figure 8.3. *28 Millimeters: Face 2 Face*, Separation Wall, Palestinian side in Bethlehem, 2007. Photograph by JR, used with permission of the artist.

Rio de Janeiro, Phnom Penh, New Delhi, Nairobi, Liberia, Sierra Leone, Shanghai, and Havana. In 2007, JR and his artist friend Marco went to Israel and Palestine and extended the *28 Millimeters* project with *Face-2Face*. This time JR sought Israelis and Palestinians who held the same kind of jobs, such as taxi drivers, lawyers, and cooks. Again using close-up shots, JR took portraits of people making faces "as a sign of commitment" (JR 2011), and with their agreement that their portraits would be pasted side by side with their Israeli or Palestinian counterpart—face to face—on houses, in street markets, and on the barrier wall.

Though one set of three portraits from the *Face2Face* project featuring an imam, a rabbi, and a priest received the most international attention, it is important to note the multiple layers of *exhibition* and *discussion* JR aims for in his projects. Above all, JR transforms places where art is minimal or absent into galleries in their own right, if only temporarily. While the team is pasting, people will ask about what they are doing. JR will respond that he is making an art project and then give a description of the project. But he won't explain the project or interpret it for anyone, opting instead for the hope of organic, local engagement

with the art. In effect, JR's art exists locally as a catalyst for both un-hinging sedimented perceptions and animating social connection. At the same time, JR takes photos of the installed posters as another layer of artwork, as well as making videos documenting the work, thus allow-ing the art project to travel in the media of other kinds of art. Further, in many instances he transforms the works by another form of travel: pasting them in (and sometimes on) museums and the surfaces of other cities imparting with the images the stories of those photographed (as when he exhibited images from *Portrait of a Generation* and *Face2Face* in London, Geneva, and Brussels in 2008). With these various types of travel come transformations of meanings, discussions, and attitudes—less a matter of self-expression in a homeplace and more a matter of an expression of human solidarity in seats of global power.

Part of the method and performance of the project is to place art in places it usually does not exist and then leave. Once JR is gone, the people whose photos were taken and pasted, as well as others involved in pasting or allowing posters to be pasted on their buildings, are the ones left explaining and engaging in discussions with other residents. One gesture of facing, then, is to make art a matter of community en-gagement; pasting art on the face of the city induces people to face each other. A big part of the beauty of this work is its simplicity: photos, paper, glue, and social connections. "My work is really minimal," JR says. "I have to paste strips one after the other, for days or months, with hundreds or thousands of people. That's what I like about the pasting: uniting people" (quoted in Michaels 2011, n.p.). Since most of JR's work is unauthorized and illegal, he needs the tacit authorization of local in-habitants, a community of co-conspirators in the making of art. Another gesture of facing is to provide the media with new questions to ask about places. Yet another is to call into question and potentially undo the mu-seum system of showing and curating art in controlled spaces (see also Feiten, chapter 9 in this volume). As JR explains, "When you paste an image, it's just paper and glue. People can tear it, tag on it, or even pee on it. . . . But the people in the street, they are the curator" (JR 2011). The physical work is ephemeral and built to decay, but the social and cultural work is designed to persist and transform.

The third iteration of *28 Millimeters* took place from 2008 through 2010 and is devoted to women. *Women Are Heroes* puts a face on the

women who sustain community in places known for poverty, war, crime, and oppression—places like the massive Kibera slum in Nairobi, Kenya, and the notorious Favela Morro Da Providencia in Rio de Janeiro, Brazil. The visual concept is similar. JR makes close-up portraits of women in these communities. The women are laughing, squeezing their eyes shut, exaggerating wide-open eyes, screwing up their mouths, blowing out their cheeks, making steely stares, holding their faces in their hands. The images are blown up to one or two stories tall—sometimes the entire faces, sometimes just a set of eyes looking out or a mouth consuming a wall in laughter. The images appear on buildings (looking back on the communities they are part of) or rooftops (gazing up at airliners and satellites) or on the sides of trains and trucks (traveling with the machinery of modernization and labor).

The concept of facing starts to come into fuller view in the artistic process, the artistic performance, and the ongoing artistic consciousness engendered in *Women*. On one level, it is JR who is motivated to face (and reface) the media portrayal of places of despair and destruction because he believes there are always other views—and an irrepressible joy of life and love—behind the face shown by the media:

> What I want to do is bring my work into places where you wouldn't imagine seeing any work at all. And that leads me into places portrayed in the media as nothing but violent. I want to try to see something else. If you go and look in the favelas for crime, then, of course, you're going to find it on every corner. But, if you go and look for hope and life, then you're going to find it in every house. And nobody's focusing on that. Art has never changed the world, but it can change your vision. (Quoted in Sooke 2011, par. 10–13)

The faces, eyes, and mouths, looming impossibly large on the surfaces of everyday life, render vision haptic—the material touch of contact. In terms of the content of the images, the most striking interrogation is of *the look* or *the pose*. The way people pose for JR is so purposeful that it is unmistakably a performance—one that appears as a performance. It is a performance of appearing. In making a face, the face finally appears. As Barthes (1981) has argued, when being photographed I constitute myself as a pose; "I transform myself in advance into an image" (10).

Being knowingly photographed is always a performance for the gaze of a camera, but it is one that often allows the face to efface itself and recede into indifference (see Agamben 2011, 79–80). One of the things JR's subjects perform with force is an absence of indifference. They face the camera, make a face, and thus create a face dominated by relations of proximity and contact, what Barthes called the look, "that crazy point where affect (love compassion, grief, enthusiasm, desire) is a guarantee of Being" (113).

For *Women Are Heroes*, JR seeks women who understand the project, agree to give their look to JR's camera, and have their portraits contribute to it. One part of facing is making contact. Upon arriving in what is often a dangerous site, with no backing by NGOs, government agencies, or other institutions, JR must make contact with locals to explain the project and secure participants. Contact is immediate communication, the materiality of human connection. It is an act of recognition and a validation of singularity. It requires facing another, face to face. Contact takes courage and calls trust into being. JR explains what it is like to show up in a new location like this:

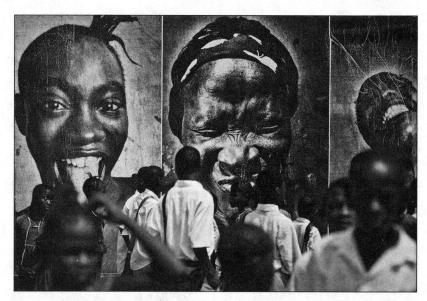

Figure 8.4. *28 Millimeters: Women Are Heroes*, Bô City, Sierra Leone, 2008. Photograph by JR, used with permission of the artist.

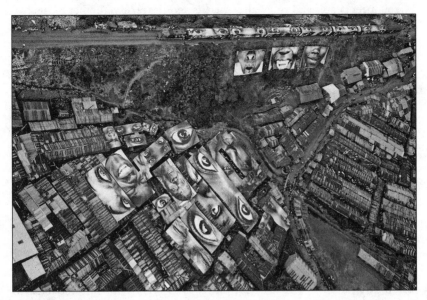

Figure 8.5. *28 Millimeters: Women Are Heroes*, action in Kibera slum, Nairobi, Kenya, 2009. Photograph by JR, used with permission of the artist.

Everything is about eye contact. The first thing they have to know is that there's no brand behind it, that's really important. I'm not trying to use the favela to advertise Red Bull or BMX bikes, and I'm not a journalist either. I could speak for hours about the origins of the poster technique, but out there, there is not the same frame of reference. You have to go straight to the point. There's this person in front of you and there is no fucking around. That's how I test my projects: If they get it, it's going to work. (Quoted in Day 2010)

In other words, the entire point has to be made on the face of it: JR has to make his case, as a stranger, without artifice, to establish trust and to enlist participants. With the social, political, and ethical immediacy of the situation, he must communicate face to face. Without contact there is no trust; without trust there is no project. The case he needs to make is to be able to bring art (and art-making) to participants and their communities by taking photos of their faces, photos of faces they are in control of, and to use these photos to alter the face of the city—indeed, to bring about an alternative face of city—through pasting:

You meet people and you realize there is another reality, another life that is not represented enough. That is why I try to emphasize portraits of people. By this method, I hope to be able to get the media interested in these places again through events other than violent ones. That means using the same media "machine," but using it to bring a new view of these places. That's why I use large-scale images, the code of advertising— communication through images, but in spaces that can't be used by advertising. (Quoted in Artinfo France 2010, n.p.)

In Rio, photos of twenty women were pasted on forty houses on a hillside in the Providencia favela, facing the city. The site underwent a tremendous transformation with this patchwork of giant faces and strong eyes looking onto Rio, facing the city from the margins of life. The gesture is perhaps the most basic expression of the political: a demand for recognition and autonomy over appearance. As Giorgio Agamben (2000) succinctly puts it, "The task of politics is to return appearance itself to appearance, to cause appearance itself to appear" (95). It is important for JR that the transformations of appearance work on several levels. "There is no reason for people to go into a place like that and create an artistic project," he says. "Because we arrived without any sponsors or political objectives, people always received us with open arms. They are happy to see another approach, and not a journalistic one—an approach where they are actors" (quoted in Gillett 2011). In many ways, JR's *Women* project faces down nothing less than the dominant mode of Western visuality captured by John Berger's (1972) aphorism, "Men act and women appear" (47). The essence of facing is the forcefulness of its appearance, which arrives as both a surprise and a demand—a demand to be seen outside of indifference.

Trust is essential for a project to work, and its enactment can be thought of as a medium of JR's projects, which are ongoing events. JR arrives with nothing prearranged, as a stranger, an outsider, and completely out of place. Once he finds some interested people, they have to trust him with their images, and he has to trust them with their urban surfaces. As Lingis (2004) writes, "Trust is a break, a cut made in the extending map of certainties and probabilities. The force that breaks with the cohesion of doubts and deliberations is an upsurge, a birth, a commencement. It has its own momentum, and builds on itself. How one

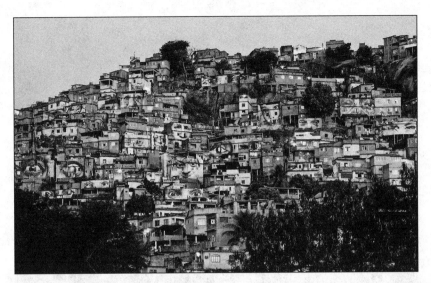

Figure 8.6. *28 Millimeters: Women Are Heroes*, action in la Favela Morro da Providência, Rio de Janeiro, Brazil, 2008. Photograph by JR, used with permission of the artist.

feels this force!" (65). For the projects to work, they need just this sort of momentum to carry the power of art beyond the presence of the artist or the stewardship of artworld institutions. Almost all of JR's projects exceed the space and time of individual pieces. The images of women's eyes and faces in Kibera were printed on vinyl in order to perform double duty as both art surface and protective roofing. In both Kibera and Providencia, JR returned to help set up community art centers—funded by sales of his work in the context of established art markets—and to encourage residents to make and paste their own portraits.

The transformation of these outside spaces into spaces of art is thus inherently political. Jacques Rancière (1999) (a different JR) describes the close relation between the political and the aesthetic: "Political activity is whatever shifts a body from a place assigned to it or changes a place's destination. It makes visible what had no business being seen, and makes heard a discourse where once there was only place for noise; it makes understood as discourse what was once only heard as noise" (30). In *Wrinkles of the City*, JR turns his investigation to the politics of memory in the changing face of modernizing cities. He began with Cartegena, Spain (2008), and Shanghai, China (2010), before mov-

Figure 8.7. *Wrinkles of the City: Shanghai Action*, Shi Li, 2010. Photograph by JR, used with permission of the artist.

ing on to Los Angeles, California (2011), and Havana, Cuba (2012). In Shanghai, for example, rapid industrialization has brought a mad rush of new urban construction and a concomitant demolition of older parts of the city. The influx of new residents has no tie to the memory of the place. JR talked with and photographed older residents of the city who retained a sense of the place prior to the recent changes. The black and white portraits highlight the subjects' wrinkles in purposeful poses. Many have eyes closed or squeezed shut, suggesting both reminiscence and dismay. Others have their hands at their faces, evoking the same dynamic of sleepy remembrance and consternation. There is a convergence of the wrinkles of the city as the images are pasted on the sides of crumbling buildings slated for demolition and surrounded by sprawling high-rises. Among rubble and decay, the effect is one of beautiful sadness, of the passing of time, and a passing of memory. Here we see that the faces of cities and the faces of its residents are affixed to each other, dance partners in the life of the city.

In *Wrinkles of the City*, JR is concerned with invoking different kinds of changes in perceptions. The point now is to focus perception on

change itself and the ephemerality of faces (both of people and cities) wrought by the passing of time. It is a question of understanding the city as a living event, as an ongoing performance of habitation and contact, in spite of decay. In effect, JR suggests that social links and connections are themselves important media of his work.

JR's latest projects push facing, and the questions it forces us to face, into new directions. *Unframed* explores what happens when taking the work of other photographers and pasting their massive blow-ups on city surfaces. Here facing is more about the viewer facing a site that is transformed by an image. *Inside Out*, JR's "wish" from the TED Prize that I mentioned at the beginning of this essay, is a global project that explores the faces of viewers themselves, getting them to face their own artistic potentials. For *Inside Out*, anyone can upload a portrait of him- or herself and JR will send back a poster of the image ready for pasting (displaying both the original photos and photos of the pasted posters on the project website ["Inside Out" n.d.]). Part of the project also involves a photo booth as a participatory installation at galleries showing JR's work, where people can sit for their contributing portraits, which are also displayed online. As of the summer of 2016, JR's website claims

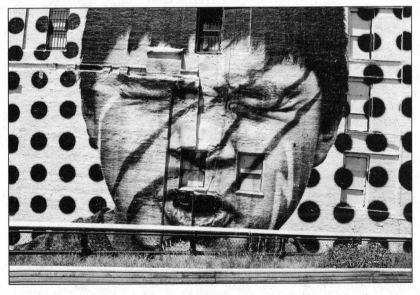

Figure 8.8. *Inside Out: Lakota Project*, Thirtieth Street, New York City, 2011. Photograph by JR, used with permission of the artist.

that over 260,000 people from 129 countries have participated ("About," n.d.). The *Inside Out* project has morphed into more direct actions in a few cases, with building-sized pastings of Native American Lakota portraits in New York City and pastings of everyday Tunisians around post-revolution Tunisia—where prior to the revolution only portraits of rulers could appear in public. JR describes the Tunisian people's right to their images as a move from autocracy to "artocracy" ("Artocracy in Tunisia," n.d.). In work like this, JR attempts to restore the faces of people and cities as places of contact and dignity and joy and trust.

The work of facing uses the most fundamental mediums of human interaction—human faces—to speak the voice of equality-in-itself. Rendered in laughter and lightness, the political and moral demands of facing the Other shouts out loud. As a form of culture jamming, facing forces contact with the great multitude of common humanity that the forces of power leave out of the realm of the visible. These giant faces disrupt and disarm the visuality of global power, its economic and political domination, and its division of the sensible. In turn, these faces perform resistance to the complacencies of cynical modernism.

NOTE

1 Includes the following steps: "1. Upload a poster; 2. Receive a poster; 3. Paste it for the world to see."

REFERENCES

Agamben, Giorgio. 2000. *Means without End: Notes on Politics*. Translated by Vincenzo Binetti and Cesare Casarino. Minneapolis: University of Minnesota Press.

Agamben, Giorgio. 2011. *Nudities*. Translated by David Kishik and Stefan Pedatella. Stanford, CA: Stanford University Press.

"About." N.d. InsideOutProject. www.insideoutproject.net.

"Artocracy in Tunisia." N.d. InsideOutProject. www.jr-art.net.

Artinfo France. 2010. "Proof through Action: A Q&A with Elusive Street Artist JR." Blouinartinfo.com, December 20. www.blouinartinfo.com.

Barthes, Roland. 1981. *Camera Lucida*. Translated by Richard Howard. New York: Hill & Wang.

Berger, John. 1972. *Ways of Seeing*. London: Penguin.

Caesar, Ed. 2009. "Poster Boy for the Third World." *Sunday Times Culture Magazine*, February 15.

Day, Elizabeth. 2010. "Street Art of JR (Interview)." *London Street-Art Design Magazine* blog, May 17. www.londonstreetartdesign.blogspot.com.

Deleuze, Gilles. 1986. *Cinema 1: The Movement Image*. Translated by Hugh Tomlinson and Barbara Habberjam. Minneapolis: University of Minnesota Press.

Gillett, Jody. 2011. "Eyes Open." *Mondomix*, January 20. jr.mondomix.com.

"Inside Out." N.d. InsideOutProject. www.insideoutproject.net.

JR. 2011. "JR's TED Prize Wish: Use Art to Turn the World Inside Out." TED Talk video, March. www.ted.com.

Lichfield, John. 2008. "The Next Big Thing." *Independent*, April 7.

Lingis, Alphonso. 2004. *Trust*. Minneapolis: University of Minnesota Press.

Michaels, Samantha. 2011. "A Conversation with JR, Intrepid French Street Artist." *Atlantic*, September 6. www.theatlantic.com.

Pratt, Mary Louise. 2008. *Imperial Eyes: Travel Writing and Transculturation*, 2nd ed. London: Routledge.

Rancière, Jacques. 1999. *Disagreement: Politics and Philosophy*. Translated by Julie Rose Minneapolis: University of Minnesota Press.

Sooke, Alistair. 2011. "JR: Artist with the City as his Canvas." *Telegraph*, February 28.

9

Answering Back!

Banksy's Street Art and the Power Relations of Public Space

BENEDIKT FEITEN

More than five hundred years after its creation, Leonardo da Vinci's *Mona Lisa* has become an icon of Western culture. Gift shops sell her true-to-original replications on postcards, posters, and coffee mugs. The lovely lady's face has been reproduced in more than two hundred paintings and three thousand advertisements (Sassoon 2001, 1). It appears in films and in the fictions of D. H. Lawrence and Dan Brown. Legendary jazz artist Nat King Cole asks in his 1950 hit "Mona Lisa," "Are you warm, are you real, Mona Lisa? / Or just a cold and lonely lovely work of art?" For centuries, the *Mona Lisa* has been a powerful force in defining artistic and aesthetic conventions.

But some artists disturb those conventions: the iconic painting has been appropriated, altered, and reinterpreted by celebrated greats like Kazimir Malevitch, Marcel Duchamp, Salvador Dali, Fernando Botero, and Andy Warhol. Their acts of appropriation target not only the *Mona Lisa*, but also the naturalized values of beauty, composition, and proportion ascribed to her. Marcel Duchamp's version, for example, is a found postcard picture of *Mona Lisa* with an added mustache and the hand-written letters "L.H.O.O.Q" underneath. In colloquial French the letters can be pronounced as "Elle a chaud au cul," which translates to "she is horny." More than destabilizing the *Mona Lisa*'s gender identity, what Duchamp (and others) achieved was to "nominate the petrified painting as a center of activity: a subject of debate, parody, paradox, criticism, thought and reinvention" (LaFarge 1996, 380).

A more recent appropriation of *Mona Lisa* that gained popularity was a work by Banksy, the anonymous and acclaimed street artist from England.[1] While Duchamp manipulated the *Mona Lisa* in the

context of museum art, Banksy abducts her to the streets, where she confronts not museum visitors, but random passersby in London. His early 2000s mural stencil rendition of the *Mona Lisa* shows her with a rocket launcher—turning her famous smile into an outlandishly menacing grin. Leonardo's creation has been transformed into an ironic piece of street art by an anonymous author, of whom we know little more than the pseudonym "Banksy." *Mona Lisa*'s enigmatic smile and the portrait model's uncertain identity mutate in Banksy's version. Devoid of demure mystery, her smile is a threatening one, while it is now the creator of the image who is shrouded in mystery.

Banksy's art seeks to provoke critical reflection upon the ways we consume images and to transform public space into a field for improvisation. He explicitly frames his work as an uncompromising opposition to advertising: "The people who truly deface our neighbourhoods are the companies that scrawl giant slogans across buildings and buses trying to make us feel inadequate unless we buy their stuff. They expect to be able to shout their message in your face from every available surface but you're never allowed to answer back" (Banksy 2005, 8). Banksy's art dares to answer back, in what I argue is a form of culture jamming. Mark Dery (1993) describes culture jammers thus: "Intruding on the intruders, they invest ads, newscasts, and other media artifacts with subversive meanings; simultaneously, they decrypt them, rendering their seductions impotent" (7). Banksy's culture jamming "intrudes on the intruders" on two levels: first, he reclaims physical space dominated by advertisements, and second, he also seeks to liberate the mental space thoroughly infiltrated by marketers. In doing so, he makes clear that street art's relationship to advertising must also be a struggle about how we perceive images and what room we give them in our thinking and feeling. In order to issue potent answers, then, Banksy's art has to succeed not only in reappropriating the space advertisements take, but also in subverting the messages they contain.

Banksy's culture jamming invades commercialized public space and creates disturbances in the ways iconic images are read and perceived. His now famous stencil graffiti style, where he cuts shapes out of paper and then applies them to a new surface with spray paint, quotes not only museum art but also news photography, advertisements, and pop cultural icons. By occupying the public space with reworked images, Banksy

adapts the language of advertising to promote a critical reception of those images—a mode of reception that questions their intended meanings. In particular, Banksy's art cleverly uses its urban surroundings for his cultural criticism and political statements. Sometimes his pieces have a playful approach, sometimes they deliberately irritate, but always they derive their meanings from and within their urban surroundings.

Examining Banksy's background in graffiti culture and the street art movement allows us to understand how his work can unmask spatial organization and its corresponding power relations and at the same time turn familiar images from sales pitches to materials for playful intervention. As I will argue, Banksy's critical stance works through ironic self-reflexivity. Robert Stam (1985) defines reflexivity as "the process by which texts . . . foreground their own production, their authorship, their intertextual influences, their reception, or their enunciation" (xiii). Even though Stam uses the concept to demonstrate how reflexivity works as a subversive impulse in literature and film, the nature and function of his examples are strikingly similar to basic strategies of Banksy's works. According to Stam, reflexive texts "share a playful, parodic and disruptive relation to established norms and conventions. They demystify fictions, and our naive faith in fictions, and make of this demystification a source for new fictions" (xi).

Of course, there are many different kinds and intended purposes of reflexivity. Banksy's stance is ironic: his reflexivity not only dismantles conventional, hegemonic, and commercialized ways of constructing meaning, but also discloses how they echo through subculture and in Banksy's own art. Linda Hutcheon (1994) describes irony as "this strange mode of discourse where you say something you don't actually mean and expect people to understand not only what you actually do mean but also your attitude toward it" (2).[2] Reflexivity and irony both express Banksy's dual focus on which meaning is communicated and, even more importantly, on how it is communicated. His art lays open the ways in which city planners and corporations shape public space. At the same time, his playful images reanimate space as collective territory that hosts a participatory and ephemeral exchange. Considering Banksy's work as ironic and self-reflexive also enables us to understand his critiques as being aimed not so much at specific brands or corporation, but rather at the logic behind their marketing strategies and ways of constructing meaning.

Who Do We Talk about When We Talk about Banksy?

Banksy is indisputably one of the most popular street artists today. His choice to work anonymously does not diminish the fact that a carefully constructed and expressive authorship is at work. In his introduction to the exhibition catalogue *Fresh Air Smells Funny*, Rik Reinking (2008) considers the author-persona Banksy to be a conscious and strategic promotional act (142), more than a means of preserving the anonymity that illegal graffiti writers must maintain. Banksy's career began as a spray-can graffiti writer in and around Bristol in the 1990s. During the millennial years he switched to what is now his signature stencil technique, which had already been a stylistic feature of French street artist Blek le Rat since the 1980s. Banksy's adaptation of this recognizable style quickly attracted a great deal of attention in the graffiti subculture, and he soon was organizing exhibitions and selling his art so successfully that Sotheby's Cheyenne Westphal (2006), when interviewed by Max Foster for CNN's *Your World Today*, called the emerging interest in other street artists that derived from his success "the Banksy effect." In spite of his tremendous popularity, Banksy guards his anonymity cautiously and is the subject of ongoing rumors and speculation. Banksy comments on that hype in one of the pieces in his 2006 exhibition *Barely Legal*: a television screen shows a deliberate misquotation of Andy Warhol's famous slogan "In the future, everyone will be world-famous for 15 minutes." Banksy's version reads, "In the future, everybody will be anonymous for 15 minutes." In the digital age when artists and corporations court people to become online followers (and potential customers), Banksy interprets anonymity as freedom, a position consistent with the skepticism his art often expresses toward public surveillance.

Issues of authorship make it difficult to talk about Banksy's art in terms of "originality"—his production strategies and visual style can easily be copied. That is also why some unauthorized works using a Banksy-esque style could not be identified as original. In 2008, several exhibits could not be auctioned at Sotheby's because Banksy's agency, Pest Control, refused to authenticate them (Collett-White 2008). Part of this ambiguity is rooted in Banksy's style, which necessarily challenges the concepts of originality and authenticity. This is most explicit in the fake artifacts he smuggled into the exhibitions of various museums. In

2005, he hit the New York City Museum of Modern Art, the Metropolitan Museum of Art, the Brooklyn Museum, and the American Museum of Natural History in New York, as well as the British Museum in London with installations including a stuffed rat with a microphone and a backpack, or a fake cave painting depicting a caveman pushing a shopping cart. All fake exhibits were carefully integrated, mimicking the exhibition style and explanatory signs of the respective museums. A spokeswoman for the British Museum admitted that the Banksy's caveman "looked very much in keeping with the other exhibits" ("Cave Art" 2005). The artifacts often remained unnoticed for a considerable amount of time, and the caveman in the British Museum even lasted several days. In this way, the installations provided solid support for Banksy's suggestion that it is not the actual exhibits that determine whether something is perceived as authentic, but rather the institutional trappings of the "museum" and how it communicates to its visitors. By imitating its ways of presenting a certain artifact, even inauthentic objects with the most explicit humorous alterations could pass as a piece of art, or as part of our cultural heritage.

Banksy's Graffiti Roots

While Banksy today is one of the most prominent figures in the street art scene, his work shows the spirit of a sprayer. Considering his background in graffiti writing helps us better understand the territorial and competitive dimensions of his art. In rare interviews, as well as in his 2005 book *Wall and Piece*, Banksy positions himself within the graffiti tradition. His art draws upon many different aspects of graffiti writing that go back to New York in the 1970s. Graffiti usually consist of messages and images outside dominant culture and mainstream media. They can serve as a means of propagating political slogans or as a vehicle for achieving underground fame by spreading a name tag all over a city or achieving recognition by conquering spectacular sites. Banksy's recurring signature, and its visibility on locations like the West Bank barrier, helped create that kind of fame. People have used graffiti for documenting their presence and leaving their traces for a long time. This aspect was especially powerful in the urban graffiti movement of the 1970s, but it is still the main motive behind tagging, and remains an

implicit or explicit force behind much of graffiti writing, and Banksy's art, too. In "Kool Killer or the Insurrection of Signs," Jean Baudrillard (1993) describes graffiti as a "new type of intervention in the city, no longer as a site of economic and political power, but as a space-time of the terrorist power of the media, signs and the dominant culture" (76). Baudrillard considers the pseudonyms on New York City walls a subversive means for diluting the significations of urban advertising and street signs. What graffiti can achieve, then, is to revive urban space as a "collective territory" (79).

The graffiti culture out of which Banksy emerges is also highly competitive. Conquering and defending urban territories by crossing or painting over pieces made by rival artists is an integral part of this subculture. There was significant controversy over Banksy's 2009 crossing of a "classic" 1985 piece by acclaimed London graffiti artist Robbo. Even though the original large "ROBBO" was hardly decipherable under scrawny tags by that time, King Robbo considered Banksy's addition of a man wallpapering the messy graffiti an insult. Robbo and his fellow writers came back and painted over Banksy's work. A vigorous exchange of blows developed, with Team Robbo attacking Banksy's pieces throughout London (Morris 2011).[3]

Those territorial tensions around Banksy's graffiti have their counterbalance in a playful dialogue reminiscent of scribblings, where random readers add their own comments to prior messages. Robert Reisner (1974) provides an example of this kind of multiple, anonymous authorship in an exchange on the wall of a public toilet. "Shakespeare eats Bacon" reads the original scribble, a pun referring to William Shakespeare's alleged superiority over philosopher Francis Bacon. A subsequent note in different handwriting announces, "It can't be Donne" (6), adding poet John Donne into the mix. Here, graffiti becomes a game open to everyone, where the greatest control over meaning is appropriated by the latest contributor.

Banksy's reworking of and commenting upon preexisting images, texts, and advertisements similarly invite people to participate. This process is what Carrie Lambert-Beatty (2010) calls invitational culture jamming, where artists apply pieces in public space that call for interventions by random passersby. In several places Banksy garnished empty walls with a stencil graffiti reading: "This wall is a designated graffiti

area." Above the letters, an emblem resembling the seal of British Royal Warrants adds official pretense: it depicts ornate lions holding a shield between them, adorned by a crown on top (Banksy 2005, 50). The Crown grants this seal to premium products in various categories such as clothing, spirits, groceries, and tea. Using the emblem for his invitation gives the impression that the graffiti space is approved by the Royal House. This plea for interaction was answered when numerous people tagged the walls Banksy had "authorized" for graffiti. Banksy's art not only calls for creative change; it is itself altered and commented on critically. For instance, Banksy's *Mona Lisa* graffito was altered into Osama Bin Laden and then removed a few days later (26–27). Even if the alteration may not be the most creative one, it is intriguing how the exchange mirrors Duchamp's original destabilization of *Mona Lisa*'s gender identity and how it expresses the iconic status not only of *Mona Lisa* but also of Osama Bin Laden's image. Like everything added to public space in an unauthorized fashion, Banksy's work runs the risk of being buffed out by graffiti removal, painted over by other artists, or gradually worn away by weather (McCormick 2010, 10). As Alain Bieber (2010) writes, "The ephemeral and anonymous artworks also match the character and rhythm of the modern major city, which demands constant renewal and a constant day-to-day urban praxis" (5). The process of mutual reworkings, comments, and reinterpretations points toward the ephemerality of street art, but also to the fleeting nature of a meaning constructed at a certain moment.

You Wanna Take This Outside?

Aside from occasional incursions into gallery spaces, the street is still the place where Banksy practices his culture jamming in full. While Duchamp and Warhol reconstructed the *Mona Lisa* in the museum space—in her "home" so to speak—Banksy takes the *Mona Lisa* out on the street. There, in public space, both street art and graffiti operate in similar fashion, but the two are not synonymous. Whereas graffiti communicates primarily with other sprayers, Banksy's street art is directed at the general public. As Evan Roth explains, "street artists are more likely to make works intended for a wider audience; whereas graffiti writers are often making works to be deciphered just from [sic] other

graffiti writers" (Roth 2010, 334). Banksy's art self-reflexively negotiates its urban surroundings. The walls of urban space are an accessible canvas and exhibition space outside established galleries; furthermore, the reach of Banksy's art is greatly expanded by the many blogs and photo-sharing websites where people document his pieces.

These feedback loops, where potential artists can see the work of others right after they have been finished and use these influences themselves in the next moment, make street art a dynamic and very rapidly changing form (McCormick 2010, 11).[4] Furthermore, a multitude of artistic approaches and production techniques makes street art a highly versatile movement. The term "street art" can be applied to any kind of installation in urban space. It can include guerrilla gardening or experimental technologies like that of the LED art in which animations and slogans are projected onto walls by laser by the Graffiti Research Lab, an international art collective. Street art's urban setting is configured by city planning, architecture, and advertisements. In "Desire," Alain Bieber (2010) asserts that "so-called public space is, in fact, public only in name, reflecting no reality except that of the dominant ideology" (4). Street art challenges the official and institutionalized control of urban space. Lukas Feireiss (2010) further illustrates the subversive position of street art activists: their "abundance of anti-authoritarian practices in everyday life marks the tactical victory of bottoms-up [sic] approaches in comprehending and experiencing the city over functionalistic top-down strategies of traditional urban planning" (2).

A street artist's work develops meanings from its specific site of attachment. Günther Friesinger and Frank Schneider (2010) interpret public space as text, explaining that "as text, the public space is an articulation of power relations, an ensemble of hegemonic symbols. . . . Or, to put it differently: the public space is ruled through and through; a formation that is economically and politically pre(infra)structured and which, as such, always already precedes our communication, which always already exposes subjects to power relations" (15). What Friesinger and Schneider call "hegemonic symbols" include a stop light, a mail box, a billboard, an overpass, or squares designed by city planners. Street art by definition operates in a setting that has already been created. Urban planning and architecture configure the city space we move in, and street art deals playfully with the shapes, lines, and designs of the urban

landscape. All of these factors influence Banksy's works, and their relationship to the urban surrounding is often motivated by formal association. Bieber (2010) uses the term "urban interventions" for street art projects: "Urban interventions result in the aestheticization of the city and the de-aestheticization of art—which can make exceptional moments the new normality, negating the art by virtually making our whole lives an artwork." He also writes that urban interventions "subvert the system, persistently throwing spanners into the works, counteracting homogeneity" (5). Bieber's term fits Banksy's approach very well. Intervention implies that something is amiss, and that street art is a constructive approach to solving it. Many of Banksy's urban interventions react to randomly found shapes and designs, as when Banksy added ears and a tail to a hole in a section of plaster, to make it resemble a rat, and spray-painted a stencil of a screaming girl standing on a chair beside that. Another example is the shark fins he installed in a lake in Victoria Park, London. These works plead for interaction, for experiencing surroundings with open eyes, for seeing and reinterpreting shapes in the urban environment.

While this positive and embellishing way of intervening certainly is a big part of Banksy's work, there are many pieces that create more drastic disturbances in their urban surroundings. For these, Banksy's stencil technique is important to his approach of interrupting the perception of the random passerby. Banksy uses the technique to create life-sized and realistic images of people, secret guests lurking in the urban surrounding. At first glance, passersby may perceive those works as real persons or objects. For example, a stencil depicting a member of the Queen's Guard tagging a wall with anarchistic graffiti elicits a moment of surprise (Banksy 2005, 36). A reproduction of a cash machine, also life-sized, pasted up with fake ten pound bills depicting Lady Diana creates a similar disturbance (96). This is not to say that someone would really try to talk to the Queen's Guard or to push his credit card into the machine's slot. The point is that these works provoke a double-take. Banksy's art changes the focus of the passerby and makes her perceive the city and its elements not only in terms of the functions they fulfill, but also as an aesthetic space, open to revision and co-creation.

Some of Banksy's works intervene still more aggressively in response to their urban surroundings. A security camera aimed at a wall in a

seemingly deserted backyard in Marble Arch, London, drew Banksy's response, "What are you looking at?" written on the wall opposite the camera (86-87). Banksy's question protests how video surveillance transforms public space into a site of control and surveillance. In Banksy's interpretation, the camera creates not security, but insecurity; it raises a question; it destabilizes, rather than stabilizes. Banksy's question implies that the camera is looking at potential crime, even when there is no apparent reason to suspect one. The interrogation, "What are you looking at?" makes passersby aware of the camera and of the fact that there is indeed not much to look at but an empty harmless backyard. The words turn the surveying eye back onto the camera itself and check the power of hegemonic surveillance. Banksy's paintings on the West Bank barrier, which depict idyllic scenes of life on the other side, work in a similar fashion, issuing a subversive critique of prevailing power relations that are expressed through the organization of space. His disruptions are a provocation to think about the spatial surroundings not as something fixed (static) but as maybe something that needs to be fixed (amended).

"Answering Back": Advertising and Its Critical Companion

Banksy (2005) explains street art's confrontation with advertising in radical terms: "Any advertisement in public space that gives you no choice whether you see it or not is yours. It belongs to you. It's yours to take, re-arrange and re-use. Asking for permission is like asking to keep a rock someone just threw at your head" (196). Street art as directed explicitly against the infiltration of corporate marketing in everyday life and experience derives from artists like the duo SAMO (Jean-Michel Basquiat and Al Diaz), whose works in the 1980s played with branding and marketing, using a © symbol in their graffiti slogans (see Buchhart 2010, 13). However, it is important to remember that the relationship between Banksy and marketing is not merely antagonistic. It is obvious that Banksy's art—operating in the same landscapes as advertising and addressing the same people—relies on similar strategies of communication as the corporate capitalism it is so often directed against. Recognition value is a critical stylistic goal of both. Corporations and artists use repetition as a sort of "branding" (McCormick 2010, 130). Clearly, Banksy's art uses seriality as a means for creating a highly

successful brand: his pieces have been auctioned for up to $1,870,000 (Sotheby's 2008).[5]

Damien Droney (2010) recognizes the problematic proximity of street art and branding when he writes that street artists in the Los Angeles area use "a discourse of resistance to advertising while many of them ironically use their art as a form of advertising" (99).[6] Similarly, Sarah Banet-Weiser (2012) proclaims that street art "nurtures a nostalgic dichotomy between the authentic and the commercial, one that relies on street art's association with graffiti and tagging" (101). It is true that in many cases artists advertise their artistic personas, or try to market their art in the way that Shepard Fairey does, in a far-reaching commercial distribution of their work on print, merchandise, and clothing. Nevertheless, it is the reflexive and ironic aspect that separates Banksy's work from merely adaptive marketing strategies. The critical force of Banksy's interventions derives from more than just claiming territory with serial images and making subversive statements about public space. Their critical potential as culture jams lies in the content of his art, in his specific way of reworking images.

Banksy achieves a critical end by appropriating and ironically reworking familiar imagery. Many of his paintings add additional meanings to preexisting pictures and disturb the conventional signification of those serialized images. Banksy's work quotes culturally charged imagery but also adds something that works against the original. As James Brassett (2009) argues, "His work interrupts mainstream narratives of global ethics, of an unfair world that needs reform, by juxtaposing familiar icons of western capitalism (for example Disney, Ronald McDonald) with icons of western imperialism (for example, bombed villagers in Vietnam)" (232). It often relies on bringing together recognizable binaries to create a moment of disturbance and reflection. Many of the controversies around Banksy derive from these strategies. Cedar Lewisohn (2008) states, "For the people who don't like it, the message is the main problem; they find it simplistic and patronising. The idea of taking well-known imagery such as the *Mona Lisa* and juxtaposing it with a loaded image like a rocket launcher has been dismissed as a trite formula" (117).

But Banksy's ironic mode subverts the simple messages his pieces convey at first sight. They very much conform to Linda Hutcheon's (1994) interpretation of irony, which "rarely involves a simple decoding

of a single inverted message; . . . it is more often a semantically com-
plex process of relating, differentiating, and combining said and unsaid
meanings—and doing so with some evaluative edge" (89). In address-
ing marketing and subversive cultures, Banksy's pieces unmask the way
conventional forms of expression permeate both. Subcultures have their
own slogans, and one of the better known might be "Eat the rich," coined
by Jean-Jacques Rousseau: "When the people shall have nothing more
to eat, they will eat the rich" (quoted in Thiers 1850, 359). The slogan
has become a popular anarchist/leftist credo and also a very common
graffiti. Banksy's version from the early 2000s shows the slogan "Eat
the Rich*" painted on a wall in erratic red letters. The asterisk refers to
a footnote that adds: "With our new 2 for 1 offer including a choice of
wine." Here Banksy invokes two visual conventions: the stenciled foot-
note is in a sans-serif typeface resembling Myriad, the font most rec-
ognizable for being part of Apple's corporate iconography. While the
lettering and the choice of words in the footnote have an official ap-
pearance, the irregular letters and content of the slogan are mimick-
ing an "authentic" subversive voice. Both commands—"Act out against
authority!" and "Consume!"—are evoked ironically: antiauthoritarian
appeal and marketing depend on their own conventionalized slogans
and visual styles, which they use in public space to address the passerby.
Here, to return to Dery's (1993) definition of culture jamming, it is not
so clear who intrudes upon whom. Not only does subculture comment
upon capitalism, but capitalism also intrudes on the logic of subversive
utterance. That influence is self-reflexively and ironically made visible
by the footnote: subversive messages come with an asterisk that hints
at the dominant cultural, spatial, and communicative relations they are
directed against, but also necessarily influenced by at the same time.

A second example is particularly interesting because it combines cor-
porate branding and the punk subculture in an environment that relates
to both. Banksy's *IKEA Punk* shows a stenciled punk standing beside
a box with a logo resembling IKEA's. The letters have been rearranged
to read "IEAK." Underneath, a label says that the box contains "Large
graffiti slogans" and that "some assembly" would be required. Two red
letters stick out from of the box. The punk, clearly recognizable with his
black hooded sweatshirt, large keychain, and a Mohawk haircut, looks
puzzled by the assembly instructions. On the wall behind him, words in

the same red letters have been applied. Though they overlap, the words "system," "smash," "police," "no", "money" and "now!" can be discerned and recognized as ingredients of stereotypical leftist slogans like "Smash the system" or "Smash the police." While the re-spelling "IEAK" might suggest "eek" as a cry of fear or disgust (see Blanché 2012, 99), other aspects of the image form a more complicated message. A tension occurs between the stencil production technique, on the one hand, and, on the other, the messy spray can letters that mark the piece as street art and the modified IKEA logo, which signifies the brand's corporate identity. IKEA, of course, is a company that has been operating on a global scale since the 1970s (Dahlwig 2003, 34).

At first glance *IKEA Punk* is an image that could work perfectly well as a poster in any hip student's apartment. Putting it in an urban context, however, adds much more to the image. Lewisohn (2008) describes the contested conditions street art finds in London: "Just as art in museums is a reflection of the cultures that produced it, street art reveals the hidden narrative of those who make it. Street art in London, for example, has to compete in an extremely media-saturated environment, and the artists are aware of and responsive to that environment" (65). Banksy positioned the IKEA punk deliberately near billboard signs, thus contesting the omnipresence of advertisements in London. The piece was also located less than a mile from an IKEA store, potentially addressing its customers and thus creating a link between IKEA's permeation of physical space and its invasion of mental space. Furthermore, the image relates to Croydon, London, as its wider surrounding. London, the city where the Sex Pistols and The Clash originated, is (together with New York) where punk culture emerged. The black clothing and the "do-it-yourself" (DIY) attitude so typical of punk rock (see Grossmann 1996, 97, 21–22) have remained. But Banksy's work suggests that DIY energy has devolved to an act of assembly that requires merely following instructions to put together prefabricated parts (Blanché 2012, 98). The punk cannot see behind those mechanisms to realize the irony of allegedly subversive messages formed by the logics of corporate communication. In that way, the image attacks the conformity IKEA produces by its global permeation (99).

More than criticizing the omnipresence of corporate advertising, the stencil graffiti also takes aim at the logic behind it. Even though the

Figure 9.1. Banksy, *IKEA Punk*, used with permission by Pest Control Department.

punk seeks to issue a subversive message, his action is governed by the rules, conventions, and clichés that have been developed by subcultures and are now reproduced with little reflection. This image criticizes a stereotypical position of "counterculture" for operating like corporate advertising, as it relies on recognizable slogans and a rhetoric drawing on a limited yet recognizable word pool. The punk's insecure and perplexed posture on the one hand alludes to the cliché of IKEA's impossible-to-decipher instruction manuals, but on the other also suggests the limits and eventual failure of these predetermined paths of expression. The work ironically breaks up a perceived discrepancy between fake commercial IKEA furniture and "authentic" counterculture. It shows their semiotic interpenetration and pokes fun at the fact that, actually, neither one is "authentic." In his essay on David Fincher's film *Fight Club*, Erik Dussere (2006) writes that the film uses IKEA's presence in people's apartments to illustrate society's loss of a private room "outside the reach of consumer culture" (24). In making an IKEA box the source of the punk's limited vocabulary, Banksy goes one step farther. He suggests that we cannot rely on a commerce-driven culture to provide us with ways of

honestly expressing ourselves as individuals. And because commercial culture permeates so many levels of meaning and memory, we cannot intuitively access what we might want to express. In that respect, the ironic reflexive mode is insufficient to solve the deeper problem of how to free ourselves from corporate logics. What Banksy's art can do, however, is to name and unmask the complex agencies at work in corporate and subcultural discourse.

Conclusion: Ambiguous Images and Semiotic Interventions

It is a paradox of subversive strategies like street art that where they succeed, they are likely to become embedded into the cultural hierarchical structures they were originally directed against. Corporate marketing strategists have been quick to adapt street art's visual language and techniques to inflect their brand names with a taste of youth culture. As a part of its "Love, Peace and Linux" campaign, for instance, IBM had icons of hearts, the peace sign, and the Linux penguin spray-painted on sidewalks in Boston, Chicago, New York, and San Francisco (Kenigsberg 2001). Scooter manufacturer Vespa infiltrated the streets of Vancouver with stencils of fashionable young people with Vespa handlebars instead of heads in 2008 (Martineau 2008). Obviously, the plan in these campaigns was to connect the open-source operating system and the stylish motor scooter brand with graffiti and street art's subversive and anti-authoritarian spirit. In this exchange of ever-evolving street art and adaptive marketing, the aesthetics of both may become similar, but their messages still differ. Vespa's campaign, for example, interacts with space on a very simple level. It addresses potential customers in hip neighborhoods, with none of the reflexive and subversive stance inherent in street art.

Banksy's culture jamming, by contrast, destabilizes the signification of visual icons in public space. His blending of graffiti's and street art's strategies intervenes creatively in the urban territories shaped by city planning and advertisements. His interventions critically address their urban surroundings, whether contesting the surveillance of public space, the control of urban management, or the ubiquity of advertising. By appropriating and modifying familiar images, Banksy creates a critical disruption that questions closed meanings and opens up urban

landscapes to alternative interpretations. Most importantly, however, while Banksy answers back to commercial images, he also discloses how their meanings are produced. It is by means of ironic reflexivity that his art can become a constructive attack, of the kind the Berlin-based street artist and professor of architecture Annett Zinsmeister (2010) promotes when she calls for street art to move beyond merely destructive gestures: "Guerilla art is rather about constructive acts, for instance in the sense of a political, socially critical communication strategy that creates (discursive) added value" (153).

Banksy does not propose distinct counternarratives, but rather creates ambiguous images and semiotic interventions. His works invite participation, discussion, and reflection upon the way messages are produced and how they spread in our modern society. James Brassett (2009) writes that "Banksy may not provide ready solutions to some of the problems he identifies, but he certainly provides credible pointers as to the kinds of power structures and hypocrisy that global ethical agendas must contend with" (233). Banksy's art undeniably provokes discussions and elicits an observant perception and active experience of urban space. Even though his work quotes corporate logos and images, it is not aimed at specific brands or corporations per se. Rather, it takes aim at the logic behind their marketing communication strategies, whose vocabulary and forms of expression radiate into our thoughts and dialogues. Banksy not only reclaims urban territory but also rescues our collective mental space from the infiltration of consumer culture by provoking a critical and ironic reflection that helps us fend off the messages bombarding us every day.

NOTES

1 One article claimed Banksy to be Robert Gunningham, a Bristol native (Joseph 2008). However, since Gunningham's whereabouts are unknown, this has not influenced Banksy's working conditions or reception significantly.

2 Brassett (2009) also understands Banksy's work in the tradition of British irony (220). However, Hutcheon (1994) is concerned more with the way irony functions in the "relations between meanings" (13) and is suited better for my approach in this article.

3 An in-depth illustrated summary of the conflict can be found at twistedsifter.com.

4 Geilert (2009) relates the evolution of street art to the historical context of an era where public space has undergone significant change. People today are

confronted with an increasing number of billboards and LCD screens, operating within a complicated signifying system. Geilert further expands the concept of public space to television and the Internet (3). Documenting, sharing, distributing, and discussing images on the Internet play a significant role for the success of street artists as it is. However, this essay focuses on how street art operates and communicates in its urban surroundings.

5 Banksy himself undermined the value of his works when he offered original works for $60 in New York's Central Park in 2013 (MacIntosh, Carrega-Woodby, and Greene 2013).

6 An example of this is Shepard Fairey. His famous "Obey!" campaign uses a consistent graphic style and consists of coloring in black and red, a high-contrast aesthetic, and the depiction of cultural and political icons in a style of close-up to medium close-up (see McDonnell, chapter 7 in this volume.). All this relates his work to propaganda and hero worship, while at the same time his placarding campaigns are based on the very principle of seriality that we know from advertisements.

REFERENCES

Banet-Weiser, Sarah. 2012. *Authentic™: The Politics of Ambivalence in Brand Culture*. New York: New York University Press.

Banksy. 2005. *Banksy: Wall and Piece*. London: Century.

Baudrillard, Jean. 1993. *Symbolic Exchange and Death*. London: Sage.

Bieber, Alain. 2010. "Desires." In *Urban Interventions: Personal Projects in Public Spaces*, edited by Matthias Hübner and Robert Klanten, 4–5. Berlin: Gestalten Verlag.

Blanché, Ulrich. 2012. *Konsumkunst: Kultur und Kommerz bei Banksy und Damien Hirst*. Bielefeld, Germany: Transcript.

Brassett, James. 2009. "British Irony, Global Justice: A Pragmatic Reading of Chris Brown, Banksy and Ricky Gervais." *Review of International Studies* 35 (1): 219–45.

Buchhart, Dieter and Gerald Matt. 2010. *Street and Studio: From Basquiat to Séripop*. Published in conjunction with an exhibition of the same name at Kunsthalle Wien. Vienna: Verlag für modern Kunst. Exhibition catalogue.

"Cave Art Hoax Hits British Museum." 2005. *BBC Online*, May 19. news.bbc.co.uk.

Collett-White, Mike. 2008. "Contested Art by Graffiti Star Banksy Fail to Sell." *UK Reuters Online*, September 29. uk.reuters.com.

Dahlwig, Anders, Ingela Goteman, and Katarina Kling. 2003. "IKEA CEO Anders Dahlwig on International Growth and IKEA's Unique Corporate Culture and Brand Identity." *Academy of Management Executive* 17 (1): 31–37.

Dery, Mark. 1993. *Culture Jamming: Hacking, Slashing and Sniping in the Empire of Signs*. Pamphlet no. 25. Westfield, NJ: Open Magazine.

Droney, Damien. 2010. "The Business of 'Getting Up': Street Art and Marketing in Los Angeles." *Visual Anthropology* 23 (2): 98–114.

Dussere, Erik. 2006. "Out of the Past, into the Supermarket." *Film Quarterly* 60 (1): 16–27.

Feireiss, Lukas. 2010. "Livin' in the City. The Urban Space as Creative Challenge." In *Urban Interventions. Personal Projects in Public Spaces*, edited by Matthias Hübner and Robert Klanten, 2–3. Berlin: Gestalten Verlag.

Friesinger, Günther, and Frank Apunkt Schneider. 2010. "Urban Hacking as a Practical and Theoretical Critique of Public Spaces." In *Urban Hacking: Cultural Jamming Strategies in the Risky Spaces of Modernity*, edited by Günther Friesinger, 13–34. Bielefeld, Germany: Transcript.

Fuertes-Knight, Jo. 2012. "King Robbo Exclusive Interview: My Graffiti War with Banksy." *Sabotage Times*, February 28. www.sabotagetimes.com.

Geilert, Gerald. 2009. "Street-Art: Eine verlockende Utopie." *kunsttexte* 1: 1–8.

Grossmann, Perry. 1996–1997. "Identity Crisis: The Dialectics of Rock, Punk, and Grunge." *Berkeley Journal of Sociology* 41: 19–40.

Hutcheon, Linda. 1994. *Irony's Edge. The Theory and Politics of Irony*. London: Routledge.

Joseph, Claudia. 2008. "Graffiti Artist Banksy Unmasked . . . as a Former Public Schoolboy from Middle-Class Suburbia." *Daily Mail*, July 12. www.dailymail.co.uk.

Kenigsberg, Amos. 2001. "Peace, Love, and Marketing: IBM's Sidewalk-Graffiti Ads Mark Another Step Forward for the Commercial Colonization of Public Spaces." *Mother Jones*, July 20. www.motherjones.com.

LaFarge, Antoinette: 1996. "The Bearded Lady and the Shaven Man: Mona Lisa Meet 'Mona/Leo.'" *Leonardo* 29 (5): 379–83.

Lambert-Beatty, Carrie. 2010. "Fill In the Blank: Culture Jamming and the Advertising of Agency." *New Directions for Youth Development* 125: 99–112.

Lewisohn, Cedar. 2008. *Street Art. The Graffiti Revolution*. New York: Abrams.

"Lot 34. Banksy (Defaced Hirst) 2007." 2008. Sotheby's New York, February 17. www.sothebys.com.

MacIntosh, Jeane, Christina Carrega-Woodby, and Leonard Greene. 2013. "Tourists Buy $31K Banksy Art for just $60 Each." *New York Post*, October 14. www.nypost.com.

Martineau, Jarrett. 2008. "The Paradox of Corporate Street Art." *Now Public*, May 16. www.nowpublic.com.

McCormick, Carlo. 2010. *Trespass: A History of Uncommissioned Urban Art*, edited by Ethel Seno. Cologne: Taschen.

Morris, Steven. 2011. "Banksy Classic Artwork Defaced in Bristol as Graffiti War Re-Erupts." *Guardian*, October 3. www.guardian.co.uk.

Reinking, Rick, ed. 2008. *Fresh Air Smells Funny*. Published in conjunction with an exhibition on Urban Art at Kunsthalle Dominikanerkirche in Osnabrück. Heidelberg: Kehrer. Exhibition catalogue.

Reisner, Robert George. 1974. *Graffiti. Two Thousand Years of Wall Writing*. London: Muller.

Roth, Evan. 2010. "Street Art[:] The 'Hip-Hop' of Fine Arts?" Interview by Sydney Ogidan. In *Street and Studio: From Basquiat to Séripop*, edited by Dieter Buchhart and Gerald Matt, 333–36. Vienna: Verlag für modern Kunst.

Sassoon, Donald. 2001. "Mona Lisa: The Best-Known Girl in the Whole Wide World." *History Workshop* 51: 1–18.

Stam, Robert. 1992. *Reflexivity in Film and Literature: From Don Quixote to Jean-Luc Godard*. New York: Columbia University Press.

Thiers, Adolphe M. 1850. *The History of the French Revolution*, vol. 2. Philadelphia: Carey and Hart.

Westphal, Cheyenne. 2006. Interview by Max Foster. *Your World Today*. CNN, December 4. transcripts.cnn.com.

Zinsmeister, Annett. 2010. "Urban Hacking: An Artist Strategy." In *Urban Hacking: Cultural Jamming Strategies in the Risky Spaces of Modernity*, edited by Günther Friesinger, 147–61. Bielefeld, Germany: Transcript.

10

Co-Opting the Culture Jammers

The Guerrilla Marketing of Crispin Porter + Bogusky

MICHAEL SERAZIO

"As a rule, we get off more on the culture jamming aspect of what we do for clients than the actual advertising aspects," said Alex Bogusky, then creative director and co-chairman of Crispin Porter + Bogusky (Contreras 2009, par. 6). The comment came as something of a throwaway line during an interview with a blogger who covers technology, marketing, and social media. Bogusky had been asked: "What is it like to be part of an agency that creates so much buzz for clients that it gets some of its own?" Yet that smug reply—hailing culture jamming as the *real* ideal animating his firm's work—perhaps best identifies the underlying logic behind the agency's diverse, even subversive promotional output and underscores how culture jamming, as a philosophy and practice, has been hijacked from its anticommercial roots.

For CP+B is not just any agency in the advertising world—it was arguably *the* hot shop at the turn of the twenty-first century. The firm was awarded *Advertising Age*'s top "Agency of the Decade" status in late 2009, and Bogusky himself was named "creative director of the decade" by *Adweek*, with the latter fawning, "Few would disagree that [he] is the one man who most shaped the creative trends in advertising over the past decade" (Lippert 2009). From its Miami Beach headquarters—distinguishing the firm as an "independent species" set apart from the "Madison Avenue advertising establishment"—to its active recruitment of freewheeling, eclectic creative talent, CP+B very deliberately struck a pose within the ad world at odds with the "man in the grey flannel suit" stereotype of old (Berger 2006, 51). And in that antiestablishment, counterculture ethos, a disposition not unlike the rebellious, avant-garde culture jammer also emerged.

CP+B's projects, including acclaimed work for Burger King, MINI automobiles, and the Truth anti-smoking campaign, demonstrate how semiotic tactics once considered subversive and oppositional are now "cool hunting" fodder—the latest incarnation in a familiar cycle of cultural cooptation. CP+B's textual poaching, media hoaxes, and performance spectacles also speak to a larger crisis in the advertising industry today: the often-frustrated effort to reach cynical consumers whose attention is a prized, if evasive, commodity and who suffer a sense of postmodern exhaustion when it comes to marketed meanings and mediated encounters. In that sense, both guerrilla marketing and culture jamming share an ironically similar point of departure for their divergent social projects: a sense that traditional, mainstream marketing feels inauthentic, trite, and dissatisfying.

This chapter uses CP+B as a case study portal to take stock of how *Adbusters'* "subvertising" spirit is now an effective marketing strategy of its own and shows how the style of anticonsumerism has been paradoxically utilized to push product. While culture jamming may have set out to issue symbolic challenges to destabilize the corporate communication that so clutters our contemporary environment, it seems to have also rejuvenated the industry it meant to parody. For *détournement*— that "perspective-jarring turnabout in your everyday life" that neo-Situationists fetishize—is, after all, just as much what *advertisers* seek (Lasn 1999, xvii).

So if, as I have posited elsewhere, culture jamming fancies itself as the appropriation of brand identity for political subversion, CP+B's approach seems to best suggest an *expropriation* of that political subversion for brand identity (Serazio 2013). And by cataloging the rise of CP+B as a way of understanding how Madison Avenue sanitizes transgressive formats and plumbs subcultural capital for mainstream brands, we might also discern a larger blueprint of how corporations recuperate creative resistance at the contemporary moment. Culture jamming's oppositional ideologies and aesthetics can be emptied out and rerouted to accommodate safer, commodified ends. In that, the attitude (and, perhaps even, politics) of the "street" are what seems to keep a certain psychographic segment spending at the mall.

* * *

CP+B's rise is, in many ways, inextricable from the crisis that has besieged the advertising industry in the past two decades—a crisis also connected to the social and political milieu that itself gave rise to culture jamming, as Naomi Klein (1999) explores in her seminal text, *No Logo*. Part of the problem for advertisers and ad-*busters* alike is that commercial clutter has left audiences feeling positively exasperated. Because the average American encounters thousands of advertisements daily, Robert Goldman and Stephen Papson (1996) suggest that we have arrived at a "mature sign economy" and are living through a "Hobbesian war" among brand images:

> Advertisers routinely raid cultural formations for the raw materials they need to construct new, more valuable signs. . . . When advertisers tap into, extract, and appropriate new cultural styles and images for the purpose of placing them in association with their commodities, they also risk a hemorrhaging of meaning. . . . The circulation of signs accelerates, driving a compulsive and reckless search for unoccupied cultural spaces and more spectacular signifying styles in order to be noticed. The turnover of ad campaigns quickens, the half-life of sign values shrinks, the clutter of images accumulates, and a new kind of cultural junk heap has taken shape. (vi)

From this commercial media saturation—more ads shouting out more appeals in more venues than ever before—culture jamming took shape, with its multifarious mischief ranging from billboard vandalism to street theater to pirate broadcasting. Christine Harold (2004; chapter 2 in this volume) simplifies the diversity of these politically aesthetic tactics to see them as, fundamentally, a strategy of "rhetorical protest" that seeks to "undermine the marketing rhetoric of multinational corporations" (189). The movement idealizes staking out a refuge from that overload and awakening consumers from the "false consciousness" that is at the heart of branding. For culture jammers, branding represents the seductive boogeyman of modern times and a necessarily political terrain for those involved in wider battles against globalization and capitalism. They believe that, because advertising seeks to create in its work an "ethical surplus"—"a social relation, a shared meaning, an emotional investment that was not there before"—consumers wind up developing

irrational attachments to corporations and the commercial goods they churn out (Arvidsson 2005, 237).

The culture jammer's task, then, is to interrupt that system of "subjective meanings or social functions" that coax loyalty from those consumers—for example, to decouple Nike from its ethos of self-improvement or Starbucks from its association with "third place" communal gathering—and to extricate that which seems otherwise inextricable (and inextricably fortified by hundreds of billions of dollars in ad spending) (Arvidsson 2005, 239). To do so would be to dry up the fount of brand equity: the affiliated imagery and identity that, at its simplest, allows Ralph Lauren to charge more for a t-shirt with a Polo logo than the very same t-shirt without it. Yet the ad-buster—tongue-in-cheek subversive cynic she may be—is still also a hopeless romantic at heart who can envision "ethical surplus" beyond the confines of commercial relations—an unmediated Eden where we communicate to and connect with each other in language lacking "logos" (Harold 2007, 30).

For Kalle Lasn (1999), author of the manifesto, *Culture Jam*, the movement was born of much the same vexation that, ironically, also plagues advertisers: "Because [advertisements are] everywhere, they're nowhere. You don't really notice them" (38). Thus, to counteract the "spectacle" of consumer culture, Lasn invokes the anarchist spirit of the Situationists—those first "postmodern revolutionaries" committed to "a life of permanent novelty"—a band of intellectual rascals "interested only in freedom" (100–101). "Culture jamming," Lasn claims, "is, at root, just a metaphor for stopping the flow of spectacle long enough to adjust your set. Stopping the flow relies on an element of surprise" (107).

It should come as little wonder, then, that advertisers also venerate these principles in much the same language. "Freedom" is perhaps, above all else, what marketing sells (no matter what the specific commodity associated with it), and "stopping the flow" of competing clutter is the daily challenge marketers face to get their message across amidst the deluge of competing advertisements. The more clutter, the harder it is for a brand to distinguish itself and build that ethical surplus—especially when audiences are more savvy than ever at avoiding advertising through technological advances like DVRs, pop-up blockers, and spam filters (Garfield 2009). Across the media landscape, so goes the conventional wisdom, power has shifted from a couch potato passively

consuming analog content to a peripatetic participant in digital domains who is now able to watch, read, and hear what she wants, when and where she wants it (Rust and Oliver 1994). This puts network television, terrestrial radio, and print newspapers in a precarious position, given that they have furnished the main space for advertising for the past century. The chairman of Proctor & Gamble, the largest national sponsor of media content, not long ago nudged those gathered at a national advertising conference to think beyond the thirty-second spot to sell his "four hundred million boxes of Tide" (Turow 2006, 73). As Warren Berger (2006) writes in *Hoopla*, a coffee table book chronicling CP+B's oeuvre:

> In the long-ago days of three television channels, advertisers could somewhat predict how much share of mind they'd command based on how much they were investing in TV airtime. The audience had not yet built up the filters that today's viewers have, and there were fewer media options and escape hatches. Hence it was assumed that if a marketer spent enough money hammering away at that captive audience, the message was bound to sink in eventually. (113)

Today, however, the evidence suggests a "mutation," as Berger terms it, of that consumer audience:

> In an age of information explosion, people *had* to mutate so they could manage to breathe in all that new information without drowning in it. . . . These new powers enabled people to not only consume information but also to absorb it, reshape it, and use it for their own individualized purposes. (51)

On some level, then, advertising faces an existential panic nowadays, albeit not necessarily the one of the culture jammer's making. "Share of mind," as Berger (2006) puts it above—the intangible quality that props up the brand's value—can no longer be simply bought and sold (which should, in theory, delight the aspiring jammer). That "mutant" consumer of the twenty-first century practices digital bricolage almost instinctively as part of everyday life, "appropriat[ing] [a] range of commodities by placing them in a symbolic ensemble which serve[s] to erase or subvert their original straight meanings" (Hebdige 1979, 104). The very notion of

a "prosumer" audience—that is, one both consuming and producing in participatory online contexts like Facebook, blogs, Wikipedia, YouTube, and Second Life—is predicated on the instinct to mash-up (Bruns 2008; Jenkins 2006; Serazio 2008).

* * *

The "subvertisement" arguably represents the most basic form of culture jamming—the building block of semiotic *détournement*. Yet, when its definition is placed side by side with that of CP+B's "anti-advertising" aims, it becomes clear how much the tactics of Lasn and the work of Bogusky fundamentally share common means to achieve conflicting ends:

Corporations advertise. Culture jammers *sub*vertise. A well-produced print *'subvertisement'* mimics the look and feel of the target ad, prompting the classic double take as viewers realize what they're seeing is in fact the opposite of what they expected. Subvertising is potent mustard. It *cuts through the hype and glitz* of our mediated reality and momentarily, tantalizingly, reveals the hollow spectacle within. . . . An effective TV subvertisement (or uncommercial) is so

In a world of hype, a few candid words can be more powerful than a thousand empty slogans and claims. From the agency's earliest days, Bogusky and Porter always had a healthy cynicism about advertising and its transparent phoniness; Bogusky tended to think of his work more as a form of *'anti-advertising'* which resisted the hyperbolism of the business and even poked fun at it sometimes. In advancing this postmodern, *'no bullshit'* sensibility, CP+B . . . seemed to connect with a newly emerging audience—one that had, itself, grown weary of blatantly false sales pitches . . . [and] seemed to respond to messages that were *less glitzy and prepackaged, more raw and authentic.* And the more candid an ad was, the more it

unlike what surrounds it on the commercial-TV mindscape that it immediately grabs the attention of viewers. It *breaks their media-consumer trance* and momentarily challenges their whole outlook. (Lasn 1999, 131–33; first emphasis in the original) seemed to resonate. . . . To effectively 'hype' something today, you must find a way *to cut through 'the hype.'* Strange as it may seem in advertising, this necessitates *telling the truth*—or at least some interesting form of it. (Berger 2006, 159–60; emphases added)

With "anti-advertising" as its antidote to advertising and "candor" as recourse to the "glitz" of competing "bullshit," CP+B casts itself as the clever teller of "truths." But it, too, is in the bullshit business: the business of misdirecting, truncating, magnifying, and, as needed, concealing "reality" beneath a smokescreen of spectacle. Whereas culture jammers see the corrective to that spectacle as carving out a more "authentic" lived experience *external to* and *escapist from* commercial culture, for CP+B, such yearning is just another valuable market segment waiting to be captured. Once again, similar tactics, divergent ends: the subvertisement being the means to liberate consumerist thinking; the anti-advertisement being the means to reimagine consumption.

One of the most enduring targets for culture jammers has long been Big Tobacco. After all, cigarette smoking represents the consumer activity arguably most "falsified" through advertising and media. By this I mean that, because cigarettes have been associated with an arbitrary set of images and values (hipness, masculinity, and so on), they are a ripe product to "uncool," in Lasn's (1999) terms. Thus, we meet Jorge Rodriguez de Gerada, a guerrilla street artist profiled in *No Logo*, who manipulates and defaces cigarette billboards—jamming that hype by exposing the public health menace beneath the smokescreen as, for example, in "morph[ing] the faces of cigarette models so they looked rancid and diseased" (Klein 1999, 291). Some of *Adbusters'* most amusing and incisive spoofs over the years have targeted the tobacco industry as well: "Joe Chemo" withering away in a hospital bed; two otherwise rugged

Marlboro Men riding into the sunset beneath the tag line, "I miss my lung, Bob." Indeed, Marlboro's shift in identity from the mid-1950s as a women's cigarette ("Mild as May," ran the old slogan) to a more masculine pitch both achieved desired sales growth and confirms Lasn's (1999) suspicions about commercialism: that consumers are smoking (and eating, and driving, and so on) *image* as much as product and that the industries that market these products happily rotate through corporate identities until they find the one that maximizes revenues.

The implication that scheming marketers are tricking credulous consumers is a central tenet of culture jamming. As it turns out, this was also the key insight for the Truth campaign, CP+B's anti-smoking public service work that probably most closely resembles culture jamming. After researching the appeal of cigarettes among young Floridians, the agency realized that traditional anti-smoking public service messages that ratcheted up the fear appeal and sternly ordained tobacco abstinence only made the *Verboten* seem sexy and, thus, the optimal vehicle for expressing rebellious identity. At the same time, the agency found that teenagers also hate to feel like someone has manipulated them. From this insight, CP+B started targeting and pranking the tobacco industry itself and, more specifically, its marketing machinations—channeling all that nonconformist angst endemic to the teens *against* the tricksters behind the curtain. "We're trying to communicate and create something that is tangible and that kids can experience at a grassroots level. It is this sort of guerrilla, subversive tone," explains Eric Asche, senior vice president of marketing for American Legacy Foundation, the nonprofit enlisting the campaign. "We are shining a light on things that the industry is doing and the industry doesn't like us doing this" (pers. comm.).

As such, Truth is a "legal" inheritor to the spirit of Gerada's work. And the campaign went beyond mere billboard vandalism to encompass a full-scale "underground propaganda movement" through films, fliers, stickers, and leaflets: "In a way, the campaign became an indictment of advertising itself, coming direct from an ad agency that had decided to tell the truth to teenagers" (Berger 2006, 159). Within four years of Truth appearing in Florida, smoking reportedly declined by more than a third among middle and high school students, and the campaign eventually expanded to a national rollout, courting controversy across a range of visual and experiential elements. One CP+B ad (disguised

as a low-budget pull-tab posting one might find tacked to college bulletin boards) featured the phone numbers of agencies on the payroll of Big Tobacco. For another, the agency designed slick movie posters for a fictional upcoming release (*Secrets of a Tobacco Executive*) from a film studio (Evil Empire Pictures) that did not even exist. And, in a bit of Barnum-worthy street theater the Yes Men might admire, the firm had 1,200 body bags dumped outside one tobacco company's headquarters. As Christine Harold has noted (2004),

> The Truth campaign does not just tell kids not to smoke. In fact finger-waving messages never appear in its literature or imagery at all. Instead, Truth encourages young people to become culture jammers, or pranksters, themselves, and even provides them with the tools to do it. . . . The content of the Truth campaign's rhetoric is not fundamentally different from the *Adbusters* strategy of negative critique. (204, 206; see chapter 2 in this volume)

To that end, CP+B's media activist pranks also included encouraging teens to leave magazines open to two-page Truth ad spreads on periodical racks (the all-caps message contained within blaring "CIGARETTE SMOKE HAS ARSENIC"); furnishing "conversation bubble" stickers that could be filled in with smart-ass messages and then affixed to Marlboro billboards and posters on the street ("When I get tired of counting cow patties, I like to count the 4,000 chemicals in cigarette smoke"); and creating pop-up signs intended to be fastened to pet excrement on sidewalks ("Cigarettes contain ammonia. So does dog poop"). Tackling the tobacco industry by recontextualizing its corporate message—whether undertaken by rogue ad-busters on the street or CP+B's annexation of those jammers' subversive sentiment and strategy—is no small task, given the enormous sums spent by marketers on constructing cigarettes as cool in our minds. Moreover, the promotion of *anti*-consumerism as the desired action might seem an odd project for an *advertising* agency. Yet contesting, even sabotaging, the imagery and narratives of product competitors is, in a sense, a phenomenon absolutely endemic to the modern marketplace; that is, brands are always attempting to jockey for mindshare in a manner that gets consumers to "unthink" the associative assumptions about commercial adversaries. Culture jamming's project

is to emancipate the consumer from that system of social conformity; guerrilla marketing's project is to channel that anticonsumerist rebellion into a different set of "cooler," supposedly more "true" products.

* * *

The culture jammer's fundamental fetish is the "underground"—that subcultural counterpart that supposedly exists in opposition to the mainstream, the mass media, and popular culture. The most evocative analogous image here might be drawn from *The Matrix*, wherein Neo and his rebellious cabal unhook themselves from an artificial reality where fellow humans sleep the sleep of mind-control (mapped here as consumerism). The social activism informed and practiced by the *Adbusters* set suggests that they, too, fancy themselves as genuinely "conscious," while shoppers remain trapped in a trance that limits political economy, self-knowledge, and global custodianship. Underground, however—spatially and semantically—a world of alternative living and thinking (and, yes, consuming) awaits.

In theorizing alternative scenes, the work of Sarah Thornton (1996) is instructive here. Investigating youth club cultures, she posits a series of contrasting binaries as understood by the "natives" who occupy those spaces: authentic versus phony, hip versus mainstream, and underground versus media.

> To be "hip" is to be privy to insider knowledges that are threatened by the general distribution and easy access of mass media. Like the mainstream, "the media" is therefore a vague monolith against which subcultural credibilities are measured. . . . As such [authenticity] is valued as a balm for media fatigue and as antidote to commercial hype. . . . Underground sounds and styles are "authentic" and pitted against the mass-produced and mass consumed. (6, 26, 117)

CP+B also seems animated in no small measure by an aversion to that "mainstream" culture in whatever guise it takes. As Berger (2006) writes, "Making Hoopla [the agency's buzzword] can be a bit like jujitsu [note that this, too, was Lasn's favored metaphor], in that one is always trying to flip reality on its head" (115). Ideologically, one might read the firm's work as an endeavor to escape the stultifying sense of sameness

that marks modern, middle-class, American life: that fear, perhaps best critiqued in Chuck Palahniuk's anticonsumerist *Fight Club*, that we have become dull, alienated automatons inhabiting office parks, frequenting corporate chains, and suffering through suburban ennui. This contemporary "iron cage," to borrow Max Weber's language of industrial disenchantment, is partly produced by the spiritual vacuity of consumer experiences being prepackaged and predictable. Because shopping culture feels so unoriginal and unfulfilling, the typical CP+B campaign interpellates its prospective audience member as someone seeking something different, something "underground."

Make no mistake, however—these campaigns still cater to elitist instincts, but they are elitist in an inverted taste hierarchy as compared to classical highbrow culture. Status here derives less from rarefied price tag and more from demonstrable esotericism. CP+B sells to an audience lured by arcane badges of hipster honor: the unmarked dive bar in the sketchy neighborhood yet to gentrify; the random thrift-store t-shirt not yet mass-produced by Urban Outfitters; the up-and-coming indie rock act that has yet to sell out on a major label. It is a Portland-ish or Brooklyn-ified trickle-up exclusivity: "Bogusky believes . . . [the] first lesson for anyone looking to communicate in a way that truly stands out [is]: You have to first separate yourself from the 'mainstream' as much as possible" (Berger 2006, 51). An example of this, and what I term an "alternate reality marketing" scheme, can be seen in their work for MINI starting in 2002.

This elaborate transmedia hoax was built on the enigmatic premise that a British engineer had secretly started assembling humanlike robots from spare car parts. Still photos, video clips, raw sketches, and firsthand reports subsequently circulated online from a reporter supposedly tracking the phenomenon—including one journal entry that popped up, linking said engineer to MINI Coopers from the 1960s. Needless to say, the entire storyline was a prank—a promotional puzzle almost cinematic in its pretense and meant to churn up viral buzz on behalf of the CP+B client. Shortly thereafter, a second, related hoax made the rounds: this con contended that, as with other "elite" brands (Gucci, Rolex, and the like), a rash of "counterfeit MINIs," clumsily constructed to resemble the iconic two-door subcompact, were plaguing flummoxed consumers. CP+B seeded this rumor by planting fake photos in *AutoTrader* maga-

zine, establishing a fictitious interest group (Counter Counterfeit Commission) dedicated to ferreting out the phonies, and peddling a short documentary on infomercial channels about the epidemic:

> CP+B was using creative mischief as a way to play games with the public, assuming that people would want to play along. . . . The agency found that most people were actually delighted by the trickery, which makes an important point: Unlike conventional advertising, which is forever struggling to seem believable and not fake, the rules of Hoopla allow for farce, tricks, pranks, and all manner of mischief. . . . The agency has also, at times, taken on the role of cultural provocateur—poking fun at popular trends or powerful institutions, or pushing the limits of acceptable language and behavior in advertising. . . . Bogusky says the agency has always tended to "celebrate the troublemaker and pay attention to the rebel." (Berger 2006, 225)

In the years before and since the MINI hoax, alternate reality marketing scenarios like this have cropped up from film (*The Blair Witch Project*) to video games (*Halo 2*) to television (*Lost*)—indeed, the motif somewhat naturally lends itself to entertainment features and franchises more so than to automakers, though it has also been utilized for ski resorts and muscle heat-wraps (Serazio 2013). Culture jamming has also staged similar "alternate reality" pranks—perhaps foremost among them, the larks of the Yes Men, a network of activists who impersonate corporate and governmental institutions so as to spoof and expose social injustices. Defenders of the Yes Men project hail their effort as a *Matrix*-style means to alternative thinking and living: "The task [of the Yes Men] is to enable something genuinely new to be *thought*, in a time in which global capitalism has such a monopoly on what we think. . . . An act of resistance that is politically significant . . . in the current epoch will give rise to an event in thought" (Hynes, Sharpe, and Fagan 2007, 109). Of course, advertising itself, again, faces this same problem in our media culture: to develop genuinely new ideas to grab audiences' attention. The pranks that CP+B has pulled over the years have, in their own words, "served to solidify the 'us against them' feeling that can give strength to a popular movement" (Berger 2006, 226). It is in this "us against them" sensibility—this cultivation of an antiestablishment vibe set apart from

and against the mainstream—that culture jammers and guerrilla marketers alike find common (under)ground.

* * *

Forging an antiestablishment vibe requires pathways of communication more "off-the-radar" than mainstream means afford. As such, culture jammers have long harbored viral aspirations—even before the term became a buzzword cliché of social media advertising. The key unit of analysis here is the "meme," which, like a self-replicating gene, gets passed through a population: "Potent memes can change minds, alter behavior, catalyze collective mindshifts and transform cultures," argues Lasn (1999). "Meme warfare has become the geopolitical battle of our information age. Whoever has the memes has the power" (123).

This, too, is a lesson that advertisers know all too well, and recent upheavals in media ecology have forced them to rethink the format of their promotional output to be more oriented toward memes. If mass broadcasting had been the default setting for a century's worth of commercial incantations, increasingly corporations must learn to navigate the "new media of mass conversation" or "mass self-communication" that flourishes online (Castells 2007; Spurgeon 2008). CP+B's "Subservient Chicken" arguably inaugurated the online commercial meme.

The campaign—if it can even be called that—centered upon a website featuring a creepy man in a chicken suit wearing a garter belt in a dingy, unremarkable living room "furnished like the set from a low-budget porn flick" (Berger 2006, 23). CP+B subcontracted to the Barbarian Group, a digital boutique, which designed the chicken to respond to one of thousands of keyword commands from users like, "bite your nails," "do yoga," and "walk like an Egyptian" in front of a webcam. As Barbarian CEO Benjamin Palmer explains, "We had been told by the agency that the stranger you could get, the better. So we really wanted to make it, like, kind of perverse" (pers. comm.). The edgy interactive project, financed by Burger King to promote a new chicken menu offering ("Have it your way"), was, as CP+B readily acknowledges, "an advertisement but only in the broadest sense of the word" (Berger 2006, 23).

Seeded in a fashion unbefitting of traditional advertising, the Subservient Chicken would, within a few years' time, draw twenty million unique visitors and five hundred million hits, and the agencies involved

won multiple international awards. The Chicken also picked up its own Wikipedia page, was debunked on Snopes, and was imitated by strippers, stick-figures, and celebrity impersonators (for instance, subservientblair.com). The technological context in which Subservient Chicken emerged in 2004, of course, owes much to its success: Web 2.0 was but in its infancy and YouTube not yet ascendant. Yet the possibility of interactive entertainment, particularly for something as preposterous as this, gained traction through e-mail pass-along, making this perhaps the starting point for viral or meme communication—"a unit of information . . . that leaps from brain to brain to brain," as Lasn (1999) describes it (123).

The objective to produce creative content that defies tidy promotional categorization runs through much of the CP+B's work. Neologisms like "nontraguerrilla" (an ungainly fusion of "nontraditional" and "guerrilla" with which CP+B characterizes itself) attempt to articulate the agency's ambition to produce work worthy of pop culture status rather than thirty-second spots that get skipped nowadays anyhow. And much like culture jamming itself, this nontraguerrilla mentality is an attempt to secure notoriety through *détournement* in the highly competitive "attention economy" of postmodern society. Guy Debord, however, would likely disavow the linkage, for this appropriation of "the dirty underworld of transgressive webcam culture" was employed not in the service of overthrowing capitalism as much as luring stoned college kids into fast-food brand loyalty (Webb 2009).

* * *

What, then, are we to make of culture jamming and its cooptation by Madison Avenue in final judgment? Are the creative talent at CP+B clever opportunists deflating the pretense of a superficial social movement or soulless mercenaries selling out the means of and potential for genuine corporate resistance—or, in fact, both?

On one hand, culture jamming represents an indictment of consumerism that few observers (with any semblance of a moral compass) could disagree with: critiquing issues like environmental degradation and oppressive gender stereotypes too often concealed beneath the gleaming sheen of marketed spectacle. These are the politics of substance, and they can seem, at times, like an insurmountable set of problems. Yet I'm

left wondering whether the politics of substance can be waged and won on the terrain of style.

Although it might be too narrowly circumscribing for some idealists, the legacy of culture jamming seems to me to be stylistic above all. This is not necessarily the same as saying culture jamming's contribution to society has been politically feckless—there is much to be gained, after all, from ad-busters taking the piss out of Nike or Marlboro or the Gap. But on the major issues of our day—the politics of substance that include, above all, a slow-rolling jobs crisis—I often find culture jamming to be too cute to say something revolutionary. Consumption is, indeed, a cultural game that can be easily skewered for those living within upper- and middle-class means (and culture jamming does so effectively). What, however, might that add to the tragedy of widespread unemployment? The ad-buster, it seems, has no shortage of good jokes about shopping, but apparently far fewer big ideas about working.

I echo Joseph Heath and Andrew Potter's (2004) shrewd claim in *Nation of Rebels* that "the market obviously does an extremely good job at responding to consumer demand for anticonsumerist products and literature" (98). Their critique of this obsession with countercultural alternatives seems an apt point, for culture jammers seem motivated mainly by a revulsion to social conformity, which suggests they're really just looking for a different set of status symbols—here, again, the unique t-shirt, independent coffee shop, and fixed-gear bicycle—that is, a desire to have in life what people in all those sprawling suburbs and soulless strip-malls *aren't* able to buy. If the great American middlebrow suddenly adopted *Adbusters*' "Blackspot" sneakers en masse, I dare say the sneakers would lose more than a little of their social cachet with the culture jamming crowd—ethically produced though they may be. On that count, guerrilla marketers like CP+B are more than willing to package commercial participation as corporate critique: thinking different, à la Apple, to ultimately, simply, *buy* differently.

In contrast to *Adbusters*' subversive protest strategy and the wink-wink tactics of culture jamming, the great grassroots upheavals of recent years—from Tahrir Square to Zucotti Park—have had a comparatively straightforward, traditional, even staid texture: bodies in the streets, chanting, marching, and unambiguously indignant over the growing concentration of wealth and the corrosive influence of that power on

democratic politics. Occupy wasn't, after all, an occupation of Madison Avenue—which it could have quite easily done just a few blocks uptown—but rather of *Wall Street* (Creamer 2011). This doesn't mean that culture jamming does not have a place in this project—indeed, *Adbusters* was instrumental in initiating Occupy (see Bratich, chapter 14 in this volume); it just means that these methods and mindset might not be the vanguard of world change as Lasn fancies. The market is, by definition, a nimble (if amoral) place. It is the task of agencies like CP+B to troll the underground for useful cultural material. The real battles that culture jammers seek to wage probably will not—perhaps, as I imply here, *cannot*—be fought on marketers' turf. For as the work of CP+B here demonstrates, the revolution has, in fact, long been advertised.

REFERENCES

"Agencies of the Decade." 2009. *Advertising Age*, December 14.

Arvidsson, Adam. 2005. "Brands: A Critical Perspective." *Journal of Consumer Culture* 5 (2): 235–58.

Berger, Warren. 2006. *Hoopla*. Brooklyn, NY: PowerHouse Books.

Bruns, Axel. 2008. *Blogs, Wikipedia, Second Life, and Beyond: From Production to Produsage*. New York: Peter Lang.

Castells, Manuel. 2007. "Communication, Power and Counter-Power in the Network Society." *International Journal of Communication* 1 (1): 238–66.

Contreras, Estaban. 2009. "Alex Bogusky Talks Ads, CP+B Culture, Fun, and Focus." *Social Nerdia*, May 27. www.socialnerdia.com.

Creamer, Matthew. 2011. "Occupiers on Wall Street as Madison Avenue Parties On." *Advertising Age*, October 10. www.adage.com.

Garfield, Bob. 2009. *The Chaos Scenario*. Nashville, TN: Stielstra Publishing.

Goldman, Robert, and Stephen Papson. 1996. *Sign Wars: The Cluttered Landscape of Advertising*. New York: Guilford.

Harold, Christine. 2004. "Pranking Rhetoric: 'Culture Jamming' as Media Activism." *Critical Studies in Media Communication* 21 (3): 189–211.

———. 2007. *OurSpace: Resisting the Corporate Control of Culture*. Minneapolis: University of Minnesota Press.

Heath, Joseph, and Andrew Potter. 2004. *Nation of Rebels: Why Counterculture Became Consumer Culture*. New York: Harper Business.

Hebdige, Dick. 1979. *Subculture: The Meaning of Style*. London: Methuen.

Hynes, Maria, Scott Sharpe, and Bob Fagan. 2007. "Laughing with the Yes Men: The Politics of Affirmation." *Continuum: Journal of Media & Cultural Studies* 21 (1): 107–21.

Jenkins, Henry. 2006. *Convergence Culture: Where Old and New Media Collide*. New York: New York University Press.

Klein, Naomi. 1999. *No Logo: Taking Aim at the Brand Bullies*. Toronto: Knopf.

Lasn, Kalle. 1999. *Culture Jam: The Uncooling of America™*. New York: Eagle Brook.

Lippert, Barbara. 2009. "Agency Creative Director of the Decade." *AdweekMedia*, December 4. www.bestofthe2000s.com.

Rust, Roland T., and Richard W. Oliver. 1994. "The Death of Advertising." *Journal of Advertising* 23 (4): 71–77.

Serazio, Michael. 2008. "The Apolitical Irony of Generation Mash-Up: A Cultural Case Study in Popular Music." *Popular Music and Society* 31 (1): 79–94.

———. 2013. *Your Ad Here: The Cool Sell of Guerrilla Marketing*. New York: New York University Press.

Spurgeon, Christina. 2008. *Advertising and New Media*. London: Routledge.

Thornton, Sarah. 1996. *Club Cultures: Music, Media, and Subcultural Capital*. Hanover, NH: University Press of New England.

Turow, Joseph. 2006. *Niche Envy: Marketing Discrimination in the Digital Age*. Cambridge, MA: MIT Press.

Webb, Rick. 2009. "Happy 5th birthday, Subservient Chicken." *Barbarian Blog*, April 6. www.barbariangroup.com.

11

Culture Jamming in Prime Time

The Simpsons *and the Tradition of Corporate Satire*

MORITZ FINK

Culture jamming aesthetics fundamentally rely on elements of satire; irony, parody, hyperbole, wordplay, and other techniques of semiotic defamiliarization have been the basic tools in the satirist's arsenal at least since the ancient Greeks. By analyzing the critical depiction of commercial culture in the television show *The Simpsons*—one of the most popular examples of political humor of our times—this chapter will spotlight an important feature in the history of culture jamming: the evolution of corporate satire in the twentieth century.

Rising to cult status in the early 1990s, *The Simpsons* spoke to a generation of viewers who would shape the "No Logo" backlash discussed by Naomi Klein (1999). To this generation, Klein argues, cultural resistance was synonymous with anticorporate resistance since "many of us who were young at the time saw ourselves as victims of a predatory marketing machine that co-opted our identities" (81).[1] As Jonathan Gray (2006) observes, *The Simpsons* answered this No Logo zeitgeist by extensively parodying the corporate world (81–82). In one such moment from the series ("Lisa vs. Malibu Stacey," 1994), Homer remarks that he is a "white male, age eighteen to forty-nine" and that this fact would make his opinion matter, regardless of how "dumb" his suggestions may be. Then we see him taking a box with snacks out of the kitchen cabinet that sports the tagline "Nuts and Gum—Together at Last!" The scene not only satirizes marketers' categorization of consumer groups and Homer's power as potent consumer, it also mocks the irrational logics and absurdities of product design and marketing.

While such superficial lampooning of consumer culture on TV had existed long before *The Simpsons* came on the air, brand parodies,

which Klein identifies as part of the No Logo spirit, are among the series' unique characteristics. Such parodies, which reflect the anticorporate rhetoric associated with culture jamming, are a distinct means by which *The Simpsons* executes satiric attacks on the corporate world. For instance, when we see a "Sprawl-Mart" store on the series, emblazoned with a banner that reads "Not a parody of Wal-Mart" ("On a Clear Day I Can't See My Sister," 2005), we are encountering a gesture of culture jamming in a context where we generally wouldn't expect it. Here I am extending Gray's work on *The Simpsons'* anticonsumerist stance by elaborating on the series' satirical representation of corporate culture—that is, on the show's deployment of visual rhetorics of culture jamming. The focus of this essay, then, is not so much on instances when the series satirizes corporate culture in a general or hypothetical way, but rather on instances when the show directly targets real-life products, corporations, and brands.

Of course, *The Simpsons* is a corporate entity—a brand—as well. One of this brand's inherent contradictions is that it represents an antiestablishment, anticapitalist attitude within the economic setting of a heavily marketed TV series, which furthermore airs on the neoconservative Fox network (see Alberti 2004). Call it paradoxical, hypocritical, or cleverly strategic, the idea for *The Simpsons* was originally conceived in opposition to the cultural mainstream and "outside" of the capitalist system of which the show itself is a part. Indeed, the incorporation of culture jamming aesthetics helped the series claim that position.[2] *The Simpsons*, in other words, exemplifies the logics of postmodernism according to which even the subversive appeal of the rhetorics and aesthetics of culture jamming becomes "integrated into commodity production" (Jameson 1991, 4).

From another angle, though, the success of *The Simpsons* demonstrates that there exists a huge audience embracing the humorous way in which the series satirizes the symbols of the dominant capitalist culture. In fact, the makers of *The Simpsons* could rely on the countercultural allure that this kind of subversive rhetoric entails. As I will show, creator Matt Groening and his team have drawn on an aesthetic tradition that has its roots in the American cartoon and gained popularity in the 1950s through the satirical magazine *MAD* and the parodic stickers that accompanied bubble gum in what was marketed to kids as Wacky Pack-

ages in the late 1960s. By embedding corporate satire within the fictional microcosm of an animated television series, the makers of *The Simpsons* creatively enhanced this lineage. Moreover, with the series satirically reworking the iconography of corporate culture—specifically corporate America as the agency of a globally homogenized culture—on broadcast TV, culture jamming aesthetics have reached a massive audience in a context normally saturated with advertising and product placements.

*MAD*ison Avenue: Corporate Satire as Cartoon Tradition

To a significant extent, *The Simpsons* can be understood as following the parodic aesthetic of the satirical magazine *MAD* (1952–). Creator Matt Groening, a member of the Baby Boom generation, has referred to *MAD*'s aesthetics and antiauthoritarian ethos as an important influence for his work (see Harrington 1988). A great deal of *MAD*'s legacy as a Boomer cult journal derived from its satirical stance toward advertisements and the corporate world. *MAD* regularly attacked Madison Avenue, its products, rhetoric, and iconography. Marlboro cigarettes, for instance, became "Marble Row" in a spoof ad (figure 11.1), or a "Toys 'R' Us" fake catalogue advertised the "Big Lady Barbie" by "Muttel."

The beginnings of corporate satire in America, however, date back well before the era of Alfred E. Neumann. A very early example is Frederick Burr Opper's 1885 portrayal of the Statue of Liberty as gigantic billboard (figure 11.2), a critical commentary on the "branding" of a nation with corporate imagery, which would also become a dominant theme in Richard F. Outcault's late-nineteenth-century *Yellow Kid* comic strip series (see Wood 2004). Later, during the Great Depression, consumer culture was becoming more and more visible, and also increasingly lampooned. *Ballyhoo* (1931–1954), a magazine that focused on the growing impact of the media and advertising, was a key purveyor of early corporate satire, "call[ing] attention to advertisers' fantastic and often false claims" (Cooper 2011, 67). *Ballyhoo*'s spoof ads such as "Ducky Wucky Cigarettes" (figure 11.3) represented the first major instance of corporate satire as a subgenre, which *MAD* magazine and *The Simpsons* later refined into serial formats that were appealing to young audiences (the comic book and the animated television sitcom, respectively). If *Ballyhoo* and *MAD* shared a critical stance toward the corporate world, this semi-

Figure 11.1. MAD's "Marble Row" spoof ad on the back cover of *MAD* magazine, no. 7, December 1966.

Figure 11.2. Frederick Burr Opper's satirical commentary on the impact of advertising in 1885: "Letting the Statue of Liberty Earn Its Construction Costs through Advertising." The Granger Collection, New York.

Figure 11.3. "Ducky Wucky" spoof ad in *Ballyhoo*, no. 2, June 1932.

otic approach has become paradigmatic of an "art of rebellion," as Steven Heller (2009) once called it. As an "art of rebellion," corporate satire expanded beyond *MAD* and its imitators (such as *Cracked*, *Sick*, *Panic*, or *Crazy* magazines) in underground press magazines like the *Realist* (1951–2001), the underground comix scene of the 1960s and 1970s, the college humor of *National Lampoon* (1970–1998) or *The Onion* (1988–), and in television shows such as *Saturday Night Live* (NBC, 1975–) and *The Simpsons* (Fox, 1989–).

With corporate satire evolving as a subgenre, commercial culture itself adopted a more ironic perspective on its products, too. In this regard, another interesting artifact is the collectible card merchandise of so-called Wacky Packages (or simply "wacky packs"). Introduced by the American company Topps during the late 1960s in its chewing gum packages, the wacky packs cards featured spoofs of original advertisements. For its new venture, Topps even hired renowned artists of the alternative comics scene—Art Spiegelman, Bill Griffith, Jay Lynch, Norman Saunders, and *MAD* creator Harvey Kurtzman (see Schwartz 2004). Of course, wacky packs were characterized mainly by their visual and product-oriented humor rather than by social satire; after all, they were designed for kids. Nevertheless, their aesthetics echoed the corporate satire of *MAD* by parodying commercial culture and its products. Ted Anthony underlines the instructional effect that wacky packs had for a "newly visual generation":

> Who among us then could imagine having the power to make fun of the load-bearing walls of consumer society such as Procter & Gamble, Lever Bros. and Heinz? Wacky packages turned the supermarket into a potential buffet of obnoxious jokes, bad puns and skeevy illustrations. (n.p.)

The 1967 wacky pack spoof of Camel cigarettes, for instance, showcases how a brand's iconography can be infused with a new meaning through what, in semiotic terms, are acts of appropriation and resignification.[3] First of all, the image mimics a Camels cigarette package with the label "Camels" being replaced by "Camals," and the original subtitle "Turkish Blend," by "Jerkish Blend" (figure 11.4). In addition, it depicts Camels' corporate icon upside-down (implying the fatal effects of smoking). While the spoof's newly created label "Camals" is probably an attempt to

Figure 11.4. "Camals" wacky pack, 1967.

avoid litigation from Camel's parent tobacco company, it is also indicative of a practice commonly used by culture jammers, which is to alter or *détourn* the brand name. Often the creators play with words to invest it with a new (counter)meaning. Similarly, slogans become the targets of creative reworking. Whereas Camel's original corporate identity evokes a certain degree of orientalism (Turkish Blend) that makes smoking seem mysterious and exotic, the slogan is inverted to reveal its banal nature: only jerks smoke.

These techniques of semiotic defamiliarization were adopted in the graphic work of culture jamming groups. The Billboard Liberation Front (BLF), founded in San Francisco in the late 1970s, for instance, or the Billboard Utilising Graffitists Against Unhealthy Promotions (BUGA UP), which emerged subsequently in Australia, adapted the aesthetic practices of *Ballyhoo*, *MAD*, and wacky packs for their "guerilla semiotics" in the public space (Dery 1993, 11). Using actual advertisements as a medium for criticizing the corporate world, the tactics of these culture jammers varied from simple graffiti vandalism to more sophisticated forms, such as the common manipulation of Marlboro ads (figure 11.5).

The most widely known culture jamming collective today is probably the Vancouver-based Adbusters Media Foundation, founded in 1989, which published the first "official" culture jamming journal, *Adbusters*. *Adbusters* represents a new generation of culture jammers who pushed "guerilla semiotics" against corporate culture to new levels. While billboard banditry in the late 1970s and throughout the 1980s involved manipulating what was already there, *Adbusters* advanced this approach. Perhaps its creators remembered the originality and wit of *Ballyhoo* or *MAD* in their notion of culture jamming when they launched a whole campaign featuring "Joe Chemo," a cancer-stricken version of Camel's iconic mascot, Joe Camel (figure 11.6).

Figure 11.5. Billboard alteration "Marlbore." Board by Simon Wagstaff & Jack Napier, BLF. Photo by Bob Campbell 1980.

Figure 11.6. Joe Chemo—Bed. Design by Adbusters.

A Society of Brands: Springfield, USA

The year 1989 saw not only *Adbusters'* launch, but also the premiere of *The Simpsons* on the newborn Fox network. Like *MAD* magazine, *The Simpsons* offers a critical perspective on corporate America and globalized corporate culture. In a satirical fashion, the show weaves organizations and capitalist iconography into its narrative by altering product logos and brand names, for example, or parodying the rhetoric of advertisements.[4] As Gray (2005) points out, an important feature that renders Springfield a satirical mirror image of Western consumer society in general, and corporate America in particular, is its own range of labels and brands. Krusty Burger, Duff Beer, Buzz Cola, Larimie Cigarettes, and Lard Lad Donuts are recurring signifiers that represent the ubiquity of corporate culture in present-day Western societies. In fact, the show's town of Springfield represents a world full of ads like our own, yet *The Simpsons'* production team "rarely allows an ad onto the streets of Springfield or onto its television without parodically criticizing and lambasting it" (229). Thus, the series' universe of fictional brands, logos, and ads effectively illustrates Gray's (2006) concept of parody as *critical*

intertextuality—that is, the way of contesting a certain text's preferred meaning via the textual discourse that surrounds this text. Laughing at *The Simpsons'* ad spoofs, for instance, involves recognizing this process of (re)contextualization; as Gray notes, it requires the viewer "to accept and share the criticism of advertising's modes of address, for jokes are not just on the internal absurdities but also, externally *and intertextually*, at ads that we have all seen before" (82). For Gray, *The Simpsons'* attack on the corporate world is, then, aimed not so much at specific brands or products but rather works on a generic level, as a powerful media literacy educator "(un)teaching" the advertisement (82).

It is also this dimension of critical intertextuality that links the examples of corporate satire discussed so far. From *Ballyhoo* through *MAD* and wacky packs, to *Adbusters* and *The Simpsons*—all appropriate commercial texts to "subvert [their] preferred meanings and to propose unofficial and unsanctioned readings" (Gray 2006, 37). Beyond the function of attacking a specific product (Camels, for example), the jamming of corporate iconography exposes the generic rhetoric of advertisements. For, in tapping into familiar themes or corporate identities, these jams call attention not only to the potential dangers of the advertised products (such as smoking), but also to the rhetorical strategies of the advertising industry itself (as in associating a product with a relaxed lifestyle). By evoking this "perspective by incongruity" (see De-Laure 2002, 247), the language of culture jamming thus offers a didactic dimension to critical media literacy.

Sprawl-Mart, Mapple, and McKrusty: Brand Parodies on *The Simpsons*

Although Springfield is "largely" free from real-life brands and logos, as Gray (2006, 81) has observed, the show's creators use fictional labels as vehicles to represent our actual commercial culture. This is often achieved through allusions—by incorporating fake products into the *Simpsons* universe that mimic labels that exist in reality, such as Krusty Burger (McDonald's/Burger King), Buzz Cola (Coca Cola/Pepsi), or Duff (Anheuser-Busch/Budweiser). Furthermore, *The Simpsons* occasionally parodies the corporate identity of specific targets. To be sure, whereas Duff Beer, Buzz Cola, and Krusty Burger are integral features of

the microcosm that is Springfield, explicit lampoons of real-life brands or organizations are less frequent. Still, it is noteworthy that such explicit brand parodies have tended to appear in the series' second decade—in the 2000s—when *The Simpsons* found itself established as a pop-cultural institution.[5] A more direct form of culture jamming, such satirical representations of actual companies have become a defining characteristic of the matured *Simpsons*.[6]

Because *The Simpsons* is a scripted TV show, its treatment of labels, products, or brands is not experienced in a "still" form as it is happens in the context of wacky packs or *MAD*; rather, parodic representations of corporations are embedded in individual story arcs. The effect of corporate satire may be further complicated by *The Simpsons'* cartoon form, which reflects a satirical, childish perspective that, according to Charles Schutz (1977), intentionally distorts "through emphasis upon, or subtraction from, characteristics of [our social reality]" (28). As Gray (2006) notes, the show is thus generally at risk of being shrugged off as "only a cartoon" (68). On the other hand, it is *The Simpsons'* parodic representation of corporate logos or corporate iconography that distinguishes the series from other cartoon programs, which we usually expect to be free of such real-life details.[7]

Since *The Simpsons'* inception, Krusty Burger has been one of the show's central, recurring motifs and a vehicle through which American consumer culture is satirized. Representing the all-American fast-food restaurant, Krusty Burger is a parodic, albeit implicit, stand-in for the ubiquitous McDonald's chain.[8] Thus, for example, McDonald's' so-called McRib sandwich is renamed "Ribwich" on the show and announced to be available temporarily at Krusty Burger ("I'm Spelling as Fast as I Can," 2003). In another episode, Krusty's offered a vegetarian "Mother Nature Burger," an allusion to McDonald's business strategy of answering to an increased health-consciousness in its target audience ("Coming to Homerica," 2009).

A caricature of Ronald McDonald, or an "anti–Ronald McDonald" (Gray 2007, 137), Krusty the Clown is portrayed as willing do anything in order to turn a profit. Like Ronald McDonald, Krusty appeals to children, and it is through Krusty's character that *The Simpsons* parodies the marketing strategy of using media entertainment as advertising platforms for consumer products.[9] A central character in *The Simpsons'*

animated world, Krusty is also a multidimensional motif through which the show's creators are able to satirize a variety of social and political issues. Bart and Lisa regularly watch *The Krusty the Clown Show* in which Krusty promotes a (manipulated) scratch-and-win game for the Olympic Games[10] in cooperation with Krusty Burger ("Lisa's First Word," 1992), operates a summer camp for children ("Kamp Krusty," 1992), or otherwise financially exploits his audience's blind faith like a modern Pied Piper of Hamelin. Krusty represents a cult leader, as well as the capitalist owner, logo-icon, and celebrity spokesperson for his products at the same time.

There are other instances, however, where *The Simpsons* is much more direct in targeting specific companies. In the episode "On a Clear Day I Can't See My Sister" (2005), for instance, Homer and Marge visit the local "Sprawl-Mart"—an unmistakable reference to the global big box-store Wal-Mart. The plot of the episode focuses on Homer, who temporarily takes over his father's job as a greeter at Sprawl-Mart. The store is introduced at the beginning of the episode in a long shot of the store, which features a Sprawl-Mart logo similar to the original Wal-Mart logo. It is styled in large blue block letters and a red star in place of the hyphen; below the logo, a banner reads, "Not a Parody of Wal-Mart" (figure 11.7). The play on the giant discount store's name clearly points to the expansive or "imperialist" business model associated with Wal-Mart and other large corporations, as well as suggesting that Wal-Mart literally "sprawls" everywhere. Moreover, the modified name, "Sprawl-Mart," also points to the criticism that big corporations, such as Wal-Mart, oust smaller locally owned stores that are unable to compete with big box-stores' discount prices.

In addition, this *Simpsons* episode thematizes the common accusation that large corporations, and especially Wal-Mart, are exploiting their employees. While working at Sprawl-Mart, Homer is told that there will be no chance for advancement in this job. He is forced into working extra hours for the same wage since he has somehow been employed under the identity of an illegal immigrant from Mexico who would be "shipped back" should he not cooperate. Eventually, Homer finds himself locked with several other workers inside the store to work all through the night, with surveillance devices implanted in their brains so that nobody can escape. While the portrayal of Sprawl-Mart/Wal-

Figure 11.7. "Not a Parody of Wall-Mart": The parodic representation of Wal-Mart in "On a Clear Day I Can't See My Sister" (2005).

Mart's practices and working conditions is certainly over the top, this exaggeration offers a subversive kind of humor that breaks up the hegemony of capitalism that usually permeates commercial television.

Another very clear example of corporate satire appears in *The Simpsons*' twentieth anniversary season in its parody of Apple (represented as "Mapple") in the episode entitled "Mypods and Boomsticks" (2010). On one level, the episode demonstrates how readily *The Simpsons* appropriates from the realm of popular culture to reflect certain trends in our fast-moving consumer society; on another, the show offers a satirical picture of corporate culture writ large. Specifically, "Mypods and Boomsticks" satirizes Apple's marketing strategy of creating a quasi-spiritual cult for its customers that is closely linked to the name of Apple's former CEO, Steve Jobs (renamed Steve Mobbs in the episode).

The setting for the episode is the Mall of Springfield where the Simpson family goes shopping. Lisa enthusiastically notices the new Mapple store, a glass cube reminiscent of Apple's flagship store in New York. It

Figure 11.8. Lisa pointing to *The Simpsons*' defamiliarization of the Apple logo in "Mypods and Boomsticks" (2010).

features a modified Apple logo mimicking Apple's iconic monochrome fruit, but with a second bite missing (figure 11.8). As Lisa goes inside, we notice her being beguiled by all the fancy stuff, most of all by the "Mypod" (*The Simpsons*' version of Apple's iPod). What is especially remarkable about the sequence is the series' visual approach to lampooning the distinct Apple iconography, design, and corporate rhetoric by presenting products like the MyCube, which, according to one of the Mapple clerks, "is fueled by dreams and powered by imagination." As Homer asks about its purpose, the clerk replies in typical Apple-speak: "You should ask yourself, what can *I* do for *it*." Other parodies of the Apple universe include the "Braniac Bar," referring to the so-called Genius Bar, the tech support stations located in Apple stores, and "MyPhonies," fake earbuds that make people think you own a fashionable MyPod even if you can't actually afford one. Mocking Apple's corporate identity, including the company's signature aesthetics and specific lingo,

the episode also parodies Apple's sales philosophy of creating a world of distinction-through-consumption for its customers.

Throughout the episode, *The Simpsons* further pokes fun at Apple's quasi-religious way of imbuing its products with spirituality and at Steve Jobs's role as "savior." In one scene, Mobbs/Jobs gives a virtual speech to the shop's customers via a gigantic monitor, a scenario that is reminiscent of Steve Jobs's legendary one-man shows announcing new Apple products. As Evgeny Morozov (2012) notes in an essay about Jobs for the *New Republic*, Jobs's vision was to sell dreams rather than computers, which is just what *The Simpsons* parodies, along with the type of consumer culture Apple has generated. As one man in the crowd of customers watching Mobbs/Jobs's speech remarks, "He's like a god who knows what we want!" Morozov also notes the revolutionary aura evoked by Apple and especially Jobs, such that, when translated to Apple users, they fancy themselves, like Freemasons, to be participating in some "world-historical mission" (21). Lampooning this notion of belonging to a select elite by renaming Steve Jobs "Mobbs," *The Simpsons* also alludes to Apple consumers' blind devotion to a Mafia godfather.

Adding to the critique of Apple as a monolithic, pseudo-religious cult, the episode comments on the potentially exploitative reality of Apple's big business. Lisa gets a Mypod and becomes addicted to downloading music from Mapple's online store, which almost leaves her broke. Here is a clear critique of Apple's business practices of charging money for all sorts of additional items, including music or software applications, and its opposition to all forms of open or "free" media. As little Lisa learns, while Mapple's posters say "Think differently" (a pun on Apple's original slogan, "Think different"), the company's "real slogan is 'No refunds.'"

Demystifying the American Dream: Advertisement Parodies

Lastly, I would like to discuss *The Simpsons'* ad parodies in relation to so-called subvertisements—the placing of subversive counter-ads in environments normally occupied by "real," "authentic" advertisements. This culture jamming practice typically takes place in the city where billboards are creatively reworked in order to communicate oppositional messages. Television, like urban space, is a commercialized context,

too (and this is especially true for the United States, where television broadcasting was founded on a competitive capitalist system). Unlike the presumed "outside" role of *MAD* and *Adbusters*, which feature subvertisements while mostly being published without real advertisements, *The Simpsons* offers ad parodies "inside" a context that is essentially shaped by corporate sponsoring, promotions, and commercials.

Of course, ad parodies appeared on TV long before *The Simpsons*. Variety comedy shows, most notably *Saturday Night Live*, have been seminal in that regard (see Mittell 2010, 294). In contrast to *SNL*, whose subvertisements emulated the visual language of "real" advertisements rather accurately, *The Simpsons* defamiliarizes the "codes" of commercial television as it mimics them through its cartoon form. Moreover, *The Simpsons'* narrative structure allows its characters to comment on the parodies or to experience their effects.[11]

The episode "Mypods and Boomsticks" is, again, illustrative here, in its parody of Apple's infamous "1984" commercial, directed by Ridley Scott and broadcast during the 1984 Super Bowl. Instead of the nameless female runner (who heralded the coming of Apple's Macintosh), we see the *Simpsons* character Comic Book Guy (who typifies the computer geek and sci-fi fan culture within the series) running with a sledgehammer through the Mapple store toward the projection of Steve Mobbs, who is speaking to the customers inside the shop. The irony of the sequence lies, of course, in the replacement of "Big Brother" who addresses the "blind masses" in the original Apple advertisement with the very spokesman of the company. While Apple initially presented itself as an alternative, or even rebellious, brand fighting the tyranny of Big Brother (that is, IBM) back in 1984, *The Simpsons'* creators *détourn* this 1984 ad by depicting Steve Mobbs/Jobs as Big Brother and displaying the hegemonic corporate and cultural status Apple holds in the postmillennial age. Hence, when Comic Book Guy throws the hammer toward the projection of Steve Mobbs, this act of destruction becomes a powerful gesture of cultural critique—a protestation, on the part of the quintessential computer geek, that Apple is no longer the agency of an alternative culture but rather the opposite: Apple has gone mainstream and, by distributing applications that work exclusively within the Apple system, generates conformity.

In a similar, yet even more sophisticated way, the 1998 episode titled "The Last Temptation of Krust" contains a commercial spot featuring the Canyonero, another fictional product in *The Simpsons'* universe,[12] which represents a satiric commentary on the SUV (sport utility vehicle) craze that emerged in North America during the late 1990s. Furthermore, the sequence lampoons the way that SUVs have been promoted in the United States as a specifically American car model by parodying the rhetorical advertising strategies that associate SUVs with wilderness, the Western frontier, personal freedom, patriotism, and so on. The French semiotician Roland Barthes (1977) used the term "myth" to refer to the internalization of such connotative attributes. Through the Canyonero subvertisement, *The Simpsons* exposes such myths as an integral part of the rhetoric of advertising. Thus the sequence is aimed at the corporate rhetoric that has transformed the SUV into a myth representing "Americanness" through the pursuit of spatial freedom and unbounded automobility.

"The Last Temptation of Krust" features Krusty the Clown, who finds himself in the midst of an identity crisis because his comedy program is no longer appealing to its audience. However, he regains both his self-esteem and his audience as he starts a successful comeback tour as an underground stand-up comedian critical of consumer society—until, that is, Krusty's old stock character as greedy media figure is reestablished when he is paid to become the spokesman for the new Canyonero SUV. As Krusty plugs the Canyonero in one of his nightly performances at Moe's Tavern, the audience boos him off the stage. Totally frustrated, Krusty gives Bart a ride home in his red Canyonero. When Bart enters the car, he says with amazement: "Wow, this *is* roomy!" Then, through Bart's point of view, we see Krusty, sitting behind the wheel, nodding coolly at Bart (and implicitly the audience). Krusty turns the key to start the engine, and we hear a country-folk song that indicates the transition to the upcoming ride in the Canyonero.

The next scene is presented in the fashion of a commercial. Blurring the boundaries between the episode's diegesis and an imagined commercial world, the soundtrack is reminiscent of the theme song of the 1960s television series *Rawhide*, but with the chorus singing "Canyonero, Can-yo-ne-ro."[13] Generally, the song functions as a sound bridge

and transition through which the line between the characters' (and implicitly our) imagination and the episode's "reality" becomes confused. Although the scene begins at the parking lot behind Moe's late at night, we suddenly find ourselves in bright daylight, viewing a long shot of the Canyonero driving through a lonely desert, which obviously violates the sequence's continuity. The segment exhibits a rather crude animation style, consisting of associative images whereby the Canyonero overcomes all kinds of natural obstacles (a river, a canyon, and so on). This overt dissonance of visual codes in relation to the sequence's verisimilitude is intensified at the level of sound. While one might have assumed that the Canyonero tune is played from the car's tape recorder at the moment Krusty starts the engine, this assumption remains unconfirmed. The audience watches the Canyonero driving through a canyon landscape while the music continues. As a non-diegetic device, the sound thus functions as musical theme or *soundtrack*—a sound component typical of commercials.

The semiotic appropriation of the codes of a commercial spot becomes explicit at the end of the half-minute sequence: the mise-en-scène is composed of a beautiful desert sunset in the background as the Canyonero stops on a prominent rock at the upper left side of the screen. Anticipated by the song, this arrangement clearly alludes to a Western scenario (the Canyonero resembling a cowboy on his horse) where everything is in perfect harmony with nature. At the end of the segment, a close-up of Krusty wearing a cowboy hat appears in a circle at the bottom right-hand corner. He holds his thumb up and says his motto: "Hey! Hey!" (figure 11.9). At this, a hastily spoken disclaimer is made in a voiceover: "The Federal Highway Commission has ruled the Canyonero unsafe for highway or city driving." By mimicking this paratextual device, the sequence parodies the conventions by which logos, celebrities' testimonials, and disclaimers are commonly incorporated into commercials.

Clearly, the whole sequence is parodic of the marketing of the SUV. One of the striking absurdities of the SUV phenomenon is, of course, that a vehicle originally designed for crossing difficult terrain has been successfully marketed as a mainstream product for people who mostly live in urban and suburban areas. The obvious explanation for this is that people buy SUVs primarily for their symbolic or "lifestyle" value,

Figure 11.9. Ad-stlye composition of the Canyonero and its celebrity spokesperson, Krusty the Clown, in "The Last Temptation of Krusty" (1998).

while function ranks secondary. To them, the SUV stands for adventure and individual freedom, mythic concepts integral to the notion of America and "Americanness." In his study of SUV advertising strategies, Leigh Glover (2000) notes that the model names—Explorer, Ranger, Cherokee, Silverado, and the like—usually connote the myth of the Western frontier. Glover explains, "Marketers seek to evoke a pseudo-nostalgia for that popular culture version of Western history, suggesting that travel was an adventure, frontiers beckoned, and survival depended on self-reliance, character, and fortitude" (362). The label "Canyonero," then, adds to *The Simpsons'* satiric take on promoting SUVs by relating them to myths of wilderness, adventure, individualism, and freedom. Through the Canyonero motif, *The Simpsons* critiques the notion of freedom inscribed in the myth of the American Dream and associated with automobility as potentially offering "escape from the static world through the 'freedom of the road,' in which the dream of personal reinvention seems possible" (362).

This image is visually reinforced by the continuous exterior view of the Canyonero driving alone through the desert, a stark contrast to the reality of traffic in urban areas. In that sense, it is not Krusty who drives the Canyonero (and, indeed, we don't see either Krusty or Bart throughout the sequence); rather, the representation of the Canyonero suggests an identity of its own. Like a cowboy on his horse, the Canyonero drives through the desert—an *auto*mobile that seems to enjoy its autonomy. This metaphorical image is also reinforced in the final shot, where the Canyonero is depicted from a low angle resting on the desert rock, a visual composition that is generic of SUV and truck commercials and, according to Martin Green (1996, 34), is meant to signify the triumph of (car) culture over nature.

That the satirical representation of the Canyonero constitutes a form of culture jamming becomes especially obvious at the very end of the episode. After the final credits, in the fashion of a reprise, the Canyonero song comes up again, and the vehicle reappears, showing its true face: the oversized vehicle hogs two lanes and causes an accident by driving recklessly; then the Canyonero chases deer and runs over them. If the Canyonero subvertisement implies a form of cultural criticism, this political dimension becomes much more aggressively pronounced during the reprise sequence. As the Canyonero forces a school bus off the road, the accompanying song's lyrics are "Twelve yards long, two lanes wide / Sixty-five tons of American pride." After that, the school bus crashes against a tree and catches fire, and a group of Boy Scouts leans out of the burning bus's windows, performing a salute. This *détournement* of "patriotic" SUV ads is even more accentuated at the very end of the sequence, where we see an image of the American flag, and after it has been literally branded by a Canyonero logo with a hot branding iron, the Canyonero enters the picture heading straight for the Stars and Stripes. As the car bursts through, the flag catches fire. The flames unveil a view of the desert road on which the Canyonero rides toward the sunset. With a tattered piece of the American flag in flames hanging across the frame, *The Simpsons* leaves the audience with a satirical picture of the marketing of SUVs and a critical commentary on the crass appropriation of patriotic symbols in advertising in the United States (see figure 11.10).

Figure 11.10. The American flag in flames as the Canyonero rides toward the sunset in "The Last Temptation of Krusty" (1998).

Culture Jamming and Commercial Television

While *The Simpsons'* universe generally exhibits fictional labels as vehicles to target business models or companies—and commercial culture in general—its writers also lampoon specific brands and real-world corporations. By satirically reflecting on consumer society, particular businesses, and corporate identities, as well as on the relationships between corporate culture and the consumer, *The Simpsons* performs moments of culture jamming that disrupt the ideological homogeneity normally associated with commercial television. The series thus constitutes a challenging touchstone that demonstrates the invasive potential of culture jamming, on the one hand, and the blurring of the concept by the cultural mainstream, on the other.

From this perspective, *The Simpsons* has blazed a trail for other television satire formats to follow.[14] In a lineage of corporate satire, which took

shape in the twentieth century with satirical magazines such as *Ballyhoo* and *MAD*, *The Simpsons* has demonstrated that there exists an audience that appreciates the show's critical take on corporate culture—an audience that the series has itself helped to cultivate. While *The Simpsons'* producers were cautious about appropriating cultural symbols back in the show's initial years due to legal concerns (see Jean et al. 2002), they have become increasingly relaxed about this over the course of the series' development. As *The Simpsons* rose to become one of the pop culture institutions of our times, its makers became bolder about practicing artistic freedom within the scope of parody and satire.[15] Given that the producers of *The Simpsons* seem to have not been sued for copyright infringement yet,[16] the show has not only set standards for what satire and parody can do on TV, but has also publicly tested the boundaries of artistic freedom and fair use in contexts of culture jamming. This again demonstrates that *The Simpsons* remains one of the most progressive and powerful television shows to date, even as it becomes a fading echo of the 1990s' No Logo spirit.

NOTES

Many thanks go out to Marilyn DeLaure, Jonathan Gray, Markus Hünemörder, Matt McAllister, and Jason Mittell for commenting on various drafts of this essay, as well as the Culture Jamming Project meetings during the winter semester of 2011–2012 at the University of Munich. I'm also indebted to Doug Gilford and the *MAD* magazine fan site (www.madcoversite.com) and Gregory Grant @ The Wacky Packages Web Page (www.wackypackages.org), as well as Jack Napier from the Billboard Liberation Front (www.billboardliberation.com) and Kalle Lasn from Adbusters (www.adbusters.org) for providing me with images from their archives.

1 Parallel to *The Simpsons*, this "No Logo" zeitgeist found articulation in the mainstreaming of rock bands espousing anticommercial attitudes, such as Rage Against the Machine or Chumbawamba, and culminated in the antiglobalization protests from Seattle to Genoa.

2 The collaboration with popular culture jammers such as Banksy in the episode "MoneyBart" (2010) or Robbie Conal, Shepard Fairey, and Ron English in the episode "Exit through the Kwik-E-Mart" (2012) is also illustrative of the attempts to provide the show with subcultural flair.

3 Similar tactics have been identified for the self-stylization of subcultures (see, for example, Clarke et al. 1976, 55).

4 *The Simpsons* has been emphasizing this aspect in its new widescreen HD opening sequence since the middle of season 20: During the zoom on Springfield's

Elementary School, a gigantic statue of the Lard Lad Donuts boy mascot and a parodic musical billboard are depicted as an integral part of *The Simpsons'* satirical universe.

5 For example, Starbucks (in "The Simpson Tide," 1998), Wal-Mart (in "The Fat and the Furriest," 2003; "On a Clear Day I Can't See My Sister," 2005), or Apple (in "Mypods and Boomsticks," 2008; "Lisa the Drama Queen," 2008; "Father Knows Worst," 2009; "Thursdays with Abie," 2010; "Flaming Moe," 2011).

6 Fans of the series recognize and appreciate this facet. Charlie Sweatpants (2010), a user of *The Simpsons* online forum Dead Homer Society, for instance, complains about the atypically uncritical representation of the social media platform Facebook in the 2010 episode "Loan-a Lisa."

7 That *The Simpsons'* visuals are often highly sophisticated when it comes to social satire is, for example, emphasized by Jared Keller's (2011) review in the *Atlantic*.

8 Interestingly, although McDonald's has actually appeared by name on the show (e.g., "Double, Double, Boy in Trouble," 2008; "Lisa Simpson, This Isn't Your Life," 2010), the company was not the target of satire in these instances. Also, the *Simpsons* characters have been used as spokespeople for McDonald's' rival corporation, Burger King, as well as Kentucky Fried Chicken, neither of which has been shown on the series.

9 In his 2001 book *Fast Food Nation*, Eric Schlosser points out how clever this strategy was by quoting McDonald's founder Ray Kroc: "'A child who loves our TV commercials,' Kroc explained, 'and brings her grandparents to a McDonald's gives us two more customers'" (41). In fact, the strategy paid off, and McDonald's not only sold tons of burgers, but its corporate mascot, Ronald McDonald, also began to rival Mickey Mouse and Santa Claus as an icon of American popular culture.

10 Here the creators of *The Simpsons* allude to McDonald's' marketing gaffe during the 1984 Olympic Games when the company proposed a free item for every scratch-off ticket if the United States wins a certain competition. Owing to the Soviet boycott of the games, however, the "When the US Wins, You Win!" campaign almost became a financial disaster for McDonald's.

11 This is significantly different from advertisement parodies as they are featured in other satiric sketch comedy programs such as *SNL*. There, ad parodies appear in short, individual narrative segments. McAllister (2004) also views the embedding of corporate satire into story arcs on *The Simpsons* as one of the unique features of the show.

12 The Canyonero is also featured in the "Screaming Yellow Honkers" (1999) as well as in the *Simpsons* video games *Simpsons Hit and Run* and *Simpsons Road Rage*. Although the games may be understood as parodic of *Grand Theft Auto*, as promotional paratexts (Gray 2010), their existence as adventure games complicate the satiric function of the Canyonero in the *Simpsons* series.

13 This is another example of how *The Simpsons'* creators have managed to speak to multiple generations of viewers; since many may be too young to know *Rawhide*, they probably associate the song with the 1980s cult film *Blues Brothers*.

14 See Gray, Jones, and Thompson (2009).

15 Within the legal framework of the fair use doctrine, the Supreme Court defined parody as "the use of some elements of a prior author's composition to create a new one that, at least in part, comments on that author's work" (*Campbell v. Acuff-Rose Music, Inc.*, 510 US, 569 [1994], at 580). As elements of culture jamming, brand parodies fall under this rubric if they "not only borrow from the trademark itself, but . . . also appropriate the device of branding and employ it to make us think critically about the role of brands in our culture" (Dogan and Lemey 2013, 492).

16 This is what I had learned from e-mail correspondence with a Fox executive in the fall of 2014; when the topic came up again in further correspondence with Fox in September 2015, the same executive was much more tight-lipped, asserting that Fox would not comment on any legal issues whatsoever.

REFERENCES

Alberti, John. 2004. Introduction to *Leaving Springfield: "The Simpsons" and the Possibility of Oppositional Culture*, edited by John Alberti, xi–xxxii. Detroit, MI: Wayne State University Press.

Anthony, Ted. 2008. "Wacky Packages Showcases the Early Age of Irony." *Gettysburg Times*, October 29.

Barthes, Roland. 1977. "Rhetoric of the Image." In *Image, Music, Text*, edited and translated by Stephen Heath, 32–52. New York: Hill & Wang.

Charlie Sweatpants. 2010. "Wanted: Background Artist." *Dead Homer Society*, October 5. www.deadhomersociety.wordpress.com.

Clarke, John, Stuart Hall, Tony Jefferson, and Brian Roberts. 1976. "Subcultures, Cultures and Class." In *Resistance through Rituals: Youth Subcultures in Post-War Britain*, edited by Stuart Hall and Tony Jefferson, 9–79. London: Hutchinson.

Cooper, Troy B. 2011. "*Ballyhoo* Magazine (United States)." In *Encyclopedia of Social Movement Media*, edited by John D. H. Downing, 67. Thousand Oaks, CA: Sage.

Crothers, Lane. 2010. *Globalization and American Popular Culture*, 2nd ed. Lanham, MD: Rowman.

Dogan, Stacey L., and Mark A. Lemley. 2013. "Parody as Brand." *UC Davis Law Review* 47 (2): 473–513.

Doonar, Joanna. 2004. "Homer's Brand Odyssey." *Brand Strategy* 179: 20–23.

DeLaure, Marilyn [Bordwell]. 2002. "Jamming Culture: Adbusters' Hip Media Campaign against Consumerism." In *Confronting Consumption*, edited by Thomas Princen, Michael Maniates, and Ken Conca, 237–53. Cambridge, MA: MIT Press.

Dery, Mark. 1993. *Culture Jamming: Hacking, Slashing and Sniping in the Empire of Signs*. Pamphlet no. 25. Westfield, NJ: Open Magazine.

Glover, Leigh. 2000. "Driving Under the Influence: The Nature of Selling Sport Utility Vehicles." *Bulletin of Science, Technology and Society* 20 (5): 360–65.

Gray, Jonathan. 2005. "Television Teaching: Parody, *The Simpsons*, and Media Literacy Education." *Critical Studies in Media Communication* 22 (3): 223–38.

———. 2006. *Watching with "The Simpsons": Television, Parody, and Intertextuality*. New York: Routledge.

———. 2007. "Imagining America: *The Simpsons* Go Global." *Popular Communication* 5 (2): 129–48.

———. 2010. *Show Sold Separately: Promos, Spoilers, and Other Media Paratexts*. New York: New York University Press.

Gray, Jonathan, Jeffrey P. Jones, and Ethan Thompson, eds. 2009. *Satire TV: Politics and Comedy in the Post-Network Era*. New York: New York University Press.

Green, Martin. 1996. "Some Versions of the Pastoral: Myth in Advertising; Advertising as Myth." In *Advertising and Culture: Theoretical Perspectives*, edited by Mary Cross, 29–47. Westport, CT: Praeger.

Groening, Matt, Al Jean, Jeff Martin, and Mike Reiss. 2002. Audio Commentary for "Three Men and a Comic Book." *"The Simpsons": The Complete Second Season*. DVD. Los Angeles: Twentieth-Century Fox.

Harrington, Richard. 1988. "The Cartoon Hell of Matt Groening: Drawing on the Humor in Life's Little Horrors." *Washington Post*, December 18.

Heller, Steven. 2009. "The Art of Rebellion." *New York Times*, August 9.

Keller, Jared. 2011. "A Visual History of Literary References on *The Simpsons*." *Atlantic*, September 24. www.theatlantic.com.

Jameson, Fredric. 1991. *Postmodernism; or, The Cultural Logic of Late Capitalism*. Durham, NC: Duke University Press.

Klein, Naomi. 1999. *No Logo: Taking Aim at the Brand Bullies*. Toronto: Knopf.

McAllister, Matthew P. 2004. "From Lard Lad to Butterfinger: Contradictions of *The Simpsons* in Promotional and Commercial Culture." Paper presented at the International Communication Association Conference, New Orleans.

Mittell, Jason. 2010. *Television and American Culture*. New York: Oxford University Press.

Morozov, Evgeny. 2010. "Form and Fortune: Steve Jobs's Pursuit of Perfection—and the Consequences." *New Republic* 243 (4): 18–27.

Schlosser, Eric. 2002. *Fast Food Nation: The Dark Side of the All-American Meal*. New York: Perennial.

Schutz, Charles E. 1977. *Political Humor: From Aristophanes to Sam Ervin*. Rutherford, NJ: Fairleigh Dickinson University Press.

Schwartz, Ben. 2004. "Culture Jamming for the Swingset Set." *Chicago Reader* 34 (39): n.p. www.chicagoreader.com.

Wood, Mary. 2004. "Selling the Kid: Outcault's Representation of Commercialism." *"The Yellow Kid" on the Paper Stage*, February 2. www.xroads.virginia.edu.

12

The Poetics of Ruptural Performance

TONY PERUCCI

Every day, do something that won't compute.
—Wendell Berry

Understanding alone can do little to transform conscious-
ness and situations. The exploited have rarely had the need
to have the laws of exploitation explained to them.
—Jacques Rancière

We are sorry for this inconvenience, but this is a revolution.
—Subcommandante Marcos

The set-up of Renee Gladman's (2003) novella, *The Activist*, is this:
News reports claim that a major urban bridge has been destroyed by
an activist group called the CPL. Some contend that the bridge fell on
its own. A group of angry commuters claims that the bridge is, in fact,
still standing—and demands the right to drive across it. Finally, a group
of Canadian scientists called in by the president determines that there
never was a bridge: "not clear it was a crossing point," their report states
(28). The head paramilitary officer assigned to track down the CPL
bemoans, "Instead of a hunger strike, they're issuing a logic one," but
goes on to say that he doesn't know what that means (49). Members of
the group are rounded up, but are then broken out of jail by their com-
rades. Their escape from jail coincides with a sudden increase of graffiti
around the city, most often expressing only the word, "No" (117).

I open with this story from Gladman's book because it illustrates the
kind of performance activism I try to get at in this essay, and which I am
calling "ruptural"—a kind of activist performance that resists legibility.
It is the performance of the logic strike. While this essay did originally

begin as a manifesto, and perhaps it still is one, I don't mean to argue against other, more clearly communicative activist performances, but rather to complement, complicate, and confound them.

In this essay, I argue for and trace out the critical characteristics of legibility-resisting forms of performance activism that are distinct less because of a communicated message of their content and more by their qualities as performance. This emergent mode pays a particular debt to the pranksterism of Abbie Hoffman, the *détournement* of the Situationists, and the absurd enactments of Dada performance. These interventions are best known today through the practices of culture jammers, including the staged performances of Reverend Billy and the Church of Stop Shopping, the Billionaires for Bush, and the Yes Men. While ruptural performance can be seen as a strain of culture jamming, it is one that diverges from the dominant model epitomized by the work of Kalle Lasn and *Adbusters*. Those practices emphasize activism that moves at the level of signification through "subvertisements" and "billboard liberation" that "rebrand" and "uncool" corporations by contesting the corporate/branded image with the ecological, economic, and social consequences of the products that underlie their profit line. Such a mode of culture jamming speaks in the grammar of advertising as it seeks to disrupt it. In so doing, such culture jamming is characterized by a clarity of message even as it subverts the advertisements it "jams." Ruptural performance, however, jams up the meaning-making process itself. It willfully confuses the issue, and utilizes the very bafflement that ensues as a strategic advantage in challenging power.

At the risk of constructing a false binary, I propose that the obverse of ruptural performance is Guy Debord's ([1967] 1995) "spectacle." Debord explains that while the society of the spectacle is indeed an "accumulation of *spectacles*," he distinguishes that "the spectacle is not a collection of images; rather it is a social relationship between people that is mediated by images" (12). While he calls it a *Weltanschauung* (worldview), it is more than an ideology or a veil of false consciousness. Rather it is "the very heart of society's real unreality" (13), and in that materiality extends the alienation of the production of the commodity to its consumption: The spectacle produces "isolation" through the shift from "doing" to "contemplation," where "the spectator's alienation from and submission to the contemplated object . . . works like this: the more he

contemplates, the less he lives" (23). Ultimately, the spectacle as "social relationship" represents the triumph of the commodity-image, the "ruling order's . . . uninterrupted monologue of self-praise" (19), whereby "the commodity completes its colonization of social life" (29). In understanding the spectacle as not merely spectacles, but a modality of experience in which separation and contemplation flatten the encounter with presence, Debord proposes "situations" specifically to intervene at the level of experience.

However, in his attempt to characterize contemporary activism, *Dream: Reimagining Progressive Politics in the Age of Fantasy*, Stephen Duncombe (2007) proposes that spectacle is itself the basis for protest, and that the distinction of the spectacle and the situation is merely "semantic" (130). Instead, he proposes "the ethical spectacle":

> Our spectacles will be participatory: dreams the public can mold and shape themselves. They will be active: spectacles that work only if people help create them. They will be open-ended: setting stages to ask questions and leaving silences to formulate answers. And they will be transparent: dreams that one knows are dreams but which still have the power to attract and inspire. And finally, the spectacles we create will not cover over or replace reality and truth but perform and amplify it. (17)

There is much to be gained from Duncombe's (2007) schematization here. And what I wish to do is revise and amplify it by challenging his dismissal of the distinctive character of "spectacle." Most significantly, this requires distinguishing that the spectacle is not just a thing to be seen, but is also a *mode of performance*. Interventionist performance, particularly that which seeks to challenge and disrupt the values, and especially the experience of the society of the spectacle, is a different modality of enactment, rather than a variation of spectacle.

While performance interventions share with spectacle the qualities of being dramatic and theatrical, what distinguishes them is that they disrupt the *experience* of daily life, a rupture of the living of social relations—what activist Reverend Billy calls "the necessary interruption" (Talen 2000, xiii). The interruption, which Walter Benjamin (1968) might call the "sudden start" or the "shock" (163), creates the space for

and initiates the experience of a ruptural performance. What follows is an attempt to trace out rupture as a modality of performance that means to disrupt, or at least to fuck with, the spectacle.

1. Ruptural performances are interruptive.
2. Ruptural performances are becoming-events.
3. Ruptural performances are confrontational.
4. Ruptural performances are baffling and confounding.
5. Ruptural performances enact becoming-a-problem.
6. Ruptural performance gives rise to the virtuosic multitude.

This listing is meant in no way to be prescriptive, exhaustive or limiting. Rather, it is intended to be a provisional, necessarily incomplete cataloguing of the features of some contemporary activist performances. Ruptural performance is perhaps best thought of as an emergent form that functions in support of a diversity of tactics that includes marches, sit-ins and long-term community engagement and mobilization.

Ruptural Performances Are Interruptive

In some way these performances halt, impede, or delay the habitual practices of daily life. They intervene at the level and in the midst of the quotidian. Such performances engage the "necessary interruption" which seeks to make conscious what is habitual so that it is available for critique. In this way it shares Debord's (2002) notion of the constructed situation: "the concrete construction of temporary settings of life and their transformation into a higher, passionate nature" (44) is inherently interruptive as it "asserts a non-continuous conception of life" (48). They seek to destabilize what the Russian Formalist Viktor Shklovsky (1965) called the "automatism of perception" (13). For Shklovsky, the role of art is to undo "habitualization," which he says, "devours works, clothes, furniture, one's wife, and the fear of war" (12). Such a reclamation of perception Shklovsky calls "defamiliarization" (13), for which the Russian phrase is *priem ostranenie*, and which translates literally as "making strange." Brecht (1964) realized the political potential for this concept as the *Verfremdungseffekt*, which is foundational in that

Figure 12.1. Opovoempé performing *Congelados* (Frozen) (2005), a *Guerrilha Magné-tica intervençõ* at a supermercado in São Paulo, Brazil.

it focuses on the experience of making the familiar strange as much as the transmission of a political message. In the speed-up of a contemporary life characterized by images and simulations, these performances engage what Brecht's associate Walter Benjamin (1968) calls the "interruption of happenings" that estranges the "conditions of life" (150). It is this interruption, Benjamin suggests, that allows performance to obtain the "special character [of] . . . producing astonishment rather than empathy" (150). Interruptive performance, however, occurs not at the level of representation, but on the field of presence. It is achieved by "putting a frame" around experience that produces what Richard Bauman (1977) calls a "heightened intensity" or "special enhancement of experience" (43).

The Brazilian group, Opovoempé ("people on their feet"), for instance, has performed their *Guerrilha Magnética* (Magnetic Guerilla) and other *intervenções* (interventions) throughout public spaces in São Paulo. In 2006, they composed and performed *Congelados* (Frozen), a series of *intervenções*, throughout the city's *supermercados*.[1] The per-

formances consisted of simple and improvised ensemble compositions constructed through the use of the theatrical practice known as Viewpoints: gesture, repetition, spatial relationship, and kinesthetic response.[2] The piece, in its basic performance of the actions of shopping, defamiliarizes those activities. The "choreography" that constitutes the "dance and music of buying" only gradually becomes evident, as the repetition of the banal gestures of shopping begins to mark their strangeness as performance (Esteves 2009). Though the content of the action is not overtly political—it does not scream its ideology—it makes the encounter with shopping, and especially its mindlessness and repetitiveness, seem strange.

At their foundation, Opovoempé's pieces are rupture-producing machines: "The interventions intend to cause rupture of communication barriers, revelation of humor and play, change in the use of public space, and the manifestation of latent contents or social tensions previously unnoticed" (Esteves n.d.). That rupture is specifically political—particularly in mobilizing the poetic state of quotidian settings. *Guerrilha Magnética* performances are intended "to break apathy and indifference, to install a creative atmosphere of play and to reveal the poetic content of the city." In *O que se viu que você vê* (What was seen that you see) (2007), the ensemble performed a structured improvisation with newspapers at the busiest intersection in São Paulo at Avenue Paulista (figure 12.2). The inspiration for the performance was local newspapers' silence on a spate of police brutality cases in the area. However, at least as important as the protest against police violence and the news media's complicity was the production of an extended dance that was intended to compel the audience that drove and walked by the performance to "see" their city again. As the ensemble moved along a preplanned path from a police substation to a tram stop to a homeless encampment and to a freeway overpass, the group constructed striking and dynamic images and actions intended to interrupt passersby so that they would re-see their surroundings in order to reconnect and reinvest in them.

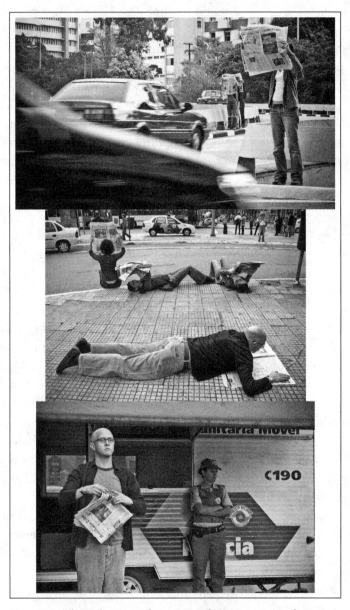

Figure 12.2. The author in performance with Opovoempé in the *Guerrilha Magnética*, "O que se viu que você vê" (What was seen that you see) (2007) on a freeway overpass and on Avenue Paulista. Photos by Christian Castanho.

Ruptural Performances Are Becoming-Events

Thus, they do, as Dell Hymes (1975) suggests, "break through into performance" (11). And while their boundaries are unstable and unfixed, it is the ruptural performances' "eventness," their status as singular in time and space, which enables the presencing that the spectacle confounds. Alain Baidou (2007) puts it this way: "This other time, whose materiality envelops the consequences of the event, deserves the name of a new present. The event is neither past nor future. It makes us present to the present" (39). The instability of the boundaries of the event is also equally significant. Ruptural performances tend to confound boundaries of the real and artificial. The actual event of performance is generated by means of artifice, yet is one in which audiences often don't initially realize that they are in a constructed situation.

In ruptural performances, audiences often first suspect that something isn't right, but are not sure if something is actually amiss. Ultimately, though, the "breakthrough" occurs when audiences realize that things aren't normal, they are strange, and we are in the midst of an event. It is this eventness (and the anticipatory process of becoming-event) that enlivens the occasion of the here and now. And that temporal immediacy is captured well by Benjamin's (1968) invocation of *Jetztzeit* or the "presence of the now" (261). One becoming-event that has been performed around the world is the "whirl."

The whirl consists of a group of fifteen or more people entering a sweatshop store a few at a time (most often a Wal-Mart, thus the sometimes-used moniker: "Whirl-Mart") who move empty shopping carts throughout the store. Once all performers are inside and with carts, the participants create a single line of carts that snakes throughout the store, splitting and refiguring as the snake of carts meets up with blocked aisles and shopping customers (which must look like a Busby Berkley dance sequence to the overhead security cameras). During the hour or more of the performance, if asked by management, security, employees, or customers what they are doing, performers respond kindly with "I'm not shopping." As performers make their rounds, it is the employees who first encounter the becoming-event, then the customers, then management (who begin manically communicating on walkie-talkies), and finally security. When security gets wise, it's time to return the carts and

Figure 12.3. The becoming-event of performing the whirl.

exit the store. As ruptural performance, the whirl does not make any specific claim on protesting the many things one could agitate against—sweatshop labor, poor treatment of store employees, predatory business practices, etc.—given that most people present could recite this litany of wrongs. Rather, the whirl enacts the becoming-event of "not shopping," which in itself can be read as an engagement against over-consumption, Wal-Mart's imperialism, unfair labor practices, or ecological devastation.

Ruptural Performances Are Confrontational

By confrontational, I don't necessarily mean aggressive, though they may be that. Rather, ruptural performance emerges, as Benjamin (1968) says

of epic theater, when a "stranger is confronted with the situation as with a startling picture" (151). Ruptural performance is thus distinguished from the "revelatory" performance that unmasks the hidden truths (though it may also do this). In our age, what Marx called the "secret of the commodity"—that its price masked the alienated labor that produced it— is now exposed. We know, for instance, that many of the products we buy are produced by sweatshop-, child- and slave-labor; but we have developed what Adrian Piper (1996b) calls "ways of averting [our] gaze" (167).

Ruptural performance is thus less a critique of false consciousness, and is more about the experience of the encounter of returning the gaze to that which one avoids in order to maintain acceptance of the inequities of the contemporary social orders. Bruce Wilshire (1982) gets at what I'm talking about when he describes phenomenology as a "systematic effort to unmask the obvious" (11). In fact, this quality is what Michael Fried (1968) complained about as the central quality of Minimal Art: its "stage presence" or "theatricality" where "the work refuses, obstinately, to let him alone—which is to say, it refuses to stop confronting him" (140). And in this way, ruptural performance owes as much to Minimalism as it does to Dada. Ruptural performances, like Minimal Art, are characterized by a "concrete thereness," that Barbara Rose (2000) holds to be a "literal and emphatic assertion of their own existence" (216). In this way, ruptural performances diverge from *Adbusters*-style culture jamming that focuses on the play of representation, emphasizing instead the experiential encounter of material presence. The sensorial act of confrontation that ruptural performances enact is itself a fundamental component of the action.

Such a sensuousness of ruptural performance's mode of confrontation occurred on February 29, 2008, two days before the Russian election that resulted in the victory for Vladimir Putin's apprentice Dmitry Medvedev, when the Russian "art-anarch-punk gang" (Dolcy 2010, n.p.) *Voina* (War) confronted patrons of the Timiryazev Museum of Biology in Moscow with a display of sensual gratification in the form of a "collective fuck action" (www.indymedia.org).[3] Five Russian couples surreptitiously disrobed and proceeded in an extended session of group sex as a bearded man with a top hat and tuxedo held aloft a sign that read, "Fuck for the heir bear cub." The phrase is a play on Medvedev's name, which is derived from the Russian word for bear (*medved*). Though Thomas (2008) described the "stunt" as

a "wry commentary on the handover of power—decried by opponents as undemocratic" (n.p.), it is certainly more than a straightforward piece of political agit-prop. If for no other reason, this can be determined by the wildly divergent interpretations of the act as it has been disseminated on the Internet. Some read it as a critique on the undemocratic qualities of the Russian election (Thomas 2008), some as offering support for the incoming president (existentia_dada 2008), some as animal rights protest in defense of bear cubs (Heer 2008), and some even as a "Crazy Russian Teen Orgy" at teen-orgies.com. But even more than any of these interpretive acts, the event of performance is constituted by the materiality of the confrontation by live bodies in the midst of public sex.

Similarly, in Voina's "Humiliation of Cop in his Own House" (2008) action days before Medvedev's inauguration, the group entered a Russian police station, pasted photos of Medvedev throughout the building, formed a human pyramid to recite a poem by Soviet dissident D. A. Prigov, and attempted to serve the officers tea and cake. In this work it is the confrontational act of performing what they call "innovative art-language" within the state-controlled space of the police station that constitutes "vivid political protest art" (Dolcy 2010, n.p.).

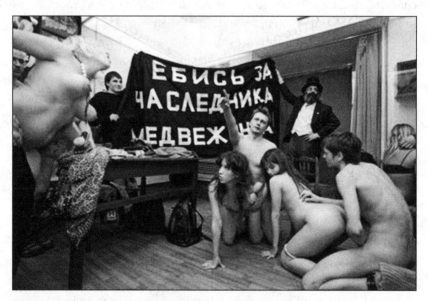

Figure 12.4. Voina's "collective fuck action," "Fuck for the Bear Cub" (2008) in the Moscow Biological Museum.

Figure 12.5. "Humiliation of Cop in His Own House" (2008): Voina reads poetry from a human pyramid of dissident poetry and serves tea and cake to police.

Ruptural Performances Are Baffling and Confounding

Rather than engaging a pragmatic approach to efficient communication that disables so much political art, ruptural performance is indebted to Mary Overlie's concept of "doing the unnecessary." For Overlie (2009), the "unnecessary" action undermines performance's "efficiencies" (McKenzie 2001) by doing that which is not called for in habitual activity: "In these unnecessary activities the body, senses and objectives leap into alertness because they do not know the routine. The body and the mind are put in a state of high awareness and therefore function with thrilling accuracy stretching performance into extraordinary performance" (Overlie 2009, n.p., under "The Unnecessary"). Thus ruptural performance is paradoxically Minimalist and Maximalist.

Ruptural performance embraces the notion that the political message is sometimes not immediately clear, and instead embodies what Artaud (1958) calls "the poetic state" (122). Rather than the clarity of agit-prop performance's political messaging, ruptural performance is characterized by "true dreams and not . . . a servile copy of reality." This "attack on the spectator's sensibility" (86), Artaud says, is a form of "direct action" (87). As such, it aligns with contemporary activism in the resurgence of neo-Situationists and neo-anarchists like CrimethInc (2004), whose *Recipes for Disaster: An Anarchist Cookbook* instructs its readers on "direct action" (which they consider to be the "opposite" of "representation" [13]) that "sidesteps regulations, representatives, and authorities" (12). In their advocacy of replacing "representations of sex" with "real sex," they assert the theatrical dimensions of direct action: "It's time to stop being spectators and start being actors" (201).

The materiality of direct action and Artaud's (1958) emphasis on the "immediacy" (123) of the poetic state occur at the "rupture between things and words" (7) and thus conjoin the phenomenological literalism of Minimalism with the willful nonsense of Dada in producing a "concrete expression of the abstract" (64). If Brecht (1964) moves from the spectacle's "ooh" to epic theater's "Aha!" (Duncombe 2007, 146), then Artaud adds the element of "huh?" Ruptural performance puts the *strange* back in estrangement. In this way, the rupture is, following Adrian Piper (1996a), "catalytic." In Piper's *Catalysis* series, the work of art was but a

Figure 12.6. Adrian Piper's *Catalysis IV* (1970), riding a crosstown bus with a towel in her mouth. Performance documentation: 5 silver gelatin print photographs, 16" x 16" (40.6 cm x 40.6 cm). Collection of the Generali Foundation, Vienna. Copyright by Adrian Piper Research Archive Foundation Berlin and Generali Foundation.

"catalytic agent between myself and the viewer" that creates an "ambiguous situation":

> For Catalysis IV, in which I dressed very conservatively, but stuffed a large white bath towel into the sides of my mouth until my cheeks bulged to about twice their normal size, letting the rest of it hang down my front and riding the bus, subway, and Empire State Building elevator; Catalysis VI, in which I attached helium-filled Mickey Mouse balloons from each of my ears, under my nose, to my two front teeth, and from thin strands

of my hair, then walked through Central Park and the lobby of the Plaza Hotel, and rode the subway during morning rush hour. (43)

Piper (1996a) explains that familiar structures of sense-making "prepare the viewer to be catalyzed, thus making actual catalysis impossible" (45). In this way, the work of art/activism can be as Félix Guattari (1995) says an activity of "rupturing sense" (131)—and in its uncategorizability, its uncontainability, and its ungraspability (Mackey 1997, 52), it is no longer easily dismissed as the known object of political performance.

Ruptural Performances Enact Becoming-a-Problem

Ruptural performance seeks to "escape the tyranny of meaning" (185), to use Barthes's (1977) phrase, and thus resists being easily managed by the spectacle. This unruly, fugitive quality is central to the aesthetics of ruptural performance. And in very particular ways, it points to the fundamental questions about performance activism in the age of crisis. A great deal of scholarship on performance activism focuses on the curative and healing (psychological and social) properties of performance. Perhaps this is due to the role of the important work of Augusto Boal in both theorizing and developing a practice for performance as a mode of social intervention. But the emphasis on celebratory and playful elements of performance activism may obscure the primary and necessary characteristic of performed activism—that it is inconveniencing, disruptive, annoying, and often willfully asshole-ic.

The history of performed activism is replete with actions that are not utopian, charming, or blissful. The precedence for the abrasiveness of contemporary ruptural performance can be found in the Black Panthers' occupation of the California State house, Abbie Hoffman's throwing of money on Wall Street traders, AIDS die-ins on the streets of New York, the Zapatistas marching by the thousands into Mexico City armed with wooden guns, and the Black Brunch protests by #BlackLivesMatter activists who recited at white brunch establishments the names of African American victims of police violence. These performances employ a form of activism that is impolite, and which is considered by some to be the "wrong" form of activism (its obnoxiousness does not take the form of a reasoned argument). Ruptural performance is disruptive to the daily

Figure 12.7. Radical negation as virtuosity: Photos of Mickey Smith holding a sign featuring this Occupy slogan spread across the Internet during the early days of Occupy Wall Street. Photo by Scott Lynch.

practices of those who come across the performance, or who are come across by it. Thus, the becoming-event quality of ruptural performance is also a condition of becoming-a-problem—an irritant form of confrontation at the level comprehension and the quietude of one's day. As a form, mode, and practice of culture jamming, ruptural performance embraces the static, feedback, and distortion that disrupts the ear when an audio signal is jammed.

This condition of becoming-a-problem reminds us of the real work that constitutes enacting rupture, and the labor of activism that exceeds such practices of "activism lite" such as Facebook petitions. To make of oneself a problem is to exceed the condition of a rhetorical practice of persuasion, but further to operate as an intruder into the consistency and continuity of others' quotidian practices. This intrusion, as a refusal of stability of meaning, legibility, and closure, irritates through its fugitive status—its refusal to be pinned down.

And it is this quality that simultaneously makes the Occupy movement both innovative and infuriating. From news magazines to academic monographs, Occupy is taken to task for its unwillingness to "occupy" a clear and cogent political platform. Headlines ask, "What does Occupy want?"—accusing the occupiers of political naiveté for not simply promoting a slate of political initiatives. But it is Occupy's status as an "open" performance and set of performances that has enabled a flexibility to speak to a diverse assemblage of political practices and social injustices—to engage with inequality at the level of multiplicities and the vast intersecting and reinforcing mechanisms that constitute a performance complex of power.

Ruptural Performance Gives Rise to the Virtuosic Multitude

In the Occupy movement, we can identify a final element of ruptural performance—the virtuosic multitude. Paolo Virno (2003) describes the virtuosic as an activity that (1) finds its fulfillment or purpose in itself and (2) does so in the presence of others (52). It is in the virtuosic—that is, the refusal to reify or objectify oneself into stability—that ruptural performance reinvigorates the publicity of the public sphere, enacting what Virno calls "radical disobedience . . . which casts doubt on the State's ability to control" (69). The virtuosic multitude enacts the affective charge of presence that moves at the heart of performance. From the durational performance of encampment to the dynamic embodiment of the human microphone, Occupy is a *movement* that cannot be separated from the condition of bodies *moving*. What Occupy has to teach us about ruptural performance is that the collectivity of action produces the affective encounter with intensities. For John Protevi, it is the political affect of "active joy" that undergirds the semantic and pragmatic elements of the Occupy movement (Protevi 2011). But Virno's notion of the virtuosic implies a more particular modality of experience in the "doing as an end unto itself." Such encounters are what psychologist Mihaly Csikszentmihalyi (1990) calls "autotelic" and which form the basis for what he names the "optimal experience" or "flow" (67, 3). Flow helps us understand the performative intensity of the virtuosic as the charged affect of the dissolving of self and act.

As flow, ruptural performance constitutes the virtuosic multitude in its enactment. That is to say, in its embodiment, it brings into being the

conditions of possibility for radical disobedience. Thus constituted, the virtuosic multitude can further realize itself through a full diversity of tactics. Ruptural performance need not stand alone in the arsenal of resistance. If, as CrimethInc (2008) puts it in the title of their field manual, we should "Expect Resistance," then ruptural performance functions to produce resistance that breaks expectations through intensities of radical disobedience and critical intervention.

NOTES

1 Opovoempé was founded in São Paulo, Brazil, in 2004 by Ana Luiza Leáo, Christiane Zuan Esteves, Graziela Mantoanelli, Manuela Afonzo, and Paula Lopez. For more on Opovoempé, see opovoempe.org.

2 The Viewpoints, first conceived by choreographer and theorist Mary Overlie (and revised by theater director Anne Bogart), works to challenge what Overlie calls the hierarchical "Vertical" theatrical system that privileges plot and character over other theatrical elements. Overlie has developed a full reconceptualization of theatrical practice, as well as specific rehearsal procedures, training exercises, and performance strategies to encourage performers and directors to engage on the "Horizontal" (Overlie 2013, 2006, 1999). Each element, or Viewpoint, of the stage is of equal value in its particularity: Space, Shape, Time, Emotion, Movement, and Story. Bogart has broken these down differently into nine aspects under the two general categories of time and space: tempo, duration, kinesthetic response, repetition (elements of time), spatial relation, shape, topography, gesture, and architecture (elements of space) (Bogart and Landau). For a discussion of the politics of Viewpoints in relation to contemporary activism, see my "Dog Sniff Dog: Materialist Poetics and the Politics of 'the Viewpoints'" (2015).

3 In 2011, Voina members Nadezhda Tolokonnikova, Pyotr Verzilov, and Yekaterina Samutsevich left the group to found the infamous punk rock protest group, Pussy Riot (see Baranchuk, chapter 16 in this volume).

REFERENCES

Artaud, Antonin. 1958. *The Theatre and Its Double*. Translated by Mary Caroline Richards. New York: Grove Press.

Baidou, Alain. 2007. "The Event in Deleuze." Translated by Jon Roffe. *Parrhesia* 2 (Winter): 37–44.

Barthes, Roland. 1977. "The Grain of the Voice." In *Image, Music, Text*, edited and translated by Stephen Heath. New York: Hill & Wang.

Bauman, Richard. 1977. *Verbal Art as Performance*. Prospect Heights, IL: Waveland Press.

Benjamin, Walter. 1968. *Illuminations: Essays and Reflections*. Edited by Hannah Arendt and translated by Harry Zohn, 147–54. New York: Schocken.

Berry, Wendell. 2008. "The Mad Farmer's Manifesto." In *The Mad Farmer Poems.* Berkeley, CA: Counterpoint Press.

Bogart, Anne, and Tina Landau. 2005. *The Viewpoints Book: A Practical Guide to Viewpoints and Composition.* New York: Theatre Communications Group.

Brecht, Bertolt. 1964. *Brecht on Theatre: The Development of an Aesthetic.* Edited and translated by John Willett. New York: Hill & Wang.

"Crazy Russian Teen Orgy." 2009. teen-orgies.com. Website now disabled.

CrimethInc. 2001. *Days of War, Nights of Love: Crimethink for Beginners.* Atlanta: CrimethInc.

———. 2004. *Recipes for Disaster: An Anarchist Cookbook.* Olympia, WA: CrimethInc. Workers' Collective.

———. 2008. *Expect Resistance: A Crimethink Field Manual.* Salem, OR: CrimethInc. Workers' Collective.

Csikszentmihalyi, Mihaly. 1990. *Flow: The Psychology of Optimal Experience.* New York: Harper & Row.

Debord, Guy. (1967) 1995. *The Society of the Spectacle.* Translated by Donald Nicholson-Smith. New York: Zone Books.

———. 2002. "Report on the Construction of Situations and on the Terms of Organization and Action of the International Situationist Tendency," translated by Tom McDonough. In *Guy Debord and the Situationist International: Texts and Documents,* edited by Tom McDonough, 29–50. Cambridge, MA: MIT Press.

Dolcy, Marlon. 2010. "Russian Art Anarchists Explain Themselves." www.dontpaniconline.com.

Duncombe, Stephen. 2007. *Dream: Re-Imagining Progressive Politics in an Age of Fantasy.* New York: New Press.

Esteves, Christiane Zuan. N.d. "What Is *Guerrilha Magnética*?" In *Opovoempé.* Self-published promotional catalogue. www.opovoempe.org.

———. 2009. "Nos Supermercados." www.opovoempe.org.

Fried, Michael. 1968. "Art and Objecthood." In *Minimal Art: A Critical Anthology,* 116–47. Berkeley: University of California Press.

Gladman, Renee. 2003. *The Activist.* San Francisco: Krupskaya.

Guattari, Félix. 1995. *Chaosmosis: An Ethico-Aesthetic Paradigm.* Translated by Paul Bains and Julian Pefanis. Bloomington: Indiana University Press.

Harvey, Stefano, and Fred Moten. 2013. *The Undercommons: Fugitive Planning and Black Study.* New York: Autonomedia.

Heer, Jeet. 2008. "Russian Animal Rights Orgy." WordPress.com, March 4. www.sanseverything.wordpress.com.

Hymes, Dell. 1975. "Breakthrough into Performance." In *Folklore: Performance and Communication,* edited by Dan Ben-Amos and Kenneth S. Goldstein, 11–74. The Hague: Mouton.

Krauss, Rosalind. 2000. "Allusion and Illusion in Donald Judd." In *Minimalism,* edited by James Meyer, 211–12. New York: Phaidon.

Mackey, Nathaniel. 1997. *Bedouin Hornbook.* Los Angeles: Sun & Moon Classics.

McKenzie, Jon. 2001. *Perform or Else: From Discipline to Performance*. New York: Routledge.

"Moscow, 7 Sep '08. 2 Homosexuals and 3 Asian Migrants Lynched in Supermarket by Voina Group." 2008. Indymedia.org. September 20. www.indymedia.org.

"Moscow, the Voina Group 'Fuck for the Heir Puppy Bear!' Action on February 29." 2008. Indymedia.org, March 2. publish.indymedia.org.

Moten, Fred. 2003. *In the Break: The Aesthetics of the Black Radical Tradition*. Minneapolis: University of Minnesota Press.

Overlie, Mary. 1999. "Change of View: The Viewpoints Bridge." *Six Viewpoints: A Destructive Approach to Theater*. www.sixviewpoints.com.

———. 2006. "The Six Viewpoints." In *Training of the American Actor*, edited by Arthur Bartow, 187–221. New York: Theatre Communications Group.

———. 2013 "Manifesto for Reification." In *Manifesto Now! Instructions for Performance, Philosophy, Politics*, edited by Laura Cull and Will Daddario, 127–41. Bristol, UK: Intellect.

Perucci, Tony. 2008. "Guilty as Sin: The Trial of the Reverend Billy and the Exorcism of the Sacred Cash Register." *Text and Performance Quarterly* 28 (3): 315–29.

———. 2015. "Dog Sniff Dog: Materialist Poetics and the Politics of 'the Viewpoints.'" *Performance Research* 20 (1): 105–12.

Piper, Adrian. 1996a. "Talking to Myself: The Ongoing Autobiography of an Art Object." In *Out of Order, Out of Sight: Volume I, Selected Writings in Meta-Art, 1968–1992*, 29–53. Cambridge, MA: MIT Press.

———. 1996b. "Way of Averting One's Gaze." In *Out of Order, Out of Sight: Volume II: Selected Writings in Art Criticism, 1967–1992*, 127–48. Cambridge, MA: MIT Press.

Protevi, John. 2011. "Semantic, Pragmatic, and Affective Enactment at OWS." *Theory & Event* 14 (4). doi: 10.1353/tae.2011.0061.

Rancière, Jacques. 2006. "Problems and Transformations in Critical Art." In *Participation*, edited by Claire Bishop, 83–93. Cambridge, MA: MIT Press.

Rose, Barbara. 2000. "ABC Art." In *Minimalism*, edited by James Meyer, 214–17. New York: Phaidon.

Shklovsky, Viktor. 1965. "Art as Technique." In *Russian Formalist Critique: Four Essays*, translated by Lee T. Lemon and Marion J. Reis, 3–24. Lincoln: University of Nebraska Press.

Talen, Bill. 2000. *What Should I Do if Reverend Billy Is in My Store?* New York: New Press.

Thomas, Peter. 2008. "Art Shock Troop Mocks Russian Establishment." Reuters.com, July 23.

Virno, Paolo. 2003. *A Grammar of the Multitude: For an Analysis of Contemporary Forms of Life*. Translated by Isabella Bertoletti, James Cascaito, and Andrea Casson. Cambridge, MA: Semiotext(e).

"Whirl-Mart Ritual Resistance." 2013. Actipedia. www.actipedia.org.

Wilshire, Bruce. 1982. *Role Playing and Identity: The Limits of Theatre as Metaphor*. Bloomington: Indiana University Press.

13

Turning Tricks

Culture Jamming and the Flash Mob

REBECCA WALKER

The art of "pulling tricks" involves a sense of the opportu-
nities afforded by a particular occasion. . . . A tactic boldly
juxtaposes diverse elements in order to suddenly produce
a *flash* shedding a different light on the language of a place
and to strike the hearer.
—Michel de Certeau, *The Practice of Everyday Life* (empha-
sis added)

When I was six, my big brother pulled a nasty trick on me. He was ten,
and this trick of his stands out in my memory for its cunning, dan-
ger, and illumination of his character. Up until this point, I had always
trusted my big brother implicitly, viewing him as my personal teacher:
a wise sharer of secrets and purveyor of real, capital "T" Truth. Using
this belief to his advantage, on one particular spring day when my
mother was out of the house and my father otherwise occupied in the
den, my brother convinced me to climb inside our 1970s, avocado-green
Hotpoint-style dryer and take a ride. He did so by proclaiming, "It's just
like a roller coaster."

After a very short, noisy, and painful ride in the dryer, I emerged,
crestfallen and suspicious. Was the dryer really like a roller coaster ride?
If so, it certainly failed to meet my expectations. Had my brother lied to
me? This seemed more likely; however, his reasons for doing so made
no sense to my small mind. Why put me in the dryer? Did he desire to
hurt me? Did he simply want to see what would happen? Or was it the
pleasure of pulling one over on me, of accomplishing one of his first
tricks?

A good trick, as Michel de Certeau (1984) notes, relies upon seizing unique opportunities afforded by specific occasions. In the case of my brother, his trick relied upon the convergence of three separate circumstances: my mother's absence from the house, my blind faith in whatever he said, and a recent family trip to a theme park with roller coasters where, unlike my brother, I had been too terrified to take a ride. Realizing the unique opportunity afforded by such a convergence, my brother jumped upon the chance to pull one over on his sister. What he failed to foresee was the enlightenment such a trick produced in my young self. In a flash, I realized my brother could not always be trusted and that his motivations were not necessarily benevolent. Such a realization did indeed, as de Certeau suggests, shed a different light on the situation.

Flash mobs are essentially choreographed group tricks. Whether created as complex communal in-jokes or taking the form of a cultural critique, flash mobs act as elaborate pranks played out within the quasi-public realm of the capitalist city, exposing its heretofore unrealized methods of operation. These methods of operation—both of the capitalist city and of the flash mob—are the focus of this chapter. Throughout, I consider new, hybridized forms of the flash mob which act as culture jams, refashioning popular cultural forms such as song and dance into guerrilla forms of performance, which highlight the shrinking nature of public space. I examine these political, hybridized types of flash mobs to outline the flash mob's strategic methods for operating as an act of culture jamming and performative resistance.

In *The Practice of Everyday Life*, Michel de Certeau (1984) discusses possibilities for creative work within a highly structured capitalist society. According to de Certeau, capitalism casts individuals in roles of consumers of merchandise or as employee-workers producing goods for sale. Within such a system, one might feel the absence of any space for truly creative endeavors—those undertaken without a monetary profit in mind. As de Certeau suggests, however, such spaces for creativity do exist, primarily within the ways we refashion and remodel the remains of capital, as well as in the items we purchase.

This hidden poeisis[1] outlined by de Certeau recalls not only the Situationists' practice of *détournement*,[2] but also the modern hipster's cultural aesthetic—reclamations of old, existing products of a capitalist system, remade into symbols of fashionable youth culture: trucker hats, Parlia-

ment cigarettes, and Pabst Blue Ribbon beer. De Certeau was right: as capitalism's control over society and social space grew, it did not manage to wipe out, sterilize, or stratify creative endeavors by turning everything into an object for purchase. Rather, people simply changed tactics, operating within the system as well as without, disguising themselves behind the wigs of ordinary conspicuous consumption and production.[3] I contend that the flash mob is one such endeavor.

Rather than remaking an object, though, flash mobs refashion both the spaces of capitalism as well as its structures, if only for a moment. The flash mob reveals the sometimes hidden power relations inherent in the capitalist model, through its tactical *takeovers and makeovers* of capitalism's pseudo-public space. I argue that flash mobs are a type of performative resistance to what Michel Foucault (2000a) labels governmentality, or the conduct of the conduct of others. This resistance occurs within what Gilles Deleuze and Félix Guattari (1989) call a control society, a world in which we are never truly finished with anything, but rather perpetually training and testing ourselves.[4] I construct this argument in three parts, focusing first on the specific tactics of the flash mob as a form of resistance, followed by a discussion of surveillance and visibility, and ending by outlining the makeup and power relations of the flash mob.

Trick Shots

September 26, 2009. Protestors angered by Whole Foods CEO John Mackey's statements regarding the national health care bill—mainly that health care, in Mackey's opinion, was no more an intrinsic right than food or shelter—gather in a park outside Oakland to rehearse a song and dance version of Toni Basil's 1980s pop tune "Hey Mickey." The words of the song have been tweaked, and this new version, "Hey Mackey," calls out the CEO for his stance on the health care bill with lyrics like, "Oh Mackey you're a swine, / You're a swine you blow my mind, / Hey Mackey." The group included amateur musicians creating a sort of de facto marching band as well as other singing and dancing participants. After a few hours of practice, the group heads over to a local Whole Foods and poses as shoppers until the opportune moment arrives. At this point, the band plays, and mobbers gather alongside frozen foods to perform their new version of "Hey Mackey." A security guard calls

the police, but the mobbers succeed in performing two rounds of their song before exiting the store and thereby escaping arrest. Apparently, according to protestors, their actions were "inspired by their conservative counterparts who have been dramatizing the health care debate" (Preuitt 2009, par. 10).

August 14, 2010. Frustrated Seattle residents surprise employees and shoppers at a local Target store around lunchtime with their own makeshift band and dancers, performing a rewritten version of Depeche Mode's "People Are People." In the new version, the lyrics ask, "Target ain't people so why should it be / Allowed to play around with our democracy?" The mob followed a call for a Target boycott by MoveOn. org, a left-leaning political website. Earlier in 2010 the Supreme Court had ruled that corporations could donate unlimited amounts to political campaigns, and in July Target donated $150,000 to Minnesota gubernatorial candidate Tom Emmer, an anti-labor and outspoken anti–gay marriage Republican. These Seattle flash mobbers, inspired by the MoveOn.org boycott, were members of AGIT-POP Communications, a "subvertising agency" offering "cutting edge videos, widgets, and boots-on-the-ground guerilla marketing to progressive campaigns" (Boyd and Sellers 2010, under "Tune in, turn on, agitate").

November 24, 2010. Dr. Etienne Lantier and several of his "students" swarm Lloyds Bank on High Borough Street in London. While bank tellers and other employees look on, Lantier stands before a makeshift cardboard lectern with a banner reading "The University for Strategic Optimism" and a sign stating "five-minute lecture" and delivers a lecture outlining the university's principles of free and open education, a return of politics to the public, and the politicization of public space (UfSOLondon 2010a). Although they encounter resistance from bank employees, who ask them to leave before they call the police, Dr. Lantier and his students continue until the five-minute lecture is finished, at which point they leave the site. A few days later, on November 30, the second lecture of the University for Strategic Optimism is delivered by Dr. Dora Kaliayev, standing before a similar cardboard lectern in the aisles of Tesco Superstore, a local supermarket chain, on Old Kent Road (UfSOLondon 2010b).

Each of these mobs represents a new offspring and/or hybridized version of the flash mob. Unique for their use of the flash mob formula

(organized online, swarming of a site, short time period) as well as for their fusion of multiple flash mob formats—song, dance, and overt politics—these performances are inevitable products of the flash mob's popularity and proliferation since the form's debut in 2003. That year, writer and cultural critic Bill Wasik stunned the world with his newest experiment, the MOB Project, which flooded the streets of New York City with strange performances, which were quickly labeled "flash mobs" by participants and local media. The typical flash mob begins when a person acting as an organizer (usually using a false name to protect identity) sends e-mails or text messages to a list of people, inviting them to arrive at a specific place at a certain time and to wait for further instructions. This anonymous organizer serves as the catalyzing force behind the creation of the mob and often invents a set of actions for the mob to perform on-site. However, the organizer of a flash mob should not be viewed as its leader, since her desires are often usurped, her initial list of addressees expands beyond her control, and her anonymity is maintained. The number of mob participants grows exponentially as each recipient forwards the invitation to his own electronically stored lists of friends and acquaintances. Usually, upon arrival, participants are given instructions on fliers detailing what they should do during the flash mob. As a rule, flash mobs tend to last no longer than ten minutes (Wasik 2006, 66). Participants arrive at a site, perform their action(s), and then leave, often just before the police arrive. These actions range from shopping en masse for a rug to pointing at a fast food menu and mooing like cows to pretending to stand in line for concert tickets (Johnson 2003; Wasik 2006).

In the ten years since Wasik's flash mobs burst onto the scene, use of this new form and/or method of performance expanded and matured. Today we see many different *kinds* of flash mobs: zombie mobs, game mobs, freezes, dance mobs, musical mobs, political mobs, techno mobs, and hybrid mobs (some combination of these other forms). My labels for these new types of flash mobs, although imperfect, focus on the qualitative changes each type made to Wasik's original flash mob formula (such as dressing up like a zombie or singing a song). I mention them here only to highlight that this article focuses on a specific kind of flash mob—one with an overt political message—and that my arguments about these types of flash mobs acting as culture jammers may

not apply to all flash mobs, particularly those created by corporations to sell products.

Bag of Tricks: Tactics and Resistance

What does a flash mob resist? Traditionally, flash mobs espouse no political or social agenda. However, as the flash mob format expanded over the past eleven years, many new hybridized forms emerged to promote particular political and/or social agendas, such as free public education or a boycott of the Target Corporation. The overt goals of such flash mobs as acts of resistance are easily ascertained. Additionally, flash mobs work against what Foucault (2000a) calls governmentality, or the management of others' behavior (324).

The aim of the flash mob is to upset and unmask the power structures that operate in our daily lives. For Foucault (2000b), governmentality presents itself in those unspoken laws of normative behavior that prevent us from singing at work or dancing in the classroom. Deleuze (1990) extended this idea with his conception of the control society, a world in which we are never done with examination and training, but rather always measuring ourselves and being measured against one norm or another. For example, every morning when I log on to my computer and my homepage website appears, so do two or three articles outlining six to ten strategies for how I can better communicate with my boss, make myself attractive to the opposite sex, and avoid those holiday calories. These articles work off assumptions about ideal norms for physical appearance, attractive behavior, and assertive communication strategies. As such, they operate as reminders of the rules of normative behavior, communication, and appearance that media, society, teachers, family, and friends shared and instructed me in since birth, in a type of ordering regime. Ultimately, the pressure to live up to these ideals, as well as the onslaught of surveillance and other disciplinary measures, creates an unconscious acceptance or docility within most people. I might not always have enough time or money to put on makeup, shave my legs and armpits, get a manicure and pedicure, go to the gym, cut and color my hair, and on and on—but I rarely question whether I want to or should do these things. After all, such pressures and desires are only *normal*. Flash mobs seek to transgress against and expose this form

of control—this conduct of our conduct. In a flash mob, participants break the norms of acceptable behavior and by doing so perform the dual function of (1) waking up their own participant bodies to the idea that other options for behavior exist and (2) reminding the audience of the mob of the absurd and arbitrary nature of so-called "normal" behavior. To say it differently, the flash mob reminds us that we actually have a choice.

Still, mobs of any sort frighten the rulers of a control society, particularly those with an overt political or social agenda. One cannot account for individual behavior, or, once formed, control the cooperative will and desires of the mob. This lack of control over the mob's behavior, however, affords the flash mob its unique and particular strength. To understand this strength, as well as its tactical nature, I return to the work of philosophers Deleuze and Guattari (1989).

In *A Thousand Plateaus*, Deleuze and Guattari (1989) outline two types of, or orientations to, space: smooth space and striated space. While these are often misunderstood as designations for particular types of places existing in the world, the terms "smooth" and "striated" actually describe processes or methods of occupying space. Striated space exists when specific points or locations are designated and people are assigned to occupy them. It is thus the space of property, a measured space akin to a suburban home lot or an office cubicle. The authors use a chess game as an example—each piece has a particular spot from which it must start the game, as well as a particular set of rules pertaining to how the piece can be moved, which is related to its identity as defined by the game—a knight, a pawn, a queen. Conversely, smooth space is an open space such as the ocean or desert, where space is not owned or assigned but rather occupied. A person occupying smooth space is not assigned a particular position, but rather can show up at any time and at any point in the space. Deleuze and Guattari use the game "Go" as an example, in which the pieces themselves, unlike in chess, are not identifiable as distinct, separate units. Rather, they are small round pellets or disks that are uniform in nature and could represent a multitude of different subjectivities. Furthermore, although Go and chess are both games of battle and conquest, the battle in Go is not coded by specific rules regarding movement and function of the pieces; rather the object

of the game is to use the pieces in such a way as to border, encircle, or shatter the opponent's strategy. As Deleuze and Guattari state:

> In Go, it is a question of arraying oneself in an open space, of holding space, of maintaining the possibility of springing up at any point: the movement is not from one point to another, but becomes *perpetual*, without aim or destination, without departure or arrival. The "smooth" space of Go, as against the "striated" space of chess. (353; emphasis added)

The authors also clarify the difference between movement and speed, as related to smooth and striated space. Thus, speed is an intensive property, found in the movements of a body or bodies in smooth space, whereas movement is an extensive quality operating in the traveling of a body from one point to another, within striated space (359–60). For example, one moves in particular, controlled patterns through the striated space of a planned garden. Even if a person moves very quickly through this space, she still does not have speed, according to Deleuze and Guattari. This is due to the fact that, typically, one moves throughout and occupies the space of a garden by traveling from point to point: turn right on this path, left on that lane, and so on. A person moving through a garden feels he is meant to occupy some parts of the space, such as the path, but not others, such as the grass or hedges. However, if a person were to treat the garden as an open space, like a field, and ignore those pathways, then that person may travel throughout the garden however she sees fit. Regardless of how quickly or slowly she moves, in fact, regardless of whether she moves at all, she still operates at a particular speed, one that allows her to spring up anywhere, at any time, moving, occupying, and even holding space. Speed and movement are applicable to both individual bodies and a multiplicity of bodies—such as the flash mob—and neither term contains a connotation of a faster or slower type of travel. Rather, the distinction regards the type of space traversed—smooth or striated—as well as the perception of the combined body traveling across it—that of a unified, collective whole, or that of a body consisting of irreducible parts, the multiplicity. The multiplicity moves in smooth space through the use of speed. The collective travels in striated space through movements from one point to another.

The body of the flash mob is a multiplicity, which realizes its potential during its formation in cyberspace—through e-mail and text messaging—and then actualizes that potential on the day of the mob at the mob site. The flash mob's use of technology creates an instant mobilization mechanism that allows individuals to turn up at any time in space, thereby escaping—if only for the brief ten-minute time period of the mob—the striated or stratified space they are typically assigned to occupy. Stated differently, the flash mob swarms a site, arriving from multiple locations and points in space to occupy one particular space (the mob site), typically in a manner opposite of the normative codes of society. In this manner, the mob occupies a smooth space, existing in an intensive zone, whereas Deleuze and Guattari are quick to remind us, even the smallest change in speed—the slightest sort of movement—produces a qualitative change in the final, actualized production.

The Target and Whole Foods flash mobs mentioned earlier serve as excellent examples. In each mob, participants entered the store in an orderly fashion typical of striated space and began to move about the store as their assigned positions—that of customers—would dictate. They calmly roamed the aisles, looking at products; some even went so far as to pick up shopping baskets and carts and pretend to shop. However, when the prearranged moment/signal occurred, participants swarmed a particular spot in the store—the front of the store checkout area in the Target mob, the back of the store frozen food area in Whole Foods—arriving at random from multiple points and occupying the space in a manner atypical of the position of customer assigned to them in the store's striated space: through the use of a song and dance performance. At this moment, the flash mob participants succeeded in creating a smooth space within which they moved at a particular speed, holding space as they saw fit. With the addition of a few significant changes (an overt political message and a previously learned song and dance routine) from Bill Wasik's original flash mob formula (in and out in ten minutes, instructions handed out on-site, no overt message), the organizers and participants in the Target and Whole Foods flash mobs created a new form: a song and dance political flash mob. These changes alter both the mob's purpose and effect, while retaining the mob's act of resistance. In fact, they further the mob's already disruptive act—its ability to turn tricks on an ever-present, always watching Big Brother—by

using it to expose the oft-hidden actions and political investments of major corporations. In so doing, these new types of flash mobs become culture jams.

In fact, one might argue that flash mobs are the perfect platforms for culture jammers of the digital age, combining the power of live performance with the mass dissemination capabilities of the viral video. In the twelve years since Bill Wasik's flash mobs first appeared on the streets of New York City, people worldwide used his formula to stage massive pillow fights, zombie crawls, surprise dance routines, and even renditions of Handel's *Hallelujah Chorus* in shopping mall food courts. Many of these flash mobs referenced popular culture in some manner, but it is only recently, in the work of groups like the University for Strategic Optimism or Seattle's AGIT-POP Communications, that we begin to see Wasik's formula being used as a method for disseminating alternative, subversive messages about corporations and government policies. In the Target, Whole Foods, and UfSO mobs discussed in this article, we see Wasik's flash mobs moving from indirect acts of resistance to direct acts of protest and advocacy.

Flash mobs, like all mobs, are uncontrollable beyond a certain point, which is part of both their danger and their appeal. The lack of external control (in favor of the pack mentality) acts as a fundamental part of the flash mob's resistance to the complete control found in the daily exercise of governmentality. Two important facts remain to be discussed regarding the flash mob as a form of resistance. First, the flash mob is a form of resistance operating within the realm of discipline, not outside of it. Without disciplined bodies—that is, bodies used to answering calls and doing what they are told—the mob could not assemble into a large collective body. Second, the resistance found in the flash mob acts as a type of critical performance, which can be understood in terms of Judith Butler's (1999) discussions of performativity. According to Butler, gender is a repeated performance we engage daily. In order to explore alternate possibilities, we must begin to repeat with a difference, to collect and explore all those moments when we slip up in our regular gender performances and find ourselves performing or acting in another manner.

Discipline, as a method, is based on repetitions, which over time produce docile and productive bodies. The flash mob uses these disciplined bodies to its advantage, asking them to repeat with a difference,

to use their particular disciplined bodies in concert with other disciplined bodies as a way to act upon the disciplinary structure of society as a whole without stepping outside of its confines. In other words, it is the very ability to follow orders and take instruction that flash mob participants use to disrupt the order of everyday society. These disruptions are brief, involve no illegal behavior, and are carried out in relative anonymity, allowing participants to act out and badger Big Brother without fear of being caught and imprisoned. Flash mobs alter the scene, turning striated space to smooth space if only for a moment. These new acts of culture jamming confound the corporation machine, intrigue passersby, and deterritorialize behavioral norms. As such, flash mobs ultimately operate as artful tricks, seizing opportunities and shedding new light on the arbitrary and unspoken rules of behavior within particular places.

Tricks of the Trade: Assemblage and Power Relations

As products of the digital age, flash mobs require the use of e-mail and text message technology created in the latter part of the twentieth century. Every flash mob begins with a message announcing the date and time of the event, along with either a set of instructions for action or the promise of instructions to be delivered on site. Recipients then forward this message to others using computers and cell phones, forming the mob (or at least its virtual potential) with each successive e-mail or text message. Usually, upon arrival, participants are given instructions on flyers detailing what they should do during the flash mob. As a rule, the actions or performative interventions of flash mobs tend to last no longer than ten minutes (Wasik 2006, 66). Participants arrive at a site, perform their action(s), and then leave, often just before the police arrive. These actions are often suggested by the site of the mob and usually involve some sort of behavior atypical of the particular time and place, such as pretending to stand in line for concert tickets on the sidewalk outside of a church. The relationship between person and tool, or participant and computer/cell phone, allows for the origination of flash mobs as an assemblage, or merging of singular entities with a shared goal to create a new, composite body. Individuals and technology work together in this assemblage to create the virtual potential of the mob, in

cyberspace, which is then actualized in material form at the mob site on the day of the performance.

The flash mob itself also forms an assemblage with what I would call the "corporation machine." I offer an example and a few definitions to begin. First, the prison system offers the best example of the machinic assemblage. That is, one can view the prison system as a machine made up of multiple parts working together, a living, social semiotic; examples of these parts include a safe, well-constructed building, well-trained guards, well-behaved prisoners, and a desire within society to rehabilitate those prisoners. For Deleuze and Guattari (1989) every social machine operates on two levels: one of content and one of expression. In other words, when examining how a machine such as the prison functions, one must look at both the components of that machine (content) as well as the discourse surrounding it (expression). According to Deleuze and Guattari, these two levels of content and expression (both of which operate simultaneously) form a *double articulation* of stratification. The term "stratification" here is used in the sociological sense, to refer to a mode of division based on the rank, or hierarchy, within a particular category. For example, within our late capitalist society, caviar appears at a higher level, or layer, of strata than shrimp cocktail. Social machines such as the prison machine form a double articulation of stratification because each articulation—that of content and of expression— has a specific form and substance.[5] Consequently, every social machine (such as the prison machine) contains a form of content and substance of content, as well as a form of expression and substance of expression. For instance, one can discuss the material makeup of a machine's components as its substance of content, while also discussing the way those components are organized/arranged as the machine's form of content.

Deleuze and Guattari (1989) argue that behind every machinic assemblage, such as the corporation machine or the prison machine, lies an abstract machine seeking to find a function for the matter with which it is concerned—a pack of human bodies (71). The prison machine's function is to discipline those individual bodies, to render them docile and therefore useful to those in power (the warden, the state, or any other sort of Big Brother). That is to say, it is abstract machines, always concerned with finding functions for human bodies, which lead to the creation of social machines like the prison or corporation.

To study the flash mob, I focus on the corporation machine. In this type of machinic assemblage, the substance of content would be the consumers of the various products it produces, and the form of content would be the particular store or marketplace in which those products are sold. The scientific study of consumption (including advertising and marketing) is the overwhelmingly privileged form of expression in the corporation machine, which is normative and rule-based. The substance of expression, therefore, would be the corporation. Just as the layout of a particular store (form of content) controls the manner in which consumers (substance of content) move and interact, the scientific study of consumption (form of expression) shapes the way our society views and relates to the corporation (substance of expression). The flash mob joins with the corporation machine to create a new assemblage, one that substitutes flash mobbers for consumers and offers a new form of expression (what Deleuze and Guattari [1989] refer to as a potential "line of flight") that differs from the previously mentioned form of expression— the scientific study of consumption based on advertising and marketing. In other words, when culture jamming flash mobs swarm a store and perform within it instead of shopping within it, they force a discussion of corporations (particularly the corporation that owns the store) that is about something other than advertising and marketing. This line of flight serves as an experimental pathway of deterritorialization, or a change in habit, allowing participants and audiences to explore alternate possibilities for personal expression emergent in their daily lives and actions.

Deterritorialization usually occurs as the result of some sort of intensification or crisis that triggers a break in our regular habits of behavior. A person's typical morning routine can be thought of as a territorialization, or set of habits: wake up, make coffee, feed the pet, read the paper, shower, and dress. An act as simple as changing this routine can be thought of as a deterritorialization, perhaps due to that person's recent discovery of Buddhist practice: wake up, make coffee, feed the pet, meditate for ten minutes, shower, and dress. Such a simple change can affect our perception and encounters throughout the day, therefore opening us up to new possibilities of connection. In addition, if we adopt this *new* routine and habitually begin to enact it each morning, a reterritorialization will occur. In the flash mob, the behavioral norms of conspicu-

ous consumption are deterritorialized into new forms of expression. I return to the lectures of the University of Strategic Optimism (UfSO), described earlier, as an example.

In the UfSO's first lecture, held at a small Lloyds Bank office, twenty to thirty students easily swarmed the site, filling the small waiting area and successfully occupying it for five minutes while Dr. Lantier gave his lecture. Such behavior is atypical of that usually found in the modern bank office. When a customer arrives at a bank, she calmly waits in line, brings her business to a cashier sitting behind a counter, transacts that business, and leaves. This is the standard form of expression one finds in a bank, and the docility of a customer's behavior is typical of the capitalist marketplace in general. Sitting, standing, or loitering at will, as well as lecturing to a large crowd, are behaviors atypical of the average bank. Rather, one expects to find such behavior in a university classroom, where students gather to hear the words of their professor. By taking the behaviors typical (or habitual) of the school environment and making them the behaviors of the bank, participants in the UfSO mob successfully deterritorialized their traditional form of expression—docile transaction of capital—and replaced it with a playful act of education. Through this act of deterritorialization, the flash mob participants make themselves and any other customers who happen to be in or around the bank at the time of the mob aware of the unspoken rules or codes of normative behavior, enacting an alternative promotional campaign that highlights the possibilities lying beyond those normative boundaries (de Certeau's [1984] "flash," which sheds a new light on the language of a place).

Furthermore, the timing and strategic choice of locations for the UfSO's first two lectures—at a bank and a supermarket—highlight the parodic and counterhegemonic nature of their flash mobs. In essence, the University for Strategic Optimism, in its reclamation of public space for politics, seems to be stating that if the United Kingdom is going to prevent equal access to public education through its upcoming tuition hikes, then they (the University for Strategic Optimism) will fix this problem by offering their own lectures in the marketplace for free. In so doing—and with every obstacle they encounter from retailers, police, and employees—these political flash mobbers indicate the lack of truly public space (or public markets), as opposed to privately owned public

space (or market space) in modern society. Unlike Bill Wasik's original flash mobs that only made visible such truths, these flash mobs overtly fight back and seek to reclaim such spaces. Wasik's 2003 mobs highlighted the lack of public space within New York City by causing alarm and often bringing out the police just for showing up in these spaces with a large group of people and doing something abnormal, but not illegal. The UfSO mobbers went one step further by explicitly protesting the lack of public space through the rhetorical act of their lectures, given while occupying privately owned public space.

Not surprisingly, the machines—whose hegemonic, normative forms of expression the flash mob dissects and interrogates—do not usually welcome such deterritorializations. Typically, the actions of the participants are seen as dangerous enough to prompt bank or store employees and managers to call the police or other authorities, who often arrive just as the mob participants are leaving. Acts of deterritorialization are threatening to those who could potentially lose power or profits were such behaviors to catch on in the population as a whole, especially if their customers were bothered enough by the mob to leave. Therefore, social machines like the corporation machine typically feel an immediate need to reterritorialize and thereby reassert their power when such actions take place. Multiple strategies exist for such reassertions (see also chapter 24 of this volume).

While multiple levels of power relations operate in the flash mob, the relationship between the flash mob and the corporation machine (which owns the site upon which the mob acts) often dominates media coverage. After all, these individuals (employees) must decide what to do: laugh, join in, call the police, or run and hide. Their decisions are usually the decisions not of an individual, but of the machinic assemblage to which they belong. Stated differently, employees at the site of a flash mob typically ask themselves, "What would my employer do?" not "What would I do?" Calling the police, however, is not the corporation machine's only alternative, as evidenced in the historical record of the flash mob.

Another strategy is that of cooptation: stealing the deterritorializing tactics of the aberrant, diverse, and disparate population in the flash mob and using them to reterritorialize a preferred set of actions—that of conspicuous consumption—as well as to redefine the population in

a unified manner. In 2005, in an effort to regain and reassert power lost to the flash mob, the corporation machine undertook both these goals. Bill Wasik (2006) recounts how in the summer of 2005 Ford Motor Company sought to coopt the tactics and techniques of the flash mob in an effort to appeal to its newest targeted customer: the coveted twenty to thirty-something hipster crowd, whose preferences dominate trends in conspicuous consumption. Ford wanted to promote its newest product—the Ford Fusion—to this group of individuals and thought the flash mob the best way to do so. Ford strategically announced a series of "Fusion Flash Concerts," via e-mail advertisements, in the hopes of "appropriating the trend . . . in order to make a product seem cool" (Wasik 2006, 61). However, compared to Wasik's original flash mobs, where information was not announced until the last minute and the whole event lasted ten minutes or less, Ford's flash mobs appeared to be something else entirely. E-mails went out six days prior to the event, and radio stations and newspapers promoted the "secret" concerts with advertisements. The actual events, or concerts, were sparsely attended and lasted much longer than ten minutes. However, Ford's cooptation of the flash mob idea did manage to succeed as an attempt at re-territorialization.

By associating itself (a huge corporation) with the flash mob, Ford successfully made flash mobs passé in the eyes of the general public, thereby emptying out the potential of the flash mob (at least in its original form) for creating future deterritorializations in the eyes of the nation's youth. To put it simply, Ford appropriated the flash mob, made it uncool, and stuck it on the shelf. This goal of the corporation machine to reterritorialize, both through the display of the police and the Ford Fusion Concert, stands as a testament of the flash mob's deterritorializing power during its earliest phases. Since that time, hybridizations and offspring of the original flash mob, such as the freeze, dance mob, and zombie mob appeared, providing additional deterritorializations. Ultimately, these new forms of flash mob were reterritorialized through the realm of pop culture, where advertisers, television producers, and even high school band directors began experimenting with the flash mob, once again capturing the phenomenon and making it family-friendly (and therefore less cool). Today, in the overtly political types of flash mobs discussed in this essay, we recognize new avenues of deterritorialization.

Tricking the Eye: Multiplicity and Visibility

Flash mobs offered Wasik's hipsters the chance to act in concert, to merge themselves into a large, communal mass of like-minded compatriots. They join masses of individualized and visible bodies together into one mob collective. In this act of conversion, individual visibility vanishes, while a sort of collective visibility emerges in its place, or, as the common saying goes, the whole is greater than the sum of its parts. Furthermore, due to the anonymity of the mob organizer, flash mobs operate with a pack mentality, pointing once again toward the democratizing collective visibility established. It is this pack mentality, distinguished from that of the average crowd or mob, that Deleuze and Guattari (1989) refer to as a "multiplicity" (29).

In his coming-out article, Wasik (2006) refers to this pack mentality when discussing his impetus for creating the flash mob. Frustrated by what he labels "*scenesterism*, the appeal of concerts and plays and readings and gallery shows deriving less from the work itself than from the social opportunities the work might engender," Wasik desired to create an art project based purely on the notion of scene, "meaning the scene would be the entire point of the work, and indeed would itself constitute the work" (58). What appears to fascinate Wasik is the fact that people not only answered his e-mails and showed up, but that they forwarded them on to their friends and acquaintances, thereby creating the large numbers of people who gathered on site to form the mob. These individuals did not attend and participate out of a desire to show off their talents, intellect, or any other special skill. Instead, they wished to be part of the scene—hip enough to know what all the other young hipsters were doing, and doing it themselves. When they arrived at the mob site, their goal was not to stand out as special or unique, but to blend into the pack and become a part of the overall herd of bodies. That is to say, they gladly shed any identifiers of their distinct individuality in order to be part of a community of bodies acting as one.

This distinction is important for a number of reasons. First it shows us that the flash mob is not an unruly, disorganized crowd comprised of anarchical bodies, wishing to wreak havoc and create chaos. The flash mob is also not a mindless mass following the whims of a dictator or leader of some sort. Rather, it operates as a pack—a formation of like-

minded individuals who either see or feel a kinship with one another and come together to act as one. Elias Canetti (1981), writing on the distinction between crowds and packs in his *Crowds and Power*, states that for the pack, "equality and direction really exist. The first thing that strikes one about the pack is its unswerving direction; equality is expressed in the fact that all are obsessed by the same goal" (93). Although Canetti might classify the flash mob as a crowd, based on its large size, one cannot deny that the mob meets his criteria for the pack. The flash mob forms quickly and solely for the purpose of creating a scene by swarming upon a predetermined site and then leaves after a ten-minute interval. Unlike Canetti's crowd, the flash mob's direction is unswerving—participants do not move outside the boundaries of the predetermined site, and they do not linger after the conclusion of the mob. Furthermore, this concerted effort to act as one body in the act of arrival, performance of an action, and departure is the sole goal of the mob. As such, the flash mob meets Canetti's second requirement for a pack: the expression of equality through the shared obsession with a particular goal.

Working from Canetti, Deleuze and Guattari (1989) make a further distinction between those who lead packs and those who lead groups. For Deleuze and Guattari, the leader of a group or mass (a crowd) maintains an outside position from which she commands, capitalizes, and consolidates. The leader of a pack, however, remains inside, acting more as a sort of tribal chief who persuades, mobilizes, and catalyzes the other members (37). Wasik chose the latter of these two options, acting as the leader of a pack more than of a crowd or mass. To begin, Wasik took part in each of the eight New York City mobs he created, never revealing his identity as "Bob," the author of the original e-mails. By maintaining an interior position, Wasik easily provoked and catalyzed action within the crowd, by passing out instructions (along with other predetermined participants) and prompting the mobbers to begin performing the actions listed on their instruction cards or e-mails by acting them out himself. Furthermore, due to his interior position, Wasik played "move by move," coordinating his actions with those of his fellow participants as the mobs deviated from their preplanned directions (33). Although all Wasik's flash mobs deviated from their printed rules, his eighth and final mob clearly shows their pack mentality.

In Mob #8, participants were told to gather in a concrete alcove on Forty-Second Street and follow the instructions coming from "the performer," a portable boom box.[6] Mobbers arrived at the scene ready to follow instructions, but their collective cheering became so loud it drowned out the instructions emanating from the boom box. Around this time, one participant opened a briefcase containing a glowing neon sign and then held up two fingers. Upon seeing this, the mob assumed this participant (and not the boom box) to be "the performer" providing instruction and collectively began chanting "Peace!" As Wasik (2006) states, "The project had been hijacked by a figure more charismatic than myself" (60). Hijacking, in my opinion, is not the right word to describe what happened in Wasik's eighth mob. I believe the mob, acting as a pack or multiplicity, displayed its own mind/will and began to follow its own movements and desires, rather than those predetermined by Wasik. Wasik, at that moment, had to choose between stepping outside the bounds of the pack and asserting his own voice/role as a leader-commander or remaining within the bounds of the pack and following their wishes. He chose the latter.

A unique power relationship operates between the flash mob and its audience, consisting of both those people who work at the site of the mob and any other individuals at the site where the mob occurs. The mob's presence frustrates the expectations of this audience, who then must choose among acquiescing to the presence of the mob by simply watching it unfold (or joining in), refusing to acknowledge the mob's presence by continuing with their regular routine, or actively fighting back. I believe that in the case of the political flash mob, there are two target audiences. The first consists of the representatives of the corporation machine encountered on site—employees, managers, and other staff. The second is anyone with access to media, as often these culture jammers seek to use flash mobs as ways to advocate for particular causes, hoping that videos of their actions will go viral or be covered in news media.

Note that by replacing their individual visibility with a shared, collective visibility, flash mobbers turn the usually invisible audience—who in more conventional performance venues sits at the back of a darkened theater and watches with a degree of invisibility—into a consciously recognized and visible set of onlookers. Something about the flash mob

shouts, "We know you are watching us daily and that you want to watch something, so let us give you something to watch." In this reversal of visibility, the flash mob turns the surveillance camera in the bank lobby back onto the bank, the corporations, the industrial complexes, and the surveillers who intently watch our everyday lives. The mobbers move from acts of obedience—typical of our control society—to acts of performance, intended for an audience that prior to the mob thought themselves powerful and secure in their invisibility. The flash mob, in essence, taunts the unseen tower guard in the panoptic prison, giving him much more to watch than he bargained for—or even, one might argue, checking to see if he's on duty at all. The performance of the mob participants, although dependent on a form of discipline,[7] uses that discipline to reverse the power structures inherent in the economy of visibility. In other words, the mobbers use discipline against itself, in an effort to reverse the gaze. This cooptation of disciplinary strategies operates as a repetition with a difference, intended to create a new form of resistance. Stated differently, the flash mob not only taunts the targeted watcher, but also pulls back the curtain on the wizard to reveal his true identity to anyone else who might be (or ultimately ends up) watching.

Trick Turning: The Lessons of the Flash Mob

So, what might we learn from the flash mob? Primarily, we learn how governmentality operates in our daily lives. The mob exposes the unwritten and unspoken rules that govern our daily behavior—rules that we rarely acknowledge, let alone question. Furthermore, the flash mob reminds us of the power of the mob or swarm as an acting body. In essence, the flash mob reminds us that we do, indeed, still have a choice. Finally, the flash mob teaches us that new technologies offer new strategies for exposing and even fighting power, in a myriad of different forms. The flash mob reminds us of the power we have at our disposal—in our ability to gather as a mass through the use of our new technologies—while acknowledging, often in silly, humorous ways, that this new power is neither good nor bad, merely dangerous. As such, one might view the flash mob as both an expression and a critique of the potential of contemporary democracy.

Through the combination of technological tools, performative bodies, and social machines, flash mobs form new assemblages offering new methods of living, performing, and communicating. Often, when used by culture jamming activisits such as those involved in the Target, Whole Foods, and UfSO mobs discussed in this article, the flash mob becomes a way of responding to the corporations and power structures that constantly feed us messages, but rarely allow us opportunities to reply. These flash mobs (like other types of culture jamming) make visible patterns of control and behavior overlooked and ignored by many, often while providing their performers and audiences with alternative ways of thinking about and/or fighting back against governments and corporations. Just as de Certeau (1984) suggested, by "shedding a different light on the language of a place," or pulling one over on us all, these flashes grab our undivided attention (37–38). It is my hope that such flashes alert their audiences not only to the fact that they have been tricked into taking a ride in an avocado-green dryer, but also to the specific ways in which they might turn that trick to their own advantage and get back at their Big Brother for such a dirty, dirty deed.

NOTES

1 As described by Plato in his *Symposium*, "poeisis" is used here to denote a type of creating, or art-making.

2 For a detailed discussion of *détournement*, see the introduction to this volume. For a longer discussion of how flash mobs operate as acts of *détournement*, see Walker (2013).

3 De Certeau (1984) defines *la perruque*, or the wig, as "the worker's own work disguised as work for his employer" which "actually diverts time . . . from the factory for work that is free, creative, and precisely not directed toward profit" (25).

4 Deleuze (1990) argued that with the advent of new technologies, most notably the computer, one no longer seeks control over individual bodies, but over networks and populations. To achieve such control, individual forms of testing and labeling that were typical of the disciplinary society, such as the examination, are replaced with more continuous forms of control, such as perpetual training. In other words, one does not move from one institution to another, as in the disciplinary society. Rather, "one is never finished with anything" but always coexisting among institutions, whose controls are manifested as slight modulations or adjustments (1).

5 Drawing from Kenneth Burke, one can think of form as the container and substance as the thing that it contains.

6 The following description is taken from Wasik's (2006) own account of the eighth and final mob he created, as described in his article of March 2006.

7 The discipline I see the flash mob operating under is that of following a set of instructions, or in certain cases, learning a particular choreography (for a dance or for an arrival and departure).

REFERENCES

Boyd, Andrew, and John Sellers. 2010. *AGIT-POP Communications*, August 15. www.agit-pop.com.

Butler, Judith. 1993. *Bodies that Matter: On the Discursive Limits of "Sex."* New York: Routledge.

———. 1999. *Gender Trouble: Feminism and the Subversion of Identity*. New York: Routledge.

Canetti, Elias. 1981. *Crowds and Power*. Translated by Carol Stewart, New York: Continuum.

De Certeau, Michel. 1984. *The Practice of Everyday Life*. Translated by Steven F. Rendall. Berkeley: University of California Press.

Deleuze, Gilles. 1990. "Postscript on the Societies of Control." *Autre Journal* 1 (May).

Deleuze, Gilles, and Felix Guattari. 1989. *A Thousand Plateaus: Capitalism and Schizophrenia*. Translated by Brian Masumi. Minneapolis: University of Minnesota Press.

Foucault, Michel. 2000a. "Omnes et Singulatim: Toward a Critique of Political Reason." In *Power: Essential Works of Foucault 1954–1984*, edited by James Faubion and translated by Robert Hurley et al., 3:298–325. New York: New Press.

———. 2000b. "The Subject and Power" In *Power: Essential Works of Foucault 1954–1984*, edited by James Faubion and translated by Robert Hurley et al., 3:326–48. New York: New Press.

Johnson, Mark D. 2003. "Good Mob, Bad Mob: The Art of the Flash Mob: An Amusing Concept Easily Ruined." *Partial Observer*, September 24. www.partialobserver.com.

Preuitt, Lori. 2009. "Whole Foods Haters Use Flash Mob Tactic." *NBCBayArea*, September 29. www.nbcbayarea.com.

UfSOLondon. 2010. "University for Strategic Optimism at Lloyds TBS [High Quality]." YouTube video, November 27. www.youtube.com.

———. 2010. "Second Lecture of the University for Strategic Optimism, Tesco Superstore." YouTube video, November 30. www.youtube.com.

Walker, Rebecca. 2013. "Fill/Flash/Memory: A History of Flash Mobs." *Text and Performance Quarterly* 33(2): 115–32.

Wasik, Bill. 2006. "My Crowd: Or, Phase 5: A Report from the Inventor of the Flash Mob." *Harper's Magazine* (March): 56–66.

14

Memes, Movements, and Meteorology

Occupy Wall Street and New Mutations in Culture Jamming

JACK BRATICH

In its annual round up, Internet meme maven *KnowYourMeme* listed Occupy Wall Street as one of its top memes of 2011. What was remarkable about this designation is that the site did not award it to any of the numerous OWS-inspired or -generated Internet memes, such as Occupy Sesame Street, We are the Nyan-nyan percent, Occupy All the Streets, or most famously, Pepper Spray Cop. Instead, OWS *itself* was categorized as a meme.[1]

Calling an emergent protest or political movement a meme might seem to devalue it as a trivial, innocuous amusement. But, in calling the movement a meme, *KnowYourMeme* had, knowingly or not, referenced something more significant, namely *Adbusters* magazine—the originators of the concept "Occupy Wall Street." In June 2011, *Adbusters* ran a call as an ad, with an image of a ballerina on the Wall Street Bull along with the words "#OccupyWallStreet—September 17, 2011—Bring Tent." To say that OWS originated with *Adbusters* immediately invites scorn, accusations of easy origin stories, and charges of an insufficient account of all the conditions that helped shape the phenomenon.[2] However, what interests me here is what we *can* definitively say: the name #Occupy-WallStreet came from that *Adbusters* call, as did the date and command ("bring tent").[3]

How can thinking about OWS as meme and as partially determined by culture jamming's premiere platform give us insights not only into Occupy's trajectory but also into the status of culture jamming itself? In this chapter, I examine OWS as the legacy of culture jamming. I do this not to claim a definitive meaning for OWS via origin stories, nor even

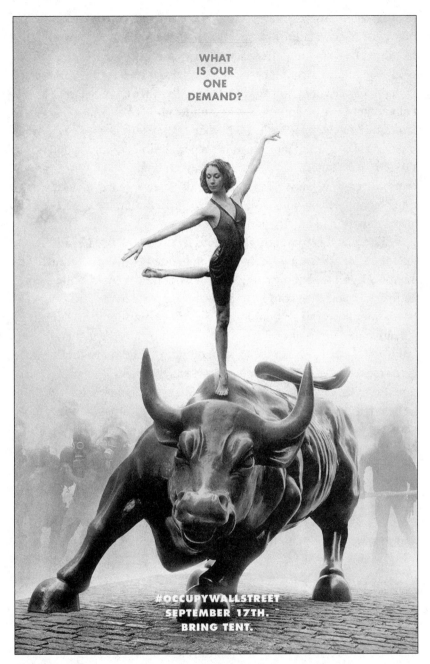

Figure 14.1. Poster: Initial call to occupy Wall Street. Design by *Adbusters*.

to promote *Adbusters'* attempts to shape the trajectory of OWS.[4] OWS is not reducible to a cultural tactic or to a formal operation. However, the fact that OWS stemmed from its culture jamming predecessors can tell us about cultural tactics, new popular organizational forms, and the ongoing dynamics of incorporation. Rather than seek to explain OWS via culture jamming (as in "OWS is best understood as a meme or a culture jamming project or *Adbusters*-controlled"), my purpose here is to track the destiny of culture jamming via its perhaps most famous operation, OWS (to ask, that is, "How can we rethink the status of culture jamming as protest tactic?"). OWS is, on one hand, a convergence of culture jamming techniques: meme, flash mob, platform. But on the other, OWS is also a mutation of culture jamming itself.

What does this mutation in culture jamming tell us? I examine the fate of culture jamming in an age of presumed convergence, real subsumption, and seemingly complete absorption by media. While culture jamming in an age of convergence has been considered passé, OWS signals a mutation rather than a demise. The "end of culture jamming" narrative in convergence discourse is limited by a presentist bias. With hindsight, I argue, we can see the first decade of the twenty-first-century convergence-as-cooptation not as foreclosure, but as a time of recuperation. From this state of dormancy came an evolutionary leap.

In other words, OWS presents a phenomenon that requires us to revisit the well-worn trope of cooptation. I argue, using an autonomist framework, that we need to move beyond thinking of cooptation and more importantly beyond the presumed body that can enact it. The Italian autonomist Marxist tradition rests on what Yann Moulier-Boutang (1989) calls the Copernican reversal of perspective in sociopolitical analyses. Instead of presuming the ontological primacy and productive activity of capital, this perspective takes labor as the agent and motor of history (to which capital reacts because it wants to emancipate itself from the working class). When it comes to culture jamming, then, this means tracing culture jamming techniques back to the emergent body (in this case OWS) that deploys them as both action and sign of strength. We move from tactics to the force or body that wields them. This force, as a type of agency or subjective capacity, is closer to a climate or ecology than to what typically gets called a "movement." My argument also entails removing culture jam-

ming from a consumer-based model of action toward popular culture, in which the strategic, or polemological, dimension resides. OWS, I argue, liberates culture jamming's status as "incorporated" by a dominant body and deploys it in a reconfigured terrain, no longer outside commercial culture but erupting from within and through it. This is a terrain in which an emergent body confronts a despotic one that seeks to repress it (mirroring the recent history of branding's recuperative techniques). The analytic frameworks for evaluating culture jamming and OWS thus need an overhaul.

Convergence and Polemology

In his touchstone book *Convergence Culture*, Henry Jenkins (2006) discusses the fate of culture jamming in the new media environment. "Perhaps . . . the concept of culture jamming has outlived its usefulness," Jenkins writes. "The old rhetoric of opposition and co-optation assumed a world where consumers had little direct power to shape media content . . . whereas the new digital environment expands the scope and reach of consumer activities" (215). While Jenkins is on to something, it is not solely for the reasons he thinks. What has indeed disappeared is the battle station outside of popular culture that risks cooptation by an inside. However, what Jenkins misses in his formulation is the continued importance of struggle, subversion, and strategic intervention besides that enacted by consumers and fans (though that has subsequently been complicated in Jenkins et al. 2016).

In saying this, I invoke a long-neglected dimension of popular culture, namely what Michel de Certeau (1984) famously called the "polemological."[5] De Certeau insisted on defining popular culture as a repository of warfare dynamics, from stratagems encoded into amusements like games, to the practices of camouflage in everyday life, to the modes of inhabiting space in cities, homes, and worksites. Popular culture analysis should study this *polemos*, according to de Certeau, by being attentive to tricks, tactics, and maneuvers, as the practices of everyday life are rife with inequalities and strategic struggles. Polemology also recognizes the importance of some of the early writings around culture jamming (Dery 1993; Lasn 1999), which discussed it in terms of semiotic warfare, infowar, and the guerrilla tactics of sabotage.

Reviving the polemological expands a notion like convergence culture beyond its configuration around producers/consumers and fans/corporations. Elsewhere I have discussed how this polemological approach complicates the notions of convergence culture and fandom, as well as their political dimension (Bratich 2011). I noted that fans moving from margin to center can be seen as a symptom of what Marx called *real subsumption*. Sniping from an "outside" (the early version of culture jamming) might be obsolete in a situation where real subsumption has made the marginal central to production. But this does not reduce tactical action to tinkering from the industry's "inside" as a way of enhancing fan capacities. Recovering the polemological subterranean tradition thus means accepting that culture jamming may not be in an external position to a branding system that absorbs it (and even turns it into a new source of value production). But that does not mean culture jamming has been neutralized or removed from the terrain of struggle. In fact, polemology suggests reconsidering that terrain and the forces/bodies that compose it.

A polemological reconsideration of this terrain means accounting for the culture jamming experiments during the time of branding expansion and cultural convergence (as many of the essays in this collection do). The first decade of the twenty-first century was indeed a moribund time for culture jamming as outsider to popular consumer culture. Many of the tactics proposed by culture jamming in the 1990s became staples of the very consumer culture it sought to undermine.[6] Subvertising, billboard defacement, *détourning* brand logos—all of these techniques were easily absorbed into the self-deprecating, ironic sensibility of fin de siècle advertising.[7] Critics noted that even *Adbusters'* rise to prominence resulted in a magazine with a barcode.

In addition to anti-ad advertising (what Frank [1997] calls a staple of commercial techniques since the mid-1960s), branding began to enlist more participatory action by users/consumers. Brands no longer were shiny abstractions beyond the public's reach, but became concepts and symbols that audiences were invited to touch and coproduce. The brand also was no longer primarily a signifier, proper name, or logo with interpretive valence. A number of authors have tracked the transformations of branding from signification to merging with cultural production (Klein 2002), creating environments, and becoming "platforms for ac-

tion" (Lury 2004); to organizing subjectivity (Arvidsson 2005); and to "making worlds" (Lazzarato 2004). From retail stores that foster moods and interactions to enclosed websites that encourage forms of participation and creativity, a brand has become more like a subject that organizes an environment in which action takes place. Of course, this action was all supposed to be done along the lines determined by its managers. What this moment of real subsumption displayed was that culture jamming, as a series of tactics, could be lifted from its anticonsumerist context and re-tourned as aesthetic devices for promoting consumerism.

During the same decade as this cooptation was taking place, social movements were still developing cultural techniques of intervention. The culture jamming tactics leapt from the page and billboard to the spaces of everyday life (Thompson and Sholette 2006). Anticonsumption projects like YoMango reconfigured the "weight" of commodities by liberating them through carnivalesque performance (from another perspective, called "shoplifting"). Reverend Billy's Church of Stop Shopping occupied retail spaces using theater and ritual, installing a PaPoP, or Performance at the Point of Purchase. Whirl-Mart used an exploit in the big-box shopping system—the acceptable practice of walking with an empty shopping cart—to create a collectively produced lack in the heart of seeming retail abundance. And Greenpeace's Kleer-cut campaign intervened into the very moment of consumer ideological production—a person-on-the-street commercial for Kleenex that harnessed user-generated content (in this case, stories and tears) to bolster the brand. Greenpeace activists hijacked the couch on the street with prank subjects, turning the commercial into an opportunity to generate sadness over Kimberly-Clark's destruction of old-growth forest for their products.

During this early twenty-first-century period, then, culture jamming followed the trail of consumer culture and branding strategies into the spaces and times of everyday life. Culture jamming jumped from text to performance to reorientation, even occupation, of space.[8] Just as brands sought to go beyond signification into becoming participatory platforms for interaction, so too did culture jamming immerse itself into the practices of everyday life.

Cooptation and incorporation thus do not signal the end of the story. Instead, they signal an incorporating body whose colonizing actions re-

sult in fissures and exploits that engender responses via mimicry and mutation, in the performative detours and occupations of those incorporations. In other words, culture jamming was not neutralized in absorption, but distributed and transmuted in subsumption.

In particular, its *subjective* aspect could not be neutralized. Culture jamming mutated when it was subsumed. Now it erupts and pushes through as convergence. However, its objectives are not coming from outside; they are not transcendent or turned into a means to an end (consumption). Even while "inside," culture jamming is nonaligned, thus creating fissures in a presumed totality. For what was subsumed was not just a series of formal techniques (playful self-critique, humorous distance, defacement, pranks). Rather, the productive force that generated these techniques also was taken in, sometimes literally in the sense of graphic designers whose skills were directed toward brand enhancement. The dominant body, then, did not necessarily increase in strength through absorption. Rather, it brought into itself a series of nonalignments and crises (in addition to the other crises defining consumption and capitalism since late 2008).

So far we have traced only how culture jamming mimicked and followed the body through its pathways into everyday life. But there is more to the story than that set up by consumer culture's definition of the situation. For that, we need to expand our analysis outside of consumer communication.

During the same time period (approximately the first decade of the 2000s), social movements also deployed culture jamming tactics, less as a consumer response than as intervention in the figures of *production*. Creating a saint for precariously employed workers—namely, San Precario—Italian youth *détourned* a deeply embedded Catholic practice (not just of canonizing saints, but merging them with locally existing figures and practices). In turn, San Precario was itself *détourned* into Serpica Naro, a collective pseudonym and meta-fashion brand whose cognitive labor–inspired couture was featured in Milan's 2005 Fashion Week. Hungry March Band, Rude Mechanical Orchestra, and others took the originally militarized marching band out of its parochial role in school sports and re-martialed it from below by parading in political demonstrations. One could even see versions of culture jamming at

work in the culture of protest itself, such as the Rebel Clown Insurgent Army's tactical *détournement* of the subjective figures of confrontation.

The examples above comprise just the tip of the iceberg.[9] The point here is not to catalog exhaustively or even representatively the jamming by social movements. Instead, it is to show that Jenkins's (and more cynical critics') declaration of culture jamming's demise was short-sighted. It saw only one path for culture jamming tactics—into the heart of interactive branding and participatory fan culture. We can also posit at least one other, less visible, path—into the "metamorphosis machine" of social movements (Patton 2000).[10]

Looking back now from a post-OWS perspective, we can view that first decade of the new millennium with a perspective not as readily available to those at the time. Some depicted the waning of culture jamming as a sign of exhausted and ineffective activism (the fatigued depression of activist disempowerment), while others saw it as an indicator of cultural victory (the gratified optimism of fan empowerment). We can now look back on it as a time of sheltering, of a temporary retreat into interstices, and of experimentation and accumulation (and also attrition). In fact, we could even call it a *recuperation* from below, in which a collective body recovers from a series of shocks and defeats (post-9/11 securitization, the Terror-War, "glocalized" police repression at demonstrations).

"Recuperation" is a term typically associated with the powers of dominant culture to absorb and neutralize oppositional forms. But this presumes a powerful, uniform, and expansive dominant body that successfully coopts external critique. And it takes the analytic perspective of that dominant body. Rather than give over renewal powers to a presumed powerful "mainstream" body, we can view agency from the perspective of the temporarily weaker one—a popular body whose relative position has had to readjust due to a maneuver by another body. This first body recuperated during an incubator-time—creating an environment for a fragile multitude to gather its strength and recompose its powers. Recent analyses of individualized depression (a condition in which desire repeatedly fails to connect to action—a paralyzing dysphoria) note its potential as a time for rumination and creativity (under the right supportive conditions). So too can we see a collective body's

depression in this way—the condition becomes a space for withdrawal as well as recomposition from below.[11]

Recomposition and recuperation here meant keeping culture jamming alive, even while some tactics found their way into most debased forms (autodestructive, autojammed, and preemptively jammed ads). Projects like the ones described above continued for the decade before the September 2011 eruption of OWS, carrying on everyday life despite the seeming depression. So when OWS initially emerged as a culture jamming call, there was a standing body ready to take it up. For instance, a great deal of organizing work was accomplished in the couple months between the *Adbusters* call and the September 17 action. This gap between announcement and action, between signifier and material composition of the flash mob, was filled with "veteran" anarchist organizers, peer network development, and logistical planning forms that had incubated in the decade of recuperation. Not all of this was culture jamming, obviously. Rather, the incubator contained actors and projects (some of which were culture jamming interventions, while others involved alternative education, library, and food/clothing distribution mechanisms) that found new resonance with the initial meme of OWS. This recompositional context, I argue, is one milieu for the emergence of OWS. The recuperation by social movements (preservative and experimental) formed the collective body out of which OWS could take hold, develop, and spread.[12]

Flash Mobs and Beyond

OWS, then, was not just another meme. It was a variation on a particular kind of culture jamming tactic, namely the *flash mob*. The name "Occupy Wall Street" was immediately linked to a flash mob action in the *Adbusters* ad: an assembly of bodies resulting from a combination of specific characteristics, including a time (in this case September 17, 2011), a place (Wall Street), and a command ("Bring tent"). The *Adbusters* call's original destination, Wall Street, was preemptively enclosed by police, spurring a logistical rerouting to a backup destination by the flex-assembly that had gathered. And here we already witness an innovation, a mimicry (of other flash mobs, of the initial command) that mutates. The time between call and action, a time of extensive

discussion and organization, resulted in a not-completely-spontaneous but not-completely-planned composition that afforded flexibility and responsiveness. The element of surprise was a key component of the early success of the occupation of Zuccotti Park—not only the quickly adjusted objectives, but also the persistence of occupiers in the early days as well as the rapid densification and self-organization over the subsequent weeks. This tactical mutability, even unpredictability, was a variation on the flash mob, which typically has a planned end time as well as a beginning.

The flash mob has transformed throughout the last twenty years from street art performance to collective brand promotion, from political street carnivals to university library dance parties, from collective shoplifting (flashrobs) to collective shop-saving (cashmobs).[13] This new variation that is called "OWS" is a *persistent* and *open-ended* flash mob whose mimicry eventually offered something new. For one thing, it mutated into a platform for other actions, even other memes (such as Pepper Spray Cop and the other Internet memes noted in my opening). For another, the temporarily formed assembly mutated into something more enduring—a decentralized but resilient networked collective body. Moreover, it developed decision-making mechanisms, material infrastructures, and communication forms (see Deseriis 2013). Certainly, OWS was more than a flash mob. It might have developed into what I have elsewhere called "flashpublics" (Bratich 2012), but this was interrupted by the police crackdown. Ultimately, it became a platform for action, one in which experiments in making-worlds began to appear before being disrupted and disbanded (at least in terms of a convergence site).

OWS, taking mutation itself as its primary engine, soon became a meme that no longer was directed by its *Adbusters* origin.[14] Probably the most explicit sign that the meme had flown the coop involves the very ending of the ongoing flash mob in Zuccotti Park. Occupiers stubbornly and heroically defended their commons within the enclosure for almost two months, until the NYPD (or what Mayor Bloomberg called his "private army") forcibly evacuated the inhabitants and intentionally destroyed the infrastructure (physical and informational) on November 15, 2011. Hours before the raid, *Adbusters* sent a communiqué proposing a *self*-withdrawal from the park accompanied by a declaration of victory

in mid-December (in other words, a delayed call to give a flash mob the usual time-limit). This strategic action was unfortunately never tested, as the police entered the gap to put an end to the flash mob/encampment. One might even say that police met this flash mob with their own flash mob (time, place, command). After this point, the meme-generator *Adbusters* had even less influence on what it had unleashed. Over the ensuing months, *Adbusters* tried to keep the momentum going with periodic calls for actions, for events like May Day, the Chicago G8/NATO summit, and a Halloween Party in Washington, DC. The "failure" of these to generate the same mimicry and mutation is a healthy sign that control no longer belongs (if it ever did) to the meme-generator; but like a good meme-generator, *Adbusters* keeps churning them out in hopes something catches.

Cooptation: Commercial and Political

As OWS went on, it was inevitably confronted with acts of cooptation. Some were recognizable for their commercial trappings. There was at least one attempt to trademark the phrase by an entrepreneur. Commercials tapped into the spirit of populist protest, from Las Vegas to McDonald's (Vega, 2012). And in one clumsy attempt, a banner ad for something called *appatyze* showed fists holding signs saying "We Monetize the 99%" and "Occupy your app with video and banner advertising." None of this is surprising. As Thomas Frank (1997) notes, Madison Avenue has had a fascination with youth-generated counterculture and protest since the mid-1960s, drawing on the rebellious spirit to give its own creative revolution the frisson of countercultural zeal and popular enthusiasm.

Key figures in OWS understood well the tendency for OWS itself to become brand-like. While some groups, like Not an Alternative, took brand participation seriously in order to produce a variety of cohesive and contagious material signifiers, others were less sanguine about the tendency. Marisa Holmes, one of the more prominent occupiers, lamented that "Occupy has become a brand now. . . . I used to think that was a good thing that it could spread like a meme. . . . Now it worries me. Because corporate groups with more resources can take that meme and push it more easily than we can" (quoted in Binelli 2012, n.p.).

More than commercial cooptation was at work in this flashpublic, however. Internally, *political* cooptation was also an ongoing issue within OWS, much as it is for many social movements. An early manifestation of these divergent perspectives involved the controversy around making demands (Dean and Deseriis 2012). Later, the well-trodden debate over diversity of tactics came to the fore, resulting in two telling summer 2012 events. One was the September 2012 livecast debate between Chris Hedges and CrimethInc over the place of insurrectionary tactics within OWS (Hedges and CrimethInc 2012). The other was Occupy's National Gathering in July 2012, in which insurrectionists felt that the last vestiges of OWS's radicalness were being neutralized by liberal activist entrepreneurs (Lennard 2012b). And as the US presidential elections began to heat up that year, so too did the perennial debates over activist relations to those elections.

Perhaps the most visible moment of such a debate around political cooptation came in the run-up to May Day 2012. While much discussion was taking place among on-the-ground organizers regarding the shape and objectives of a May Day demonstration, I want to focus on just one public discussion that revolved around the issue of cooptation. A number of articles appeared in early to mid-April of that year, mostly dealing with the rise of a project called 99%Spring. A *Counterpunch* article revealed that MoveOn.org owned the domain name and project. This ignited a firestorm of controversy.

An article by Lasn (2012) himself warned that the soul of the movement was at stake and created a new meme called #DefendOccupy: "They're threatening to neutralize our insurgency with an insidious campaign of donor money and co-optation." Cooptation was the volatile issue of the day, appearing in article titles like "Did MoveOn Rip Off Occupy?: Occupiers Fear that the Organization's New 99 Percent Spring Campaign Will Co-Opt Their Message" (Lennard 2012a) and "99%Spring Is a Bust at Co-Opting Occupy Wall Street" (Resa 2012). Meanwhile, for others, the 99%Spring was a mobilizing project, gearing populist energy into forms for effective results, not an electoral sell-out (Schechter 2012). For still others, the tables were turned, with ripostes like "How Occupy Co-Opted MoveOn.org" (Harkinson 2012). Origin stories were met with responses that the movement did not belong to the initial core of organizers, but had expanded and now was in danger of

being coopted, not by mainstream culture, but by a cadre of antidemocratic activists. What was interesting about this back and forth was the fact that each contingent *accused the other of cooptation.*

We could chalk this up to what blogger J. A. Myerson (2012) wryly pointed to with the title "Only Sectarian Factionalism Can Save Us Now!" but we could also say that this controversy now afforded a reconsideration of cooptation and incorporation. Aesthetic and political issues around recuperation merged in ways that certainly have a history (see Shukaitis 2009), but now the very *agents* of cooptation were engaged in a battle over its very meaning. Cooptation thus does not remain at the level of signification or aesthetics, but foregrounds the very bodies and subjects engaged in the struggle. Formal cooptation would no longer suffice as the end of the story. The process of incorporation was no longer contained by the mainstream/alternative binary; it moved beyond participatory consumer culture. We can say that OWS, insofar as it involves a culture jamming legacy, pushes us to think beyond total incorporation for political movements.[15]

Beyond Cooptation: Repression and Antagonism

OWS's emergence and trajectory, as well as the continuing debates around cooptation allow us to revisit the very processes of incorporation and recuperation in culture jamming. For one thing, the severe police crackdown on OWS—not just in New York but also in dozens of cities around the United States—is not separable from this culture jamming dimension. Techniques for managing and neutralizing place-based dissent movements, like street protests and encampments, have been doggedly developed by a variety of police forces for over a decade. Police research conferences have focused on controlling demonstrations and mass assemblies, in part by creating private/public networks of collective intelligence gathering (Bratich 2014). In OWS's case, repression obviously doesn't emerge as a response to culture jamming per se. However, we now see a flourishing of the techniques of repression that were only sporadically deployed when it came to consumer culture.[16]

OWS activists found themselves targeted extensively by police networks. The strict repression of presumed threats became excessive to the point of absurdity. The relentless police obsession with all things

OWS persisted well after the evacuation of Zuccotti Park. Police routinely flouted public assembly laws on the ground in real time (call it the Jack Bauerification of protest-criminalization) only to be dismissed in the sclerotic courts later. Perhaps the most absurd case of this excess occurred with the OWS action on December 12, 2011. OWS, itself a persistent flash mob, became a more traditional flash mob-generator when it launched a spontaneous dance-off in the lobby of the World Financial Center (a public space). Participants were quickly met with a reactive police flash mob, which made arrests and harassed a journalist, as if they had been given time/space coordinates and one command: Do not let this take place!

In this microcosmic event, we witnessed a bifurcation of flash mobs: some, like the ones sponsored by airlines, TV shows, processed and fast food products, and shoe companies, are incorporated as buzz generators and brand ambassador performances (and put on by firms like Dance Mob Nation and Flash Mob America). But some are met with direct repression. The point of focusing on the repressive angle is that we need to move beyond a *totalizing* notion of cooptation (as if the main body completely absorbs and neutralizes its threat). As both culture jamming and OWS have demonstrated, there is no cooptation in general without a remainder, without a policing of the limit, without repression. Real subsumption engenders a crisis that demands real discipline, command, and intervention (and not just by corporations).

This also means that there is no cooptation without contestation, no incorporation without a new production of antagonism. "Cooptation" is not primarily a formal process by which an industry absorbs and neutralizes an act aesthetically, but a *subjective* intervention by an adversary, be it the corporate attempts at capture and command, a political organization's work to guide a movement, or the police efforts to preempt and neutralize. What is often mystified in accounts of incorporation and cooptation is that the mainstream is not just a space but also a subject (given its capitalist makeup): it acts "not simply as the organization of a context of conflictuality, but also and above all . . . as a subject . . . opposed to other subjects" (Negri 2005, 130). Capital, in each case of cooptation that involves repression, becomes a starker subject of *deprivation*. For instance, it continuously seeks to restrict the range of "participation" to that which benefits consumer culture, it reduces types of usage and

modification to those regulated by values of private property, and it extracts value from more practices (like online interactions) while removing the user-laborers from access to that value (Terranova 2000; Cote and Pybus 2007; Andrejevic 2008).

We are now glimpsing the terrain that currently defines culture jamming. A body (in Spinoza's sense, which here would be the *corpore* in the process of incorporation), no matter how hegemonic, is not equivalent to a totality like "the mainstream" or "the body politic." It is only a particular figure emerging out of a milieu, an ecology in which one subject must consistently reveal its punitive instrumentality. Returning to the matter of repression, this too has a subjective dimension. Antonio Negri (2005) argues that capital, rather than being a structure that produces and positions subjects, is itself a subject. What kind of subject is capital? An interventionist one, acting through expropriation and exploitation. Capitalist production of subjectivity necessitates blocking the political expression of productive forces, specifically their communicative capacities, and especially with the socialization of productive forces found in immaterial labor (132).

And what of the other body, namely the emergent body of OWS we have been tracking? Given the explicit (often clumsy and hypocritical) efforts to control it, that a subjective response emerges is no surprise. Sometimes this takes a playful form, such as the Mockupy action of December 8, 2011. Three weeks after the OWS eviction, the TV crime show *Law and Order: SVU* designed an outdoor set simulating Liberty Square just a few blocks away from the actual site. When occupiers caught wind of this classic example of cultural cooptation, dozens flash mobbed the set, occupying it as though it were the real park (eating food from the kitchen, having political discussions, hanging out on the furniture, reading the books). That evening the mockupiers were booted out, but only because the set itself was unpermitted and so was dismantled by police order. A brief, light action like this one is innocuous enough. But the innocuous, like the seemingly insignificant meme, tends to hide things (as de Certeau reminds us). In the Mockupy case, what was learned is that it is possible not just to *respond* to incorporation (in a communicational sense) but also to *inhabit* it. In this case, culture jamming's swarm-like subject once again demonstrated its flexible mimicry—it assembled quickly, moved lightly, played briefly, and dispersed swiftly.[17]

Getting beyond cooptation here means recognizing the *subjective* dimension of what formerly appeared to be a set of sign wars or form battles. We have thus moved beyond culture jamming as a set of actions and returned it to a *subjective capacity to act*. Culture jamming is not a series of desubjectified tactics; culture jamming involves actions that indicate, and recursively affect, the relative strength of the actor. From one perspective, OWS started as a meme from meme experts and then became a sign filled with the convergence of tactics. From another, we could say that OWS mutated into a meme-generator, flash mob, and platform, as well as a subject-operation (similar to Anonymous's rise from a series of operations launched from a platform [4chan]; see Coleman 2014).

The emergent body, one capable of re-occupying, *de-* and *re-tourning*, of experimenting and innovating, comprises what Negri (2005) calls a *constitutive ontology* (129). Subjects, according to Negri, are not substantialist beings, but mechanisms and agencements, expressing themselves historically at a moment of accumulation. We can say that OWS is one of these moments of accumulation, a convergence of practices and subjects within a legacy of culture jamming (among others). By tying tactics to compositional power, OWS fleshes out the "outsider" set of formal techniques. The very tactics absorbed by consumer culture to divide and isolate now are returned to a subject that deploys them in the service of its own objectives. These different objectives are crucial here—they are *nonaligned* with those of consumer culture, favoring an expansion of the common and an aspiration for "real democracy" (Hardt and Negri 2012). Culture jamming is *re-tourned* and returned from its "incorporation" via OWS's own power of reappropriation.[18]

In other words, incorporation involves a new body. This is the compositional power of a body that, while dispersed in one formulation (occupying a park), persisted as a *platform* that launched new projects. In New York City, some of the more prominent include Arts and Labor, Occupy Homes, Occupy Sandy, and Strike Debt (McKee 2016). The loss of the park occupation deprived OWS of some expansions, especially around the spatial concentration of people as well as the ability to develop decision-making mechanisms and OWS's own "dispositifs of subjectivity" (Negri 2008). But it did not spell the end of the "movement"—it only decentralized the projects and people into interstices and less visible nodes.

Focusing on this emergent body alone is not enough. It is important to return our argument to how this body relates to (1) the other body that sought to dismantle and preempt it and (2) the milieu that gave rise to it. In other words, we need to bring back the polemological and add the ecological. First, we now know that the police crackdown was not simply a single, local action. Public/private alliances were forged among local law enforcement, banks, private security firms, and federal agencies to spy on, restrict, and disrupt occupations. We saw the creation of "fusion centers" where "information sharing environments" were cultivated to enhance police powers (Hodai 2013). More than a series of tactics or actions, the police networks themselves constitute a body, an accumulation of mechanisms through institutional partnerships. Their objective, I am arguing, is to prevent the eruptions that follow from real subsumption—eruptions no longer "outside" commercial culture as with previous forms of culture jamming, but mutations and pulsations within the very spaces of the dominant body (a park, a TV simulation, social media, commodified streets).

We have thus returned to the polemological, as this repression takes on elements recognizable in low intensity warfare as well as features of the War on Terror (Ciccariello-Maher 2013). One does not need Bloomberg's remark about the NYPD being his "private army" to understand the militarization of policing protests. From the riot gear to the low intensity warfare weaponry to the multijurisdictional training forces to the categorization of protestors as "terrorists," the defining framework for managing dissent is war, not jurisprudence (Williams, Messersmith-Glavin, and Munger, 2013). As Hardt and Negri (2004) note, the cycles of struggles and uprisings are inseparable from historical transformations in conducting warfare.[19]

One could even say that, when it comes to dissent, domestic policing has employed a "full spectrum dominance" approach to protests (originally developed as part of the Revolution in Military Affairs, or RMA). Full spectrum dominance (FSD) is more than military power. It involves social, cultural, ideological, political strategies, or as Hardt and Negri (2004) argue, this new form of warfare operates directly on "biopower" (51–62). RMA places greater importance on nonlethal weaponry than previous warfare strategies, searching not to destroy the enemy, but to neutralize it. As Paul Virilio (2000) asserts about RMA, "What one is

seeking to eliminate is only ever life, the opponent's energetic vitality" (52). Seeds of this strategy can be found in decades-old counterinsurgency plans, in which combatting guerrilla uprisings involved "environment deprivation" (taking away supports for the guerrillas, from disruption of activist groups to material destruction of resources and populations).

Creating an environment that seeks to *deprive* the enemy of its resources and capacities, FSD is repressive not as a single lightning strike but as a climate. In the case of OWS, FSD policing eradicated the camp as the basis and site of developing powers, depriving the actors of the ability to develop their mechanisms and dispositifs. Preemptive arrests, elements of low-grade shock and awe, information control, total surveillance, infiltration of social networks—all these dimensions find their roots in the military strategies of FSD. Meanwhile, the police body networked its own powers via alliances and fusion centers, accumulating its own mechanisms asymmetrically. This type of network despotic power depends on preventing another body from acting, especially by controlling the milieu/terrain of emergence (Bratich 2014). The upsurge of repressive command that has reacted to culture jamming in its various forms (including that aspect of OWS) is thus also the clarification of *antagonism*.

But a new wrinkle has emerged in thinking through this antagonism, which brings us to our second theme (already signaled by FSD): the ecological. Rather than a confrontation between subjects, or a conflict between subject and structure, we might look to these newest social movements like OWS through a different lens, one that acknowledges their innovative composition. Spanish philosopher Amador Fernández-Savater (2012), writing about the recent social struggles primarily visible in encampments, asks us to reconsider the metaphor of a social "movement" altogether in favor of an "atmosphere" or "climate." In "How to Organize a Climate?" Fernández-Savater points out that the most visible dimensions of recent movements (camps, confrontations, leaders, named groups, media events) are only a part of the process, spatially and temporally. He speaks of "the motionless part of the movement," namely the people touched and affected by the encampment in Plaza del Sol in Madrid during the 2011 occupations, even though they have not taken part in the camp directly. Moreover, the temporality of such phenomena

is also different from movements. The progressive quality inherent in the idea of a "movement" engenders its own mechanisms of evaluation (Where has it gone? How much has it accomplished? How far along is it?). A climate has a different pace and relation to visibility, and therefore different modes of evaluation. OWS has been said to have "failed" (in terms of not becoming a mass movement, of not linking up to established parties or other institutions). But this presumes the political terrain, goals, and forms are already determined. More importantly, it ignores the key role of the antagonistic state in thwarting and preempting recognizable "success." Rather than judge it as a *movement* (which needs to "go forward" or "advance" to be successful), can we think of other ways to evaluate retreat or withdrawal? This climate is marked by relative dormancy—one might even say *recuperation*—followed by convection, condensation, and eruption in a rapidly changing, unstable environment. If OWS is understandable not just in its most visible convergence (in the square, in the news) but in its retreat and divergence, then better language is needed to understand the state of dissent and surges of protest. Along with movement, rest. Along with highly visible embodiment, less visible recuperation.

OWS, as meme, meme-platform, and flash mob, does not simply fail once its most visible early features wane. OWS was and is a convergence, in which innumerable desires, practices, and groups turned a flash mob into a climate, into a protest ecology that is no longer a tactic, strategy, or even organization. It has no visible center, proper name, or form. OWS has opened up new paths and emboldened voices, generating traces too small to measure, but ready to come together again when the next strange attractor emerges, by crisis or by call. In addition, the new outbreaks of post-OWS already carry with them similar debates about cooptation (Occupy Sandy, Strike Debt).

OWS is an eruption from the climate, but also became a name for that climate (producing future storms). Of course, OWS was already part of a global wave of struggles that preceded it (Egypt, Spain, Greece) and followed it (Turkey, Brazil). OWS's body is thus *both* climate and subject, or really the passage between them—a milieu that individuates into an antagonistic collective body, which feeds back into that milieu. Giving concepts to these ecological arrangements is a task for a "movement analysis" that appreciates the singularity of the present as well as climate change.

Culture Jamming as Metamorphosis-Machine

If we begin to see OWS in this light, we can also envision the transmutation of culture jamming. Culture jamming, after OWS's emergence, can no longer be limited to a series of formal tactics. Culture jamming has left the sphere of cultural aesthetics and returned to its proper home—*polemology*. Culture jamming is a war machine, in the sense defined by Deleuze and Guattari (1989), Pierre Clastres (1987), and Peter Lamborn Wilson (1998). In these formulations the war machine was not geared primarily toward destruction and domination. It was the source for innovation and creativity (of new forms of life). By preventing rigidity and domination, war allowed for the invention of possible worlds. Paul Patton (2000) finds this element to be so central to the concept that he prefers to rename it *metamorphosis-machine*. From innovative tactics of resisting external invaders to techniques of preventing internal domination, the history of struggles is a wellspring of creativity. The relationship between the war machine and the state is uneasy—one is never fully subordinated to the other, even while integration can fuse them historically. After the state appropriation of the war machine, these maneuvers and customs were relegated to "secret corners and cracks" (Wilson 1997, 76). Among those interstices and hiding places, though, was popular culture. In other words, the cooptation and incorporation so often associated with mainstream consumer culture's absorption of the margins does not belong solely to commodification—it has also been the ongoing dynamic between state and war machine. The polemological and the cultural have been deeply intertwined as "hidden transcript" (Scott 1993), which now has erupted under the name Occupy Wall Street.

The legacy of culture jamming continuously produces hybrids and mutants whose evaluation retains none of the "final word" that permeates cultural critics' totalizing categories of incorporation and cooptation. Culture jamming is not lost to the body politic or to corporate convergence culture but rather has mutated during real subsumption. Its resurgence expresses a moment in which the making of worlds, or ecology, is its newest material expression. In fact, we might not even call it culture jamming anymore. Could it just be called "culture"? And how will we invent modes of evaluation, a meteorology, for this climate?

NOTES

1 This harkens back to a pre-Internet conception of the meme (from Richard Dawkins onward) as a cultural unit or bit of information that is passed along via nongenetic means of transmission, such as contagion.

2 To summarize some key subsequent events: during a six week period from the call until September 17, dozens of organizers and interested parties (some estimates count 200) met in downtown Manhattan (primarily in Tompkins Square Park and the art/activist space 16Beaver) to work out, via general assembly and other means, the objectives and logistics of the action. On September 17, a group went to occupy Wall Street but was thwarted by preemptive police blockades of key sites. The group decided to occupy Zuccotti Park instead, setting up what would become the main encampment. For two months, OWS grew in numbers, media visibility, and intensity of actions and spawned a number of similar nodes in other cities in the United States and abroad. After those vibrant and expansive couple of months, New York City Mayor Bloomberg sent in what he calls his "private army" (the NYPD) to evacuate and dismantle the encampment. This was part of a coordinated effort among a network of mayors, local police, and federal agencies to eliminate the growing movement. Subsequently, OWS continued as a series of sporadic actions, decentralized projects, and media presence.

3 Of course *Adbusters* founder Kalle Lasn was already well known as a leading proponent of culture jamming. In his book *Culture Jam*, Lasn (2000) grounds his project in memetics. While the word "meme" has recently become tightly articulated to Internet memes, the version Lasn proposed came from his popularization of Richard Dawkins's assessment of cultural transmission of ideas.

4 Lest readers see this as an essay that tries to posit OWS as essentially, primarily, or even mostly a phenomenon of culture jamming, let me be clear. The question here is, given the empirical reality that the hashtag, name, and call for action originally came from *Adbusters*, what can this lineage tell us not only about OWS but as importantly for the purposes of this chapter, about the fate of culture jamming? Historical events demand that we revisit our concepts and embedded assumptions. This essay tries to do that with regard to what up until recently seemed to be a "settled" matter when it came to culture jamming.

5 De Certeau was certainly included in of Jenkins's early work as well, but he was left behind in Jenkins's later studies. While I agree that culture jamming and de Certeau no longer have the same status as twenty years ago due to transformations in consumer culture, I don't think we need to limit our political practices to those performed by consumer subjects. Here I also agree with Jenkins that culture jamming has moved beyond sabotage and blocking flows toward shaping imagination (even worlds). But this isn't relegated to those attached to elaborating consumer media culture.

6 See for instance Serazio, chapter 10 in this volume.

7 An example of the the last item is the 2006 Burger King campaign that asked its fans to make user-generated videos with an officially distributed BK "king" mask.

8 This kind of material occupation as response to consumption occurred even earlier. Reclaim the Streets was an outfit that reappropriated material spaces for the publics that use them rather than for policed lines of commodity flow.

9 For an extensive account of social movements and aesthetic interventions, see Stevphen Shukaitis (2009).

10 This phrase is how Paul Patton (2000) redefines Deleuze and Guattari's concept of the "war machine." The war machine in these formulations was geared not primarily toward destruction and domination but toward innovation and creativity in preventing the accumulation of power as well as in creating forms of life. Here I mention it to note how the polemological opens the constituent process. For more on this see the conclusion of Bratich (2011).

11 See Berardi (2009) for a discussion of the politics of collective depression both in late 1970s Italy and in contemporary movements, as well as its relationship to withdrawal and exodus. We can say that all of the talk of exodus was still marked by a will to act (we will leave!) rather than power to receive conditions (we have been exiled!). But perhaps the former is precisely the "hope" that allows persistence despite the latter.

12 Of course, many of the OWS participants did not come out of this earlier phase. This new generation, which provided much of the enthusiasm and indefatigability, often had no experiences with previous movement actions or groups. In fact, there were tensions within OWS around this disjuncture from the past (including similar education, street, and food projects that had occurred in New York City just a couple years prior). However, in a telling sign of OWS's immanent and rapid response mechanisms, there were also experiments in intergenerational activist communication set up to address these tensions.

13 See Walker, chapter 13 in this volume.

14 See Galloway and Thacker (2007) on "polymorphic" viruses, which "are able to modify themselves *while they replicate and propagate through networks*. Such viruses contain a section of code—a 'mutation engine'—whose task is to continuously modify its signature code, thereby evading or at least confusing antivirus software" (85).

15 I find that the terms "cooptation," "recuperation," and "incorporation" are used rather interchangeably in critical analyses of consumer culture and culture jamming discourse, for better or worse. In my argument, I would say *cooptation* is what the writers around OWS were most concerned with (e.g., the titles of the articles above). It can refer to both consumer culture's acts of neutralizing the opposition by using its tactics as well as a political party's absorption of radical groups for their own ends. *Recuperation* and *incorporation* refer to the bodies that act—the latter term indicating the process of "taking into the body" and the former referring to the presumed effects of recovery, reinvigoration, and sustenance.

16 Cooptation by dominant consumer culture has involved more direct modes of intervention (see Klein 2002; Atkins and Mintcheva 2006). When brands were becoming immanent, when they moved from being signs to being platforms and environments for action, their ability to *control* the types of participation was paramount (Arvidsson 2005; Lazzarato 2004). The limits of participation were clear, though often invisible and episodic. If participation did not enhance the brand image, if it tarred or tainted the glossy logo, then it was "disappeared." This could take place via prevention (a critical comment simply would not show up on a forum due to moderator filtering), censorship (the Peretti case of Nike's refusal to allow the user-generated word "sweatshop" on its shoes; see the introduction to this volume), or criminalization (around intellectual property). In other words, the seeming incorporation by brands of culture jamming tactics is neither smooth nor total. Real subsumption here involves not just absorbing some signs or formal practices (like defacement), but disciplining the range of production of those practices. As Naomi Klein elegantly puts it, branding immersing itself in culture entails censorship. From the perspective that sees OWS as an outgrowth of culture jamming, we can also examine this repressive response to its actions.

17 We see a later, substantial expression of this in the lead up to the #BlackLivesMatter interventions. In April 2014, the New York Police Department, fresh off of its OWS-related bad publicity, sought to enhance its friendly image with a Twitter promotion campaign called #MYNYPD. Users were asked to upload images of themselves showing positive moments with the police. The participatory campaign was quickly occupied with a humorous political *détournement*. Users uploaded pics of police violence with the hashtag and biting captions like "changing hearts and minds, one baton at a time." This particular campaign also traded on the intimate-customization strategy for brands (turning a brand into "my" possession). What commentators call "Black Twitter" was an emergent body (different in lineage from OWS, though with some overlaps) whose culture jamming tactics of pranking police campaigns contributed to the radical media ecology through which #BlackLivesMatter also expressed itself.

18 For Negri (1999), an ontological subject is formed via four powers that he argues constitutes affective production (85–86). These four qualities are (1) the power to act (capacity, agency, ability to produce effects); (2) the power of transformation (to combine activities, to connect an action to what is common); (3) the power of appropriation (in which every obstacle overcome determines a greater force of action; actions absorb the conditions of their realization); and (4) expansive power (as appropriation persists in an omnilateral diffusion, the capacities to act themselves increase to the point of a *transvaluation* of their conditions). Any act or deployment of a culture jamming technique expresses some degree of these powers.

19 For an analysis of contemporary network modes of warfare, see also Thacker and Galloway 2007.

REFERENCES

Andrejevic, Mark. 2008. "Watching Television without Pity: The Productivity of On-line Fans." *Television and New Media* 9 (1): 24-46.

Arvidsson, Adam. 2005. "Brands." *Journal of Consumer Culture* 5:35–58.

Atkins, Robert, and Svetlana Mintcheva, eds. 2006. *Censoring Culture: Contemporary Threats to Free Expression*. New York: New Press.

Berardi, Franco. 2009. *Precarious Rhapsody*. London: Minor Compositions.

Binelli, Mark. 2012. "The Battle for the Soul of Occupy Wall Street." *Rolling Stone*, June 21. www.rollingstone.com.

Bratich, Jack. 2007. "Popular Secrecy and Occultural Studies." *Cultural Studies* 21 (1): 42–58.

———. 2011. "User-Generated Discontent: Convergence, Polemology, Dissent." *Cultural Studies* 25 (4–5): 620–39.

———. 2012. "My Little KONY: Rise of the Flashpublics." *Counterpunch*, March 13. www.counterpunch.org.

———. 2014. "Adventures in the Public Secret Sphere: Police Sovereign Networks and Communications Warfare." *Cultural Studies <=> Critical Methodologies* 14 (1): 11–20.

Ciccariello-Maher, George. 2013. "Counterinsurgency and the Occupy Movement." In *Life during Wartime: Resisting Counterinsurgency*, edited by Kristian Williams, Lara Messersmith-Glavin, and William Munger, 126–45. Oakland, CA: AK Press.

Clastres, Pierre. 1987. *Societies against the State*. New York: Zone.

Coleman, Gabriella. 2014. *Hacker, Hoaxer, Whistleblower, Spy: The Many Faces of Anonymous*. London: Verso.

Cote, Mark, and Jennifer Pybus. 2007. "Learning to Immaterial Labour 2.0." *Ephemera* 7 (1): 88–106.

De Certeau, Michel. 1984. *The Practice of Everyday Life*. Translated by Steven Rendall. Berkeley: University of California Press.

Deleuze, Gilles. 1978. "Lecture Transcripts on Spinoza's Concept of Affect." Cours Vincennes. January 24. www.webdeleuze.com.

Dery, Mark. 1993. *Culture Jamming: Hacking, Slashing and Sniping in the Empire of Signs*. Pamphlet no. 25. Westfield, NJ: Open Magazine.

Deseriis, Marco, and Jodi Dean. 2012. "A Movement without Demands?" *Possible Futures*, January 3. www.possible-futures.org.

Deseriis, Marco. 2013. "The People's Mic as a Medium in Its Own Right: A Pharmacological Reading." *Communication and Critical/Cultural Studies* 1–10. doi: 10.1080/14791420.2013.827349.

Fernández-Savater, Amador. 2012. "How to Organize a Climate?" *Making Worlds*. www.makingworlds.wikispaces.com.

Foucault, Michel. 1977. "Nietzsche, Genealogy, History." In *Language, Countermemory, Practice*, edited by Donald F. Bouchard, 139–64. New York: Cornell University Press.

———. 1997. "What is Enlightenment?" In *Foucault, Ethics: Subjectivity and Truth*, edited by Paul Rabinow, 303–20. New York: New Press.

Frank, Thomas. 1997. *The Conquest of Cool: Business Culture, Counterculture, and the Rise of Hip Consumerism*. Chicago: University of Chicago Press.

Galloway, Alexander R., and Eugene Thacker. 2007. *The Exploit: A Theory of Networks*. Minneapolis: University of Minnesota Press.

Hardt, Michael, and Antonio Negri. 2004. *Multitude*. Cambridge, MA: Harvard University Press.

———. 2012. *Declaration*. New York: Argo-Navis Press.

Harkinson, Josh. 2012. "How Occupy Co-Opted MoveOn.org." *Mother Jones*, April 13. www.motherjones.com.

Hedges, Chris, and CrimethInc. 2012. "Violence and Legitimacy in the Occupy Movement and Beyond: A Debate between Chris Hedges and the CrimethInc. Ex-Workers Collective on Tactics & Strategy, Reform & Revolution." MobileBroadcastNews.com, September 12. www.mobilebroadcastnews.com.

Hodai, Beau. 2013. "Dissent or Terror: How the Nation's Counter Terrorism Apparatus, in Partnership with Corporate America, Turned on Occupy Wall Street." *Center for Media and Democracy/DBA Press*, May 20. www.sourcewatch.org.

Jenkins, Henry. 2006. *Convergence Culture: Where Old and New Media Collide*. New York: New York University Press.

Jenkins, Henry, Sangita Shresthova, Liana Gamber-Thompson, Neta Kligler-Vilenchik, and Arely Zimmerman. 2016. *By Any Media Necessary: The New Youth Activism*. New York: New York University Press.

Klein, Naomi. 1999. *No Logo: Taking Aim at the Brand Bullies*. Toronto, Canada: Knopf.

Know Your Meme. 2011. "KYM Review: Memes of 2011." www.knowyourmeme.com.

Lasn, Kalle. 1999. *Culture Jam: The Uncooling of America™*. New York: Eagle Brook.

———. 2012. "Battle for the Soul of Occupy." *Adbusters*, April 12. www.adbusters.org.

Lazzarato, Maurizio. 2004. "Struggle, Event, Media." MakeWorlds.org, April 4. www.makeworlds.org.

Lennard, Natasha. 2012a. "Did MoveOn Rip Off Occupy?" *Salon*, April 9. www.salon.com.

———. 2012b. "After National Gathering, Is There Room for Insurrectionary Anarchism in Occupy?" *Truthout*, July 17. www.truth-out.org.

Lury, Cecilia. 2004. *Brands: The Logos of the Global Economy*. London: Routledge.

McKee, Yates. 2015. *Strike Art: Contemporary Art and the Post-Occupy Condition*. London: Verso.

Moulier-Boutang, Yann. (1989) 2005. Introduction to *The Politics of Subversion, A Manifesto for the Twenty-First Century*, 1–44. Oxford, UK: Polity Press.

Myerson, J. A. 2012. "Only Sectarian Factionalism Can Save Us Now!" JAMyerson.com, April 11. www.jamyerson.com.

Negri, Antonio. 1999. "Value and Affect." *boundary2* 26:77–88.

———. 2005. *Politics of Subversion*. Cambridge, UK: Polity.

———. 2008. *The Porcelain Workshop: For a New Grammar of Politics*. Los Angeles: Semiotext(e).

Patton, Paul. 2000. *Deleuze and the Political*. New York: Routledge.

Read, Jason. 2011. "The Affective Composition of Labour." *Unemployed Negativity Blog*, May 17. www.unemployednegativity.blogspot.com.

Resa. 2012. "99% Spring Is a Bust at Co-Opting Occupy Wall Street." *Daily Kos*, April 11. www.dailykos.com.

Scott, James C. 1992. *Domination and the Arts of Resistance: Hidden Transcripts*. New Haven, CT: Yale University Press.

Schechter, Danny. 2012. "Is Occupy's 'Purity' under Assault?" *Consortium News*, April 14. www.consortiumnews.com.

Shukaitis, Stevphen. 2007. "Affective Composition and Aesthetics: On Dissolving the Audience and Facilitating the Mob." *Journal of Aesthetics and Protest* 5. www.joaap. org.

———. 2009. *Imaginal Machines: Autonomy and Self-Organization in the Revolutions of Everyday Life*. London: Minor Compositions.

Terranova, Tiziana. 2000. "Free Labor: Producing Culture for the Digital Economy." *Social Text* 63 (18): 33–57.

Thompson, Nato, and Gregory Sholette, eds. 2006. *The Interventionists: User's Manual for the Creative Disruption of Everyday Life*. Cambridge, MA: Mass MoCA / MIT Press.

Vega, Tanzina. 2012. "In Ads, the Workers Rise Up . . . and Go to Lunch." *New York Times*, July 7. www.nytimes.com.

Virilio, Paul. 2000. *Strategy of Deception*. London: Verso.

Wilson, Peter Lamborn. 1998. *Escape from the Nineteenth Century and Other Essays*. New York: Autonomedia.

Williams, Kristian, Lara Messersmith-Glavin, and William Munger, eds. 2013. *Life during Wartime: Resisting Counterinsurgency*. Oakland, CA: AK Press.

15

Jamming the Simulacrum

On Drones, Virtual Reality, and Real Wars

WAZHMAH OSMAN

One of my earliest memories of war is from when I was six years old. I was in the first grade at Lycée Malalai, a large French-funded state school for girls in Kabul, where my mother, Mina Homayun Osman, was a teacher. During recess I was playing with my classmates when dust clouds rose all around us. Everyone became a blur of uniforms running in and out of dust and smoke. . . . I could tell something was very wrong. I went and stood on the stone wall that enclosed the playground to look for my mother. I don't know how much time passed—it seemed like forever—but she finally came for me.

From the rockets striking the exterior of our apartment complex, to shrapnel shattering our balcony windows, to spending days hiding out in my grandmother's basement, I keep many other memories of war from the multiple coups and battles that led to the full Soviet invasion of Afghanistan. To this day, flaring lights, certain burning smells, and the roaring sound of some airplane engines disturb me.

For a child, it is difficult to make sense of war. For an adult, it is easy to assemble the pieces and see that wars are essentially about base human desires of greed and profiteering. Whether motivated by geopolitical imperial ambitions or to feed the machine of the military-industrial complex, war is always first and foremost an immensely profitable business that involves the building and maintaining of everything from bases, to prisons, to weaponry. Yet none of these motives makes sense if you have been on the receiving end of war. If you have seen the adverse domino effect of how a single act of aggression—one battle, one bullet, one missile, one bomb—can throw a peaceful country like Afghanistan into four decades of endless war with atrocious international human rights violations, war never makes sense.

I was the first generation of war. Although the war completely destroyed our lives in many ways, including the imprisonment of my father and the killing of two of my uncles by the Soviet-backed regimes, my immediate family was relatively fortunate in that we managed to escape Afghanistan alive. Between 1979 and 1989, more than half the country's residents became refugees—even more when internal refugees are considered.

During my many subsequent trips to visit my father, who remained in the region, I saw firsthand the atrocities left in the wake of the Soviet Occupation, first with the violence of the civil war and then with the rise of the Taliban regime. During my most recent post-9/11 research trips, I met and interviewed a new generation of war victims: many children and adults who have been impacted by US drone strikes. Although drone victims were not the explicit focus of my research trips, there is no avoiding the war-wounded and disabled in Afghanistan. Drone warfare, or what the US government calls "targeted killings," has been carried out predominantly in the ethnically Pashtun provinces of Afghanistan, such as Farah, Paktia, and Kunar, and along the Northwest Frontier (NWF), on the border with Pakistan. Drone victims and their families were coming to Kabul, where I was mostly stationed, for medical treatment, surgeries, and amputations. I also visited the above provinces.[1]

The vast majority of the drone strikes and resulting civilian casualties of the Af-Pak region are in the Northwest Frontier, where my family and I used to live and where we still have relatives. The NWF has become the ground zero of drone violence because historically, the region was set up by the British as a "buffer zone" to protect then British India. After the Second Anglo-Afghan War, the British annexed parts of Afghanistan to India. With the signing of the Durand Line Treaty in 1893, the British split the Pashtun tribes of Afghanistan, whom they deemed to be particularly unruly and rebellious. Since the Partition, although the region is technically a part of Pakistan, to this day, neither government has been able to fully control the contested region, and Afghan people refuse to recognize the border.

Given that the NWF does not have a formal government and therefore lacks civilian protection and oversight, the region's population remains vulnerable to the Faustian collusion that emerged between the Pakistani and US governments. These governments have turned the

NWF into an experimental lab for testing both their surveillance drones, which monitor the region insistently, and their secret assassination program to eliminate people that both governments deem to be politically problematic. These drones terrorize and kill people without any due process of the law. Imran Khan, the popular former cricket champion turned politician, is one of the few regional politicians who has made these connections and has vowed to protect the people. An ethnic Pashtun himself, he has amassed a huge following in his efforts to reorganize and restructure various government bodies and draconian laws so that there is some semblance of oversight and accountability to the residents of the region.

The Dominant US Narrative

Back in the United States, the dominant narrative told by government officials and reported in the mainstream media generally applauds drones for their efficacy. John Brennan (2012), the director of the CIA and former chief counterterrorism advisor to President Obama, has stated that the "targeted drone killings" are "wise" and "surgically and astonishingly precise." Furthermore, Brennan claims they are also "ethical," "just," and "humane" in being able to "distinguish more effectively between an al-Qaida terrorist and innocent civilians." According to Brennan, "It is hard to imagine a tool that can better minimize the risk to civilians than remotely piloted aircraft." To address the critics, Brennan also stated, "There is absolutely nothing casual about the extraordinary care we take in making the decision to pursue an al-Qaida terrorist, and the lengths to which we go to ensure precision and avoid the loss of innocent lives."

Since the US government's multiple drone programs are shrouded in secrecy and lack democratic transparency, it is difficult to ascertain the protocols for marking, targeting, and killing a "terrorist." However, a number of individuals and institutions have emerged to provide data that dispute the government's shady zero-to-single-digit "collateral damage" numbers (Friedersdorf 2013). Based on in-depth research, Stanford University, New York University, and Columbia University's human rights and global justice law clinics, as well as the Bureau of Investigative Journalism, have produced reports that show drone deaths in the Af-Pak region alone to be in the three thousand to four thousand range—more

than the number of people killed on 9/11—with many of the victims having no connections to terrorist networks (Cavallaro, Knuckey, and Sonnenberg 2011; Grut 2013; "Covert Drone War").

The promotion of drones as effective targeted killing machines is one part of the larger technological fetishization strategy that the US government deploys in conjunction with the entertainment and weapons industries. Their marketing and PR campaigns simultaneously extol robotics, long-distance warfare, and surveillance while dehumanizing the subjected populations by reducing the value of their lives to zero. It is a smoke-and-mirrors spectacle that distracts people with dazzling special effects, while the real blood, flesh, and gore are hidden from view.

Simulacra and Representation

In his analysis of the shift from modernity to late capitalist postmodernity, Jean Baudrillard was one of the first scholars to observe a dramatic change in the way we represent the world. In *Simulacra and Simulation* (1981), Baudrillard hypothesized that the order of symbolic representation has moved into a stage wherein signs and images no longer represent anything real. The abstracted and spectacular televisual representations of the first Iraq War provided the perfect opportunity for him to expand his theories to the confluence of new technologies of war with new media technologies. In his controversial book, *The Gulf War Did Not Take Place* (1991), Baudrillard argues that the danger of simulated and long-distance warfare is that it deliberately blurs the distinction between the real and the virtual, thereby obfuscating accountability. The hazard lies at the moment that the simulation moves beyond imitation or being a mimetic copy and becomes its own truth by surpassing the real and becoming the hyperreal—or as Paul Virilio (1994) puts it, the moment virtual reality overtakes the real thing. For Virilio, the Gulf War was a "world war in miniature." This simulacrum of war was created in part by the daily live televisual coverage of the Gulf War, which used satellite transmission, night vision cameras, and footage from cameras on board US bombers. The weapons of choice touted at the time for their precision bombing were the F-15, F-16, and F-117 bombers in tandem with AGM-130 missiles. The image that is projected to audiences back home was of a new kind of smart, clean, and bloodless war.

Not surprisingly, the distinction between war and video games is also disappearing. War-themed video games resemble real military operations. For example, the video game *Operation Flashpoint: Red River* (Codemasters 2011), based on the fictional premise of the US invasion of Tajikistan due to the rise of an Islamic regime, is eerily similar to Operation Anaconda, which was the post-9/11 joint US military attack that ousted the Taliban regime from power in Afghanistan. Needless to say, the Tajik public was outraged by the game's premise. "This computer game is a result of sick fantasy by Tajikistan's foes, who dream that our country will remain in the abyss of constant conflicts," said Davlatali Davlatzoda, a member of the ruling People's Democratic Party. "It is painful and horrible to watch how our villages and cities are being destroyed as a result of anti-extremist actions by the Chinese and the Americans," he said (quoted in "Tajikstan Tantrum Over 'Red River'" 2011).

Even more troubling than blurring the line between the real and the virtual for the general public playing war games on their consoles or watching the spectacle of war on their screens at home is when war effectively becomes a video game for active military personnel. Drone operators stationed thousands of miles away in over sixty drone bases around the world have even less connection to their targets than do conventional military pilots.[2] Despite the government's claims that "high-value terrorist" targets are vetted and confirmed by multiple sources, the human rights and global justice clinics of Columbia, New York, and Staford Universities, as well as the Bureau of Investigative Reporting, paint a different picture, one in which target selections are often based on flawed intelligence and little understanding of the region, its people, and its geography.

For drone operators carrying out orders from above, remote killing has become a stationary sport that costs lives in the Af-Pak region, but reaps profit for defense contractors. US expenditures for its various drone programs comprise an ever-increasing share of the already obscenely large, multi-trillion-dollar defense budget. When you take into account that each Predator or Reaper aircraft (the drones used in Afghanistan and Iraq) costs $13 million, each Hellfire missile costs $1 million, and the cost of each flight is an additional $1 million, the "mission" then seems to be primarily about feeding the military-industrial

complex beast. (Needless to say, the cost of a "foreign"/other human life is insignificant in this multi-trillion-dollar accounting equation.)

Journalistic reports have also surfaced that drone operators, sitting in their arcade video game-style drone consoles based in secret locations from Kandahar to Las Vegas, have only a vague idea of their supposed targets, and sometimes boast about their killing exploits as if they were part of a virtual game (Rose 2012). In his in-depth *Rolling Stone* exposé of drone culture, journalist Michael Hastings (2012) describes how for "a new generation of young guns" raised on video games, killing has become too "easy and desensitized." Hastings reports that the military lingo for people killed by drone strikes is "bug splat," "since viewing the body through a grainy-green video image gives the sense of an insect being crushed" (n.p.). He goes on to recount drone operators' "electrified" and "adrenalized" experiences of killing, noting how they compare the experience to various video games and science fiction films from their childhoods. In fact, as the International Security Armed Forces (ISAF) has revealed, operators rarely see the actual dead or injured bodies at the sites they target.

#NotABugSplat

Many relatives of drone victims, together with activists and human rights lawyers, want the operators to see the people they are killing. Despite extreme opposition and attempts at suppression by the Pakistani and the US governments, they have spoken out about how countless people who have been targeted and killed were innocent civilians with no history of terrorist activity. They want to honor their deceased loved ones by restoring their humanity and communicate their outrage at the injustices of drone warfare.

Culture jamming tactics have emerged as guerrilla tools for activists on the ground to bring visibility to the victims of drone strikes. One group, the Foundation for Fundamental Rights (FFR), using the hashtag and website #NotABugSplat, is literally putting a human face on the ground by installing on the landscape massive portraits of children who have been killed or whose families have been killed in the NWF. The international artist collective hopes to create "empathy and introspection amongst drone operators" and "create dialogue amongst policy mak-

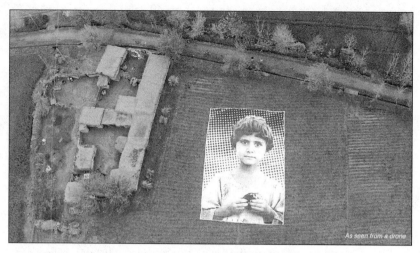

Figure 15.1. #NotABugSplat, Foundation for Fundamental Rights.

ers" (par. 3). Viewed through the lens of the drone cameras from 15,000 feet, actual people are barely recognizable: age, gender, and race become indistinguishable. Since the simulacrum makes the lives of people on the ground seem inconsequential, FFR hopes that seeing faces of real people, especially those of innocent children, will make drone operators at least think twice before pressing the kill button.

The Logic and History of Racism and Sexism

Whereas the latest manifestation of war technophilia in the form of drones is new, the patterns of racism and othering operating here have a long history. The logic of this embedded racism is based on colonial iconographies and tropes that have gained new currency since 9/11. In the US mainstream media, whereas African Americans were long subjected to overt racism, now people from the Middle East and North Africa (MENA) region and Central and South Asia are being overtly stereotyped and represented in very problematic ways. For example, while blackface and other caricatures of African Americans were permissible in the history of early broadcast and cinema, they are no longer acceptable. Media scholars have noted this trajectory of othering in terms of

a shift from traditional to modern types of racism (Entman 1992; Hall 2000; 2003). Modern types of racism are more subtle and complex but equally problematic because they often go unnoticed. Given the blatant racist imagery of Arabs, Persians, and Central and South Asians that permeate today's "war on terror" media (Jhally 2006; Salloum 2006; Shaheen 2003, 2008), I would argue that these minority groups are in the first phase of representation, the traditional racist one.

After 9/11, Afghan people were increasingly stereotyped in the mainstream Western media and popular culture. In order to justify the American military assault on the Taliban, all Afghan women became powerless victims of their backward, misogynist, and villainous brethren. Afghan culture is interpellated as static, unchanging, and bound by problematic archaic traditions. The US military intervention was thus not merely retribution for the attacks on the World Trade Center and Pentagon; it was also framed by the US government as a liberatory project to save the helpless natives from their own barbarism.

This double-edged white savior sword creates what Ella Shohat and Robert Stam (1995) have termed "the rape and rescue" fantasy and what Gayatri Spivak (1988) has called the "white men saving brown women from brown men" complex. As part of America's self-appointed "white man's burden" or civilizing missions, the saving of racialized women from the global South and East is used as a moral veneer to cover over the zealous calls for the annihilation of savage and barbaric racialized men, most notoriously Osama and Saddam.

Critics of the popular discourse about the saving of third-world women have demonstrated the implicit and explicit colonial agenda of American media pundits, political analysts, and key political figures. Lila Abu-Lughod (2003) stresses the importance of making broader political connections when analyzing the media: "We need to be suspicious when neat cultural icons are plastered over messier historical and political narratives, so we need to be wary when Lord Cromer in British-ruled Egypt, French ladies in Algeria, and Laura Bush, all with military troops behind them, claim to be saving or liberating Muslim women" (785). That said, one does not have to be white to adopt the white savior rhetoric: the torch of saving Muslim women has been passed down from the Bushes to the Clintons to the Obamas.

#BringBackOurGirls, Malala, and Nabila

Michelle Obama's #BringBackOurGirls Twitter campaign, meant to support the 276 Nigerian female students and teachers kidnapped in April 2014 by the Islamist terrorist group Boko Haram, backfired terribly when drone jammers reappropriated it. Twitter users from around the world turned the First Lady's #BringBackOurGirls picture into various mutations of "Nothing will #BringBackOurGirls killed by your husband" and "BringBackYourDrones" (Elder 2014). These remakes pointed out the sad irony that many more girls have been killed and displaced by Obama's drone strikes than by the Islamic extremists. This social media jam brought attention to the fact that during Obama's tenure in the Oval Office, our "Hope" and "Change" president has not only continued many of the warmongering practices of the Bush/Cheney regime, but has actually ramped up the drone program, with its deadly consequences, to new levels.

In a similar vein to the jamming of Michelle Obama, activists appropriated the image of another prominent figure with considerable global cultural capital, circulation, and recognition—namely, Nobel Peace Prize winner Malala Yousafzai. The culture jamming of her image is another exemplary use of social media to draw attention to the shady policies of the US government abroad. Although Malala herself is a Pashtun and an outspoken critic of drone warfare, she has become a poster child for the

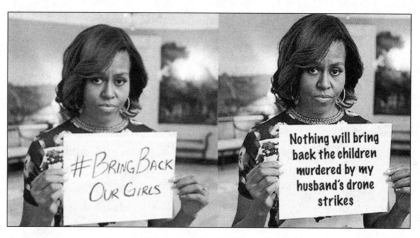

Figure 15.2. Michelle Obama #BringBackOurGirls jam.

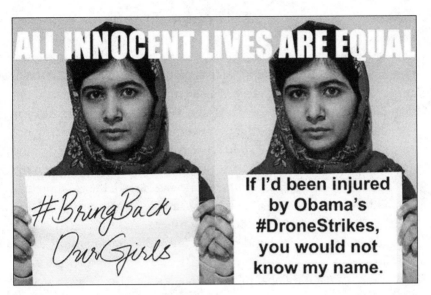

Figure 15.3. Malala Yousafzai drone jam.

trope of rescuing Muslim women and girls from their savage brethren. For several months, Googling Malala's name would bring up countless images of her with the caption "How many of you would know my name if I was murdered by a US drone strike?" (Muslim Public Affairs Committee). This simple and now ubiquitous jam issues an uncomfortable reminder to the American public that we frame children and people from the MENA region in ways that serve our own agendas.

In fact, on October 29, 2013, only five out of 430 US congressional representatives attended the testimony of another little girl, Nabila Rehman, whose family members were injured and killed in the NWF by a Predator drone strike (Hussain 2013). Her lawyer and translator, Shahzad Akbar, was denied a visa to accompany Nabila from Pakistan to Capitol Hill. Ever since Mr. Akbar, a human rights lawyer, began representing more than 150 family members of those killed by drones, as well as survivors of drone attacks, he has encountered problems gaining entry into the United States (Devereaux 2013). Mr. Akbar was also denied a visa to attend the Drones and Aerial Robotics Conference (DARC) held at New York University in 2013; he was to be a fellow speaker with me on one of the few panels that addressed the impact of military drones, titled "Life under Drones."

Malalai Joya, a prominent Afghan women's rights activist and former parliamentarian, also began having visa problems when she started critiquing US foreign policy, particularly drone strikes in her home province of Farah in Afghanistan.[3] Pakistani parliamentarian and staunch anti-drone critic Imran Khan was also removed from a plane and detained by US immigration officials. As Glenn Greenwald (2012) has documented, this is part of the US government's ongoing strategy not only to serially harass anti-drone activists and even journalists writing unfavorable accounts, but also to equate them with terrorists, as in the case of a senior US counterterrorism official smearing the good reputation and sources of the Bureau of Investigative Journalism.

So while Malala Yousafzai and a few other handpicked activists are internationally celebrated and paraded for public consumption, many progressive voices from the global South and East are silenced when they speak against the global ruling elite and deviate from the prescribed script. It is acceptable, and even encouraged, to critique local warlords and Islamists, but critiquing US warlords is strictly off limits.

Local perspectives will be buried if they fail to serve the dominant narrative. When critics speak truth to power by pointing out that drone strikes and similar US foreign policies have fueled Islamic extremism and terrorism, and when they demand accountability and justice, they stop being the ideal natives and need to be managed, controlled, or disposed of altogether. Indeed, one of the biggest grievances of progressive and secular activists from the affected regions is that the actions of the US military and its foreign policy more broadly are largely responsible for the rise of Islamism and terrorism there. As Timothy Mitchell (2002) explains in his article "McJihad: Islam in the US Global Order," American financial and military support for the ultra-religious Afghan and Pakistani groups was neither random nor coincidental. "When other governments moved closer to the United States—Egypt under Anwar Sadat in the 1970s, Pakistan under Zia ul-Haq in the 1980s—their political rhetoric and modes of legitimation became avowedly more Islamic" (1).

So when strong, popularly supported local activists like Akbar, Joya, Khan, and countless others—who bravely fight for human rights, equality, and justice—also question and challenge US imperialism, they be-

come dangerous. They challenge the false binaries between religiosity and secularism, as well as the simplistic discourses of progress, development, and humanitarian/human rights intervention (Asad 1986, 2003; Chatterjee 1997; Gole 2006; Mahmood 2005). Their stories can no longer be easily subsumed into narratives of victimhood or terrorism.

Disposable Journalists and the Robo-Reporter

The US military has also targeted journalists in war zones. US missile strikes during the 2003 Iraq invasion killed a reporter from Al Jazeera and cameramen from Reuters, Spanish TV, and several local TV stations in Baghdad (Noujaim 2004). In Afghanistan during the post–9/11 launch of Operation Anaconda and Operation Enduring Freedom, the US military also bombed the Al Jazeera Kabul office along with at least three local news agencies.

As seasoned antiwar activists know, showing the realities of war and war-related violence is a very effective means of influencing public opinion and shifting the tide against war. If we are to truly understand "life under drones," then having journalists on the ground documenting the impact of military drones, including war crimes, is essential. Reporters play a key role in bringing the realities of war home, thereby countering the simulated, distant, and sanitized versions that hegemonic institutions present. The US government learned all too well with the Vietnam War and the Civil Rights movement, and the more recent Black Lives Matter movement, that televising violence mobilizes people to act and demand change. As a result, news-based televisual violence is censored by the overlapping interests of the advertising industry, media executives, and the government. For example, since the Vietnam War, the US government has banned the news media from showing the flag-draped coffins of America's war dead.

While the censoring of war imagery is clearly meant to hide the real cost of war from the American public, showing realistic images of violence is productive in stirring people to wake up from their consumerist stupors to see the true impact of war. Therefore, local journalists play an especially vital role in the international news production chain. They have the access and cultural understanding, including language skills and local ties, which enable them to report in many regions that foreign

correspondents could not traverse alone. Their cultural access also frees them from embedded journalism and reliance on prepackaged news. Often without ties to agenda-setting institutions, local reporters can uncover international-local connections and cover-ups. They are also more likely to get to the frontlines to show the realities and atrocities of war at its most gruesome.

During my fieldwork in Afghanistan, I witnessed the power dynamics and hierarchies that favor international correspondents and embedded journalists while placing local fixers, translators, camera people, and journalists in grave danger. Reporters on the frontlines face an onslaught from international military forces, insurgents, and mercenaries. They are targeted in their hotels, studios, and in the field. When danger strikes, including kidnappings and attacks, the international correspondents are usually negotiated for or rescued, while the locals are left behind, deemed disposable. The larger structures of racism and sexism are also embedded in the disparities that exist in the international news production chain. There are many Afghan journalists, like Ajmal Naqshbandi and Sultan Munadi, who were killed in the line of duty when working for international correspondents and media organizations while their international counterparts were rescued.

To shed light on the vital work of frontline journalists and the dangers they face, Chris Csikszentmihalyi, an engineer and media professor, used his MIT Media Lab's Computing Culture Group credentials and resources to create the first nonmilitary, nonhuman roving war correspondent. His Afghan Explorer, dubbed the "first robo-journalist," hit the mainstream press and was picked up by news outlets around the world (Burkeman 2002; Maney 2002; Wieners 2002; Wakefield 2002). What the press did not realize, though, was that they were being jammed. The Afghan Explorer was not actually functional. Csikszentmihalyi's goal was to highlight the US government's troubling policy of limiting access for combat-zone journalists and endangering their lives in order to generate public discussion about these gross violations of the freedom of press. As he explained, "It's terrifying that unmanned Predator drones are killing innocent Afghan civilians and that the news coverage is precensored. It will always be better if human journalists are able to move freely but since they're not, I thought, if the military can have drones, why can't we?"[4]

Figure 15.4. Chris Csikszentmihalyi's solar-powered Afghan Explorer Robo-Reporter.

Jamming the Simulacra of War

The technophiliacs have built an imaginary techno-utopia, with words, images, and computer graphics superimposed over the dystopic reality they have created. Unlike your parents' rudimentary wars, the latest version of the iWar is sleek, sanitized, and sexy, right out of a James Bond movie. Innocent adults and children don't get indiscriminately killed; only fully identified, dark, and barbaric terrorists—who hate our freedoms, deny their own women freedom, and want to kill us (and therefore deserve to die)—are preemptively killed.

Simultaneously, real images that show the true cost of war from the ground are censored. Victims are silenced or effaced by various means, including being racialized, abstracted, and othered in such a way that they are already labeled "terrorists" and thereby never given due process or the protection of any international laws. They are targeted, persecuted, tried, condemned, and imprisoned or killed by extrajudicial means and in extrajudicial places and zones, far away from the public eye.

The drone victims do not have multibillion dollar lobbies to support them, as does the drone industry. That is why scholars, activists, and artists have risen to the challenge, shattering the myth of the new glossy aseptic war by showing the realities of drone warfare, demanding accountability, and putting people back into the equation and the picture, quite literally. Chris Csikszentmihalyi's robo-journalist, the Afghan Explorer, successfully shed light on the vital work done by journalists and the shameful and illegal ways they have been targeted by the US military. The Foundation for Fundamental Rights (FFR) is resisting the "bug splat" by rendering visible actual and potential victims by literally placing images of their faces in the fields of the North-west Frontier. And the viral visual culture jams of Michelle Obama and Malala Yousafzai challenge the premise of centuries-old colonial tropes of othering, stereotyping, and racializing of people from the global South and East. These memes remind people that the white savior rhetoric that underlies many US foreign interventions is only a ruse to cover up complicated and messy geopolitical agendas and the hypocrisy of US foreign policy. Through rehumanizing drone victims and jamming the multimillion dollar PR campaigns of the military-industrial complex, drone jammers are fighting to dismantle the simulacra of war.

NOTES

1 Due to the presence of the international aid community, Kabul has more of an infrastructure of medical facilities to treat and rehabilitate the war injured and disabled. According to the United Nations, with over 10 million land mines, Afghanistan is one of the most heavily land-mined countries in the world. As such, the victims of both one of the oldest and the newest war weapons come to Kabul. Yet many also have severe emotional and psychological problems as a result of regular exposure to drones, something that often goes entirely unaddressed and untreated due to a lack of resources.

2 From Las Vegas, Nevada in the United States, to locations in Afghanistan, the United Arab Emirates and Africa, journalists are uncovering more details about the extent and locations of drone operating facilities: see Turse (n.d.).

3 In 2012, Malalai Joya was sponsored by two New York City-based organizations, the War Resistors League and the South Asia Solidarity Initiative to promote the launch of her US book tour for her new book, *A Woman amongst Warlords,* but she was denied visas multiple times.

4 In conversation, New York City, fall 2013.

REFERENCES

Abu-Lughod, Lila. 2003. "Do Muslim Women Really Need Saving? Anthropological Reflections on Cultural Relativism and Its Others." *American Anthropologist* 104 (3): 785.

Baudrillard, Jean. 1981. *Simulacra and Simulations.* Translated by Sheila Faria Glaser. Ann Arbor: University of Michigan Press.

Baudrillard, Jean. 1991. *The Gulf War Did Not Take Place.* Indianapolis: Indiana University Press.

Brennan, John O. 2012. "The Efficacy and Ethics of US Counterterrorism Strategy." Wilson Center video. April 30. www.wilsoncenter.org.

Burkeman, Oliver. 2002. "Robohack Wired for War Zones." *Guardian,* March 26. www.theguardian.com.

Cavallaro, James, Sara Knuckey, and Stephan Sonnenberg. 2011. "Living under Drones: Death, Injury and Trauma to Civilians from US Drone Practices in Pakistan." www.livingunderdrones.org.

"Covert Drone War." *Bureau of Investigative Journalism.* www.thebureauinvestigates.com.

Devereaux, Ryan. 2013. "Pakistani Drone Victims' Lawyer Accuses US of Blocking His Visit to Congress." *Guardian,* September 24. www.theguardian.com.

Elder, Miriam. 2014. "People Are Turning Michelle Obama's #BringBackOurGirls Pic into an Anti-Drone Campaign." *BuzzFeed News,* May 12. www.buzzfeed.com.

Friedersdorf, Conor. 2013. "Dianne Feinstein's Outrageous Underestimate of Civilian Drone Deaths." *Atlantic,* February 11. www.theatlantic.com.

Entman, Robert. 1992. "Blacks in the News: Television, Modern Racism and Cultural Change." *Journalism Quarterly:* 341–61.

Greenwald, Glenn. 2012. "US Detention of Imran Khan Part of a Trend to Harass Anti-Drone Advocates." *Guardian,* October 28. www.theguardian.com.

Grut, Chantal. 2013. *Counting Drone Strike Deaths.* New York: Columbia Law School Human Rights Clinic. web.law.columbia.edu.

Hall, Stuart. 2000. "Racist Ideologies and the Media." In *Media Studies: A Reader,* 2nd edition, edited by Paul Marris and Sue Thornham, 271–282. New York: New York University Press.

———.2003. "The Whites of Their Eyes: Racist Ideologies and the Media." In *Gender, Race, and Class in Media: A Text-Reader,* 2nd edition, edited by Gail Dines and Jean

M. Humez, 89–93. Thousand Oaks, CA: Sage. Hastings, Michael. 2012. "The Rise of the Killer Drones: How America Goes to War in Secret." RollingStone.com, April 16. www.rollingstone.com.

Hussain, Murtaza. 2013. "Malala and Nabila: Worlds Apart." *Al Jazeera*, November 1. www.aljazeera.com.

Jhally, Sut. 2006. "Reel Bad Arabs: How Hollywood Vilifies a People." YouTube video, November 1. www.youtube.com.

Maney, Kevin. 2002. "Roving Reporter on Battlefields Could Be a Robot." *USA Today*, March 19. www.usatoday.com.

Mitchell, Timothy. 2002. "McJihad: Islam in the US Global Order." *Social Text* 20 (4): 1–18.

Muslim Public Affairs Committee [@MPACUK]. 2013. "How Many of You Would Know My Name If I Was Murdered by a US Drone Strike?" Twitter. www.twitter.com, March 22.

"#NotABugSplat." www.notabugsplat.com.

Noujaim, Jehane, dir. 2004. *Control Room*. New York: Magnolia Pictures.

Rezak, Achariya Tanya. 2012. "'Red Dawn Makes Me So Racist!' An Asian American Woman Reacts to the Remake of 'Red Dawn.'" xoJane.com, December 11. www.xojane.com.

Rose, David. 2012. "CIA Chiefs Face Arrest over Horrific Evidence of Bloody 'Video-Game' Sorties by Drone Pilots." DailyMail.com, October 20. www.dailymail.co.uk.

Salloum, Jackie. 2006. "Planet of the Arabs." YouTube video. www.youtube.com.

"Selma: CNN Drones It and Fox News Plays the White Victim." 2015. *The Daily Show with Jon Stewart*, March 9. YouTube video, posted by "The Big Screen," March 10. www.youtube.com.

Shaheen, Jack G. 2003. "Reel Bad Arabs: How Hollywood Vilifies a People." *Annals of the American Academy of Political and Social Science*, 171–93.

———. 2008. *Guilty: Hollywood's Verdict on Arabs After 9/11*. Massachusetts: Olive Branch Press.

Shohat, Ella, and Robert Stam. 1995. "Tropes of Empire." In *Unthinking Eurocentrism: Multiculturalism and the Media*, 156–60. London: Routledge.

Spivak, Gayatri. 1988. "Can the Subaltern Speak?" In *Marxism and the Interpretation of Culture*, edited by Cary Nelson and Lawrence Grossberg, 271–316. Urbana: University of Illinois, Press.

"Tajikstan Tantrum over 'Red River' Invasion Videogame." 2011. *New Zealand Herald*, June 20. www.nzherald.co.nz.

Turse, Nick. N.d. "America's Secret Empire of Drone Bases." *The World Can't Wait*. www.worldcantwait.net.

Virilio, Paul. 1994. *The Vision Machine*. Bloomington: Indiana University Press.

Wakefield, Jane. 2002. "Robo-Reporter Goes to War." *BBC News*, March 28. news.bbc.co.uk.

Wieners, Brad. 2002. "Do Androids Dream of First Amendment Rights?" Salon.com, February 25. www.salon.com.

16

Balaclavas and Putin

Pussy Riot, Carnivalesque Protest, and Political Culture Jamming in Russia

ANNA BARANCHUK

Adding to a growing chorus of civil discontent over tightened state control, the Russian political opposition scene welcomed a new force in 2011. A self-proclaimed "militant, punk-feminist street band," Pussy Riot aims to mobilize Russian public energy "against the evil crooks of the Putinist junta" and highlight the issues of gender discrimination, LGBT rights, and the overall political voicelessness of Russia's civil society (Langston 2012). Clad in colorful dresses and balaclavas and endowed with a rebellious spirit, the Russian punk feminists see themselves as androgynous "superhero cartoon characters [who] emerged from TV screens to storm the streets" (Zagvozdina 2012).[1] Antiauthoritarian with a feminist bent, Pussy Riot's "punk poetry" (Rumens 2012) unites performance art and political protest (Zagvozdina 2012).

To convey its "exaggerated political stance" (Langston 2012), Pussy Riot performs in an "ironic and somewhat provocative form to effectively resist general conservatism" in Russia ("Interview with Pussy Riot" 2012). At the same time, Pussy Riot claims that its actions are not outrageous. Referring to their anti-Putin "punk prayer" "Bogoroditsa, Putina Progoni" (Virgin Mary, Mother of God, drive Putin away) in Moscow's Cathedral of Christ the Savior on February 21, 2012, band members say that they are deeply saddened that their performance was perceived by many Russians as blasphemous and explain that they did not mean to offend anyone (Masiuk 2013). Instead Pussy Riot says its actions have always been thoughtful ("Sobchak" 2012). As a result of the "punk prayer," three members of the band were arrested, two of whom were sentenced to two years in prison for "hooliganism driven by religious hatred"

("Pussy Riot Found Guilty" 2012). Even more lamentable is the dramatic rift in Russia's society caused by Pussy Riot's prank. The Russians who paid attention to Pussy Riot's trial or otherwise heard about the "punk prayer" divided almost in half between supporters and opponents. Among the former are mostly atheists and young (under forty-five years old) educated people, while the latter includes primarily religious people and the elderly (Zagvozdina 2013).

By analyzing Pussy Riot's form of culture jamming and attending particularly to the "punk prayer," this essay explores the possibilities and limitations of a comically driven protest in an authoritarian state. By combining Jacques Lacan's theory of subjectivity and Kenneth Burke's theory of human motives, and by expanding on Naomi Klein's and Christine Harold's vision of culture jammers as merry pranksters, I argue that Pussy Riot has failed to playfully reappropriate Putin's "tragic" national brand of Russia and mobilize the Russian public. Despite the band's overall comic attitude, the grotesque fantasy-frame used by Russian punk feminists in the band's high-profile performance in one of the most important churches in Russia took on a tragic valence. As the modus operandi of the "punk prayer," the tragic grotesque could only backfire in Russia. For, as I explain in this chapter, Pussy Riot's tragic grotesque rhetoric turned out to be too coherent, or reliant on the Imaginary,[2] and thus was unable to mobilize Russian society against Putin's authoritarian regime. Instead, Pussy Riot should have relied on the comically driven burlesque. The burlesque as the fantasy-frame of radical ambiguity is a more suitable protest tactic to counter a cynical authoritarian state, as it verges toward what Lacan calls symbolic stupidity and invites a wide range of unexpected interpretations and reactions.

The Tragedy of the National Brand: The Russian Case

To explain what the Russian political culture jammers failed to do and how they could have effectively resisted Putin's national brand, one must first consider what those hegemonic formations, including the national brand, are. Nation branding is much more than a "practice that selects, simplifies and deploys only those aspects of a nation's identity that enhances a nation's marketability" in the age of globalization (Jansen 2008, 122). Rather, nation branding is a practice of national

identity-building that often taps the antidemocratic, tragic potential of national identity construction.

The concept of nation branding emerged in the age of globalization. Some scholars insist that globalization has invigorated national attachments. As Zala Volcic and Mark Andrejevic (2011) note, the increased flow of goods, capital, labor, and technology has infused the idea of branded national identity with "a particular sense of urgency" (612). At the same time, promoting national interests and fostering a sense of unity and belonging are not new: these aspirations have been a fundamental part of the politics of nation-states since their very inception (Olins 2003). Viewed form a Lacanian-Burkean perspective, nation branding is a process of national identity-building. While national identities can be negotiated differently (tragically or comically), the tragic impulse inherent in the process of national identity construction is more discernible in the practice of nation branding.

There are two modes of national identity construction relevant to my analysis: "tragic" and "comic." Here I combine Lacan's theory of the subject with Burke's ([1934] 1984) *Attitudes toward History*—"[one's] notion of the universe" (3)—in order to differentiate between two distinct ethical positions in the process of national identity negotiation. Depending on how national subjects choose to symbolically perform their national selves (either in relation to or at the expense of the national other), an ethical position can be characterized as comic or tragic, respectively. A tragic position, performed nonreflectively or cynically, is the most politically dangerous and ethically questionable, while a stance of sincere comic self-reflection is the most politically progressive and ethically sophisticated.

The tragic ethical position always requires killing the enemy. Aggressive and ruthless attempts of the national tragic drama are directed toward resolving some underlying antagonisms by telling compelling narratives about the national self and national others, who "stole" something that otherwise makes the nation perfect. In contrast to tragedy, comedy is the ultimate attitude of what Burke (1984) calls "humane enlightenment" (41), and it helps one to view the national other not as an enemy to be symbolically or physically sacrificed, but as a reminder, however troubling, that the national self is always imperfect or lacking. Comedy is truly self-reflective, since it reinvents the evil villain as a

mistaken fool and reminds us that being mistaken is a necessary human condition.

Burke's comedy approximates what Lacan saw to be the ethical goal of psychoanalysis, which is also the ethical goal of culture jamming—namely, to maintain the position of comic self-reflection. To structure national fantasies comically is to recognize the truth about one's desire—the truth about the national self as constantly lacking and thus in an eternal search for something (in the Other) that can supposedly complete it.[3] To speak truthfully about one's nation, one must come to terms with the fact that all national attachments and animosities are performed (on the symbolic level) only for the sake of covering up for irrecoverable lack, and this process of covering up the ultimate insufficiency of the self results in the production of a satisfying (but ultimately illusory) image of the self.

At the same time, a comic ethical stance acknowledges the very necessity of the constitutive outside and a healthy distance between the self and the other, with the latter being perceived as an adversary (the comic other) and not an enemy (the tragic other). On a larger, societal scale, the intrinsic agonism of comedy promotes a vision of porous, imperfect social formation, in which conflict is a necessary element.[4] Unlike comedy, tragedy acts on a totalitarian impulse by aspiring to a purportedly conflict-free, homogenous society—an attitude that stems from an ultimately tragic infatuation with an image of the whole national self. As an ethically sophisticated stance, comedy requires one to resist the lure of "untroubled happiness" (Lacan 1992, 302) offered by the Imaginary—the lure, that is, of appealing national narratives of the perfect national self and evil national others. Viewed through the prism of a Lacanian-Burkean theory, then, nation branding is an example of how branding agents (governments and PR companies) often cynically tap into "conflictual" relationships with the Other in order to build appealing images of the nation.

Since the early years of Putin's first presidency, the Kremlin has been aggressively building a brand of a new Russia and its people—"desirable," "attractive," and "influential" (Putin 2012b). To win the global "popularity contest," the Kremlin has promised to abandon the foreign policy tactics of military or economic pressure ("hard power") popular during the Soviet times. Instead, Putin (2012a) advocates "soft

power"—"promoting [Russia's] interests and opinions through persuasion and by winning over" the country's strategic partners. Despite the Kremlin's attempts, however, Russia's image in the West still is not as glamorous as the Kremlin hopes it to be. According to the 2012 Freedom House and Transparency International rankings, Russia's political regime failed to qualify as an electoral democracy (the country was ranked as "not free" in political rights and civil liberties), and Russia's economy was declared to be one of the most corrupt in the world ("Russia" 2012).

Despite the Kremlin's reassurances that the country's diplomacy has become more "dynamic, constructive, pragmatic, and flexible" (Putin 2012a), Russia does not come across as a "soft power." It would be enough to recall gas conflicts between Russia and Belarus, Ukraine, Georgia, and Turkmenistan; Russia's bans on import of certain products from Belarus, Georgia, and Moldova; numerous disputes between Russia and Georgia over Georgia's break-away regions of Abkhazia and South Ossetia; and, finally, the annexation of the Ukrainian peninsula of Crimea by Russia in March 2014. The Kremlin allegedly resorts to economic coercion tactics against ex-Soviet republics in order to bolster its geopolitical influence in the regions. Whatever Russia's motivation behind such actions (whether purely economic or also political), Russia does not seem to give up on its national image as a great power. While Putin does not want Russia to be openly perceived by the world as an aggressive empire, he certainly aspires to restore Russia's world power status as the essence of Russian nationhood.

The "Russianness" qua "strength" qua "greatness" is promoted not only abroad, but also, and even more so, at home. With the collapse of the Soviet Union, Russians suffered a tremendous national identity loss. Other ethnic groups living in the former Soviet Union, in addition to their Soviet identity, always held tight to their specific nationalities, defining themselves primarily as Georgian, Ukrainian, and so on, and only secondarily as Soviet people. For Russians, however, ethnic and Soviet identities were firmly merged. When the other fourteen Soviet republics acquired a long sought-after independence from Russia in 1991, Russia ceased to be what it thought it always was: a large and powerful state. That national injury has proved golden for Putin. Confusion over what the new Russia is—a modern Western state or a successor to the Soviet

Union (or maybe even the Russian Empire)—gave the Kremlin an opportunity to renegotiate Russia's national brand, Putin-style.

Like the idea of what it meant to be Soviet, Putin's vision of Russian national identity is imbued with sentiments of Russian imperial messianism and preference for traditional "Russian ways." The latter includes a peculiar fusion of Orthodox Christianity and autocracy, which produces unquestionable trust in the divine autocrat as messianic savior. In modern Russian society, these customary attitudes have taken shape, for example, in the rapprochement between the state and the Russian Orthodox Church (ROC), and have contributed to Putin's popularity among the Russian people. In turn, Putin promises to defend the "traditional" central status of Russian Orthodoxy, guarantee Russia's stability, and restore the country's greatness. Playing on Russia's longing for stability and nostalgia for greatness, Putin—in a tragic fashion—builds his narrative upon supposed domestic and foreign threats and enemies to justify his "strong" (read "autocratic") leadership. It is not surprising that the Russians perceive their history as a never-ending attempt to fight off enemies and build a strong state, since they resisted the powerful nomadic Tatar Mongols tribes from the East for centuries, and later dealt with numerous military threats from the West. In modern Russia, traditional suspicion of anything or anybody foreign has also expressed itself in the rise of ethnic Russian nationalism; religious-, gender-, and sexual-orientation-based discrimination; disregard for human and political rights; and a listless civil society.

Pussy Riot and Political Culture Jamming in Russia

Russia is certainly far from being a comic state able to accommodate political dissent and a potent civil society. But Russia cannot afford to be openly tragic either. Notwithstanding the endemic Russian indifference to political freedom, the country has to function within the dominant global network of liberal democracies. In an utterly cynical fashion, Putin has been building an image of the country that supposedly respects international agreements and lives by the rule of law. Putin's tragic nation branding has been met with vehement resistance by Russian political culture jammers—among them, most infamously, Pussy Riot. The band has taken upon itself a moral and civic duty to

disrupt the tragic national brand cynically articulated by Putin. One of the major problems, however, is that the Russian legislature has increasingly restricted civil liberties under a cloak of a purportedly "healthy and civilized" legal system ("Direct Line" 2013).[5] Under such conditions, playful culture jamming has more potential to disrupt Putin's tragic national brand than does serious protest (such as the 2011–2013 oppositional rallies in Russia).[6]

I must stress that serious protest is not necessarily tragic, while humorous resistance is not always comic. Both serious and humorous protest can be tragic and comic. In national narratives, the broadly tragic and comic attitudes to life acquire specific forms: tragedy, comedy, epic, elegy, satire, the burlesque, and the grotesque. Epic, elegy, and tragedy are serious narratives, or fantasy-frames, in which to express one's attitude. Satire and the burlesque are humorous expressions of the tragic and comic ethical positions, while comedy and the grotesque can be both earnest and playful. While serious protest is not always tragic, the serious Russian opposition most often resorts to tragedy proper, or tragic tragedy (for example, the slogan of the liberal opposition is "Russia without Putin"), tragic elegy (such that the slogan of Russian communists is "Power to millions, not millionaires"), and tragic epic (as in the ultra-right slogan, "Russia is for the ethnic Russians"). In contrast, the culture jammer as a merry prankster relies on comically driven humorous fantasy-frames, such as comic satire, comedy proper, and the comically marked burlesque and grotesque. In addition to often serious or violent reactions to political opposition, a tragic state can also rely on a humorous fantasy-frame, in particular, ironic laughter (as an element of tragic satire) to cynically counter a comically driven protest.

Pussy Riot was founded in 2011—as band members explain, "after the Arab Spring when it became clear that Russia is lacking political and sexual freedom, audacity, a feminist whip, and a female president" ("Interview with Pussy Riot" 2012). Toward the end of September 2011, as news about Putin's decision to return for the third term spread, Pussy Riot sprang into action (Langston 2012). Their first music video "Osvobodi bruschatku" (Release the cobblestones) was released on YouTube on November 6, 2011, and a day later posted on the band's blog.[7] November 7, 2011, officially marked the beginning of Pussy Riot's protest activity (Glazko 2011).

Russian punk feminism is closely linked to its Western counterpart, more precisely to Riot Grrrl, "a loosely affiliated group of young, generally punkish, take-no-prisoners feminists" (Gilbert and Kile 1996, 5). In many interviews, the Russian feminists draw connections to Bikini Kill, a leading punk music band of the feminist punk-rock movement Riot Grrrl, formed in the early 1990s in the United States under the slogan "Revolution Girl Style Now."

As a proud heir of the Riot Grrrl movement, Pussy Riot has embraced an image of "masked avengers" so well executed by another feminist collective, the Guerrilla Girls, "a group of anonymous [gorilla mask-wearing] do-gooders" (Cooper 2010), engaged in "acts of theatrical satire" to address feminist issues in the world of art (Schechter 1994, 22). Anonymity is vital for Pussy Riot. First, it prevents the audience from fixating on particular individuals instead of the band's message. Also it helps to counter potential accusations that the band has commercial aspirations. Besides, neon-colored balaclavas protect the members (at least temporarily) from possible repercussions from the state. But even more importantly, a mask, as Pussy Riot insists, is "our response to the authorities fearful of any nonstandard and independent expressions of contemporary youth" (Glazko 2011). Wearing bright balaclavas, colorful dresses, and tights and showing up in unexpected places, the band hopes to catch the Kremlin off balance, to intimidate and weaken the oppressive regime.

In addition to anonymity, Pussy Riot's peculiar masks help to promote seriality of feminist punk resistance as another important characteristic of culture jamming. As a band member explains, "[Pussy Riot has] nothing to worry about, because if the repressive Putinist police crooks throw one of us in prison, five, ten, fifteen more girls will put on colorful balaclavas and continue the fight against their symbols of power" (quoted in Langston 2012, n.p.). Thus balaclavas help the collective remain "a pulsating . . . body" of civil unrest, sustaining the protest no matter who performs it.

The inflammatory image created by Pussy Riot also has much to do with the punk band's name. It contains an obvious allusion to the Riot Grrrl movement and a provocative reappropriation of the woman's body from male discourse. For many, the band's name, which in Russia is usually pronounced or written in English, is unrepeatable and obscene

(Shishova 2012; "Witness" 2012). When asked his opinion of Pussy Riot's case, Putin told the journalist to translate the name of the band into Russian, and when the journalist refused, Putin concluded that "if you can't say it in my presence, it means these words are inappropriate" ("Unknown Putin" 2012). Making people uncomfortable even pronouncing the band's name, Pussy Riot has challenged the boundaries of what is acceptable or customary, and thus achieved a certain political effect.

According to Pussy Riot members, the band's name embodies both soft feminine qualities (the first part of the name, *pussy*, which may refer to a cat) and more decisive power (the second part of the name, *riot*) (Dobrokhotov 2012). Obviously, the name is also a play on words, where *pussy* is slang for female genitalia. As a Pussy Riot member puts it:

> A female sex organ, which is supposed to be receiving and shapeless, suddenly starts a radical rebellion against the cultural order, which tries to constantly define it and show its appropriate place. Sexists have certain ideas about how a woman should behave, and Putin, by the way, also has a couple [of] thoughts on how Russians should live. Fighting against all that—that's Pussy Riot. (Langston 2012)

Armed with microphones, electric guitars, colorful flares, purple and pink feminist flags, combustible powder, and a fire extinguisher, Pussy Riot activists gave punk-rock performances all over Moscow between October 2011 and February 2012. The first "unsanctioned tour" of the band took place in Moscow's subway and atop trolley buses to protest against the upcoming and prospectively flawed State Duma elections, the construction of a new highway through the Khimki Forest, and the 2011 anti-abortion law.[8] Singing their then new song "Osvobodi bruschatku" (Release the cobblestones), Pussy Riot members tore apart feather pillows and encouraged their impromptu audience to "spend a wild day among strong women" ("Series of Performances" 2012).

In less than a month, another series of performances, known as the "illegal tour against Putin's glamour," was held at "places of gathering of rich *putinists*" (avid supporters of Putin). Pussy Riot called Russians to boycott the illegitimate 2011 State Duma elections in order to destabilize the political situation in Russia. Singing "Kropotkin Vodka"[9] in luxury boutiques, on the roofs of popular bars, and at a fashion show (where

Pussy Riot members almost set themselves on fire), the band aimed to fight against "passivity, conformity," and "the stultifying chic of Putin's glamour" ("Second Illegal Tour" 2011).

Only two weeks later, on the roof of a garage next to a detention center, Pussy Riot performed at an "illegal concert" for political prisoners—that is, jailed participants of oppositional rallies held in connection with the purportedly fraudulent 2011 State Duma elections. With their song "Smert' tur'me, svobodu protestu" (Death to prison, freedom to protest), Pussy Riot called for the peaceful occupation of city squares and the release of political prisoners ("Illegal Concert" 2011). Then, on January 20, 2012, in what Pussy Riot described as its "breakthrough" event, the band performed the song "Putin zassal" (Putin got scared) at Lobnoye Mesto on the Red Square. The band wanted to show that Putin was afraid of losing his power and to remind Russians of both the politics of total control and the dissident tradition in the former Soviet Union ("Breakthrough" 2012).[10]

Following the concert on Lobnoye Mesto, for which eight members of the band were charged with misdemeanors, Pussy Riot gave its most resonant and controversial performance in Moscow's Cathedral of Christ the Savior. Around eleven o'clock in the morning, a group of five Pussy Riot performers, as well as a film crew, band supporters, and a couple of journalists, entered the cathedral. Dressed in clothes in accordance with the rules of Russian Orthodoxy, they successfully passed a metal detector and a bag search. Shortly afterward, having changed into their usual colorful dresses and neon balaclavas, the performers jumped over a rail onto the pulpit (an elevated place where only clergy are allowed) and started singing, jumping, kneeling, and crossing themselves. The whole performance lasted around fifty seconds before it was interrupted by church security. Pussy Riot managed to sing only one verse and one chorus without backup music, as the band was not able to unpack musical instruments in time. While there was no service in progress at the time, and while nobody was harmed and no property was damaged, the performance clearly disturbed several parishioners, church staff, and clergy.

A music video titled "Virgin Mary, Mother of God, Drive Putin Away" surfaced on YouTube shortly after the performance and allegedly became evidence justifying three Pussy Riot members' arrest. The video was clearly a montage of two different performances: the one at

the Cathedral of Christ the Savior, and the other from three days prior at the Cathedral of the Theophany in Yelokhovo. A sound track was added, and the video was edited in such a way that the whole thing looked like a single organic performance. Nadezhda Tolokonnikova, Maria Alyokhina, and Yekaterina Samutsevich were arrested two weeks later and held in custody from March 2012 until their trial began on July 30, 2012.

The arrested Pussy Riot members were clearly treated as dangerous criminals. They were imprisoned before the trial and zealously guarded by beefed-up security in court: four special forces troops, three guards, a man in plain clothes with a radio, and a Rottweiler. The jailed performers, as one of Pussy Riot's lawyers puts it, were "tortured"—denied decent food and adequate sleep (quoted in Elder 2012b, n.p.). In addition, the accused were not given enough time to prepare for the trial, nor could they talk confidentially with their lawyers. On the first day of the hearing, Judge Marina Syrova prohibited any photo- or video- recording of the proceedings, fearing for the safety of prosecution witnesses. This made the hearing virtually closed. Only once were the defendants allowed to meet with the media, represented by none other than Arkadiy Mamontov, a well-known Russian Orthodox journalist. To top it all off, a Russian Orthodox priest visited one of the women, and when she refused to talk to him, sprinkled her with holy water against her will.

The trial was nothing short of a farce, from the judge's visibly biased attitude toward the defense team, to the prosecution witnesses' statements, to the evaluation of the "punk prayer" by court experts and a blatant exclusion of any politically significant evidence from Pussy Riot's lawyers. While the judge accepted testimonies of only three out of twenty intended defense witnesses, the prosecution brought in as many witnesses as it wanted. Some of them were not even present during Pussy Riot's performance, but "researched" it by Googling "feminism" and watching the edited "punk prayer" music video. The judge dismissed most of the questions Pussy Riot's lawyers asked the prosecution witnesses after the prosecution had criticized the defense for "satirically jeering at the victims"—all those who purportedly suffered emotionally from Pussy Riot's performance, regardless of whether the "victims" saw the "punk prayer" in person or later online (Malover'yan 2012).

The court-ordered "expert witnesses" were even more laughable. The experts—highly biased and incompetent in the spheres of religion, art,

or psychology—based their conclusions on the same music video down-loaded from the Internet ("Pussy Riot Hearing. Day Four" 2012). While the political background of Pussy Riot's performance was ignored, the court and the prosecution were most interested in whether women are allowed to step on the pulpit, what the proper way to cross oneself is, and what clothing one can wear inside the church.

To many Russian and foreign liberal-minded analysts and journalists, the trial was a greater obscenity than the "punk prayer" could ever have been.[11] In her verdict, the judge declared feminism to be a motive of Pussy Riot's "religious hatred": "Being a feminist in the Russian Federation is not . . . a crime. [Yet a] number of religions, including Russian Orthodoxy . . . have a religious-dogmatic foundation incomparable with feminism" (quoted in Zateychuk 2012, n.p.). In addition, Yelena Pavlova, a lawyer for several "victims," declared that feminism "does not corre-spond with reality. Feminism is a mortal sin" (quoted in Elder 2012a, n.p.). Thus, according to the court, feminists are dangerous in that they support ideas of female equality and promote hatred against Russian Orthodox believers. In the eyes of the Orthodox Christian public, the "punk prayer" revealed a large-scale anti-Russian and anti-Orthodox conspiracy that originated in the diabolic West.

The Pussy Riot hearing—a shameful blend of a Soviet show trial and a medieval witch hunt—resulted in a two-year jail term in a Rus-sian prison colony for the three women, who "disparaged the spiritual foundation of the state" and "debased century-long principles . . . of the ROC" ("Day One" 2012; "Twitching" 2012). After an appeal, Samutsev-ich was released on probation as she was held back by the church secu-rity who prevented her from performing on the pulpit with other Pussy Riot members. The other two prosecuted performers, Tolokonnikova and Alyokhina, were released from prison in December 2013, a few months shy of serving their full two-year sentences. The amnesty hap-pened just before the 2014 Winter Olympics in Sochi and was regarded by Pussy Riot as "a sham act," "a PR stunt" pulled by the Kremlin aiming to enhance the image of the country staging a large-scale international event ("If I Could" 2013).

The jailed women refused to admit guilt and explained the political motives for their performance thus: disheartened by the inefficacy of peaceful oppositional protests, the strengthening of the union between

the state and the church, and the overall sexism of Putin's regime, the punk feminists asked for divine help, as the "punk prayer" lyrics had it, "to drive Putin away." They also stated that "it is disturbing . . . how Patriarch Kirill says that Orthodox people do not go to [oppositional] rallies, but instead pray to Virgin Mary, the Mother of God" ("Patriarch Kirill on Protests" 2012), and "it is nauseating how [he] unashamedly campaigns for Putin" ("punk prayer" 2012). For Pussy Riot, Putin is "the face of everything bad, evil, immoral . . . in contemporary Russian [politics]" (Masiuk 2012), and Moscow's Cathedral of Christ the Savior is nothing less than a symbol of the shameful cooperation between the ROC and the state.

Commenting on the "punk prayer," the collective emphasizes that "what happened was art . . . it leads to discussion" (Moiseev 2012). However, the artfulness of the "punk prayer"—particularly in the view of a Russian audience—is dubious. While the West has been broadly supportive of the "punk prayer," Pussy Riot's cathedral performance has revealed a deep rift between the authoritarian, Christian Orthodox and the liberal, pro-Western, secular Russia. Since the Christianization of Kievan Rus' in 988, the idea of Russianness has been inseparable from Orthodox Christianity. Orthodoxy has always served as a consolidating force against foreign invaders or influences, and the church has claimed to be a protector of the "true" Russian spirit. The "punk prayer" has only stirred anew the centuries-old Russian animosity toward the non-Orthodox, "unholy" West.[12] Pussy Riot's performance and overall rhetoric were widely interpreted as anti-Russian, pro-Western actions directed against Russian Orthodoxy and by extension, everything Russian (Frolov 2012).

As Pussy Riot explains, the punk prayer was "an ironic, funny, but also desperate action, it was . . . a heartfelt political cry, but in a totally ironic, funny way" (quoted in Masiuk 2013, n.p.). To counter the ridiculous farce of Putin's "democracy," the Russian punk feminists arranged for the "punk prayer" to coincide with Maslenitsa, a traditional Christian Orthodox festival marking the start of Lent, "a time of *skomoroshetvo* [buffoonery] and the world turned upside-down" (Kuraev 2012). Implicitly referring to Mikhail Bakhtin's subversive and liberating carnivalesque (1984), Pussy Riot members stress they "are buffoons, *skomorokhi*, maybe even, holy fools, [who] mean no harm" ("Pussy Riot

Trial" 2012). Indeed, the grotesque imagery of Pussy Riot's "punk prayer" was in tune with the carnivalesque spirit of Maslenitsa: brightly colors balaclavas were reminiscent of *skomorokhi* hats, while the "punk" chanting and exaggerated genuflecting and crossing challenged the order of a proper religious service.

As some scholars insist (Harold 2004; Klein 1999; Shepard 2004), carnivalesque protest that aims to subvert authority by means of parody, irony, and grotesque behavior, tends to perpetuate instead of erase binaries and can be easily coopted by modern cynical hegemonic regimes. Others argue that the carnivalesque irony, if it is reflexive (Szerszynski 2007) and performed from the position of "agonistic pluralism" (Mouffe 2000), is actually able to "[put] an end to 'bipolar politics'" (Tabako 2007, 48). Expanding the idea of the reflexive, agonistic logic of protest, I want to propose that the success of resistance depends on the ethical goal (tragic/comic) and the format (playful/serious) of a protest action in particular settings.

The grotesque is a precarious resistance tactic as it is of a dual character. The grotesque simultaneously invokes laugher and instills terror, pleases and disgusts. Depending on which element—fearful or frolicsome—prevails, the grotesque, in John Ruskin's terminology (1853), can be sportive or terrible. Though conceived as a funny performance, the "punk prayer" failed to actually be one. Instead, it turned into offputting absurdity, the terrible, or serious, grotesque. Such transformation of the "punk prayer" was bound to happen due to the tragic nature of the performance in contemporary Russia. As I have stressed before, a tragic protest can be both humorous and earnest. Yet, the grotesque "prayer" was too threatening—both due to the selected protest space and the message—for many Russians and the state to see it as an innocent prank.

On the one hand, Pussy Riot enthusiastically advocates a comic ethical position. The Russian feminists stress that a "human being is a creature that is always in error, never perfect" and insist that they "rely on cultural protest," not physical violence (Tolokonnikova 2012). The performers justly believe that a truly comic protest inspires unending, creative readings, "[allowing] people their own transformation" (Kahlo and Kollwitz 2008).

On the other hand, in its interviews and lyrics, Pussy Riot calls for an "angry" revolution ("Breakthrough" 2012) and a "ruthless" riot ("Second Illegal Tour" 2011) as the only way to end the political crisis in Russia. Pussy Riot's protest, as the band puts it, is feminism armed with "brass knuckles" ("Second Illegal Tour" 2011) and "batons" ("Series of Performances" 2011), marching on the Kremlin and "blowing up" windows in the Russian Federal Security Service building ("Breakthrough" 2012). The Russian punk feminists see their political others as enemies who must be sacrificed. In the "punk prayer," for instance, Pussy Riot, asks the Virgin Mary to drive Putin away. In the song "Kropotkin Vodka," the Russian punk feminists want Putin and other "Kremlin bastards" to die from drinking Kropotkin Vodka, a metaphoric revolutionary liquor. Pussy Riot invites Russian women to "become [feminists], to kill the sexist . . . to wash down his blood!" ("Texts of Pussy Riot's Album" 2012). Although Pussy Riot members insist that they "are not going to kill anyone" (Tolokonnikova 2012), their symbolic sacrifice of political enemies is nevertheless a characteristic of a tragic protest.

While the overall rhetoric of Pussy Riot's protest is only partially tragic, Pussy Riot's grotesque "prayer" lost its comic impulse completely. As I explain next, the "punk prayer" relied heavily on the work of the inherently tragic Imaginary—an unambiguous, coherent national narrative offered by Pussy Riot in exchange for Putin's tragic national brand. The extreme directness of Pussy Riot's protest rhetoric—as well as the choice of the performance space and specificity of demands—led to a no less straightforward response from many Russians.

Pussy Riot, as the band explains, chose to perform in the cathedral since it "is not a place of worship, but a place of business" (quoted in "Consider the Beam" 2012, n.p.).[13] Besides, the band insists, playful protests in unsanctioned places scare Putin more than serious resistance of the Russian liberal opposition. Unlike Russia's serious protesters who participate in sanctioned rallies, Pussy Riot refuses to accept the "empty gesture" (Žižek 1997, 27–30) of Putin's sham "democracy." By joining peaceful demonstrations, as Pussy Riot fairly points out, protesters willingly participate in a cynical illusion that "the authorities . . . are ready to listen to them and provide them with public platforms" (quoted in Chernov 2013, n.p.).

The "punk prayer," however, turned out to be even less apt at resisting Putin's tragic national brand than peaceful oppositional demonstrations, which either unintentionally reinforce Putin's cynical "democracy" or are treated by the state as extremism sponsored by Russia's enemies. While the conservative Russian public views serious protests as a nuisance, or skeptically ignores them as baseless and self-interested, Pussy Riot has earned a far more negative reputation. The grotesque "prayer" offended religious feelings of Orthodox Christians, who make up most of the Russian population. At the same time, however, the explosion of public indignation at the "punk prayer" does not demonstrate extreme religiosity of Russian society.[14]

The very selection of the performance venue functioned as a narrative on its own, which would explain why the "punk prayer" hurt many Russians despite the well-known political, not religious, background of the protest. Being an Orthodox Christian is an inalienable part of Russian national identity, and for many, the cathedral is a metonymic expression of the national self, rather than the ROC. The grotesque singing and dancing in the church thus triggered in Russians a strong and expected emotional reaction—after all, inappropriate behavior in a church is unlikely to invite a favorable response. While Pussy Riot intended to attack the allegedly ungodly religious institution and Putin's authoritarian power, many Orthodox Christians saw the performers vandalizing their national fantasy-frame. At the instigation of Patriarch Kirill and encouraged by the state, public resentment turned into aggression and calls for revenge. The "outraged Russian Orthodox public" ("Russians on the Pussy Riot" 2012) insisted on the criminal prosecution of the Russian punk feminists. The choice of the performance venue thus afforded both the church and the state with an excellent opportunity to deafen the voice of the protest by turning the performers into the enemies of many uneducated and conservative Russians. In other words, a specific rationale behind the "prayer" as a form of Pussy Riot's protest lost out to an even more straightforward and easily acceptable narrative suggested by the authorities.

In addition to what the Russian punk feminists admitted was the ethically problematic choice of the performance venue, the specific protest message of the "prayer"—which, according to the band, makes its anti-Putin protest "more substantial and persuasive" (quoted in "Why"

2012, n.p.)—has not been helpful either. In the song performed in the cathedral, the Russian feminists "prayed" to Virgin Mary to help "change something in our soulless country." Pussy Riot asked divine power to rid Russia of the country's biggest villain, Putin—ironically referred to as Russia's "chief saint," "His Holiness"—and his lackey Patriarch Kirill, who, according to the band, believes in Putin rather than God. While Russians are worried by the questionable rapprochement of the Russian State and the ROC, the anti-Putin protest message did not find many supporters. The majority of Russians support and pin their hopes on Putin, albeit primarily in the absence of any viable alternatives.

Conceived mainly as a protest against Putin and the open support for the country's authoritative leader by the church, the "punk prayer" also touched upon the problems of freedom of speech ("the phantom of freedom is in heaven"; "The head of the KGB . . . leads protesters to jail"), corruption on many levels ("The sacred procession of black limos, / A preacher is your teacher, / Go to class, bring him money!"), sexism ("not to offend His Holiness women must give birth and love"), and homophobia ("Gay pride is sent to Siberia in irons"). These directly confrontational lyrics threatened the hopes and values of conservative Russians and hindered the subversive potential of the "punk prayer." For comic protesters to succeed, they do not have to convince the targeted audience of certain propositions. Instead of interpellating conservative Russians into a specific national story, that is, the Imaginary, Pussy Riot needed to engage the Symbolic. In other words, rather than offering its audience the already developed particular national narrative, the band should have generated a flow of unfinished multiple discourses, which secular or religious authorities would not see as dangerous, the state-sponsored media could not interpret in predictable ways, and the mainstream public could not reject. A good example of such performance of the Symbolic in Russia is a mock demonstration that takes place in various Russian cities on May 1. Participants in this so-called *monstration* dress in odd costumes and carry posters with apolitical and absurd slogans, thus playfully protesting the absence of space for civic action in the country. However, protests that invite predictable responses from the state (including state-sponsored media) are more likely to alienate a cynical and passive civil society and to promote yet another "true" national narrative.

As Lacan (1975) points out, conscious narratives nourished in the Imaginary always aim at maximum coherence, and thus lack psycho-analytic, or liberatory power. In contrast, comically driven playful resistance as a kind of psychoanalytic practice operates on the level of the Symbolic. It aims at revealing the stupidity of signifiers, at showing that behind its appeasing coherence the national self is rhetorical, made of originally meaningless signifiers.[15] The goal of a comic protest must be to strip the national image of any meaning, thus showing it for what it is: irremediable lack and perpetual desire to recover this lack by any means possible. The realization of the fundamental lack of the national self is certainly unsettling. But it is also pleasing in a sense that, as Åsa Wettergren (2009) notes, it sets the national subject free from unreflective desire to be something else, something that the self is not.

People, however, cannot but live within particular national fantasies; they cannot but rely on the Imaginary. While enjoying comparatively healthy (comic) national narratives, we must still be constantly aware of the rhetorical fallibility characteristic of the process of national identity construction. Culture jammers, like psychoanalysts, seek to prompt the national subject to realize the ultimate incompleteness of the national self and the danger of the fundamental urge to constitute the national image at the expense of the national other. Additionally, psychoanalysis in its traditional and social forms educates national subjects "to take responsibility [for the way national subjects enjoy themselves] in the face of the contingency of all action" (Wettergren 2009, 7).

By adopting satire, comedy, or the burlesque, culture jammers as "[analytic] practitioners of the symbolic function" (Lacan 2006, 235) attempt to "[suspend] the subject's certainties" expressed in the Imaginary (209). This can be achieved by destabilizing master signifiers defining the "essence" of national identity. Which fantasy frame possesses greater destabilizing potential depends on the political situation and historic circumstances in a particular society. Satire and comedy are more readable than the burlesque and likely to succeed in a mildly tragic political regime with a comparatively active civil society, which is susceptible to alternative national visions. In a more tragic state, especially one that meets playful resistance with a cynical sneer and is largely supported by the conservative public, as is the case in modern Russia, a more elegant tactic is required. By deploying the comic burlesque as the ultimate "perspective by incongruity," the

merry prankster attempts to render privileged signifiers unintelligible or stupid, thus allowing chains of signifiers to unpredictably unfold and mutate. In other words, the burlesque disturbs previously established meanings, or the Imaginary, exposing the very Symbolic meaninglessness that is foundational of any identity. The burlesque, however, risks being too obscure to produce the necessary effect.

Pussy Riot's protest would have been more successful had the Russian feminists engaged in the comically driven burlesque, rather than in the serious tragically marked grotesque resistance. Although the grotesque and burlesque both rely heavily on parody and caricature, the grotesque takes exaggeration and incompatibility of elements to the extreme. In other words, in its humorous form, the grotesque overlaps with the burlesque. However, if taken too far, the grotesque loses its capacity to evoke laughter, thereby fully embracing its terrifying side. In the case of the "punk prayer," the nature of the protest space and the message proved to be too excessive to remain a humorous and ambiguous play (which is executed well in burlesque performances). Pussy Riot failed to channel its anger with Putin's growing authoritarianism into an innocently "'foolish' protest . . . that [is] difficult for the opponents to define and strike against" (Wettergren 2009). An originally comic spectacle that the Russian feminists hoped to put on in a playful fashion turned, in practice, into a somber, tragically marked grotesque.

In theory, Pussy Riot is in tune with the ethics of culture jamming protest. Echoing Lacan's remarks on the irony of revolution, Pussy Riot emphasizes that no new leader (or in Lacanian terms, "master") can ever provide a perfect solution.[16] Yet in practice, the band promotes certain symbolic positions from which its alternative national image is supposed to look "better" than Putin's tragic national brand. Both Pussy Riot and the Russian liberal opposition invite the Russians to embrace the master signifier of Western liberal democracy—the signifier that reassembles Russia's national narrative into another coherent story about the national self and national others. In other words, in exchange for Putin's version of "Russianness," the opposition simply offers Russians an alternative image of the "true" Russian path. In light of their traditional distrust of the elite, the catastrophic liberal reforms of the 1990s, and their longstanding paranoid suspicion of the West, Russians, however naively or cynically, prefer Putin's master signifier of Russian "democracy."

Toward a Comic Burlesque

Two months after the "punk prayer," ten thousand (or, according to some sources, nearly seven thousand) Orthodox Christians gathered at the Cathedral of Christ the Savior to pray together with Patriarch Kirill "in support of faith, desecrated holy places and relics, the Church and its good name" ("Patriarch's Speech" 2012). As a reply to Pussy Riot's performance in the church in particular and to "aggressive liberalism" ("ROC Will Call" 2012) in general, the mass prayer became a telling event. The ROC avowed its determination to stand up to all those who allegedly hope to arrest "the strengthening of Orthodoxy, the revival of [Russian] national identity, and the people's initiative" ("Address" 2012). Led by the church and encouraged by the state, many Russians blazed up with overwhelming animosity and aggression. Instead of inspiring the Russian public to resist the creeping authoritative power of the state, the "punk prayer" revealed the deep-seated tragedy of Russian national identity—a need to hate the national other in order to shore up the national self.

As I have shown, Pussy Riot's "punk prayer" failed to be comic. Built on the straightforward anti-Putin narrative, the grotesque performance in the cathedral was easily turned into allegedly extremist rhetoric by the church and failed to compete with Putin's national brand—an image far more attractive to conservative Russians. Had the band chosen the comic burlesque—a more subtle and ambiguous protest form—the feminist punk collective would have stood a better chance of countering Putin's tragic national brand and mobilizing passive and cynical Russians. The burlesque as the fantasy frame of radical ambiguity is more capable of inviting a wide range of unexpected interpretations and reactions. By relying on the burlesque, the protester maintains a delicate balance between a protest message obscure enough to seem "harmless" to the state, on the one hand, and a protest message sufficiently suggestive to initiate renegotiation of a tragic national narrative, on the other. The burlesque deals extensively with incongruity and encourages a wide range of interpretations.

How exactly Pussy Riot might have staged a burlesque performance is perhaps a topic for another essay. The very essence of punk as an aggressive and loud antiestablishment spirit, however, is antithetical to the tactical obscurity of the comic burlesque. For instance, there

is nothing subtle about the band's "straightforward, clear and brutal" rhetoric (quoted in "Y. Shevchuk" 2012) and its performances held in unsanctioned, often highly controversial places. Considering the historical, cultural, and political context of protest action in modern Russia, the burlesque spectacle is more artful, more apt at "creative subjectivity" (Lacan 2006, 234) than other comically driven humorous fantasy-frames. The comic burlesque mildly shocks the dominant system and provokes diverse and surprising reactions. Whether Pussy Riot can revise its openly antagonistic politics in light of the scandalous "punk prayer" and adapt the aesthetic of punk protest to the modern Russian conditions remains to be seen.

NOTES

1 Unless indicated otherwise, all translations of words, titles, and citations from sources in Russian are mine.

2 Simply put, Lacan's theory of the subject is built on the principle that there is lack, or imperfection, at the center of any identity. This inherent otherness, or incompleteness of the self, arises from the fact that the subject and its social world are constructed rhetorically, along the imaginary and the symbolic dimensions. Signifiers, or elements that make up the Symbolic, are meaningless, or stupid, in isolation. To make sense, or to produce a mental image, signifiers have to be placed in certain relations to one another. In other words, the Imaginary is a consciously accessible meaning, or product, of the unconscious play of signifiers. From this very brief introduction of Lacan's Symbolic and Imaginary, one can glean that the latter, which is supposed to make sense to the speaking subject, emphasizes harmony and coherence, while the former is the sphere of incongruity and the originary uncertainty of meaning

3 For an in-depth discussion of Lacan's theory of subjectivity, see Fink (1995).

4 I follow Camille Lewis (2007), who supplements Burke's notion of the comic with Chantal Mouffe's idea of the essential agonism of the political. Mouffe's (2005) notion of "a vibrant 'agonistic' public sphere of contestation" (3) complements Lacan's thesis that the subject comes to enjoy an (illusory) image of the self only in a necessary proximity to the other (be it another human being or a social system and language one is born into).

5 See, for example, the reports on the misuse of anti-extremist legislation in Russia compiled by the Sova Center for Information and Analysis at sova-center.ru.

6 One of the largest scale oppositional rallies in the last two decades took place in May 2012. What was planned as a peaceful demonstration quickly transformed into a violent clash between the protesters and the police. More than twenty of the protesters have faced up to eight years in prison if found guilty of inciting mass

riots, and up to five years if found guilty of violence against the police ("At the Bandbox" 2012).

7 See Pussy Riot's official blog at www.pussy-riot.livejournal.com.

8 What began as an environmental action to protest the construction of a new highway through the Khimki Forest later morphed into an antigovernment revolt. Khimki forest became a metaphor for the country's suffering under Putin's repressive and lawless regime. See "Russian Government" (2010).

9 The song "Kropotkin Vodka" is titled after Pyotr Kropotkin, a Russian philosopher and anarchist of the end of the nineteenth century and the beginning of the twentieth. In the song, for Putin and his supporters Kropotkin vodka is deadly liquor.

10 Lobnoye Mesto has a long and rich history and symbolic meaning. It is an ancient execution place in front of St. Basil's Cathedral. It is viewed as a symbol of the state authority and also associated with antiestablishment protests in Soviet and post-Soviet times.

11 In his evaluation of the "punk prayer," Slavoj Žižek (2012) said: "What is a modest Pussy Riot obscene provocation in a church compared to the accusation against Pussy Riot, this gigantic obscene provocation of the state apparatus which mocks any motion of decent law and order?"(n.p.)

12 The Time of Troubles—a period of dynastic confusion, foreign invasions, and partial disintegration of the Russian state in the seventeenth century—is one of the most striking examples of Russia's political and religious confrontation with the West. This traumatic period in Russia's history left the ROC extremely conservative and the Russians suspicious of the West.

13 In the Cathedral of Christ the Savior "the [pro-Kremlin] United Russia party holds its conventions, meets with churchmen, discusses plans to turn Russia into a patriarchic slave state without any elements of democracy and emancipation," note the Russian punk feminists (Dobrokhotov 2012, n.p.).

14 While between 70 and 80 percent of Russians identify themselves as Orthodox Christians, the strictly observant people comprise less than 10 percent; see "There Are" (2012).

15 On stupidity of signifiers, see Lacan (1975, 11–21).

16 When Lacan was confronted by the student revolutionaries, he famously replied: "You demand a new master. You will get it!" (quoted in Forter and Miller 2008, 83). Pussy Riot expresses a similar skeptical attitude toward a new form of domination by insisting that "we do not have illusions that some guy will come and fix everything" (quoted. in Turovsky 2012, n.p.).

REFERENCES

"An Address of Supreme Church Council of the Russian Orthodox Church." 2012. Russian Orthodox Church, April 3. www.patriarchia.ru.

"At the Bandbox." 2012. Rambler Media Group, May 7. www.lenta.ru.

Bakhtin, Mikhail M. 1984. *Rabelais and His World*. Bloomington: Indiana University Press.

"The Breakthrough and Arrest of Pussy Riot at *Lobnoye Mesto*, the Red Square with the Song 'Putin Zassal.'" 2012. *LiveJournal*, January 20. www.pussy-riot.livejournal.com.

Burke, Kenneth. (1934) 1984. *Attitudes toward History*. Berkley: University of California Press.

———. 2003. *On Human Nature: A Gathering while Everything Flows, 1967–1984*. Berkeley: University of California Press.

Chernov, Sergey. 2013. "Female Fury." *St. Petersburg Times*, June 20. www.sptimes.ru.

"Consider the Beam that Is in Your Own Eye." 2012. *Pussy Riot LiveJournal Blog*, February 23. www.pussy-riot.livejournal.com.

Cooper, Ashton. 2010. "Guerrilla Girls Speak on Social Injustice, Radical Art." *Columbia Spectator*, September 22. www.columbiaspectator.com.

"Day One of Pussy Riot Hearing. Court Video." 2012. Russian Legal Information Agency, July 30. www.rapsinews.ru.

"Direct Line with Vladimir Putin." 2013. Kremlin, April 25. news.kremlin.ru.

Dobrokhotov, Roman. 2012. "Pussy Riot Interview on the Day of the Performance: 'The Church Merged with the State.'" Slon.ru, August 18. www.slon.ru.

Elder, Miriam. 2012a. "Pussy Riot Trial: Prosecutors Call for Three-Year Jail Term." *Guardian*, August 7. www.guardian.co.uk.

———. 2012b. "Pussy Riot Trial 'Worse than Soviet Era.'" *Guardian*, August 3. www.guardian.co.uk.

Fink, Bruce. 1995. *The Lacanian Subject: Between Language and Jouissance*. Princeton, NJ: Princeton University Press.

Forter, Greg, and Paul Allen Miller. 2008. *Desire of the Analysts: Psychoanalysis and Cultural Criticism*. Albany: State University of New York Press.

Frolov, Kirill. 2012. "Statement of the Highest Church Council of the Russian Orthodox Church." *Revizor*, April 10. www.revizor.ua.

Gilbert, Laurel, and Crystal Kile. 1996. *Surfergrrrls: Look Ethel! An Internet Guide for Us!* Berkeley, CA: Seal Press.

Glazko, Lidiya. 2011. "Interview with Pussy Riot." *PublicPost*, November 18. www.publicpost.ru.

Harold, Christine. 2004. "Pranking Rhetoric: 'Culture Jamming' as Media Activism." *Critical Studies in Media Communication* 21 (3): 189–211.

"'If I Could I Would Have Refused Putin's Mercy': Maria Alyokhina's Interview for Dozhd Right after the Release." 2013. *Dozhd*, December 23. www.tvrain.ru.

"An Illegal Concert of the Pussy Riot Band on the Roof of the Detention Center." 2011. *LiveJournal*, December 14. www.pussy-riot.livejournal.com.

"Interview with Pussy Riot." 2012. *LiveJournal*, January 6. www.livejournal.ru.

Jansen, Sue Curry. 2008. "Designer Nations: Neo-Liberal Nation Branding Brand Estonia." *Social Identities* 14 (1): 121–42.

Kahlo, Frida, and Kathe Kollwitz. 2008. "Oral History Interview with Guerrilla Girls." *Archives of American Art*, January 19–March 9. www.aaa.si.edu.

Klein, Naomi. 1999. *No Logo: Taking Aim at the Brand Bullies*. Toronto: Knopf.

Kuraev, Andrei. 2012. "*Maslenitsa* Festival in the Cathedral of Christ the Savior." *Diak Kuraev LiveJournal Blog*, February 21. www.diak-kuraev.livejournal.com.

Lacan, Jacques. 1975. *The Seminar, Book XX: On Feminine Sexuality. The Limits of Love and Knowledge, 1972–1973*. Translated by Bruce Fink and edited by Jacques-Alain Miller. New York: Norton.

———. 1992. *The Seminar, Book VII: The Ethics of Psychoanalysis, 1959–1960*. Translated by Dennis Porter and edited by Jacques-Alain Miller. London: Routledge.

———. 2006. *Écrits: The First Complete Edition in English*. Translated by Bruce Fink. New York: Norton.

Langston, Henry. 2012. "Meeting Pussy Riot." *Vice*. www.vice.com.

Lewis, Camille Kaminski. 2007. "Imagining Tragedy, Comedy, and Romance." In *Romancing the Difference: Kenneth Burke, Bob Jones University, and the Rhetoric of Religious Fundamentalism*, 1–12. Waco, TX: Baylor University Press.

Malover'yan, Yuri. 2012. "'Absentee' Witnesses Testified at Pussy Riot's Hearing." *BBC Russia*, August 1. www.bbc.co.uk.

Masiuk, Yelena. 2012. "Nadezhda Tolokonnikova (Pussy Riot): 'We Are Political Prisoners, No Doubt.'" Novayagazeta.ru, August 1. www.novayagazeta.ru.

———. 2013. "Two Years Correction Facility for Pussy Riot." Novayagazeta.ru, January 22. www.novayagazeta.ru.

Moiseev, Vladislav. 2012. "Feminist Riot." *Russkiy Reporter*, February 24. www.rusrep.ru.

Mouffe, Chantal. 2000. *The Democratic Paradox*. London: Verso.

———. 2005. *On the Political*. London: Routledge.

Olins, Wally. 2003. *On Brand*. New York: Thames and Hudson.

"Patriarch Kirill on Protests." 2012. Gazeta.ru, February 1. www.gazeta.ru.

"Patriarch's Speech at the Prayer in Support of Faith." 2012. *Orthodox Christianity and the World*, April 22. www.pravmir.ru.

"The Punk Prayer 'Virgin Mary, Mother of God, Drive Putin Away' in the Cathedral of Christ the Savior." *LiveJournal*, February 21. www.pussy-riot.livejournal.com.

"Pussy Riot Found Guilty of Hooliganism." 2012. *Guardian*, August 17. www.guardian.co.uk.

"Pussy Riot Hearing. Day Four. Online." 2012. Russian Legal Information Agency, August 2. www.rapsinews.ru.

"Pussy Riot Trial: The Debates Are Over." 2012. Newsru.com, August 7. www.newsru.com.

"Putin: 'Our Imperial Image Scares Our Neighbors.'" 2011. Liga.net, December 16. www.smi.liga.net.

Putin, Vladimir. 2012a. "Meeting with Ambassadors and Permanent Representatives of Russia." Kremlin, July 9. www.kremlin.ru.

———. 2012b. "President's Address to the Federal Assembly." Kremlin, December 12. www.kremlin.ru.

"The ROC Will Call a War on 'Aggressive Liberalism.'" 2012. Rambler Media Group, April 8. www.lenta.ru.

Rumens, Carol. 2012. "Pussy Riot's Punk Prayer Is Pure Protest Poetry." *Guardian*, August 20. www.guardian.co.uk.

Ruskin, John. 1853. "Grotesque Renaissance." In *The Stones of Venice*, 3:112–65. London: Smith, Elder. Google e-book.

"Russia." 2012. Freedom House. www.freedomhouse.org.

"Russian Government OKs Controversial Highway through Khimki Forest." 2010. *Radio Free Europe Radio Liberty*, December 14. www.rferl.org.

"Russians on the Pussy Riot Case." 2012. Levada Center, July 31. www.levada.ru.

Schechter, Joel. 1994. *Satiric Impersonations: From Aristophanes to the Guerrilla Girls*. Carbondale: Southern Illinois University Press.

"Second Illegal Tour of Pussy Riot with Fire and Occupation." 2011. *Pussy Riot Live-Journal Blog*, December 1. www.pussy-riot.livejournal.com.

"A Series of Performances of the Feminist Punk Band Pussy Riot in Moscow." 2011. *Pussy Riot LiveJournal Blog*, November 7. www.pussy-riot.livejournal.com.

Shepard, Benjamin. 2004. "A Post-Absurd, Post-Camp Activist Moment: Turning NYC into a Patriot Act Zone." *CounterPunch*, February 5. www.counterpunch.org.

Shishova, Tatyana. 2012. "Interview with Larisa Pavlova, the Lawyer Representing Three Victims of Pussy Riot." *Banned Art*, July 29. www.artprotest.org.

"Sobchak and Sokolova: Yekaterina Samutsevich. Unpacked." 2012. Snob.ru, October 12. www.snob.ru.

Tabako, Tomasz. 2007. "Irony as a Pro-Democracy Trope: Europe's Last Comic Revolution." *Controversia* 5 (2): 23–53.

"Texts of Pussy Riot's Album 'Kill the Sexist.'" 2012. *Kain_Ne_Avel LiveJournal Blog*, August 23. www.kain-ne-avel.livejournal.com.

"There Are 74% of Orthodox Christians and 7% of Muslims in Russia." 2012. Levada Center, December 17. www.levada.ru.

Tolokonnikova, Nadezhda. 2012. "Pussy Riot Closing Statements." Translated by Maria Corrigan and Elena Glazov-Corrigan. *N+1*, August 13. www.nplusonemag.com.

Turovsky, Daniil. 2012. "'What Are You Doing, Girls?' Pussy Riot on the Fight against the Regime and Love for Pussies." Afisha.ru, January 24. www.gorod.afisha.ru.

"Twitching in Court." 2012. Rambler Media Group, August 7. www.lenta.ru.

"Unknown Putin." 2012. YouTube video posted by "ntvru," October 7. www.youtube.com.

Volcic, Zala, and Mark Andrejevic. 2011. "Nation Branding in the Era of Commercial Nationalism." *International Journal of Communication* 5:598–618.

Wettergren, Åsa. 2009. "Fun and Laughter: Culture Jamming and the Emotional Regime of Late Capitalism. " *Social Movement Studies* 8 (1): 1–17.

"Why Did They Let Yekaterina Samutsevich Go?" 2012. Colta.ru, October 10. www.colta.ru.

"Witness Translated the Name of Pussy Riot in Court." 2012. *Newsland*, August 1. www.newsland.ru.

"Y. Shevchuk on the Church, Pussy Riot and the song Putin Zassal." 2012. *Caseof-pussyriot LiveJournal Blog*, March 11. www.caseofpussyriot.livejournal.com.

Zagvozdina, Darya. 2012 "We Came to the Street to Fight." Gazeta.ru, February 27. www.gazeta.ru.

———. 2013. "The Public Pressured the Court." Gazeta.ru, September 12. www.gazeta.ru.

Zateychuk, Marina. 2012. "Pussy Riot Verdict." Slon.ru, August 22. www.slon.ru.

Žižek, Slavoj. 1997. *The Plague of Fantasies*. London: Verso.

———. 2012. "The True Blasphemy." *Dangerous Minds*, October 8. www.dangerous-minds.net.

Culture Jammers' Studio

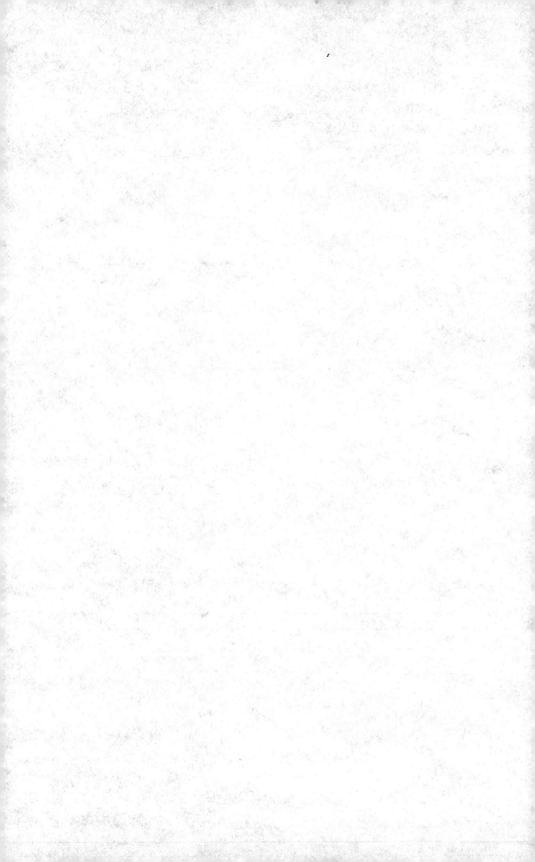

17

The Day I Killed Freedom of Expression

KEMBREW MCLEOD

I have a confession to make. On October 16, 2004, I killed freedom of expression. This wasn't murder—it was more like involuntary manslaughter, a death caused by negligence. Just to be clear, I'm not speaking in metaphors. According to the US government, freedom of expression is officially dead: so says the US Patent and Trademark Office (USPTO).

What, exactly, does the USPTO have to do with freedom of expression? On January 6, 1998, this government agency, which decides what can be patented and trademarked, granted me ownership of the phrase "freedom of expression." This trademark was assigned its own serial number (#2127381), and it was approved the same year Fox News became the steward of another iconic phrase: "fair and balanced" (#2213427).

Today, the oddly named "Live/Dead Indicator" on the USPTO's website announces that my trademark is "DEAD" (the word is unambiguously spelled entirely in caps, no less). How does one kill a trademark? Before I answer that question, I should explain why I trademarked freedom of expression in the first place, why I brought it to life as an intellectual property. It was a joke, a prank, though a very serious one.

Over the years I have witnessed the insidious ways our overreaching copyright clearance culture creates unnecessary obstacles for teachers, researchers, artists, and other creators. This is something I have written about in my book *Freedom of Expression®: Resistance and Repression in the Age of Intellectual Property*. The book's second chapter also shares its title with a documentary I co-produced, *Copyright Criminals*, which aired on PBS's Independent Lens series in 2010.

It was this sort of thing that compelled me to trademark Freedom of Expression® over ten years ago. When I submitted my application, it was a kind of dare. Even though I obviously hoped that freedom of expression could not be privatized, the bureaucracy that processed my applica-

tion believed otherwise. At first the USPTO informed me that parts of my application were "not acceptable"—but not because the thought of cordoning off "freedom of expression" was troubling.

No one at the USPTO seemed to be morally, socially, or politically unsettled by this notion. Instead, a civil servant lawyer explained to me that it was unacceptable because I had filled out the application incorrectly: "the mark is not typed entirely in capital letters." The USPTO seems to love capitalization.

Six months after dutifully filing yet another piece of paperwork, I received a certificate in the mail informing me that I owned FREEDOM OF EXPRESSION. To be clear, this did not mean that I could regulate the use of freedom of expression in all contexts, because my trademark covered only certain areas (it fell within Class 16 on the "International Schedule of Goods and Services," which covers, in short, printed matter). However, it did give me a monopoly over the phrase in certain contexts, which was funny enough for me, in a black humor kind of way.

If, for instance, the American Civil Liberties Union (ACLU) decided to publish a magazine titled *Freedom of Expression*, I could have conceivably blocked its distribution with a court injunction. I never did sue anyone, certainly not the ACLU, for flagrantly using freedom of expression without permission, though there were a couple instances when I strategically targeted an "infringer" with a Cease and Desist letter.

In 2003, I paid an attorney to go after AT&T when the telecommunications giant used the phrase—*without my consent!*—in a newspaper advertisement. The *New York Times* broke my silly story in an article that began with the sentence, "Freedom of Expression, it turns out, may not be for everyone." Although AT&T refused to respond formally to the Cease and Desist letter, I made my point. The news media became my megaphone, and the story has since spread virally, especially on the Internet. I suspect the story was so popular because it contained such a glaring, absurd internal contradiction. The sentence "Did you hear about the guy who trademarked freedom of expression?" performs my critique about the privatization of culture with little verbiage.

You may be wondering, how exactly did I *kill* Freedom of Expression®? In order to keep a trademark registration alive, the USPTO states that during the fifth year of a trademark's life, the owner must file more

paperwork. "Failure to file the Section 8 Declaration," the guidelines state, "results in the cancellation of the registration." Or, to use that jarring, capitalized legal-bureaucratic term, it is DEAD.

I forgot to do so, which resulted in the death of my beloved trademark. I had always planned, in concluding my little performance art piece, to faux-magnanimously return freedom of expression to the public domain, but I didn't think this would occur involuntarily. Nor did I imagine its passing would go undetected by me for such a long time. No fanfare, not even a form letter stating, "Dear Mr. McLeod, we regret to inform you that your right to freedom of expression has been terminated."

Now I must live with the fact that I'm no Swiftian satirist, or even just a prankster with a good idea. Rather, I'm the incompetent jerk who carelessly let freedom of expression die.

Freedom of Expression®

R. I. P.

January 6, 1998–October 16, 2004

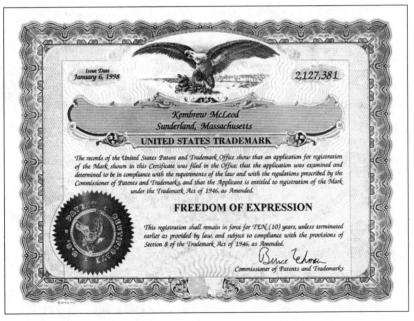

Figure 17.1. Certificate of ownership of FREEDOM OF EXPRESSION.

INTERVIEW WITH THE ROBO-PRANKSTER-PROF, KEMBREW
MCLEOD

MARILYN DELAURE. How did you first get involved in pranking and culture jamming?

KEMBREW MCLEOD. I think it was partially rooted in my personality, which was influenced a bit by my parents. I remember I had a really sick sense of humor, and when I was eleven or twelve, I would make it a game to hide my little *Sesame Street* Ernie doll in places like a cabinet with a knife stuck through it—or hanging from the shower head. Fortunately, my parents had a good enough sense of humor, and it was a pre-Columbine massacre era, so they didn't medicate me. And then in high school, I was a theater kid. My pranking side was further encouraged by friends in my theater troupe in Virginia Beach, Virginia. For instance, one of my theater friends was disabled, and she had to walk on crutches, so we would do these street or mall theater kind of events where we would follow behind her and say really outrageous things. Not mean things, but still really outrageous things about her disability. And of course she was fully in on it, and she had a good sense of humor, so we wanted to see how other people would react when they saw what we were doing.

Moving on to college, I guess I can say I had an education in pranks at James Madison University. I came across a group of friends much like my friends in high school who had similar sensibilities, and who also had this impulse to provoke people in public situations in order to see their responses. For a class project, I did my first big prank, which was a campaign to change the school's mascot—which was a bulldog in a purple crown and cape—to something really ridiculous and silly: a pink three-eyed pig with antlers. This prank was directly inspired by a couple of political events happening around the same time. One was a Supreme Court ruling that asserted it was a First Amendment right to burn American flags. And in 1991, we invaded Iraq for the first time, and there were many American flags around campus at that time. It was very jingoistic. So the school mascot prank was inspired by my curiosity about what happens when you threaten a symbol that people are so invested in, like a flag or, in this case, the holy school mascot. I thought that maybe some people might get bent out of shape, but I had no idea that it would get as out

of hand as it did. I still remember the school paper at the height of the "Duke Dog Controversy," which ran it as the lead story *above* a story that read, "Tragedy at Gunpoint: Find Out How a Former Grad Dealt with Being Shot." That was the first time I realized how easy it is to manipulate media. I was an undergraduate sociology major who had no practical experience in the world of media, and no PR background or anything, but this story made the front page of regional papers, and ABC and NBC local news affiliates covered our protest. The joke was that, in order to show how serious we were about changing the mascot, dozens of us married ourselves to bananas in a mass wedding ceremony. We planted many clues to indicate that it was a prank, but a lot of people took it seriously, and it became a scandal on campus. And that news coverage eventually ended up on CNN as part of a larger story about controversies in the 1990s around racist mascots like the Braves, the Indians, and the Redskins. CNN somehow found a way to integrate the three-eyed pig with antlers into the story, which completely torpedoed the gravity of that news story. So I realized if *I* could create these ripple effects, and I had very little experience with media, imagine what companies and hired PR firms do on a daily basis with a lot more money and expertise at their disposal. That was a really eye-opener: after that, I looked at media and culture differently.

MARILYN DELAURE. Tell me about your best culture jamming intervention.

KEMBREW MCLEOD. I think the best one was my "freedom of expression" prank. In 1997, when I was a graduate student, I applied to trademark "freedom of expression" through the US Patent and Trademark office. I was worried that the USPTO was going to see through it as obviously a joke, or they might just find it appalling that someone would want to trademark "freedom of expression." But the only problem that bureaucrats who received my application had with it was that I didn't write "FREEDOM OF EXPRESSION" in all capital letters in the application. So I resubmitted the application, and they gave me "freedom of expression." A few years later, though, my trademark died because I didn't file a "Section 8 form" which, if you grew up watching *M*A*S*H*, you would know is a term for someone who is crazy—so it was beautiful.

MARILYN DELAURE. Nice irony.

KEMBREW MCLEOD. Yeah, sometimes I am really bad with paper-
work, so I forgot to file it five years into the trademark's lifetime. A
colleague of mine, Ted Striphas, was researching online one day, and
he noticed that my trademark had been canceled. And the legal term
for that is it is "dead." So there is an actual government website that
says, "Freedom of expression is dead."

MARILYN DELAURE. I'm curious—now that they killed it, could some-
one else trademark it?

KEMBREW MCLEOD. Yes someone could. It's public domain, but some-
one could recapture it.

MARILYN DELAURE. Don't tell Fox News that.

KEMBREW MCLEOD. Yeah, exactly. The reason I think it was so suc-
cessful is because a good prank is like a meme that self-replicates. I
threatened to sue AT&T over using "freedom of expression" without
my permission in an advertisement that they ran in 2003. That brief
story does a lot of cultural and intellectual work, because it gets peo-
ple thinking about what it means to live in an age where something
like "freedom of expression" can be privately owned and regulated.
And I also think that a lot of successful pranks and culture jamming
interventions have a storytelling component. The ones that are most
successful are the ones that capture people's imaginations, and either
inspire someone to do their own stunt or tell someone else about, for
instance, the fact that someone trademarked "freedom of expression."

MARILYN DELAURE. What was your least successful jam?

KEMBREW MCLEOD. I think my least successful prank, but prob-
ably my most notorious one, was when Bill Clinton came to stump
for Hillary Clinton when she was campaigning for the Democratic
nomination in 2007. (This was when she was the front-runner, before
Obama's victory in the 2008 Iowa Caucuses.) So I decided to inter-
rupt Clinton's speech dressed as robot demanding that he apologize
to Sister Souljah. Sister Souljah was a young black activist. She is now
a writer, a successful novelist. But at the time she was a black activist
associated with the hip-hop group Public Enemy. In 1992, she had
been asked by a reporter in the wake of the Los Angeles riots about
why the truck driver, Reginald Denny, got dragged from his truck
and beaten by the mob. She replied with a long, thoughtful analysis

that included her critique of Los Angeles city officials and the mayor, noting that black people have been killing black people on the streets on a daily basis and government officials didn't do anything about it. And there is one full quote that Bill Clinton took out of context where she said, "If black people are killing black people every day, why not kill a white person?" But that was like the money shot, the money quote that Bill Clinton used to attack her at Jesse Jackson's gathering of the Rainbow Coalition in 1992. And it was a clear strategic move to position himself to the right of the perceived position of the Democratic Party, so he would be successful in a larger national campaign. Well, that incident always bothered me. In some ways I saw Bill Clinton's actions as a prank, as I define it—a public intervention or provocation that's meant to stir debate or convince someone of a particular position. So he used deception much like a lot of pranksters, but this was much more of what I would call an "evil prank," a prank that was intellectually dishonest.

What became known as "the Sister Souljah moment" had bothered me for many years, and so when I heard that Bill Clinton was speaking on the University of Iowa campus just a block away from my office, I had the idea to dress as a robot. The reason I wanted to dress as a robot and critique him for the Sister Souljah moment was because I didn't want to be like a screechy screaming chest-beating activist. I don't like the kind of aggressive activism, which can be really macho and reify particular gendered normative behaviors. I thought it'd be more interesting and funny if I dressed as a robot. (*The Des Moines Register* coined "Roboprofessor," which I've continued to use because I just love that term.) The night of the Clinton prank, I set up a website that explained why I did it, and I had little explanatory fliers that I threw up in the air so that journalists would catch them. But what I found was that by picking such an obscure topic—something that most people didn't remember, or at least *misremembered*—it required way too much backstory to be effective in getting my point across. What ended up happening in a lot of news reports was a further distortion of the original incident. CNN's anchor actually said, "Sistah Souljah was a young black activist who called for a 'kill white people week,' which Bill Clinton called racist." And that's an exact quote. It would've taken a CNN intern with ac-

cess to Google thirty seconds to debunk that statement. So with the Clinton prank, I feel like I did more harm than good in some ways.

Four years later, when another presidential candidate, Michelle Bachman, came to town, I was very cognizant of the fact that my message about Sister Souljah and Bill Clinton was lost in translation. Effective pranks need to be clear in some way; even if they're evoking confusion and chaos at some moments, the message needs to be clear. So I called out Michelle Bachman on her homophobia, and dressed as a robot and outed Roboprofessor as a gay robot. When she got off her campaign bus, I followed her into the Hamburg Inn, a local campaign stop, and I said "not only are you a homophobe, you're a robo-phobe." I knew that the words "gay robot" would be the hook that attracted reporters.

One of the strategic moves I made was getting a friend to take a cheap HD camera and document the event. I then edited the footage down to sixty seconds and uploaded it to YouTube. Later that night, MSNBC ran a news story about it with the full minute of footage that my friend shot. So that prank was much more planned out, in terms of the clarity of the message. A lot of the supporters of Michelle Bachman who were in the restaurant just started screaming at me and shoving me; they were not happy with me, and some started a chant, "Go back in the closet, go back in the closet." And I was like [in robotic voice] "I cannot help myself, I am a gay robot, I am programmed to do this." Anyway, I quickly left after that because I had no interest in making the Hamburg employees' jobs that much worse, and because there were also Occupy protesters in the restaurant screaming at the Bachman supporters, so the gay robot was almost like a side show. But I knew that the gay robot would be a perfect hook that could carry the story far and wide, and it did: it fanned out internationally, strangely enough. By critiquing Bachman on something that was a prominent part of her political profile, I knew that even if people didn't agree with me, at least my argument was legible.

MARILYN DELAURE. In your book *Freedom of Expression* (2007) you write, "We live in a consumer culture, which sometimes obscures the fact that we first and foremost live in a democratic society" (169). Do your pranks work to attack the former [the consumer culture]

in order to assert the latter, and more broadly, do you think culture jamming is a vital tool for promoting and protecting democracy?

KEMBREW MCLEOD. In many ways, pranking and culture jamming are twisted versions of participatory democracy in action. Another way of thinking about pranking and culture jamming is that pranking— unlike a formal theater experience in which the audience is separated from the performers by stage lights and the stage itself—pranking blurs the line between audience and observer. It invites people to engage in the spectacles that pranksters create. Even if they are just observing something that briefly turns the world upside down, it holds the potential for the observer to see the world, even very briefly, from a new perspective. Observing satire and irony in action requires some sort of critical thinking because, when an ironic joke is launched, it requires the observer to think about what the teller or performer does *not* mean. It requires some form of critical thinking. So yeah, I sort of see pranking as a form of participatory democracy. A really weird version of it, sure, but one that encourages people to stop being bystanders, engage with their daily lives, and deviate from their daily routines. Even if it's just for a moment, that can be productive.

REFERENCES

McLeod, Kembrew. 2007. *Freedom of Expression®: Resistance and Repression in the Age of Intellectual Property*. Minneapolis: University of Minnesota Press.

18

Notes on the Economic Unconscious from a Billionaire for Bush

ANDREW BOYD

In 2004 I helped start an unlikely organization: Billionaires for Bush. Dressed in tuxedos, top-hats, gowns, and tiaras, we took to the streets with slogans like "Blood for Oil," "Free the Enron 7," and "Corporations are People, Too." Through a combination of irony and infotainment, we hoped to enter the political fray and paint Bush as a handmaiden of the corporate elite. The media and our audiences ate it up. We grew to one hundred chapters and became a celebrated part of the grass-roots effort (that eventually failed) to defeat George Bush.

But there was more to our success than funny slogans and well-packaged shtick. Whether we'd intended to or not, we'd tapped into something deeper—you might call it the economic unconscious, or the mythic dimension of money—a contradictory complex of taboos and fantasy that we all have around money.

Extremes of wealth and poverty are an unspoken Other, maybe less celebrated in academic-chic circles as their gender, race, and noble savage cousins, but nonetheless conjuring up all sorts of unconscious projections: from exotic fascination, to dreams of limitless freedom, to bloody-minded justice.

We told ourselves that we were putting on our tuxes and hitting the streets because it was a creative and effective way to make the case to regular folks that their economic interests would not be served by another four years of tax cuts for the wealthy and no-bid contracts for Halliburton. But what we unconsciously dug down into to animate our characters and theatrical energies was a complex brew of guilt, envy, fascination, and class hatred.

For us mostly middle-class social-justice-minded Lefties, B4B provided a kind of get out of jail free card, a moral license to let our id

run wild over a number of ideological taboos. Under cover of irony and high-concept theatrics, we were free to class-bash the upper crust, instruct the (misguided) working class about their own economic self-interest, all the while indulging our own (largely unacknowledged) fantasies of being rich beyond imagining.

We weren't doing this in a vacuum, of course. Our culture as a whole fosters a schizophrenic relationship to money. We love it, and we also love to hate it. We want it, but we want to be free of it—and somehow, if we just had enough of it, we think we could be. Meanwhile, those who have too much of it we revile and revere in equal measure. Money is the epitome of bad faith, as well as the ultimate truth teller. Can you deliver? Show me the money. Why does the world work as it does? Follow the money. It reveals the hand of power.

And revealing the hand of power was exactly what we were trying to do. "It's a class war and we're winning," we proclaimed with glee. By inhabiting the voice of the corporate elite and cheekily celebrating their narrow self-interests without the sugar coating of Bush's faux-populism, we aimed to drag their normally hidden agenda out into the open and paint as much of an Us-versus-Them, the-Super-Wealthy-versus-the-Rest-of-Us picture as possible.

This picture was not always easy to paint. Economic inequality, though more extreme than any time since 1929, remains largely invisible. Bill Gates looks just like any other white-collar chump in khakis and a polo. So we had to pull our characters and costumes from a broader repertoire of archetypes: top-hatted Gilded Age robber barons, Southern debutantes, Arabian sheiks, Texas oil magnates, cigar-chomping CEOs, Thurston Howell IV, long-white-gloved uptown society ladies, and so on. Not the face of modern wealth at all, rather an outlandish and over-the-top tableau reflecting the denizens of our economic unconscious or "wealth imaginary." Up against this, at events or in on-the-street interactions, our audience would find themselves in the role of the straight man—a regular American middle-class Joe Sixpack kind of straight man.

But not everyone played along. Although the Great Recession and Occupy Wall Street uprising have shifted these numbers a bit, Americans tend to identify overwhelmingly up the economic ladder. In 2004, a full 19 percent thought they actually were among the richest 1 percent of

income earners, while a further 20 percent thought they one day would be (Brooks 2003). When nearly 40 percent of Americans are identifying with the richest 1 percent, it is harder to paint the wealthy as Other. While we were trying our damnedest to say, "The rich are not like us," much of our target audience was saying, "The rich are us, or soon will be."

In some ways, money is the last taboo. You're more likely to talk to your buddies about your herpes sores than to share salary figures. In the public sphere, there's the great shame of America: How can such poverty live amidst such wealth? And the (literally) billion-dollar question that no one wants to go near: Do the wealthy have too much and what to do about it? And for all of us, there's the ever-repressed knowledge that money is a pure abstraction, a consensual hallucination hiding a profoundly arbitrary system of value—and don't be the one to wake us up, because this teetering house of cards will all fall down. For all these reasons, great and small, our culture is uncomfortable talking honestly about money. Maybe what made the Billionaires for Bush of such enduring interest was how its strange mix of directness and indirectness provided a rich and relatively safe space to poke at an area of public life laced with taboo.

Sometimes, in fact, too safe. . . . There was a moment at the Republican National Convention when we were all dressed up, affecting our upper crust accents, drinking champagne as we shuttled from party to party in the back of a limo (which we'd hired to be more "authentically" in character), when I realized we'd become a kind of cult—a fun and politically effective cult, but a cult, nonetheless—an elite club of ironic faux-riche activists, that in some weird self-congratulatory way was microcosmically mirroring the real elite club of super-wealthy planet-destroyers we were supposed to be taking down a notch. And so, a final note to all self-styled economic revolutionaries, even ironic ones: the repressed will always find a way to return . . . keep an eye out.

REFERENCES

Brooks, David. 2003. "The Triumph of Hope over Self-Interest." *New York Times*, January 12. www.nytimes.com.

19

Artwork and Commentary

THE GUERRILLA GIRLS

Do Women Have to Be Naked to Get into the Met. Museum?

When the Public Art Fund of New York asked us to design a billboard, we conducted a "weenie count" at the Metropolitan Museum of Art, comparing the number of nude males to nude females, and the number of male versus female artists in the artworks on display. The results were very "revealing." The PAF turned down our proposal for the project, stating it was "unclear." What was clear to us was that they were unwilling to publicly criticize a major New York museum. So we rented ad space on city buses and sent this now iconic work around New York. It's become our most popular poster.

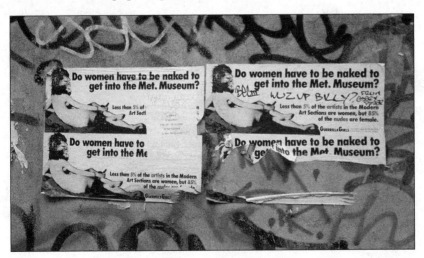

Figure 19.1. Poster: *Do Women Have to Be Naked to Get into the Met. Museum?*, 1989. Copyright © Guerrilla Girls, courtesy www.guerrillagirls.com.

Billionaires Hijacking Art/Income Inequality, 2015

The huge earnings gap between the super-rich and everyone else is one of the biggest scourges facing our planet. Everything that's wrong with the world economy is wrong with the economy of the art world. We can't let billionaires control art—or politics, for that matter. Our new series of stickers calls out the corrupt system that art collectors, galleries, and museums perpetuate.

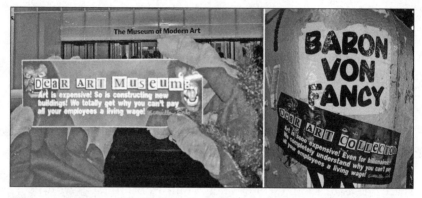

Figure 19.2. Stickers outside New York museums. Copyright © Guerrilla Girls, courtesy www.guerrillagirls.com.

The Birth of Feminism Movie Poster, Rotterdam, 2007

Hollywood producers have come to us over the years, saying they want to make a movie about the history of feminism in the United States. We tell them our ideas and then never hear from them again. One day, we started wondering what a Hollywood film about feminist history would be like. So, we decided to make our own satirical movie poster of the film we hope NEVER gets made the Hollywood way.

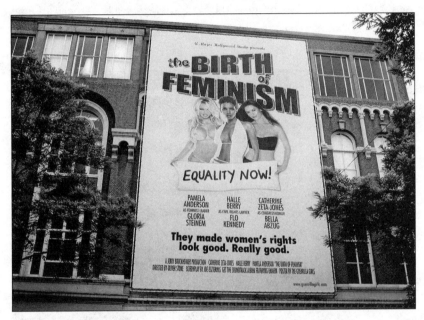

Figure 19.3. Poster: *The Birth of Feminism*, Witte de With façade. Copyright © Guerrilla Girls, courtesy www.guerrillagirls.com.

The Anatomically Correct Oscar, 2002

We decided it was time for a little realism in Hollywood, so we rented a billboard near the Oscar ceremony in Los Angeles, and for the month of March 2002, presented *The Anatomically Correct Oscar*. We redesigned the golden boy to look more like the white guys who take him home each year. And guess what: at the Academy Awards on March 25, Halle Berry became the first ever African American woman to win Best Actress, and Denzel Washington the second ever African American man to win Best Actor. We were jazzed by that, but the film industry still has a long way to go.

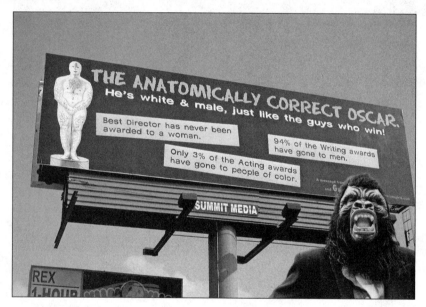

Figure 19.4. Image of billboard in Hollywood. Copyright © Guerrilla Girls, courtesy www.guerrillagirls.com.

Do Women Have to be Naked to Get into Music Videos, 2014

When Pharrell Williams asked us to be in an exhibition called "G I R L" at Galerie Perrotin Paris, we said okay, but *only* if we could show two new posters: one about women in music and another about women artists at Perrotin. After watching lots of videos, we had a question for Pharrell: Why do women have to be naked to get into music videos while 99% of the guys are dressed? We did a remix of one of our classic posters with a still from Williams's and Robin Thicke's notorious *Blurred Lines* music video.

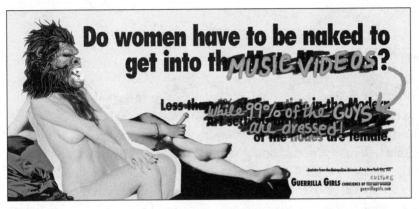

Figure 19.5. Poster: *Do Women Have to Be Naked to Get into Music Videos while 99% of the Guys Are Dressed?* Copyright © Guerrilla Girls, courtesy www.guerrillagirls.com.

20

Delocator.net

Using the Web to Organize and Promote Alternative Behaviors

XTINE BURROUGH

What does it mean when a whole culture dreams the
same dream?
—Kalle Lasn

As a new media artist, my practice often consists of designing online media
and hoping for participation. Starting in 2005, I have relied on design pat-
terns of the web 2.0, such as harnessing collective intelligence, serving the
long tail, having users adding value, and marking work with only some
rights reserved (O'Reilly 2005), to resist the hegemonic dominance of
mass media. As Henry Jenkins (2006) suggests in *Convergence Culture*,
"no sooner is a new technology . . . released to the public than diverse
grassroots communities begin to tinker with it, expanding its functional-
ity, hacking its code, and pushing it into a more participatory direction"
(244). It is this participatory direction that O'Reilly anticipated in 2005 as
he wrote about BitTorrent's "architecture of participation," which fosters
"a built-in ethic of cooperation, in which the service acts primarily as an
intelligent broker, connecting the edges to each other and harnessing the
power of the users themselves" (n.p.). My works "tinker" with familiar
online tools, revitalizing behaviors such as searching and sharing to pro-
mote and encourage individual exploration and interpretation. I rely on
the web as a platform that can harness collective intelligence, put the user
in control of her data, promote an architecture for participation, and trust
users as co-developers, or at least collaborators, in an effort to resist tar-
geted behaviors in mainstream culture.

Culture Jamming and Tactical Media

I first understood culture jamming through *Adbusters* magazine, which features subvertisements, the Blackspot "anti-sweatshop" shoe, shop-dropping narratives, and Buy Nothing Day. This led me to (perhaps wrongly) assume that culture jamming is an anticonsumerism movement driven by outraged activists who believe in Kalle Lasn's (1999) dictum that "Economic 'progress' is killing the planet" (xiv). My view broadened when I read Graham Meikle's (2007) claim that culture jamming is "not just about advertising and consumerism, but encompasses a range of uses of media products and images" (179). Mark Dery (1993) suggests that *jamming*, a word etymologically associated with pranks and interruptions on short distance (CB) radios, includes noisy interruptions resistant to the "manufacture of consent through the manipulation of symbols" (6). This manipulation of symbols includes the persuasive use of language, graphics, video, hypertext, and interactivity for the purposes of resistance and opposition.

Commonalities among jammers and tactical media practitioners include resistance, interruption, subversion, amateurism, and collective action. Both are informed by the Situationist International's notion of *détournement*.[1] The primary difference between the two forms of media activism is that tactical media takes a philosophically hybrid approach to media manipulation, avoiding a form of activism based on reaction and incorporating time (in addition to space) as a viable element of the tactical arsenal. In "The ABC of Tactical Media," David Garcia and Geert Lovink (2013) posit that "although tactical media include alternative media, we are not restricted to that category. In fact we introduced the term tactical to disrupt and take us beyond the rigid dichotomies that have restricted thinking in this area, for so long, dichotomies such as amateur Vs [versus] professional, alternative Vs mainstream. Even private Vs public" (n.p., capitalization in original). In their introduction to *Net Works: Case Studies of Web Art and Design*, Critical Art Ensemble (2011) provides two underlying sources that emerge as scaffolding for understanding the aim of the tactical media practitioner: military discourse and cultural manifestations of tacticality. While military discourse defines tactics as "the art of the weak" (von Clausewitz 1911, 210), Michel de Certeau (1984) offers tactics as "the space of the other" (37). De Certeau

demonstrates the differences between strategies and tactics in *The Practice of Everyday Life* with the analogy of architectural plans (representing a government approved strategy) in relationship to a citizen's usage of a city (tactical movements). Citizens, with or without awareness of the government's strategic plan, employ tactical operations as they deviate from the structure of the city to stroll through alleyways or skateboard down handrails. The design of tactical media, much like a tactical move in the city, is devious, subversive, and timely. It utilizes the dominant paradigm to resist structures of authority while simultaneously inserting the voice of the amateur in its place. Given these differences between tactical media and culture jamming, I believe my project (which is reactionary and does not overtake, for instance, Starbucks' virtual space) may be a better example of culture jamming than of tactical media.

Delocator.net

In the fall of 2004 I was traveling in the SoHo neighborhood of New York City, known for its unique shopping experiences and history of creative residents,[2] when I decided to rest in a coffee shop. Since corporate stores such as Starbucks offer consistent products, the experience in each store is predictable—a feeling at odds with exploration. I was stunned when I walked several blocks in SoHo only to find multiple Starbucks stores. Although this was before the era of smart phones, I remember saying, "I wish I had a list of local stores at my disposal." Thus, *Delocator* was born.

Dominant Paradigm: Starbucks

Starbucks (like big box stores or entertainment chains) represents the hegemonic invasion of the corporation into local neighborhood economies.[3] Local coffee shops, in addition to directly fueling the local economy, offer authentic insights to individual communities.[4] In 2005, online search results for locally owned coffee stores were anything but comprehensive. Owners of most local shops did not have the skills or budget to create a web presence. By contrast, corporate retail websites always included the ubiquitous "online store locator." This was the point of departure for the Delocator.

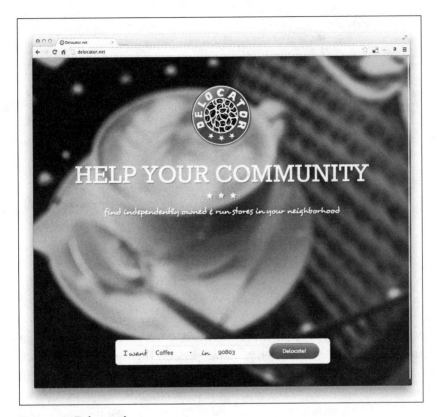

Figure 20.1. Delocator home page, 2015.

Resistant Message

On April Fool's Day, 2005, I launched Delocator.net, a website that contained two segments in its database. One held the address of every Starbucks store in the United States (at the time, about 6,500 stores). The other was an empty database where users could upload information about local coffee shops.[5] On the site, anyone could search a US zip code to find coffee store information—local venues were listed on the left side of the page and Starbucks on the right. I never used language in direct opposition to Starbucks, even on the "About" page. The Delocator, in my mind, offered a robust listing of stores as well as providing a subtle comparison between local and corporate venues, which might have an impact on visitors looking for a nearby café. I did not intend to "take on

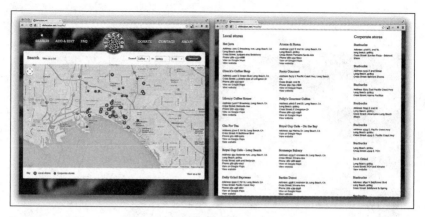

Figure 20.2. Delocator results page in map and list form, 2015.

Starbucks" with the website, nor did I realize that the site would capture the zeitgeist of coffee culture. I simply developed a tool I wanted to use.[6]

Delocator.net was purposefully designed to suggest a comparison between the anticorporate store locator and Starbucks.com. The style of the website and its logo were a visual play on the well-branded green and white colors seen in the Starbucks "mermaid" logo and stores. In 2005, both websites showcased a soft photographic image portraying coffee house items in the background of the page with a navigation tool in black text at the top of the page.

Challenges and Outcomes

Within months all fifty states were represented in the independent database. Much of this success was due to coverage in blogs and newspapers. *StayFree* and *BoingBoing* linked to the project within days of its release. In the summer of 2005 I was interviewed by more than forty reporters from a variety of domestic and international papers and radio and television programs, as well as for a documentary film. What I found most interesting was how some journalists described Delocator as an "Anti-Starbucks" website.[7] By listing addresses for both Starbucks and local coffee shops, I thought I had represented a multidimensional view. Funnily enough, I also received occasional e-mail messages from fans of the site asking, "If you want to support local cafés, why do you list

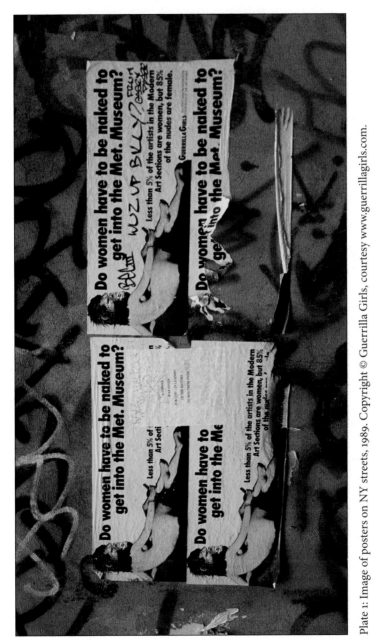

Plate 1: Image of posters on NY streets, 1989. Copyright © Guerrilla Girls, courtesy www.guerrillagirls.com.

Plate 2: Image of stickers outside New York museums. Copyright © Guerrilla Girls, courtesy www.guerrillagirls.com.

Plate 3: Image of banner on Witte de With façade. Copyright © Guerrilla Girls, courtesy www.guerrillagirls.com.

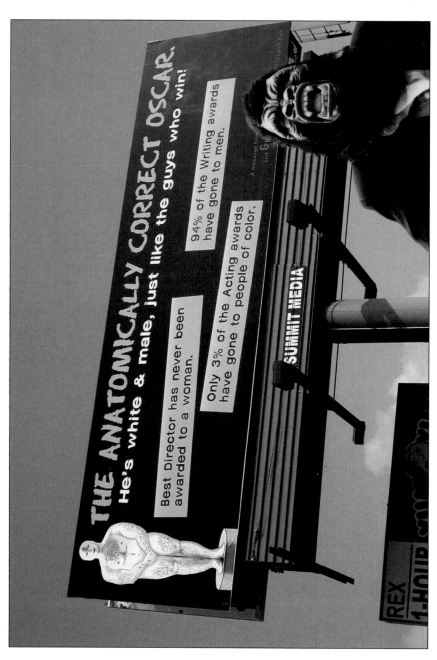

Plate 4: Image of billboard in Hollywood. Copyright © Guerrilla Girls, courtesy guerrillagirls.com.

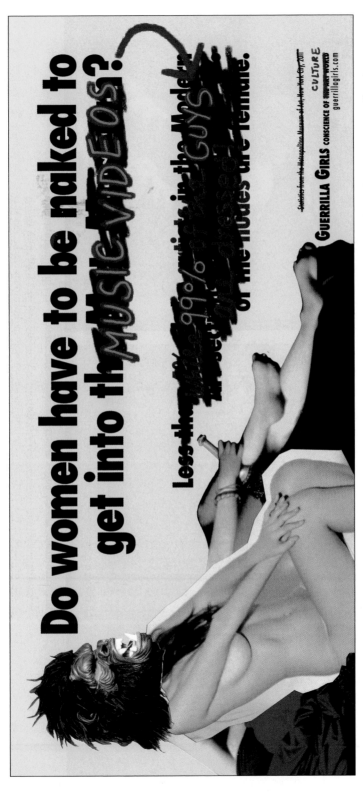

Plate 5: *Do Women Have to Be Naked to Get into Music Videos while 99% of the Guys Are Dressed?* Copyright © Guerrilla Girls, courtesy guerrillagirls.com.

Plate 6 and Plate 7 (facing page): *Where Is the Girl One.* 2014. Human hair, found materials, sticky tack. Fairfax, CA. Matilda Jones Briggs, age four, wondered why there were no female cyclists depicted in the "Birth of Mountain Biking" mosaic in downtown Fairfax. So she added some braids and ponytails, which lasted for about three weeks.

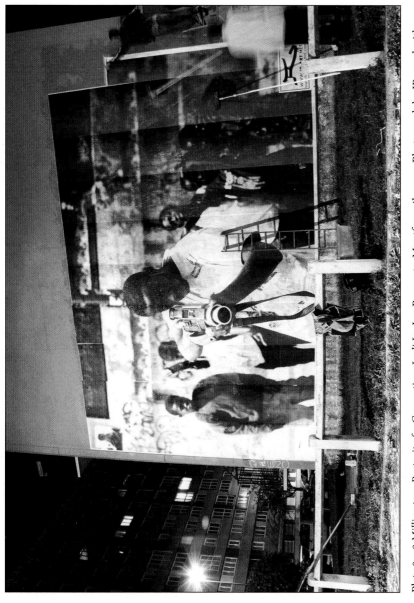

Plate 8: *28 Millimeters: Portrait of a Generation, Ladj Ly*, Les Bosquets, Montfermeil, 2004. Photograph by JR, used with permission of the artist.

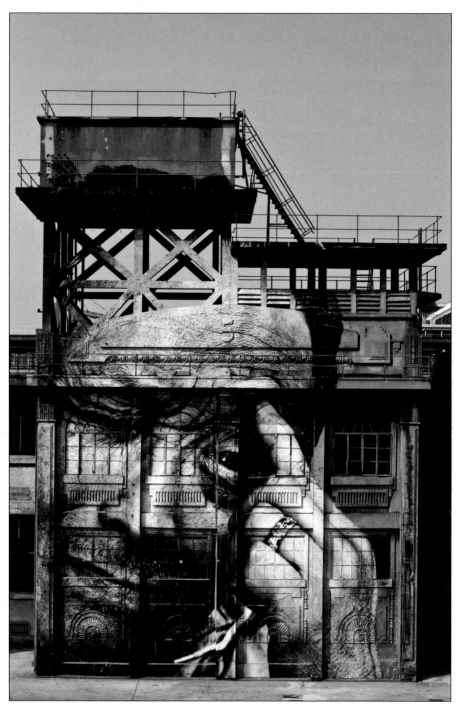

Plate 9: *Wrinkles of the City: Shanghai Action*, Rony Zhuang, 2010. Photograph by JR, used with permission of the artist.

Starbucks addresses?" Despite attempts at explaining the purpose of the site to both journalists and my new online friends, many people projected their own strong opinions onto the project at the intersection of coffee and corporate cultures.

Another challenge is maintenance. I have always shared the code that made the site work so that anyone with programming skills could download and create a Delocator site. In 2006 Delocator was active in the United States, Canada, and the United Kingdom. Neither the Canadian nor the UK sites remain in operation.[8] I continue to receive messages from web users who would like to see particular changes implemented on the site, but which I do not have the time or skills to produce.

Related to maintenance, a third, quirky issue arose that I never expected from a successful culture jam. Some viewers were fooled into believing that my voice (the site) is yet another corporate entity. I spent about a year developing the project without a budget because it was something I wanted to make. The site is not, and was never intended to be, profitable. However, some users request the type of customer service common to large web companies.[9] Though it is tempting (mainly to rid myself of maintenance guilt and the burden of communication with the public), I have resisted multiple offers from companies that I can only assume are similar to Yelp and that want to purchase the database.

Conclusion

In 2005 "Web 2.0" and "architectures of participation" were uncommon phrases. I did not know then that those were the driving technological ideas that would make Delocator so successful. Today, user-generated content commonly adds values to participatory websites. If someone wants to find coffee in her neighborhood, she is more likely to use a smart phone app (such as Google Maps, Yelp, or TripAdvisor) than she is to search a website. However, in the beginning of 2013 a programmer from the United Kingdom, Tom Brickman, e-mailed me with an interest in retooling the Delocator website. It is this amazing collaboration between users and myself as the "host" that seems to keep this project alive. Each time I think I'm finished with the site, someone in the Delocator community volunteers to assist with maintenance and updates.

In a 1990 article for the *New York Times*, Dery wrote that culture jammers "expose the ways in which corporate and political interests use the media as a tool of behavior modification." Tactical media interrupts mainstream media to insert the voice of the media artist, or the tactical jammer. In the early 1990s, Critical Art Ensemble (1993) called for political resistance to embrace digital media as "a virtual geography," where "the core of political and cultural resistance must assert itself" (3). Delocator demonstrates that using the web to organize participants, disseminate alternative messages, and encourage autonomous behaviors is feasible when participants strongly agree with the message. Sometimes the dream common to Lasn's (1999) "whole culture" is simply a placeholder for an alternative. Online participants, in my experience, are delighted to wake up and rebel.

NOTES

1 See Debord ([1967] 2014, 109–10).

2 Artist residents included Phillip Glass, Twyla Tharp, Nam June Paik, Chuck Close, and Frank Stella. See www.sohonyc.com.

3 Search online for "Starbucks cluster strategy" or see www.ukessays.co.uk.

4 In my neighborhood there are more than eight local coffee shops in a five-mile radius. I regularly frequent them, and I enjoy being able to decide which shop fits my needs or mood as some have live music or community meet-ups, while others are quiet places to read. One has the best bagel in town, the other has the best Mexican hot cocoa. These types of differences are simply not part of the corporate scheme.

5 It is surprising that the National Coffee Association website still does not offer a complete listing of its members.

6 I have always been reliant upon a programmer to create or maintain the database. Vasna Sdoeung created the first database for Delocator.net in 2005. Kyle Cummings reworked it in 2006. In 2009 Jim Bursch further developed the database and added a much needed Captcha for security purposes.

7 See "When You Want Anything but Starbucks" (2006), which begins with: "A project to figuratively take Starbucks off the map started with one irked woman." See also Dizon 2006.

8 In January 2013 I received a message from someone in the United Kingdom who wants to resurrect the Delocator.co.uk website. Now the problem is that somebody (whom I do not know) owns the URL and has it directing to my site. So there are technical challenges that arise from such amateur operations. There's nothing I can do about the UK site. The new developer will simply have to give his site a slightly different name.

9 I still receive e-mails monthly asking questions such as why doesn't the site work in other countries, or on an iPad, or why there is no app available, and so on. From 2005 to 2007 I received an estimated thirty e-mail messages each week in regard to the website (can I change something in the database, or someone uploaded the wrong picture, or some listing is showing up in the wrong zip code area, and so on).

REFERENCES

Critical Art Ensemble. 1993. *The Electronic Disturbance*. Brooklyn, NY: Autonomedia.

———. 1996. *Electronic Civil Disobedience and Other Unpopular Ideas*. Brooklyn, NY: Autonomedia.

———. 2011. "Tactical Media." In *Net Works: Case Studies of Web Art and Design*, edited by xtine burrough, 145–47. New York: Routledge.

De Certeau, Michel. 1984. *The Practice of Everyday Life*. Translated by Steven Rendall. Berkeley: University of California Press.

Debord, Guy. (1967) 2014. *Society of the Spectacle*. Translated and annotated by Ken Knabb. Berkeley, CA: Bureau of Public Secrets.

Dery, Mark. 1990. "The Merry Pranksters and the Art of the Hoax." *New York Times*, December 23. www.nytimes.com.

———. 1993. *Culture Jamming: Hacking, Slashing and Sniping in the Empire of Signs*. Pamphlet no. 25. Westfield, NJ: Open Magazine.

Dizon, Kristin. 2006. "Web Site Steers Away from the Corporate Chains for an Independent Cup of Java." *Seattle Post-Intelligencer*, January 24. www.seattlepi.com.

Garcia, David, and Geert Lovink. 2013. "The ABC of Tactical Media." *Nettime*, February 11. www.nettime.org.

Jenkins, Henry. 2006. *Convergence Culture: Where Old and New Media Collide*. New York: New York University Press.

Lasn, Kalle. 1999. *Culture Jam: The Uncooling of America™*. New York: Eagle Brook.

Meikle, Graham. 2007. "Stop Signs: An Introduction to Culture Jamming." In *The Alternative Media Handbook*, edited by Kate Coyer, Tony Dowmunt, and Alan Fountain, 166–79. New York: Routledge.

O'Reilly, Tim. 2005. "What is Web 2.0?" *O'Reilly Media*, September 30. www.oreilly.com.

Von Clausewitz, Carl. 1911. *On War*. Translated by J. J. Graham. London: Keegan Paul Trench Trubner.

"When You Want Anything but Starbucks." 2006. *Toronto Star*, February 7. www.thestar.com.

21

The Yes Men

An Interview

MARILYN DELAURE

MARILYN DELAURE. How did you first get involved in your form of activism?

MIKE BONANNO. It all began out of a basic compulsion to do mischief. When we first started the Yes Men in the late 1990s, we were operating as a part of the big antiglobalization movement. We didn't really need to find our exact way of fitting in because there were lots of people doing things that all worked in sync with the movement. Then, after September 11, that movement took a hit. Because of changes to the ways policing was done all over the world, the big street protests became much more sparse, and at that point we naturally started teaming up with NGOs and smaller organizations that had campaigns on specific issues. And then I think we started working more broadly again when Occupy Wall Street started happening.

MARILYN DELAURE. A signature tactic of the Yes Men is "identity correction." What is that, and how did you invent it?

ANDY BICHLBAUM. Well, like everything we've done, it sort of happened by accident. We didn't set out thinking, "This is the best way to really sock it to them and this is our strategy for highlighting these issues"; it was more a result of using whatever technologies were around at the time and what we knew how to do. In 1999, we knew how to copy websites. So since tens of thousands of people were headed to Seattle, we kind of followed their lead and made a fake website about the World Trade Organization. The WTO seemed like the right target to all of those activists: it was a very high profile body that was making bad decisions for the world.

We were inspired by the antiglobalization movement, and we wanted to contribute what we could, so we made this fake website. And then because the WTO reacted to it, instead of reacting to the tens of thousands of people heading their way—because I think they were a little more embarrassed about the protesters—they chose to react to our website and wrote a press release about it. Nobody read the WTO's press release about our fake website, and so their head of PR wrote to us directly and said, "You guys should stop what you are doing because you made us write a press release about this." And so we sent that message on to thousands of journalists and others on our mailing list, and some articles got written about it. At the time, if you searched "World Trade Organization," search engines would pick up our site as well as the real one because of these articles. And then we started getting mail intended for the WTO, including invitations to conferences. So we started accepting the invitations: the first was for a conference in Salzburg [Austria], and that's how we started doing what we ended up calling identity correction.

MARILYN DELAURE. You've called your central strategy "laughtivism." Why are humor, jokes, and playful pranks so important?

MIKE BONANNO. Well, for one thing, it's fun. That should be self-evident. It's also effective. People like to share things that are funny. And that extends to journalists wanting to write about things that are funny, and funny things tend to fly beneath the radar of the sort of editorial protocols that usually keep certain stories from making it into the press. Because what we're doing is helping journalists to basically write an interesting story, or giving them a little bit of a news hook.

MARILYN DELAURE. Describe your relationship with mainstream news media. Do they love you? Hate you? Does it depend on the action?

ANDY BICHLBAUM. We've been told that they love us. George Monbiot actually said at one point, "It's really weird you guys fool the media all the time but they love you. What's up with that?" That was just a very small sample I think he was referring to, but mostly what we do isn't fool the media. Rather, we provide excuses for the media to cover important issues, so it's a collaboration. In a way, we are journalists. Other people do the research and hard work and the

writing itself, but we provide the little nugget they can use to extract stuff and cover something that hasn't been getting as much coverage as it should. Or sometimes the issue has been getting lots of coverage, but our action gives them an excuse to add more to it.

MARILYN DELAURE. Tell me about the Yes Men's most successful interventions.

MIKE BONANNO. Success can be measured in many ways. There's how much media attention something got: by that measure, probably the Dow Chemical announcement[1] was the most effective. It was also particularly effective in hammering their stock price and, I'm sure, making Dow freak out. On the level of counterespionage, or on the level of—what would you call it?—messing with a corporation inside the corporation, I've heard that some stuff we did with Shell Oil was also particularly effective.[2] Those are sort of harder to measure than just media hits.

And then sometimes you just like the message at the end, or you judge it the way you would a good poem. I mean in the case of the final action of the newest film [*The Yes Men Are Revolting*, 2015],[3] the strength of the idea is just so important. The idea that, first of all, almost everybody is willing to embrace renewable energy and, secondly, ready to embrace renewable energy that's owned and operated by local communities, not by these big corporations. . . . The idea of addressing social justice at the same time as environmental justice and energy transition makes perfect sense. So that was why that action seemed like a really huge success to me.

ANDY BICHLBAUM. Yeah, I think it was a really big success too. . . . The usual way we've measured the success of an action is just how many hits it's gotten, or how much it's gotten an issue covered in the mainstream media. And that may not necessarily be the right measure. Having a really powerful conclusion—a moving conclusion—to a movie is success, certainly, because the movie is then seen by people and hopefully prompts them to ask, "What's stopping us from making change? Why aren't we making change?" So that's success.

But usually we just count hits like with the BBC action on Bhopal,[4] which got like six hundred articles in the US press mentioning the catastrophe, using the hoax as a way of getting in there, and that's

in a country that usually doesn't cover Bhopal much. And then the Chamber of Commerce thing came on at a time when there was a lot of stuff going on around the Chamber of Commerce so it added a couple of days of TV coverage to that.[5] None of these [actions] is successful in themselves. The individual actions don't actually change anything, but in contributing to these movements with media coverage, I think they're successful insofar as the movement is successful.

MARILYN DELAURE. What would you say is most powerful about your form of activism?

MIKE BONANNO. I actually think the most powerful result of the activism often is just getting other people involved. . . . I think the movies are most effective because they get to places you don't expect, and we get e-mails from high school students who say, "Hey I never even considered thinking about these things and now I'm out on the streets." With that sort of thing, you can't underestimate the effects, because you don't actually need that many people out there; you need some dedicated, excited people to move things forward. There is also another thing often overlooked, and that is the fact that people like to be entertained by poking fun at these things that seem so powerful and so immovable, which proves in some ways that they are not as powerful. And I think our work has been encouraging to a lot of our friends doing more important, but perhaps more monotonous or boring jobs in the movement, you know? Entertaining people who are in the trenches is important.

ANDY BICHLBAUM. I agree. With Occupy Wall Street, a lot of people said that one of the first influences on them was seeing one of our movies when they were younger. This made us feel like we were a part of the movement, even though we didn't help organize Occupy. Like many people, we just heard in the news about this plan to occupy Wall Street and take it over. . . . We just thought they were nuts, but then when it happened and, you know, had such repercussions, it just felt like, "Wow, okay, we were a part of that," because all these people came up and told us that they had seen our movie. So the biggest success, I think, is that sort of thing—the way our work enters the culture and makes people think, "Yeah, there are cracks in this system. Yeah, just a few people can really make a difference. . . . And I'm going to be one of them."

NOTES

1 In 2004, Andy appeared live on the *BBC World News* posing as a spokesman for Dow Chemical to comment on the twentieth anniversary of the Bhopal disaster, an industrial gas leak that killed thousands of people. Speaking as Mr. Jude Finisterra, Andy announced that Dow Chemical planned to take full responsibility for the disaster, clean up the plant site, and compensate victims and their families. Though the ruse was quickly discovered, this stunt generated considerable media attention about ongoing problems in Bhopal and shed light on Dow's refusal to do anything proactive. See www.beautifultrouble.org.

2 In June 2012, the Yes Men helped stage a gala in Seattle's Space Needle to celebrate Shell's Kulluk drilling rig, which was about to depart for the Arctic. The party's centerpiece was a model of the Kulluk nestled on an ice sculpture, meant to dispense cola for drinking. The first glass was to go to the guest of honor, the widow of the rig's designer (who was in reality eighty-four year-old Occupy activist Dorli Rainey); instead, the display sprayed her in the face. Video footage of the event went viral under the hashtag #ShellFAIL. That same day, they launched a fake website at ArcticReady.com that purported to be Shell's social media site. It included an image gallery and caption generator with phrases like, "You can't run your SUV on 'cute.' Let's go." and "Because Fuck You, Earth. Let's go." See www. yeslab.org.

3 Posing as an undersecretary of the US Department of Energy, Andy spoke at a Homeland Security Expo in Washington, DC, in 2013, announcing that the United States would move to completely renewable energy sources by 2030. The wind and solar power plants were to be owned by Native American tribes, as partial reparations for the history of American genocide. Appearing with the Yes Men were Gitz Crazyboy and Tito Ybarra.

4 See note 1.

5 In October 2009, the Yes Men organized a press conference at the National Press Club in Washington, DC. Speaking on behalf of the US Chamber of Commerce, Andy announced that the Chamber was reversing its position on climate change policy and would stop lobbying against the Kerry-Boxer Bill aimed at reducing carbon dioxide emissions. The hoax was revealed when Eric Wohlschlegel, the real Chamber spokesperson, barged into the room and declared the event a fraud. The action was covered by media around the world. See www.yeslab.org.

22

Networked Reality Flow Hacks

PAOLO CIRIO

Media are hybridizing and multiplying quickly. There is awesome potential for jammers to intervene in the complex apparatus of networked media: Subtle messages and subversive memes flow through various media, reaching individuals and even power structures as never before. Images, videos, texts, maps, money: All forms of information flow as data in the networks, creating a massive informational environment in which we are all immersed.

The machines and software that process the flux of information flowing in the networks profoundly shape our existence. Global financial trading, just like our intimate relationships, is influenced by endless communications flowing through smart phones, e-mail inboxes, social media, instant news services, and mainstream media. Today, we use networked personal media for relating to each other, accessing knowledge, and organizing our personal lives and communities. By being constantly connected, people consume huge amounts of information while simultaneously feeding these networks with their personal data. People relate to their environments and each other mainly through networked media. Hence interventions in the flow of communications can influence power structures and shift perspectives in people's lives.

My project *Face to Facebook* (2011), developed in conjunction with Alessandro Ludovico, illustrates the potential of jamming the networked media by exploiting one of the most widely used social media platforms. Facebook documents the private lives of almost one billion persons all over the world, who share their intimate information and communicate in their most important social relationships using a social network owned by a private corporation. Consequently, Facebook has an incredible concentration of power over all these people, because Facebook holds and manages their data and their communications.

To subvert Facebook and disrupt its business and the trust that people put in it, we had to do a radical jamming action. I coded a little script that exploited a vulnerability of Facebook, enabling me to download one million public profiles of random Facebook users. It took months to harvest all the data; the script went automatically through thousands of profiles just by following friendship connections. The public data downloaded was just what is available on Google: name, surname, profile pictures, location, and likes. The second step of the project was to analyze the data gathered by processing all the pictures using custom-coded facial recognition software able to determine the gender of the person and his or her facial expression. At the end of this process the software found two hundred thousand faces and sorted them by six categories of temperaments for each gender. Our third step was to publish the sorted data on a custom-made fake dating website called Lovely-Faces.com. Thousands of random people from more than fifty countries were published on a cheesy dating website listed by presumed temperament, name, surname, location and personal likes, without knowing it.

As soon as we publicized the project through a press release to a few journalists, the news about the dating website Lovely-Faces.com went viral. After the first twenty-four hours the main German TV news channel and CNN covered the project, which caused the dating website to be flooded by people looking for their data.

The project was a culture jamming action against Facebook in that we subverted its primary resource: the data of the users and the relationships among them. However, it also became a social experiment, which was about looking at people's reactions when their data is provocatively used in another context without authorization. Through the website we received many messages from people—some angry insults (including five death threats), some enthusiastic support. (It's important to say that Lovely-Faces.com wasn't indexed by Google and we removed all the profiles of those who found themselves on the dating website. We didn't want to hurt anyone, and all the data was exposed only inside an artistic context.)

After two days, Facebook sent us a first cease-and-desist letter, asking us to shut down the dating website and delete all the "stolen" data; we were also banned from their services forever. We kept Lovely-Faces.com up for a week more before pulling it offline, because we couldn't afford a

lawsuit. Facebook lawyers have continued to send us letters asking us to stop promoting the project.

Face to Facebook demonstrated the power of networked media flows and hacks today. On the one hand, it's possible to directly and intimately involve millions of people in a culture jamming project just though the network with which they are all connected. On the other hand, a subversive meme can spread globally in a very short span of time via mainstream and social media, influencing public opinion on issues regarding the whole society. Today memes flow by passing from node to node in networks; they are open to commentary and revision, and mutate as they circulate.

A few years later—in the wake of the global financial crisis of 2008–2009, Occupy Wall Street, and austerity debates—I launched another culture jamming project as a critical commentary on the increasing disparity in the distribution of wealth. *Loophole4All.com* (2013) promoted the sale of the real identities of over two hundred thousand anonymous Cayman Islands companies at low cost to democratize the privileges of offshore businesses in tax havens.

I hacked the governmental website of the Cayman Islands Company Register to compile a list of all companies registered in the major Caribbean offshore center. I made the data public for the first time, exposing it by digitally creating counterfeited certificates of incorporation documents for each company, all issued with my real name and signature. The counterfeit certificates were published on the website Loophole4All.com, where everyone was invited to hijack firms' identities by buying certificate of incorporations, starting at 99 cents, which would enable them to avoid taxes.

This massive corporate identity theft benefited from the legitimate Cayman companies' anonymous nature: The secrecy surrounding their real owners allows anyone to impersonate them. In short, this idea turned the main feature of offshore centers into a vulnerability, which was subsequently exploited by forging the legal paper documents of the certificate of incorporation.

This performance generated international media attention, engaged an active audience, and drew outrage from authorities on the Cayman Islands, global banks, the companies' real owners, international accounting firms, and law firms. I received ten international legal

threats and two cease-and-desist letters from Chinese firms for this artwork.

Using aggressive business strategies to compete against Cayman's incorporation services, the project set up a scheme to publish the stolen information through a company incorporated in City of London (Paolo Cirio Ltd.) and a data center in California, while the identities of the Cayman companies were sold through Luxembourg via PayPal.com to route the profit of the sale to Cirio's operational headquarters in Manhattan. The scheme took advantage of specific jurisdictions for legal liability, financial transactions, and publishing rights. I used physical mailboxes in the Caymans, London, and New York and set up most of this scheme through my passport, ultimately shielding my personal legal liability through my Italian citizenship.

Loophole4All provocatively questions the transparency, secrecy, and anonymity of the global financial industry, exposing the mechanics of institutionalized illegality and the inequality of globalization, as well as some of the origins of austerity measures like budget cuts on public services and jobs in Western countries.

The website received significant amounts of traffic from India, Hong Kong, Singapore, and China. Not coincidentally, these countries are frequently involved in offshore centers like the Cayman Islands. Such offshore centers facilitate political corruption, misreport manufacturing costs and retail prices, and obfuscate foreign investments as tricks to maximize profit for the development of these new economic powers.

The infrastructure provided by new media and networked culture offers great possibilities for tech-savvy culture jammers. Hacking and phishing data can help create memes that reveal flawed policies and dishonest business practices inherent in the corporate world. As these memes spread, they awaken people to the injustices of existing power structures.

IOCOSE

Art, Authority, and Culture Jamming

PAOLO RUFFINO, MATTEO CREMONESI, FILIPPO CUTTICA, AND DAVIDE PRATI (IOCOSE)

When we started working as a group in 2006, we wanted to replicate the methods of those who inspired us: the Yes Men and the net.art movement (mostly Eva and Franco Mattes, Vuk Cosik and Ubermorgen), as well as the culture jamming work featured in the magazine *Adbusters*. The net.art movement was the reason for our initial interest in concepts such as authorship, fakes, and originality as they were emerging within digital culture. We were particularly fascinated by how these topics were somehow permeated by a political layer: the freedom to copy, modify, and circulate images and texts seemed to involve an antiauthoritarian impulse. We were drawn to the practice of reappropriating existing images and ideas and reversing their intended meanings. Our culture jams test the limits of what the public buys as "real" and what is detected as fake.

Among our earliest works, some are more directly inspired by culture jamming rather than the art context, or they circulate as "art" only at a later stage. *Yes We Spam!*, for instance, involved creating a spam e-mail campaign during the month preceding the 2008 national elections in Italy. At the time we were pissed off, like many others, by the right-wing conservative approach of the Italian Democratic Party, which was supposed to be the major left-wing party opposing Silvio Berlusconi. In the political propaganda of the Democratic Party of that period, we found a close tie to commercial spam campaigns. The rhetoric of the party, oddly enough, resembled an advertisement for penis enlargement, which everyone knows is likely to be faux, and yet attracts great interest in the form of clicks (or votes?). Our dismay at not seeing a true alterna-

tive to the dominant conservative ideology moved us to reflect on how we could somehow expose such rhetoric.

The expectation we had for our action was that political propaganda was so similar to a spam campaign that no one would notice the difference between the two. We prepared a series of e-mails, translating some of Obama's speeches (which were often referred to by the Italian Democratic Party) with some of the automatic translators available online. The result was a series of confused and grammatically incorrect sentences, containing phrases such as "more democracy for you" and "free ringtones with each vote." We then sent these e-mails to a list of contacts gathered from the Internet. For about one month the e-mails went out as if the Democratic Party was sending them. We did this through a web domain that the party had somehow left unused and still sounded quite official: "partitodemocratico2008.org." A significant number of recipients answered in anger, sometimes accusing the party of misusing the Internet, sometimes accusing us of being Berlusconi in disguise. We did not receive any accusation of having orchestrated a prank, although it seemed to us to be rather obvious considering the nature of the e-mails we were sending. This confirmed our deepest fear: Political propaganda was getting so close to the jargon of spam campaigns, that the general public seemed unable to spot the difference.

The following year, we launched another politically-charged culture jam: *Sokkomb* (2009). Crafted in conjunction with the group Falegnameria Sociale ("social woodwork"), *Sokkomb* was an IKEA-style guillotine. Supposedly selling at the price of € 99, the guillotine was made with the help of some amazing independent craftsmen and was then smuggled into several IKEA stores around Europe to be temporarily put on display as a new product. The first public exposure of *Sokkomb* took place at the IKEA store in Bologna, Italy, in the summer of 2009, but the major action was one year later in the IKEA store of Barcelona, Spain. On the latter occasion we acted in conjunction with the Influencers Festival, a yearly event about unconventional art, guerrilla communication, and radical entertainment, and the guillotine remained on exhibition for several hours at the store, between kitchen furniture and sofas. Surprisingly, not even the security noticed the new installation. As had happened with *Yes We Spam!*, *Sokkomb* assumed the style and language of the environment it was attempting to critique. The point of *Sokkomb*

Figure 23.1. *Sokkomb*, by IOCOSE, is an IKEA-style guillotine for DIY justice.

was to test to what extent IKEA consumers would be shocked by the prospect of a cheap tool for DIY justice. Eventually, only a few people reacted with surprise or disgust, while many seemed to be seriously interested in buying the product.

Sokkomb was a response to a political scenario that was emerging at that time in Italy, and around Europe in general. The domestic guillotine was presented as a cheap and yet reliable tool for vigilante justice, which at that time was being touted as a valid choice for those concerned with immigration. This was a recurring topic in the news of that period, and it obviously had an underlying racist statement that we felt had to be contested. This DIY justice discourse circulating in the mainstream press was apparently a topic hot enough to bring some IKEA consumers to seriously consider assembling a guillotine in their living room. *Sokkomb* aimed to ridicule the public obsession for security and "justice," which amounted to the execution of power over the poor, criminals, and immigrants.

Both *Yes We Spam!* and *Sokkomb* made relatively clear political statements. The message we wanted to convey, in both cases, was

grounded in a specific context and aimed at providing a reference point that could be fun, and yet provocative, for all those who shared a feeling of disappointment for the current situation. However, we also felt that this approach had its limitations, or was somehow only marginally hitting the point. In terms of real effectiveness, our political critique seemed to have limited potential. We also felt that exposing the absurdity of political propaganda, in the one case, and the non-sense of DIY justice, on the other, was too simply perpetuating the idea that truth, and the absurdity of the layers that had been put on top of it, had to be unveiled in order to make people reflect. Nonetheless, we started thinking that our projects also worked on a different level, by suggesting a possible way to approach a critique of what exists. The projects themselves might not achieve concrete political goals, but they could inspire the collective imagination, showing that a different framing of authority was possible and that mimicking that authority was always an option. We realized our work was more about contesting the power and legitimacy of the voices speaking than about a specific political agenda.

We developed this line of thought in a later project, where the link to culture jamming was still present although more marginally. Our 2009 *Doughboys* project was a documentation of a group of real-life super heroes who defended illegal issues. The *Doughboys* were three masked guys who were sometimes seen in the streets of Rome. The idea itself seemed bizarre to us, and yet we noticed there was not much documentation of their activity. We managed to approach them and realized that their performance had a sort of activist purpose. In fact, the three *Doughboys* circulated through Rome dressed as a yuppie, a soccer goalkeeper, and as a pope, respectively. These carnivalesque costumes were used to protect their identities and were also associated with their respective purposes. The yuppie was in fact distributing CDs with illegal content downloaded from the Internet (a sort of critique of the marketing of culture and information), the goalkeeper set up instant soccer matches in the streets to contest the privatization of public spaces, and the pope, the most inconsistent of the three, shared joints of marijuana with passersby to protest laws regarding the use of drugs.

The *Doughboys* did not leave any traces of their work in online or printed news websites, and they also seemed reluctant to work in that direction. In a sense, the *Doughboys* were a hallucination. They were spreading joy to the people, and then disappearing almost immediately. More than in the topics of their political statements, we were interested in their life as characters, as a potential reference point for popular culture (particularly in the contexts of the city of Rome and of Italy). Also, we found out that it was precisely the absence of communication about their activity that made them ineffable and yet ineffective in persuading people about file sharing, the reappropriation of the streets, and drug legalization. We started wondering how to document and share the story of this seemingly paradoxical activity, wanting to see to what extent mass media, and their public, could believe that a bunch of self-declared superheroes were roaming in the capital city of Italy doing mostly illegal stuff.

Our project was the documentation of something that was real, because these three masked men were actually present in the city, and yet unreal, as the very existence of superheroes was obviously referring to nonfactual elements of pop culture. We called it a "real-time mockumentary," highlighting its paradoxical nature of a documentary about a series of happenings belonging to an imaginary world the *Doughboys* had created for themselves. Our concern was precisely to reflect on what kind of authority can make stories real for the masses. We decided the most interesting way to approach the *Doughboys* was to let the media narrate our mockumentary and let the *Doughboys* become real superheroes by letting news media spread the word about them.

The photographic documentation we provided made it into the local and then national press. In the hot summer of 2009, even the mayor of Rome was questioned, during an interview on the public television channel, about what he intended to do with regard to the superheroes who were circulating in his city and conducting illicit activities. "It is just folklore" he said; "everyone has fun in his own way."

In a sense, the mayor got the point of the whole project. Bringing the imagination of three guys to the level of "folklore" made the story simply unstoppable and inspiring regardless of its actual political message. We believe the topics the *Doughboys* were fighting for were marginal in this

particular story. The utopian imagination of three crazy masked men started a legitimate political debate, thus challenging the authority of those who are usually in charge of setting up the political agenda. In that summer the hallucination of a few became a mass hallucination, which involved us, the mayor, the media, and everyone else in between. And it was fun, a lot of fun.

24

"Say Yes"

An Interview with Reverend Billy and Savitri D

MARILYN DELAURE

MARILYN DELAURE. Tell me about the origins of Reverend Billy.

SAVITRI D. Bill was talked into this by an Episcopalian priest, Sidney Lanier, who wasn't preaching anymore (though he was always quick to point out that he had never been defrocked). In a funny way Sidney is a very early culture jammer. He left the church in the late 1960s, but he was always deploying his religiosity in a pretty strategic way toward our culture-making. . . . [1]

BILL TALEN ("REVEREND BILLY"). Sidney pulled me out of theater. I had been a theater person—a student and producer of monologists. Sidney said that America needs a new kind of preacher who is post-religious, but who understands that even secular Americans derive meaning from Bible stories. Sidney kept saying, "It's basic to Americans that we run our meaning on simple moral tales," and he said, "Artists *get* this, artists who have Americans in their audience get this." So he took me on a ride and hired me away from my own theater. I went to conventions and gatherings studying the historic Jesus and the non-biblical or extra-biblical Jesus. Finally I found myself on Forty-Second Street in New York City, in front of the Disney Store with Reverend Sidney Lanier instructing me that our new devil was Mickey Mouse. Disney was our devil (with products made in sweatshops, and union busters)—it is very much a company that invades the dream life of children, very much a religious system. I led discussions out on that sidewalk about consumerism with German tourists and Japanese tourists. . . . I probably was out in front of the Disney Store for a year and a half before the group that was with me on the sidewalk went into the store, and we continued our town hall meeting inside.

SAVITRI D. What is so interesting is how this coincides with the antiglobalization movement. At that time, there was a growing group of people who were also in front of the Disney Store in what was an increasingly unified social movement, a global one, and Billy happened to be there, and they recognized that he was a bullhorn. He was a bullhorn for them, and those activists claimed Reverend Billy as part of their culture. Appropriating this character Reverend Billy—this white Christian guy from the Midwest—turned out to be useful and political and dynamic, and had so much traction in a political context: the activists saw that and saw Reverend Billy as a tool. To me that is as much a part of the creation story of Reverend Billy as the mentoring he went through with Sidney. And at the time, Billy was open enough to recognize that this was a better way to go, better than trying to make this art or theater, so he said yes. It's like that ultimate theatrical rule: say yes. There are people in front of him saying yes, so say yes. And I think that's really how he got swept into what we now look at as creative resistance or culture jamming.

MARILYN DELAURE. Tell me about what happened once you went inside the Disney Store.

BILL TALEN. We have one action called the Cell Phone Opera, where twelve or fifteen of us would go into the Disney Store and situate ourselves near other customers. (We would have practiced this off-site before we came in play-acting.) So you're buying a gift for your niece, and you're not quite sure of the gift, so you need to ask about whether it's okay to purchase a Pocahontas doll that has a little wasp waist. So you pretend to "call" the mother and start a discussion, and then start having an argument with her. Maybe the mother says, "Oh yeah, that's okay." And you say, "You know what? I don't have that thin of a waist myself," and you start arguing with your sister-in-law or whoever it is. The audience—other shoppers—can overhear you without feeling like they are invading. But these "calls" are happening all over the store, as our choir members are staging arguments with friends or families on their cell phones. Gradually, the volume of these arguments increases, and they get more intense, and before you know it, the other shoppers are backing off and seeing that in each aisle, there is a cell phone person who is having a conversation with a relative about the gift they were supposed to buy, an errand that

has become controversial. Then you look around and you realize that the entire place . . . of course, the manager of the store makes this same discovery, and what would happen at this point as our volume rose, sometimes the manager of the store would turn up Elton John or Julie Andrews or whoever is on the soundtrack at that moment. So you have all these people shouting into the cell phones, and then they start singing into their cellphones, but at that point you'll have "Chim chiminee, chim cheroo!"—the soundtrack from the store cranked way up and it becomes really chaotic! Then you get a signal from the action captain to start handing out the information about the sweatshops.

MARILYN DELAURE. And eventually you're ushered out of the store by someone . . .

BILL TALEN. Or to jail. I've definitely gone from that situation to jail.

MARILYN DELAURE. How do shoppers in the store react?

BILL TALEN. Now in the Disney Store in particular—but also at Starbucks or Chase Bank—once you were seen to have repurposed the space away from the general design of the corporate retailer, people jump in different directions. Some people start shaking, some people giggle, some start clapping; we've even had some people join the choir at that point. People are suddenly released from their own relationship (which they didn't realize was so strict) to that overall macro-retail design. And it's interesting to watch people go all over the place.

SAVITRI D. To see how mad people get—

BILL TALEN. Some people cover up their children's heads, and to some parents, it's just awful that the basic script has been violated, and they cover their kid's head and rush out the door. They think it's violent.

SAVITRI D. Or rude, rude. [They say,] "Stop being rude!"

BILL TALEN. Yeah—

SAVITRI D. And you know, well, I think a sweatshop is kind of rude.

MARILYN DELAURE. Savitri, in your essay "Missed Cues, Stolen Script" (2011) you write: "We make it our mission to open up seams on the edges of things, break open space. . . . Retail environments, with their lack of feedback and human connection, are incubators of isolation, alienation, and crisis. And that's what happens when public space gets dismantled, when the First Amendment is abandoned,

when the primacy of openness gives way to the primacy of profit."
Tell me about that process, how you break open space.

SAVITRI D. To begin with, most retail space resembles other retail
spaces. . . . Those spaces are not that different from each other. The
entrance might be at a different angle, the cash register might be in
a different position, but essentially those are replicated rooms. They
are all just like the other ones. So over time you begin quite easily to
imagine what might happen and how you will be physically in that
space. But we do approach it choreographically: we will look and see
where the best view is, who is going to see it, who is the audience.
You ask all those basic blocking questions, and then I think you have
to just throw all that to the wind, and just let the performance take
over, and that's where having performance chops really helps.

What you quickly realize is that there are only about three or four
things going on in those spaces. You reach into the pocket, reach
out from the body, above the waist interaction with people around
you, low eye-contact, maybe smiling but not *too much* smiling, the
volume is always at a certain level: it's a very contained and pro-
scribed environment. And so if you start doing something even the
slightest bit off—I mean if I went on and I was just wobbling like
this [wobbles upper torso and head] and just doing all the things
I'd normally do as a shopper, people might be thinking, "Oh she's a
freak," but then I start saying, "Well you know, gosh! I always heard
that fair trade coffee was a lot easier on your body, but I was drinking
it all day and ugh, maybe I should switch back to the non-fair trade
coffee?!" I mean, I can have a whole normal conversation with you
and one little thing is adjusted in that space and it becomes crazy,
you know?

BILL TALEN. One time Savitri was in a Starbucks, and she started say-
ing the word "Starbucks" repeatedly. "Starbucks, Starbucks."

SAVITRI D. Not even very loud—just slightly above normal conversa-
tional volume.

BILL TALEN. And a security person asked you to leave.

SAVITRI D. No, they called the cops, and I was practically arrested.

MARILYN DELAURE. You've recently expanded your ministry from
"Stop Shopping" to address climate change with the "Revolt of the
Golden Toad" campaign, where you and the Stop Shopping Choir

members don beautiful golden toad masks and invade branch offices
of the big banks, like Chase. What are your aims with this campaign?

BILL TALEN. We are hoping to suggest that species and ecosystems
have been impacted in a deadly way by the investments of those
institutions. Especially at the time that Hurricane Sandy seemed to
be aimed at Wall Street, we noticed that there's an absence of any
causality suggested between Wall Street and climate change. But our
research indicates that Chase, Citibank, B of A, UVS, HSBC, Royal
Bank of Scotland, Deutsche Bank—these banks are actively, on a
daily basis, moving billions of dollars into coal-fired power which is
responsible for 40 percent of global CO_2 emissions. So that collec-
tive censorship that we all participate in, just not publicly asking the
question, "Where does the CO_2 come from?"—we noticed that, and
we just thought, well, let's step into that gap, into that silence with a
species that most scientists agree has been killed by climate change,
the golden toad from Central America. So it's about getting the
information out there: people see a bunch of orange-looking frogs
in a bank lobby. They need something else as well. They need some
text, they need some verbiage, which comes from the preaching and
the singing, and then from the handouts, and then with the handouts
you can go all the way to the websites, to Facebook, and then you can
point people directly to Rainforest Action Network and to Bank-
Track.org and then Benevolence, which is actively researching the
investments of the individual banks.

SAVITRI D. But let's divorce ourselves right away from any kind of
self-satisfaction—because this might be great what we're doing,
but it's not working. We are trying as hard as we can every day, but
eventually it's time for all activists and all artists to be realistic about
how much impact we're having. There are not many people at this
point who don't know about climate change. This is not an educa-
tional campaign. So either we are going to end capitalism and turn
consumers back into citizens and become citizens of the Earth again
(or for the first time for some of us)—or not. I don't think any of us
should kid ourselves about effectiveness at this point. I mean we are
doing what we can, and we are going to try everything we can until
we just keel over, and Billy doesn't like it when I talk like this because
he is a more cheerful person than I am.

Yes, we have had successes in our campaigns; we have changed corporate practice on a large-scale . . . but it's not nearly enough. The Limited Brands can start using recycled paper, and that's a big deal. They use so much paper for Victoria Secret catalogues that they have to repurpose other paper mills so there's enough recycled pulp. I mean you can affect things at a pretty large scale and still not affect anything at all. It's a really tough time to make work and keep making work.

MARILYN DELAURE. Yes, this is a crucial question with culture jamming or with any form of activism: Is it making a difference?

SAVITRI D. Well, it is making more of a difference than if we weren't doing it at all. . . . I can be sure of that. Is it making *enough* of a difference? We have people every day contacting us, writing us, and talking to us and telling us what's happening in their world, and this is coming into them in a real way . . . and then you know I can say yes to those things, it's just . . . the picture is not getting rosier out there.

MARILYN DELAURE. Savitri, in your essay "Coney Island: The Mermaid in the Window" (2011), you write, "Maybe reinvigorating our imaginations, our sense of play, is the way, at least a way, back to our politics. We start with fairy tales and pretty soon we are marching out to sea. Crack open the imagination, inspire naiveté, stir up dreams and memories, and find the seed of another imagining: You mean we might be able to wrest a beloved place from an unscrupulous developer? Or a corrupt government? We might actually save Coney Island?" Tell me about how your work brings imagination and play into activism.

SAVITRI D. Well, I'm just always still amazed that I still have an imagination! I'm amazed that in the midst of the American monoculture, that I can have one, and believe me, days go by where I don't have one. I do know that the way out of the monoculture has always been, for me personally and culturally—I mean I grew up in the 1980s, and the only way out of the 1980s was imagination—it was music and it was books. But now, I feel like you have to fight *against* culture to get your imagination.

BILL TALEN. And it's not just the corporate marketing—there are so many entities, so many objects, so much language and imagery representing itself *as our imagination* that comes from the outside . . .

SAVITRI D. I mean you could go up to the most imaginative person you know and say, "Yeah, okay, here, this is a thought experiment for you. What about if there was no more capitalism?" And you will be amazed, 99.9 percent of people will have no thought. They'll just say, "What? What?" And you'll say, "No, no, just dream for a second and dream of the fairyland with moss and tiny little creatures. . . . I mean the place where instead of money we rub heads together and make our scalps glow," or whatever the imaginative response might be. I mean you can't even do that at a cocktail party, so how are we actually supposed to conceive of a world that's different from this one if we can't even in a playful way imagine anything else?

 I just think if we could give ourselves those tools, those tactics— and maybe that's where culture jamming is actually the most effective—you can just pretend for a minute, you can pretend something else. I grew up in the woods. For me there was always a place where I could go and find my creative self, because if you're in an actual integrated environment like a forest . . . anytime you look at the bark of tree, suddenly you realize, oh I didn't know there were ten colors of brown in that one square inch. But in the monoculture that's much harder. That complexity doesn't talk back to you. What talks back to you? Nothing. You just get depressed, and then your brain shuts down, and you don't have any ideas.

MARILYN DELAURE. It strikes me that there are different types of attention: you're paying attention in a quiet and focused and deep way to the ten colors of brown in the square inch of bark, whereas if you're immersed in the screen devices in your hand or on your desk, with everything that you're watching, there's so much coming at you. And even the way television has changed since we were kids: there used to be just one person talking and maybe a logo in the corner. Now you watch CNN and there are eight different things going on simultaneously, including that ticker across the bottom. . . . So we are constantly in this state of hyper-distraction, and are unable to pay deep attention to anything.

BILL TALEN. That's right, that's right.

MARILYN DELAURE. That's the root of a lot of these problems.

SAVITRI D. I definitely think it is. One thing we can do is give each other permission to disengage from that mainstream culture. That's

definitely a purpose that the Church of Stop Shopping serves . . .
because there are all these people who are in the commercial space of
the Internet and/or that kind of quasi- . . . what is it? What is going
on? Am I working, am I surfing? And then they encounter this thing
that sort of gives them permission to . . .

BILL TALEN. Stop shopping!

NOTE

1 In 1963, Sidney Lanier gutted St. Clement's Episcopal Church in Manhattan, trans-
forming it into the experimental and influential American Place Theater. Lanier,
who was a cousin of playwright Tennessee Williams, passed away in October 2013,
not long after this interview was conducted.

REFERENCES

Savitri D. 2011. "Coney Island: The Mermaid in the Window." In *The Reverend Billy
Project*, by Bill Talen and Savitri D, edited and with an Introduction by Alisa Solo-
mon, 63–80. Ann Arbor: University of Michigan Press.

Savitri D. 2011. "Missed Cues, Stolen Script." In *The Reverend Billy Project*, by Bill
Talen and Savitri D, edited and with an Introduction by Alisa Solomon, 84–94. Ann
Arbor: University of Michigan Press.

Andy Bichlbaum and Mike Bonnano, also known as the Yes Men, have been pranking and hoaxing and jamming for nearly two decades, performing identity correction on Barbie dolls, political candidates, corporations, and entities like the WTO.

Anna Baranchuk earned her BA and MS in Modern Philology from Minsk State Linguistic University (Belarus), her MA in Discourse and Argumentation Studies from the University of Amsterdam (Netherlands), and is currently a doctoral candidate in Public Communication at Georgia State University.

Andrew Boyd is an author, humorist, and long-time veteran of creative campaigns for social change. He led the decade-long satirical media campaign "Billionaires for Bush," co-founded the Other 98%, and has launched the handbook and platform *Beautiful Trouble: A Toolbox for Revolution* (2012). He's the author of several books, including *Daily Afflictions, Life's Little Deconstruction Book* (2002) and the forthcoming *I Want a Better Catastrophe: Hope, Hopelessness, and Climate Reality*. Unable to come up with his own lifelong ambition, he's been cribbing from Milan Kundera: "To unite the utmost seriousness of question with the utmost lightness of form." He and his laptop live in New York; you can find him at andrewboyd.com and beautifultrouble.org.

Jack Bratich is Associate Professor in the Department of Journalism and Media Studies at Rutgers University. His research critically examines the intersection of popular culture and political culture. He is author of *Conspiracy Panics: Political Rationality and Popular Culture* (2008) and co-editor, along with Jeremy Packer and Cameron McCarthy, of *Foucault, Cultural Studies, and Governmentality* (2003).

xtine burrough is a media artist and scholar. She is co-editor with Eduardo Navas and Owen Gallagher of *The Routledge Companion to Remix Studies* (2014), author of *Foundations of Digital Art and Design* (2013), and editor of *Net Works: Case Studies in Web Art and Design* (2012). Informed by the history of conceptual art, she uses social networking, databases, search engines, blogs, and applications in combination with popular sites like Facebook, YouTube, or Mechanical Turk to create web communities promoting interpretation and autonomy. As Associate Professor at The University of Texas at Dallas, she bridges the gap between histories, theories, and production in new media art and education. Her website is at missconceptions.net.

Paolo Cirio, an Italian media artist and hacker, works with information systems to impact norms and dynamics of social systems. Cirio's artworks investigate fields affected by communication networks, such as privacy, copyright, finance, and law. His work has been exhibited in leading museums worldwide, and he has won prestigious art awards including the Golden Nica at Ars Electronica, the Transmediale Prize, and the Eyebeam fellowship. Cirio is also regularly threatened with prosecution for his subversive actions, which have been covered in the global media.

Christof Decker is Professor of American Studies at the Ludwig-Maximilians-University in Munich (LMU). He has published widely on documentary and Hollywood cinema, avant-garde film, literary and cultural history, melodrama, and the history of mass media. Most recently he edited *Visuelle Kulturen der USA* [Visual cultures of the USA] (2010) and co-edited with Astrid Böger *Transnational Mediations: Negotiating Popular Culture between Europe and the United States* (2015).

Marilyn DeLaure is Associate Professor in the Communication Studies Department at the University of San Francisco. Her research explores how people work to effect social change and focuses specifically on embodied performance. She has published a number of essays on dance, civil rights rhetoric, and environmental activism.

Mark Dery is a cultural critic. His writings on media, technology, pop culture, and American society have appeared in *Artforum*, *Cabinet*, *Elle*, the *New Yorker*, the *New York Times Magazine*, *Rolling Stone*, *Salon*, *Spin*, and *Wired*, among others. He lectures frequently in the United States and abroad. Dery's books include *The Pyrotechnic Insanitarium: American Culture on the Brink* (1999) and *Escape Velocity: Cyberculture at the End of the Century* (1996), which has been translated into eight languages. He edited the scholarly anthology *Flame Wars: The Discourse of Cyberculture* (1994) and wrote the monograph *Culture Jamming: Hacking, Slashing, and Sniping in the Empire of Signs* (1993). His latest book is the essay collection *I Must Not Think Bad Thoughts* (2012).

Marco Deseriis is Assistant Professor in the Program in Media and Screen Studies at Northeastern University. He is the author of *Improper Names: Collective Pseudonyms from the Luddites to Anonymous* (2015) and co-author with Marano Giuseppe of *Net.Art: L'Arte della Connessione* (2008). In the 2000s, Deseriis collaborated with culture jamming groups such as the Yes Men and 0100101110101101.org and helped organize the culture jamming festival "The Influencers" in Barcelona.

Benedikt Feiten is a freelance writer. He studied American Literature at the University of Munich, where he completed a doctoral dissertation about music and transnationalism in the films of Jim Jarmusch. His academic interests include independent film, film music, graphic novels, narratology, transnationalism, and strategies of subversion.

Moritz Fink is a media scholar and author. He holds a doctoral degree in American Studies from the University of Munich, and has published on *The Simpsons*, media satire, and visual representations of the grotesque.

The Guerrilla Girls are a bunch of anonymous culture jammers who use facts, humor, and outrageous visuals to expose discrimination and corruption in art, film, politics, and pop culture. Over the past thirty-one years they have reinvented the f-word "feminism" in more than a hundred posters, street projects, actions, books, and billboards. Most recently they did a stealth sticker campaign in New York about the super-rich hijacking

art, and a billboard in Reykjavik about discrimination in the Icelandic film industry. Their retrospectives in Bilbao and Madrid have attracted thousands. They travel the world doing gigs and workshops, collaborating with others who want to create their own activist campaigns.

Christine Harold is Associate Professor of Communication at the University of Washington. Her research explores opportunities for meaningful political action in a world increasingly defined by the logics and rhetorics of the marketplace. Her book, *OurSpace: Resisting the Corporate Control of Culture* (2007), evaluates strategies of resistance to the commercialization of public life.

IOCOSE is a collective of four artists who have been working as a group since 2006. IOCOSE's art investigates the after-failure moment of the teleological narratives of technological development, in regard to both their enthusiastic and pessimistic visions. They have exhibited internationally at several art institutions and festivals, including the Venice Biennale (2011, 2013), Tate Modern (London, 2011), Science Gallery (Dublin, 2012), Jeu de Paume (Paris, 2011), FACT (Liverpool, 2012), and Transmediale (Berlin, 2013, 2015), and have been featured in publications such as *Wired* magazine, *The Creators Project, Flash Art, Neural, Liberation, Spiegel,* and *El País.* Their website is at iocose.org.

Henry Jenkins is the Provost's Professor of Communication, Journalism, and Cinematic Arts at the University of Southern California. He is the author and/or editor of twelve books on various aspects of media and popular culture, including *Textual Poachers: Television Fans and Participatory Culture* (1992), *Hop on Pop: The Politics and Pleasures of Popular Culture* (2003), *Fans, Bloggers and Gamers: Exploring Participatory Culture* (2006), and *Convergence Culture: Where Old and New Media Collide* (2006). His latest co-authored book, with Sangita Shresthova, Neta Kligler-Vilinchik, Liana Gamber-Thompson, and Arely Zimmerman, is *By Any Media Necessary: The New Youth Activism* (2016). He has also written for *Technology Review, Computer Games, Salon,* and the *Huffington Post.*

Michael LeVan is an independent scholar in Vancouver, WA. His research explores intersections among aesthetics, political philosophy,

performance studies, and public memory. His essays have appeared in *Performance Research*, *Text & Performance Quarterly*, and *International Journal of Translation*. He is editor of *Liminalities: A Journal of Performance Studies*.

Mark LeVine is Professor of Modern Middle Eastern history at University of California, Irvine, and Distinguished Visiting Professor at the Center for Middle Eastern Studies at Lund University. A long-time columnist at *Al-Jazeera* and a professional musician working with artists across Africa, the Middle East, and Europe, he is the author of *Heavy Metal Islam: Rock, Resistance and the Struggle for the Soul of Islam* (2008), *Impossible Peace: Israel/Palestine since 1989* (2009), and *The Five-Year-Old Who Toppled a Pharaoh* (forthcoming), as well as co-editor, with Gershon Shafir, of *Struggle and Survival in Palestine/ Israel* (2012).

Evelyn McDonnell is Associate Professor of English and Director of the Journalism Program at Loyola Marymount University. She is the author or co-editor of six books, including *Mamarama: A Memoir of Sex, Kids, and Rock 'n' Roll* (2007) and *Queens of Noise: The Real Story of the Runaways* (2013). Her articles have appeared in the *New York Times*, the *Los Angeles Times*, *Rolling Stone*, the *Village Voice*, *Spin*, *Ms.*, and many other publications.

Kembrew McLeod is Professor of Communication Studies at the University of Iowa and an independent documentary filmmaker. McLeod's books include *Freedom of Expression®: Resistance and Repression in the Age of Intellectual Property* (2007), *Creative License: The Law and Culture of Digital Sampling* (2011, co-authored with Peter DiCola), *Pranksters: Making Mischief in the Modern World* (2014), the anthology *Cutting across Media: Interventionist Collage, Appropriation Art, and Copyright Law* (2011, co-edited with Rudolf Kuenzli), and *Parallel Lines* (2016), about Blondie, punk, and disco in the 1970s. McLeod's music and cultural criticism have appeared in *Rolling Stone*, the *New York Times*, the *Washington Post*, the *Los Angeles Times*, *Wilson Quarterly*, the *Village Voice*, *MOJO*, *SPIN*, and the *New Rolling Stone Album Guide*.

Wazhmah Osman is a filmmaker and Assistant Professor in the Department of Media Studies and Production at Temple University. Currently, she is writing a book analyzing the impact of international funding and cross-border media flows in Afghanistan. She is also researching how new technologies of war, violence, and representation, predicated on old colonial tropes, are being repackaged and deployed in "The War on Terror." Her critically acclaimed documentary *Postcards from Tora Bora* has screened in festivals nationally and internationally.

Tony Perucci is Associate Professor of Communication at the University of North Carolina at Chapel Hill. He is the author of *Paul Robeson and the Cold War Performance Complex: Race, Madness, Activism* (2012). His writings on the politics and aesthetics of performance have appeared in the journals *Performance Research, TDR: The Drama Review, Text and Performance Quarterly*, and *Liminalities*, as well as the books *Iraq War Cultures* (2011), *Performing Adaptations* (2010), and *Violence Performed* (2010). He is a founding member of The Performance Collective, which makes performance and trouble.

Bill Talen (Reverend Billy) and Savitri D are directors of the Church of Stop Shopping, a New York City–based radical performance community with fifty performing members and a congregation in the thousands. They are wild anticonsumerist gospel shouters, as well as earth-loving urban activists who have worked with communities on four continents defending land, life, and imagination from reckless development and the extractive imperatives of global capital. They employ multiple tactics and creative strategies, including cash register exorcisms, retail interventions, and cell phone operas, combined with grass roots organizing and media activism.

Michael Serazio is Assistant Professor in the Department of Communication at Boston College. His studies focus on popular culture, advertising, politics, and new media. He is the author of *Your Ad Here: The Cool Sell of Guerrilla Marketing* (2013). His scholarly work has appeared in the *Journal of Communication*, the *International Journal of Communication, Critical Studies in Media Communication*, the *Journal of Consumer Culture, Communication Culture & Critique*, and *Televi-*

sion & New Media, and he has written essays on media and culture for the *Atlantic*, the *Wall Street Journal*, the *New Republic*, the *Nation*, and *Salon*.

Rebecca Walker is Assistant Professor in the Department of Communication Studies at Southern Illinois University–Carbondale, where she teaches classes in performance studies and persuasive communication. Her research on flash mobs has been published in *Text and Performance Quarterly*, *Liminalities: A Journal of Performance Studies*, and the *Kenneth Burke Journal of Communication*.

INDEX

Abel, Alan, 94–99

ACT UP, 48, 50

Adbusters (magazine)/Adbusters Media
Foundation, 8–9, 14, 21, 25–27, 49,
62–64, 66–67, 72, 79, 85, 87, 113–14, 143,
153, 186, 238, 243, 245–46, 251–52, 262–
64, 270, 281, 289, 322–24, 326, 330–32,
342n4, 411, 427; "Blackspot" sneaker,
26–27, 62–63, 67, 88, 251, 411; Buy Noth-
ing Day, 9, 411; "Joe Chemo," 13, 63, 85,
243, 262–63; Occupy Wall Street (*see*
Occupy Wall Street movement); TV
Turnoff Week, 9

Adorno, Theodor, xi, 93, 116–17, 121–22,
128–29, 131n6. *See also* Frankfurt
School

ad parodies. *See under* parody

Afghanistan, 106, 348–49, 352, 359–60,
363n2; US intervention in, 20, 349, 352,
355, 359–60

Agamben, Giorgio, 116, 201, 210, 212

Ant Farm, 39–40, 133

antiglobalization movement, 10, 113, 128,
135, 239, 276n1, 418–19, 434. *See also* G8
summit in Genoa; International Mon-
etary Fund; World Trade Organization

Anonymous, 16, 337

Apple (multimedia corporation), 229, 251;
parodied on *The Simpsons*, 267–70,
277n5

appropriation, 8, 11–14, 27, 63, 68–68,
73–74, 77, 85, 101, 106, 121, 134, 153, 180–
89, 196, 198–99, 218, 223, 228, 232–33,
238–39, 241, 250, 260, 264, 267, 272, 274,
276, 278n15, 341, 344n18, 356, 372, 427,
434, 434

appropriation art, 8, 14, 184, 186, 218; legal
challenges posed by, 14, 197–99

Arab Spring, 16, 115, 125–30, 136, 139, 371;
post–Arab Spring era, 129–30

Artaud, Antonin, 8, 23, 47, 292

Artfux, 52–53

Associated Press (AP), 14, 75, 179; lawsuit
against Fairey, 180, 194–99; Obama
photo by Garcia, 179, 188, 194, 197

A/Traverso (collective), 100–101

Autonome a.f.r.i.k.a. gruppe, 10, 17, 99–
100

Bakhtin, Mikhail, 31n14, 64, 377

Ballyhoo (satire magazine), 16, 256, 259,
262, 264, 276

Banet-Weiser, Sarah, 26, 181, 195, 228

Banksy, 13, 15–17, 195, 218–19, 276n2; and
advertising, 219, 227, 230; anonymous
identity of, 218, 221; being co-opted,
227–28; challenging museum art, 219,
221–22, 224, 234n5; *IKEA Punk*, 229–32;
Israeli West Bank Barrier paintings,
227; *Mona Lisa* remix, 219, 224, 228;
operating in public space, 219–20, 230,
225–26

Barbie Liberation Organization (BLO), 19,
74–76, 80

Barthes, Roland, 53, 117, 130n2, 209–10,
271, 294

Baudrillard, Jean, 45, 54, 91, 93, 223, 351.
See also hyperreality